Comic Art in Africa, Asia, Australia, and Latin America through 2000

Comic Art in Africa, Asia, Australia, and Latin America through 2000

An International Bibliography

John A. Lent

Bibliographies and Indexes in Popular Culture, Number 11

PRAEGER

Westport, Connecticut
London

Library of Congress Cataloging-in-Publication Data

Lent, John A.
 Comic art in Africa, Asia, Australia, and Latin America through 2000 : an international
bibliography / John A. Lent.
 p. cm. — (Bibliographies and indexes in popular culture, ISSN 1066–0658 ; no. 11)
 Updated version of Comic art in Africa, Asia, Australia, and Latin America.
 Includes index.
 ISBN 0–313–31210–9 (alk. paper)
 1. Caricatures and cartoons—History—Bibliography 2. Wit and humor,
Pictorial—Bibliography. I. Comic art in Africa, Asia, Australia, and Latin America. II.
Title. III. Series.
 Z5956.C3L458 2004
 [NC1325]
 016.7415′09—dc22 2004040078

British Library Cataloguing in Publication Data is available.

Library of Congress Catalog Card Number: 2004040078
ISBN: 0–313–31210–9
ISSN: 1066–0658

First published in 2004

Praeger Publishers, 88 Post Road West, Westport, CT 06881
An imprint of Greenwood Publishing Group, Inc.
www.praeger.com

Printed in the United States of America

The paper used in this book complies with the
Permanent Paper Standard issued by the National
Information Standards Organization (Z39.48–1984).

10 9 8 7 6 5 4 3 2 1

CONTENTS

PREFACE

It is gratifying to witness the acceleration of professional and scholarly dimensions concerning comic art in the past decade and a half. Academic conferences in mass communications and popular culture, and occasionally in other disciplines, feature panels and/or papers, rare activity before the late 1980s. Articles appear regularly in various periodicals, including trade, fan, professional, and academic magazines and journals, and books on comic art are becoming so plentiful that entire presses (Fantagraphics, now defunct Kitchen Sink) and parts of others (such as Hampton, McFarland, University of Mississippi, Greenwood) are devoted to them. Two academic journals, *International Journal of Comic Art* and the defunct *Inks*, have served the field. There are other good signs of the professionalization of cartooning studies – the creation of comic art conferences (Comic Art Conference aligned with the San Diego comics convention, International Comic Art Festival) and comics groups within Popular Culture Association and International Association for Media and Communication Research, and a belated acceptance of comic art scholarship in the academy, with scattered courses and some dissertations and theses. University of São Paulo in Brazil for a number of years had a degree program in comics, perhaps a first worldwide, and in a short span in the mid- to late-1990s, South Korea started about 40 animation studies (mainly practical) programs. At my own university, I have supervised nine Ph.D. dissertations and six other graduate students' research on comic art of China, Cuba, India, Japan, Kenya, Korea, Nepal, Peru, Taiwan, Thailand, and Turkey.

The regions identified in this book (Africa, Middle East, Asia, Australia/Oceania, Latin America and Caribbean), were always short shrifted in the little scholarship done on comic art. (Japan is an exception.) But, even that is changing. The compiler of this bibliography has been responsible for books on comic art of Asia (*Animation in Asia and the Pacific*, *Illustrating Asia*, *Themes and Issues in Cartooning*, and *Pipeline to Toontown: Korean Animation* [with Kie-un Yu, Hampton, forthcoming]), Africa (*Cartooning in Africa*,

Hampton, in press), and Latin America (*Cartooning in Latin America*, Hampton, in press), as well as special numbers of *Asian Cinema, Asian Thought and Society, Journal of Asian Pacific Communication, Philippines Communication Journal*, and *Southeast Asian Journal of Social Science*, and numerous articles, panels and paper presentations on cartooning in these regions.

In Latin America, scholars and cartoonists have biennial conferences on comic art and publish a quarterly, *Revista Latinamericana de Estudios sobre la Historieta*; the Japanese manga scholars have organized, as have the animation researchers. They publish *Manga Studies* and *The Japanese Journal of Animation Studies*, respectively. University of Botswana professors have taken the initiative in attempting to organize southern African cartoonists. In a few countries, not many to be sure, libraries have seen the need to collect and preserve cartoon materials.

This bibliography, as did its 1996 predecessor, *Comic Art in Africa, Asia, Australia, and Latin America: A Comprehensive International Bibliography*, attempts to redress some of the shortcomings concerning scholarship in these regions, by providing a bibliographic database of all types of comic art (animation, caricature, comic books and magazines, comic strips, editorial or political cartoons, gag, illustrative, and magazine cartoons, and humor magazines), organized by continent or region, country, and a number of identifying characteristics. The present volume is part of a planned six-book set, three others on the United States and Canada and two on Europe. All six works are fuller in numbers of citations, not simply because of an expansion of writings on comic art, but also because of the compiler's opportunities to search for bibliographic items on site while lecturing or researching in various countries. For instance, in the 1996 chapter on Africa, South Africa merited 33 citations; this version has 570 South African sources mainly because of what I was able to find in Durban and Johannesburg during a 1996 visit. Similarly, New Zealand went from 27 citations in the earlier listing, to 156 in this one, largely because of my interviews in Auckland in 1999.

Thus, some countries have many more citations than others for the above reason, but the unevenness is also attributable to: 1. In some countries, cartooning is more developed as a profession or is more often a subject of journalistic or academic scrutiny, 2. Some countries have benefited from the arduous efforts of an individual(s) who did bibliographic work on cartooning.

This and the other five new volumes are additions to those published in 1994 and 1996, and a serious attempt was made not to duplicate what appeared earlier. The earlier volumes should be used in conjunction with the current ones; not to do this can lead to misperceptions. To take a few examples, the

current Africa, Asia, Australia, Latin America bibliography lists one citation on Mexico's Ríus, while the 1996 book had 51; Brazil's K. Lixto and Mexico's Miguel Covarrubias had 33 and 45, respectively earlier, and two and none in this volume.

Eighty-seven countries are included here (as opposed to 67 in the 1996 volume). Twenty-eight are in Asia, 23 in Africa, 15 in South and Central America, 9 in the Middle East, 8 in the Caribbean, and 4 in Australia/Oceania. Of course, the numbers of citations are very lopsided, ranging from hundreds on China, Japan, South Korea, and South Africa to only one on Ivory Coast, Kazakhstan, Uzbekistan, Maldives, Paraguay, Barbados, Haiti, etc.

Most of the work in this volume deals with the individual countries, although most chapters begin with a section on continental and inter-country perspectives. This section is subdivided by categories such as references, general sources, animation, caricature, comic books, comic strips, and political cartoons. Of course, the degree of sub-categorizing depends on the number of citations. Most chapters and some larger country listings have a general sources section, usually consisting of items that are either too general or too vague to fit elsewhere or that are cross category in nature. The Asia and Central and South America chapters also contain periodical directories of 34 and five entries, respectively. The directories provide names, addresses, typical contents, and inaugural dates for comic art-related journals, magazines, and fanzines. (As with other topics, the user of this volume should also check the global and comparative perspectives chapter of the current Europe volume, as well as similar sections in the 1994 and 1996 books, for additional periodicals.)

The more substantial chapters contain sections on references, general sources, cartooning and cartoons, cartoonists and their works, characters and titles, animation, caricature, comic books, comic strips, and political cartoons, and are sometimes further split into anthologies, artistic aspects, festivals and exhibitions, genres, historical aspects, legal aspects, technical aspects, etc. The huge Japan component is divided into *anime* and *manga*, with many of the above categories under each.

Wherever they appear, sections on resources include any of the following: bibliographies, dictionaries, encyclopedias, catalogues, collections, libraries, checklists, guides, fanzines, and indices. Historical aspects include citations that by their approach or content denote history, and the cartooning and cartoons category takes in genres not provided separate headings (gag, illustrative, and magazine cartoons), as well as festivals, competitions, exhibitions, training, humor magazines, professionalism, business aspects, governmental and legal aspects, and multi-cartoonist anthologies. Throughout,

cartoonists and their works is a catch-all category, also including a few individuals who are not cartoonists but who are closely aligned to the profession. The criterion used in giving a cartoonist or cartooning-related individual a separate heading is that he or she was the subject of at least two citations. This does not necessarily relate to the cartoonist's status, but more pragmatically to the number of sources I found on him/her. Cartoonists and their works consists of autobiographies, biographies, memoirs, profiles, interviews, sketchbooks, news items, and obituaries.

The category characters and titles also breaks out those that merited at least two citations. In some periodicals, cartoonist profiles are intermingled with accounts of their characters or the titled works for which they are known. Thus, the user of this bibliography will find in the sections on characters and titles much biographical information about the authors of those works, and conversely, much on characters and titles in cartoonists' profiles and interviews.

Difficulties presented themselves while I was compiling these bibliographies. The word "caricature" in some countries takes on more meanings than in the United States, including cartooning in a general sense. In some countries, it is hard to distinguish comic strip from comic book, and even gag cartoon from political cartoon. It can be a chore in South Korea, for instance, figuring out what is meant by the terms comic book, comic magazine, or comic strip. Also, animation and cartoon are used interchangeably in different places. Throughout, it was often difficult categorizing cartoonists by genre and by country. Some artists work in nearly all types of comic art and are almost unclassifiable. The late Larry Alcala of the Philippines was a gag, strip, *komiks*, and political cartoonist, as well as animator; the same with Malaysia's Lat (Mohd. Nor Khalid) who does social commentary, gag, and strip cartoons and animation. The constant migration of African, South American, Caribbean, and to lesser degrees, Australian/New Zealand and Asian cartoonists, makes it almost impossible to pigeonhole these individuals by country. For example, Napier Dunn has lived and worked as a cartoonist (and/or musician) on every continent. Such multi-genre and multi-country cartoonists were usually placed where they were most prominent; admittedly, some placements were made rather arbitrarily.

Difficult decisions had to be made concerning placement within some of the continental/regional chapters. Especially perplexing were sources on comics in the Islamic and/or Arab world. For convenience sake, they were put in the Middle East chapter, with full recognition that the Islamic/Arab world refers to a religion and national/ethnic groups that extend into North Africa, other parts of Asia, and elsewhere.

Placement of Japanese citations into *anime* and *manga* categories presented problems because of frequent name changes of animation stories and comics titles (especially when exported) and because of the duplicitous nature of *anime* and *manga*. Many titles have both *anime* and *manga* versions, and are parts of series with different names. The user of this bibliography is therefore encouraged to cross-reference the Japanese *anime* and *manga* characters and titles sections.

The citations are in a number of languages. In many cases, only the English translation of titles is given. Although an attempt was made to obtain the most accurate translations in all instances, there were shortcomings. Most citations are full, but again, because of different ways of doing things (in this case, citing) in other cultures, sometimes page numbers and even specific dates are missing. Some periodicals, especially fanzines, are not dated and/or do not number pages. Others change series or alternate, without any seeming logic, between using dates and volume numbers or months and seasons of the year. Also, some citations were taken from clippings in obscure periodicals sent by cartoonists who had not fully documented them.

Nevertheless, a serious effort was put forth to compile a comprehensive and usable bibliography. No item was too small or insignificant to be listed; if it dealt with comic art, it could become a citation. The compiler works on the premise that both systematically-researched and ephemeral materials are useful during the course of developing a field of study.

Having said that, I must point out some limitations on comprehensive-ness. Obviously, it is not possible to know of everything published in thousands of books and periodicals in all corners of the world. Even the so-called new information technology is incapable of knowing this. Oftentimes, the only way to obtain substantial information on a country's cartooning is to go there, an expensive and time-consuming process. Even the librarians in some countries are not of much use in pointing out literature, partly because they have not concerned themselves with comic art, especially where it is considered a lowly popular culture form not worthy of study. So, much like an archeologist, the compiler of a bibliography of this scope and magnitude digs and scratches through all types of materials, looking for a "find."

The bibliography is representative in covering various publications, writing formats and styles, time periods and languages. Most of the citations are current, predominantly from the mid-1990s when the predecessors to these volumes were published, to early 2003. But, hundreds of "older" citations missed in the 1994 and 1996 volumes are picked up here.

Many problems surfaced in the course of doing this work. Some have already been discussed. One especially perplexing problem was the avoidance of duplication when dealing with such a voluminous amount of information presented (sometimes inaccurately) in different bibliographic styles. Although I have attempted to eliminate, or at least to minimize duplication, some is bound to exist.

The citations are arranged alphabetically by author, or by titles of article when an author is not listed, and are numbered consecutively. Rather consistently, the first letters of all words, except short prepositions and conjunctions, are capitalized.

Search Process

The search for literature was mostly manual, since this is the way the compiler works, and because some of the literature, being journalistic, anecdotal, or brief, may not be in computerized databases. Many bibliographies, indices, and bibliographic periodicals, too numerous to list here, were used.

On a regular basis and rather systematically, the compiler has attempted to keep abreast of the literature on mass communications and popular culture for about 40 years. For the most part, works on comic art are expected to be found in those fields, as well as in art. Hundreds of journal titles in these three fields and others, published on all continents, are looked at regularly by the compiler.

No effort is made to list all these periodicals, only those expected to yield some articles. Among the 388 periodicals in my comic art database, perhaps these were most useful: *Animation, Animation Journal, Animation World, Animato!, Animatoon, Animerica, Art AsiaPacific, ASIFA Magazine, ASIFA San Francisco, Bild & Bubbla, Borderline, Cartoonist PROfiles, Comic Art, Comic Book Artist, Comic Effect, Comicguia, Comicology, Comics Buyer's Guide, Comics Journal, El Wendigo, Fat Comic, FECO News, The Funnies Paper, Fūshiga Kenkyū, Gauntlet, Gül Diken, Historia de los Comics, Hogan's Alley, The Hollywood Eclectern, Humor, Humour & Caricature, Inklings, Inks, International Journal of Comic Art, Jack Kirby Collector, Japanese Journal of Animation Studies, Journal of Popular Culture, Karikatürk, Kayhan Caricature, Keverinfo, McBoing Boing's, Mangajin, Manga Max, Mangazine, Nemo, Persimmon, Phénix, Plateau, Ran Tan Plan, Revista Latinoamericana de Estudios sobre la Historieta, Ron Goulart's Comics History Magazine, The Rose, Striprofiel, Stripschrift, Studies in Latin American Popular Culture, Thud, WittyWorld, ZozoLala.*

Additionally, the compiler looked at hundreds of other periodicals in comic art, mass communications, area studies, etc. "Fugitive" materials, such as dissertations not indexed through the University of Michigan, theses, catalogues, conference papers, and pamphlets also make up part of the bibliographies.

Besides using scores of libraries worldwide, the compiler found other ways to gather sources on comic art. Many citations were made available to me during my interviews with hundreds of cartoonists and comic art specialists on every continent. Much of my interviewing has taken place on the continents which are the focus of this book. Just since 1986, I have interviewed cartoonists in Taiwan and Malaysia, 1986; Philippines, 1988; Bahamas and Trinidad, 1990; Cuba, 1991; South Korea, Taiwan, Hong Kong, Philippines, Singapore, Brazil, and Indonesia, 1992; Jamaica, India, Bangladesh, Myanmar, Sri Lanka, Thailand, Malaysia, Vietnam, China, and Japan, 1993; South Korea, 1994; Curaçao, South Korea, 1995; South Africa, Australia, 1996; Cuba, 1998; New Zealand, Australia, and Iran, 1999; Cuba, Singapore, Malaysia, Japan, and Botswana, 2000; Cuba, China, 2001; China, Mexico, Brazil, 2002. Outside these regions, many other interviews were made with cartoonists in Belgium, Canada, France, Hungary, Macedonia, Netherlands, Poland, Scotland, Slovakia, Turkey, Ukraine, U.S., Yugoslavia, and elsewhere.

At various times, generous individuals (acknowledged later) took the time to compile lists of references for their countries. Also, contacts I have made while editing *International Journal of Comic Art* have helped.

ACKNOWLEDGEMENTS

Always at the top of the list of those to whom I owe a great debt of gratitude are the many hundreds of cartoonists and comics authorities I have interviewed on every continent. They are some of the kindest and most interesting people I have met. They have shared with me their experiences, cartoons, scrapbooks, and clippings; they have showered me with hospitality, motored me around crowded cities, found me places to stay, or put me up in their homes, and given me the benefits of their own comic art research.

All of them should be mentioned, but space does not permit. Many of them and other supporters were acknowledged in the first four-volume, comics bibliography series I compiled in 1994 and 1996. Especially helpful in subsequent research, and to whom I am very thankful, are: He Wei, Chen Jian Yao, Linger Liao, Liao Bingxiong, Feng Yiyin, Fang Cheng, and Wang Fu Yang, in China; Park Jae Dong, Nelson Shin, and Kim Song-Whan, in South Korea; Lat (Mohd. Nor Khalid), Muliyadi Mahamood, Rejab Had, Hassan Muthalib, and Jaafar Taib, in Malaysia; Lim Cheng Tju, Hup (Lee Hup Kheng), and Cheah Sin Ann, in Singapore; Massoud Shojaei Tabatabaei, M. Niroumand, Mohamad Rafi-Zeyaei, and Touka Neyestani, in Iran; Tan Oral, Izel Rozental, Turgut Çeviker, and Nezih Danyal, in Turkey; Andy Mason and Neil Napper, in South Africa; Oleg Dergachov and Vladimir Kazanevsky, in Ukraine; Osmani Simanca, in Brazil; Ares (Aristides Hernandez), Garrincha (Gustavo Rodriguez), Lauzén, Caridad Blanco, and scores of other Cuban cartoonists; Frédéric Back, Pierre Hébert, Chris Hinton, in Canada; Julien Bohdanowicz and Marek Wojciech Chmurzyński, in Poland; Julijana Zivković, Branko Najhold, and Yugoslav Vlahovic, in Yugoslavia; Dylan Horrocks, in New Zealand; Peter Nieuwendijk, Ab Moolenaar, and Kees Kousemaker, in the Netherlands, and Hans Nissen and Leif Packalén, of Finland.

Besides planned research trips, other opportunities to gather information firsthand were seized when I was invited to serve on international cartoon competition juries in Brazil, Cuba, Iran, Mexico, Poland, Slovakia, South Korea, and Yugoslavia, and to lecture on comic art in Australia, Botswana, Brazil, Burma, Canada, China, Cuba, France, Hungary, India, Iran, Italy, Japan, Malaysia, Netherlands, Scotland, Singapore, Slovakia, South Africa, South Korea, Spain, Taiwan, Turkey, Ukraine, United States, Yugoslavia, and elsewhere.

Many individuals were extremely kind and generous during my travels in search of cartooning information: China's Dr. Peng Ji Xiang and other Peking University faculty, Dr. Jin Guanju and Shi Chuan, of Shanghai University, and Tian-yi Jin of *New Film Works Magazine*; Dr. Fusami Ogi and Dr. Jaqueline Berndt, in Japan; Dr. Francis B. Nyamnjoh and Dr. Selolwane, of the University of Botswana; Dr. Roh Byungsung, in South Korea; Dean Ligia Maria Vieira da Silva, in Brazil; Marco de Blois, of Cinémathéque Quebécoise; the Doğam family (Elmas, Mahmut, Cahit, Fatos, Mehmet, Seyhmus, and Erim), Murat Bilgütay, Mehmet Ilgürel, and members of Yeni Yüksektepe, all in Turkey; Branko Najhold and Julijana Zivkovic in Serbia, and the Shelest Foundation and Dergachov family (Oleg, Gala, and Vladik), in Ukraine.

Former and current students lent much appreciated support, particularly doctoral students whom I supervised as they wrote Ph.D. dissertations about comic art: Dr. Hongying Liu-Lengyel, on China; Dr. Hsiao Hsiang-wen and Dr. Hong-Chi Shiau, on Taiwan; Dr. Rei Okamoto, on Japan; Dr. Yu Kie-Un, on Korea; Dr. Asli Tunç, on Turkey; Aruna Rao, on India; Levi Obonyo, on Kenya, and Mercedes Diaz on Cuba. Others who carried out comic art fieldwork under my guidance and were very helpful were Fungma Fudong, on Nepal; Dr. Monsinee Keeratikrainon, and Sudjai Karuchit, on Thailand; Jae-Woong Kwon and Sueen Noh, on Korea; Chang-de Liu, on Taiwan, and Teresa Archambeault, on Peru. I am very proud of their accomplishments; at least four of these former and current students are looked upon as the authorities on their countries' cartooning, by academics and cartoonists alike.

Various graduate research assistants have had parts in this ongoing research. On these particular volumes, Mu Lin, Dr. Daiwon Hyun, Dr. Chyun-Fung Shi, Dr. Betsi Grabe, and especially Jae-Woong Kwon and Dr. Asli Tunç, gave yeomen service.

Cartoonists and comic art specialists who kindly made information available included the always encouraging Maurice Horn, who sold or gave me a substantial part of his library; Michael Rhode, who kept me busy in a satisfying way by flooding me daily with materials and citations; Xu Ying, who

searched China's Nationwide Newspapers Writings about Films Catalogue Index and pulled out all citations to animation; Jean-Marie Bertin, who took the time to correct citations in the first volumes and to inventory parts of his huge library and provide me with lists of the books therein; Chieh-chun Lee, who copied every item on comic art in Taipei's Central Library, 1995-97; Kornel Földvári of Slovakia, who at year's end, sends me his copious writings that year on cartoonists; Francisco Tadeo Juan of Spain, who sent many difficult-to-find back numbers of various Spanish comics materials; Fredrik Stromberg of Sweden and Rik Sanders of the Netherlands, who mailed many copies of their periodicals, *Bild & Bubbla* and *Stripschrift*, respectively; Faustino Rodríguez Arbesú, editor of *El Wendigo*, who sent his magazine, its indices, and many clippings; Osvaldo de Sousa of Portugal, who gathered 522 sources (plus some of the works) on Brazil, Portugal, and Spain; Zbigniew Kraska of Poland, who found hundreds of Polish citations for me; Tan Oral of Turkey, who allowed me to rummage through his extensive home library in Istanbul; Karikatürculer Derneği (Cartoonists Association, Turkey) and its bookstore, which gave many numbers of its periodical, *Karikatürk*, and the anthologies it has published; Greta Halsberghe of Belgium, who provided back numbers of *Plateau*; Jorge Artigas, who sent materials on Spanish animation; Louis Cance of France, who made available copies of his *HOP!*; Lauzén of Cuba, who mailed many rare items, and Juan Cerrado, Gary Groth, Jon B. Cooke, Todd Hignite, Dario Mogno, Isao Shimizu, Donald Cook, who sent exchange copies of their periodicals, *Quevedos*, *Comics Journal*, *Comic Book Artist*, *Comic Art*, *Revista Latinoamericana de Estudios Sobre la Historieta*, *Fūshiga Kenkyū*, *The Funnies Paper*, respectively.

I also thank Lisa Dieffenbacher who typed and formatted these volumes with great patience and much skill.

Finally, I want to thank my family, especially my mother, Rose, for her encouragement; my daughter, Andrea Murta and her husband, Dave, for providing many services that freed me to travel, research, and write, as well as my other children, Laura Barrett, John V., Lisa, and Shahnon. And my sincerest gratitude to Xu Ying, for helping with research and in so many other wonderful ways.

I have been a lucky man to have had such friends and collaborators and to have been able to spend my life doing, for the most part, work that was pleasurable and rewarding.

As with my previous works, these bibliographies were completed without outside grants. Temple University awarded me a sabbatical in Spring 2001, giving that greatest of commodities, time, for me to work on three of these

volumes, and Temple's Center for East Asian Studies gave $1,000 towards typing expenses. The other thousands of dollars needed to research and compile these works came from my own pocket.

John A. Lent

1

AFRICA

CONTINENTAL AND INTER-COUNTRY PERSPECTIVES

General Sources

1. Arab, E.G. "La Caricature Comme Arme de Combat." *Révolution Africaine* (Paris). February 1972, pp. 64-65.

2. Lent, John A. "Out of Obscurity: African Cartoonists Make Pitch for Recognition." *Comics Journal.* February 2001, pp. 16-17.

3. Lent, John A. "The Rock-and-a-Hard-Place Options of Cartooning in Southern Africa." *Comics Journal.* May 2001, pp. 49-51.

4. McKee, Neill. "The Adolescent Girl Communication Initiative of Eastern and Southern Africa." In *Drawing Insight,* edited by Joyce Greene and Deborah Reber, pp. 50-54. Penang: Southbound, 1996.

5. Mason, Andy. "Drawing Ridicule." *Action.* No. 231, 2000, pp. 1-3

6. Mwampembwa, Godfrey (Gado). "African Cartoonists Take Risks." *Media Development.* 4/1997, pp. 17-18. (Political cartoons).

7. Ogunbadejo, Bisi. "Cracks." *West Africa.* September 1985, p. 1852.

8. Packalén, Leif. "Africa." *WittyWorld International Cartoon Magazine.* Spring 1997, pp. 4-5.

9. Sahlstrom, Berit. Political Posters in Ethiopia and Mozambique. Visual Imagery in a Revolutionary Context. Stockholm: Almquvist & Wiskell International, 1990.

10. Slaoui, Abderrahman. The Orientalist Poster: A Century of Advertising Through The Slaoui Foundation Collection. Casablanca: Malika Editions, 1997. 144 pp.

11. Slyomovics, Susan. "Cartoon Commentary: Algerian and Moroccan Caricatures from the Gulf War." *Middle East Report.* 23:1 (1993), pp. 21-24.

Animation

12. "Animated Documentary in Africa." *Animation World.* March 1997, 1 p.

13. Edera, Bruno. "African Animation." In *Drawing Insight,* edited by Joyce Greene and Deborah Reber, pp. 111-113. Penang: Southbound, 1996.

14. "Sara, The Special Gift." *Femed.* April 1997, p. 3.

Comics

15. *A L'Ombre du Baobab: Des Auteurs de Bande Dessinée Africains Parlent d'Education et de Santé.* Luçon: Equilibres et Populations, 2001. 64 pp. (Cameroon, Democratic Republic of Congo, Bénin, Madagascar, Senegal, Togo, Gabon).

16. Duncan, Hall. "Evaluating African Magazine Readership Response to Mopela the Monkey Cartoon Strip." Graduate study paper, School of Education, Indiana University, 1961.

17. Packalén, Leif. "African Comics in Development." Vantaa, Finland: Comics Power!, 1998. 11 pp.

18. Packalén, Leif. "Comics in the Development of Africa." *International Journal of Comic Art.* Spring 1999, pp. 104-121.

19. Packalén, Leif. *When You Have Something To Say, Consider Using the Powerful Medium of Comics!* Vantaa, Finland: World Comics, 1998. 16 pp.

20. Pierre, Michael. "A Certain African Dream: Visions of Africa and Africans in French Language Comics." Paper presented at the International Comics and Animation Festival, Georgetown University, Washington, D.C. September 27, 1996.

ALGERIA
Cartooning, Cartoons

21. Boivin, Micheline. "Le Salon du Rire d'Alger. Les Dix de la Caricature." *Pied Noirs d'Hier et d'Aujourd'hui.* November 1992, pp. 14-15.

22. Chaulet-Achour, Christiane. "Le Parti sans Rire – Le Parti d' En Rire: Les Intégristes Algériens dans Dessins de Presse et BD." *L'Humour Graphique: CORHUM No. 5,* edited by Gérard V. Martin, pp. 145-158. Paris: CORHUM, 1997.

23. Vive la Démocratie! La Vie des Algériens Vue par les Caricaturistes Dahmani, Daiffa, Elho, Fathy, Gyps, Melouah, Sigg, Slim. Thionville: Algérie Solidarité Thionville, 1997.

Political Cartoons

24. "Cartoonist Murdered in Algerian Freedom of Expression Struggle." *WittyWorld International Cartoon Bulletin.* 1/1996, p. 2.

25. "CPJ Protests Cartoonist Jailing." *Editor & Publisher.* July 27, 1996, p. 6.

26. "Fundamentalists Are No Fun." *Inklings.* Spring 1995, p. 5.

27. Lent, John A. "The Horrors of Cartooning in Slim's Algeria." *International Journal of Comic Art.* Spring 1999, pp. 150-156.

28. "Slim." "Guest Artist: Slim." Lecture presented at International Comics and Animation Festival, Bethesda, Maryland. September 24, 1998.

BOTSWANA
General Sources

29. Chiepe, B.D. "Reflections from a Cartoonist." In *Botswana's Media and Democracy: Selected Papers from the Seminar on Media in a Democracy,* edited by M. Leepile. Gaborone: Mmegi Publishing House, 1996.

30. King, Tony. "Chanda Exhibits Works of Many Themes." *Mmegi.* December 5-11, 1997. p. 27.

31. Vermeulen, Elsje. "Unique Cartoon Art Exhibition." *Vaalweekblad.* September 6-8, 2000.

CAMEROON
General Sources

32. "African Cartoon Week." *Penstuff*. September 1999. p. 6.

33. Mbembe, Achille. "The 'Thing' and Its Double in Cameroonian Cartoons." In *Readings in African Popular Culture,* edited by Karin Barber, pp. 151-163. Bloomington: Indiana University Press, 1997.

Political Cartoons

34. Kigha, Joan K. "Profile of a Satirical Comedian in Cameroon." *Media Development.* 4/1997, pp. 21-22.

35. Monga, C. "Cartoons in Cameroon: Anger and Political Derision under Monocracy." In *The Word Behind Bars and the Paradox of Exile,* edited by Kofi Anyidoho, pp. 146-169. Evanston, Illinois: Northwestern University Press, 1997.

36. Nyamnjoh, Francis B. "Political Rumour in Cameroon." *Cahier de l'UCAC.* No. 2, 1997, pp. 93-105.

37. Nyamnjoh, Francis B. "Press Cartoons and Politics in Cameroon." *International Journal of Comic Art.* Fall 1999, pp. 171-190.

CONGO
General Sources

38. "Banned in Congo." *Inklings.* Spring 1999, p.8.

EGYPT
Cartooning

39. Azmy, Rîme. "A Note from Rîme Azmy." FECO News. No. 29, 1999, p.3.

40. Bayouny, Heba. "How Cartoons Portrayed Press 93." Cairo, Egypt. Unpublished paper.

41. *Cartoons from Egypt and Europe.* N. P.: Federation of European Cartoonist Organisations, 1997. 112 pp.

42. Dabbous, Sonia. [Egyptian Cartooning]. Ph.D. dissertation, University of Canterbury, 1982.

43. Douglas, Allen and Fedwa Malti-Douglas. *L'Ideologie par la Bande: Heros Politiques de France et d'Egypte au Miroir de la BD.* Cairo: Centre d'Etudes de Documentation Economique, Juridique, et Sociale, 1987.

44. Effat, Esmail M. "FECO Egypt Exhibition for Children with Cancer." *FECO News.* No. 28, 1999, p. 4.

45. "Egyptian Cartoons." In *2. Uluslararasi Ankara Karikatür Festivali,* pp. 114-120. Ankara: Karikatür Vakfi Yayinlari, 1996.

46. Exhibition of the Artists. The Egyptian Caricature Artists. Cairo: Ministry of Culture, n.d. Unpaginated.

47. Fenoglio-Abd El Aal, Irène. "Caricature et Rèprèsentation du Mythe: Goha." In Images d'Egypte, De la Fresque à Bande Dessiné. Cairo: CEDEJ, 1992.

48. "Greetings from Egypt." *FECO News.* No. 30, 2000, p. 5.

49. Khalil, Rayed. "Cartoons' Origin: East or West?" *Kayhan Caricature.* December 2000, pp. 16-18.

50. Nieuwendijk, Peter. "An Egyptian Adventure." *FECO News.* Summer 1997, pp. 18-21.

51. Pohle, Marlene. "Egypt Through European Eyes." *FECO News.* Summer 1997, pp. 10-15.

52. Reynolds, Eric. "Syndicate Produces Cairo Exhibit for U.N." *Comics Journal.* November 1994, p. 36.

53. "The Sphinx Is Back." *Inklings.* Fall 1995, p. 12

54. "Syndicate Produces Exhibition in Egypt." *Editor & Publisher.* September 10, 1994, p. 36.

55. Wally, Youssuf. "Cartoons Touska 2200." *FECO News.* No. 26, 1998, p. 8.

56. "With FECO in Egypt." *FECO News.* Summer 1997, pp. 16-17

Effat (Mohamed Efat Esmail)

57. Fähndrich, H. "Porträt Effat. Egyptischer Karikaturist und Volksmaler." *El Masri Magazine* (Switzerland). May 1996, pp. 18-19.

58. "Misir Karikatürü Sergisi Hazirlaniyor. Muhammed Effat ve Adil Kamil Istanbul'a Geldiler." *Karikatürk.* No. 29, 1996, p. 343.

59. "Mohamed Effat Esmail." *Humor and Caricature.* November/December 1996, p. 13.

Animation

60. "'10+2' Premiada en El Cairo." *ASIFA Catalonia Noticies.* May-June 1996, p. 6.

61. Warg, Peter. " 'Nights' Dazes Arabian Viewers." *Variety.* February 26-March 3, 1996, pp. 169-170.

Political Cartoons

62. Astor, David. "Egyptian Paper Drops Cartoons." *Editor & Publisher.* April 26, 1997, p. 95. (Ranan Lurie).

63. Boylan, Richard F. and Sonia Dabbous. "The Political Use of Cartoons in Egypt: The Case of Press Law 93: A Presentation of Sample Cartoons." Paper presented at International Association for Mass Communication Research, Comic Art Working Group, Sydney, Australia, August 1996.

64. Dean, Michael. "Caricature Lands Egyptian Cartoonist in Jail." *Comics Journal.* December 2000, pp. 13-14.

65. El Komos, Omnia F. "Egyptian Humor: A Pragmatic Analysis of Selected Social and Political Cartoons." Paper presented at 1999 International Society of Humor Studies Conference, Oakland, California, June 29-July 3, 1999.

66. "Encarcelan a Un Caricaturista en Egipto." *La Piztola.* February 2001, p. 3.

67. Fenoglio-Abd El Aal, Irène. Défense et Illustration de l'Egyptienne Aux Débuts d'Une Expression Féminine. Cairo: CEDEJ, 1988.

68. "4 Egyptian Journalists Face Fines." Associated Press release, April 1, 2000.

69. Lancaster, John. "U.S. Envoy Target of Caricature: Cairo Magazine Lampoons 'Rabbi.'" *Washington Post.* March 12, 1998, p. A22.

70. Rosenfeld, Stephen S. "The War of the Cartoons: Egyptian Cartoons Make Israelis Less Inclined To Compromise." *Washington Post.* March 14, 1997.

71. Russell, Robert. "Go Directly to Jail." *Quill Magazine.* June 2000, pp. 38-39.

72. "3 Journalists Sentenced in Egypt" [Political cartoonist Essam Hanafi]. Associated Press release. August 14, 1999.

GHANA
General Sources

73. Priebe, Richard. "Popular Writing in Ghana: A Sociology and Rhetoric." *Research in African Literatures.* 9:3 (1978), pp. 395-432, especially p. 421 (Comic strips).

IVORY COAST
General Sources

74. "FECO Ivory Coast." *FECO News.* No. 22, 1997, p.12.

KENYA
Animation

75. Olielo, Justus. "Video Parlors Take Root in Kenya." *Animation World.* November 1997. 2 pp.

Political Cartoons

76. Gado. *Democrazy! By Gado. Editorial Cartoons from The Daily Nation, Nairobi 1992-1999.* Nairobi: Sasa Sema Publications, 2000. 126 pp.

77. Gado. *Gado Looks at Europe.* Supplement to *Kumppani.* June 1997, 14 pp.

78. Stano. *Gitonga na Stano.* Nairobi: Sasa Sema Publications, 1996. 32 pp.

79. Szabo, Joe. "Gado." *WittyWorld International Cartoon Bulletin.* No. 1, 1997, pp. 1, 3.

MADAGASCAR
Comic Books

80. Saint-Michel, Serge. "Adventures dans l'Ocean Indien." *Bédésup.* No. 34, 1985, p.12.

MALAWI
Comic Strips

81. Chimombo, Steve. "The Dupe in Modern Context." *Baraza: The Journal of the Arts in Malawi.* April 1986, pp. 48-68.

82. Chimombo, Steve. "The Trickster and the Media." *Baraza: The Journal of the Arts in Malawi.* June 1984, pp. 3-21.

MOROCCO
Comics

83. Packalén, Leif. "Report from an Anti-Corruption Comics Workshop in Casablanca, Morocco, November 2000." Vantaa, Finland: World Comics-Finland, 2000. 4 pp.

MOZAMBIQUE
General Sources

84. Playfair, Charles. *Rhodesia Laughs.* 1958.

Comics

85. Dekker, Baldi, Jr. "Een (Honger) Wereld Apart!" *Stripschrift.* No. 217, 1988, pp. 16-20.

86. Packalén, Leif. "Comics in Development – Workshop in Maputo." Vantaa, Finland: World Comics, 1998. 8 pp.

NAMIBIA
General Sources

87. Levinson, Orde, comp. and ed. *I Was Lonelyness: The Complete Graphic Works of John Muafangejo.* Cape Town: Struik Winchester, 1992. 427 pp.

NIGERIA
General Sources

88. Brooke, James. "Goodbye to Tarzan, Meet Captain Africa." *New York Times.* September 27, 1988, p. C22. (Comics).

89. Ebong, Moses. *The Nigerian Factor: The Moses Ebong Cartoons.* Lagos: Briscoe, in association with Moses Ebong, 2000.

90. Medubi, Oyin. "Leadership Stereotypes and Lexical Choices: An Example of Nigerian Cartoons." *International Journal of Comic Art.* Spring 2000, pp. 198-206. (Political cartoons).

91. Okoye, Innocent. "Video in the Lives of Nigerian Children: Some Socio-Cultural Implications." *Africa Media Review.* 7:3 (1993), pp. 63-74. (Animation).

RWANDA
General Sources

92. Vinsot, François. "Laughing in Rwanda." *Index on Censorship.* 6/2000, pp. 143-144.

SOMALIA
Animation

93. Clark, Christian. "The Somalian Child." In *Drawing Insight,* edited by Joyce Greene and Deborah Reber, pp. 114-116. Penang: Southbound, 1996.

SOUTH AFRICA
Resources

94. Albertyn, C. F., editor. *Ensiklopedie van die Wêreld.* 2. 1971.

95. Alexander, Fritz L. *South African Graphic Art and Its Techniques.* Cape Town: Human and Rousseau, 1974.

96. Berman, E. *Art and Artists of South Africa.* Cape Town: Balkema, 1970.

97. Engel, E. P. "Art Life in Johannesburg, 1886-1920." *Africana Aant. en Nuus.* 15 (1963), pp. 267-306.

98. Gordon-Brown, A. *Pictorial Art in South Africa.* London: Sawyer, 1952.

99. K., W.H. *The Arts in South Africa.* Durban: Knox, 1933-1934.

100. Kennedy, R. F. *C.O.P.A.M.* Johannesburg: Africana Museum, 1966, 1968.

101. "Our Illustrations." *South African Review.* Christmas 1897.

102. Rosenthal, Eric. *South African Dictionary of National Biography.* London: Frederick Warne, 1966.

103. South African Library, Cape Town, editor. *A South African Bibliography to the Year 1925.* London: Mansell, 1979.

104. Suidwes-Afrikaanse Kunsvereniging. *Register van Suidwes-Afrikaanse en Kunstenaars.* Cape Town: Hoofkwartier van die S. A. Kunsvereniging, 1969.

105. Verbeek, J. A. *Natal Art Before Union.* Pietermaritzburg: Biblioteek, Universiteit van Natal, 1974.

Anthologies

106. *Carpio Capers.* Johannesburg: Hayne and Gibson, 1962.

107. Clapham, E. W. "Humour in War" *Kommando.* July 1962.

108. Horn, Tinus and Alastair Findlay. *Hemel op Aarde.* Johannesburg: 1977. 60 pp. (Graphic novel).

109. Kennedy, R. F. *Catalogue of Pictures in the Africana Museum.* 1-7. Johannesburg: Africana Museum, 1966-1970.

110. Van Schorr, M.C.E. *Spotprente van die Anglo-Boerreoorlog.* Cape Town: Tafelberg, 1981.

Cartooning

111. Andrew, Rick and Jeff Rankin. "The Bridge – Five Years Later." *Design Education Forum of South Africa.* July 1993, pp. 1-9.

112. Hawkins, Theodore J. "Changing Attitudes to Cartooning in South Africa." Thesis, Higher National Diploma, Port Elizabeth Technikon, 1983. 54 pp.

113. Lent, John A. "Cartooning with a Social Conscience." *WittyWorld International Cartoon Bulletin.* 7/1996, p. 1.

114. Lent, John A. "Cartoons and Comics with a Social Conscience: The Case of South Africa." Paper presented at Popular Culture Association, San Antonio, Texas, March 28, 1997.

Cartoonists and Their Works

115. "[Anderson, David]." *Argus News.* August 1980; *Rand Daily News.* December 31, 1981.

116. Astor, David. "Overseas Opinions Offered at Meeting: South African Artists and International Experts Talk to Editorial Cartoonists at New Orleans Convention." *Editor & Publisher.* July 9, 1994, pp. 34-36.

117. B., H. M. "The Human Angle." *South Africa Jewish Times.* July 20, 1951. (Matthew Centner).

118. Bauer, Derek. *S.A. Flambé and Other Recipes for Disaster.* Cape Town: David Philip, 1989. 106 pp.

119. Boekkooi, J. "Drawing History in Pen and Ink: Exploring the Cartoonist's World." *The Star* (Johannesburg). March 22, 1983, p. 10.

120. "[Bosman, Willem]." *Beeld.* March 9, 1982, September 5, 1981.

121. Bradlow, F. R. *Thomas Bowler – His Life and Work.* Cape Town: Balkema, 1967.

122. "[Brown, Ralph Carson]." *The Forum.* June 29, 1946, April 19, 1947.

123. "[Cain, Charles W.]." *South Africa.* July 4, 1930, p. 9; *The Star.* February 9, 1962.

124. Camp, B. E. "Lieut. S. H. K. Wilson." *Die Landdros/The Magistrate.* 2:7 (1967), p. 163.

125. "Cartoonists." In *S.E.S.A.3.,* edited by D. J. Potgieter. Cape Town: Nasou, 1970.

126. "The Cartoonist's Lot (2)." *News/Check.* 8:20 (1970), pp. 14-19.

127. "[Celliers, Jannie L.]." *Rapport.* March 30, 1975, September 12, 1982; *Sunday Times.* March 30, 1975.

128. Charlton-Barrett, J. *Celone Circus.* Durban: Singleton and Williams, 194?.

129. Chisholm, Fiona. "Out and About – No Jealousy Among SA Cartoonists." *The Cape Times.* July 9, 1970.

130. Collins, Frank. "Four South African Humorists." *The Forum.* February 1958, pp. 33-36.

131. Cowen, Charles. "Memoir of the Life of William Howard Schröder." In *The Schröder Art Memento.* Pretoria: "The Press," 1894.

132. Creasy, Martin. *African Holiday.* Cape Town: Howard Timmins, 1963.

133. Currie-Wood, Edin. *Poolmanship.* Currie-Wood, 1962.

134. "[Cutler, Charles]." *The Star.* December 3, 1981.

135. Danziger, C. South African History 1910-'70 Cartoons/Suid-Afrikaanse Geskiedenis 1910-'70 Spotprente. Kaapstad: Oxford University Press, 1977.

136. "[De Jager, Albert]." *The Friend.* March 3, 1956.

137. Derry, Debbie. "Cartoonist a Determined, Polite Artist." Post Elizabeth, South Africa *Weekend Post.* n.d. (Theodore Hawkins).

138. "[DeVries, Isidor M. A.]." *The Natal Daily News.* April 17, 1947.

139. "[Dunn, Normand R.]." *The Forum.* February 5, 1949.

140. "Durban Funky Cats No. 2 – Rob Heasley." *I-Jusi.* No. 2, 1995, last page.

141. "[ED]." *The Lantern.* Christmas, 1881.

142. "Emile Maurice." In *Art of the South African Townships,* by Gavin Younge, pp. 66, 94. New York: Rizzoli, 1988.

143. "[Esterhuyse, Frans A. N.]." *Beeld.* October 20, 1981; *Oggendblad.* March 4, 1975, May 29, 1975.

144. "[Esterhuysen, Jacobus]." *Dagbreek en Sondagnuus,* March 19, 1967; *Die Huisgenoot,* February 7, 1941; *Rapport,* March 23, 1975; *Die Transvaler,* July 1944-1946, February 10, 1970; *Die Vaderland,* February 9, 1970, May 17, 1971.

145. Fisher, Hugh. A Collection of Cartoons and Other Material. Place, publisher, date, (?).

146. "[Gaskill, David T.]." *Beeld,* November 11, 1981; *Checkers Value,* November 1978, March/April 1979; *The Citizen,* September 7, 1976, May 12, 1977; *Radio & TV Dagboek,* March 3-9, 1980; *Signature,* September/October 1975, January 1976; *Suid-Afrikaanse Panorama,* November 1978; *Sunday Times,* December 31, 1978, September 9, 1979.

147. "[Goba, Newell.]." *Echo*. July 30, 1981.

148. "[Grogan, Anthony.]." *Beeld,* May 7, 1979; *The Cape Times,* December 6, 1980; *The Cape Times Weekend Magazine,* October 11, 1975; *Grocotts Mail,* November 16, 1979; *The Natal Witness,* January 28, 1981; *Personality,* August 22, 1975

149. "[Hayes, Alfred]." *The Cape Argus*. April 12, 1967.

150. "[Heath, John]." *Evening Post,* January 22, 1953, January 25, 1953, September 5, 1954, March 5, 1955, June 17, 1969, June 18, 1969.

151. "[Henning, Lourens]." *Rapport*. August 9, 1981; *Die Transvaler*. October 3, 1973.

152. Holland, D.F.E. *Political Cartoons*. Reprinted from *The Star*. Johannesburg: Argus Printing and Publishing Co., 1907(?).

153. "[Hutton, Edward T.H.]." *South African Digest*. July 18, 1969

154. Immelman, R.F. "Johannes Cornelius Poortermans." *Die Huisgenoot*. December 21, 1934, pp. 24-25+.

155. "[Ivanoff, Connolly, Etam, Honiball, Leyden]." *Brandwag*. August 5, 26, 1955

156. "[Joubert, Derek]." *The Friend*. August 22, 1979.

157. Kennedy, D. and H. Georgiades. *A Slice of Fun*. Cape Town: Howard Timmins, 1965.

158. "[Kenyon, Donald]." *The Daily Dispatch*. September 25, 1979.

159. Kirby, Robert. "Rest in Peanuts." *Personality*. September 24, 1970. (Ivor van Rensburg).

160. Lee, Marshall, "Laughter Is Their Business." *The Star*. October 4, 1969.

161. Legum, Colin. "The Art of the South African Cartoonist." *Illustrated Bulletin*. July 31, 1946, pp. 12-13.

162. "[Madden, Marjorie (Carey)]." *The Star,* February 27, 1931; *Rand Daily Mail,* July 15, 1931.

163. Menge, Lin. "Cartoons That Make the Little Man's Day." *Rand Daily Mail*. September 3, 1977.

164. "[Middleton, Frances]." *Family Radio & TV*. September 13-19, 1982; *Midlands Mail*. February 1982.

165. Morgan, M. S. "Cartoonist Cop." *The Outspan*. February 13, 1953. (Frederick Lund).

166. Morris, Arthur. *The Witchways.* Durban: Tom Chalmers Enterprises, 1978.

167. "[Mouton, Frederick]." *The Argus,* March 17, 1982, *Beeld,* June 3, 1978, August 6, 1978, August 22, 1978, October 14, 1981; *The Natal Witness,* March 9, 1978; *Rapport,* March 5, 1978, March 12, 1978; *South African Panorama,* November 1978.

168. N. B. "Early Orange Free State Cartoon." *Africana Aant. en Nuus.* 25 (1982), pp. 123-127. (H.J. Hofstede).

169. "Old at the New." *South African Panorama.* May 1969, pp. 22-25. (Samuel J. Fourie).

170. Ploeger, Jan. "W. F. Mondriaan." *Lantern.* September 1971, p. 91.

171. Pretoria City Art Museum. *South African Cartoonists and Comic Strip Artists.* Place, publisher, date, (?).

172. Rand Daily Mail. The Situation at a Glance. Selection of Rand Daily Mail. 1948.

173. Rosenthal, Eric. "South African Cartoonists – Old and New." *Trek.* August 10, 1945, pp. 12-13.

174. Rosenthal, Eric. "South African Cartoonists – II." *Trek.* August 24, 1945, p. 14.

175. S., A. H. "Charles Davidson Bell – Designer of the Cape Triangular Stamps." *Africana Aantekeninge en Nuus.* 11 (1953/1954), pp. 81-87.

176. Santry, Denis. *War Cartoons.* Johannesburg: CNA, 1915.

177. Scholtz, J. du P. *Strat Caldecott.* Cape Town: Balkema, 1970.

178. Schoonraad, Murray. "Introduction" to Catalogue, *Suid-Afrikaanse Spot–en Strookprentkunstenaars/South African Cartoonists and Comic Strip Artists.* Pretoria: Kunsmuseum, 1973.

179. Schoonraad, Murray. *Suid-Afrikaanse Spot–en Strookprentkunstenaars.* Roodepoort: CUM Boeke, 1983.

180. Schoonraad, Murray and Elzabé Schoonraad. *Companion to South African Cartoonists.* Johannesburg: Ad Donker, 1988.

181. Schoonraad, Murray and Elzabé Schoonraad. "'n Ontluikende Kunstenaar – Walter Westbrook." *Historia.* 13:3, pp. 198-202.

182. Schoor, M.C.E. *Spotprente van die Anglo Boereoorlog.* Place, publisher, date, (?).

183. "[Smith, Fedler, Mouton, Leyden, Winder, Jackson, Lindeque, Scott, Grogan, Lessing]." *Personality*. August 22, 1975.

184. "[Smith, Richard J. T.]." *The Bloody Horse*, March-April 1981; *Eastern Province Herald*, January 29, 1981; *Eve*, May 7, 1976; *Rand Daily Mail*, November 27, 1973, May 5, 1976, May 6, 1976, May 10, 1976, July 1, 1976; *The Star*, October 4, 1969, May 6, 1976; *Die Transvaler*, November 24, 1973.

185. Stidolph, Anthony (Stidy). *Riding the Rainbow: Best of Stidy's Cartoons 1991-1995*. Pietermaritzburg: The Natal Witness, 1995. Unpaginated.

186. "Tommy Motswai." In *Art of the South African Townships,* by Gavin Younge, pp. 50-51, 95. New York: Rizzoli, 1988.

187. Ullmann, Ernest. *Designs on Life.* Cape Town: Howard Timmins, 1970.

188. Wallis, J. P. R. *Thomas Baines*. Cape Town: Balkema, 1976.

189. Winder, H. E. "Art of Jean Welz." *The Forum*. July 1953, pp. 41-42.

190. Winder, H. E. "Winder by Winder." *The Outspan*. November 28, 1947, pp. 50-51.

191. X. Y. Z. "South African Caricatures III. Mr. H. E. King." *The State*. January 1910, pp. 33-38.

Alexander, Fritz Ludwig

192. Alexander, Fritz L. *Kuns in Suid-Afrika Sedert 1900.* Cape Town: Balkema, 1971.

193. "[Alexander F. L..]." *Die Burger*. July 26, 1971, September 25, 1971, October 23, 1971, November 18, 1971.

194. Holloway, V. "Introduction." *Katalogus: Hulde aan F. L. A.,* Suid-Afrikaanse Kunsvereniging, Cape Town, November 16, 1974.

195. Trümpelmann, G. P. J. "Huldigingswoord aan F. L. Alexander." In *Suid-Afrikaanse Akademie vir Wetenskap en Kuns Jaarboek.* 1971, pp. 75-77.

Ashley-Cooper, Michael

196. "[Ashley-Cooper, Michael.]." *The Cape Argus*. September 12, 1968.

197. "[Ashley-Cooper, Michael.]." *Katalogus, Cape Arts Festival Cartoon Exhibition* Cape Town: Stuttafords, 1968.

Ashton, William P.

198. "[Ashton, William P.]." *Suid-Afrikaanse Panorama.* August 1964, pp. 30-31, November 1978, pp. 22-23.

199. "[Ashton, William P.]." *Sunday Times TV Magazine.* February 9, 1975.

Baden-Powell, Robert S. S.

200. "[Baden-Powell, Robert S. S.]." *The Star.* January 18, 1941.

201. Grinnell-Milne, Duncan. *Baden-Powell at Mafeking.* London: Bodley Head, 1957.

Barber, Charles J.

202. "C. J. M. Smith and C. J. Barber." *Africana Aantekeninge en Nuus.* 17:7 (1967), pp. 343-344.

203. P., A. "Charles J. Barber – Cartoonist." *Looking Back.* 6:4 (1966), p. 6.

Barry, Charles

204. "[Barry, Charles.]." *Die Volksblad.* September 21, 1936; November 16, 1979, p. 23.

205. "'Barry' of *Die Transvaler."* *The Forum.* June 13, 1938, p. 35.

Berry, Abe

206. Berry, Abe. *South Africa and How It Works.* Johannesburg: Jonathan Ball, 1980.

207. "[Berry, Abe]." *The Natal Witness,* January 31, 1973, September 23, 1982; *South African Panorama,* August 1964; *The Star,* November 4, 1969, July 30, 1970, August 15, 1970, July 3, 1971, December 17, 1971, March 11, 1972, June 19, 1972, March 31, 1973; *Sunday Times,* July 4, 1971; *S. A. Jewish Times,* December 24, 1970.

208. Boekkooi, J. "Berry Draws the Line on Life As He Sees It." *The Star* (Johannesburg). June 15, 1983, p. 3.

Boonzaier, D. C.

209. Benyon, J. A. "Mr. Hoggenheimer's Weight Problem." Inaugural lecture. Pietermaritzburg: University of Natal Press, 1977.

210. Bokhorst, M. " Die Kuns van 'n Kwarteeu." *Standpunte.* 9:3 (1954), pp. 39-45.

211. Bokhorst, M. "The Story of Fine Art." In *Cape Town: City of Good Hope,* p. 171. Cape Town: Timmins, 1966.

212. "Boonzaaier's "[sic]." *Forum.* January 17, 1942, p. 8.

213. Boonzaier, D. C. *My Caricatures.* Cape Town: D. C. Boonzaier, 1912.

214. Boonzaier, D. C. *Owlographs: A Collection of Cape Celebrities in Caricature.* Cape Town: Cape Times, 1901.

215. Boonzaier, D. C. *Rand Faces.* Cape Town: Argus, 1915.

216. Boonzaier, D. C. *South African News Cartoons.* Cape Town: South African Newspaper Co., 1904.

217. "[Boonzaier, D. C.]." *Beeld,* July 4, 1981; *Die Burger,* March 21, 1950, July 23, 1965, August 10, 1965, August 17, 1974, July 25, 1975; *The New Era,* January 30, 1904; *Rand Daily Mail,* March 21, 1950; *S. African Print,* March 1950; *The Star,* November 4, 1981.

218. Du Plessis, F. "Onverwags en Seldsaam." *Suid-Afrikaanse Bibli.* October 1967, pp. 35-65.

219. Fagan, H. A. "Foute en Mislukkings Kon Ons Nie Stuit Nie." *Die Huisgenoot.* December 5, 1952, pp. 32-37, 51.

220. Fransen, Hans. *Drie Eeue Kuns in Suid-Afrika.* Pietermaritzburg: Anreith-uitgewers, 1981.

221. Friedlaender, Ernst. "'n Ope Brief aan Mnr. Boonzaier." *Die Huisgenoot.* May 2, 1925, p. 7.

222. Hattingh, A. S. J. *Kunswaardering.* Johannesburg: Voortrekkerpers, 1973.

223. Hofmeyr, H.J. *D. C. Boonzaier -- Rand Faces.* Johannesburg: Publisher (?), June 1915.

224. King, R. "'n Spotprent Kan die Hardste Hou Slaan." *Die Burger.* July 23, 1965.

225. S. J. du P. "Boonzaier, Daniel Cornelis." In *S. Afrikaanse Biografiese Woordeboek Deel I,* edited by W.J. de Kock. Cape Town: Nasionale Boekhandel, 1968.

226. Scholtz, J. du P. "Daniel Cornelis Boonzaier." In *S.E.S.A. I,* edited by D. J. Potgieter, pp. 422-423. Cape Town: Nasou, 1970.

227. Scholtz, J. du P. "D. C. Boonzaier." *Die Huisgenoot.* November 28, 1947, pp. 33-35.

228. Scholtz, J. du P. D. C. Boonzaier en Pieter Wenning – Verslag ran 'n Vriendskap. Cape Town: Tafelberg, 1973.

229. Scholtz, J. du P. "'n Vergete Afrikaanse Weekblad." *Standpunte.* October 1970, p. 1.

230. Scholtz, J. du P. *Oor Skilders en Skrywers.* Cape Town: Tafelberg, 1979.

231. Shain, Milton. Hoggenheimer Ghost Still Walks." *The Star.* November 4, 1981.

232. Shain, Milton. "Hoggenheimer – The Making of a Myth." *Jewish Affairs.* September 1981.

233. Trümpelmann, J. "Gregoire Boonzaier – 'n Waardering." *Lantern.* March 1960, pp. 234-236.

234. V. S., A. M. (with Eric Rosenthal). "Boonzaier van 'Die Burger.'" *Fleur.* October 1946, pp. 19-22, 63-64.

235. Wagener, F. J. "How an Afrikaans Classic Came To Be Translated into English." *Lantern.* December 1964, pp. 41-46.

236. Werth, A. J. "Die Lewe en Kuns van Pieter Wenning." *Lantern.* June 1967, pp. 12-13.

Burrage, Leslie T.

237. "Burrage." *Noord-Vrystaat Weermag Jaarblad Kroonstad.* 1978, pp. 37-42.

238. "[Burrage, Leslie T.]." *Dagbreek,* July 13, 1947; *Dagbreek en Sondagnuus,* April 4, 1948; *Dagbreek en Landstem,* November 22, 1970; *Rand Daily Mail,* October 30, 1948; *Sandton Chronicle,* April 28, 1979, *SA Sapper,* December 1981.

239. Katalogus: *Die Tweede Wêreldoorlog Kunswerke van Burrage, Suid-Afrikaanse Amptelike Oorlogskunstenaar.* Johannesburg: Suid-Afrikaanse Nasionale Museum vir Krygsges-Kiedenis, 1981.

Carey, M.

240. Carey, M. Album of newscuttings including numerous cartoons, 1929-1932. Johannesburg: Johannesburg S. Store 920, date (?).

241. Carey, M. Newspaper cuttings from *Sjambok.*

Claassen, Wynand

242. "[Claassen, Wynand.]." *Beeld.* March 24, 1982; *Rapport,* March 28, 1982.

Clapham, Victor J.

243. Clapham, Vic. *101 Thrifty Ideas for Energy Conservation.* Cape Town: Boy Scouts, 1980.

244. Clapham, Vic. *Pins and Needles.* Cape Town: Vic Clapham, 1939.

245. "[Clapham, Vic.]." *Daily News.* May 13, 1965.

246. LeRoux, A. "'n Bok vir Skilder." *Huisgenoot.* March 4, 1982, pp. 156-157.

Connolly, Robert

247. "Bob Connolly – of the *Daily Express.*" *The Forum.* July 11, 1938.

248. Cartwright, A. P. "Connolly Flashing Quips in a Sombre World." *Flying Springbok.* March 1982, p. 83.

249. Connolly, Bob. "I Like the Human Face." *The Forum.* July 1958. pp. 37-38.

250. Connolly, Bob. "The Inside Story of Those Tickey Traps." *Rand Daily Mail.* May 9, 1959.

251. Connolly, Bob. "Pardon My Slip." *The Outspan.* November 27, 1953, pp. 22-23.

252. Connolly, Bob. "Quips for Breakfast." *The Forum.* September 1957, pp. 26-27.

253. Connolly, Bob. "Sometimes the Truth Hurts." *The Forum.* July 1953, pp. 50-51.

254. Connolly, Bob. "To the Aid of Baseball Fans." *The Forum.* February 1958, pp. 22-23.

255. Connolly, Robert. An Album of War Cartoons – A Commentary on the First Year of War. Johannesburg: CNA, 1940.

256. Connolly, Robert. An Album of War Cartoons – A Commentary on the Second Year of War. Johannesburg: CNA, 1941.

257. Connolly, Robert. *An Album of War Cartoons.* Johannesburg: 1943.

258. Connolly, Robert. *The Bob Connolly Story.* Cape Town: Cape Times Ltd., Howard Timmins, 1957.

259. Connolly, Robert. *Connolly Cartoons.* Proceeds in aid of *Rand Daily Mail* Christmas Fund. Burlington: 1963.

260. Connolly, Robert. *Now You Know.* Johannesburg: CNA, 1950 (?).

261. Connolly, Robert. *The Situation at a Glance.* Johannesburg: CNA, 1948.

262. Connolly, Robert. *Victory Cartoonews.* Johannesburg: CNA, 1946.

263. Connolly, Robert. *War Cartoonews – Fifth Selection of War Cartoons.* Johannesburg: CNA, 1945.

264. Connolly, Robert. *War CartoonNews – Fourth Selection of War Cartoons.* Johannesburg: CNA, 1944.

265. Connolly, Robert. *Who's Who in Cartoons – Bob Connolly's Personalities.* Johannesburg: Rand Daily Mail, Pacific Press, 1949.

266. "[Connolly, Robert.]." *Daily News,* November 4, 1957; *The Forum,* November 30, 1940; *The Natal Witness,* October 28, 1981; *Rand Daily Mail,* December 4, 1959, June 13, 1952, July 28, 1960, November 19, 1960, December 16, 1960, November 22, 1963, June 10, 1964, May 6, 1969, July 10, 1971, September 10, 1973, November 8, 1973, December 10, 1973, December 20, 1973, January 27, 1974, December 5, 1974, July 15, 1975, June 1, 1976, September 30, 1976, May 23, 1977, November 6, 1978, August 30, 1980, January 29, 1981, February 1, 1981, October 28, 1981, October 29, 1981, October 30, 1981, November 1, 1981, November 10, 1981; *The Star,* June 13, 1961: *Sunday Express,* August 3, 1980, *Sunday Times, Business Times,* November 3, 1974; *Sunday Times,* June 11, 1972.

267. "Connolly Se Bekendes." Suid-Afrikaanse Panorama. April 1961, pp. 16-17.

268. "I Used To Draw for Nothing As a Kid – Now I Get Paid for It." *The Outspan.* September 28, 1951.

269. "Ma (a) newales." *Suid-Afrikaanse Panorama.* September 1969, pp. 11-13.

270. "Ons Spotprenttekenaars nr. 2. Bob Connolly." *Die Brandwag.* August 12, 1955.

Coughlan, Seán

271. Birkby, C. "He Took Us for a Ride." *Rand Daily Mail.* October 28, 1958.

272. "[Coughlin, Seán.]." *Rand Daily Mail.* June 27, 1952.

273. "Seán of the *Daily News.*" *The Forum.* May 6, 1938, p. 35.

Crealock, John N.

274. Brown, R. A. "John North Crealock." *Africana Aantekeninge en Nuus.* 18:1 (1967), p. 28.

275. Brown, R. A. *The Road to Ulundi.* Pietermaritzburg: Universiteit van Natal, 1969.

276. Clark, John. "An Artist and a Soldier." *Personality.* November 6, 1969.

Cross, Wilfrid

277. L., D. "Wilfred (sic) Cross – The Man and His Work." *South African Architectural Record.* 21 (1936), pp. 428-431.

278. "Wilfrid Cross of the *Rand Daily Mail.*" *The Forum.* July 25, 1938, p. 21.

Dixon, Clive M.

279. Dixon, Clive M. *The Leaguer of Ladysmith.* London: Eyre and Spottiswoode, 1900.

280. "[Dixon, Clive M.]." *The Natal Witness.* October 17, 1979.

D'Oyly, Charles

281. Langham – Carter, R. R. "D'Oyly, Sir Charles." In *Dictionary of South African Biography,* edited by C. J. Beyers, p. 239. Cape Town: Nasionale Boekhandel, 1977.

282. Langham-Carter, R. R. "Some Notes on Sir Charles D'Oyly." *Africana Aant. en Nuus.* 12 (1977), pp. 284-286.

Dunn, Napier

283. Dunn, Napier. *Mightier Than the Sword.* Durban: The Mercury, n.d. (ca. 1993). Unpaginated.

284. "Music from South Africa: Cartoons by Napier Dunn." *FECO News.* No. 30, 2000, p. 15.

Egan, Beresford P.

285. Allen, Paul. *Beresford Egan: An Introduction to His Work.* London: Scorpion Press, 1966.

286. Egan, Beresford P. *No Sense in Form: A Tragedy in Manners.* London: Archer, 1933.

287. Egan, Beresford P. *Pollen: A Novel in Black and White.* London: Archer, 1933.

288. Egan, Beresford P. *Epilogue.* London: Fortune Press, 1945 (?).

289. Egan, Beresford P. *Epitaph: A Double-Bedside Book for Singular People.* London: Fortune Press, 1943 (?).

290. "[Egan, Beresford P.]." *Rand Daily News.* July 14, 1926.

Egersdörfer, Heinrich

291. Kennedy, R.F. "Egersdörfer's Coloured Postcards." *Africana Aant. en. Nuus.* 16 (1964/65), pp. 19-23.

292. Rosenthal, Eric. *Heinrich Egersdörfer, An Old Time Sketch Book.* Cape Town: Nasionale Boekhandel, 1960.

Evenden, Charles A. (Evo).

293. Evenden, Charles A. *Old Soldiers Never Die.* Durban: Robinson, 1952.

294. [Evenden, Charles A.]. *The Natal Mercury.* June 11, 1937, January 28, 1960, April 3, 1961, April 5, 1961; *The Natal Witness,* November 11, 1977; *Sunday Times,* April 2, 1961.

295. Evo. *Cartoons.* Durban: Tomango, 1940, 1941, 1942, 1943.

296. Evo. *Like a Little Candle.* Durban: Knox, 1960.

297. "'Evo' of the 'Natal Mercury.'" *The Forum.* June 27, 1938.

298. Hope, Wilfrid. "Modern Cartoonists III 'Evo.'" *Review of Reviews.* January 1935, pp. 23-26.

299. Wilks, Terry. *For the Love of Natal.* Durban: Robinson, 1977.

Fedler, Dov

300. "Dov Fedler." *News/Check*. March 20, 1970, pp. 29-34.

301. Fedler, Dov and F. *My Son the Cartoonist*. Braamfontein: Printed by S. Fedler (Ply) Ltd., published by Peter Brown, 1974.

302. [Fedler, Dov]. *De Arte*, May 1971; *The Motorist*, May 1980; *The Pretoria News*, October 20, 1971; *The Star*, March 1, 1969; September 19, 1969; December 18, 1971, September 13, 1974, July 30, 1977.

303. Van Zyl, M. "The Men Who Make You Laugh – and Sometimes Cry." *Personality*, August 22, 1975.

Gerber, Oswald

304. [Gerber, Oswald]. *Die Afrikaner*, April 24, 1970; *The Pretoria News*, May 4, 1970; *Water*, May 6, 1970.

305. Konya, Phyllis. "Art That Travels." *The Pretoria News*. November 7, 1979.

306. Van Graan, Riena. Fyn Natuurtonele in Ink en Waterverf." *Beeld*. November 14, 1979.

Griffith, Richard

307. Griffith, Richard. *The Beat of Drum*. Johannesburg: Raven Press, 1982.

308. [Griffith, Richard]. *Beeld*, November 25, 1978; *Management*, June 1981.

Henderson, H. en Müller (Hemi)

309. Castle. *Army Howlers*. Johannesburg: South Africa Brouerge, n. d.

310. Hemi. *Cartoons in Both Official Languages*. Johannesburg: Argus Printing and Publishing Co., date (?).

311. Hemi. *Spotprente/Cartoons*. Pretoria: Die Verenigde Suid-Afrikaanse Nasionale Party se Organisasie, 1943 (?).

312. "Know About These Cartoonists? Brief." *The Star*. September 20, 1982.

Honiball, Thomas O.

313. Honiball. T. O. and H. De Villiers. *Deur n Politieke Bril*. Cape Town: Nasionale Pers Bpk., 1945.

314. [Honiball, T.O.]. *Beeld,* July 14, 1977, September 14, 1977, February 27, 1978, August 8, 1978, November 12, 1979, October 4, 1980; *Die Burger,* March 28, 1953, August 22, 1953, May 25, 1957, July 13, 1957, February 15, 1958, July 23, 1965, October 31, 1970, May 22, 1974, May 25, 1974, June 1, 1974, June 30, 1974, March 22, 1977, July 14, 1977, September 13, 1977, September 14, 1977, November 11, 1977, November 26, 1977, July 21, 1979.

315. Louw, Jorda. "Sy Pen Spot Byna 'n Kwart Een Met die Mens." *Die Huisgenoot.* January 29, 1965, pp. 14-18.

316. Van der Byl, Piet. *The Shadows Lengthen.* Cape Town: Howard Timmins, 1973.

Ivanoff, Victor

317. Bender, A. "Vurige Sanger." *Rooi Rose.* September 19, 1954.

318. "Bou 'n Monument vir Ivanoff!" *Die Brandwag.* September 22, 1961.

319. Bruwer, Johan. "Sal die Ware Ivanoff Asseblief Opstaan." *Beeld.* June 2, 1976.

320. Cloete, S. A. *Tandheelkunde in Skool en Huis.* Johannesburg: Voortrekkerpers, 1940.

321. Engel, E.P. "Introduction." *Katalogus. Oorsig Uitstalling van die Werk van Spotprentkenaar, Victor Ivanoff, Skilpaddopsaal.* Johannesburg: Randsé Afrikaanse Universiteit, 1973. Exhibit, February 12-26, 1973.

322. Fritz, Bennie. "Van 'n Don Kossak met Liefde." *Rooi Rose.* August 26, 1970, pp. 87-93.

323. Ivanoff, Victor. *Die Tweede Wêreld-Oorlog in Spot-Prente.* Johannesburg. Afrikaanse Pers-Boekhandel, 1946.

324. Ivanoff, Victor. " 'n Vrou Het Geen Verstand Nie." *Die Brandwag.* September 8, 1961

325. "South African Cartoonists: Ivanoff of *Die Vaderland." The Forum.* July 4, 1938, p. 15.

326. "To Draw or To Sing?" *The Outspan.* February 15, 1952.

327. Van der Westhuysen, H. M. "Karikatuurkunstenaar by Uitnemendheid." *Die Brandwag.* May 31, 1946.

328. "Victor Ivanoff." *Die Brandwag.* August 5, 1955, pp. 40-41.

329. Visser, R.P. "Sy Tekeninge Het Gepraat." *Die Brandwag.* February 8, 1957.

Jackson, John H.

330. Green E. "J. H. Jackson." *Lantern.* July 1982, pp. 37-41.

331. Green, E. "J. H. Jackson, South Africa's Funniest Cartoonist." *Milady.* December 1953, p. 79.

332. Jackson, J. H. *Joking Apart.* Cape Town: Howard Timmins, 1973.

333. Jackson, J. H. *Out of This World.* Cape Town: Howard Timmins, 1980.

334. Jackson, J. H. *Running Commentary.* Cape Town: Howard Timmins, 1967.

335. Jackson, J. H. *Through Jackson's Eyes.* Cape Town: HAUM, 1961.

336. Jackson, J. H. *UDI and All That.* Cape Town: Howard Timmins, 1961.

337. Lurssen, Neil. "It Pays To Have a Sense of Humour." *Personality.* December 12, 1963.

Johnson, Richard T.

338. Johnson, Richard T. and Mary Phillips. *The Bushman Speaks.* Cape Town: Howard Timmins, 1961.

339. Johnson, Richard T. and Stella Bassett. *Huberta.* Cape Town: Lions Head, 1970.

340. [Johnson, Richard T.]. *The Cape Times,* June 5, 1945, January 1955, January 24, 1956, October 25, 1967; *Die Huisgenoot,* May 15, 1970.

Kirby, Walter H.

341. Kirby, Walter H. *Hunting the Hun.* Johannesburg: Argus, 1915.

342. Kirby, Walter H. "A South African at the Front." *The Union Annual for South Africa.* Christmas 1917, pp. 20-26.

Leibbrandt, Eben

343. Blom, Wim. "Introduction." Exhibition of Sculpture by Eben Leibbrandt, Goodman Gallery, Hyde Park, Johannesburg, November 11-25, 1972.

344. Harmsen, F. "Grafiese Werk van Eben Leibbrandt." *Lantern.* September 1966, pp. 14-21

Lessing, Paul

345. Lessing, Paul. *Die Van der Merwes.* Durban: Robinson, 1973.

346. [Lessing, Paul]. *Personality.* August 22, 1975; *Pretoria News,* November 2, 1970; *Rand Daily Mail,* January 29, 1973; *Ster,* July 24, 1970.

Leyden, Jock

347. Leyden, Jock. *All My Own Work: The Leyden Cartoon Book No. 2.* Cape Town, Purnell and Sons, 1964.

348. Leyden, Jock. All the Best. Select of 96 Cartoons Reproduced by Courtesy of Natal Daily News. Durban: Natal Daily News, 1940.

349. Leyden, Jock. *The Fifth Leyden Cartoon Book.* Cape Town: Purnell and Sons, 1967.

350. Leyden, Jock. *The Fourth Leyden Cartoon Book.* Cape Town: Purnell and Sons, 1966.

351. Leyden, Jock. *The Laugh Round-up.* Red Cross Memorial Building Fund, 1945.

352. Leyden, Jock. *The Leyden Cartoon Book No. 1.* Cape Town: Purnell and Sons, 1963.

353. Leyden, Jock. *The Leyden Cartoon Book No. 3.* Cape Town: Purnell and Sons, 1965.

354. Leyden, Jock. *100 Not Out.* Durban: *The Daily News,* 1978.

355. Leyden, Jock. *There's a Thing!* Durban: Singleton and Williams, 1944.

356. [Leyden, Jock.]. Argus News, July 1981; Die Brandwag, August 26, 1955; Capital News Supplement, January 3, 1982; The Cape Argus, October 25, 1969; The Forum, September 4, 1943; The Mercury's S. A. Woman's Weekly Supplement, February 25, 1982; The Natal Witness, April 25, 26, 1977; The (Natal) Daily News, passim, July 18, 1939 through February 10, 1982; The Star, October 4, 1969, April 23, 1970, March 10, 1981; Sunday Tribune, December 18, 1966.

Lindeque, Leonard

357. Lindeque, Len. "In Hollywood Was Net Brynner se Voete Groter as Myne." *Rooi Rose.* September 23, 1970.

358. [Lindeque, Len.]. *Beeld,* February 10, 1979, November 12, 1980, November 15, 1980; *Die Burger,* November 12, 1980; *Dagbreek en Landstem,* May 12, 1963; September 28, 1969, November 23, 1969, December 7, 1969, February 15, 1970, July 19, 1970, August 9, 1970, November 22, 1970; *Diamond Fields Advertiser,* November 12, 1980; *The Jewish Herald,* January 9, 1979; *Korhaan,* February 1978, September 1978, July 1980; *Oosterlig,* May 25, 1970, *Paratus,* April 1978, *The Pretoria News,* February 1, 1971.

359. Krygskuns. *Suid-Afrikaanse Panorama.* November 1978.

360. Pienaar, Max. "Ons Fleurige Seun, Len Lindeque." *Dagbreek en Landstem.* May 10, 1970.

361. "Unique Contemporary War Art Exhibition." *Paratus.* April 1978.

Lloyd, Arthur W.

362. Fraser, Maryne. "Cartoons, Politics and Magnates." *Africana Aant. en Nuus,* December 1979.

363. Lloyd, Arthur W. "Jambo" or With Jannie in the Jungle. Thirty East African Sketches. Johannesburg: CNA, 1917.

364. Lloyd, Arthur W. *"Sunday Times" Book of Cartoons.* Johannesburg: Argus, 1907.

365. [Lloyd, Arthur W.]. *Rand Daily Mail,* June 10, 1925, May 19, 1967; *Southern Africa,* January 25, 1963; *The Star,* November 18, 1912, July 4, 1925; *Sunday Times,* January 27, 1963; *The Times,* May 18, 1967

366. Stuart, John. "South African Caricaturists No. 1. Mr. A. W. Lloyd." *The State.* November 1909, pp. 556-562.

367. "Vanishing Spoors – Brief Chronicles." *Libertas.* June 1947.

l' Ons, Frederick T.

368. K., R. F. "l'Ons, F. T. Surgeon Nathaniel Morgan or Surgeon-Major Benjamin Swift." *Afrikana Aant. en Nuus.* 20 (1972/1973), pp. 237-240.

369. Redgrave, J. J. and E. Bradlow. *Frederick l'Ons, Artist.* Cape Town: Maskew Miller, 1958.

Lyons, Alfred

370. Lyons, Alfred. Rand People No. 1: Some Johannesburg Johnnies. Johannesburg (?): 189 - ?.

371. Lyons, Alfred. A South African Alphabet of the War: Cartoons and Doggerel. Johannesburg: 1914.

372. [Lyons, Alfred.]. The Gold Fields Times, March 5, 1890; The Nugget, February 16, 1893, March 9, 1893; Pall Mall Budget, February 6, 1890; Rand Daily Mail, April 19, 1905.

MacKinney, H. W.

373. G. "South African Caricaturists. II. Mr. H. W. MacKinney." *The State.* December 1909, pp. 720-725.

374. MacKinney, H. W. *Cartoons of the Great War, 1914-1916,* Cape Town: Maskew Miller Cape Times Ltd., 1916.

375. MacKinney, H. W. *Cartoons of the Great War, 1916-1917.* Cape Town: Maskew Miller Cape Times Ltd., 1917.

376. MacKinney, H. W. *Cartoons of the Great War, 1917-1918-1919.* Cape Town: Maskew Miller Cape Times Ltd., 1919.

377. MacKinney, H. W. *Character Sketches.* Cape Town: Darter Brothers, 1909.

378. MacKinney, H. W. Pictorial Politics, 1913-1914. Cape Town: Cape Times, 1914.

379. MacKinney, H. W. *Political Shots.* Cape Town: *Cape Times,* 1910.

380. MacKinney, H. W. *Scrapbook of Cartoons from Cape Times, 1907-1910.* Cape Town: Maskew Miller Cape Times, 1910.

381. [MacKinney, H. W.]. *The Cape,* January 27, 1911, January 23, 1925; *The Cape Times Centenary Supplement,* March 27, 1976.

382. Pelzer, A. N. "Pretoria in Karikatuur." In *Pretoria (1855-1955),* edited by S. P. Engelbrecht, J. A. Agor-Hamilton, A. N. Pelzer, and H. P. H. Behrens. Pretoria: Stadsraad van Pretoria, 1955.

Marais, David D.

383. Fransen, H. "David Marais–Spotprenttekenaar." *SANG/SANK Inligtingsblad* (Suid-Afrikaanse Nasionale Kunsmuseum), 1978.

384. Marais, David. *All The Nudes That's Fit To Print.* Cape Town: Howard Timmins, 1972.

385. Marais, David. *Europeans Only.* Cape Town: Jan Botha, 1960.

386. Marais, David. *Hey! Van der Merwe.* Cape Town: Jan Botha, 1961.

387. Marais, David. *I Got a Licence. A New Collection of Cartoons.* Cape Town: Books of Africa (Pty), Ltd., 1962.

388. Marais, David. *I Like It Here.* Cape Town: Jan Botha, 1964.

389. Marais, David. *Out of This World.* Cape Town: Books of Africa, 1963.

390. Marais, David. *Ag. Sis Man. Reproduced from Cape Times.* Cape Town: Howard Timmins, 1965.

391. Marais, David. *This Is a Hi-Jack.* Cape Town: Howard Timmins, 1974.

392. [Marais, David]. *The Cape Argus,* July 25, 1964, November 1, 1969, June 9, 1978; *The Cape Times Centenary Supplement,* March 27, 1976; *The Cape Times Weekend Magazine,* August 20, 1960; *The Cape Times,* January 3, 1974, August 3, 1974, November 20, 1974, June 8, 1978, July 6, 1978; *Pretoria News,* January 3, 1974.

Mogale, Dikobe B.

393. *Katalogus* – Tentoonstelling van Tekeninge deur Mogale Saam met Kunswerke deur ander Swart Kunstenaars in 'The Cathedral Centre,' Pietermaritzburg, October 26 – November 1, 1980.

394. [Mogale, Dikobe B.]. *Capital News,* November 6, 1980; *Staffrider,* April/May 1981.

Muller, Willem (Wim)

395. Fransen, H. *Katalogus* vir 'n Tentoonstelling van Wim Muller se Humoristiese Plakkate, Spotprente en Illustrasies: 1974 Suid-Afrikaanse Nasionale Kunsmuseum, Cape Town. April 2-27, 1975. Pretoriase Kunsmuseum.

396. "Wim Muller Buitengewoon Humoristies." *Die Transvaler. March 26, 1975.*

397. Van Graan, Riena. "Sierlike ou Plakkate." *Beeld.* April 14, 1975.

Packer, Edgar A.

398. *Katalogus*. Uitstalling van Skilderye deur Mary Packer, RAU, May 9-23, 1977.

399. Lefebvre, D. "Quip – The Artist and Some Facets of His Work." *South African Architecture Record*. February 1933, pp. 38-39.

400. [Packer, Edgar A.]. *The Outspan,* December 30, 1932; *The Sjambok,* June 7, 1929; *The Star,* December 17, 1932, April 26, 1967.

401. "Quip." *Tielman.* Johannesburg: CNA, 1925.

Papas, William

402. "Bill Papas, South African-Born Artist and Cartoonist, Dies in Plane Accident." *New York Times.* June 28, 2000.

403. Goldberg, A. "Griekeland, Jerusalem en die Transvaalse Platteland – 'n Vinjet." *Buurman.* September/November 1982, pp. 39-42.

404. [Papas, William.]. *Beeld,* August 27, 1981; *Cape Argus,* September 22, 1952; *Dagbreek en Sondagnuus,* July 21, 1957, *New Statesman,* November 1, 1968; *Die Transvaler,* July 29, 1957; *Twentieth Century,* 178 (1970).

405. Van Biljon, M. "Aegean Journey" *Fair Lady.* February 19, 1975.

Papenfus, Rufus

406. Papenfus, Rufus. Die Grootste Reeks, Suid-Afrika Teen Nieu-Seeland/The Greatest Series: Springboks vs New Zealand. Cape Town: Malherbe, 1970.

407. [Papenfus, Rufus.]. Argus News, January 1981; The Cape Times, February 2, 1978; Pretoria News, February 14, 1976, August 6, 1976, May 20, 1977.

Penstone, Constance and Charles

408. K., R. F. "Charles and Constance Penstone, Cartoonists." *Africana Aant. en Nuus.* 19(1971), pp. 249-252.

409. [Penstone, Constance and Charles.]. *Die Burger,* October 22, 1925; *The Cape Argus,* May 22, 1926; *The Cape Times,* May 7, 1928, May 8, 1928; *The Cape Times Weekly Edition,* March 21, 1906, February 20,

1907; *The Cape Times Centenary Supplement,* March 27, 1976; *The Star,* May 6, 1925.

Playfair, Charles

410. Playfair, Charles. *Kidtoons.* Cape Town: Howard Timmins, 1929.

411. Playfair, Charles. *"Shot!"* Cape Town: Howard Timmins, 1954.

412. [Playfair Charles]. *The Cape Argus,* December 4, 1954; *Cape Times,* December 2, 1954; *Pretoria News,* January 3, 1955; *The Star,* December 15, 1954; *The Sunday News,* December 19, 1954.

Robert, Earl

413. Robert, Earl. *The Rand of Hope and Glory Under Martial Law.* Johannesburg: *Transvaal Leader,* 1914.

414. Robert, Earl. *The Snow Age of the Transvaal: Humorous Details and Sketches of the "Great Fall."* Johannesburg: CNA, 1909.

415. Robert, Earl. *South Africa Under the Iron Heel or a Teutonic Xmas Dream, Incorporating a Second Part: The Awakening.* Johannesburg: Wm Dawson and Sons for *Transvaal Leader,* 1914.

416. Robert, Earl. *A Souvenir of the Record Reign: Illustration of the Jubilee Festivities.* Johannesburg: Argus Co., 1897.

Robinson, Paul Herman (Robin)

417. Robin. *Cartoons.* Durban: *The Natal Mercury,* 1966, 1970.

418. [Robin.]. *Diamond Fields Advertiser,* April 30, 1964; *The Natal Mercury,* March 15, 1965, October 26, 1966, October 24, 1970, January 15, 1971; *Rand Daily Mail,* October 24, 1970; *South African Panorama,* August 1964.

419. Wilks, Terry. *For the Love of Natal.* Durban: Robinson, 1977.

Robinson, Wyndham

420. Robinson, Wyndham. *Cartoons from the Cape Times.* Cape Town: Central News Agency, Ltd., date (?).

421. Robinson, Wyndham. *Cartoons from the Morning Post.* London: Jenkins: 1937

422. Robinson, Wyndham. *Political Pie.* Compound of *Cape Times* Cartoons. Cape Town: Central News Agency Ltd., 1932.

Sak, Leonard

423. Sak, Leonard. *The World of Jojo.* Johannesburg: Argus, 1974.

424. [Sak, Leonard.]. *Argus News,* May 1981; *The Star,* October 4, 1969, December 19, 1974; *Sunday Post,* March 4, 1979.

Schonegevel, Johan M. C.

425. Bradlow, F. "Johan Marthinus Carstens Schonegeval, Artist, Lithographer and Painter." *Africana Aant. en Nuus.* 15 (1963), pp. 150-154.

426. [Schonegevel, Johan M. C.]. *Het Volksblad.* February 21, 1871.

Schröder, William H.

427. Bouma, Paddy. "Die Spotprente in Suid-Afrika." *Informa IV. Geskiedenis van die Karikatuur.* Dept. Beeldende Kunste, Universiteit van Stellenbosch, 1973.

428. Brander. "William Howard Schröder." *Naweek.* December 25, 1941, pp. 3-4.

429. Cowen, C. "Memoir of the Life of William Howard Schröder." In *The Schröder Art Memento,* edited by C. Cowen. Pretoria: The Press, 1894.

430. Langham-Carter, R.R. "Background to Schröder." *Africana Aant. en Nuus.* 20 (1973), pp. 234-240.

431. Sawyer, E.J. "A South African Cartoonist." *Trek.* October 6, 1944, p. 14.

Shackleton, Charles W.

432. Shackleton, C.W. *East African Experiences 1918.* Durban: Knox, 1940.

433. Shackleton, Moth Charles. The Story of Home Front Magazine. Fifty Years of the Memorable Order of Tin Hats. Durban: MOTH, 1977

Shilling, George F.

434. Shilling, Frederick. South African Sports Cartoons and Personalities. Cape Town: CNA, 1948.

435. [Shilling, Frederick.]. Cape Times, June 5, 1946, June 19, 1946, June 20, 1946, August 1, 1947, December 30, 1948, June 17, 1978; The Forum, 1948-1950.

Solomon, Joseph M.

436. G., T. "Solomon, Joseph Michael." In *Dictionary of South African Biography,* edited by W. J. De Kock, pp. 682-683. Cape Town: Tafelberg, n.d.

437. "Obituary J.M. Solomon." *Architect, Builder and Engineer*. September 1920.

438. "Obituary J. M. Solomon." *Building*. September 1920, p. 381.

Soobben, Nanda

439. Singh, Niyantha. "Paintings by Soobben Fetch Top Auction Prices." *Natal Post.* June 19, 1996.

440. Naidoo, Yasantha. "President Laughs at Himself." *Sunday Tribune.* n.d., 1995.

Thamm, Erik (Etam)

441. Etam. *Die Politieke Stryd in Beeld.* Johannesburg: HNP, 1949.

442. Thamm, Erik. Die Politieke Stryd in Beeld. Spotprente van Posbus 8124 JHB. Uitgegee deur H. N. P. Van Tvl.

443. [Thamm, Erik.]. *Beeld,* November 9, 1978; *Die Brandwag,* August 19, 1955, August 9, 1957; *Die Transvaler,* April; 1, 1950, September 29, 1973.

Urry, Patricia

444. Urry, Pat. *The History of the Hedgehog.* Johannesburg: S.A.S.P.U., 1980.

445. [Urry, Pat.]. *Rand Daily Mail,* March 30, 1980; *Sunday Express,* December 21, 1980.

Van Wouw, Anton

446. "Anton van Wouw." *Trek.* August 10, 1945.

447. "Anton van Wouw als Spotprenttekenaar." *Nieuws uit Zuid-Afrika.*
 October 1968, p. 24.

448. Dekker, G. "Anton van Wouw." In *S.E.S.A,* edited by D.J. Potgieter, pp.
 176-177. Cape Town: Nasou, n.d.

449. Rosenthal, Eric. "Van Wouw as Spotprenttekenaar." *Die Brandwag.*
 September 28, 1945, p. 11.

450. Schoonraad, Murray. "Anton van Wouw (1862-1945)." *Antiques in
 South Africa.* 5 (1979), pp. 69-73.

451. Schoonraad, Murray. *Katalogus: Pierneef – Van Wouw.*
 Teentoonstelling aangebled deur die Kunsstigting Rembrandt van Rijn,
 1980.

452. Universiteit van Pretoria. *Anton van Wouw 1862-1945 en die Van
 Wouwhuis.* Durban: Butterworths, 1981.

Zapiro (Jonathan Shapiro)

453. Nyamnjoh, Francis. "Zapiro and South African Political Cartooning."
 International Journal of Comic Art. Fall 2000, pp. 54-76.

454. Shapiro, Jonathan. *Zapiro. Call Mr. Delivery.* Cape Town: David Philip,
 1999. 160 pp.

455. Shapiro, Jonathan. *Zapiro. The Devil Made Me Do It.* Cape Town:
 David Philip, 2000. 160 pp.

456. Shapiro, Jonathan. *Zapiro. End of Part One.* Cape Town: David Philip,
 1998. 160 pp.

457. Shapiro, Jonathan. *Zapiro. The Hole Truth.* Cape Town: David Philip,
 1997. 152 pp.

458. Shapiro, Jonathan. *Zapiro: The Madiba Years.* Cape Town: David
 Philip, 1996. 160 pp.

Historical Aspects

459. Blenkin, J. H. "Weekly Papers of the Past – The Comic Press of Cape
 Town." *The Cape.* May 6, 1910, pp. 8-9.

460. Department of Creative Arts. *History of Caricature.* Afdeling
 Kunsgeskiedenis en Documents. 1963 – 1973.

461. G. "South African Caricaturists II. Mr. H. W. Mackinney." *The State
 Des.* 1909, pp. 720-725.

462. Jeppe, H. *Suid-Afrikaanse Kunstenaars 1900-1962.* Johannesburg: Afrikaanse Pers-Boekhandel, 1964.

463. Johnson, Richard T. *Major Rock Paintings of Southern Africa.*Cape Town: David Philip, 1979.

464. Johnson, Richard T., Hyme Ribinowitz, and Percy Sieff. *Rock Paintings of the South West Cape.* Cape Town: Nasionale Boekhandel, 1957.

465. Kennedy, R. F. "Early South African Cartoons." In *Africana ByWays,* edited by Anna H. Smith. Johannesburg: Ad Donker, 1976.

466. Pelzer, A. N. "Pretoria in die Karikatur." In *Pretoria 1855-1955,* edited by S. P. Engelbrecht. Pretoria: Stadsraad van Pretoria, 1955.

467. Saycell, K. J. "The Use of the Cartoon in the Classroom." *Crux.* October 1979, pp. 20-28.

468. Van Riet Lowe, C. "Rock Paintings Near Cathedral Peak." *South African Archaelogical Bulletin.* March 1949, pp. 28-33.

Animation

469. Moins, Philippe. "William Kentridge: Quite the Opposite of Cartoons." *Animation World.* October 1998. 3 pp.

470. O'Sullivan, Michael. "Kentridge's Troubling Shades of Truth." *Washington Post.* March 9, 2001, p. WE53.

Comic Books

471. Joseph, Michael and Esther Ramani. "The Communal Reading of Comics: A Case Study of an Extensive Reading Project for Adult Basic Literacy." Paper presented at Annual English Language Educational Trust Conference, University of Natal, Durban, South Africa, August 1999. Available from The Storyteller Group, Johannesburg.

472. Krouse, Matthew. "Little Magazines, Large Impact." *Arts 2000* (South Africa). 2000, pp. 19-21.

473. Kruger, Karla. "Land in Zicht—Zuid-Afrika." *Stripschrift.* March 2000, p. 21.

474. Lent, John A. "Comics for Development: The South African Case." Paper presented at International Society of Humor Studies, Osaka, Japan, July 26, 2000.

475. Mason, Andy. "Graphic Narratives and Resistance Discourses in the South African 'Alternative Press' (1985-1994)." Masters thesis, University of Natal, Centre for Culture and Media Studies, 2000.

476. Napper, Neil and Peter Esterhuysen. *Popular Literature.* Johannesburg: The Storyteller Group, n.d. 39 pp.

477. Rifas, Leonard. "Taking on the Historical Moment: Comics Get Real in South Africa." *Reflex.* October/November 1995, pp. 6-9.

478. "SA AIDS Comic 'Roxy.'" *Nursing RSA.* October 1994, p. 4.

479. Shariff, Patricia. "Dialogue, Gender and Performance: Producing a Rural South African Comic Beyond the Learner Paradox." Doctoral dissertation, University of the Witwatersrand, Johannesburg, 1999.

480. Shariff, Patricia Watson, and L. Kruger. "'Shoo – This Book Makes Me To Think.' Education, Entertainment and 'Life-skills' Comics in South Africa." *Poetica Today.* Forthcoming [2001?].

Bitterkomix

481. Davey, Adele. "For Art's Sake." *Die Matie.* September 15, 1994.

482. de Waal, Shaun. "Doodling in the Margins." *The Weekly Mail and Guardian.* June 17-23, 1994.

483. de Waal, Shaun. "Full-Frontal Attack on Taboos." *The Weekly Mail and Guardian.* October 14-20, 1994, p. 41.

484. Meesters, Gert. "Bitterkomix." *Stripschrift.* February 1999, pp. 32-33.

485. Morris, Michael. "Strip Teasers." *Sunday Life.* July 16, 1995, pp. 6-9.

486. Powell, Ivor. "The Bitterness and the Transgression." *The Weekly Mail and Guardian.* February 10-16, 1995, p. 38.

487. Tayler, Jamie. "Bitterkomix: Pan Africanist Afrikaner Sex Comics." *Night Life.* April 1996.

488. Tayler, Jamie. "Comics Are Nothing To Laugh About." *Cape Times.* May 24, 1996, pp. 1, 3, "Top of the Times" Section.

Kannemeyer, Anton

489. "A. Kannemeyer Antwoord Kritici." *Die Burger.* November 11, 1995.

490. Ismail, Farhana. "Anti-Porn Protestor Sprays Sex Painting." *Sunday Tribune.* October 22, 1995.

491. Ismail, Farhana. "Artist Shocks Viewers." *Sunday Weekend Argus.* October 28/29, 1995, p. 7.

492. Nolte, M. A. "Peet Skep 'n Pertinente Kunsplaneet." *Burger.* June 13, 1966.

Storyteller Group

493. Bahr, Mary Ann. "Dear Story-Net Participants." *Storynet.* March 1992, pp. 1-2.

494. Bahr, Mary Ann and Carol Rifkin. *The River of Our Dreams: Interim Research Report.* Johannesburg: Storyteller Group, 1992.

495. Bahr, Mary Ann and Carol Rifkin. *Story Net Interim Research Report.* Johannesburg: The Storyteller Group, 1992, 44 pp.

496. Clacherty, G.E. The Storyteller Group's Urban Environmental Education Comic Project: Report on the Evaluation of the Pilot Edition of the Earthshaker Comic. Johannesburg: Storyteller Group, March 1993, 29 pp.

497. Dicker, Craig. "From Multimedia to Multilingualism." *Bua!* May 1995, p. 31.

498. Esterhuysen, Peter. *The River of Our Dreams.* Johannesburg: Storyteller Group, 1991.

499. Esterhuysen, Peter. *Spider's Place.* Vols. 1-4. Johannesburg: Handspring Press, 1994.

500. Esterhuysen, Peter. "Spinning the Web of Science." *Bua!* May 1995, pp. 30-32.

501. Esterhuysen, Peter. *Towards a Dialogic Approach to Communication.* Storynet Newsletter. Johannesburg: Storyteller Group, 1991.

502. Esterhuysen, Peter. "Towards a Dialogic Approach to Communication." *Story Net.* July 1992, pp. 1-2.

503. Esterhuysen, Peter. "Using Comic Books To Challenge Dominant Literacies in South Africa." In *Challenging Ways of Knowing – In English, Moths and Science,* edited by Dave Baker, John Clay, and Carol Fox, pp. 147-158.

504. Hendricks, Carl. "From Creative Writing to Urbanisation." *Storynet.* March 1992, p. 2.

505. "Massive Reading Promotion." *Storynet.* March 1991, pp. 1-2.

506. Napper, Neil. Draft. Proposal/Discussion Document To Change the Reading Environment, To Adaft African Film to Comic History, and To Establish a Centre for Popular Visual Communication. Melville, South Africa: The Storyteller Group, 1997, 26 pp.

507. "99 Sharp St. Goes Rural!" *Storynet.* March 1992, p. 3.

508. Perold, H. and J. Jansen. How Do Teachers Use Innovative Science Material? A Report on an Evaluation of Spider's Place. Johannesburg: Handspring Trust for Puppetry in Education, 1994.

509. Radus, Colleen. "A Gateway to Local Literature." *Bua!* 1994 (?), p. 26.

510. "Reading and 'The River of Our Dreams.'" *Storynet.* March 1992, p.5.

511. Rifkin, Carol and Andre Croucamp. "Approaches to the Comic Story Medium as an AIDS Educational Resource." An unidentified AIDS publication, South Africa, 1995, pp. 12-13.

512. "The River of Our Dreams: The Story Behind the Story." *Storynet.* March 1991, pp. 3, 4.

513. "The Role of Comic Stories." *Story Net.* July 1992. pp. 3-4.

514. Shariff, Patricia Watson and Hilary Janks. "Changing Stories: The Making and Analysis of a Critical Literacy Romance Comic." *International Journal of Comic Art.* Fall 2001.

515. Storyteller Group. "Does Heart to Heart Work As an Effective Resource in Sexuality Education? A Preliminary Research Report." Johannesburg: Storyteller Group, n.d. 16 pp.

516. Watson, Patricia. "Comics and Rural Development." *Mathasedi.* November/December 1994, pp. 28-31.

517. Watson, Patricia. "The Politics of Popular Visual Literature – The Action and Reflection of a Comic Narrative in Process." Honors long essay, University of the Witwatersrand, 1992.

518. Watson, Patricia. "Producing a Rural Comic. Beyond the Learner Paradox." Master's thesis, University of the Witwatersrand, 1996/1997.

519. Watson, Patricia and Peter Esterhuysen. "Does *Heart to Heart* Work As an Effective Resource in Sexuality Education?" Johannesburg. Unpublished paper.

520. Watson, Patricia and Peter Esterhuysen. *Heart to Heart.* Johannesburg: Storyteller Group, 1994.

521. "Which Way to Umnandi?" *Storynet.* March 1992, p. 4.

522. "Workers Find 'A Little Bit More English.'" *Storynet.* March 1992, p. 5.

Comic Strips

523. Andrew, Richard. "Narrative Strip Illustration for Print, with an Emphasis on the Human Figure." Thesis, National Higher Diploma, Technikon Natal, 1988. 83 [36] pp.

524. Goldstuck, Arthur. "Comics: South Africa's New Moral Battleground." *Times of London.* Mach 2, 1992.

"Madam and Eve"

525. Contreras, Joseph. "At Last, It's Time for a Laugh." *Newsweek.* n.d., 1994.

526. Francis, S., H. Dugmore, and Rico. *Madam and Eve, All Aboard for the Gravy Train.* London: Penguin Books, 1995, 176 pp.

527. Francis, S., H. Dugmore, and Rico. *The Madam and Eve Collection.* London: Penguin Books, n.d.

528. Francis, S., H. Dugmore, and Rico. *Madam and Eve, Free at Last.* London: Penguin Books, 1994. 176 pp.

529. Francis, S., H. Dugmore, and Rico. *The Madams Are Restless: A New Madam and Eve Collection.* Johannesburg: Rapid Phase, 2000. 176 pp.

530. Francis, S., H. Dugmore, and R. Schacherl. *Madam & Eve's Greatest Hits.* Parktown, South Africa: Penguin Books, 1998. 240 pp.

531. Higdon, Hal. "Is She Available Tuesdays?" *CAPS.* September 1997, pp. 55-62.

532. Keller, Bill. "Time To Laugh? The Beloved Country Thinks So." *New York Times.* April 5, 1993.

533. Lindon, Mathieu. "Blague Is Black." *Liberation Livres Special Bande Dessinée.* January 22, 1998, p. 10.

534. Lyden, Jacki. "Madam and Eve." National Public Radio's Weekend Edition Sunday. December 14, 1997.

535. Milton, Blue. "Rapidphase." *Ada.* January 1996, pp. 24-25.

536. Matloff, Judith. "'Madam and Eve' Tickles the Funny Bone of South Africa's Thirtysomething Set." *Jerusalem Post.* September 23, 1993.

537. "So This Is What You Readers Like, Heh?" *Mail and Guardian.* October 27 – November 2, 1995.

538. "South Africans Find a Funny Bone." *Cartoon World.* October 1995, p. 14.

539. Taylor, Paul. "Finding S. Africa's Funny Bone." *Washington Post.* December 18, 1993, pp. A19, A26.

540. Wells, Ken. "South Africans Find a Spot in Common: It's the Funny Bone." *Wall Street Journal.* October 5, 1995, pp. 1, 7.

"Shoestring"

541. Rob (Robert Schormann) and Dr. Jack (Jack Swanepoel). *Shoestring.* Sandton: Hobotoons, Struik Books, 1994. 111 pp.

542. Rob and Dr. Jack. *Shoestring II.* London: Hobotoons, Penguin, 1995. 138 pp.

Political Cartoons

543. Connolly, Bob. "Political Cartooning." *The Forum.* July 1952, pp. 12-13.

544. Dugmore, Harry, Stephen Francis, and Rico. *Nelson Mandela: A Life in Cartoons.* Claremont: David Philip Publishers, 1999. 191 pp.

545. Goldstuck, Arthur. "Censors Caught Between Rockets and a Hard Plot." *Weekly Mail.* February ?, 1992.

546. Schoombee, Pieter. *Die Nuwe Suid-Afrika en Ander Liegstories.* South Africa: Tafelberg-Uitgewers Beperk, 1992.

547. Vernon, Ken. Penpricks. *The Drawing of South Africa's Political Battle Lines.* Claremont: Spearhead Press, 2000. 200 pp.

TANZANIA
Cartooning

548. Kaguo, Titus. "Cartoon Journalism and Democracy in Tanzania." Paper presented at International Workshop on Cartoon Journalism and Democratisation in Southern Africa, University of Botswana, Gaborone, November 9, 2000. 10 pp.

549. Mukajanga, Kajubi. "How Obscene Is Obscene in Our Cartoon Strips?" *Media Watch* (Media Council of Tanzania). November 2000.

Comics

550. Packalén, Leif. "Comics in Development 1996. Monogoro, Tanzania." *Taarifa Newsletter* (Helsinki) 3, 1996, pp. 1-8.

551. [Packalén, Leif]. *Mustaa Valkoisella.* Helsinki: Suomi-Tansania Seura, 1997. 32 pp.

TUNISIA
General Sources

552. *Caricatures de Aly Abid.* Tunis: A.G.E.P., 1976.

553. Douglas, Allen and Fedwa Malti-Douglas. "Islamic 'Classics Illustrated': Regendering Medieval Philosophy in a Modern Tunisian Strip." International Journal of Comic Art. Fall 1999, pp. 98-106.

554. Omri, Mohamed-Salah. "'Gulf Laughter Break': Cartoons in Tunisia During the Gulf Conflict." Princeton Papers: Interdisciplinary Journal of Middle Eastern Studies. Spring 1997, pp. 133-154.

ZAIRE
General Sources

555. "Afrikaans Stripfestival." *Stripschrift.* July 1991, p. 34.

556. Diamani, J.-P. "L'Humour Politique au Phare du Zaire." *Politique Africaine.* June 1995, pp. 151-157. (Political cartoons).

ZAMBIA
Political Cartoons

557. Ford, Trevor. *Yuss. At Large! 1991-2000.* Lusaka: Aguila Printers, 2000.

ZIMBABWE
General Sources

558. Frederikse, Julie. *None But Ourselves: Masses Versus Media in the Making of Zimbabwe.* Harare: ZPH, 1982.

559. Lucock, Edward. Books by, in Zimbabwe: *Laugh with Lu, It's a Mad World, Bowling with Lu, More Bowling with Lu, Golfing with Lu, Our*

Man at the Ministry, *Fun and Game*, *Fun in the Forces*; in South Africa: *Bowls Mad* (1980), *Fishing Mad* (1980), *Hospital Mad* (n.d.), and *Forces Mad* (1981).

560. [Lucock, Edward]. *Rhodesia Calls*. May/June 1975, pp. 29-30.

561. McCarthy, Irene. "Book Illustration in Zimbabwe." *Zimbabwe Insight*. July 1, 1986, p. 37.

562. Meintjes, Hannes. *Ghost Squad* 1, 2. Bulawayo: Friendly Publications, 1976.

Comics

563. *Bazania File, The*. Africa Intrigue Comics, No. 1, October 1983.

564. McLoughlin, T. O. "Reading Zimbabwean Comic Strips." *Research in African Literatures*. Summer 1989, pp. 217-241.

Political Cartoons

565. Maliki, Boyd and Geoff Nyarota. *Nyathi Cartoons, Vol. 1*. Bulawayo. N.p., n.d.

566. Musengezi, H. *The Honourable M. P.* Gweru: Mambo, 1984.

567. "No Laughing Matter." *Index on Censorship*. July/August 1997, p. 9.

568. [Review of *Nyathi*]. *Herald* (Harare). June 29, 1987.

569. *Rhodesia: The Propaganda War*. Salisbury: Catholic Commission for Justice and Peace, n.d. (1977).

2

MIDDLE EAST

REGIONAL AND INTER-COUNTRY PERSPECTIVES

General Sources

570. Afary, Janet. "Journalism, Satire, and Revolution: Exposing the Conservative Clerics, Denouncing the Western Powers." In *The Iranian Constitutional Revolution, 1906-1911,* pp. 116-142. New York: Columbia University Press, 1996.

571. Atil, Esin. "Humor and Wit in Islamic Art." *Asian Art and Culture.* Fall 1944, pp. 12-29.

572. *Caricature Arabe.* Paris: Institut du Monde Arabe, 1988.

573. Gallini, Clara. "Arabesque – Images of a Myth." *Critica Sociologica.* April/June 1989, pp. 98-104.

574. Marsot, Afaf Lutfi al-Sayyid. "Humor: The Two-Edged Sword." *Middle Eastern Studies Bulletin.* 14:1 (1980), pp. 1-9.

575. Shahid, Aminah. "Heartless Middle East Humor." *Washington Post.* October 28, 2000, p. A23. (Censorship of "B.C." and Tony Auth cartoon).

576. Shimizu, Isao. "Stressful Society and Comics: Reflections on My Trip to Egypt and Turkey." *Fūshiga Kenkyū.* July 20, 1997, pp. 7-8, 16.

577. "A Talk with the Manager of Arab Great Encyclopedia." *Kayhan Caricature.* June/July 2000, 2 pp.

578. Uri, Dan. "Mideast Cartoons Use Viagra To Make, Uh, Point." *New York Post.* June 21, 1998.

579. Uysal, Hasan. "Yapacaksan Adam Gibi Yap!" *Karikatür.* No. 17, 1994, p. 10.

Animation

580. "Accused of Arab Slur, Aladdin Is Edited." *New York Times.* July 14, 1993, p. A18.

581. "Arab-Americans Set Disney Protest." *Animation World.* September 1996, 5 pp.

582. "Does *Aladdin* Stereotype Arabs? Children Say Yes – and No." *Los Angeles Times.* June 14, 1993, p. F3.

583. "A Lot of People Are Angry with Disney This Summer." *ASIFA San Francisco.* September 1997, p. 5.

584. Scheinin, Richard. "*Aladdin's* Portrayal of Arabs, Muslims Sparks Anger." *Boston Globe.* January 12, 1993, p. 71.

585. Scheinin, Richard. "Arabian Slights." *San Jose Mercury News.* January 2, 1993.

586. Shaheen, Jack. "Aladdin: Animated Racism." *Cineaste.* 20:2 (1993), p. 49.

587. Shaheen, Jack. "Arab Caricatures Deface Disney's *Aladdin.*" *Los Angeles Times.* December 21, 1992, p. F-3.

588. Shaheen, Jack. "Disney Has Done It Again." *Islamic Horizon.* March/April 1966, pp. 38-39.

589. Walker, Christopher. "Disney's *Aladdin* Rubs Arabs Up the Wrong Way." London *Times.* May 22, 1993.

Comic Strips

590. "Arabische Strips." *Stripschrift.* August 1994, pp. 32-33.

591. Davis, Eric. "Arab Comic Strips." *Middle East Journal.* 49:1 (1995), p. 153,

592. Douglas, Allen and Fedwa Malti-Douglas. "Arab Comics: Between Children's Literature and Adult Politics." Paper presented at International Comics and Animation Festival, Bethesda, Maryland, September 24, 1998.

593. Webber, Sabra J. "Arab Comic Strips." *Inks*. November 1996, pp. 39-41.

Political Cartoons

594. Al-Hajji, Maher Nasser. "The Portrayal of Arab Image in Selected Events in Three Newspapers Editorial Political Cartoons for October 1973 to November 1990." MA thesis, Brigham Young University, 1992.

595. Alizadeh, Javad, Mik Jago, John A. Lent, and Joe Szabo. "Middle East." *WittyWorld International Cartoon Magazine*. Spring 1997, pp. 9-10.

596. Alizadeh, Javad, Mik Jago, John A. Lent, and Joe Szabo. "'Şakaya Gelmez' Orta-doğu Karikatütü." *Karikatürk*. No. 43, 1997, p. 519. (Iran, Israel).

597. Berghold, J. "La Lampada di Saladino: La Satira degli Arabi Sulla Guerra del Gulfo" (Aladdin's Lamp: Arab Satirical Cartoons on the Gulf War). *Journal of Psychohistory*. 22:1 (1994), p. 115.

598. Glanville, Jo. "Lines of Attack." *Index on Censorship*. 27:5 (1998), pp. 26-30.

599. Göçek, Fatma Müge. "Political Cartoons as a Site of Representation and Resistance in the Middle East." *Princeton Papers: Interdisciplinary Journal of Middle Eastern Studies*. Spring 1997, pp. 1-12.

600. Göçek, Fatma Müge, ed. Political Cartoons in the Middle East: Cultural Representations in the Middle East: Princeton, New Jersey: Markus Wiener, 1997, 160 pp.

601. Kamalipour, Yahya R., ed. *The U.S. Media and the Middle East*. Westport, Connecticut: Praeger, 1997. (Allen W. Palmer, "The Arab Image in Newspaper Political Cartoons" and Jack A. Nelson and Maher N. al-Hajji, "American Students' Perception of Arabs in Political Cartoons").

602. Kishtainy, Khalid. *Arab Political Humor*. London: Quartet, 1985.

603. Nesbit, Mark. "Dead Funny: Cartoons Can Seriously Damage Your Health." *Index on Censorship*. 6/2000, pp. 118-120. (Saudi Arabia, Algeria, Turkey, Palestine).

BAHRAIN
General Sources

604. "Bahreynli Çizer Derneğimizi Ziyaret Etti." *Karikatürk.* May 1999, p. 3. (Hamad Al-Gayeb).

IRAN
General Sources

605. "Black Crow-White Crow." *Kayhan Caricature.* December 2000, 2 pp.

606. "Cartoons and Modernity." *Kayhan Caricature.* December 2000, 2 pp.

607. "Comic Strip." *Kayhan Caricature.* January 2000, pp. 4-9.

608. "Design in Cartoons." *Kayhan Caricature.* December 2000, 3 pp.

609. Ghazbanpoor, Jassem and Aydin Aghdashloo. *Aqa Lotf-'Ali Suratgar Shirazi.* Tehran: Iranian Cultural Heritage Organization, 1977. 180 pp.

610. "Gol-agha's Ali Radmand." *Kayhan Caricature.* October 2000. (Humor magazine).

611. "Iran 'da Timsah Kavgasi." *Karikatürk.* No. 72, 2000, p. 1.

612. "Iran Konsolosluğu'nda 'Salman Rüşdü Karikatür Sergisi." *Karikatürk.* March 1994, p. 44.

613. "Kishoo Banc Banc." *Kayhan Caricature.* April/May 2000, 3 pp.

614. Koasar, Nik Ahang. "Face Caricature." *Kayhan Caricature.* January-February 1995.

615. "Past Cartoons vs. Pressent [sic] Cartoons." *Kayhan Caricature.* October 2000.

616. "Press Conference." *Kayhan Caricature.* November-December 1999, 4 pp.

617. Sachs, Susan. "The Funny, but Fictional, Mullah." *New York Times.* August 20, 2000, p. 16.

618. Samini, Mehrnaz. "The Destiny Is Here." *Azadegan.* October 17, 1999, p. 8.

619. Sprachman, Paul. "Persian Satire, Parody and Burlesque." In *Persian Literature,* edited by Ehsan Yarshater, pp. 226-248, N. P.: Bibliotheca Persica, 1988.

620. "Success During One Year!" *Kayhan Caricature.* February/March 2000, 2 pp.

Anthologies

621. "Elections." *Kayhan Caricature.* January 2000, 11 pp.

622. *Freedom of the Press.* Tehran: Jamae Iran Ma, 2001.

623. Iradj Mashemiadeh. *Cartoons from Persia.* Craz, Austria: Druk Phil, 1994. Unpaginated.

624. Rostami, Ardeshir. *Fumigated Boiler: Collection of Cartoons. First Book.* Tehran: Farhang Kavesh, 2001.

625. "This Issue: Kayhan of Childrens [sic]." *Kayhan Caricature.* December/January 1995, pp. 21-32.

626. "This Issue: Shoe." *Kayhan Caricature.* June/July 2000, 19 pp.

Cartoonists

627. "Dr. Hassan Sheikh-Aghaei." *Kayhan Caricature.* October 2000.

628. "Interview, Mohammed Kazem Hassan Vand." *Kayhan Caricature.* January-February 1995.

629. "Javad: A Glance to Javad-Alizadeh's Exhibition." *Kayhan Caricature.* February/March 2000. 2 pp.

630. Lent, John A. "Iran, a Country Teeming with Cartoonists." *Comics Journal.* May 2001, pp. 46-48.

631. Lent, John A. "Iran: A Country Teeming with Cartoonists." *Kayhan Caricature.* October 2000, pp. 2-3.

632. Mehrabi, Massoud. Looking Between the Shades: Drawings and Cartoons by Massoud Mehrabi. Tehran: RAD, 1992.

633. [Mrs. Elahe Ziaei]. *Kayhan Caricature.* January 2000, 2 pp.

634. "Snapshot: Parvin Kervani." WittyWorld International Cartoon Bulletin. 1, 1997, p. 2.

635. Szabo, Joe. "Khanali: A Prolific and Versatile Iranian." *WittyWorld International Cartoon Bulletin.* No. 9, 1996, p. 3.

Divandari, Ali

636. [Ali Divandari]. *Kayhan Caricature*. January 2000, 2 pp.

637. "Ali Divan-Darri." *Kayhan Caricature*. October 2000.

638. "Kayhan Dergisi Çizeri Ali Divandari Misafirimizdi." *Karikatürk*. Haziran 1994, p. 80.

639. "The Cartoon Exhibition by Ali Divandari." *Kayhan Caricature*. December/January 1995, p. 5.

Karimzadeh, Hassan

640. Karimzadeh, Hassan. *Universal Declaration of Human Rights*. Tehran: Hassan Karimzadeh, 2001.

641. Pour Manouchehr Karimzadeh Journaliste Iranien Condamné à Dix Ans de Prison pour Un Dessin. Paris: Fnac/Reporters sans Frontières, 1994.

Kowsar, Nik Ahang

642. "¿Agradece Nik Ahang Kowsar a Quienes lo Metieron a la Cárcel?" *La Piztola*. February 2001, p. 20.

643. Mobasser, Nilou. "Crocodile Smile." *Index on Censorship*. 6/2000, pp. 153-154.

644. "Iran Clerics Back Minister's Death." Associated Press release, February 4, 2000.

645. "Iranian Cartoonist Gets No Laughs; Iran Frees Cartoonists Held over 'Insulting' Drawing." Reuters release, February 10, 2000.

646. "Political Cartoons Are No Laughing Matter in Iran." *Toronto Star*. February 17, 2000.

Mohassess, Ardeshir

647. Mohassess, Ardeshir. *Ardeshir and Stormy Winds*. Tehran: 1972.

648. Mohassess, Ardeshir. *Ceremonies*. Tehran: AVE Gallery, 1972.

649. Mohassess, Ardeshir. *Congratulations*. Tehran: Morvareed, 1976.

650. Mohassess, Ardeshir. *Heathen's Notebook*. Tehran: Bamdad Publications, 1975.

Neyistani, Mana

651. Neyistani, Mana. *It Is Not Forbidden To Laugh.* Tehran: Rozane, 2001.

652. Neyistani, Mana. *Nightmare.* Tehran: Rozane, 2001.

Tabatabai, Massoud Shojai

653. Tabatabai, Massoud Shojai. *Collection of Cartoons of Massoud Shojai Tabatabai.* Tehran: Barg Tirage, 1993.

654. Tabatabai, Massoud Shojai. Becoming an Intellectual Step by Step. Collections of Cartoons Massoud Shojai Tabatabai. Tehran: Isargran, 1996.

Festivals

655. "Another Exhibition in 'The House of Soureh.'" *Kayhan Caricature.* February/March 2000, 2 pp.

656. Anti Narcotics. The First International Cartoon Exhibition. Tehran: Anti-Narcotics Propaganda Commission, 1997. 227 pp.

657. "Atomic Bomb." *Kayhan Caricature.* November-December 1999, 1 p.

658. "Atomic Bomb" – Selected Works of Golagha Caricature Contest. Tehran: Golagha. 1999. 198 pp.

659. Cartoon Festivals and Competitions in the World. Tehran: 1999.

660. Divandari, Ali. "Jury's Report and News About the New International Cartoon Festival in Iran." *Keverinfo.* No. 22, 1997, p. 24.

661. "4th Cartoon Exhibition of 'White Crow' 01/01/2000." *Kayhan Caricature.* February/March 2000, 2 pp.

662. "The Fourth Tehran International Cartoon Biennial." *Kayhan Caricature.* November-December 1999, 5 pp.

663. [House of Cartoons Conference on Comic Strips]. *Kayhan Caricature.* January 2000, 8 pp.

664. [The House of Soureh Exhibition]. *Kayhan Caricature.* February/March 2000, 22 pp.

665. [International Cartoon Exhibitions.] *Kayhan Caricature.* February/March 2000, 2 pp.

666. "Jury Panel Second Tehran Cartoon Biennial." *Kayhan Caricature.* December/January 1995, p. 3.

667. "1993 1. Tahran Karikatür Festivali Sonuçlandi" *Karikatürk.* Aralik 1993, p. 10.

668. "1997 Tahran Bienali'nden Karikatürler." *Karikatürk.* No. 45, 1997, pp. 562-563.

669. "Notes on the Second Tehran Cartoon Biennial." *Kayhan Caricature.* December/January 1995, p. 3.

670. ["Rain" Competition, Tehran]. *Kayhan Caricature.* April/ May 1997.

671. "The Second Biennial in Iran." *FECO News.* No. 21, 1996, p. 7.

672. *A Selection of Works Participated at the 4th Tehran International Cartoon Biennial, Tehran Museum of Contemporary Art, Tehran, Iran, October 1999.* Tehran: Visual Arts Center, 1999.

673. "6th Cartoon Exhibition in Isfahan." *Kayhan Caricature.* April/May 2000, 4 pp.

674. Tabatabai, Massoud Shojai, comp. *The International Civilization Competition in Iranian House of Cartoon.* Tehran: Soroush Press, 2001.

675. "Tahran Karikatür Bienali'nde Değerlendirme Yapildi." *Karikatürk.* No. 18, 1995, p. 211.

676. "Tehran Cartoon Biennial." *Humour and Caricature.* September/ October 1999, 2 pp.

677. *Tehran Cartoon Biennial. The First International Exhibition, 1993.* Tehran: Visual Arts Association, 1994.

678. "Tehran Cartoon Biennial 1995." *Kayhan Caricature.* December/ January 1995, pp. 38-39.

679. "Tehran Cartoon Biennial 95." *Humour and Caricature.* October/ November 1995, p. 18.

680. *Tehran Cartoon Biennial. The Second International Exhibition, 1995.* Tehran: Iran Visual Arts Association, 1995.

681. *The Third International Exhibition Tehran Cartoon Biennial 1997.* Tehran: Iran Visual Arts Association with Tehran Museum of Contemporary Art, 1997. 142 pp.

682. "Uprising of the Rocks." *Kayhan Caricature.* December 2000, pp. 2-5.

Animation

683. "Animation." *Kayhan Caricature.* October-November 1999, 1 p.

684. "Production of Animation Film 'The Vagrant Dog' by Baroqtian." *Kayhan Caricature.* June/July 2000, 2 pp.

685. Talebinejad, Ahmad. "Infahan: We Belong to Another Generation." *Film International.* 1:4 1993, pp. 30-39.

686. "Tehran's Animation Festival." *Film International.* Summer 1999, p. 10.

687. "To Co-Produce or Not To Be! An Interview with Iranian Animator Noureddin Zarrinkelk." *Film International.* 1:4 (1993), pp. 50-51.

688. Zarrinkelk, N. "Who Is Who in ASIFA – Iran." *ASIFA News.* 9:2 (1996), p. 4.

Political Cartoons

689. Balaghi, Shiva. "The Iconography of Power: The Political Cartoons of *Kashkul* and the Anglo-Russian Convention of 1907." Forthcoming.

690. Balaghi, Shiva "Political Culture in the Iranian Revolution of 1906 and the Cartoons of *Kashkul.*" *Princeton Papers: Interdisciplinary Journal of Middle Eastern Studies.* Spring 1997, pp. 59-82.

691. Massoud Shojai Tabatabai. "Politics and Caricature." *Kayhan Caricature.* January-February 1995.

IRAQ
General Sources

692. Conners, Joan L. "Representations of Saddam Hussein As the Enemy: Political Cartoons During the Persian Gulf Crisis." Paper presented at the Association for Education in Journalism and Mass Communication, Washington, D.C., August 9-12, 1995.

693. "La BD au Pays d'Iznogoud" *La Lettre.* March/April 2000, pp. 18-19. (Comic book).

ISRAEL
General Sources

694. "ASIFA-Isreal [sic] Has Become Really Active." *ASIFA San Francisco.* February 2001, p. 4.

695. "Holon Municipality Interested in Founding Cartoon Art Museum." *Shpitz*. No. 9, 1995, p. 80.

696. "ICA Puts on Sports Gear." *Shpitz*. March 1996, p. 80.

697. "Illustrated Homage to the Late Prime Minister Yitzhak Rabin." *Shpitz*. March 1996, p. 80.

698. "Israeli Cartoons for Japan." *FECO News*. No. 29, 1999, p. 9.

699. *Is'raelidade – Humor Gráfico em Israel 1938-1993.* Introductions by Paulo Pereira and Osvaldo de Sousa. Lisbon: Ed Humorgrafe/Museu Bordalo Pinheiro de Lisboa, January 1994.

700. "News from Israel." *FECO News*. No. 16, 1995, p. 10.

701. Nilsen, Alleen P. "Humor in the News." *Humor*. 8:2 (1995), p. 207.

702. "Rysulą w Izraelu." *AQQ*. No. 8, 1995, p. 47.

703. "Sex A to Z." *Shpitz*. March 1996, pp. 2-55.

704. "Something Strange Happened on the Way to Cairo." *Shpitz*. No. 9, 1995, p. 80.

705. Zajdman, Anat. *Humor* Tel Aviv: Papyrus-Tel Aviv University Press, 1994. 231 pp.

706. ZIV, Avner and Jean-Marie Diem. *Le Sens de l'Humour.* Paris: Dunod, 1987. 152 pp.

Cartoon Exhibitions

707. "The First International Cartoon Contest Haifa." *FECO News*. No. 20, 1996, p. 12.

708. The Second International Cartoon Contest. Movies and Neighbours. 100 Selected Caricatures. Haifa, Israel: Israel Cartoon Association, 1996.

709. The Third International Cartoon Contest. 120 Selected Cartoons. Haifa, Israel: Israel Cartoon Association, 1997.

Cartoonists

710. "Art from Overseas Is at New Museum." *Editor & Publisher*. April 6, 1996, p. 42. (Ze'ev).

711. Jago, Mik. "FECO Israel Representatives at St. Just le Martel." *FECO News*. No. 20, 1996, p. 21.

712. Jago, Mik. "To Be a Palestinian Cartoonist in Israel Is Like Being Between a Rock and a Hard Place." *WittyWorld.* December 1998, pp. 4-5.

713. McCarty, Denise. "World of New Issues: Israel" *Linn's Stamp News.* October 4, 1999. (Michael Kichka).

714. "Mysterious Cartoonists Organisation in Haifa." *Shpitz.* No. 9, 1995, p. 80.

715. Varghese, Arun. "Sketch of a Cartoonist's Life." *Sunday Observer* (Bombay). January 22, 1995. (Ya'acov Farkas).

Dosh (Kariel Gardosh)

716. Kishon, Ephraim and Dosh (Kariel Gardosh). *So Sorry We Won!* Tel Aviv: Ma'ariv Library, 1967.

717. Spurgeon, Tom. "Israeli Cartoonist Kariel Gardosh Dead at 79." *Comics Journal.* April 2000, p. 33,

Jago, Mik

718. Jago, Mik. *Dead End.* Israel: Kibbutz Mevo Hamma, 1998.

719. "Jago in Cyprus." *Shpitz.* No. 9, 1995, p. 80.

Animation

720. Cohen, Karl. "Is This the Most Powerful Artist's Image Ever Created? Cartoonist in Israel Faces 24 Years in Jail." *ASIFA San Francisco.* September 1997, p. 4.

721. "Curricula and Filmographia." *Plateau.* Autumn 1983, pp. 21-27. (Joseph Baud, Tsvika Oren, Avigdor Cohen, Albert Kaminski, Eli Shahar, Oshri Evenzohar, Dan Levkovitch, I. Yoresh).

722. "Gil Alkabetz Talking about the Graphic Design of His Films." *Plateau.* 20:2 (1999), pp. 18-19.

723. "The Life of ASIFA Israel." *ASIFA News.* 9:1 (1996), p. 3.

724. Oren, Tsvika. "Animation Production in Israel." *Plateau.* Autumn 1983, pp. 9-12.

725. Oren, Tsvika. "ASIFA –Israël." *ASIFA News.* 13:2 (2000), p. 11.

726. Oren, Tsvika. "The Case of Animation in Israel." In *Ottawa 96 International Animation Festival.* Program, pp. 56-59. Ottawa: Canadian Film Institute, 1996.

727. "Sassan Guetta: Filmbiography." *Plateau.* Autumn 1985, p. 15.

728. Yoresh, I. "Animation in Israel." *Plateau.* Autumn 1983, pp. 4-8.

729. Yoresh, I. "Animation Studies at the Bezalel Academy." *Plateau.* Autumn 1983, pp. 13-19.

Comic Books

730. "Actus Tragicus: Rutu Modan and Yirmi Pinkus." Lecture presented at International Comics and Animation Festival, Bethesda, Maryland, September 26, 1998.

731. Buhle, Paul. "Of Mice and Menschen: Jewish Comics Come of Age." *Tikkun.* March 1992, pp. 9-16.

732. Hatfield, Charles. "Mesmerizing Actus Tragicus." *Comic Book Artist.* March 2000, p. 6.

733. Meesters, Gert. "Actus Tragicus." *Stripschrift.* September 1999, pp. 32-33.

734. Roth, Gil. "Actus Tragicus Makes Their Appearance Count." *Comics Journal.* November 1998, p. 35.

Political Cartoons

735. Astor, David. "Political and Social Cartoon from Israel: 'Dry Bones,' by ex- U.S. Resident Yaakov Kirschen, Is a Comic That Has Been Compared to 'Doonesbury.'" *Editor & Publisher.* January 8, 1994, pp. 30-31.

736. "De Strip als Politiek Instrument." *Stripschrift.* No. 10, n.d., p. 5.

737. Gardosh, Kariel (Dosh). "Political Caricature as a Reflection of Israel's Development." In *Jewish Humor,* edited by Avner Ziv, pp. 203-214. New Brunswick, New Jersey: Transaction Publishers, 1998.

KUWAIT
General Sources

738. "It's a Viking Thing, You Wouldn't Understand." *Hogan's Alley.* No. 3, 1996, p. 16.

Animation

739. Elias, Diana. "From Islam Comes an Animated Movie Based on the Koran." *Philadelphia Inquirer.* June 25, 1995, p. H-5.

740. Warg, Peter. "Censors Changing Their Toons." *Variety.* October 2-8, 1995, pp. 95-96.

741. "Muslim Group Makes Islamic Cartoons To Counter Tom & Jerry." *Plateau.* 16:2 (1995), p. 21.

LEBANON
Animation

742. "Cleric Cool on Pokemon, But Won't Ban It." Reuters release, May 18, 2001.

Cartoonists

743. "Mahmoud Khahil." *Kayhan Caricature.* January-February 1995.

744. Szabo, Joe. "Habib Haddad." *WittyWorld International Cartoon Magazine.* Spring 1997, pp. 12-15.

PALESTINE
General Sources

745. de Sousa, Osvaldo. "Naji Al-Ali: Handala Nunca Morrerá." *Diário de Notícias.* March 31, 1991.

746. de Sousa, Osvaldo. "O Humor em Todas as Frentes: Palestina." *Diário de Notícias.* February 24, 1991.

747. El-Ali, Nagi. "I Am From Ain Al-Helwa." *Al Muwagaha.* 1985. http.//www.shaml.org/archives/Al-Haram.

748. Mirsky, Jonathan. "The Life of a Palestinian Cartoonist." *Index on Censorship.* July 1997, p. 98.

SAUDI ARABIA
Cartooning, Cartoons

749. "Jailed Due to 'B.C.'" *Editor & Publisher.* August 7, 1993, p. 38.

Animation

750. Abdallah, Diana. "Arab Media Want Action in Disney Row." Reuters release, September 21, 1999.

751. Abdallah, Diana. "Gulf Media Say Disney Boycott Threat Must Stay." Reuters release, September 19, 1999.

752. Abdallah, Diana. "Saudi's Alwaleed Says Arabs Got Disney Concessions." Reuters release, September 19, 1999.

753. Al-Issawi, Tarek. "Saudi Bans Pokemon Games, Cards." Associated Press release. March 26, 2001.

754. Slackman, Michael. "Pokemon under Fire in Arab World: It Promotes Anti-Islamic Acts, Critics Say." *Philadelphia Inquirer.* April 29, 2001, p. A22.

Comic Books

755. Durán, Díaz. "*Mak*: El Comic Sinistrorsum de un Saudita." *Comics Camp Comic In.* November 1974, pp. 33-35.

SYRIA
Political and Satirical Cartoons

756. Jehl, Douglas. "Poking Fun Must Be Artfully Done." *New York Times.* January 31, 1998, p. A4.

757. Parsons, Claudia. "Syrian Cartoonist Champions Free Speech." Reuters release. April 2, 2001.

758. "Syria Publishes 1st Satirical Paper." Associated Press release, February 26, 2001.

759. "Syrische Satire." *Stripschrift.* April 2001, p. 27.

3

ASIA

CONTINENTAL AND INTER-COUNTRY PERSPECTIVES

General Sources

760. Dissanayake, Wimal and Hui Kwok. "What Makes Asia Laugh?" *Asiaweek.* January 18, 1987, p. 82. (Sri Lanka and China).

761. Molekhi, Pankaj. "Drawing a Few Strokes of Laughter." *The Pioneer.* (Delhi). December 30, 1998.

Periodical Directory

762. *Animace.* British fanzine dealing with Japanese comic art, with interviews, video, game, and CD reviews, features, and other information. *Animace,* c/o Melissa Hyland, 38 Anchor Road, Tiptree, Colchester, Essex, CO 5 0AP, United Kingdom. No. 6 in 1995.

763. *Animacing.* Fanzine of Anime-Work Group Holland. Club news, Dutch anime sources, news, art, in 20 pages. Sander Peters, Rijksweg 12, 6247 AH Gronsveld, the Netherlands.

764. *Animatoon.* Korean publication since 1995, with English language section; articles, reviews, news, interviews on Korean and international animation. Nelson Shin, 71-7 Munjung-Dong, Song Pa-Ku, Seoul, Korea 138-200.

765. *Animeco.* Quarterly of Japanese Animation Society of Hawaii, since January 1996. Includes animation techniques, history, reviews, columns, profiles. Limelight Publishing Co., 1513 Young Street #2, Honolulu, Hawaii 96826. No. 12, 2000.

766. *Anime Fantastique.* Published by Anime-Fantastique, 7240 W. Roosevelt Rd., Forrest Park, Illinois 60130. Includes essays, reviews, profiles on Japanese anime, but also US, Korean, other animation. First number, Spring 1999.

767. *Animenia.* Dutch-language fanzine about Japanese animation. In 48 pages, covers European video releases, features, game reviews, fan art, and Euromanga. Animenia Publishing, Postbus 2048, 3000 CA, Rotterdam, The Netherlands.

768. *Anime Reference Guide.* Published occasionally by The Society for the Promotion of Japanese Animation, 2425B Channing, Suite 684, Berkeley, California 94704. Mainly a series of synopses of anime. First issue, August 1991; 3:1, 1995.

769. *Anime 2.* Published by Greater Chicago Megazone. Fanzine in tradition of early *Animag* and *Protoculture Addicts.* Village Hall Productions, P.O. Box 5252, Vernon Hills, Illinois 60061. Five issues published by Fall 1996.

770. *Animovement.* Published bimonthly as a newsletter/fanzine of Japanese *anime* and *manga.* News, reviews, fan art, special features. Randy Navarro, Jr., 8520 Sturbridge Circle West, Jacksonville, Florida 32244-5797.

771. *British Manga.* Japanese comics fanzine with strips, occasional articles. James Taylor, 95 Waverley Road, Harrow, Middlesex, HA 2 9RO, United Kingdom. No. 5, September 1995.

772. *Cartoon News.* Official newsletter of Fil-Cartoons with news on the company, columns, profiles on staff members, obituaries. Manila.

773. *Cartoon Playground.* (Manwha Teah). Korea Cartoonists Association quarterly periodical. No. 1, Winter 1995 – International competitiveness of Korean cartoons by Kwon Young-Sup; reports on Japanese imported culture; essays by cartoonists, animators, graphic designers on their work, travel experiences, and philosophies.

774. *Chibi L. A.* Fanzine focusing on Atlanta anime club; includes artwork, comics news, conventions. Available via fax and modem. Lloyd Carter, 727 Morosgo Dr. #7, Atlanta, Georgia 30324-3510.

775. *Don't Panic.* Monthly dealing with fan fiction from internet and comics. Denver Anime International, P.O. Box 200992, Denver, Colorado 86220-0992.

776. *Dragon Press.* Bi-monthly comic/fanzine of 32 pages, dealing with Japanese comics. Reviews, strips, guides. Francis and Simon Yip, 94 Wingfield Close, Shrewsbury, SYI 4 BJ, United Kingdom. First issue in 1995.

777. *Fant-Asia.* A 96-page magazine devoted to Asian fantasy cinema, primarily Hong Kong. Includes articles and reviews of Asian animation also. Published by Pierre Corbeil, Montreal, Canada. In French and English, since 1997.

778. *Game On!* The Magazine of Electronic Manga Gaming. Features, news, product reviews, game-based comics. Monthly of 80 pages. Viz, P.O. Box 77010, San Francisco, California 94107. First issue, May 1996.

779. *Generation Otaku.* Quarterly fanzine focusing on manga, anime music, etc. Sam Emoto, 12483 Montego St., Spring Hill, Florida 34609.

780. *G-Fan.* Bimonthly magazine for fans of "Godzilla" and other Japanese live-action monster movies. Daikaiju Enterprises, Box 3468, Steinbach, Manitoba R0A 2A O.

781. *J.A.M.M.* (Japanese Animation and Manga Magazine). Fanzine on anime and manga published since 1991 by J.A.M.M., Parkplein 5, B-9000 Ghent, Belgium. In English.

782. *The Japanese Journal of Animation Studies.* Started in 1999 by the newly-formed Japan Society for Animation Studies for the promotion of animation scholarship in Japan. Includes articles, reviews, news, primarily about Japan, although other countries are represented.

783. *Kaiju Review. The Journal of Japanese Monster Culture.* Reviews, essays, episode guides, news, plot synopses, and art dealing with monsters in Japanese popular culture, including comics. Dan and Diane Reed, 301 East 64th Street, Suite 5F, New York, New York 10021. Volume 1, November 8, 1995.

784. *Lianhuanhua Yanjiu.* (Studies of Lianhuanhua). 1978-1989.

785. *Lianhuanhua Yishu* (Lianhuanhua Art). 1987-.

786. *Manhua* (Cartoon). 1936.

787. *Manhua Shenghua* (Comics and Life).

788. *Manhua Shijie* (Cartoon World). 1936.

789. *Manga Mania.* Published by Titan Magazines, 42-44 Dolben St., London SE 1 0UP, England. Includes reviews, news, fan letters, columns, and interviews on Japanese *manga* and *anime* and Asian live action film. No. 46, July/August 1998.

790. *The Manga Playground.* Fanzine mainly made up of Martyn Brown's stories and characters, plus editorials. M. Brown, 6 Elliott Street, The Hoe, Plymouth, Devon PL 1 2 PP, United Kingdom. No. 4, Summer 1995.

791. *Manga Vizion.* Published monthly by Viz Communications, P.O. Box 77010, San Francisco, California 94107. Billed as "America's only monthly manga anthology." *Manga Vizion* includes about four stories each issue, plus an editorial and letters. Started in 1995.

792. *Mangazine.* Published monthly by Antarctic Press, 7272 Wurzbach, Suite 204, San Antonio, Texas 78240. Made up mainly of illustrated adventures, with some articles, letters. Vol. 1, No. 1, July 1999.

793. *Mega Comics.* Published quarterly (?) by G. Press, P. O. Box 684036, Austin, Texas 78768-4036. Mainly an anthology of *manga*, with articles, letters. First issue, Summer 1991.

794. *Museum News.* Eight-page newsletter, fully illustrated in color, about exhibitions and other activities dealing with Kawasaki City Cartoon Museum. Vol. 35, 1996.

795. *Operation 7G.* Newsletter of Oklahoma megazone, with news, reviews, commentary. James Staley, P.O. Box 268, Jones, Oklahoma 73049.

796. *Our Manwha* (Woori Manwha). Periodical to promote Korean cartoons. Irregular frequency, published by Woori Manwha Association. Third issue, April 1994; fourth issue, August 1994.

797. *Playanime.* "Entertainment for the liberated anime fan." Erotic fanzine about *anime* characters; 110 pages. Arts 'R' Us, 3219 Tate St., Baltimore, Maryland 21226-1032.

798. *Role Call.* RPG fanzine in Great Britain, dealing with Japanese *anime* and games. Reviews, strips, features. Rachel Ryan, 25 Oakdene Avenue, Woolston, Warrington, Cheshire WA14NU, United Kingdom.

799. *Rutgers Anime News.* Monthly fanzine with local *anime* events and industry news. Steve Pearl, 359 Lloyd Rd., Aberdeen, New Jersey 07747-1826.

800. *Sentai.* The Journal of Asian S/F and Fantasy. Published by Antarctic Press, 7272 Wurzbach Suite #204, San Antonio, Texas 78240. Articles, news, letters, interviews. Since 1994.

801. *Shanghai Manhua* (Shanghai Cartoons). 1928-30.

802. *Shanghai Puck.* 1918

803. *Shidai Manhwa* (Time Cartoons). 1934-37.

804. *Special Slump Fanzine.* Spanish-language fanzine on Akira Toriyama's pre-*Dragonball* series, *Slump.* Includes episode listings, character names, and biographies. Juan Luis Manzano Martin, SSF, Calle Isabel Garau 72, 1, 07458 Ca'n Picafort, Illes Balears, Spain. No. 3 in 1995.

805. *Sugoi.* First magazine in Peru devoted to *anime.* Publicaciones Creativas, Van Dyck 188, San Borja, Lima 41, Peru. First issue, April 1997.

806. *Tokion.* Bilingual (Japanese, English) publication about Japanese pop culture, including *manga.* Hideo Obara, Big Top Publishing, 833 Market St., #602, San Francisco, California 94103. No. 1, Autumn 1996.

807. *Tsunami.* Quarterly anime fanzine of the Terrapin Anime Society, University of Maryland, College Park, Maryland 20742. News, articles, guides, directories, reviews. First issue, Winter 1995.

Artistic Aspects

808. Addiss, Stephen. *The Art of Zen.* New York: Harry N. Abrams, 1986.

809. Awakawa, Yasuichi. *Zen Painting.* New York: Kodansha; Harper and Row, 1970.

810. "Humor." Special Number. *Asian Art and Culture.* Fall 1994.

811. Hyers, Conrad. "Humor in Daoist and Zen Art." *Asian Art and Culture.* Fall 1994, pp. 30-45.

812. Hyers, Conrad. *The Laughing Buddha: Zen and the Comic Spirit.* Durango, Colorado: Longwood Academic, 1990.

813. Lent, John A. "Inter-relationship of Art and Cartooning in Asia." In *Sanatta Karikatür/Cartoon in Art,* pp. 17-20, edited by Nezih Danyal. Ankara: Karikatür Vakfi Yayinlari, 1997.

Cartooning, Cartoons

814. *Asian Cartoon Exhibition.* Seoul: Japan Foundation, Japan Cultural Center, 2001. 24 pp. (Miao Yin Tang, China; Mario de Miranda, India; G. M. Sudarta, Indonesia; Kim Song Hwan, Korea; Lat, Malaysia; Aw Pi Kyeh, Myanmar; Roni Santiago, Philippines; Annop Kitichaiwan, Thailand; Morita Kenji and Kusahara Takao, Japan).

815. *Asian Cartoon Exhibition: Asia – The Population Issue in My Country Seen Through Cartoons, 2ⁿᵈ, Tokyo, August 24-September 12, 1996.* Tokyo: The Japan Foundation Asia Centre, 1996. 39 pp.

816. *Asian Cartoon Exhibition: The Women of Asia Seen Through Cartoons, Tokyo, July 18-August 10, 1995.* Tokyo: The Japan Foundation Asia Center, 1995. 43 pp.

817. Basler, Barbara. "Peter Pan, Garfield and Bart – All Have Asian Roots." *New York Times.* December 12, 1990, pp. A35, A36.

818. Ehrlich, Linda C. and David Desser. *Cinematic Landscapes: Observations on the Visual Arts and Cinema of China and Japan.* Austin: University of Texas Press, 1994. (Cartoons, pp. 162, 170, 273).

819. Foyle, Lindsay. "Cartoons Shouldn't Be Laughed At." *Panpa Bulletin.* October 1955, pp. 61-64.

820. Lent, John A. "Asia." *WittyWorld International Cartoon Magazine.* Spring 1997, pp. 5-6.

821. Lent, John A. "Asya Kitasinda Resim-Karikatür. Ilişkisi…." *Yenidüzen.* June 23, 1997, p. 8.

822. Lent, John A. "Cartooning in Myanmar and Bangladesh." *Comics Journal.* July 1995, pp. 35-38.

823. Lent, John A., ed. *Illustrating Asia: Comics, Humor Magazines, and Picture Books.* Richmond: Curzon Press; Honolulu: University of Hawaii Press, 2001.

824. Lent, John A. "Introduction." In *Illustrating Asia: Comics, Humor Magazines, and Picture Books,* edited by John A. Lent, pp. 1-10. Richmond: Curzon Press; Honolulu: University of Hawaii Press, 2001.

825. Lent, John A. "Introduction." In *Themes and Issues in Asian Cartooning: Cute, Cheap, Mad and Sexy,* edited by John A. Lent, pp. 1-8. Bowling Green, Ohio: Popular Press, 1999.

826. Lent, John A. "An Overview of Trends and Problems in Cartooning Worldwide, with an Emphasis on Asia." In *1995 International*

Symposium and Lecture for Seoul International Cartoon and Animation Festival, pp. 5-44. Seoul: SICAF 95 Promotion Committee, 1995.

827. Lent, John A., ed. *Themes and Issues in Asian Cartooning: Cute, Cheap, Mad and Sexy.* Bowling Green, Ohio: Popular Press, 1999. 212 pp.

828. Ono. Kosei. "The Changing World of Asian Cartoons." In *Asian Cartoon Exhibition – The Women of Asia Seen Through Cartoons,* pp. 34-35. Tokyo: The Japan Foundation Asia Center and The Japan Cartoonists Association, 1995.

829. Roger-Marx, Claude. *La Caricature Etrangère, 4. Extrême-Orient.* Paris: Laboratoires Le Brun & Mictasol, n.d. [1937?].

830. Shimizu, Isao. "Asian Cartoon Culture Expedition." In *The 2nd Asian Cartoon Exhibition: Asia – The Population Issue in My Country Seen Through Cartoons,* pp. 33-35. Tokyo: The Japan Foundation Asia Center and The Japan Cartoonists Association, 1996.

831. Shimizu, Isao. "The Cartoon Is a Mirror That Reflects Society." In *Asian Cartoon Exhibition – The Women of Asia Seen Through Cartoons,* pp. 38-39. Tokyo: The Japan Foundation Asia Center and The Japan Cartoonists Association, 1995.

832. Shimizu, Isao. "A Report on the Research of Asian Comic Art Culture (2): India, Korea, China." *Fūshiga Kenkyū.* No. 19 (July 20, 1996), pp. 6-10.

833. Shimizu, Isao. "Understanding the Population Problem Through Cartoons." *Look Japan.* December 1996, pp. 28-30.

Cartoonists

834. "Asean Cartoonists Form Association." *Asian Mass Communications Bulletin.* May/June 2000, p. 7.

835. "Asean Cartoonists Form Own Association." *The Star* (Malaysia). March 26, 2000.

836. *Comedian of Laughter.* 1997 Beijing and Japanese Cartoonists' New Works. Tokyo: 1997. (China, Japan).

837. Hong, Tong. *Significant Cartoonists in Asia.* Taipei: Male Lion, 2000. 135 pp. (Japan, Taiwan).

838. Pijbes, Wim. "The Artists of the Tropics: The Artists of the Future." *IIAS Newsletter.* October 2000, p. 37. (Southeast Asia).

839. "Profiles." In *Asian Cartoon Exhibition – The Women of Asia Seen Through Cartoons,* pp. 40-42. Tokyo: The Japan Foundation Asia Center and The Japan Cartoonists Association, 1995. (Malai Yunus Malai Yusof, Brunei; Xu Peng-fei, China; Pochampally Sridhar Rao, India; Mochamad Fauzie, Indonesia; Choi Jung Hyun, Korea; Roslan bin Kasim, Malaysia; Tito Ma, Coll Milambiling, Philippines; Poh Yih Chwen, Singapore; Arun Watcharasawat, Thailand; Nguyen Hai Chi, Vietnam; Imahase Harumi, Japan; Kojima Koh, Japan; Satonaka Machiko, Japan; and Mitsuhashi Chikako, Japan).

840. "Profiles." In the *2^nd Asian Cartoon Exhibition: Asia – The Population Issue in My Country Seen Through Cartoons,* pp. 36-37. Tokyo: The Japan Foundation Asia Center and the Japan Cartoonists Association, 1996. (Xia Qingquan, China; Ekkanath Padmanabhan Unni, India; Koesnan Hoesi, Indonesia; Cho Kwan Je, Korea; U Hlaing Kywe, Myanmar; Leonilo Ortega Doloricon, Philippines; Sakda Saeeow Thailand; Tran Minh Dung, Vietnam; Uno Kamakiri, Japan; Maekawa Shinsuke, Japan; Fujiyama Joji, Japan).

Animation

841. Amdur, Meredith. "Turner Takes Cartoon Network Abroad." *Broadcasting & Cable.* March 15, 1993, pp. 34-35.

842. "Animation Grows As Variety Shows." *Television Asia.* July/August 1996, pp. 22-23, 25, 27-29.

843. "Asian Contagion." *Newsweek International.* November 1, 1999, p. 6.

844. "Asia's Toonsville." *The Economist.* February 22, 1997, p. 75.

845. Chen Hongyuan. "The Wonderful and Colorful Cartoon World: A Perspective on the Contemporary Animation Film Art of USA, Japan, Mainland China, and Taiwan." *Central Daily* (Taipei). June 8, 1998.

846. Cheng, Maria. "Hair of the Dog." *Asiaweek.* March 23, 2001, p. 14.

847. Deneroff, Harvey. "At Your Service." *Animation.* December 1999, pp. 15, 18-20.

848. Deneroff, Harvey. "Global View: On the Brim of the PacRim." *Animation.* January 1999, pp. 11-14, 51.

849. Dobson, Terence. "The Filmmaker as Overseas Aid: Norman McLaren in Asia." Paper presented at Society for Animation Studies, Brisbane, Australia, August 5, 1999.

850. "Felix Goes Global." *Animation World.* April 1997, p. 57.

851. "First Asia Computer Animation Festival (ACAF) To Debut in November." *Animation World.* August 1996, 1 p.

852. Forney, Matt and Nigel Holloway. "Silent Movie." *Far Eastern Economic Review.* December 12, 1996, p. 74.

853. Forrester, Chris. "More Than Just Cartoons." *Television Asia.* October 1998, pp. 42-43.

854. Goodman, Martin. "FantAsia." *Animation World.* December 1999, 6 pp.

855. Hornik, Susan and Constance Soh. "Of Colours and Cels." *Television Asia.* October 1998, pp. 44-41.

856. Hu, Gigi. "News From Southeast Asia." *Society for Animation Studies Newsletter.* Winter 1995, p. 1.

857. Kenyon, Heather. "Old Countries Are Learning New Tricks." *Animation World.* August 1998, 3 pp.

858. "Korean, Japanese Firms Jointly Develop 3-D Cartoon Series." *Korea Herald News.* April 2, 2001.

859. Lee, Hannah. "The 1st Asia Television Forum." *Animatoon.* No. 29, 2001, pp. 44-45.

860. Lent, John A. "Animation in Asia: An Overview." Paper presented at Popular Culture Association, San Diego, California, April 1, 1999.

861. Lent, John A. "Animation in Asia: Appropriation, Reinterpretation, and Adoption or Adaptation." *Screening the Past.* No. 11, November 2000.

862. Lent, John A. "Animation in Asia: Random Thoughts Culled from Interviews with Six Pioneer Animators." Paper presented at Mid Atlantic Region Association for Asian Studies, Newark, Delaware, October 25, 1998.

863. Lent, John A. *Animation in Asia and the Pacific.* Sydney: John Libbey & Co., 2001.

864. Lent, John A. "Animation in Southeast Asia." *ASIFA News.* 13:2 (2000), pp. 3-5, 12-14, 19-21.

865. Lent, John A. "Animation in Southeast Asia." *Media Asia.* 26:4 (1999), pp. 192-195, 205.

866. Lent, John A. "Animation in the Subcontinent." In *Animation in Asia and the Pacific,* edited by John A. Lent, pp. 199-206. Sydney: John Libbey & Co., 2001.

867. Lent, John A. "Introduction." In *Animation in Asia and the Pacific*, edited by John A. Lent, pp. 1-4. Sydney: John Libbey & Co., 2001.

868. Lent, John A. "The Many Faces of Asian Animation." *The Japanese Journal of Animation Studies*. Vol. 2, No. 1A, pp. 25-32.

869. Lent, John A. "The Status of Animation in Asia Based on Interviews with Animators in China, Hong Kong, India, Indonesia, Malaysia, Singapore, Burma, Bangladesh, Thailand." Paper presented at Society for Animation Studies, Greensboro, North Carolina, September 29, 1995.

870. McKinsey, Kitty. "War Games." *Far Eastern Economic Review*. March 29, 2001, p. 47.

871. "Nickelodeon International." *Animation*. September 1998, p. 48.

872. "Pacific Rim Animation Companies." *Animation* December 1997, pp. 19, 57.

873. "Prrfect Animation Creates Animated Id for MTV-Asia Using Traditional Chinese Papercut and Imagery." *Animation World*. October 1996, 1 p.

874. Shaffer, Bretigne. "Personal Investment: The Art of Animation." *Asian Business*. May 1993, p. 59.

875. Simons, Rowan. "A New Lease of Life." *Television Asia*. January 1996, pp. 18-19.

876. Song, Jung A. "Dreams Come True." *Far Eastern Economic Review*. January 13, 2000, pp. 66-67.

877. Thornton, Emily. "That's Not All, Folks." *Far Eastern Economic Review*. June 22, 1995, pp. 86, 88.

878. Vallas, Mike. "Digital Technology in Asian Studies." *Animation World*. March 1999, 8 pp.

879. "Wild Brain Continues to Wow the Public With Their Work." *ASIFA San Francisco*. May 2000, p. 2.

880. Willard, Nedd. "Art Form or Industry: Animation Is Bursting at the Seams." *Diffusion*. Winter 1995/96, pp. 20-26

Children's Television

881. Goonasekera, Anura. "Children's Voice in the Media: A Study of Children's Television Programmes in Asia." *Media Asia*. 25:3 (1998), pp. 123-129.

882. Goonasekera, Anura, *et al. Growing Up with Television: Asian Children's Experience.* Singapore: Asian Media Information and Communication Centre, 2000. 313 pp.

883. Ninan, Sevanti. "Selling Cartoons to Children." *The Hindu.* December 21, 1997.

884. "Promoting Research on Television and Children in Asia." In *Report of Activities 1997,* pp. 6-8. Singapore: Asian Media Information and Communication Centre, 1998.

Disney in Asia

885. Felperin, Leslie. "The Thief of Buena Vista: Disney's *Aladdin* and Orientalism." In *A Reader in Animation Studies,* edited by Jayne Pilling, pp. 137-142. London: John Libbey and Co., 1997.

886. Leger, John. "Asia's Leading Companies." *Far Eastern Economic Review.* December 28, 1995-January 4, 1996, p. 5.

887. McGurn, William. "Prophet of Profit." *Far Eastern Economic Review.* November 21, 1996, pp. 72-74.

888. Sullivan, Maureen. "Star TV Gets Disney Pay Rights in Asia." *Daily Variety.* October 21, 1998, p. 8.

889. White, Timothy R. and J. Emmett Winn. "Islam, Animation and Money; The Reception of Disney's *Aladdin* in Southeast Asia." *Kinema.* Spring 1995, pp. 54-69.

890. White, Timothy R. and J. Emmett Winn. "Islam, Animation, and Money: The Reception of Disney's *Aladdin* in Southeast Asia." In *Themes and Issues in Asian Cartooning: Cute, Cheap, Mad and Sexy,* edited by John A. Lent, pp. 61-76. Bowling Green, Ohio: Popular Press, 1999.

891. Williams, Ann. "Disney Puts the Mickey in Asia." *Straits Times* (Singapore). December 3, 1993, Life Section, p. 11.

"Meena"

892. Aghi, Mira. "Formative Research in The Meena Communication Initiative." In *Drawing Insight,* edited by Joyce Greene and Deborah Reber, pp. 37-43. Penang: Southbound, 1996. (South Asia).

893. Carnegie, Rachel. "Animated Film and Communication for Empowerment." In *Drawing Insight,* edited by Joyce Greene and Deborah Reber, pp. 44-49. Penang: Southbound, 1996. (South Asia).

894. Clark, Christian. "Meena Comes to a Store Near You...If You Live in South Asia." *Animation World Magazine.* October 1997, 3 pp.

895. Kenyon, Heather. "Animation for Development in South Asia." In *Animation in Asia and the Pacific,* edited by John A. Lent, pp. 225-238. Sydney: John Libbey & Co., 2000.

MIP Asia

896. Baisley, Sarah. "MIP Asia: On the Co-Production Fast Track." *Animation.* January 1999, p. 15.

897. "MIP Asia." *Animatoon.* No. 12, 1998, pp. 18-21.

898. "MIP Asia." *Animatoon.* No. 23, 2000, pp. 20-23.

899. "MIP Asia 98." *Animatoon.* No. 17, 1999, pp. 8-17.

900. "MIP-ASIA '98, Now 83 Companies from 23 Countries Signed up for the Event." *Animatoon.* No. 14, 1998, p. 44.

901. "MIP-Asia'96– Most Companies of Asian Broadcasting and Visual Industries Participate." *Animatoon.* No. 8, 1997, pp. 68-75.

902. "'98 Mip-Asia Conference Program." *Animatoon.* No. 16, 1998, pp. 56-57.

903. "The '99 MIPASIA." *Animatoon.* No. 22, 1999, p. 53.

904. "Co-Production with Asia: Opportunities for Animation." *Animatoon.* No. 16, 1998, p. 57.

Overseas Service Production

905. Deneroff, Harvey. "East Asian Service Studios Hard Hit by Downturn in U.S. Production Due to Anime." *Animation.* November 2000, pp. 18-19.

906. Deneroff, Harvey. "The Leaders: Checking in on the State of Service Studios Worldwide." *Animation.* December 1999, pp. 15-17, 40.

907. Deneroff, Harvey. "Pacific Rim: Co-Production Efforts Prove Key to Riding Out Tough Period in the Region." *Animation.* December 1999, pp. 13-14.

908. Deneroff, Harvey. "Pacific Rim: From Work-for-Hire to World-Class Programming." *Animation.* December 1997, pp. 15-18, 57.

909. Deneroff, Harvey. "13 Overseas Animation Service Studios With Whom To Do Business." *Animation.* February 1999, pp. 113-115, 121-122. (Hong Kong, South Korea, Philippines, China, Taiwan).

910. Lent, John A. "The Animation Industry and Its Offshore Factories." In *Global Productions: Labor in the Making of the "Information Society,"* edited by Gerald Sussman and John A. Lent, pp. 239-254. Creskill, New Jersey: Hampton Press, 1998.

911. Lent, John A. "Overseas Animation Production in Asia." In *Animation in Asia and the Pacific,* edited by John A. Lent, pp. 239-246. Sydney: John Libbey & Co., 2001.

912. Raugust, Karen. "Growing Through Partnerships." *Animation.* November 2000, pp. 14-16.

913. "Service Providers Forecasts." *Animation.* February 2000, pp. 99-100, 106.

914. Sussman, Gerald and John A. Lent. "Global Productions." In *Global Productions: Labor in the Making of the "Information Society,"* edited by Gerald Sussman and John A. Lent, pp. 1-12. Creskill, New Jersey: Hampton Press, 1998.

Theme Parks

915. Deckard, L. "Itochu-Iwerks Cinetropolos Projects Moving Forward in Far East, U.S." *Amusement Business,* April 19-25, 1993, pp. 24, 27.

916. Deckard, L. "New Park Plans Unveiled for Emerging Asian Market." *Amusement Business.* May 4-10, 1992, pp. 1, 19.

917. Larkin, John, *et. al.* "Themes for a Dream." *Asiaweek.* November 12, 1999, pp. 56-57. (South Korea, China, Japan, Taiwan, Singapore).

918. Ray, S. "Iwerks Harvests 11 Projects in Fertile Far East Market Place." *Amusement Business.* June 6-12, 1994, pp. 16, 21.

Comics

919. Lent, John A. "Amerikan Etkisi Altindaki Asya Karikatürü." *Gül Diken.* Yaz 1998, pp. 30-42.

920. Lent, John A. "The American Influence on Asian Comics." *Fūshiga Kenkyū.* No. 20, 1996, pp. 3-7.

921. Lent, John A. "Asian Comic Art." *Art AsiaPacific.* Issue 21, 1999, pp. 66-71.

922. Lent, John A. "The Birthing of a Research Tradition for Asian Comic Art." Paper presented at Popular Culture Association, Las Vegas, Nevada, March 28, 1996.

923. Lent, John A. "Comic Art in Asia's Past." Paper presented at International Comic Arts Festival, Bethesda, Maryland, September 16, 1999.

924. Lent, John A. "Comic Art in East Asia: Historical and Contemporary Perspectives." Paper presented at Asian Popular Culture Conference, Victoria, Canada, April 18, 1998.

925. Lent, John A. "Comic Art in South Asia." *Asian Thought and Society.* September-December 1999, pp. 184-205.

926. Lent, John A. "Comic Art of Asia: An Invisible Giant Awakened." Plenary lecture presented at International Comics and Animation Festival, Bethesda, Maryland, September 24, 1998.

927. Lent, John A. "Comics in East Asian Countries: A Contemporary Survey." *Journal of Popular Culture.* Summer 1995, pp. 185-198.

928. Lent, John A. "Comics in the Philippines, Singapore and Indonesia." *Humor.* 11:1 (1998), pp. 65-77.

929. Lent, John A. "Easy-Going Daddy, Kaptayn Barbell, and Unmad: American Influences Upon Asian Comics." *Inks.* November 1995, pp. 58-67, 71-72.

930. Lent, John A. "Introduction." *Southeast Asian Journal of Social Science.* 25:1 (1997), pp. 1-9.

931. Lent, John A. "Introduction: Comic Art in Asia; Historical, Literary and Political Roots." *Journal of Asian Pacific Communication.* 7:1/2 (1996), pp. 1-4.

932. Lent, John A. "Manga and Anime in Asia." *Anime UK Magazine.* May 1995, pp. 8-10.

933. Lent, John A., ed. "Special Focus: Cartooning and Comic Art in Southeast Asia." *Southeast Asian Journal of Social Science.* 25:1 (1997), pp. 1-166.

934. Lent, John A., ed. "Symposium on Aspects of Asian Comic Art." *Asian Thought and Society.* September-December 1999, pp. 183-249.

935. Sharma, Yojana. "Comic Culture Mushrooms." *Times Educational Supplement.* January 17, 1997, p. 17.

936. Shimizu, Isao. "A Report on the Research of Asian Comic Art Culture, 1: Philippines, Vietnam, Myanmar, Thailand." *Fūshiga Kenkyū.* April 20, 1996, pp. 10-14.

937. Smith, Andrew. "From Asian Super-Heroes to Namorita." *Comics Buyer's Guide.* April 27, 2001, pp. 28-29.

938. Spurgeon, Tom. "Southeast Asian Journal of Social Science Vol. 25, #1." Comics Journal. September 1998, p. 119.

939. Tadeo Juan, Francisco. "Los Mangas Comic O lo Que Sea." *Circulo Andaluz de Tebeos.* No. 17, 1995, p. 41.

940. Tunç, Asli. "Karikatüre Akademik Yaklaşim ve John Anthony Lent." *Gül Diken.* Yaz 1998, pp. 25-29.

Comic Books

941. Brandt, Thomas and Henry Hendrayaddy. *Asia Comic.* Bad Oldesloe: Goasia Verlag, 1998. 148 pp.

942. Brimmicombe-Wood, Lee and Motoko Tamamuro. "Manga Marvels." *Manga Max.* June 2000, pp. 16-19.

943. Kunzle, David. "Dispossession by Ducks: The Imperialist Treasure Hunt in Southeast Asia." *Art Journal.* Summer 1990, pp. 159-166.

944. Lent, John A. "American Influences on Asian Comics. Part II." *Fūshiga Kenkyū.* No. 22, 1997, pp. 5-8.

945. Lent, John A. "Asian Manga." *Fūshiga Kenkyū.* July 20, 1995, pp. 11-14.

946. Lent, John A. "Comics Controversies and Codes: Reverberations in Asia." In *Pulp Demons: International Dimensions of the Postwar Anti-Comics Campaign,* edited by John A. Lent, pp. 179-214. Madison, New Jersey: Fairleigh Dickinson University Press; London: Associated University Presses, 1999.

947. Lent, John A. "Fantasy and Humor in Asian Comic Books." Paper presented at International Comics and Animation Festival, Silver Spring, Maryland, September 20, 1997.

948. Lent, John A. "Local Comic Books and the Curse of Manga in Hong Kong, South Korea & Taiwan." *Asian Journal of Communication.* 9:1 (1999), pp. 108-128.

949. Lent, John A. "The U.S. Anti-Comics Campaign of the 1950s: Reverberations in Asia." Paper presented at Popular Culture Association, Orlando, Florida, April 9, 1998.

950. Ng, Wai-ming. "A Comparative Study of Japanese Comics in Southeast Asia and East Asia." *International Journal of Comic Art.* Spring 2000, pp.44-56

951. Ono, Kōsei. "Ajiano Komikku Senpū." In *AERA Mook: Komikkugaku no Mikata,* pp. 129-135. Tokyo: Asahi Shimbunsho, 1997.

952. Salajan, Ioanna. *Zen Comics.* Rutland, Vermont: Charles E. Tuttle, 1974. **88** pp.

953. Sharma, Yojana. "Lessons in Light Relief." *South China Morning Post.* January 14, 1997, p. 20.

954. "Spot the Manga." *Sunday Times* (Singapore). October 24, 1999. (Hong Kong, Japan, Singapore, Taiwan).

955. Tsen Wen-Ti. "Asian American Comic Book." *Amerasia Journal.* 18:1 (n.d.) pp. 27-38.

Comic Strips

956. Lent, John A. "The Asian Comic Strips." Paper presented at Popular Culture Association, Philadelphia, Pennsylvania, April 12, 1995.

957. Lent, John A. "Asian Comic Strips: Not Quite a Century." Paper presented at Mid-Atlantic Region/Association for Asian Studies, Towson, Maryland, October 21, 1995.

958. Lent, John A. "Asian Comic Strips: Old Wine in New Bottles." *Asian Culture.* Winter 1995, pp. 39-62.

959. Lent, John A. "Sanmao, Kenkoy, Tokai: The Comic Strip in Asia." In *Understanding the Funnies: Critical Interpretations of Comic Strips,* edited by Gail W. Pieper, Kenneth D. Nordin, and Joseph Ursitti, pp. 140-172. Lisle, Illinois: Procopian Press, 1997.

960. Lent, John A. "Sanmao, Kenkoy, Tokai: The Comic Strip in Asia." Paper presented at Popular Culture Association, San Antonio, Texas, March 29, 1997.

Political Cartoons

961. Dietz, Robert. "Toon Time in Asia." *Asiaweek.* August 30, 1996, pp. 41-44.

962. Lent, John A. "Asian Political Cartoons: An Overview." Paper presented at Popular Culture Association, New Orleans, Louisiana, April 22, 2000.

963. Lent, John A. "Broken Pencils: The Broken Savage Pencils of Southeast Asia." In *Savage Pencils*. Exhibition Catalogue, Silicon Pulp Animation Gallery, Sydney, February 2-April 1, 2000, pp. 7-9. Sydney: Graber Hill/Silicon Pulp Animation Gallery, 2001.

AFGHANISTAN
General Sources

964. Afrane (Amitié Franco-Afghane). *Afghanistan. Images d'Une Résistance.* Paris: Nouvelle Société des Éditions Encre/Éditions Jupilles, 1986.

965. Gabreel, A.O. and J. Butt. "Making Health Messages Interesting." *World Health Forum.* 18:1 (1997), pp. 32-34.

AZERBAIJAN
Cartooning, Cartoons

966. Akhmedov, Ayaz. "Notes of an Accused Man." *Index on Censorship.* July/August 1997, pp. 94-101.

967. Azerbaycan'dan Sevgi Elçileri Karikatür Albümü. Istanbul: Karikatürlёr Derneği, 1992.

968. Geray, Nazim. *Azerbaycan'dan Sevgi Elçileri* (Ambassadors of Love from Adzerbaijan). Ankara: Kübra Kerimzade Hayratinin bir Kütür Hizmeti, 1992.

969. Tucker, Ernest. "The Newspaper Mullah Nasr al-Din and Satirical Journalism in Early Twentieth Century Azerbaijan." Unpublished paper, Chicago, 1987.

BANGLADESH
Cartooning, Cartoons

970. "Interview: Artist Kazi Abul Kashem and His Cartoons." *Chabuk.* 1996.

971. Lent, John A. "The Off-Beaten and Divergent Paths of Cartooning in Bangladesh." *The Daily Star Weekly Magazine* (Dhaka). October 27, 1995, pp.1-2.

BRUNEI
Disney in Brunei

972. "Disney Meets Group on 'Aladdin' Charges." *Borneo Bulletin* (Brunei). May 22/23, 1993, p. 11.

973. Gambar, Ali. "At the Movies: Aladdin." *Borneo Bulletin.* August 13, 1993, p. 16.

974. "Group Wants Ban on 'Aladdin.'" *Borneo Bulletin.* May 29/30, 1993, p. 3.

975. "US Arab Group Pressures Walt Disney To Alter 'Aladdin' Lyrics." *Borneo Bulletin.* July 12, 1993, p. 12.

BURMA
Cartooning, Cartoons

976. Leehey, Jennifer. "Message in a Bottle: A Gallery of Social/Political Cartoons from Burma." *Southeast Asian Journal of Social Science.* 25:1 (1997), pp. 151-166.

977. Thaung, U. *A Journalist, a General and an Army in Burma.* Bangkok: White Lotus, 1995. (Cartoons and censorship, pp. xvi, 7-8, 133).

978. U Ngwe Kyi. "Myanmar Cartoon World and History." In *The 2ⁿᵈ Asian Cartoon Exhibition: "Asia – The Population Issue in My Country Seen Through Cartoons,"* pp. 27-29. Tokyo: The Japan Foundation Asia Center and The Japan Cartoonists Association, 1996.

CAMBODIA
Political Cartoons

979. "Cambodia." *Human Rights Watch/Asia.* November 1995, p. 11.

980. Marston, John. "Cambodian News Media in the UNTAC Period and After." In *Propaganda, Politics, and Violence in Cambodia,* edited by S. Heder and J. Ledgerwood, pp. 208-242. Armonk, New York: M. E. Sharpe, 1996. (Cartoons, pp. 211, 216, 222-223, 234, 238.)

981. Marston, John. "Cambodian Political Cartoons and the Representation of Hierarchy." Paper presented at Association for Asian Studies, Honolulu, Hawaii, April 12, 1996.

982. Marston, John. "Em Sokha and Cambodian Satirical Cartoons." *Southeast Asian Journal of Social Science.* 25: 1 (1997), pp. 59-77.

983. Mehta, Harish C. *Cambodia Silenced: The Press Under Six Regimes.* Bangkok: White Lotus, 1997. (Huy Hem and Khut Khun, pp. 59-61, 64.).

CENTRAL ASIA
General Sources

984. "'Dünya Karikatür Sanati Türk Dili Konuşan Ülkelerin Bu Daldaki Yeri.'" *Karikatürk.* No. 67, 2000, pp. 4-5.

985. Türk Dili Konuşan Ülkeler Istanbul' da Buluştu." *Karikatürk.* No. 67, 1999, p.1.

CHINA
General Sources

986. Lim, Shirley Geok-lin. "Gender Transformations in Asian/American Representations." In *Gender and Culture in Literature and Film East and West: Issues of Perception and Interpretation,* edited by Nitaya Masavisut, George Simson, and Larry E. Smith, pp. 95-112. Honolulu: University of Hawaii and East-West Center, 1994.

987. Liu Xiaodai, ed. *Chinese New Year Pictures.* Beijing: Cultural Relics Publishing House, 1995. Unpaginated.

988. Tian Yuan. *Ancient Chinese Toys and Ornaments.* Beijing: Foreign Language Press, 1983.

989. Tian Yuan. *Chinese Folk Toys.* Beijing: Foreign Language Press, 1979.

990. Williams, C. A. S. *Chinese Symbolism and Art Motifs.* Edison, New Jersey: Castle Books, 1974. Earlier editions by Charles E. Tuttle, 1974, and Kelly and Walsh, 1941.

Artistic Aspects

991. *Dreams of Spring. Erotic Art in China From the Bertholet Collection.* Amsterdam: The Pepin Press, 1997. 208 pp.

992. Fu, Shen C. Y. "Puns and Playfulness in Chinese Painting." *Asian Art and Culture.* Fall 1994, pp. 46-65.

993. Galikowski, Maria. *Art and Politics in China 1949-1984.* Hong Kong: Chinese University Press, 1998. (Cartoons, pp. 40, 46, 62-63, 71, 81, 86, 117, 142-143, 145, 187, 197).

994. Hua Junwu. "Meishujia Bixu Jiji Canjia He Fanying Jieji Douzheng" (Artists Must Actively Participate in and Reflect Class Struggle). *Fine Art.* No. 8, 1955.

995. Hua Junwu. "Qingchu Meishu Gongzuozhongde Fei Weichanjieji Sixiang" (Eliminate from Art Work Thinking Which is Not Proletarian). *Literary and Art Gazette.* December 1951.

996. Hua Junwu. "Qinian Laide Huiwu Gongzuo" (The Work of the Artists' Association Over the Last Seven Years). *Fine Art.* No. 8/9, 1960.

997. Hua Junwu. "Yidian Ganxiang" (A Thought). *Fine Arts in China.* No. 8, 1986.

998. Hua Junwu. "Yongyuan Shi Yige Gaizao He Xuexide Guocheng" (It Will Always Be a Process of Reform and Study). *Fine Art.* No. 3, 1962.

999. Silbergeld, Jerome. "Art Censorship in Socialist China: A Do-It-Yourself System." In *Suspended License: Censorship and the Visual Arts,* edited by Elizabeth C. Childs, pp. 299-332. Seattle: University of Washington Press, 1997.

1000. Tanzer, Andrew. "China's Dolls." *Forbes.* December 21, 1992, pp. 250-252.

1001. Wells, Henry W. *Traditional Chinese Humor: A Study in Art and Literature.* Bloomington: Indiana University Press, 1971.

Cartooning, Cartoons

1002. Andrews, Julia F. "Judging a Book by Its Cover: Book Cover Design in Shanghai." Paper presented at Association for Asian Studies, Chicago, Illinois, March 14, 1997.

1003. Bai Shan Cheng. "Cartoons Imply, Not Directly Express." *Cartoon Art Research.* October 26, 2000, p. 4.

1004. Cao Chang Guang. "Cartoon as Comic Art." *Cartoon Art Research.* March 5, 2001, pp. 1-2.

1005. *Cartoon Information.* Chinese newsletter. In Chinese; 6(22) published in 1992.

1006. *Cartoons from Contemporary China* (Tang Tai Chung-kuo Man Hua Chi). Beijing: New World, 1989. 318 pp.

1007. "Çin'den Karikatürler." *Karikatürk.* No. 61, 1999, p. 3.

1008. Ding Cong. *You Write and I'll Draw – Portraits of Literati.* Beijing: Foreign Languages Press, 1996. 156 pp.

1009. Fang Cheng. *Cartoon Environment and Creation.* Beijing: Peking University Press, 2000. 319 pp.

1010. Fang Cheng. *Fang Cheng Talking Cartoon Art.* Changsha: Hunan Art Press, 1999. 311 pp.

1011. Fang Cheng. *Fang Cheng Talking Humor.* Shijiazhuang: Hebei Educational Press, 1999. 280 pp.

1012. Fang Cheng. "From Cartoon to Humor." *Art Observation.* May 2001, pp. 58-59.

1013. Fang Cheng. *Language in Painting.* Guangdong: Guangdong People's Press, 2000. 202 pp.

1014. Fang Cheng. *Newspaper Cartoon.* Wuhan: Wuhan University Press, 1989. 179 pp.

1015. Fang Cheng. *Squeezing Columns.* Beijing: People's Daily Press, 1987. 184 pp.

1016. Fang Tang. "Talking About Creative Thinking." *Cartoon Art Research.* October 26, 2000, p. 3.

1017. Feng, C. L. "Cartoon Exhibition: 'Olympics of Laughter and Satire.'" *Beijing Review.* June 5-11, 1989, pp. 43-45.

1018. Harbsmeier, Christoph. "Some Preliminary Notes on Chinese Jokes and Cartoons." In *China in the 1980s – and Beyond,* edited by K. Brodsgaard and B. Arendrup. London: Curzon Press, 1986.

1019. He Ting. *Black and White Door.* Beijing: Foreign Language Press, 1994. 140 pp.

1020. He Wei and Japanese Cartoonists. *Brush and Ink Fate.* Beijing: Hui Ya Cartoon Art Center, 2001. 112 pp.

1021. Hua Junwu. "Some Thoughts on Cartooning." *Chinese Literature.* No. 10, 1963, p. 86+.

1022. Huang Xuanzhi. "1957 Nian Quanguo Xin Manhua Zhanlan Qingkuang He Qunzhong Yijian" (The 1957 National New Cartoon Exhibition and the Opinions of the Masses). *Fine Art.* No. 6, 1958.

1023. Huang Ying. "212-Part China-Made Cartoon To Be Published." People's Daily Online. February 5, 2001. ("Brothers Haier").

1024. Huang Yuan Lin. "The Trend of Chinese Cartooning: Where Is It Going?" *Cartoon Art Research.* July 24, 2000, p. 1.

1025. Huang Yuan Lin. "Trends of Chinese Cartoon." *Zhongguo Manhua.* No. 4, 2000, pp. 6-7.

1026. Jiang Pei Yang. "Cartoon Diversity: Who Is the Main Role?" *Zhongguo Manhua.* No. 8, 2000, p. 44.

1027. Kong Ling Qiang. "Cartoon and Humor Advertisement." *Zhongguo Manhua.* No. 1, 1999, pp. 10-11.

1028. Koop, Stuart. "Warrior Girl: Kaye Beynon's Tussle with Language." *Art AsiaPacific.* No. 29, 2000, pp. 56-61.

1029. Lan Jian'an. "What Is a Cartoon?" *Cartoon Art Research.* October 26, 2000, p. 3.

1030. Lan Jian'an and Shi Jicai, comps. *Cartoons from Contemporary China.* Beijing: New World Press, 1989.

1031. Lengyel, Alfonz. "Chinese Cartoons in Omiya (Japan) International Cartoon Festival." Paper presented at Association for Asian Studies, Chicago, Illinois, March 13, 1997.

1032. Li Qun. "Lun Manhuade Xingshi Wenti" (On the Problem of Form in Cartoons). *Fine Art.* No. 3, 1956.

1033. Liu-Lengyel, Hongying and Alfonz Lengyel. "Ancient Literature and Folklore in Modern Chinese Cartoons." *Journal of Asian Pacific Communication.* 7: 1 /2, 1996, pp. 45-54.

1034. Mi Gu. "Zhangwo Manhua Yishu Texing, Chuangzuo Chu Duozhong Fenggede Manhua Lai – Canguan Quanguo Manhuazhan Yougan" (Grasp the Particular Qualities of Cartoons as an Art Form, and Create Cartoons with a Variety of Styles – Thoughts after Seeing the National Exhibition of Cartoons). *Fine Art.* No, 2, 1957, pp. 4-6.

1035. Ming Hao. "Yinggai Shedang Zengjia Youmo Manhuade Chuangzuo" (We Should Increase to an Appropriate Level the Number of Humorous Cartoons Produced). *Fine Art.* No. 3, 1956.

1036. Ran Mao Jin. "Laughter Is the Best Medicine." *China Art Newspaper.* December 1, 2000.

1037. "Retrospective and Perspective." *Workers Daily.* December 11, 1998, p. 8.

1038. "2nd Black and White Cartoon Competitive Prize Works." *Workers Daily.* December 26, 1995, p. 8.

1039. "Second Cartoon Art Committee April 2-3, China Artists Association." *Cartoon Art Research.* July 24, 2000, p. 4.

1040. 2nd Exhibition of Workers Daily Cartoon Competition: Selected Works. Beijing: Workers Daily, 1987. 148 pp.

1041. Shanghai Art Office. "Pujiang Liang'an, Manhua Rechao" (On Both Sides of the Pu River Is a High Tide in Cartoons). *Fine Art.* No. 1, 1977, p. 35+.

1042. Sharma, Yojana. "China: Authorities Sanction Cartoons." *Times Educational Supplement* (London). January 17, 1997, p. 17.

1043. Sun Guang Mao. "Calling the Scientifics of Cartoon Theory Criticism." *Cartoon Art Research.* July 24, 2000, p. 2.

1044. Tan Li Xuan. "Talking Casually about Cartoons." *Zhongguo Manhua.* No. 9, 1998, pp. 15-17.

1045. Wang Da Guang. "Two Problems About Creative Thinking." *Cartoon Art Research.* March 5, 2001, p. 2.

1046. Wang Jing Feng. "Facing Challenge and Making Brilliance." *Cartoon Art Research.* March 5, 2001, p. 3.

1047. Wang Shunhong. "Humor and Modern China Xiangsheng (Comic Dialogue) and Comic Skit." In International Humor Symposium: Western Humor and Eastern Laughter, July 27, 2000, Kansai University Centenary Hall, Senriyama Campus, Osaka, Japan, pp. 50-54. Osaka: 2000 International Humor Conference, Kansai University, 2000.

1048. "Workers Cartoons." *Workers Daily.* September 12, 1997, p. 7.

1049. Xiao Zheng. "2000 Chinese Cartoon Exhibition." Program. Beijing: 2000.

1050. Xu Peng Fei. "Hiding." *Cartoon Art Research.* October 26, 2000, p. 4.

1051. Xuan Wenjie. "The First National Cartoon Exhibition." *Beijing Daily.* December 14, 1980.

1052. Xu Pengfei. "The Overview of Chinese Cartoon." In *1995 International Symposium and Lecture for Seoul International Cartoon and Animation Festival,* pp. 145-160. Seoul: SICAF 95 Promotion Committee, 1995.

1053. Yangshi, Yang. "Chinese Rediscover Art of Humour." *China Daily.* December 4, 2000, p. 9.

1054. Ying Tao. "Talking About Titles." *Cartoon Art Research.* October 26, 2000, p. 3.

1055. Yong Fei. "Exploring the Origins of Cartoon Image." *Cartoon Art Research.* July 24, 2000, p. 4.

1056. Zhang Yaoning. "Cartoon Art in China." In *Sanatta Karikatür/Cartoon in Art,* edited by Nezih Danyal, pp. 92-105. Ankara: Karikatür Vakfi Yayinlari, 1997.

1057. Zhang, Yingjin. "The Corporeality of Erotic Imagination: A Study of Pictorials and Cartoons in Republican China." In *Illustrating Asia: Comics, Humor Magazines, and Picture Books,* edited by John A. Lent, pp. 121-136. Richmond: Curzon Press; Honolulu: University of Hawaii Press, 2001.

Cartoonists and Their Works

1058. Bi Keguan. "Feelings of Reading Hua San." *Cartoon Art Research.* October 26, 2000, p. 3.

1059. "Cartoonists of Shandong Province." *Zhongguo Manhua.* No. 5, 2000, pp. 14-15.

1060. "Cartoons To Criticize Fa Lun Gong." *Cartoon Art Research.* March 5, 2001, p. 4. (Lu Shi Min).

1061. Chen Huiling. "Happy To See Hou Jun Shan." *Zhongguo Manhua.* No. 10, 2000, pp. 20-21.

1062. "Chinese Cartoonist Winner of the Golden Hat 1999 in Knokke-Heist Belgium." *FECO News.* No. 30, 2000, p. 22.

1063. *The Colour Ink and Wash of Lichun.* Np, nd. 8 pp.

1064. Ding Su. "My Past Friend Bochen." *Shanghai Manhua.* 18 (1928), n.p.

1065. Dong Fang Er. "Talking on the Web: Chinese Cartoonists Involved in Book World Cartoon." *Zhongguo Manhua.* No. 8, 2000, p. 14.

1066. Fang Cheng. "Cartoonist Chiang Fan." *Zhongguo Manhua.* No. 9, 1998, pp. 26-27.

1067. Hua, Chun-wu. "Some Thoughts on Cartooning." *Chinese Literature.* No. 10, 1963, pp. 86-94.

1068. Hua Junwu. "Jiang Feng Fandangde Fabao Zhiyi 'Zongpai Daji.'" ("Factional Attack," One of Jiang Feng's Anti-Party Weapons). *Fine Art.* No. 9, 1957.

1069. Hua Junwu, Ding Cong, Liao Binxiong, Fang Cheng, Yong Fei, eds. *China Contemporary Cartoonists Dictionary.* Beijing: Zhejiang Peoples Press, 1997. 617 pp.

1070. Huang Yuan Lin. "Diligent To Think; Brave To Explore." *Zhongguo Manhua.* No. 8, 2000, pp. 8-9. (Ai Zao Xuan).

1071. Huang Yuan Lin. "Introducing 100 Most Famous Cartoonists: Part 3." *Zhongguo Manhua.* No. 3, 2001, pp. 8-9. (Ma Xing Chi).

1072. I-Shu. "Tseng Fan The Man and His Paintings." *Monthly Comic Magazine.* December 1990, p. 4-6.

1073. Lei Rui Zhi. "Wang Mi's Cartoon Sketch and His Sketched Cartoon." *Zhongguo Manhua.* No. 4, 1998, pp. 30-31.

1074. Liao Yin Tang. "Cartoonist Talks about Cartoons." *Zhongguo Manhua.* No. 1, 1999, pp. 18-19.

1075. Ling Tao. "A Memory of My Teacher Shen Manyun." *Lianhuanhua Yanjiu.* 25 (1981), pp. 82-88.

1076. Liu-Lengyel, Hongying. "Drawing Is Challenge and Therapy for Handicapped Chinese Cartoonist." *WittyWorld International Cartoon Magazine.* Spring 1997, p. 19.

1077. Lu Shimin. "Cartoon Made Me Become Accused." *Zhongguo Manhua.* No. 8, 2000, p. 22.

1078. Mihalca, Matei P. "Profile: Ding Cong – Peking's Political Cartoonist Emeritus." February 4, 1993, p. 62.

1079. Mo Zi. "*China Daily*'s Three News Cartoonists in the Art Department: Zhang Yaoning, Li Jian Hua, and Li Zheng Ming." *International News World.* May 28, 2001, p. 7.

1080. "Morals and Art Are Both Very Good with Chinese Cartoon Artists." *Zhongguo Manhua.* No. 4, 2000, pp. 2-3.

1081. "The Pluck of an Artist." *Inklings.* Summer 1997, p. 4. (Ge Gao).

1082. "Snapshot, Jiang Yousheng." *WittyWorld International Cartoon Bulletin.* 2/1996, p. 2.

1083. Wang Fuyang. "Persevering Cartoonist." *Zhongguo Manhua.* No. 5, 2000, pp. 8-9. (Wang Di).

1084. Wang Yamin, *et al. The Series of Chinese Cartoons, Liao Binxiong.* Shijiazhuang: Hebei Educational Publishing House, 1994.

1085. Wang, Yamin, *et al. The Series of Chinese Cartoons, Zhang Guangyu.*
 Shijiazhuang: Hebei Educational Publishing House, 1994.

1086. Wei Wen Hua. "Cartoonists in My Imagination." *Cartoon Art Research.*
 October 26, 2000, p. 3.

1087. Weiwandege. *Bai Shan Cheng Manhuaji* (Bai Shan Cheng Cartoon
 Collection). Anhuimeishuchubanshe. 1994. 134 pp.

1088. "Wisdom Snack." *FECO News.* No. 22, 1997, p. 21. (Zheng Xin Yao).

1089. Wu Chuan Qiu. "Mi Gu's Cartoons' Realistic Characteristics."
 Zhongguo Manhua. No. 9, 1998, pp. 8-9.

1090. Xu Peng Fei. *Chinese Modern Cartoonists: Xu Peng Fei Cartoons.*
 Changchun: Jilin Literature & History Press, 1989. 149 pp.

1091. Zhang Ding. *Zhang Ding's Cartoons: 1936-1976.* Liaoning: Liaoning
 Art Publishing House, 1984. 130 pp. Chinese.

1092. Zhang Hanwen. "Flower on a Higher Plateau." *Zhongguo Manhua.* No.
 4, 2000, pp. 8-9. (He Fucheng).

1093. Zheng Yimei. "A Memory of Some Cartoonists." *Fengci Yu Youmo.* 3
 (1979), n.p.

1094. Zhou Hong Wei. "On the Field of Thinking: Zhao Xiao Su's Works."
 Zhongguo Manhua. No. 12, 2000, pp. 20-21.

Fang Cheng

1095. Fang Cheng. *Fang Cheng Cartoons.* Beijing: People's Daily Press,
 1998. 143 pp.

1096. Fang Cheng. *Fang Cheng Cartoon Volume.* Shanghai: Shanghai Science
 and Technology Information Press, 2000. 82 pp., 12 color plates.

1097. Fang Cheng. *Fang Cheng Strip Columns.* Changchun: Jilin Art Press,
 1985. 94 pp.

1098. Wang Ya Min. *The Series of Chinese Cartoons: Fang Cheng Volume.*
 Shijiazhuang: Hebei Educational Press, 1994. 137 pp.

Feng Zikai

1099. Feng Zikai. *Feng Zikai: An Anthology.* Hong Kong: Chungwah
 Publishing, 2000. 231 pp.

1100. Huang Yuan Lin. "Memories of Mr. Feng Zikai's 100th Birthday." *Zhongguo Manhua*. No. 12, 1998, pp. 2-3.

1101. Wang Yamin, *et al. The Series of Chinese Cartoons, Feng Zikai.* Shijiazhuang: Hebei Educational Publishing House, 1994.

1102. Zhu Guangqian. "A Memory of My Old Friend Feng Zikai." *Art World.* 1, 1980, p. 25.

He Wei

1103. He Wei. *He Wei's Cartoon.* Beijing: China Workers Press, 1994. 16 pp.

1104. He Wei. *Pen Emotion and Ink Interests.* Chinese Water and Ink Cartoon; Japanese Line and Ink Poem Cartoons. Beijing: China Work Press, 1996.

1105. Lengyel, Alfonz. "He Wei – Chinese Cartoonist Pioneer in Brush and Ink Technique." Paper presented at Mid-Atlantic Region/ Association for Asian Studies, Towson, Maryland, October 21, 1995.

Hua Junwu

1106. Hua Junwu. "How I Think and How I Draw Cartoons." *Zhongguo Manhua*. No. 3, 2001, p. 16.

1107. Hua Junwu. *Hua Junwu Manhua 1945-1979.* (The Cartoons of Hua Junwu 1945-1979) Chengdu: Sichuan Meishu Chubanshe, 1986.

1108. Hua Junwu. *Hua Junwu's Cartoons.* Zhejiang: People's Art Press, 1990. 152 pp.

1109. Hua Junwu. "Some of My Experience on Cartoon Nationalization." *Cartoon Art Research.* October 26, 2000, p. 1.

1110. Hung Yu. "Hua Chun-wu [Hua Junwu] Is an Old Hand at Drawing Black Anti-Party Cartoons." *Chinese Literature.* No. 4, 1967, pp. 133-135+.

1111. Lengyel, Alfonz. "Hua Junwu and His Interior Satire of the 1950s and 1960s in China." Paper presented at Popular Culture Association, Philadelphia, Pennsylvania, April 12, 1995.

Shen Tong Heng

1112. Huang Yuan Lin. "Shen Tong Heng and Cartoon Group Gong Xue Tuan." *Art Observation.* February 2001, pp. 47-49.

1113. Liu Yong Sheng. "Shen Tong Heng, A Cartoonist Who Pays Attention to Theory, Reearch." *Art Observation.* February 2001, pp. 58-59.

Ye Qianyu

1114. Bi Keguan, ed. *Mr. Wong and Xiao Chen.* Beijing: Peoples Art Press, 1982. 240 pp.

1115. Wang Yamin, *et al. The Series of Chinese Cartoons, Ye Qianyu.* Shijiazhuang: Hebei Educational Publishing House, 1994.

1116. Xie Bo. *Biography of Ye Qianyu.* Changchun: Jilin Art Publishing House, 1991.

Zhang Leping

1117. Wen-Chuan. "Talking About Le-Ping Chang's 'Three-Hair' Comics." *Monthly Comic Magazine.* October 1990, p. 33-36.

1118. Wang Yamin, *et al. The Series of Chinese Cartoons, Zhang Leping.* Shijiazhuang: Hebei Educational Publishing House, 1994.

1119. Zhang Leping's Caricatures. n.p. 1993, 1997. 382 pp.

Historical Aspects

1120. Bi Keguan. "Zheng Guang Yu's Historical Contribution to Development of Chinese Cartooning." *Cartoon Art Research.* March 5, 2001, p. 3.

1121. *Chinese Satirical Drawings Since 1900.* Hong Kong: Hong Kong Institute for Promotion of Chinese Culture, 1987. 153 pp.

1122. Choy, Philip P., Lorraine Dong, and Marlon K. Hom. *The Coming Man: 19th Century American Perceptions of the Chinese.* Seattle: University of Washington Press, 1994. 178 pp.

1123. Fischer, Roger A. "The Coming Man: 19th Century American Perceptions of the Chinese." *Inks.* May 1996, p. 44.

1124. He Wei. "Thoughts After Reading *One Hundred Years of Cartoons.*" *Cartoon Art Research.* July 24, 2000, p. 3.

1125. He Wei. "Thoughts After Reading *100 Years of Cartoons.*" *Zhongguo Manhua.* No. 5, 2000, p. 21.

1126. Hua Junwu, chief editor. *Modern Chinese Art: Cartoons.* Beijing: Tianjin Peoples Art Press, 1998. (Includes Huang Yuan Jin, "General Survey of Chinese Cartoon Development," pp. 3-31.

1127. Huang Yuan Lin. "Adapt to Society's Needs; Insist on Following the Facts. How I Wrote *100 Years of Cartoons." Art Observation.* May 2001, p. 48.

1128. Huang Yuan Lin. "Lu Xun and *Cartoon." Cartoon Art Research.* October 26, 2000, p. 2.

1129. Huang Yuan Lin. *One Hundred Years of Chinese Cartooning.* Beijing: Modern Press, 2000. Vol. I, 1898-1918, 274 pp.; Vol. II, 1898-1999, 286 pp.

1130. Landsberger, Stefan. *Chinese Propaganda Posters, from Revolution to Modernization.* Armonk, New York: M. E. Sharpe, 1995. 240 pp.

1131. Landsberger, Stefan. *Chinese Propaganda. From Revolution to Modernization.* Singapore, Amsterdam: Pepin Press, 1998.

1132. Li, Danke. "Cartoon and Vernacular Power in Sichuan Railway Rights Protection Movement." Paper presented at Association for Asian Studies, Chicago, Illinois, March 23, 2001.

1133. Liu-Lengyel, Hongying. "Man Hua: Cartoons and Comics in China Before 1949." *Comics Journal.* May 2001, pp. 43-45.

1134. Liu-Lengyel, Hongying. "Revival of Ancient Popular Culture in Contemporary Chinese Caricatures." Paper presented at Popular Culture Association, Philadelphia, Pennsylvania, April 12, 1995.

1135. Mair, Victor H. *Painting and Performance: Chinese Picture Recitation and Its Hidden Genesis.* Honolulu: University of Hawaii Press, 1988. 278 pp.

1136. Mair, Victor H. "Scroll Presentation in the T'ang Dynasty." *Harvard Journal of Asiatic Studies.* June 1978, pp. 35-60.

1137. Shen Bochen. "The Responsibilities of the Magazine." *Shanghai Puck.* 1:9 (1918), n.p.

1138. Wang Jian. "Unique 100 Years: Glimpses of Chinese Contemporary Cartoons." *Zhongguo Manhua.* No. 1, 1999, p. 20.

1139. Wang Zimei. "The Evolution and Prospect of Chinese Cartoons." *Manhua Shenghuo.* 2:1 (1935), p. 1.

1140. Xu Zhihao. *A Brief Index of Art Groups of China.* Shanghai: Shanghai Calligraphy and Painting Publishing House, 1994.

1141. Xu Zhihao. *1911-1949: A Survey of Chinese Art Periodicals.* Shanghai: Shanghai Calligraphy and Painting Publishing House, 1994.

1142. Zarrow, Peter. "The Gentle Art of Fengci: Irony, Sarcasm, and Savage Ridicule in the Early Twentieth Century." Paper presented at Association for Asian Studies, Washington, D.C., April 8, 1995.

1143. Zhang, Zongren. "In the Eye of the Storm." *Asian Art News.* November-December 1999, pp. 38-41. (Woodblock prints).

Animation
General Sources

1144. Chen Bochui. "Appreciate Animation with Children." *Popular Film.* 5, 1979, p. 2.

1145. *Cinéma d'Animation de la République Populaire de Chine.* Peking: Chinese Film Distribution Co., n.d.

1146. Ehrlich, David with Tianyi Jin. "Animation in China." In *Animation in Asia and the Pacific,* edited by John A. Lent, pp. 7-13. Sydney: John Libbey & Co., 2000.

1147. Furniss, Maureen. "Sunrise over Tiananmen Square." *Animation World.* April 1999, 3 pp.

1148. Hao Yuemei. "Foreign Cartoon Films and Our Children's View on TV and Films." *Film Art.* No. 5, 1999, pp. 88-91.

1149. Hermelin, Francine G. "Multimedia Impresario: From Tunes to Toons." *Working Woman.* July 1994, p. 39.

1150. Hu Yihong. "Some Ideas of Contemporary Animation." *New Film.* No. 5, 1997, p. 48.

1151. Jin Tianyi. "Chinese Cartoon Film." *Film Art.* No. 5, 1999, pp. 34-39.

1152. Li Chun. "Thinking About the Recent Children's Films." *Film Art.* No. 5, 1999, pp. 85-87.

1153. Mondello, Bob. " 'Mulan' Storms China, Box Office." National Public Radio's Weekend All Things Considered. June 21, 1998.

1154. "One, Two, Three with Da Niao." *Asiaweek.* October 31, 1997, p. 44.

1155. Qiang Yunda. "Animation and Cartoon Pictures." *New Film.* No. 4, 1997, pp. 56-57.

1156. Research Team, Center for Documentation & Information, Chinese Academy of Social Sciences. "An Assessment of Children's Programmes in the People's Republic of China." In *Growing up with Television: Asian Children's Experience,* edited by Anura Goonasekera,

pp. 12-47. Singapore: Asian Media Information and Communication Centre, 2000.

Animators

1157. Ehrlich, David. "A Da, China's Animated Open Door to the West." In *Animation in Asia and the Pacific,* edited by John A. Lent, pp. 17-20. Sydney: John Libbey & Co., 2001.

1158. Jin Tianyi. "Animation Production Idea: The New Phase: Interview with Chang Guang Xi." *New Films.* September 1999, pp. 43-47.

1159. Xu Ying. "Director Cao Xiaohui and Beijing Animation." Paper presented at Popular Culture Association, Philadelphia, Pennsylvania, April 14, 2001.

1160. Ye Qianyu. "The Paintings of Qi Baishi Moved." *People's Daily.* July 8, 1960, p. 8.

Te Wei

1161. Alder, Otto. "Tei Wei, Chinese Doyen of Animation." *Plateau.* 15:2 (1994), pp. 4-8.

1162. Ehrlich, David. "Vignette: Te Wei's Life and Work." In *Animation in Asia and the Pacific,* edited by John A. Lent, pp. 14-16. Sydney: John Libbey & Co., 2001.

1163. Te Wei. "Create National Animation." *Arts.* 10, 11, 1960, p. 50.

1164. Te Wei. "For Creating Chinese National Animation Advance Bravely." *Literature and Art Journal.* 15/16, 1960, p. 73.

1165. Te Wei. "Great National Animation." *Renmin Daily.* August 31, 1960, p. 7.

1166. "Té Wei (China)." *Plateau.* 14:1 (1993), p. 12.

Wan Brothers

1167. "Animation 'Create Disturbances in Heavenly Palace' I Has Been Completed; Artist Wan Laiming's Long Wish Has Been Fulfilled Today." *People's Daily.* November 3, 1961, p. 4.

1168. Bao Jigui. "The Wan Brothers and the Cinema of Chinese Animation --- A Tribute to Wan Laiming on the 100th Anniversary of His Birth." *HKFA Newsletter.* May 2000, pp. 6-7.

1169. Bao Jigui. "The Wan Brothers and The Cinema of Chinese Animation – A Tribute to Wan Laiming on the 100th Anniversary of His Birth." *HKFA Newsletter.* August 2000, pp. 11-12.

1170. Biagini, Alessandra. "Lo Stile Nazionale nel Cinema d'Animazione Cinese: Proposta di Analisi Attraverso l' Esame di Danao Tiangong di Wan Laiming." Thesis, University of Venice, 1993. 131 pp.

1171. Cao Si. "Talk from the Experience of Wan Laiming – The Development Situation of Chinese Animations." *Yangcheng Evening Paper.* August 21, 1962, p. 3.

1172. He Yi. "Two Fresh Flowers in the Animation Garden – Brief Talk About 'Create Disturbances in Heavenly Palace' and 'Silk Waistband.'" *Popular Film.* 2, 1963, p. 22.

1173. Quiquemelle, Marie-Claire. *The Wan Brothers and 60 Years of Animated Film in China.* Annecy: Jica Diffusion, 1985. 38 pp.

1174. Wan Laiming. "No More Happier Than To Have Long-Cherished Wish Fulfilled." *People's Daily.* July 29, 1962, p. 5.

1175. Wan Laiming. "Recall Our First Talkie Animation 'Camel Dance.'" *Popular Film.* 8, 1957, p. 31.

1176. Yao Fangzao. "Wan Brothers and 'Create Disturbances in Heavenly Palace.'" *Art World Collection.* 1, 1979, p. 24.

1177. Zhang Guanhong. "Around the Birth of 'Create Disturbances in Heavenly Palace' – Interview with Animation Artist Wan Laiming." *Wenhui Journal.* November 12, 1961, p. 2.

Zhan Tong

1178. Lengyel, Alfonz and Hongying Liu-Lengyel. "Zhan Tong (1932-1995)." *WittyWorld International Cartoon Bulletin.* 1/1996, p. 2.

1179. Lent, John A. "*Vignette:* Zhan Tong, A Stickler to the Chinese Style." In *Animation in Asia and the Pacific,* edited by John A. Lent, pp. 29-32. Sydney: John Libbey & Co., 2001.

1180. Liu-Lengyel, Hongying. "Zhan Tong – Innovator of Chinese Animation, Cartooning and Theme Park Design." Paper presented at Mid-Atlantic Region/Association for Asian Studies, Towson, Maryland, October 21, 1995.

Censorship

1181. "China Bans Turner's Cartoon Network Broadcasts." *Asian Mass Communications Bulletin.* March-April 2000, p. 8.

1182. " 'China Boots Cartoon Network'" Was a Great Associated Press Headline, But It Wasn't Exactly True." *ASIFA San Francisco.* March 2000, p. 4.

1183. "China Targets Cartoons." Associated Press release. October 4, 2000.

1184. "Scooby Doo No More: Transparency in China." *Far Eastern Economic Review.* February 17, 2000, p. 66.

1185. "TNT Cartoons Shown Exit in China." Associated Press release, February 3, 2000.

Disney in China

1186. Groves, Don. "Chilly China May Thaw Disney Relations." *Variety.* August 10-16, 1998, p. 13.

1187. Li Ning. "Disney Comes to China National Radio." *Beijing Review.* August 26-September 1, 1996, p. 30.

1188. "Mulan's China Woes." *Asiaweek.* April 2, 1999, p. 39.

1189. Neal, Jim. "Disney Wins Piracy Suit in China." *Comics Buyer's Guide.* June 23, 1995, p. 82.

Historical Aspects

1190. "Animation Should Be Named 'Beauty.'" *Wenhui Journal.* March 22, 1979, p. 2.

1191. "Artists Talk About Animation." *Popular Film.* 5, 1960, p. 21.

1192. Bing Xin. "Leap Forward with Animation." *Wenhui Journal.* May 31, 1960, p. 3.

1193. Cheng. "An Episode of Grasslands' Life – Recording Days, the Animation 'Wood Girl' Production Unit Lives in Inner Mongolia." *Popular Film.* 10, 1957, p. 27.

1194. Cheng Bochui. "Look at Animation from Fairy Tales." *Literature and Art Journal.* 4, 1960, p. 40.

1195. "Constantly Bring Forth New Ideas in the Path of Nationalization and Masses. Many Animations of Shanghai Are Renowned in International Film Circles." *Wenhui Journal.* August 11, 1962, p. 1.

1196. Fan Yang. "New Creation of Animation." *Chinese Cinema*. 1, 1959, p. 12.

1197. Fang Cheng. "Delightful New Achievement." *Chinese Cinema*. 4, 1959, p. 62.

1198. Fang Cheng. "Just Talk About the Art Exaggeration of Animation." *Guangming Daily*. February 19, 1960, p. 3.

1199. Fang Qun. "Chinese Animation Is Changing with Each Passing Day." *Guangming Daily*. June 18, 1960, p. 3.

1200. Ge Zhang. "Animation Takes on an Entirely New Look." *People's Film*. 3, 1976, p. 18.

1201. He Gongchao. "Our Animations Are Scaling Artistic Heights of the World." *Wenhui Journal*. May 31, 1960, p. 3.

1202. He Ning. "Behind the Scenes of Animation." *Nanfang Daily*. August 19, 1962, p. 1.

1203. Hu Jinqing. "A Bold Creating Innovation, Developing Our New Animation Art!" *Guangming Daily*. June 11, 1960, p. 3.

1204. Hu Tonglun. "Talking About the National Form of Animation." *Guangming Daily*. June 12, 1963, p. 2.

1205. Hua Junwu. "Commendable Good Harvest – Comment on the National Style of Our Chinese Animations." *Renmin Daily*. February 18, 1960, p. 7.

1206. Hua Junwu. "Great Creation." *Film Art*. 7, 1960, p. 23.

1207. Hua Junwu. "Two Points of Thanks – Talking About Animation." *People's Daily*. August 6, 1979, p. 4.

1208. Huang Ke. "Bumper Harvest of Animation Films." *New Culture Journal*. March 1, 1959, p. 4.

1209. Huang Yongyu. "See Animation with Children." *Popular Film*. 5, 1961, p. 10.

1210. Huang Zongying. "Good Fellows" (Jottings of Seeing Animation with Children). (Poem). *Popular Film*. 12, 1962, p. 26.

1211. Hutman, Kenneth. "Sinomation: Shanghai Animation Studio – Yesterday, Today and Tomorrow." *Animation World*. April 1996, 3 pp.

1212. Ji Shi. "Two Animations Are Completed Recently." *Popular Film*. 23, 1957, p. 34.

1213. Jiang Yousheng. "An Audience's Opinion." *Chinese Cinema.* 4, 1959, p. 63.

1214. Jin Tianyi. "Chinese Cartoon: History of Fifty Years." *Film Art.* No. 2, 1999.

1215. Jin Xi. "Art Conception of Animation." *Film Art.* 4, 1962, p. 16.

1216. Jin Xi. "Bring the Art Characteristic of Animation into Full Play." *People's Film.* 5, 1974, p. 4.

1217. Jin Xi. "The Development of Chinese Animation." *Film Art.* 4, 1959, p. 62; 5, 1959, p. 81.

1218. Jin Xi. "Exaggerated and 'Comfortable.' – Jottings of Animation Created Problems." *Film Art.* 1, 1963, p. 55,

1219. Liao Di. "On Animation Art." *Guangming Daily.* November 20, 1954, p. 3.

1220. Lu Bing. "Magnificent Picture, a Paean of Times." *Popular Film.* 13, 1960, p. 19.

1221. Lu Zhengxin. "Brief Talking About Animation." *Xinhua Daily.* December 31, 1978, p. 4.

1222. McLaren, Norman. *The Healthy Village: An Experiment in Visual Education in Western China.* Paris: UNESCO, Monographs in Fundamental Education 5, Art Department Report, 1949.

1223. McLaren, Norman. "I Saw the Chinese Reds Take Over." *McLean's.* October 15, 1950, pp. 73-76.

1224. Ma Guoliang. "Both Skillful and Excellent." *Chinese Cinema.* 3, 1956, p. 35.

1225. Nai Jun. "Colorful Animation." *Popular Film.* 1, 1963, p. 23.

1226. Nai Jun. "The 'Secrets' of Animation Production." *Chongqing Daily.* June 13, 1960, p. 3.

1227. Nai Jun. "Sing the Praises of New Morals and New Habits; the Creation of Animation Is Flourishing." *Popular Film.* 7, 1964, p. 27.

1228. Qu Baiyin. "New Achievements of Animation." *Wenhui Journal.* May 31, 1960, p. 3.

1229. Ren Rongrong. "Children Need Animation." *Liberation Daily.* June 1, 1979, p. 4.

1230. Reporter. "Exciting, Praising, and Inspiring. The Minutes of Film Audience Discussing Animation." *Popular Film.* 5, 1960, p. 22.

1231. "Scale the Heights in Animation Art." *Arts.* 7, 1960, p. 48.

1232. Shanghai Animation Studio. "'The Gang of Four' Is the Chief Criminal of Destroying the Development of Animation." *People's Film.* 10/11, 1978, p. 8.

1233. Song Lin. "Animation Should Go to the Nationalizing Road." *Film Art.* 2, 1979, p. 49.

1234. Song Lin. "Talk About the Characteristics of Animation Scripts." *Film New Works.* 2, 1979, p. 78.

1235. Song Yuan. "Making the Wonderful Flower of Animation Come into Bloom." *Chinese Cinema.* 1, 1956, p. 24.

1236. Tang Cheng. "Talking About Animation." *Zhejiang Daily.* September 23, 1962, p. 4.

1237. Tang Jin. "Jottings of Animation Appreciation." *Popular Film.* 24, 1957, p. 6.

1238. Tian Ao. "Talk About Artistic Treatment of Animation." *People's Daily.* September 16, 1962, p. 5.

1239. Wang Shuchen. "Add Delightful Color for Festival." *Film Stories.* 10, 1979, p. 4.

1240. Wu Lun. "Animation in 1958." *Chinese Cinema.* 6, 1958, p. 31.

1241. Wu Lun. "Animation Reflects Modern Life Problems." *Film Art.* 4, 1963, p. 53.

1242. Wu Lun. "Animation Reflects the Problem of Socialist Construction and Worker- Peasant- Soldier's Life." *Guangming Daily.* June 5, 1962, p. 2.

1243. Wu Lun. "Life with Fantasy Wings – Talking Animation with Youth!" *Chinese Youth Paper.* May 31, 1961, p. 4.

1244. Wu Lun. "Marching Forward of Animation." *Wenyi Journal.* 6, 1957, p. 9.

1245. Wu Yang. "Fairy Tales World – Report on the Exhibition of Animation." *Popular Film.* 6, 1959, p. 26.

1246. Wu Yang. "New Flower of Animation." *Popular Film.* 6, 1958, p. 31.

1247. Yang Hansheng. "Cheer for the Achievements in Animation Films." *Renmin Daily.* February 8, 1960, p. 8.

1248. Yang Hansheng *et al.* "Forum on Animation." *Film Art.* 2, 1960, p. 31.

1249. Yu Wei. "Delightful Harvest – The Minutes of Artists Discussing on a Few Domestic Animations." *Popular Film.* 10, 1957, p. 14.

1250. Zhang Guangyu. "Just Talk About Art of Animation." *Renmin Daily.* February 18, 1960, p. 7.

1251. Zhang Shaonan and Li Chunxin. "Praise New Films of Children's Holiday (Festival)." *Wenhui Journal.* June 1, 1966, p.4.

1252. Zhang Xonglin. "Forty Years of Shanghai Animation Film Studio (Shanghai Fine Arts Film Studio)." *New Film.* No. 4, 1997, pp. 60-62.

1253. Zhang Zhengyu. "New Modelling of Animation." *Wenhui Journal.* June 28, 1963, p. 4.

Industry

1254. Baisley, Sarah. "Colorland Animation." *Animation.* April 2001, p. 40.

1255. Brent, Willie. "China Sets Sights on Animation." *Variety.* January 3-9, 2000, p. 78.

1256. "Cartoon Struggle In China." *Asian Mass Communications Bulletin.* November/December 2000, p. 7.

1257. Chang, Guangxi. "Facing the Commercial Market and Changing Our Policy: Chinese Animation Creation Now!" *New Film.* No. 4, 1997, pp. 58-59.

1258. "China: Cartoon Patriotism." *Far Eastern Economic Review.* April 10, 1997, p. 13.

1259. "China's Searainbow Inks Deal with Disney Internet." Reuters release, March 9, 2001.

1260. "Chinese Animation Industry with Ambitious Mid-Long Plan for World Market." *Animatoon.* No. 8, 1997, pp. 76-79.

1261. "Chinese Animation Output up 100 Per Cent." *Asian Mass Communications Bulletin.* November-December 1998, p. 17.

1262. "Chinese Cartoon Industry Steps Out of Depression." People's Daily Online. November 17, 2000.

1263. Gelman, Morrie. "Animation Services Group: One-Stop Shop Comes Full Circle." *Animation.* January 2000, p. 25.

1264. Gong Qian. "Animation Industry Faces Hurdles." *China Daily.* October 1996. (Day unknown.)

1265. Guider, Elizabeth. "Regional Nets Grab WB Toon Series." *Variety.* November 1-7, 1999, p. 28.

1266. Halligan, Fionnuala. "Chinese Toon Factories Thrive on H.K. Biz." *Variety.* June 24-30, 1996, p. 103.

1267. Holland, Lorien. "Tuned in to China." *Far Eastern Economic Review.* April 1, 1999, p. 50.

1268. Keenan, Faith. "1 Country, 2 Wabbits: Getting Bugs Bunny to China Wasn't Exactly Kids' Stuff." *Far Eastern Economic Review.* May 23, 1996, p. 68.

1269. Jin Tianyi *et al.,* eds. "The Contemporary Situation of Chinese Animation and Perspective: Policy and Market." *New Film.* No. 4, 1997, pp. 54-55.

1270. Jin Tianyi and Chang Guangxi. "International Animation's Situation and Perspective of Chinese Animation." *New Film.* No. 5, 1997, pp. 44-48.

1271. McDonald, Joe. "China Tries To Become a Cartoon-Making Power." Associated Press dispatch, October 4, 2000.

1272. "Pixibox Expands All the Way to China." *Animation World Magazine.* July 1997, p. 76.

1273. "Sino- US Trade War Claims Bugs Bunny." *Indian Express.* June 1, 1996.

1274. "Special Report: The New Progress and Wave of Shanghai Animation Art Studio: Over 3,000 Minutes of Animation Films Will Be Made in the Year of 1998 to 1999. *China Film News.* August 13, 1998.

1275. Street, Rita. "Chinese Cartoon Biz Loosening Up." *Variety.* June 19-25, 1995, pp. 50, 58.

1276. Te Zheng. "Chinese Animation: Where Does It Exist?" *China Film News.* June 18, 1998.

1277. Te Zheng. "Where Will Chinese Animation Film Go? *Beijing Broadcast and TV News.* May 19, 1998.

1278. Vallas, Milt. "China – The Awakening Giant: Animation Broadcasting in the Mainland." *Animation World.* August 1998, 4 pp.

1279. "Viacom To Launch Nickelodeon in China." Reuters release, March 30, 2001.

1280. Xu Ying. "Animation Production of Beijing Science and Education Film Studio." *Film Report.* No. 2, 2000, pp. 21-22.

1281. Xu Zheng Jun. "Exploring the Chaotic Situation and Prospective Possibilities of Chinese Domestic Animation Films." *Film Art.* No. 3, 2001, pp. 91-93.

1282. Zhou Keqin. "The Future of Shanghai Animation Film Studio." *New Film.* No. 4, 1997, pp. 63-65.

Techniques
Ink and Wash Animation

1283. Dong Yu. "Hail the Birth of 'Ink and Wash Animation' – Jottings of a Forum of Beijing Artists and Writers." *Popular Film.* 11, 1960, p. 14.

1284. Tang Yun. "Contribution of National Painting – Ink and Wash Animation." *Wenhui Journal.* May 31, 1960, p. 3.

1285. Ye Lan. "Animation Studio for First Time Uses Ink and Wash Paint and Product Animation." *Popular Film.* 11, 1960, p. 26.

Paper Cut Animation

1286. Wan Guchan. "Refer to New Type of Animation – Paper Cut Films." *Guangming Daily.* February 17, 1960, p. 3.

1287. Wu Yang. "A New Kind of Film – Paper Cut Film." *Popular Film.* 16, 1958, p. 25.

1288. Zhang Ting. "Paper-Cut Films of Animation." *Renmin Daily.* February 18, 1960, p. 7.

Paper Folding Animation

1289. Yu, Zheguang. "Make Paper Folding Animals Lively – Notes of the Creation of 'Paper Folding Films.'" *Popular Film.* 13, 1960, p. 19.

1290. Yu Zheguang. "Paper Folding Films." *Liberation Daily.* February 11, 1962, p. 4.

1291. Yu Zheguang. "Talk About the Creation of Paper Folding Films." *Shanghai Film.* 11, 1961, p. 13.

Puppet Animation

1292. Bao Di. "Chinese Animation and Puppet's Home." *Popular Film.* 10/1953, p. 5.

1293. Cao Maotong. "Animation and Puppet Film Art Are Rich in National Color." *Dagong Paper*. July 16, 1961, p. 3.

1294. "Japanese Film Delegation Visiting China Made a Speech Highly Praising Chinese Animation and Puppet Films." *Popular Film*. 10, 1957, p. 37.

1295. Jin Xi. "Talk About the Characteristic of Puppet Films." *Chinese Cinema*. 5, 1957, p. 32.

1296. Jin Xi. "We Worked at Puppet's Home." *Popular Film*. 3/ 1955, p. 12.

1297. Luo Ming. "Color Puppet Film 'Mr. Dongguo' and 'Magical Brush.'" *Popular Film*. 5, 1956, p. 33.

1298. Ma Ke. "Should Bring the Characteristic of Puppet Films into Full Play." *Popular Film*. 7, 1959, p. 14.

1299. Nai Jun. "Cloth Bag Puppet Play Goes on Screen." *Popular Film*. 9, 1962, p. 22.

1300. Su Hong. "Two Puppet Films Are in Production." *Popular Film*. 10, 1959, p. 27.

1301. Yao Fangzao. "Secrets of Puppet Films." *Popular Film*. 6/1950, p. 16.

Theme Parks

1302. "Disney May Build Two Parks in China." *Global Media News*. Summer 1999, p. 9.

1303. "A One-Horse Race." *Asiaweek*. March 26, 1999, p. 10.

1304. Speigel, D. "China's Park Industry About Faces After Staff, Operational Changes. *Amusement Business*. May 27, 1991, p. 3.

Titles

1305. Cao Maotang. "Festively Singing and Dancing in Sun Palace – See Animation 'Sun's Little Ghosts.'" *Popular Film*. 8, 1961, p. 21.

1306. Cao Maotang. "Pleased To See Animation 'Young Swallow.'" *Shanghai Film*. 6, 1961, p. 13.

1307. Cao Maotang. "Splendid Prospects – See Big Color Animation 'A Zhuang Nationality Brocade.'" *Popular Film*. 5, 1960, p. 21.

1308. Cao Zhipei. "Myth, Legend and Others – See 'Red Army Bridge' and Three Other Animations." *Anhui Daily*. November 20, 1977, p. 4.

1309. Deng, Gang. "Chinese Cartoon To Land in US." People's Daily Online. May 28, 2001. ("Haier Brothers").

1310. Fang Cheng. "Two Good Animations." *People's Daily.* June 10, 1961, p. 8.

1311. Hua Junwu. "A Good Animation ('Story in Murals')." *Literature and Art Journal.* 4, 1960, p. 18.

1312. Huang Shixian. "Art Buds of Beauty – See 'Two Little Peacocks.'" *People's Film.* 5, 1978, p. 10.

1313. Huang Xinxin. "Creation Originally Comes from Life. Wisdom Comes from Mass-Color Animation 'Bamboo Shoots Growing in the House.'" *Changsha Daily.* March 26, 1977, p. 3.

1314. Jiang Ling. "New Paper Cut Film – 'Fishing Boy.'" *Popular Film.* 5, 1959, p. 28.

1315. Li Gan. "Fine Horses Gallop Ten Thousand Li on Grasslands – Review on Color Puppet Film 'Fine Horses at a Full Gallop.'" *Wenhui Journal.* March 20, 1975, p. 4.

1316. Li Han. "Don't Forget Class Struggle – Impressions of Animation 'After School.'" *Guangming Daily.* July 4, 1972, p. 3.

1317. Li Xin. "Gifts for Children's Festival – Introduce Animation 'Golden Antelope.'" *Popular Film.* 10,1956, p. 34.

1318. Li Xin. "Gifts for Children's Festival – Introduce Animation's 'Frog Princess.'" *Popular Film.* 10, 1956, p 33.

1319. Liang. "Changchun Film Studio Produces First Color Puppet Film 'A Little Girl With a Red Undergarment.'" *Popular Film.* 19, 1960, p. 19.

1320. Lin Wenxiao and Chang Guangxi, "Exploration of Emotional Style: Directors' Summary of Animation 'Jiazi Rescues a Deer.'" *China Film Yearbook, 1986,* pp. 7-15 to 7-16.

1321. Mei Ming. "We Need Animation – Introducing 'Thank Spotted Kitten' and 'Xiao Tiezhu.'" *New Film.* 6, 1951, p. 24.

1322. Ni Guyin. "Animation Should Also Express Advanced People – See Animation 'Half Past Four' and Others." *Wenhui Journal.* December 16, 1964, p. 2.

1323. "Our Film 'Magical Brush' Won Award Abroad Again." *Popular Film.* 22, 1957, p. 37.

1324. Qing Lan. "Unique Conception, Deep Implied Meaning – Impressions of Animation 'One Night in Gallery.'" *Wenhui Journal.* July 19, 1978, p. 2.

1325. Tang Jia. "See Paper Cut Animation 'Zhubaijie Eats Watermelon.'" *Popular Film.* 3, 1959, p. 14.

1326. "Tiger Fears Goat – Puppet Film 'Quick-Witted Goat' Is One of Doing a Rush Job and Increasing Production." *Popular Film.* 24, 1956, p. 31.

1327. Wang Shuchen. "Cartoon-Like Animation –'Dream Gold.'" *Wenhui Journal.* May 19, 1963, p. 4.

1328. Wu Liangrong. "Learn from the Hunter. Eliminate Jackals and Wolves – Impressions of 'Mr. Dongguo.'" *Chongqing Daily.* April 30, 1978. p. 3.

1329. Xiao Ying. "Present 'Golden Conch' on Screen." *Shanghai Film.* 2, 1962, p. 23.

1330. Xin Jiting. "New and Interesting Paper Folding Film 'Clever Little Duck.'" *People's Daily.* July 16, 1960, p. 8.

1331. Xu Jingda *et al.* "How To Create Animation 'Catch Up with England?'" *Popular Film.* 22, 1958, p. 28.

1332. Yao Fangzao. "Real People, Puppet and Cartoon Altogether Making 'Song of Peace.'" *Popular Film.* 13, 1950, p. 18.

1333. Yi Bing. "High Style, Style High – Introducing Animation 'New Thing on the Side of the Road.'" *Hebei Daily.* February 24, 1965, p. 3.

1334. Zhao Yueming *et al.* "Literature and Art Revolution Grows New Flowers – See Color Animation 'Trial Trip' and Color Paper Cut Film 'Golden Wild Goose.'" *Guangming Daily.* July 5, 1976, p. 3.

1335. Zhong Ling. "New Field of Animation – Brief Review on 'New Thing on the Side of the Road.' 'Half Past Four,' 'Cock Crow at Midnight,'" and 'Red Army Badge.'" *Film Art.* 3, 1965, p. 70.

1336. Zou Luzhi. "Beautiful and Colorful – Impressions of 'Small Stream' and 'Red Cloud Cliff.'" *Popular Film.* 3, 1964, p. 27.

"Arfanti"

1337. Guo Bowen and Jian Fangtu. "Arfanti, the Embodiment of Wisdom and Idealism." *Popular Film.* 6, 1979, p. 17.

1338. Huang Shixian. "Charming Taste of Puppetry – Pleased To See Puppet Film 'Arfanti.'" *Popular Film.* 12, 1979, p. 11.

"Bows and Arrows with Sound"

1339. Xi Yun. "Children's Literature Works Should Pay Attention to Children's Characteristics – Furthermore Talk About Color Paper Cut Film 'Bows and Arrows with Sound.'" *Wenhui Journal.* December 25, 1974, p. 3.

1340. Xue Ying. "Take Over the Bows and Arrows of the Older Generation of Revolutionaries – Impressions of the Color Paper Cut Film 'Bows and Arrows with Sound.'" *Liberation Daily.* November 27, 1974, p. 3.

"Conceited General"

1341. Ke Ruo. "New Animation of Shanghai Film Studio 'Conceited General.'" *Popular Film.* 5, 1957, p. 18.

1342. Tong Heng. "Animation Has Had Its National Style – Talk About 'Conceited General' and Others." *People's Daily.* June 5, 1957.

"Create Disturbances in Heavenly Palace"

1343. Bian Shanji. "Jottings of the Artistic Aspects of 'Create Disturbances in Heavenly Palace.'" *Guangming Daily.* January 1, 1978, p. 4.

1344. Cao Maotang. "Charm of Animation Art – Pleased To See Animation 'Create Disturbances in Heavenly Palace' I." *Popular Film.* 5, 6, 1962, p. 33.

1345. Du Zhonghua. "Having a Unique Style, Full of Wit and Humor – Review on Color Animation 'Create Disturbances in Heavenly Palace.'" *Tianjin Daily.* December 19, 1977, p. 3.

1346. Han Shangyi. "'Create Disturbances in Heavenly Palace' To Be Loved by Children." *Wenhui Journal.* June 1, 1979, p. 4.

1347. Han Shangyi. "Praise the Art Treatment of 'Create Disturbances in Heavenly Palace.'" *Shanghai Film* 5, 6, 1962, p. 34.

1348. Huang Shixian. "Roses, Violets and Others – Impressions of Seeing Animation 'Create Disturbances in Heavenly Palace' Again." *People's Daily.* February 1, 1978, p. 3.

1349. Li Shaochun. "Magical, Wonderful and Skillful – See 'Create Disturbances in Heavenly Palace.'" *China Youth Journal.* June 9, 1962, p. 4.

1350. Ma Ke. "Magical Myth World – Talk About Animation 'Create Disturbances in Heavenly Palace.'" *People's Daily.* May 31, 1962, p. 5.

1351. Ou Guanyun. "Gathering Images of 'Create Disturbances in Heavenly Palace' -- Wan Laiming Talks About the Characteristics of Modeling Figures of Zhang Guangyu." *Xinmin Evening Paper.* June 5, 1962, p. 2.

1352. Tang Cheng. "Talk About the Characteristic of Animation from 'Create Disturbances in Heavenly Palace.'" *People's Film.* 2, 3, 1978, p. 28.

1353. "The Thirteenth Karlovy Vary International Film Festival Closed. 'Create Disturbances in Heavenly Palace' Won Short Film Special Award." *Popular Film.* 7, 1962, p. 22.

1354. Xu Suling. "The Artistic Aspects of 'Create Disturbances in Heavenly Palace.'" *People's Daily.* May 31, 1962, p. 2.

"Fat Sister-in-Law"

1355. Lu Heng. "Fat Sister-in-Law and Me." *Popular Film.* 10, 1957, p. 16.

1356. Xiao Hong. "Careless Fat Sister-in-Law" ("Fat Sister-in-Law Back in Parent's Home"). *Popular Film.* 24, 1956, p. 31.

"Ferry"

1357. Fu Xin. "Great Storms Train New People – Impressions of Color Animation 'Ferry.'" *Liberation Daily.* June 26, 1975, p. 3.

1358. Hu Lide. "Moving Images, Distinct Characteristics – Review on Color Animation 'Ferry.'" *Wenhui Journal.* August 19, 1975, p. 4.

"Flame Mountain"

1359. Long Wen. "Brief Talk About 'Flame Mountain.'" *Popular Film.* 7, 1959 p. 14.

1360. Lu Fang. "How We Made 'Flame Mountain.'" *Popular Film.* 7, 1959, p. 15.

"Ginseng Baby"

1361. Cao Maotang. "Talk from the Paper Cut Film 'Ginseng Baby.'" *Shanghai Film.* 7, 1961, p. 24.

1362. Ou Guanyun. "Before the Production of 'Ginseng Baby' – Wan Guchan Talks About the Experience of Paper Cut Film's Creation." *Xinmin Evening Paper.* December 1, 1961, p. 2.

"Golden Wild Goose"

1363. Shi Yongkang. "A Young Hero of the Anti-Restoration Struggle – Review on Color Paper Cut Film "Golden Wild Goose."" *Liberation Daily.* May 21, 1976, p. 3.

1364. Zaxi Danba *et al.* "Sunshine on the Snow, Young Wild Goose Gets Ready for Flight – See Animation 'Golden Wild Goose.'" *People's Film.* 3, 1976, p. 17.

"Heroic Sisters on Grasslands"

1365. Bian Shanji. "Vivid Images, Moving Art: Review on Color Animation 'Heroic Sisters on Grasslands.'" *People's Daily.* March 11, 1966, p. 6.

1366. Liu Yuanzhang and Wang Xilin. "Try Hard To Portray Heroic Images in Mao's Times – Pleased To See Animation 'Heroic Sisters on Grasslands.'" *Liberation Daily.* June 10, 1966, p. 3.

1367. Zhou Qinglin. "Animation Should Serve for Training Successors of Communism – Introduce Color Animation 'Heroic Sisters on Grasslands." *Popular Film.* 6, 1966, p. 26.

"Little Carp Jumps Over The Dragon Gate"

1368. "'Beautiful and Moving Fairy Tales World – Introducing 'Little Carp Jumps Over the Dragon Gate' and Four Other Animations." *Popular Film.* 18, 1959, p. 31.

1369. He Yi. "Be Immersed in the Poetic Sense and Painting Flavor – Jottings on 'Fishing Boy,' 'Little Carp Jumps the Dragon Gate' and other Animations." *Film Art.* 6, 1959, p. 25.

"Little Dull Buddy"

1370. Xie Fei. "Bravo! 'The Little Dull-Buddy.'" *People's Daily.* December 17, 1997.

1371. Xie Fei, Fang Zufeng, Su Zhe, *et al.* "Discussion: Why Children Like 'The Little Dull-Buddy?'" *People's Daily.* June 5, 1998.

"Little Hero"

1372. He Yi. "Try Hard for the Development of Children Film Cause – See Puppet Film 'Little Hero' and Others." *Popular Film.* 22, 1954, p. 12.

1373. Jiang Hui. "First Domestic Color Puppet Film 'Little Hero' Achieved Original Success in Production." *Popular Film.* 14, 1952, p. 13.

1374. Jin Xi. "The Process of Making 'Little Hero,' The First Color Puppet Film Is Born." *Popular Film.* 22, 1954, p. 16.

1375. Yu Suoya. "Precious Beginning – Talk About Color Puppet Film 'Little Hero.'" *Popular Film.* 22, 1954, p. 16.

"Little Soldiers of the Eighth Route Army"

1376. Municipal Folk Art Theater Puppet Troupe. "Try Hard To Portray Heroic Images of Children – Impressions of Color Puppet Film 'Little Soldiers of the Eighth Route Army.'" *Harbin Daily.* April 25, 1974, p. 3.

1377. Pan Guoxiang. "Sunshine, Rain and Dew Make the New Seedlings Strong – Impressions of Color Puppet Film 'Little Soldiers of the Eighth Route Army.'" *Wenhui Journal.* February 26, 1974, p. 3.

1378. Yu Changjiang *et al.* "The Heroic Images of Children's League – Review of Color Puppet Film "Little Soldiers of the Eighth Route Army.'" *Guangming Daily.* March 11, 1974, p. 4.

1379. Yin Ping. "Educator Successors with the Revolutionary Spirits of the Proletarian – Review on Color Puppet Film 'Little Soldiers of the Eighth Route Army.'" *People's Daily.* March 31, 1974, p. 3.

1380. Yuan Chang. "Be Sure Not To Look Down Upon 'Children League' – Impressions of Color Puppet Film "Little Soldiers of the Eighth Route Army.'" *Shenyang Daily.* April 13, 1974, p. 3.

"Little Tadpoles Look For Mother"

1381. Huang Ke. "Pleased To See the First Ink and Wash Animation 'Little Tadpoles Look for Mother.'" *Popular Film.* 24, 1960, p. 22.

1382. "In France, Annecy International Animation Film Festival: 'Little Tadpoles Look For Mother' Won Children's Film Award." *Popular Film.* 7, 1962, p. 22.

1383. Nai Jun. "Wonderful Flowers Blooming in Animation – Jottings of 'Little Tadpoles Look for Mother,' 'Young Swallow,' and Others." *Popular Film.* 12, 1961, p. 8.

1384. Qiu Cao. "Delighted To See 'Little Tadpoles Look For Mother.'" *Shanghai Film.* 1, 1960, p. 20.

"Little Trumpeter" and "Little Sentry of East Sea"

1385. "Animation 'Little Trumpeter' and 'Little Sentry of East Sea' Will Be Released During National Day." *Wenhui Journal.* October 3, 1973, p. 2.

1386. Ar Meng. "Portray Revolutionary Little Heroes from Class Struggle – Impressions of Color Animation 'Little Trumpeter' and 'Little Sentry of East Sea.'" *Zhejiang Daily.* March 29, 1974, p. 3.

1387. Bian Shanji *et al.* "Jottings of Children's Literature and Art Creation – Impressions of Color Animation 'Little Trumpeter' and 'Little Sentry of East Sea.'" *Study and Criticize.* 3, 1973, p. 62.

1388. Bian Shanji. "Two New Flowers of Animation – Review of Color Animation 'Little Trumpeter' and Color Paper Cut Film 'Little Sentry of East Sea.'" *Wenhui Journal.* October 19, 1973, p. 3.

1389. Changsha Chuyi School Red Little Sentry Group. "Pleased To See the Heroic Images of Revolutionary Successors – Impression of Color Paper Cut Film 'Little Sentry of East Sea.'" *Hunan Daily.* December 6, 1973, p. 3.

1390. Chen Sulan *et al.* "Flowers Are All Blooming toward the Sun – Impressions of Color Animation 'Little Trumpeter' and Color Paper Cut Film 'Little Sentry of East Sea.'" *Dazhong Daily.* December 27, 1973, p. 2.

1391. Chen Zhong *et al.* "Violent Storm Tests Young Eagles – Impressions of Color Animation 'Little Trumpeter' and 'Little Sentry of East Sea.'" *Jilin Daily.* November 30, 1973, p. 3.

1392. Chen Zunsan *et al.* "Young Eagles Fly Through the Sky, the Flowers on the Mountains Are Red Toward the Sun – Pleased To See the Color Animation 'Little Trumpeter' and 'Little Sentry of East Sea.'" *Liaoning Daily.* November 23, 1973, p. 3.

1393. He Xuan. "Good Films Are Deeply Loved by Children – Impressions of Color Animation 'Little Trumpeter' and 'Little Sentry of East Sea.'" *Yunnan Daily.* December 29, 1973, p. 3.

1394. Jiang Quan. "Color Pens Sing of Heroes and Paint New Seedlings on Screen – Impressions of Color Animation 'Little Trumpeter' and 'Little Sentry of East Sea.'" *Liberation Daily.* October 29, 1973, p. 3.

1395. Liwan District Children's Home Literature and Art Creation Group. "Try Hard To Portray the Children as Heroic Images of Our Age – Impressions of Color Animation 'Little Trumpeter' and Color Paper Cut Film 'Little Sentry of East Sea.'" *Guangzhou Daily.* November 27, 1973, p. 3.

1396. Lou Guanghua *et al.* "Pleased To See The Two New Flowers of
 Children's Literature and Art -- Impressions of Color Animation 'Little
 Trumpeter' and the Paper Cut Film 'Little Sentry of East Sea.'" *Guizhou
 Daily.* December 27, 1973, p. 3.

1397. Lu Shuchen. "Insist on the Correct Direction of Children's Literature
 and Art Creation -- Review on Color Animation 'Little Trumpeter' and
 'Little Sentry of East Sea.'" *Changjiang Daily.* January 17, 1974, p. 3.

1398. Ren Yulin. "Lifelike Images of Children's Heroes -- Impressions of
 Color Animation 'Little Trumpeter' and Color Paper Cut Film 'Little
 Sentry of East Sea.'" *Xinhua Daily.* November 21, 1973, p. 3.

1399. Wang Jinqin. "Children Love To See and Hear the Good Film --
 Impressions of Color Animation 'Little Trumpeter' and Color Paper Cut
 Film 'Little Sentry of East Sea.'" *People's Daily.* November 17, 1973, p.
 3.

1400. Wang Shuchen *et al.* "Conduct Literature and Art Creation with Party's
 Basic Line -- The Experience of Making the Animation 'Little
 Trumpeter.'" *Wenhui Journal.* December 12, 1973, p. 3.

1401. Wu Chaozhu. "A Good Film To Be Loved by Children -- See Color
 Animation 'Little Trumpeter.'" *Hunan Daily.* December 6, 1973, p. 3.

1402. Xue Ke. "Animation Sings the New Seedlings -- Impressions of Color
 Animation 'Little Trumpeter' and 'Little Sentry of East Sea.'"
 Guangming Daily. December 23, 1973, p. 4.

1403. Zhang Boqing. "Good Teaching Material To Educate Children About
 Class Struggle -- Impressions of Color Animation 'Little Trumpeter' and
 'Little Sentry of East Sea.'" *Beijing Daily.* November 5, 1973, p. 3.

1404. Zhao Zheng *et al.* "Two New Flowers -- Pleased To See the Color
 Animation 'Little Trumpeter' and 'Little Sentry of East Sea.'" *Shanxi
 Daily.* November 23, 1973, p. 3.

1405. Zheng Chuhao. "Two New and Lively Animations -- Impressions of
 Color Animation 'Little Trumpeter' and Color Paper Cut Film 'Little
 Sentry of East Sea.'" *Qinghai Daily.* January 3, 1974, p. 3.

"Long Live Dayuejin"

1406. Cheng Sui. "Delight To See The Animation 'Long Live Dayuejin' and
 'The Stories in Murals.'" *Popular Film.* 1, 1960, p. 12.

1407. Shen Yan. "Describe the Glorious Achievement of General Line with Color Pens, Animation Studio Product Animation 'Long Live Dayuejin.'" *Popular Film.* 22, 1959, p. 26.

"Lotus Lantern"

1408. Li Yin Su. "A Cultural Explanation of Contemporary Animation Art: A Comparative Analysis of Chinese Ghost Story, Mulan, and Lotus Lantern." *Film Art.* No. 3, 2001, pp. 87-90.

1409. Zhan Xin. "New Space for Free Made Sound Creation." *New Films.* September 1999, pp. 48-50.

"Monkey King"

1410. Farquhar, Mary Ann. "Monks and Monkey: A Study of National Style in Chinese Animation." *Animation Journal.* Spring 1993, pp. 4-27.

1411. Gilsdorf, Ethan. "Chinese Animation's Past, Present, and Future: The Monkey King of Shanghai." *Animato!* Winter 1988, pp. 20-23.

"Neza Stirs Up Sea"

1412. Han Shangyi. "A Magical Flower in Art Garden – Appreciate the Artistic Treatment of 'Neza Stirs Up Sea.'" *Liberation Daily.* October 16, 1979, p. 4.

1413. Jia Ming. "Neza on Screen (Color Animation 'Neza Stirs Up Sea')." *Film Stories.* 2, 1979, p. 25.

1414. Jin Jin. "Fascinating Art – Talk About Animation 'Neza Stirs Up Sea.'" *Popular Film.* 11, 1979, p. 9.

1415. Tian Ao *et al.* "Be in Perfect Harmony – See Animation 'Neza Stirs Up Sea.'" *Popular Film.* 9, 1979, p. 14.

"One Shoe"

1416. Bai Xuming. "My Understanding About Traditional Formulations – Talk About the Treatment of Tiger in Puppet Film 'One Shoe.'" *Popular Film.* 6, 5, 1961, p. 34.

1417. Qian Ping. "Tyranny Is Fiercer Than a Tiger" (My Opinion About "One Shoe"). *Popular Film.* 3, 4, 1961, p. 37.

1418. Wang Chaowen. "Tiger Is a 'Man' – Talk from Puppet Film 'One Shoe.'" *People's Daily.* June 21, 1961, p. 7.

1419. Wang Chaowen and Huang Gang. "Our Understanding About Puppet Film 'One Shoe.'" *Popular Film.* 6, 1961, p. 18.

1420. Zhao Futian *et al.* "Can a Tiger Become King?" (Audience's Opinions About Puppet Film "One Shoe.") *Popular Film.* 1961, p. 37.

"Red Cloud Cliffs"

1421. Chen Weibo. "Animation Can Also Reflect Actual Life – See Puppet Film 'Red Cloud Cliffs.'" *Liberation Daily.* October 8, 1963, p. 4.

1422. Sun Yi. "One Successful Try – See Animation 'Red Cloud Cliffs.'" *Popular Film.* 10, 1963, p. 15.

"Section Chief Li Cleverly Baffled Kitchen Squad"

1423. Cheng Yu. " 'Section Chief Li Cleverly Baffled Kitchen Squad.'" *Film Art.* 1, 1966, p. 29.

1424. Ye Jiwen. "Good Content, Skillful Form -- Pleased To See 'Section Chief Li Cleverly Baffled Kitchen Squad.'" *Beijing Evening Paper.* January 12, 1966, p. 3.

"Trial Trip"

1425. Chu Zheng. "New Achievements of Animation's Revolution – Impressions of Color Animation 'Trial Trip.'" *People's Daily.* June 9, 1976, p. 3.

1426. Tang Zugang. "Revolution Does Not Fear Storm – Impressions of Color Animation 'Trial Trip.'" *Liberation Daily.* May 21, 1976, p. 3.

1427. Zhang Wei. "'Gang of Four' Makes Use of 'Trial Trip' for What?' *People's Film.* 11, 1977, p. 25.

"We Love Countryside"

1428. Wang Xuelin. "Good 'Staff Officer' of Audience in 'Countryside.'" *Popular Film.* 1, 1966, p. 25.

1429. Yang Qingsheng. "New Figure, New Ideology and New Content – See Animation 'We Love Countryside' and Others." *Popular Film.* 1, 1966, p. 24.

1430. Zhu Dexing. "Zhang Dazhi and Me. 'We Love Countryside.'" *Popular Film.* 1, 1966, p. 24.

Toys, Games

1431. "Corrupting Forces." *Asiaweek.* April 13, 2001, p. 13.

1432. Greenholdt, Joyce. "Profile: Precision Design Workshop." *Comics Buyer's Guide.* November 15, 1996, p. 84.

1433. Zhao, Bin and Graham Murdock. "Young Pioneers: Children and the Making of Chinese Consumerism." *Cultural Studies.* May 1996, pp. 201-217.

Comics

1434. Bi Keguan. "Yilang Geng Bi Yilang Gao, Manhua Chuangzuode Xin Jieduan." *Fine Art.* No. 4, 1985, p. 18+

1435. *Chinese Drama Comics: Renkanga.* Tokyo: Tabata Shoten, 1974.

1436. "Chinese Edition of Belgian Albums Hits Bookstand." *People's Daily Online.* May 22, 2001.

1437. de Vries, Sjoerd. "Plaatjes van het Dak van de Wereld." *Stripschrift.* No. 192, 1985, pp. 22-29. (Tibet).

1438. Faison, Seth. 'Beijing Journal: If It's a Comic Book, Why Is Nobody Laughing?" *New York Times.* August 17, 1999.

1439. He, Wei. "'Man Hua' Was Born from Manhua Bird." *Guangming Daily* (Beijing). March 26, 1996.

1440. Hodge, Bob and Kam Louie. *The Politics of Chinese Language and Culture.* New York: Routledge, 1998. ("From Cult to Comics: Forms of Circulation in Popular Culture," pp. 133-137).

1441. Johnson, Elizabeth L. *"The People's Comic Book,* Translated from the Chinese by Endymion Wilkinson," *Pacific Affairs.* 47:1 (1974), p. 73.

1442. Liao Yin Tang. "Newspaper and Cartoon Strips." *Cartoon Art Research.* July 24, 2000, p. 3.

1443. Li, Shan. "Also on Manhua Bird." *Guangming Daily* (Beijing). March 26, 1996.

1444. Liu-Lengyel, Hongying. *"Adventures in the Paradise:* The Comic Strip of Ye Qianyu." Paper presented at Association for Asian Studies, Chicago, Illinois, March 13, 1997.

1445. Louie, Yun-ying Belinda and Douglas H. Louie. "Chinese Comics in Transition." *Bookbird.* 33:3-4 (1995), pp. 31+.

1446. Mufson, Steven. "China's 'Soccer Boy' Takes on Foreign Evils." *Washington Post.* October 9, 1996, pp. A31-A32.

1447. Shen, Kuiyi. "Comics, Illustrations, and the Cartoonist in Republican Shanghai." Paper presented at Association for Asian Studies, Chicago, Illinois, March 14, 1997.

1448. Shen, Kuiyi. *"Lianhuanhua* and *Manhua* – Picture Books and Comics in Old Shanghai." In *Illustrating Asia: Comics, Humor Magazines, and Picture Books,* edited by John A. Lent, p. 100-121. Richmond: Curzon Press; Honolulu: University of Hawaii Press, 2001.

1449. "Teachers Dismayed at Prevalence of Western Comics." Agence France Presse release. January 20, 1999.

1450. "Tintin Conquers China." BBC News Online. May 23, 2001.

1451. "Upset at Tintin's 'Chinese Tibet.'" BBC News Online. May 23, 2001.

1452. Yu Wong. "Boy Wonder." *Far Eastern Economic Review.* October 3, 1996, p. 26.

1453. Zhang Leping. *Sanmao the Vagabond Story.* Shanghai: Children's Publishing House, 1995. 250 pp.

"Mr. Wang"

1454. Du Yunzhi. *Zhongguo Dianying Qishi Nian* (Seventy Years of Chinese Film). Taipei: Film Development Foundation, 1986. (Discussion of strip, "Mr. Wang," on pp. 179-180).

1455. Shu Ping. "Cong Lianhua Dao Xiliepian De 'Wang Xiansheng'" ("Mr. Wang": From a Cartoon Strip to Film Series). *Dianying Shijie.* January 1990, p. 30.

Lianhuanhua

1456. Andrews, Julia F. "Literature in Line: Pictures Stories in the People's Republic of China." *Inks.* November 1997, pp. 16-32.

1457. Bai Chunxi, *et al.* "Illustrated History of the Development of Chinese Lianhuanhua." *Lianhuanhua Yishu.* 1(February 1989), pp. 114-129; 12 (April 1989), pp. 77-129.

1458. Chen Guangyi. "The Origin of the Term Lianhuanhua." *Lianhuanhua Yanjiu.* 15:11 (1979), pp. 66-69, 71.

1459. Chen, Guangyi. "Producing *Lianhuanhua* for Most of My Life." *Studies of Lianhuanhua.* 25 (1981), pp. 70-77.

1460. Chen Yiming, Liu Yulian, and Li Bing. "Guanyu Chuangzuo Lianhuanhua *Feng* de Yixie Xiangfa" (Some Thoughts on the Creation of the Picture-Story Book *Maple*). *Fine Art*. No. 1, 1980, pp. 34-35+

1461. He Rong. "Jiang Rensheng Youjiazhide Dongxi Humie Gei Ren Kan – du Lianhuanhua *Feng* He Xiangdaode Yixie Wenti" (Letting Everyone See the Destruction of the Most Important Things in Life – A Few Issues That Spring to Mind After Reading the Picture-story Book *Maple*). *Fine Art*. No. 8, 1979, p. 14 +.

1462. Huang Rougu and Wang Yiqiu. "The Concise History of Shanghai Lianhuanhua." *Shanghai Meishu Tongxun*. 45:12 (1993), pp. 12-23.

1463. Huang Ruogu and Wang Yiqiu "From Gongyili to Taoyuan Road – A Special Distribution System of *Lianhuanhua*." *Lianhuanhua Yishu*. 11:3 (1989), pp. 115-119.

1464. Huang Ruogu and Wang Yiqiu. "It Is the Real Old Brand, Beware of Imitations." *Lianhuanhua Yishu*. 9:1 (1989), pp. 118-122.

1465. Li Song. "Yougong Youwei Zhi Shi, Youzhi Youxin Zhi Ren – Fang *Lianhuanhua Bao* Bianjibu" (A Successful Achievement, Conscientious People – A Visit to the Editorial Offices of The *Picture-Story Book*). *Fine Art*. No. 4, 1981.

1466. Lu Shicheng. "'The Life as a Bedbug' Is Gone Forever." *Studies of Lianhuanhua*. 25 (1981), pp. 91-94.

1467. Lu Shicheng. "A Unique Distribution Network." *Lianhuanhua Yanjiu*. 21 (1981), pp. 27, 51-53.

1468. Shen, Kuiyi. "Comics, Picture Books, and Cartoonists in Republican China." *Inks*. November 1997, pp. 2-15.

1469. Shen, Kuiyi. "Selected Bibliography Related to Lianhuanhua and Manhua." *Inks*. November 1997, pp. 33-35.

1470. "Women dui Lianhuanhua *Feng* de Yijian." *Fine Art*. No. 8, 1979, pp. 33+.

1471. Zhao Erchang. "A Memory about *Lianhuanhua*." *Lianhuanhua Art*. 27:3 (1993), pp. 64-72.

1472. Zhao Hongben. "Producing *Lianhuanhua* for Forty-Seven Years, the Years of 1931-1939." *Studies of Lianhuanhua*. 13 (1978), pp. 55-62.

1473. Zhao Hongben. "Producing *Lianhuanhua* for Forty-Seven Years, the Years 1943-49." *Studies of Lianhuanhua*. 17 (1980), pp. 60-63.

1474. Zhao Jiabi. *An Editor's Memory*. Beijing: Joint Publishers, 1984.

1475. Zhao Jiabi. "Lu Xun and Lianhuanhua." In *Lu Xun on Lianhuanhua,* pp. 44-64. Beijing: People's Art Press, 1982.

1476. Zhao Jiabi. "A Speech at the Celebration Meeting of the Establishment of Shanghai *Lianhuanhua* Society." *Studies of Lianhuanhua.* 25 (1981), pp. 16-22.

1477. Zhu Ghuangyu. "A Memory of My Father Zhu Runzai." In *Selected Lianhuanhua of Zhu Runzai.* Beijing: People's Art Press, 1982.

Political Cartoons

1478. "Caricaturing China's Deng: The Face of Reform." *Newsweek.* September 1, 1986, p. 57.

1479. China Daily Art Staff. *China Daily Newscartoons, 1981-2001.* Beijing: Wu Zhou Communication Press, 2001. 200 pp.

1480. Croizier, Ralph C. "The Thorny Flowers of 1979: Political Cartoons and Liberalization in China." In *China from Mao to Deng: The Politics and Economics of Socialist Development,* edited by *Bulletin of Concerned Asian Scholars,* pp. 29-38. Armonk, New York: M.E. Sharpe, 1983.

1481. Judge, Joan. *Print and Politics: "Shibao" and the Culture of Reform in Late Qing China.* Stanford: Stanford University Press, 1996. 298 pp.

1482. Lengyel, Alfonz. "Protest Art and Socio-Political Cartoons After Mao." In *Facing East/Facing West: North America and the Asia/Pacific Region in the 1990s,* September 13-15, 1990, pp. 387-388. Fetzer Business Development Center, Kalamazoo, Michigan. Kalamazoo: Western Michigan University, 1990.

1483. Szabo, Joe. "A Cartoon Mission Taken Up by the World's Largest Political Apparatus." *WittyWorld.* No. 6, 1996, p. 5.

1484. Zhang Yaoning. *Focus and Plane.* Jersey City, New Jersey: Waymont International, 1995. 176 pp. Preface by Wang Fuyang.

1485. Zhang Yaoning. "Talking Casually." *Zhongguo Manhua.* No. 1, 1999, p. 4.

HONG KONG
Cartoonists and Their Works

1486. Chu, Vivian. "Artist's Brush with Greatness." *South China Morning Post International Weekly.* August 26, 1995, p. 5. (Yim Yee-King).

1487. Lau, Emily. "Monied Friends." *Far Eastern Economic Review.* September 17, 1987, pp. 52-53. (Tony Wong).

Au Yeung, Craig

1488. Au Yeung, Craig. *Love Kills.* Taipei: Classic Communications, 1999.

1489. Cheng, Maria. "Crazy Little Thing Called Love." *Far Eastern Economic Review.* October 21, 1999, pp. 54-55.

Feign, Larry

1490. Barnathan, Joyce. "Hong Kong: Beijing Is Already Muffling the Media." *Business Week.* June 12, 1995, p. 60.

1491. Browning, Michael. "As Era Draws to a Close, American Cartoonist Is Ready To Move on." *Miami Herald.* July 3, 1997.

1492. Chow, Rey. "Larry Feign, Ethnographer of a 'Lifestyle': Political Cartoons from Hong Kong." *Boundary 2.* 24:2 (1997), pp. 21-45.

1493. Danziger, Jeff. "Beijing and Its Rulers Lack a Sense of Humor." *Christian Science Monitor.* June 21, 1995.

1494. Edwards, Bob. "Comic View of Hong Kong." National Public Radio's Morning Edition, June 26, 1997.

1495. Feign, Larry. *Aieeyaaa! I'm Pregnant!* Hong Kong: Hambalan Press, 1996, 200 pp.

1496. Feign, Larry. *Banned in Hong Kong.* Hong Kong: Hambalan Press, 1995.

1497. Feign, Larry. *Fong's Aieeyaaa, Not Again.* Hong Kong: Hong Kong Standard, 1987. 113 pp.

1498. Feign, Larry. *Hong Kong Fairy Tales.* Hong Kong: Hambalan Press, 1994. 232 pp.

1499. Feign, Larry. *Let's All Shut Up and Make Money!* Hong Kong: Hambalan Press, 1997. 108 pp.

1500. Feign, Larry. *The World of Lily Wong. A Far-Eastern Cross-Cultural Cartoon Love Story.* Hong Kong: Hambalan Press, 1993. 129 pp.

1501. "Feigning Poverty." *Far Eastern Economic Review.* June 1, 1995, p. 12.

1502. "Feign Wins Award." *Editor & Publisher.* June 29, 1996, p. 42. Also see, July 22, 1995, p. 34.

1503. Fenby, Jonathan. "Mr. Feign and the Hong Kong Press." *The Independent.* (London). March 24, 1997, p. 16.

1504. "Hong Kong." *Human Rights Watch/Asia.* November 1995, pp. 23-24.

1505. [Larry Feign]. *Asahi Shimbun Weekly.* June 26, 1966, p. 66.

1506. [Larry Feign]. *Next Magazine* (Hong Kong). May 26, 1995, pp. 78-79.

1507. [Larry Feign]. *Tin Tin Daily News.* May 24, 1995.

1508. [Larry Feign]. *Weekendarisen* (Denmark). July 20, 1995.

1509. Lent, John A. "Hong Kong Tolerance Watch." *Comics Journal.* August 1995, pp. 28-29.

1510. Levenson, Claude. "La Foire des Organes en China." *L'Hebdo.* June 15, 1995, p. 33.

1511. McGeean, Ed. "Ink Blots." *CAPS.* October 1995, pp. 6-7.

1512. Mirsky, Jonathan. "Anti-Peking Cartoonist Erased from Payroll." *London Times.* May 22, 1995.

1513. Moyes, Jojo. "No Holds Barred in Cartoon Swan Song." *The Independent.* March 24, 1997.

1514. Rogers, V. Cullum. "The Incredible Shrinking Job Market." *Hogan's Alley.* No. 3, 1996, pp. 22-26.

1515. Spaeth, Anothony. "Already a Puppet Regime?' *Time* (*International*). July 10, 1995, pp. 18-19.

1516. Szabo, Joe. "Hong Kong Cartoonist's Joke Proves Fatal to His Strip." *WittyWorld.* Summer/Autumn 1995, p. 5.

1517. "Wer Zuletzt Lacht ..." *Focus* (Germany). 22/1995, p. 286.

1518. Weyler, Martin Vander. "We Were Reluctant To Rig Elections." *The Spectator.* June 3, 1995, pp. 12-14. Letters in June 10, 1995 issue.

"The World of Lily Wong"

1519. "Anti-Peking-Cartoon Eingestellt." *Der Spiegel.* Undated (ca. May 24, 1995).

1520. Canals, Francesc. "Entre el Cielo y el Infierno." *La Vanguardia.* June 18, 1995, p. 12.

1521. "Censor Fear on Cartoon." *Sydney Herald Sun.* May 24, 1995, p. 35.

1522. "The End of Lily Wong." *TV and Entertainment Times.* May 29 – June 4, 1995.

1523. Farley, Maggie. "Comic Stripped from Hong Kong Paper." *Los Angeles Times.* May 27, 1995, p. A-2.

1524. Fenby, Jonathan. "Strip Off." *The Guardian.* June 7, 1995.

1525. Field, Catherine. "Wong Decision Robs Hong Kong of Humour." *The Guardian.* May 23, 1995.

1526. Field, Catherine. "Wong Decision Strips Hong Kong of Humour." *Guardian Weekly.* May 28, 1995.

1527. Fitzpatrick, Liam. "Strip Off the Old Block." *Eastern Express* (Hong Kong). August 5-6, 1995.

1528. Gargan, Edward A. "China's Cloud Over Hong Kong: Is '97 Here?" *New York Times.* July 5, 1995, pp. A-1, A-6.

1529. Hagerty, Bob. "'Lily Wong' Is Sent Packing After Barb Tossed at Beijing." *Asian Wall Street Journal.* May 23, 1995, p. 12.

1530. Holberton, Simon. "Hong Kong Lily Killed Off." *Financial Times* (London). May 23, 1995.

1531. "Hong Kong Strip Is Popular on the Web." *Editor & Publisher.* September 16, 1995, p. 41.

1532. "Hong Kong: The Demise of Lily Wong." *Newsweek* (Asia-Pacific). June 5, 1995.

1533. Hutchings, Graham. "End of Lily Wong's World Sparks Hong Kong Censorship Row." *The Daily Telegraph* (London). May 23, 1995. Also in: *Los Angeles Times,* May 26.

1534. Karp, Jonathan. "Post-Mortem: Hong Kong Daily Cuts Popular Cartoon, 25 Staffers." *Far Eastern Economic Review.* June 8, 1995, pp. 50-51.

1535. "Lily's Back – With a Vengeance." *Asiaweek.* May 19, 2000, p. 45.

1536. "Lily Wong er Død." *Politiken Vørdag* (Denmark). June 10, 1995.

1537. McGurn, William. "Cyberspace: Net Assets." *Far Eastern Economic Review.* July 27, 1995, pp. 68-70.

1538. Manthorpe, Jonathan. "Disappearance of 'Famous Lady' Increases Jitters in Hong Kong." *The Vancouver Sun.* May 30, 1995, p. A9.

1539. Mitchell, Mark. "Hong Kong/ Lily." *Far Eastern Economic Review.* June 8, 2000, p. 15.

1540. "Mystery Death of Lily Wong." *Comics Journal.* July 1995, p. 30.

1541. Palou, Jordi. "Taurons a Hong Kong." *Avui* (Barcelona). August 5, 1995, p. C-4.

1542. "Philippines To Protest Comic Strip in Malaysian Paper." *Philippine Sunday Inquirer.* May 26, 1996.

1543. "Selbstzensur in Hong Konger Zeitung aus Furchtvor Peking: Die Wunderbare Lily Wongmußschweiger." *Tageszeitung.* May 24, 1995.

1544. Seno, Alexandra A. "Lily Wong: Alive in London." *Asiaweek.* April 4, 1997, p. 41.

1545. "Unbequemer Strip." *Comic!* December 1995, p. 4.

1546. Vines, Stephen. "China Fails To See the Funny Side." *The Independent on Sunday* (London). May 28, 1995.

1547. Vines, Stephen. "Mystery Death of Lily Wong." *The Independent.* May 23, 1995.

1548. Vittachi, Nury. "My Fair Lily." *Far Eastern Economic Review.* September 25, 1997, p. 138.

1549. "Where to Now, Lily Wong?" *Asian Advertising and Marketing.* June 2, 1995, p. 1.

Zunzi (Kwan Wong Kee)

1550. "Caught With His Pants Down." *Asiaweek.* February 9, 2001, p. 49.

1551. "Zunzi" (Kwan Wong Kee). *Cartoonist PROfiles.* June 1986, p. 73.

Animation

1552. Chu, D. and B. McIntyre. "Sex Role Stereotypes on Children's TV in Asia: A Content Analysis of Gender Role Portrayals in Children's Cartoons in Hong Kong." *Communication Research Reports.* 12:2 (1995), pp. 206-219.

1553. Hansen, Jeremy. "Absence of Magic: Digital Animation Requires Blood, Sweat and Dollars." *Asiaweek.* April 27, 2001, p. 41.

1554. Hansen, Jeremy. "Digital House Picks up Feature 'Brush.'" *Variety.* April 16-22, 2001, p. 47.

1555. Hu, Gigi. "The 'Art' Movement Between Frames in Hong Kong Animation." In *Animation in Asia and the Pacific,* edited by John A. Lent, pp. 105-120. Sydney: John Libbey & Co., 2001.

1556. Hu, Gigi. "The 21st Hong Kong Film Festival." *Animation World.* May 1997, 3 pp.

1557. "Kowloon Kitty." *Manga Max.* January 2000, p. 8. ("Shen Mue").

1558. McGill, Peter. "Hong Kong Flirts with the Magical Lure of Mickey Mouse." *Asahi Evening News.* March 7, 1999, pp. 1-2.

1559. "Red Snow." *Manga Max.* December 1999, p. 4.

"A Chinese Ghost Story"

1560. Granitsas, Alkman. "A Chinese Fairy Tale." *Far Eastern Economic Review.* July 27, 2000, pp. 70-71.

1561. Hu, Gigi. "A Chinese Ghost Story." *Society for Animation Studies Newsletter.* Spring/Summer 1997, p. 3.

1562. Hu, Gigi. "Review: A Chinese Ghost Story." *Animation Journal.* Spring 1998, p. 92.

1563. Macias, Patrick. "A Chinese Ghost Story: The Tsui Hark Animation." *Animerica.* 7:3 (1999), pp. 14-15.

1564. Macias, Patrick. "Tsui Hark." *Animerica.* 7:10 (1999), pp. 8-9. 35-37.

1565. Wood, Miles. "Ghost Writing." *Manga Max.* January 2000, pp. 46-49.

"Hello Kitty"

1566. Au-yeung, Karvin. "Hello Kitty Enters the World of PCs and She Does Have Her Good Points; Black Coat Hides Weak Miaow." *South China Morning Post.* January 20, 2000, p. 12.

1567. "H.K. Launch Set for Hello Kitty Personal Computer." Japan Economic Newswire, January 10, 2000.

1568. "Kitty Bares Her Clause." *Asiaweek.* June 15, 2001, p. 8.

"Teenage Mutant Ninja Turtles"

1569. Gerrie, David. "Turtle Hero Worship." *Marketing.* June 14, 1990, pp. 28-29.

1570. Lewis, George H. "From Common Dullness to Fleeting Wonder: The Manipulation of Cultural Meaning in the Teenage Mutant Ninja Turtles Saga." *Journal of Popular Culture.* Fall 1991.

1571. "Teenage Mutant Ninja Burgers: Bringing Cartoon Characters to the Dinner Table." *Leisure Management.* 16:11 (1996), p. 56.

Theme Parks

1572. Beveridge, Dirk. "Disneyland Planned for Hong Kong; Government To Put Up." *Washington Post.* November 2, 1999, p. E3.

1573. Chung, Yulanda. "Making a Magic Kingdom." *Asiaweek.* November 12, 1999, pp. 52-55.

1574. Cordingley, Peter. "Donald and Mickey." *Asiaweek.* March 12, 1999, pp. 44-45.

1575. "Fantasyland Stock Rally." *Asiaweek.* March 19, 1999, p. 59.

1576. Gilley, Bruce. "Mighty Mouse: Disney Drives a Hard Bargain Over Hong Kong Park." *Far Eastern Economic Review.* August 12, 1999, p. 27.

1577. Gilley, Bruce and Joanna Slater. "Aieeyaaa! A Mouse." *Far Eastern Economic Review.* November 11, 1999, pp. 50-51.

1578. "'I Think It's a Balanced Deal.'" *Asiaweek.* November 12, 1999, p. 54.

1579. Laris, Michael. "The Magic of Mickey: Hong Kong's Turnaround Tied to Disneyland Plan." Albany, New York *Times Union.* June 18, 1999, p. D3.

1580. Lee, Carrie. "Disney Craze Sweeps Hong Kong." Reuters dispatch, December 23, 1999.

1581. "Not a New Theme, This Park." *Far Eastern Economic Review.* November 18, 1999, p. 90.

1582. Sullivan, Maureen. "Disney's Park May Give Tourism Industry a Much Needed Boost." *Variety.* December 6-12, 1999, p. A-40.

1583. "Who's Hyping Mickey?" *Asiaweek.* February 5, 1999, p. 8.

Comic Books

1584. Allen, Henry. "Comic Books: Ninja Turtles Take Hard-Shell Approach." *Detroit News.* November 30, 1999.

1585. Cheng, Maria. "Tung-in-Cheek Winner: Hong Kong's Gaffe-Prone Chief Executive Inspires a Hit Comic Book." *Asiaweek.* August 18-25, 2000, pp. 118-119.

1586. Chung, Steven. "Land in Zicht—Hong Kong." *Stripschrift.* February 2001, p. 21.

1587. Clements, Jonathan. "Hong Kong Comics, The Second Wave." *Anime FX.* February 1996, pp. 18-21.

1588. Clements, Jonathan. "Riders on the Storm II." *Manga Max.* March 1999, pp. 59-62.

1589. "Click-On Comics." *Far Eastern Economic Review.* June 1, 2000, p. 38.

1590. "Comic Mocks Chinese Leaders over 1989 Crackdown." Reuters release, April 17, 2001.

1591. Dean du Mars, Roger. "Shh…It's Not for Everyone." *Asiaweek.* April 20, 2001, p. 14.

1592. Doran, Michael and Matthew Brady. "Scouting About Image." *Comics Buyer's Guide.* December 18, 1998, p. 8.

1593. "Heroic Bloodshed." *Manga Max.* March 1999, p. 57.

1594. "HK Advertisers Turn to Comic Books." *Asian Mass Communications Bulletin.* May/June 1999, p. 13.

1595. "Hong Kong Comic Expo." *Comics International.* January 1998, p. 29.

1596. Lee, Alan. "Comics Craze Has Long and Colourful History." *Sunday Morning Post* (Hong Kong). April 8, 2001, p. 14.

1597. Lee, Alan. "Comics More Than Just a Laughing Matter." *Sunday Morning Post* (Hong Kong). April 15, 2001, p. 14.

1598. "Not Manga …Man-hwa!" *Manga Max.* May 1999, p. 25.

1599. Roberts, Paul D. "Report from Hong Kong." *Comics International.* October 1998, pp. 43-44.

1600. "SpaceLord." *Manga Max.* January 1999, p. 7.

1601. Taylor, Sally A. "Serious 657Business – and Comics Galore – at Hong Kong Fair." *Publishers Weekly.* August 7, 1995, p. 303.

1602. Wong, Wendy Siuyi. "The Emerging Image of the Modern Woman in Hong Kong Comics of the 1960s & 1970s." *International Journal of Comic Art.* Fall 2000, pp. 33-53.

1603. Wong, Wendy Siuyi and Lisa M. Cuklanz. "Humor and Gender Politics: A Textual Analysis of the First Feminist Comic in Hong Kong." In *Comics & Ideology,* edited by Matthew P. McAllister, Edward Sewell, Jr., and Ian Gordon, pp. 69-98. New York: Peter Lang, 2001.

1604. Wong, Wendy Siuyi and Waipong Yeung. *An Illustrated History of Hong Kong Comics.* Hong Kong: Luck-Win Book Store, 1999. 200 pp.

Jackie Chan Comics and Animation

1605. "Activision Acquires Jackie Chan." Coremagazine.com. May 11, 2001.

1606. "A Big-Time Action Hero Is Cut Down to Size." *Newsweek.* October 2, 2000. (Jackie Chan Adventures).

1607. Byrne, Bridget. "A Real Cutup: Jackie Chan Packs Fun and Adventure." *Washington Post.* March 9, 2001, p. C11.

1608. [Jackie Chan Comics]. In *Jackie Chan Inside the Dragon,* edited by Clyde Gentry III, p. 175. Dallas: Taylor, 1997.

1609. Hunt, Dennis. "'Adventure' Series Is Like Chan's Movies, Only for Kids." *USA Today.* October 13, 2000, p. 11E.

1610. Witterstaetter, Reñee. *Dying for Action. The Life and Films of Jackie Chan.* New York: Warner Books, 1997. "Comics Preview," pp. 47-53.

Political Cartoons

1611. Hutcheon, Robin. *SCMP: The First Eighty Years.* Hong Kong: *South China Morning Post,* 1983. (Cartoons, pp. 111, 159).

1612. Kwong, Kevin. "Tung in Cheek." *Index on Censorship.* 6/2000, pp. 45-47.

INDIA
General Sources

1613. Beach, Milo Cleveland and Stuart Clay Welch. *Gods, Thrones, and Peacocks.* New York: Asia Society, 1965.

1614. Bhattacharyya, Narendra Nath. *History of Indian Erotic Literature.* New Delhi: Munshiram Manoharlal, 1975. 135 pp.

1615. Ferro-Luzzi, Gabriella E. *The Taste of Laughter: Aspects of Tamil Humour.* Wiesbaden: Otto Harrassowitz, 1992. 218 pp.

1616. Greenberger, A.J. *The British Image of India.* London: 1969.

1617. Maity, Pradyot K. "Folk Entertainment and the Role of the Patuas." *Folklore.* 13, 12 (1972), pp. 484-488.

1618. Mitton, Roger. "India: The Media Factor" *Asiaweek.* August 11, 2000, pp. 44-45.

1619. Sequeira, Isaac. *Popular Culture: East and West.* New Delhi: R.B. Publishing Corporation, 1991.

1620. Siegel, Lee. "Why Did the Child Laugh? The Comic in Indian Traditions." *Asian Art and Culture.* Fall 1994, pp. 66-75.

1621. Singh, Ramindar. "Comic Art" (Editorial). *Times of India.* n.d., 1996.

1622. Srinivasan, Sumitra Kumar. "Ajanta Rediscovered Through the Magic Lens." *The Hindu.* June 27, 1993, p. xii.

Artistic Aspects

1623. Goswamy, Brijindra Nath. *Rasa, Les Neufs Visages de L'Art Indien.* Paris: Grand Palais, 1989. English-language catalogue of this exhibition published as *Essence of Indian Art,* San Francisco: Asian Art Museum, 1986.

1624. Guha-Thakurta, T. The Making of New "Indian" Art: Artists, Aesthetics and Nationalism in Bengal, c. 1850-1920. Cambridge: Cambridge University Press, 1922.

1625. Khanna, Balraj. *Kalighat: Indian Popular Painting 1800-1930.* Boston: Shambhala Redstone Editions, 1993. Unpaginated.

1626. Mitter, Partha. *Art and Nationalism in Colonial India: Occidental Orientations.* Cambridge: Cambridge University Press, 1994.

1627. Rao, Aruna. "Immortal Picture-Stories: Comic Art in Early Indian Art." In *Asian Popular Culture,* edited by John A. Lent, pp. 159-174. Boulder, Colorado. Westview, 1995.

1628. Rossi, Barbara. *From the Cream of Painting: India's Popular Paintings 1589 to the Present.* Oxford and New York: Oxford University Press, 1998. 295 pp.

1629. Sen Gupta, Sankar, ed. *The Patas and the Patuas of Bengal.* Calcutta: Indian Publications, 1973.

1630. Welch, Stuart Clay. *India: Art and Culture, 1300-1900.* New York and Ahmedabad: Metropolitan Museum of Art; Holt, Rinehart and Winston, 1985, 1988.

1631. Welch, Stuart Clay. "A Matter of Empathy: Comical Indian Pictures." *Asian Art and Culture.* Fall 1994, pp. 76-103.

Cartooning, Cartoons

1632. "Animated India ...Fifty Years On." *Action.* October 1997, p. 3.

1633. Bhattacharya, Sanwana. "Funny World." *Indian Express.* July 28, 1996.

1634. "Cartoon As Commentary." In *The Press in India: A New History,* by G. N. S. Raghavan, pp. 165-172. New Delhi: Gyan Publishing House, 1974.

1635. "Cartoons on Ghandi." *Vidura.* January – March 1998, pp. 25-29.

1636. Chandhry, Vibha. "Kissa Kartoon Ka." *Dharmyug.* August 16-31, 1993, p. 11.

1637. "Hagars Seek Humour in the Horrible." *The Statesman.* April 2, 1995.

1638. Mitter, Partha. "Cartoons of the Raj." *History Today.* September 1997, p. 16 (6).

1639. "News from India." *FECO News.* No. 22, 1997, p. 24.

1640. Sahay, K. N. *Anthropological Study of Cartoons in India.* New Delhi: Commonwealth Publishers, 1998. 304 pp.

1641. Saltuk, Kerem. "Hindistan ve Karikatür." *Karikatürk.* No. 70, 2000, p. 5.

1642. Singh, Jyotsna. "India's Cartoon Cricketers: Cricket Has a Fanatic Following in India." BBC News Online. May 28, 2001.

Cartoonists and Their Works

1643. Anshumali. "Bhashai Kartoonists KoDoyem Daje Ke Kyo Mana Jata Hai?" *Dharmyug.* August 16-31, 1993, p. 23.

1644. Hosabettu, Vasantha. "International Opportunities Galore for Cartoonists." *Sudha Kannada Weekly.* March 19, 1995, pp. 68-70.

1645. *Madan Jokes II.* Madras: Ananda Vikatan, 1993. 144 pp.

1646. Pai, Anant. "Indian Cartoonist Conference." *Foreign Comic Reviews.* No. 3, 1973, p. 16.

1647. Panneerselvan, A.S. "Government-Wrecker." *Asiaweek.* May 7, 1999, p. 31. (Cho Ramaswamy).

1648. Pavan. "Cartoonist Ban ne see Purv Achcha Admi Bano: Rajendra (Cartoonist Rajendra Se Batchit)." *Prabhat-Khabar, Patrika.* June 13, 1993, p. 8.

1649. Sahgal, Rakesh. "Drawing My Own Conclusions." *Times of India.* December 5, 1993.

1650. Sen, Jayanti. *The Art of Satyajit Ray.* Calcutta: Oxford Bookstore-Gallery, 1995.

1651. Subnis, Vikas. "A Real Master of the Brush." *Times of India.* January 23, 1997, p. 5.

1652. Tagore, Sundaram. "The Story of a Jagged Line: The Art of M. F. Husain." *Art AsiaPacific.* No. 19, 1998, pp. 52-59.

1653. "This Is It (A Bellyful of Laughter of Sudhir Dar)." *Vikas News.* August 1976, p. 1.

1654. Vyas, Awadhesh. "Mujhe Nahi Pata Mai Kya Hun (Mario Miranda Se Batchit)." *Dharmyug.* August 16-31, 1993, p. 18.

Laxman, R.K.

1655. Dwivedi, Sudarshna. "Pata Nahi Mai Kaise Kartoonist Ban Gaya (R.K. Laksman Se Batchit). " *Dharmyug.* August 16-31, 1993, p. 15.

1656. Jakimowicz-Karie, Marta. "Sage in a Clown's Garb." *Deccan Herald.* June 11, 1995, p. 2.

1657. Laxman, R. K. *The Best of Laxman.* New Delhi: Penguin Books, 1994. 225pp.

1658. Laxman, R.K. "Pot Shots at a Range of Human Frailties." *Times of India.* March 7, 1996.

1659. Laxman, R. K. *The Tunnel of Time: An Autobiography.* New Delhi: Viking Penguin Books, 1998. 236 pp.

1660. Rajadhyaksha, Radha. "The Uncommon Man." *Times of India.* June 30, 1996.

1661. "A Very Unusual 'Common Man': R. K. Laxman." In *Shooting from the Hip,* by Shobha Dé, pp. 54-57. New Delhi: UBSPD, 1994.

Pai, Anant

1662. [Anant Pai]. *Sandesh.* June 4, 1994.

1663. "'Uncle Pai' Delights Children." *Free Press Journal.* June 21, 1994.

1664. "Uncle Pai, Tantri the Mantri, Shikhari Shambu and Raja Hooja Will Be at Crossword on Sunday." *Sunday Mid-Day.* June 19, 1994.

Phadnis, Shivram D.

1665. Athale, Gouri Agtey. "Laughing All the Way." *Indian Express.* September 12, 1993.

1666. Phadnis, S. D. *Laughing Gallery.* Pune: Studio S. Phadnis, 1969, 1982, 1994. 104 pp.

1667. Phadnis, S. D. *Miskil Gallery – Collection of New Cartoon, Some with Marathi Titles.* Pune: Utkarsha Prakashan, n.d.

Shankar (K. Shankar Pillai)

1668. Dutt, Balbir. "Shankar, Meri Bhi Lihaj Mat Karna." *Samshmarananjali.* December 28, 1989, 2nd Part, p. 7.

1669. Narayan, S. Venkat. "Doyen of Indian Cartoonists Is 69." *Illustrated Weekly of India.* August 1, 1971, pp. 40-41.

Thackeray, Bal

1670. "Bombay Is Rumbling." *Asiaweek.* August 4, 2000, p. 18.

1671. Dwivedi, Sudarshna. "Maine Apne Peshe Se Rajniti Ko Samjha Hai (Bal Thackeray Se Batchit)." *Dharmyug.* August 16-30, 1993, p. 18.

1672. "The 'I' of the Storm: 'I Will Fight to the Finish.'" *Times of India.* January 23, 1997, p. 2.

1673. Joshi, Manohar. "Thackeray Does Not Believe in Caste Politics." *Times of India.* January 23, 1997, p. 3.

Animation

1674. "Action on the Indian Front." *Animation.* No. 16, 1998, pp. 57-58.

1675. Aggrawal, B. C. *Television Expansion and the Indian Child: A Historical Perspective on Television and the Indian Child: A Handbook.* New Delhi: Unicef, 1987.

1676. Aghi, M. "Children and Television: The What and How." *Eve's Weekly.* (Mumbai). February 16-22, 1980, p. 2.

1677. Beardmore, Marie. "India: Branching Out." *Animation.* September 1998, pp. 28, 30.

1678. "Behind the Curtains of Indian Animation." *Animation World.* November 1999, 4 pp.

1679. Collins, Keith. "Disney's Beachhead." *Variety.* June 12-18, 1995, pp. 44, 46.

1680. Deneroff, Harvey. "The Week with the Masters Animation Celebration: Notes from India." *Animatoon.* No. 28, 2000, pp. 20-27.

1681. De Sarkar, Bishakha. "How Kerala Keeps in Toon." *The Telegraph* (Calcutta). July 7, 1995.

1682. Dhume, Sadanand. "Hello Hollywood." *Far Eastern Economic Review.* January 13, 2000, pp. 67-68.

1683. Eashwer, Lalita. "A Report on Children's Television Programmes in India." In *Growing Up With Television: Asian Children's Experience,* edited by Anura Goonasekera, pp. 48-123. Singapore: Asian Media Information and Communication Centre, 2000.

1684. "Film Roman Says Pentamedia Deal Meets Problem." Reuters release, April 7, 2001.

1685. "First Animation School To Open in India." *Animation.* April 2001, p. 84.

1686. Gelman, Morrie. "Station X." *Animation.* November 2000, pp. 52, 56.

1687. "India's Body Shops Go Shopping." *Asiaweek.* April 27, 2001, p. 43.

1688. "Kids-Only Channels Set To Grow in India." *Asian Mass Communications Bulletin.* November-December 1999, p. 13.

1689. Lahiri, Indrajit. "Beyond Indian Shores." *Asia Image.* October 2000, pp. 24, 26.

1690. Lahiri, Indrajit. "Indian Epic Made in Japan." *Television Asia.* July/August 1996, pp. 28-29.

1691. Mathur, Arti. "TNT & Cartoon Network To Speak Hindi in India." *Daily Variety.* October 16, 1998, p. 34.

1692. Sen, Jayanti. "India's Expanding Animation Horizons." *Animation World.* December 1999, 6 pp.

1693. Sen, Jayanti. "India's Expanding Animation Horizons." *Animation World.* February 2000, 10 pp.

1694. Sen, Jayanti. "India's Growing Might." *Animation World.* October 1999, 13 pp.

1695. Sen, Jayanti. "The Neglected Queen of Indian Animation." *Animation World.* October 1999, 3 pp.

1696. Seno, Alexandra A. and Roger Mitton. "Toy Story Too? Bit by Byte, Shyam Ramanna Is Building India's Rep as a Computer Animation Superpower." *Asiaweek.* April 27, 2001, pp. 38-40, 42-44, 46.

1697. Thakur, B.S. and Binod C. Agrawal, eds. *Media Utilization for the Development of Women and Children.* New Delhi: Concept Publishing, 1989. 169 pp. (Includes: Mira B. Aghi. "Children's Television," pp. 51-54; Rina Gill, "Television for Children," pp. 37-49).

Mohan, Ram

1698. Lent, John A. "Ram Mohan and RM-USL: India's Change Agents of Animation." *Animation World.* August 1998.

1699. "On a Desert Island With . . . Asian Animators (Ram Mohan and Frank Saperstein)." *Animation World.* August 1998.

Toonz Animation

1700. "ASIFA Opens First Indian Chapter at Toonz." *ASIFA News.* 14:1 (2001), p. 5.

1701. Deneroff, Harvey. "Toonz, Elephants and Paradise." *Animation.* June 2001, pp. 14-15.

1702. "Derek Lamb and Jeff Hale Team Up With Toonz Animation India To Create a Comic Animated Short." *ASIFA San Francisco.* October 2000, p. 5.

1703. Mathur, Arti. "India Toon House Opens, Preps First Pic." *Daily Variety.* October 23, 1998, p. 6.

1704. "Toonz Animation India." *Animation.* August 1999, p. 90.

1705. "Toonz Animation India Pvt. Is Opening Soon." *ASIFA San Francisco.* July/August 1999, p. 5.

Comic Books

1706. Babb, Lawrence A. "Introduction." In *Media and the Transformation of Religion in South Asia,* edited by Lawrence A. Babb and Susan S. Wadley, pp. 1-20. Philadelphia: University of Pennsylvania Press, 1995.

1707. Bhade, Abhijit. "Where Has Sad Sack Gone?" *Island.* May 1993, pp. 38-39.

1708. Blackwell, Fritz. "Options in Teaching the Mahabharata." *Education about Asia.* Winter 1999, pp. 10-16.

1709. Dey, Sudipto. "RRIs Plan To Relaunch Comic Book Heroes." *Economictimes.Com.* April 25, 2001. (US animated superheroes in India).

1710. *Grassroots Comics From India.* Vantaa, Finland: World Comics-Finland, 2000. 28 pp.

1711. Luyten, Sónia. "Bandas Desenhadas: O Novo Tesouro da India." In *Catálogo.* 9^0 *Festival Internacional de Banda Desenhada, Amadora 98. [Cinemamação],* p. 12. Amadora, Portugal: Cãmara Municipal da Amadora, 1998.

1712. Packalén, Leif. *Comics for Social Change: A Report from a Workshop in Tamil Nadu, India, October 6-11, 1998.* Vantaa, Finland: World Comics, 1998, 12 pp.

1713. Packalén, Leif. "Comics Power in India: Report on the Cartoon/Comics for Social Change- Workshop in Karasanoor, Tamil Nadu, 16-20.9.97." Vantaa, Finland: Comics Power!, 1997. 8pp.

1714. Packalén, Leif and Katja Tukiainen. *Grassroots Comics in Tamil Nadu, 2000.* Vantaa, Finland: World Comics-Finland, 2000. 12 pp.

1715. Padmanabhan, Manjula. "The Serious Side of Comix." *The Pioneer* (Delhi). July 17, 1995.

1716. Pai, Anant. "Comic Books in India." *Foreign Comic Reviews.* No. 3, 1973, p. 16.

1717. Pai, Anant. "Comics as a Vehicle of Education and Culture." *Indian Horizons.* 44:2 (1995), p. 107.

1718. Ramnarayan, Gowri. "Great Children's Books . . . Alas, Still a Fairytale." *Hinduism Today.* April 1995, pp. 1, 14.

1719. Rao, Aruna. "Bahadur the Dacoit-Hunter, Dora the Terror of Terrorists, and Other Stories: How Indian Comics Represent Events from 1970-

1990." Paper presented at Mid-Atlantic Region/ Association for Asian Studies, Towson, Maryland, October 21, 1995.

1720. Rao, Aruna. "From Dynamite to Parmanu: The Many Incarnations of the Indian Comic Book Superhero." Paper presented at Popular Culture Association, San Antonio, Texas, March 28, 1997.

1721. Rao, Aruna. "From Self-Knowledge to Super Heroes: The Story of Indian Comics." In *Illustrating Asia: Comics, Humor Magazines, and Picture Books,* edited by John A. Lent, pp. 37-63. Richmond: Curzon Press; Honolulu: University of Hawaii Press, 2001.

1722. Rao, Aruna. "From Self-Knowledge to Superheroes: The Story of Indian Comics." Paper presented at Association for Asian Studies, Chicago, Illinois, March 13, 1997.

1723. Rao, Aruna "Goddess/Demon, Warrior/Victim: Representations of Women in Indian Comics." In *Themes and Issues in Asian Cartooning: Cute, Cheap, Mad and Sexy,* edited by John A. Lent, pp. 165-182. Bowling Green, Ohio: Popular Press, 1999.

1724. Rao, Aruna. "National Identity and Comics in India." Paper presented at Popular Culture Association, Philadelphia, Pennsylvania, April 12, 1995.

1725. Rao, Aruna. "Nymphs, Nawabs and Nationalism: Myth and History in Indian Comics." *Journal of Asian Pacific Communication.* 7: 1/ 2 (1996), pp. 31-44.

1726. Rao, M. "Children's Books in India" (including comics). Paper presented at Conference on Children's Literature in the Service of International Understanding and Peaceful Cooperation, Tehran, Iran, May 1975.

1727. Ray, Sandip. "Comics Are Wow!" *The Statesman.* February 2, 1991, "Saturday Statesman" section, pp. 1, 8.

1728. Ruy, José. "À Descoberta da Índia." In *Catálogo. 9° Festival Internacional de Banda Desenhada, Amadora 98 [Cinemanimação],* p.13. Amadora, Portugal: Câmara Municipal da Amadora, 1998.

1729. "South India Awash with Comics." *Asian Mass Communications Bulletin.* May/June 2000, p. 7.

1730. Zielinski, C. "Publishing for the Grass Roots: A Comic Book on Immunization." *World Health Forum.* 7:3 (1986), pp. 273-277.

Amar Chitra Katha

1731. Hawley, John S. "The Saints Subdued: Domestic Virtue and National Integration in *Amar Chitra Katha.*" In *Media and the Transformation of Religion in South Asia,* edited by Lawrence A. Babb and Susan S. Wadley, pp. 107-136. Philadelphia: University of Pennsylvania Press, 1995.

1732. Kavitha K. "Comic Release." *Deccan Herald.* May 20, 1995, "Open Sesame" Section, p. 1.

1733. McCarthy, Brenda. "Amar Chitra! Zoom! Zoom! Zoom!" *Revolver* (U. K.). October 1990.

1734. Pritchett, Frances W. "The World of *Amar Chitra Katha.*" In *Media and the Transformation of Religion in South Asia,* edited by Lawrence A. Babb and Susan S. Wadley, pp. 76-106. Philadelphia: University of Pennsylvania Press, 1995.

1735. Thomas, Maya M. "Picture Perfect." *Deccan Herald.* May 20, 1995, "Open Sesame" Section, p. 1.

Chacha Chaudhary

1736. Gupta, Ashih. "Taking the Mickey Out." *India Express Sunday Magazine.* February 21, 1993, p. 1.

1737. Kumar, Malviya Kishore. "Cartoonist Pran ka Chacha Chaudhry America Sangrahalaya Me." *Rachi Express* (daily newsletter). February 27, 1993.

1738. Singh, Kanwaldeep. "25 Years of Wise Old Chacha and the Original Indian Comic." *Times of India.* September 9, 1994, p. 2.

Tinkle

1739. Srinivasan, Priya. "Mag with a Mission." *Free Press Journal.* June 26, 1994.

1740. "Tinkle Twinkle." *Mid-Day.* June 18, 1994, "Junior Midday" Section, p. 3.

Political Cartoons

1741. Boustany, Nora. "Diplomatic Dispatchers: Drawing on Laughter." *Washington Post.* January 16, 1998, p. A17.

1742. Hussain, Irfan. "'Poison Pen' Rules the Roost." *The Pioneer* (Delhi). June 1, 1996.

1743. Venkatachalapathy, A. R. "Lampooning the Raj, Subramania Bharati and the Cartoon in Tamil Journalism, 1906-1910." *ICCTR* (Indian Council for Communication Training and Research) *Journal.* 5:1-2.

INDONESIA
General Sources

1744. McGowan, Kaja Maria. "Balancing on Bamboo: Women In Balinese Art." *Asian Art and Culture.* Winter 1995, pp. 75-95.

1745. Miklauho-Maklai, B. *Exposing Society's Wounds: Some Aspects of Contemporary Indonesia Art Since 1966.* Adelaide: Flinders University Asian Studies Monograph No. 5, 1991.

1746. van den Hanenberg, Patrick. "Indonesie." *Sic.* n..d. (1990?), pp. 28-29.

1747. "When Bali Cast A Special Spell." *Asiaweek.* November 26, 1999, pp. 44-45.

Cartoonists and Their Works

1748. Chudori, Leila. "R. A. Kosasih: Di Tengah Pandawa da Kurawa." *Tempo.* December 21, 1991, pp. 41-67.

1749. Van Eijck, Rob. "Thé Tjong Khing." *Stripschrift.* No. 20, n.d., pp. 10-11.

Animation

1750. Guntarto, B. "An Assessment of Children's Television Programmes in Indonesia." In *Growing Up With Television: Asian Children's Experience,* edited by Anura Goonasekera, pp. 124-156. Singapore: Asian Media Information and Communication Centre, 2000.

1751. Kurasawa, Aiko. "Aijia ha Wakon no Juyo Dekiruka? (Can Asia Be Japanized?)." In *Ajia Teki Kachi to wa Nan nika* (What is Asian Value?), edited by Aoki Tamotsu and Saeki Keishi, pp. 180-181. Tokyo: TBS Buritanka, 1998.

1752. Lent, John A. *"Vignette:* Dwi Koendoro and His Quest for Viable Indonesian Animation."* In *Animation in Asia and the Pacific,* edited by John A. Lent, pp. 181-184. Sydney: John Libbey & Co., 2001.

1753. Ryanto, Tony. "Boffo First Cartoon Fest Draws in the Crowds." *Variety.* March 5-11, 2001, p. 37.

1754. Shiraishi, Saya. "Japanese Cartoon Heroes Come to Indonesia." Paper presented at Association for Asian Studies, Honolulu, Hawaii, April 14, 1996.

"Aladdin"

1755. "Aladdin in Town." *Jakarta Post.* June 19, 1993, p. 3.

1756. "'Aladdin' Mengekor Sukses 'Beauty and the Beast.'" *Merdeka* (Jakarta). June 27, 1993, p. 7.

1757. "Arab Americans Say Disney Film 'Aladdin' Contains Racial Slurs." *Jakarta Post.* June 11, 1993, p. 7.

1758. "Film 'Aladdin': Potret Manusia dalam Katun." *Kompas* (Jakarta). June 13, 1993, p. 6.

1759. "4 Tokoh Film 'Aladin' [sic] Bertumu Anak2 Indonesia." *Suara Karya* (Jakarta). June 19, 1993, p. 3.

1760. "Pelanggaran Hak Cipta, Film, dan Video, Penyebab Indonesia Masuk, 'Watch List.'" *Kompas* (Jakarta). May 4, 1993, p. 2.

Comic Books

1761. "Antihero dalam Komik" (Antiheroes in Comics). *Hai.* May 30, 1995, pp. 66-68.

1762. Berman, Laine. "Comic Book Art and Social Protest in Indonesia." Lecture given at Monash University (Australia), Centre of Southeast Asian Studies, March 27, 1997.

1763. Berman, Laine. "Comics as Social Commentary in Java, Indonesia." In *Illustrating Asia: Comics, Humor Magazines, and Picture Books,* edited by John A. Lent, pp. 13-36. Richmond: Curzon Press; Honolulu: University of Hawaii Press, 2001.

1764. Berman, Laine. "Land in Zicht—Indonesië." *Stripschrift.* June 2000, p. 23.

1765. Berman, Laine. "Paint It Black in Daliland: Introduction to the Bad Times Story." In Athonk. *Bad Times Story,* pp. i, 21. Jogyakarta: Athonk Productions, 1995.

1766. Bonneff, M. *Les Bandes Dessinées Indonesiennes: Une Mythologie en Images*. Paris: Puyraimond, 1976.

1767. Bunanta, Murti. "Other Voices: The Comics Invasion in Indonesia." *Bookbird.* Summer 1995, p. 35.

1768. Captain Esther. "Indonesisch Dossier." *Stripschrift.* November 1999, pp. 22-24.

1769. "Comeback – nya Panji Tengkorak" (The Comeback of Panji Skull). *Suara Merdeka.* November 9, 1996.

1770. "Comic Craze Boosts the Indonesian Comics Industry." *Jakarta Post.* August 1, 1996.

1771. "Indonesian Comics Industry Crippled by Poor Quality, Costs." *Straits Times* (Singapore). September 28, 1995.

1772. "Jagoan, Figur Abadi dalam Komik" (Heroes, Eternal Figures in Comics). *Suara Merdeka.* November 9, 1996.

1773. Lindsay, Timothy. "Captain Marvel Meets Prince Rama: 'Pop' and the Ramayana in Javanese Culture." *Prisma: The Indonesian Indicator.* 43 (1987), pp. 38-52.

1774. "Mas Malio." *JeJAL.* January 1994.

1775. "Nasionalisme Masa Lalu Konik Kita" (Past Era Nationalism in Our Comics). *Suara Merdeka.* November 9, 1996.

1776. "Pak Bei." *Suara Merdeka.* June 27, 1993.

1777. Sears, Laurie J. "R.A. Kosasih and the *Wayang* Comics." In *Shadows of Empire: Colonial Discourse and Javanese Tales,* pp. 273-286. Durham, North Carolina: Duke University Press, 1996.

1778. "Si Jin Kui dalam Imajinasi Oto" (Si Jin Kui in Oto's Imagination). *Tempo.* April 30, 1988, p. 90.

1779. "Si Sarmun ke New York "(Sarmun Goes to New York). *Hai.* February 21, 1995, pp. 58-60.

1780. "Tawaran Baru Komik Kontemporer" (New Offers in Contemporary Comics). *Suara Merdeka.* November 9, 1996.

1781. Tjandraningsih, Christine T. "Japan's *Manga* Oust Rivals from Indonesian Market." *Japan Times.* January 11, 1995.

Political Cartoons

1782. Irianto, Asmudjo Jono. "An Unsettled Season: Political Art of Indonesia." *Art AsiaPacific.* No. 28, 2000, pp. 78-83.

1783. "Paper Apologizes for Wahid Cartoon." *Far Eastern Economic Review.* October 12, 2000, p. 10.

1784. Prayitno, D. "Suharto Cartoon." *Asiaweek.* March 20, 1998, p. 7.

1785. Spanjaard, Helena. "'Reformasi Indonesia!' Protest Art, 1995-2000." *IIAS Newsletter.* October 2000, p. 38.

1786. Warren, Carol. "Mediating Modernity in Bali." *International Journal of Cultural Studies.* April 1998, pp. 83-108.

JAPAN
Resources

1787. Aish, Sergei L. "An Anime Fan's Holiday '95 Video Game Shopping Guide." *Animerica.* 3:12 (1995), p. 63.

1788. "Animato! Anime Guide." *Animato!* Fall 1994, pp. 63-64.

1789. "Animato! Anime Guide." *Animato!* Winter 1995, pp. 59-63.

1790. "Anime Hasshin's 10th Anniversary." *The Rose.* January 1997, pp. 26-30.

1791. "The Anime/Manga Store Directory for the Washington, DC Area." *Tsunami.* Winter 1995, pp. 20-22.

1792. "Animerica Ultimate Summer Anime Guide." *Animerica.* 3:7 (1995), pp. 15-17.

1793. Bachollet, Raymond. "Le Catalogue des Journaux Satiriques. La Lanterne Japonaise." *Le Collectionneur Français.* June 1990, pp. 5-7; September 1990, pp. 5-7; November 1990, pp. 6-9.

1794. Beam. John. "An *Animato!* Introduction to Anime." *Animato!* Fall 1994, pp. 60-61.

1795. Beam. John, *et al.* "*Animato!* Anime Guide." *Animato!* Spring 1995, pp. 50-53.

1796. Camp, Brian. "The Complete Anime Guidebook: Book Review." *Animation World Magazine.* July 1997, pp. 60-62.

1797. Clements, Jonathan. "The Final Encyclopaedia?" *Manga Mania.* October-November 1997, pp. 22-23.

1798. "The Content of the Quarterly Fūshiga Kenkyū, Nos. 1-20." *Fūshiga Kenkyū.* No. 21, 1997, pp. 3-4.

1799. Cowie, Geoff. "Anime, Bulletin Boards and the INTERNET – A Guide for the Clueless." *Anime FX.* August 1995, p. 23.

1800. "Danger Areas in Anime and Manga Research." *Anime FX.* February 1996, pp. 42-43.

1801. Duquette, Patrick, *et al.* "Animato! Anime Guide." *Animato!* Fall 1995, pp. 51-54.

1802. Fakuya, Inc., ed. *'95 Comic CATALOG.* Tokyo: Fukuya, 1995.

1803. Furness, Maureen. "Dreamland Japan: Manga's Paradise." *Animation World Magazine.* July 1997, pp. 14-16.

1804. "Index of *Fūshiga Kenkyū,* Nos. 1-20." *Fūshiga Kenkyū.* No. 21, 1997, pp. 5-13.

1805. Japan Cartoonists Association, ed. *Nihon Mangaka Katarogu* (Catalog of Japan's Manga Artists). Tokyo: Japan Cartoonists Association, 1992.

1806. Kreiner, Rich. "Meet the Comics Press: *Animerica; Fresh Pulp; Mangaphile.*" *Comics Journal.* December 2000, pp. 101-104.

1807. Kreiner, Rich. "Return to Comics Island: *Dreamland Japan; Writings on Modern Manga.*" *Comics Journal.* March 1997, pp. 37-39.

1808. Kyte, Steve. "A to Z of Anime: S." *Anime UK.* December 1994/January 1995, pp. 10-11.

1809. Kyte, Steve. "A to Z of Anime. Part Two M-S." *Anime UK.* April 1995, 6 pp. insert.

1810. Kyte, Steve. "A to Z of Anime. Part Three, S-Z." *Anime UK.* May 1995, 8 pp. insert.

1811. Ledoux, Trish. "The First Five Years (1992-97)." *Animerica.* 5:3 (1997), p. 2.

1812. Ledoux, Trish and Doug Ranney. *The Complete Anime Guide, Japanese Animation Video Directory and Resource Guide.* Issaquah, Washington: Tiger Mountain Press, 1995. 215 pp.

1813. Lent, John A. "Dreamland Japan: Writings on Modern Manga, by Frederik L. Schodt." Review. *Inks.* November 1997, pp. 36-37.

1814. *Manga Bakari Yome! Komikku Dorankā no Tame no Manga Gaido* (Read Only Manga! Manga Guide for Comics Drunkards!). *03 Tokyo Calling.* September 1991, pp. 18-71.

1815. "Mangazine." *Stripschrift.* August 1994, pp. 1-12.

1816. Marmex, Timon. "A Guide to Dubbed and Subtitled Anime." *Tsunami.* Winter 1995, pp. 6-11.

1817. "Message from the President." *Animerica.* 3:12 (1995), p. 71.

1818. Moe, Anders. "*The Anime Movie Guide.*" *The Rose.* April 1997, p. 27.

1819. "New Books." *The Rose.* October 1998, p. 29.

1820. Ng, Ernest. "Art Book Reviews." *The Rose.* October 2000, pp. 12-13. (*Nakajima Atsuko Works, Alpha [Newtype Illustration Collection], Der Mond [Newtype Illustration Collection]*).

1821. Nihon Mangaka Meikan 500 Committee, ed. *Nihon Mangaka 500* (Directory of 500 Japanese Manga Artists). Tokyo: Aqua Planning, 1992.

1822. Patten, Fred "Samurai from Outer Space: Understanding Japanese Animation. *Animation World.* May 1997, 3 pp.

1823. Pelletier, Claude J. "The Shaping of Protoculture." *Protoculture Addicts.* November-December 1991, p. 8.

1824. "Protoculture Addicts Third Anniversary Special." *Protoculture Addicts.* August-September 1991, pp. 18-19.

1825. Santoso, Widya. "Book Review: Samurai from Outer Space. *The Rose.* April 1997, pp. 14, 31.

1826. Savage, Lorraine. "50 Issues of *The Rose.*" *The Rose.* October 1996, pp. 22-26.

1827. Savage, Lorraine. "Magazine Review: Animeco." *The Rose.* October 1997, p. 12.

1828. "The Shaping of Protoculture." *Protoculture Addicts.* April 1990, p. 9.

1829. "The Shaping of Protoculture." *Protoculture Addicts.* August-September 1991, p. 7.

1830. *Shuppan Shihyō Nenpō: 1995-Nenban.* (Annual Indices of Publishing: The 1995 Edition). Tokyo: Zenkoku Shuppan Kyōkai/Shuppan Kagaku Kenkyū Sentā, 1995.

1831. Society of Friends of Eastern Art. *Index of Japanese Painters*. Rutland, Vermont: Charles E. Tuttle, 1958. Eighth printing, 1982. 160 pp.

1832. Swallow, Jim. "Manga in Focus: Holiday Special: The Yuletide Manga Gift Guide." *Anime FX*. January 1996, pp. 14-15.

1833. Swint, Lester. "Anime Fantastique." *The Rose*. February 1999, p. 19.

1834. *Taishû Bunka Jiten* (Encyclopedia of Popular Culture). Tokyo: Kôbundô, 1991.

1835. Uryu, Yoshimitsu. "Genealogy on 'Manga Studies.'" *The Bulletin of the Institute of Socio-Information and Communication Studies, The University of Tokyo*. No. 56, 1998, pp. 135-154.

1836. Wang, Albert Sze-Wei. "The Beginner's Survival Guide to Anime." *A-ni-mé*. January 1991, p. 3.

1837. Yumoto, Goichi. "Collection of Keiichi Suyama, Owner by Kuwasaki Citizens Museum." *Fūshiga Kenkyū*. January 20, 1996, p. 14.

1838. *Zasshi Shinbun Sōkatarogu* (Japan's Periodicals in Print). Tokyo: Media Research Center 1979.

Museums

1839. Bush, Laurence. "Hidden Otaku of Kansai." *The Rose*. June 2000, pp. 22-23, 28. (Tezuka Museum).

1840. Chiba, Hitoshi. "The Comic King's Castle." *Look Japan*. December 1995, pp. 36-37. (Tezuka Museum).

1841. Coakley, Jane. "Museum of Fantasy." *Kansai Time Out*. October 1995, p. 41. (Tezuka Museum).

1842. International Cartoon Museum." *The Rose*. July 1997, p. 20.

1843. Leahy, Kevin. "Osamu Tezuka Manga Museum." *The Rose*. July 1996, pp. 24-25. Also includes excerpts from *The Japan Times*, April 24, 1994, May 12, 1994.

1844. Leger, Jackie. "The Osamu Tezuka Manga Museum: A Cultural Monument." *Animation World*: August 1998.

1845. Ono, Kosei. "Japan's Most Popular Cartoon Museum: The Anpanman Museum." *Animation World*. February 1999.

1846. [Ozamu Tezuka Memorial Museum]. *Look Japan*. December 1995.

1847. Schodt, Frederik. "The Osamu Tezuka Manga Museum." *Animerica.* 2:7 (1994), pp. 36-37.

1848. Shimizu, Isao. "Japanese Manga Museums: Lists of Materials During Meiji Period 20-45 (1887-1912)." *Fūshiga Kenkyū.* January 20, 1996, pp. 5-10.

1849. Tezuka Productions. *Tezuka Osamu Kinenkan* (The Osamu Tezuka Manga Museum). Takarazuka: Takarazuka City Osamu Tezuka Manga Museum, 1994.

General Sources

1850. Ayako, Ishida. "Low Brow Meets High Tech." *Asiaweek.* January 22, 1999, p. 40.

1851. "Anime/Manga News." *Comics Buyer's Guide.* February 14, 1997, pp. 72, 78.

1852. "Behind the Scenes of a Japanese Original." *Japan Times.* December 25, 1993, p. 16.

1853. Berthet, Philippe and Jean-Claude Redonnet. *L'Audiovisuel au Japon* (The Audiovisual Industry in Japan). Paris: P U F, 1992, 128 pp.

1854. Bissey, Laura. "A Boy, His Father, an Empty Eye Socket and the Ghosts of Japan: (Gegege no Kitarou Manga/Anime). *Sequential Tart.* May 2000.

1855. Craig, Timothy J., ed. *Japan Pop! Inside the World of Japanese Popular Culture.* Armonk, New York: M.E. Sharpe, Inc., 2000. 360 pp. (Includes Mark W. MacWilliams, "Japanese Comic Books and Religion: Osamu Tezuka's Story of the Buddha"; Eri Izawa, "The Romantic, Passionate Japanese in Anime: A Look at the Hidden Japanese Soul"; Keiji Nakazawa, "Hadashi no Gen ("Barefoot Gen"): Volume 8, pp. 17-31; Maia Tsurumi, "Gender Roles and Girls' Comics in Japan: The Girls and Guys of *Yukan Club";* William Lee, "From *Sazae-san* to *Crayon Shinchan:* Family Anime, Social Change, and Nostalgia in Japan"; Anne Allison, "Sailor Moon: Japanese Superheroes for Global Girls"; Saya Shiraishi, "Doraemon Goes Abroad").

1856. English Discussion Group. *Japanese Women Now.* Tokyo: Women's Bookstore, 1992.

1857. *Fresh Pulp: Dispatches from the Japanese Pop Culture Front (1997-1999).* San Francisco, California: Cadence Books, 1999. 184 pp.

1858. Gill, Tom. "Transformational Magic: Some Japanese Super-heroes and Monsters." In *The Worlds of Japanese Popular Culture: Gender, Shifting Boundaries and Global Cultures,* edited by D. P. Martinez, pp. 33-55. Cambridge: Cambridge University Press, 1998.

1859. Hsiao, Hsiang-Wen. "The Way Heroes See Is Different: A Comparison of Japanese and American Hero Characters." *Central Daily News.* June 16, 1998, p. 23.

1860. Kogawa, Tetsuo. "New Trends in Japanese Popular Culture." *Telos.* Summer 1985.

1861. Koh, Barbara. "Cute Power! (Japanese Popular Culture)." *The Bulletin With Newsweek.* November 9, 1999, p. 88.

1862. Martinez. D.P., ed. *The Worlds of Japanese Popular Culture: Gender, Shifting Boundaries and Global Cultures.* Cambridge: Cambridge University Press, 1998. 213 pp.

1863. Moeran, Brian. *Language and Popular Culture in Japan.* Manchester: Manchester University Press, 1989.

1864. Morikawa, Kathleen. "More Than Mind Candy." *Japan Quarterly.* January-March 1997, pp. 92-94.

1865. Netto, C. and G. Wagener. *Japanischer Humor.* Leipzig: Brockhaus, 1901.

1866. "News." *Protoculture Addicts.* November-December 1991, pp. 30-33.

1867. "News." *The Rose.* January 1996, pp. 12-14.

1868. "News." *The Rose.* January 1997, pp. 10-12.

1869. Oshiguchi, Takashi. "On Live-Action Movies of Manga and Anime." *Animerica.* 4:10 (1996), p. 58.

1870. Roman, Annette, ed. *Japan Edge: The Insider's Guide to Japanese Pop Subculture.* San Francisco, California: Cadence Books, 1999. 199 pp.

1871. Sato, Tadao. "Teizoku Bunka to wa Nani ka?" (What Is Low Culture?). *Manga Ronsō,* special issue of *Bessatsu Takarajima.* 13 (1981), pp. 62-71.

1872. Schodt, Frederik L. "Robot Icons of Popular Culture." *Animag.* No. 5, 1988, pp. 36-39.

1873. Sheidlower, Jesse T. "Dictionary Update." *Copy Editor.* August/September 1996.

1874. Swallow, James. "Nippon Europa." *Mangazine.* September 1994, p. 7.

1875. Tartan, Suzannah. "Japan's Cultural Underground Exposed in Edgy New Guide." *Japan Times.* January 7, 2000.

1876. Tesoro, Jose M. "Asia Says Japan Is Top of the Pops." *Asiaweek.* January 5, 1996, pp. 34-39.

1877. Utatane, Hiroyuki. *Countdown: Sex Bombs.* Seattle, Washington: Eros, 1996. 144 pp.

1878. Wells, Marguerite. *Japanese Humor.* New York: St. Martin's Press, 1996. 208 pp.

Artistic Aspects

1879. "The Curious Art of Origami." *Animation World.* April 1997, p. 58.

1880. Iwasaki, Haruko. "The Preface as a Guide to 'Shuko' in Kibyoshi [Pictorial Comic Fiction]." Paper presented at Association for Asian Studies, March 27, 1998.

1881. Okudaira, Hideo, ed. *Chôjû Giga* (Scrolls of Animal Caricatures). 5th Ed. Tokyo: Iwasaki Bijutsusha, 1989.

1882. Seckel, Dietrich. *Emakimono: The Art of the Japanese Painted Hand-Scroll.* New York: Pantheon Books, 1959

1883. Shimizu, Yutaka. *Nara Picture Books.* Los Angeles, California: Dawson's Book Shop, 1960. 46 pp.

1884. Suzuki, D.T. *Sengai: The Zen of Ink and Paper:* Boston and London: Shambhala, 1999. 191 pp.

1885. Tanahashi, Kazushi. *Penetrating Laughter: Hakuin's Zen and Art.* Woodstock, New York: Overlook Press, 1984.

1886. Toda, Kenji. *Japanese Scroll Painting.* Chicago: University of Chicago Press, 1935.

1887. Tsuji, Nobuo. *Playfulness in Japanese Art.* Translated by Joseph Seubert. Franklin D. Murphy Lectures 7. Lawrence, Kansas: Spencer Museum of Art, University of Kansas, 1986.

1888. Vukov, Elaine. "*Kamishibai,* Japanese Storytelling: The Return of an Imaginative Art." *Education About Asia.* Spring 1997, pp. 39-41.

1889. "The World of Picture Stories." Program for Exhibition, Adachi-ku, Tokyo, Kyōdo Hakubutsukan, 1993.

Graphic Design

1890. Fraser, James, Steven Heller, and Seymour Chwast. *Japanese Modern: Graphic Design Between the Wars.* San Francisco, California: Chronicle Books, 1996. 132 pp.

1891. Mannering, Douglas. *Great Works of Japanese Graphic Art.* New York: Shooting Star Press, 1995. 79 pp.

1892. Thornton, Richard. *Japanese Graphic Design.* London: Lawrence King 1991. 240 pp.

Haiga and Haiku

1893. *Eiri Haisho to Sono Gakatachi* (Illustrated Haiku Books and Their Artists). Itami: Kakimori Bunko, 1992.

1894. Okada, Rihei. *Haiga no Sekai* (The World of Haiga). Kyoto: Tankōsha, 1966.

1895. O'Mara, Joan H. *The Haiga Genre and the Art of Yosa Buson (1716-1784).* Ann Arbor: University Microfilms, 1989. Ph.D. dissertation.

1896. *Peinture a l'Encre du Japon (Nanga et Haiga).* Geneva: Collections Baur, c. 1968.

1897. *Schertsend Geshetst: Haiku-Schilderigen.* Belgium: Europalia, 1989.

1898. Zolbrod, Leon M. *Haiku Painting.* Tokyo: Kodansha, 1982.

Shunga

1899. Fagioli, Marco. *Shunga: The Erotic Art of Japan.* New York: Universe, 1998. 174 pp.

1900. Forrer, Matthi. "Shunga Production in the 18th and 19th Centuries: Designing 'Un Enfer en Style Bibliographique.'" *In Imaging/Reading Eros,* edited by Sumie Jones, pp. 21-25. Bloomington: Indiana University East Asian Studies Center, 1996.

1901. Haga, Toru. "Precariousness of Love, Places of Love." In *Imaging/Reading Eros,* edited by Sumie Jones, pp. 97-102. Bloomington: Indiana University Center for East Asian Studies, 1996.

1902. Hibbett, Howard. "The Yoshiwara Wits: Edo Sexual Humor." In *Imaging/Reading Eros,* edited by Sumie Jones, pp. 13-20. Bloomington: Indiana University East Asian Studies Center, 1996.

1903. Inoue, Charles Shirō. "Pictocentrism – China As a Source of Japanese Modernity." In *Imaging/Reading Eros,* edited by Sumie Jones, pp. 148-152. Bloomington: Indiana University East Asian Studies Center, 1996.

1904. Jones, Sumie. "Interminable Reflections: the Semiotics of Edo Arts." In *Imaging/Reading Eros,* edited by Sumie Jones, pp. 83-94. Bloomington: Indiana University Center for East Asian Studies, 1996.

1905. Jones, Sumie. "Sex, Art, and Edo Culture: An Introduction." In *Imaging/Reading Eros,* edited by Sumie Jones, pp. 1-12. Bloomington: Indiana University East Asian Studies Center, 1996.

1906. Nobuhiro, Shinji. "Santo Kyōden's Sharebon: Private Life and Public Art." In *Imaging/Reading Eros,* edited by Sumie Jones, pp. 142-147. Bloomington: Indiana University East Asian Studies Center, 1996.

1907. Pollack, David. "Marketing Desire: Advertising and Sexuality in Edo Literature, Drama and Art." In *Imaging/Reading Eros,* edited by Sumie Jones, pp. 47-62. Bloomington: Indiana University East Asian Studies Center, 1996.

1908. Smith, Henry. "Overcoming the Modern History of Edo 'Shunga.'" In *Imaging/Reading Eros,* edited by Sumie Jones, pp. 26-33. Bloomington: Indiana University East Asian Studies Center, 1996.

1909. Ueno, Chizuko. "Lusty Pregnant Women and Erotic Mothers: Representation of Female Sexuality in Erotic Art in Edo." In *Imaging/Reading Eros,* edited by Sumie Jones, pp. 110-114. Bloomington: Indiana University East Asian Studies Center, 1996.

Ukiyo-e

1910. Chance, Frank L. "The New Emperor's Clothes: Japanese Woodblock Prints from the Frederick and Jean Sharf Collection." Paper presented at Mid-Atlantic Region/Association for Asian Studies, West Chester, Pennsylvania, October 26, 1997.

1911. Clark, Timothy. *Ukiyo-e Paintings in the British Museum.* London: British Museum Press, 1992.

1912. Clark, Timothy, Donald Jenkins, and Osamu Ueda. *The Actor's Image: Printmakers of the Katsukawa School.* Princeton, New Jersey: Princeton University Press, 1994. 544 pp.

1913. "A Collection of NMS: Woodblock Print Caricatures During the Edo Period." *Fūshiga Kenkyū.* No. 21, 1997, pp. 2, 13.

1914. Faulkener, Rupert. *Masterpieces of Japanese Prints: The European Collections: Ukiyo-e from the Victoria and Albert Museum.* Tokyo: Kodansha, 1991.

1915. Graybill, Maribeth. "Ideology and Prints of the Satsuma Rebellion." Paper presented at the Mid-Atlantic Region/Association for Asian Studies, West Chester, Pennsylvania, October 26, 1997.

1916. Harigaya, Shōkichi *et al.,* eds. *Ukiyo-e Bunken Mokuroku.* Tokyo: Mitō Shooku, 1972.

1917. Huzikake, S. *Japanese Woodblock Prints.* Tokyo: Board of Tourist Industry, Japanese Government Railways, 1938. 86 pp.

1918. Illing, Richard. *Japanese Prints from 1700 to 1900.* Oxford: Phaidon Press, 1976.

1919. *Imaging Meiji Emperor and Era 1868-1912. Japanese Woodblock Prints from the Collection of Jean S. and Frederic A. Sharf.* Exhibition at Cantor Filzgerald Gallery, Haverford College, Haverford, Pennsylvania, 21 March – 2 May 1997. Haverford: Haverford College, 1997. 34 pp.

1920. Inumaru, Kazuo. "Ukiyo-e del Presente: Tematiche dei Cartoni Giapponesi." *If.* December 1983, pp. 46-48.

1921. Jenkins, Donald. *The Floating World Revisited.* Honolulu: University of Hawaii Press, Portland Art Museum, 1993. 253 pp.

1922. Kikuchi, Sadao. *Ukiyo-e.* Translated by Fred Dunbar. Tokyo: Hoikusha, 1964.

1923. Kobayashi, Tadashi. *Ukiyo-e: An Introduction to Japanese Woodblock Prints.* Translated by Mark A. Harbison. Tokyo: Kodansha, 1992.

1924. Kojima, Usui. *Edo Makki No Ukiyo-e.* Tokyo: Azusa Shobō, 1931.

1925. Kyoto National Museum, Tokyo National Museum and *The Kyoto Shimbun. Ukiyo-e from the Matsukata Collection.* Tokyo: 1991.

1926. Lane, Richard. *Images from the Floating World: The Japanese Print.* London: Alpine Fine Arts Collection (UK), 1978.

1927. Lin, Diana. "Long-in-Coming Show To Boost Appreciation of Japanese Art." *Free China Journal.* May 8, 1998, p. 5.

1928. Meech, Julia. "Woodblock Prints and Photographs: Two Views of Nineteenth-Century Japan." *Asian Art.* Summer 1990, p. 37-63.

1929. Meech-Pekarik, Julia. *The World of the Meiji Print. Impressions of a New Civilization*. New York: Weatherhill, 1986. 259 pp. ("Satire: Harsh Critics of New Japan," pp. 179-199).

1930. Merritt, Helen. *Modern Japanese Woodblock Prints*. Honolulu: University of Hawaii Press, 1990. 324 pp.

1931. Merritt, Helen and Nanako Yamada. *Guide to Modern Japanese Woodblock Prints: 1900-1975*. Honolulu: University of Hawaii Press, 1992. 365 pp.

1932. Mertel, Timothy. "Surimono. Ukiyo-e Refined." *Arts of Asia*. September, October 1987, pp. 80-88.

1933. Newland, Amy and Chris Uhlenbeck, eds. *Ukiyo-e: The Art of Japanese Woodblock Prints*. New York: Smithmark, 1994.

1934. Newland, Amy and Chris Uhlenbeck, eds. *Ukiyo-e Shin Hanga: The Art of Japanese Woodblock Prints*. Leicester: Manga Books, 1990.

1935. Ryall, Julian. "Picture Perfect." *Far Eastern Economic Review*. January 13, 2000, pp. 44-45.

1936. Soulié, Bernard. *Japanese Art of Loving*. Fribourg-Geneva: Productions Liber SA, 1993. 96 pp.

1937. Stewart, Basil. *A Guide to Japanese Prints and Their Subject Matter*. New York: Dover, 1979. 382 pp. Reprint of *Subjects Portrayed in Japanese Colour Prints*. New York: E.P. Dutton, 1922.

1938. Strange, Edward F. *Japanese Colour Prints*. London: HMSO, 1931.

1939. Suzuki, Jūzō. *Ehon to Ukiyo-e*. Tokyo: Bijutsu Shappansha, 1979.

1940. *Ukiyo-e Geijutsu*. No. 51, 1976, pp. 3-27.

1941. Ulak, James T. *Japanese Prints*. New York: Abbeville, 1995. 320 pp.

1942. *Utagawa Kuniyoshi*. Exhibition To Commemorate the 200th Anniversary of Utagawa Kuniyoshi's Birth. Nagoya City Museum, October 26 – December 1, 1996. Nagoya: Nihon Keizai Shimbun, 1996. 300 pp.

1943. Watson, William, ed. *The Great Japan Exhibition: Art of the Edo Period 1600-1868*. London: Royal Academy of Arts/Weidenfeld and Nicholson, 1981.

1944. Yoshida, Teruji. *Ukiyo-e Jiten*. 3 Vols. Tokyo: Gabundō, 1974.

Business Aspects

1945. Chin, Oliver. "Selling Anime and Manga: Converting New Enthusiasts into New Customers." *Comics Retailer.* January 1999, pp. 68, 70/

1946. Kaneko, Maya. "New Creature Gently Panders to Fatigued Japanese." Japan Economic Newswire. January 3, 2000.

1947. Koh, Barbara, *et al.* "Cute Power!" *Newsweek.* November 8, 1999, p. 54.

1948. McCarthy, Helen. "Manga Mania's Christmas Shopping Guide." *Manga Mania.* January-February 1998, p. 8.

1949. "Product Placement." *Manga Max.* Summer 2000, p. 5

Anime (Animation)

1950. "Animation: Master, Fine Comic Art and Anime." *Animation.* March 2000, p. 22.

1951. "Anime and Manga Gift List." *Animerica.* 6:11 (1998), pp. 16-19.

1952. "Anime Manufacturers and Distributors." *Comics Buyer's Guide.* June 29, 2001, p. 24.

1953. "Anime Shopping Guide." *Animerica.* 6:11 (1998), pp. 20-21.

1954. "Appendice 3: Il Mercato Discografico." *If.* December 1983, p. 87.

1955. "Big Business all'Italiana." *If.* December 1983, p. 84.

1956. Brimmicombe-Wood, Lee. "Worst Case Scenarios." *Manga Max.* June 2000, p. 58.

1957. "Cinquanta Schede." *If.* December 1983, pp. 57-83.

1958. Clements, Jonathan. "The Gospel According to Gainax." *Manga Mania.* July-August 1997, pp. 14-16.

1959. Efron, Sonni. "Disney Dives into Japanese Film Business." *The Rose.* October 1996, pp. 18-19. Reprinted from *The Los Angeles Times.* July 24, 1996.

1960. Gelman, Morrie. "Corporate Profiles: TMS-Kyokuichi Corp." *Animation.* December 1999, p. 20.

1961. Gelman, Morrie. "Sony Pictures Family Entertainment Group." *Animation.* October 1999, p. 50.

1962. Groves, Don. " 'Bat' Wings Clipped at Japan B. O." *Variety*. June 26-July 9, 1995, pp. 8, 16.

1963. Herskovitz, Jon. "Japan Net Looks Inhouse for Animation." *Variety*. April 5-11, 1999, p. 64.

1964. Iwabuchi, Koichi. "Return to Asia? Japan in Asian Audiovisual Market." In *Consuming Ethnicity and Nationalism: Asian Experiences*, edited by Kosaku Yoshino, pp. 179-183+. Honolulu: University of Hawaii Press, 1999.

1965. "Japan's Gaga Communications Enters Feature Animation." *Animation World*. June 1996, 1 pp.

1966. Kurosu, Masao. "Competition Elements of Japanese Animation Industry." *Animatoon*. 3:9 (1997), p. 86.

1967. Macias, Patrick. "The Tatsunoko Heroes." *Animerica*. June 1999, pp. 6-9, 28.

1968. Magee, Michelle. "Disney, Tokuma Shoten Ink Toon Pact." *Variety*. July 29-August 4, 1996, p. 12.

1969. "New Company: Digital Manga." *The Rose*. October 2000, p. 17.

1970. O'Brien, T. "MCA Announces Plans for Japan Studio Attraction." *Amusement Business*. January 17-23, 1994, p. 28.

1971. Osaki, Tad. "Toho Dances to Toons." *Variety*. June 18-24, 2001, p. 49.

1972. Oshiguchi, Takashi. "On Anime Magazines and the Anime Industry." *Animerica*. 4:12 (1996), p. 61.

1973. Oshiguchi, Takashi. "'On Studio Ghibli's Future Plans.'" *Animerica*. 6:9 (1998), p. 63.

1974. Oshiguchi, Takashi. "On Tatsunoko Animation." *Animerica*. June 1999, p. 68.

1975. Patten, Fred. "Money Talks." *Manga Max*. January 2000, pp. 14-20.

1976. Patten, Fred. "The World's Biggest Animation Home Video Market?" *Animation World*. November 1997, 4 pp.

1977. Pierre and Olivier. "Disney-Tokuma: L'Alliance de David et Goliath." *Animeland* (Paris). September 1995.

1978. Pollack, Andrew. "Disney in Alliance for Films of Top Animator in Japan." *The Rose*. October 1996, pp. 18-19. Reprinted from *The New York Times*. July 24, 1996.

1979. Raugust, Karen. "Licensing 2000: Anime Still in the Lead." *Animation.* September 2000, pp. 59-60.

1980. Raugust, Karen. "Merchandising in Japan: It's Big Rewards and Competition." *Animation World.* October 1997, 5 pp.

1981. Savage, Lorraine. "Anime-Rican Revolution: PROS vs. Fans." *The Rose.* July 1995, pp. 4-6.

1982. Savage, Lorraine. "Commercial Aspects of Anime." *The Rose.* February 1999, pp. 18-19.

1983. Savage, Lorraine. "Industry Report." *The Rose.* October 1995, pp. 6-7.

1984. Segers, Frank. "Towa Founder Put Focus on Global Biz." *Variety.* May 18-24, 1998, p. 48.

1985. Soh Tiang Keng. "Surfing Bananas Gets $21M Capital Injection." *Business Times.* January 28, 2000, p. 8.

1986. Tachikawa, Mayumi. "Inside Japan's Beloved Toei Animation." *Animation World.* September 1999, 5 pp.

1987. "Tokyo Communication Art Professional School: Training into a Professional in CG Animation and Game for the Business World." *Animatoon.* No. 22, 1999, p. 37.

1988. "Vote for Viz." *Manga Max.* January 2000, p. 4.

Manga (Comic Books)

1989. "Appendice 2: Il Giappone Fatto in Casa." *If.* December 1983, pp. 85-86.

1990. "Appendice 4: Il Merchandising." *If.* December 1983, pp. 88-90.

1991. Chandler, Clay. "A Cultural Shock to the System: Out of Japan's Upheaval Spring Hit Film, Books." *Washington Post.* November 9, 1999, pp. E1, E15.

1992. "Dēta de Miru Komikkusu Shijō '95" (The 1995 Comics' Market According to the Data). *Shuppan Geppō.* March 1995, pp. 4-9.

1993. "Diamond Goes Direct with Major Japanese Suppliers." *Comics Buyer's Guide.* August 27, 1999, p. 12.

1994. "Dokyumento: Haru no Komikku Māketto" (Document of the Spring Comic Market). *Comic Box.* June 1989, pp. 20-34.

1995. French, Howard W. "The Rising Sun Sets on Japanese Publishing." *New York Times Book Review*. December 10, 2000, p. 51.

1996. Fulford, Benjamin. "Comics in Japan Not Just Funny Business." *Nikkei Weekly*. February 17, 1997, p. 1.

1997. Ishigami, Yoshitaka. "The Masque of the Red Otaku." *Animerica*. 3:5 (1995), p. 60.

1998. Kenyon, Heather. "Turning Manga into Wine Sales." *Animation World*. July 1999, 3 pp.

1999. "Manga Close-up; Holiday Book Bonanza!" *Animerica*. 4:11 (1996), pp. 60-61.

2000. "Manga Sōkessan: 1988" (Settling of Accounts for Manga: 1988). Special issue of *Comic Box*. March/ April 1989.

2001. "Manga Sōkessan: 1989" (Settling of Accounts for Manga: 1989). Special issue of *Comic Box*. May 1990.

2002. "Manga Sōkessan: 1992" (Settling of Accounts for Manga: 1992)" Special issue of *Comic Box*. August 1993.

2003. "Manga Sōkessan: 1994-95" (Settling of Accounts for Manga: 1994-95). Special issue of *Comic Box*. July 1995.

2004. "Manga Superstore." *Manga Max*. August 1999, p. 9.

2005. Ono, Kosei. "Manga Publishing: Trends in Asia." *Japanese Book News*. 15 (1996), pp. 6-7.

2006. Ono, Kosei. "Manga Publishing Trends in Europe." *Japanese Book News*. 17 (1997), pp. 6-7.

2007. Oshiguchi, Takashi. "On Manga Specialty Stores in Japan." *Animerica*. 5:7 (1997), p. 61.

2008. Pollack, Andrew. "Disney in Pact for Films of Top Animator in Japan." *New York Times*. July 24, 1996, pp. D-1, D-19.

2009. Shimizu, Isao. "Forged Wanted Posters Often Appear in Used Book Markets." *Fūshiga Kenkyū*. No. 16, 1995, pp. 13-14.

2010. Simons, Lewis M. "No One Laughs at Comic-Book Sales in Japan." Bergen, New Jersey *Record*. March 24, 1985, p. A31.

2011. Swallow, Jim. "The Rise and Rise of Pseudomanga." *Manga Max*. May 1999, pp. 20-25.

2012. "Tre Milioni di Sogna Viola e Arancio." *If*. December 1983, pp. 49-51.

2013. "Used Manga Book Store." *The Rose*. July 1997, p. 20.

2014. "Yarikuri Company by Hashimoto Iwao." *Mangajin*. February 1997, pp. 84-86.

Cartooning, Cartoons

2015. Allen, Joseph R. "Dressing and Undressing the Chinese Woman Warrior." *positions*. Fall 1996, pp. 343-379.

2016. "Anime and Manga News." *Protoculture Addicts*. September-October 1997, pp. 6-7.

2017. "Belgen in Japan!" *Keverinfo*. No. 11, n.d. (1993?), pp. 9-11.

2018. *The Best Cartoons of Nippon '95*. Omiya: The Preparatory Committee for the Establishment of the Omiya City Humor Center, 1995. 95 pp.

2019. Bomford, Jen. "Why Do They Keep Saying That?! Catchphrases from Anime and Manga." *Sequential Tart*. January 2001.

2020. Evans, Peter J. "The Way of the Knuckle Sandwich." *Manga Max*. January 2000, pp. 26-30.

2021. "Jerry Robinson's Japan Trip." *Inklings*. Spring 1997, p. 18.

2022. Koh, Barbara. "Cute Power!" *Newsweek* (Atlantic Ed.). November 8, 1999, p. 54.

2023. Miyamoto, Takaharu. "Hanako-san: The Mask Worn." *Cinemaya*. Winter 2000, pp. 65-68.

2024. News of Japanese Cartoons." *Manhwa Teah*. Winter 1995, p. 47.

2025. "News from Japan." *The Rose*. October 1997, p. 23.

2026. *Rires et Cris. Dessins d'Humour Japonais sur les Essais Nucléaires*. Aix-en-Provence: Galerie Claire M. Laurin, 1995.

2027. Ross, Martin. "The Party's Over." *Manga Max*. January 2000, p. 66.

2028. Shimatsuka, Yoko. "Do Not Pass Go." *Asiaweek*. June 29, 2001, pp. 54-55.

2029. Shimizu, Isao, ed. *100 Selected Modern Japanese Cartoons (1997)*. Tokyo: Iwanami Shoten, 1997.

2030. Uni, Kazuhiito. "Osaka." *Persimmon*. Spring 2001, pp. 9-10.

2031. Shindo, Takahiro. "The Best Cartoons of Nippon." *FECO News*. No. 29, 1999, p. 11.

Fandom and Fanzines

2032. Ajima, Shun. *Dôjinshi Handbook '95,* Fanzine Annual. Tokyo: Kubo Shoten, 1994.

2033. "Anime FX Fanzine Awards for 1995." *The Rose.* October 1996, p. 30.

2034. "Anime Info for the Otaku Generation." *Animerica.* 6:10 (1998), pp. 22-23; 6:11 (1998), pp. 22-23.

2035. "Cyberage #2." *Manga Max.* January 1999, p. 29.

2036. Davis, Julie and Trish Ledoux. "How To Be an Idol" (Or Just Look Like One). *Animerica.* 3:1 (1995), p. 9.

2037. Contino, Jennifer M. "Head Fanboy: C. B. Cebulski Talks Anime." *Sequential Tart.* September 2000.

2038. Dawley, Kourtney. "Otaku Abroad! A Canadian Otaku in Japan." *Sequential Tart.* October 2000.

2039. Dawley, Kourtney. "Two Otaku in the Big City Adventure in the JET Program." *Sequential Tart.* March 2001.

2040. Ekering, Ted. "Anime Fandom and the 'Otaku' Subculture." Paper presented at Japanese Popular Culture Conference, Victoria, Canada, April 11, 1997.

2041. "Fan Scene." *Anime UK.* May 1995, p. 57.

2042. "Fan Scene." *Manga Max.* December 1998, pp. 42-43.

2043. "Fan Scene." *Manga Max.* April 1999, p. 44.

2044. "Fan Scene." *Manga Max.* August 1999, pp. 44-45. *(Cyberage #3, Cartoonist 7).*

2045. "Fan Service # 1." *Manga Max.* April 1999, 46.

2046. "Fanscene Roundup." *Anime UK.* December 1944/January 1995, p. 54.

2047. Fletcher, Dani. "Otaku! Or, What Price, Fandom? Part One: Girlgeek." *Sequential Tart.* October 2000.

2048. Fletcher, Dani. "Otaku! Or: What Price, Fandom? Part Two: Strange New Worlds." *Sequential Tart.* November 2000.

2049. Fletcher, Dani. "Otaku! Or: What Price, Fandom? Part Three: Playing to the Cheap Seats." *Sequential Tart.* January 2001.

2050. Fletcher, Danielle. "The Few, the Proud, the Fanclubs." *Sequential Tart.* April 2000.

2051. "Focus: Reality of Japanese Animation. Wild Enthusiasm (Mania) for Japan Animation, Driven by the Lack of Choice." *Animatoon*. No. 22, 1999, p. 62.

2052. "Games: Worlds of the Otakuverse." *Animeco*. No. 12, 2000, pp. 12-21, 25-26.

2053. Ishigami, Yoshitaka. "Anime Fans Assemble: News from the Dōjinshi Front Lines." *Animerica*. 3:5 (1995), p. 61.

2054. Ishigami, Yoshitaka. "Business As Usual: The Fanzine Market Overview." *Animerica*. 3:5 (1995), p. 61.

2055. Kato, Masaaki. "47th Comiket Harumi." *Anime UK*. April 1995, pp. 24-26.

2056. Kowalski, Frankie. "On a Desert Island with . . . Mango, I Mean, Manga Mania!" *Animation World Magazine*. August 1996.

2057. McCarthy, Helen. "Why Aren't There More Females in Anime Fandom?" *Anime UK*. July 1995, p. 53.

2058. McLennan, Jim. "Fanzine in Focus." *Anime UK*. December 1994/January 1995, p. 55.

2059. Moe, Anders. "Norway – Gomen Nasai." *The Rose*. October 1996, pp. 28-29.

2060. Newitz, Annalee. "Anime Otaku: Japanese Animation Fans Outside Japan." *Bad Subjects*. April 1994, pp. 13-20.

2061. Nimiya, Kazuko. *Otaku Shôjo no Keizaigaku*. Tokyo: Kôsaidô, 1995.

2062. Okada, Toshio. "Anime Culture Is Way Cool! America's Japanophile Otaku." *The Rose*. January 1996, pp. 24-25. Reprinted from *Aera*. October 2, 1995, pp. 43-44.

2063. Okada, Toshio. "Anime Bunka wa Chō Kakkoii!!: Nihon ni Koi Suru Beikoku no Otaku" (Anime Culture Is Ultra Cool! American *Otakus* in Love with Japan). *Aera*. October 2, 1995, pp. 43-44.

2064. Okada, Toshio. *Otakugaku Nyûmon*. Tokyo: Ôta Shuppan, 1996.

2065. "Poland [Anime Club]." *The Rose*. October 1996, p. 29.

2066. "Rave Otaku." *Animerica*. 8:6 (2000), pp. 63, 65.

2067. Savage, Lorraine. "Anime Essentials: Everything a Fan Needs To Know." *The Rose*. February 2001, p. 8.

2068. Savage, Lorraine. "Fanzine Review: *Anime Filk/ Parody Fanzine.*" *The Rose.* January 1997, p. 34.

2069. Shiraishi, Nobuko. "The Viewing Habits of Young Children." *Broadcasting Culture and Research.* Autumn 1998, pp. 12-15.

2070. Sprague, Jonathan. "Anime Mania." *Asiaweek.* December 10, 1999, p. 73.

2071. Sullivan, Kevin. "Wolf-girl of Japan: 'Princess Mononoke' Fans Fill the Movie Theaters." *Washington Post.* September 17, 1997, pp. D-1, D-4.

2072. Velasquez, Phil. "Nichibei Anime Club." *The Rose.* October 1996, p. 27.

2073. Wajnberg, Allen. "Brazil—Abrademi." *The Rose.* October 1996, p. 28.

2074. Weber, Christof. "Germany." *The Rose.* October 1996, p. 29.

Festivals and Competitions

2075. Andersen, John. "Teen Tokyo Exhibit—Boston." *The Rose.* April 1995, p. 28.

2076. "Anime: Festival Within the Festival." *Animation.* March 1998, pp. 54-55.

2077. "Anime Nation Grand Tour—Dateline 1996." *Animerica.* 4:8 (1996), pp. 8-9, 26.

2078. "Anime Nation Grand Tour. Dateline 1996." *Animerica.* 4:10 (1996), pp. 7, 22-24.

2079. "Atomic Sushi." *Manga Max.* Summer 2000, p. 4.

2080. "The Big, Big Book Fair – Japan's Summer Comic Market." *Animerica.* 5:6 (1997), p. 59.

2081. "'Bizi Nasil Bilirsiniz?' Türk Karikatürcülerinin Çizgileri Japonya'da." *Karikatürk.* No. 67, 1999, p. 3.

2082. "CNA 1999." *Manga Max.* November 1999, p. 46.

2083. "Convention Circus." *Mangazine.* January 1994, p. 7.

2084. "Convention '97." *Animerica.* 5:9 (1997), pp. 8-9, 24.

2085. 'Convention '97—Part 1." *Animerica.* 5:8 (1997), pp. 4-5, 18-19.

2086. "Convention '99." *Animerica.* 7:8 (1999), pp. 11, 13,

2087. Dubois, Robert. "Anime Tour '93." *Protoculture Addicts*. December 1993, pp. 20-21.

2088. "Ekşioğlu'na Japonya' dan Ödül." *Karikatürk*. Şubat 1994, p. 32.

2089. "Fant-Asia: Montreal's International Fantastic Films Festival." *Protoculture Addicts*. September-October 1997, pp. 18-21.

2090. Fletcher, Dani. "Con Report: AKA Kon, Vancouver B.C., November 26 and 27." *Sequential Tart*. January 2001.

2091. Horn, Carl G. "Tara Releasing's Festival of Anime." *Animerica*. 3:10 (1995), p. 15.

2092. Howell, Shon. "Wonder Festival." *Mangazine*. August 1993, p. 8.

2093. Howell, Shon. "Wonder Festival, Part 2." *Mangazine*. September 1993, p. 5.

2094. Kennard, Mary. "Mad about Dōjinshi: Amateur Manga Artists Draw Thousands of People at Dōjinshi Fan Fests Around Japan." *Mangazine*. March 1997, pp. 50-52, 58-59.

2095. King, Martin. "Manga Speaks." *Mangazine*. May 1995, p. 17.

2096. McCarthy, Helen. "F.A.C.T.S. TV Report." *Anime FX*. December 1995, p. 41.

2097. McCloy, Stephen. "Project A-Kon 6." *The Rose*. July 1995, p. 27.

2098. Maxwell, Joe. "Robocon 10." *The Rose*. January 1996, p. 28.

2099. Oshiguchi, Takashi. "A Convention by Any Other Name." *Animerica*. 3:1 (1995), p. 20.

2100. "Outline of the First Conference of JSAS." *The Japanese Journal of Animation Studies*. 2:1A, 2000, pp. 47-48.

2101. Savage, Lorraine. "Evolution of a Con." *The Rose*. January 1996, pp. 5-6.

2102. Savage, Lorraine. "NASFIC/Dragon Con." *The Rose*. October 1995, p. 26.

2103. Savage, Lorraine. "New York Stories." *Animerica*. 7:4 (1999), pp. 58-59.

2104. "Streamline Survives Quake, Starts Filmfest." *Mangazine*. January 1994, p. 8.

2105. Walker, Craig. "Minami Con II." *The Rose*. October 1996, p. 35.

2106. "Yarişmaler. 18. Yomiuri/Japonya." *Karikatürk.* No. 30, 1996, p. 360.

AnimEast

2107. "AnimeEast '94." *Animerica.* 3:1 (1995), pp. 12-14.

2108. Barnes, William. "ANIMEast." *Tsunami.* Summer 1995, pp. 15-16.

2109. King, Martin. "AnimEast." *Mangazine.* January 1995, pp. 28-29.

2110. Savage, Lorraine. "AnimEast '95." *The Rose.* January 1996, p. 26.

Anime Expo

2111. "Anime Expo '97: Report." *Protoculture Addicts.* September-October 1997, p. 41.

2112. Bush, Laurence. "Convention Report: Anime Expo 2000." *The Rose.* October 2000, p. 14.

2113. "Convention Reports": Anime Expo (Laurence Bush), Anime Weekend Atlanta (Lorraine Savage). *The Rose.* October 1999, pp. 33-34.

2114. Graham, Miyoko. "Anime Expo '97: Anecdotes from Mr. Akira Kamiya." *Protoculture Addicts.* September-October 1997, p. 43.

2115. Graham, Miyoko. "Anime Expo '97: Anecdotes from Mr. Kazuo Yamazaki." *Protoculture Addicts.* September-October 1997, p. 45.

2116. Graham, Miyoko. "Anime Expo '97: Anecdotes from Mr. Nobuteru Yuuki." *Protoculture Addicts.* September-October 1997, p46.

2117. Graham, Miyoko. "Anime Expo '97: Anecdotes from Mr. Yasuhiro Imagawa." *Protoculture Addicts.* September-October 1997, p. 42.

2118. Graham, Miyoko. "Anime Expo '97: Anecdotes from Ms. Miho Shimogasa." *Protoculture Addicts.* September-October 1997, p. 44.

2119. Ishiguro, Noboru. "Anime Expo '97." *Animerica.* 5:10 (1997), p. 62.

2120. Pang, Steven. "Anime Expo." *The Rose.* October 1997, pp. 24-25.

2121. Pang. Steven. "Anime Expo '96." *The Rose.* October 1996, p. 34.

Anime North

2122. Graham, Miyoko. "Anime North '97: Report." *Protoculture Addicts.* September-October 1997, p. 47.

2123. Lyon, Matt. "Anime North." *The Rose.* October 1997, pp. 26-27.

Anime Weekend, Atlanta

2124. Merrill, David. "Anime Weekend Atlanta." *The Rose.* January 1996, p. 27.

2125. Savage, Lorraine. "Anime Weekend Atlanta." *The Rose.* January 1997, p. 32.

2126. Savage, Lorraine. "Anime Weekend Atlanta." *The Rose.* February 1998, p. 28.

International Animation Festival, Hiroshima

2127. Alder, Otto. "Hiroshima '96." *ASIFA News.* 9:4 (1996), pp. 4-5.

2128. "Animation Workshops – Hiroshima '96." *ASIFA News.* 9:4 (1996), pp. 6-7.

2129. d'Hondt, Ivan. "Animation Histories." *Plateau.* 13:3 (1992), pp. 4-10.

2130. d'Hondt, Ivan. "The 3ʳᵈ International Animation Festival in Japan. Hiroshima '90. Love and Peace." *Plateau.* Autumn 1990, pp. 8-10.

2131. Edera, Bruno. "Lettre du Japon." *Plateau.* 15:3 (1994), pp. 12-14.

2132. Ehrlich, David. "6ᵗʰ International Hiroshima Animation Festival Report." *ASIFA San Francisco.* October 1996, pp. 7-8.

2133. "The 8ᵗʰ Hiroshima International Animation Festival." *Animatoon.* No. 27, 2000, pp. 8-15.

2134. "Hiroshima: Au Secours!" *Plateau.* 21:3 (2000), p. 32.

2135. "Hiroshima '96." *Animatoon.* No. 6 (August), 1996, pp. 24-27.

2136. "Hiroshima '96." *Animatoon.* No. 7, 1996, pp. 32-36.

2137. "Hiroshima '98 Awards." *ASIFA News.* 11:3 (1998), p. 9.

2138. Jackson, Wendy. "Images from Hiroshima '96." *Animation World.* September 1996.

2139. Kinoshita, Sayoko. "Screening & Lecture: The Best Selection of International Animation Festival Hiroshima." *The Japanese Journal of Animation Studies.* 2:1A, 2000, p. 49.

2140. Renault, Monique. "Festival Diary." *Animation World.* September 1996.

2141. Renault, Monique. "Hiroshima Diary." *Animation World.* September 1996, 6 pp.

2142. Renoldner, Thomas. "What Was the ASIFA Board in Hiroshima Talking About." *ASIFA News.* 9:4 (1996), p. 2.

2143. "Report at the Spot 2. The 6th International Festival in Hiroshima '96." *Animatoon.* No. 7, 1996, pp. 32-36.

2144. "6th International Animation Festival Hiroshima '96." *Animatoon.* No. 6, 1996, pp. 24-27.

2145. Webb, Pat R. "Hiroshima '96." *Society for Animation Studies Newsletter.* Fall 1996, pp. 4, 6.

Katsucon

2146. Adkins, Alexander. "Katsucon 3." *The Rose.* April 1997, pp. 26, 31.

2147. Bissey, Laura. "Katsucon 7: Adventures at an Anime Con." *Sequential Tart.* March 2001.

2148. Flage, Karon. "It Is All About the Fundraising." *Sequential Tart.* March 2001.

2149. Luu, Loan. "Remembering KatsuCon" *Tsunami.* Summer 1995, pp. 13-15.

2150. Nelson, Brandon. "Katsucon." *The Rose.* July 1997, p. 26.

2151. Savage, Lorraine. "Convention Report: KatsuCon." *The Rose.* April 1995, p. 25.

Otakon

2152. Lillard, Kevin. "Otakon 1999." *Manga Max.* September 1999, p. 45.

2153. Savage, Lorraine. "Otakon." *The Rose.* October 1995, p. 26.

2154. Savage, Lorraine. "Otakon." *The Rose.* October 1997, pp. 25-26.

2155. Savage, Lorraine. "Otakon '96." *The Rose.* October 1996, pp. 34-35.

San Diego Comic Con

2156. Oshiguchi, Takashi. "On the 1996 San Diego Comic Convention." *Animerica.* 4:9 (1996), p. 60.

2157. Oshiguchi, Takashi. "On the 1999 San Diego Comic Convention." *Animerica.* 7:10 (1999), p. 68.

2158. Oshiguchi, Takashi. "On the San Diego Comic Convention." *Animerica.* 3:10 (1995), p. 45.

2159. Savage, Lorraine. "San Diego Comic Con." *The Rose.* October 1997, pp. 27-28.

Yomiuri International Cartoon Contest

2160. "Humour & Satire. The 21 Yomiuri International Cartoon Contest." *Kayhan Caricature.* June/July 2000, 4 pp.

2161. "Tokio. Yomiuri International Cartoon Contest." *Sic.* No. 7, n.d., pp. 12-13.

2162. "Yomiuri Hakkinda." *Karikatürk.* Şubat 1994, p. 27.

2163. "Yomiuri Shimbun 'dan Ödüller." *Karikatürk.* March 1999, p. 10.

2164. "The Yomiuri Shimbun 1999." *FECO News.* No. 30, 2000, p. 18.

2165. "The Yomiuri Shimbun 10th Biennale di Caricatura." *Kayhan Caricature.* December/January 1997, pp. 8-9.

Characters and Titles
Anime (Animation)
Reviews, Synopses: Multiple Titles

2166. "America's Bestselling Anime." *Animerica.* 3:12 (1995), p. 18.

2167. "America's Top Sellers." *Animerica.* 2:7 (1994), p. 17.

2168. "Animation Update." *Animag.* No. 5, 1988, p. 3.

2169. "Anime Countdown." *The Rose.* October 1999, p. 17.

2170. "Anime Express." *Animerica.* 3:9 (1995), pp. 12-18.

2171. "Anime Forecasts." *Animation.* February 2000, pp. 98, 109.

2172. "The Anime/Manga Shelf." *Comics Buyer's Guide.* April 23, 1999, p. 20.

2173. "The Anime/Manga Shelf." *Comics Buyer's Guide.* May 7, 1999, p. 22.

2174. "The Anime/Manga Shelf." *Comics Buyer's Guide.* May 14, 1999, p. 24.

2175. "The Anime/Manga Shelf." *Comics Buyer's Guide.* May 21, 1999, p. 24.

2176. "The Anime/Manga Shelf." *Comics Buyer's Guide.* May 28, 1999, p. 22.

2177. "The Anime/Manga Shelf." *Comics Buyer's Guide.* June 4, 1999, p. 26.

2178. "The Anime/Manga Shelf." *Comics Buyer's Guide.* June 11, 1999, p. 22.

2179. "The Anime/Manga Shelf." *Comics Buyer's Guide.* June 18, 1999, p.20.

2180. "The Anime/Manga Shelf." *Comics Buyer's Guide.* June 25, 1999, p. 22.

2181. "The Anime/Manga Shelf." *Comics Buyer's Guide.* July 2, 1999, p. 20.

2182. "The Anime/Manga Shelf." *Comics Buyer's Guide.* July 9, 1999, p. 30.

2183. "The Anime/Manga Shelf." *Comics Buyer's Guide.* July 16, 1999, p. 58.

2184. "The Anime/Manga Shelf." *Comics Buyer's Guide.* July 30, 1999, p. 22

2185. "The Anime/Manga Shelf." *Comics Buyer's Guide.* August 6, 1999, p. 12.

2186. "The Anime/Manga Shelf." *Comics Buyer's Guide.* August 13, 1999, p. 26.

2187. "The Anime/Manga Shelf." *Comics Buyer's Guide.* September 10, 1999, p. 22.

2188. "The Anime/Manga Shelf." *Comics Buyer's Guide.* September 24, 1999, p. 24.

2189. "The Anime/Manga Shelf." *Comics Buyer's Guide.* October 22, 1999, p. 20.

2190. "The Anime/Manga Shelf." *Comics Buyer's Guide.* November 12, 1999, p. 40.

2191. "The Anime/Manga Shelf." *Comics Buyer's Guide.* March 10, 2000, p. 43.

2192. "The Anime/Manga Shelf." *Comics Buyer's Guide.* August 27, 1999, p. 20.

2193. "The Anime/Manga Shelf: Games Publisher Adds New Anime Titles to Line-up." *Comics Buyer's Guide.* April 30, 1999, p. 20.

2194. "Anime Radar." *Animerica.* June 1999, pp. 26-27.

2195. "Anime Radar." *Animerica.* 7:4 (1999), pp. 24-25.

2196. "Anime Radar." *Animerica.* 7:7 (1999), pp. 26-27.

2197. "Anime Radar." *Animerica.* 7:8 (1999), pp. 25-27.

2198. "Anime Radar." *Animerica.* 7:9 (1999), p. 26-27.

2199. "Anime Radar." *Animerica.* 7:11 (1999), pp. 25-27.

2200. "Anime Radar." *Animerica.* 7:12 (1999), pp. 26-27.

2201. "Anime Radar." *Animerica.* 8:1 (2000), pp. 28-29.

2202. "Anime Radar." *Animerica.* 8:3 (2000), pp. 30-31.

2203. "Anime Radar." *Animerica.* 8:4 (2000), pp. 32-34.

2204. "Anime Radar." *Animerica.* 8:5 (2000), pp. 31-33.

2205. "Anime Radar." *Animerica.* 8:6 (2000), pp. 32-33.

2206. "Anime Radar." *Animerica.* 8:7 (2000), pp. 32-33.

2207. "Anime Reviews ["Devil Hunter Yohko," "Cutey Honey," "Gunnm," "Guyver: Out of Control"]." *Kung-fu Girl.* Winter 1994, pp. 47-50.

2208. "Animerica Extra." *Animerica* 7:4 (1999), p. 63-65.

2209. "Animerica Radar." *Animerica.* 3:12 (1995), p. 19.

2210. "Animerica Radar." *Animerica.* 4:2 (1996), p. 16.

2211. "Animerica Radar." *Animerica.* 4:3 (1996), pp. 14-15.

2212. "Animerica Radar." *Animerica.* 4:4 (1996), p. 16.

2213. "Animerica Radar." *Animerica.* 4:5 (1996), p. 15.

2214. "Animerica Radar." *Animerica.* 4:6 (1996), p. 15.

2215. "Animerica Radar." *Animerica.* 4:7 (1996), pp. 14-15.

2216. "Animerica Radar." *Animerica.*4: 8 (1996), pp. 14-15.

2217. "Animerica Radar." *Animerica.* 4:9 (1996), pp. 14-15.

2218. "Animerica Radar." *Animerica.* 4:10 (1996), pp. 14-15.

2219. "Animerica Radar." *Animerica.* 4:11 (1996), pp. 14-15.

2220. "Animerica Radar." *Animerica.* 4:12 (1996), pp. 14-15.

2221. "Animerica Radar." *Animerica.* 5:1 (1997), pp. 14-15.

2222. "Animerica Radar." *Animerica.* 5:2 (1997), p. 15.

2223. "Animerica Radar." *Animerica.* 5:3 (1997), pp. 14-15.

2224. "Animerica Radar." *Animerica.* 5:4 (1997), p. 15.

2225. "Animerica Radar." *Animerica.* 5:5 (1997), p.15.

2226. "Animerica Radar." *Animerica.* 5:6 (1997), p. 15.

2227. "Animerica Radar." *Animerica.* 5:7 (1997), p. 15.

2228. "Animerica Radar." *Animerica.* 5:8 (1997), pp. 14-15.

2229. "Animerica Radar." *Animerica.* 5:9 (1997), p. 15.

2230. "Animerica Radar." *Animerica.* 5:10 (1997), pp. 14-15.

2231. "Animerica Radar." *Animerica.* 6:9 (1998), pp. 22-23.

2232. "Animerica Radar." *Animerica.* 6:12 (1998), pp. 20-21.

2233. "Animerica Radar." *Animerica.* 9:1 (1999), pp. 20-21.

2234. "Animerica's Sound Bites." *Animerica.* 5:6 (1997), pp. 26-27.

2235. "The Animerica Top Five." *Animerica.* 5:4 (1997), p. 14.

2236. "The Animerica Top Five." *Animerica.* 5:7 (1997), p. 14.

2237. "The Animerica Top Ten: Japan's Bestselling LDs." *Animerica.* 3:11 (1995), p. 18.

2238. "Anime Series OAV." *Animerica.* 4:12 (1996), pp. 4-5.

2239. "Anime Series Roundup." *Animerica.* 5:6 (1997), pp. 4-5.

2240. "Animexpress." *Animerica.* 4:2 (1996?), pp. 11-16. ("Sailor Soldiers, Sail On," "Tenchi at the Edge of Forever," "She Sells Sanctuary," "Gunsmith Cats," "Blue Seed," "Hyper Dolls," "Mobile Suit Gundam Team 08," "Dangaioh," "Cybernetics Guardian").

2241. "Animexpress." *Animerica.* 4:10 (1996), pp. 10-12.

2242. "Animexpress." *Animerica.* 4:12 (1996), pp. 10-13. ("Fushigi Yūgi," "El-Hazaard," "Legend of Crystania," "Kummen Jungle Wars," "Darkstalkers," "Lone Wolf and Cub," "Bakuretsu Hunter," "Kizuna," "Bronze Zetsuai," "Bubblegum Crisis").

2243. "Animexpress." *Animerica.* 5:2 (1997), pp. 10-13. ("Dog of Flanders," "Cutey Honey Flash," "Armored Trooper Votoms: The RPG," "Ani-Mayhem Demo Day," "Yūsha-Ō Gowaiga," "Power Dolls," "Urusei Yatsura," "Psycho Driver," "Sanctuary: The Movie").

2244. "Animexpress." *Animerica.* 5:3 (1997), pp. 10-13. ("Gunhed, X/1999," "Eat-Man," "Ranma ½," "Utena," "Armored Trooper Votoms," "Ushio and Tora, Dark Myth").

2245. "Animexpress." *"Animerica.* 5:4 (1997), pp. 12-13. ("Magic Knight Rayearth OAV Series," "New Tenchi Muyō! TV Series," "Welcome to Lodoss Island," "Cowboy Be-Bop," "Haunted Junction," "Boy," "Hyper Police").

2246. "Animexpress." *Animerica.* 5:5 (1997), pp. 10-14. ("Blue Oru," "Inu-Yasha," "Girlish Revolution Utena," "Slayers," "Clamp Gakuen Tanteidan," "Maze," "Crusher Joe," "The Case Files of Young Kindaichi," "Adieu Galaxy Express 999," "Black Jack").

2247. "Animexpress." *Animerica.* 5:6 (1997), pp. 10-12. ("Ranma ½," "Jungle Emperor," "Battleship Nadeshiko," "Psychic Force," "VS Knight Lamune and 40 Fresh," "Yakumo Tatsu," "Photon," "Shadow Skill").

2248. "Animexpress." *Animerica.* 5:7 (1997), pp. 10-13. ("Warrior Nun Areala," "Devil Hunter," "El Hazard," "Night Warriors: Darkstalkers' Revenge," "Machine Robo," "Ryūki Denshō," "Yakusai Kocho," "Yokohama Shopping Travelogue," "Ghost in the Shell," "Dragon Ball Z," "Yotoden," "Bio-Hunter," "Gatchaman," "Psycho Diver").

2249. "Animexpress." *Animerica.* 5:8 (1997), pp. 10-14. ("Macross," "Steamboy," "Noiseman," "Misutenai Daisy," "Outlaw Star," "Jin-rō," "Tamagotchi," "Perfect Blue," "Crusher Joe").

2250. "Animexpress." *Animerica.* 5:10 (1997), pp. 10-11. ""Kasei Ryodan Dnasight 999.9," "Makai Tenshō," "Cats Eye," "Tekken").

2251. "Animexpress." *Animerica.* 6:9 (1998), pp. 20-21. ("Eat-Man '98," "Yusha-Ō Gaogaigâ," "Saber Marionette J2," "Gundam A Project," "Patlabor Game," "Voltron: The Third Dimension," "The Slayers: Record of Lodoss War").

2252. "Animexpress." *Animerica.* 6:10 (1998), pp. 16-19. ("Gen 13," "Bubblegum Crisis: Tokyo 2040," "Black Magic," "Mobile Suit Gundam: Blue Destiny," "Shadow Lady," "Madoka," "Majutsushi Ōfen," "Best Wars Special," "Kurogane Communication," "Glass No Kamen," "Devilman Lady").

2253. "Animexpress." *Animerica.* 6:12 (1998), pp. 14-15. ("Mobile Suit Gundam 0079, "Harlock Saga," "The Sandman," "Birdy the Mighty," "Marriage," "Tenchi in Tokyo," "Toki no Daichi").

2254. "Animexpress." *Animerica.* June 1999, pp. 20-25. ("Five Star Stories," "Sailor Moon," "City Hunter," "Fake," "Dark Angel," "Lain," "Anime Box Sets," "Moon Over Tao," "Studio Ghibli Limited-Edition Art," "Ironcat," "Futaba-kun Change! New Vampire Miyu," "Anime RPGS," "Schell Bullet," "Eden's Boy," "City Hunter Emergency Live Broadcast," "Super God Princess Dangaizer 3").

2255. "Animexpress." *Animerica.* 7:2 (1999), pp. 16-21. ("Tenchi Muyo! In Love 2," "Pokémon," "Mahô Tsukai-Tai!" "Anime Wall Art," "Card Captor Sakura: The Movie," "To Heart," "Cyber Squad Akihabara," "Sorcerer Hunters," "Sailor Moon Super S," "Saber Marionette R," "Neon Genesis Evangelion," "Oh My Goddess!" "Geobreeders").

2256. "Animexpress." *Animerica.* 7:4 (1999), pp. 18-19. ("Original Dirty Pair," "DNA Sights 999.9," "Sailor Moon," "Oh My Goddess!" "Sakura Wars," "Pokémon").

2257. "Animexpress." *Animerica.* 7:6 (1999), pp. 20-23. ("Castle of Cagliostro," "Record of Lodoss," "The Alternative World," "Outlaw Star, Cowboy Bebop," "Gundam Blue Destiny," "Hyper Speed Grandoll," "Princess Rouge," "Surfside High School," "D," "Jubei-Chan," "Chivas 1-2-3," "Tokimeki Memorial").

2258. "Animexpress." *Animerica.* 7:8 (1999), pp. 20-24. ("Neon Genesis Evangelion," Dirty Pair," "Gundam: The 08th Ms Team," "Card Captor Sakura," "Fushigi Yûgi," "Steam Detectives," "X/1999," "Magic Knight Rayearth," "Macross," "Sol Bianca: The Legacy," "Drakuun," "Outlanders," "Oh My Goddess!" "The Vision of Escaflowne," "GTO," "The Big O," "Goddess Cadets").

2259. "Animexpress." *Animerica.* 7:9 (1999), pp. 20-21. ("Sandman: The Dream Hunters," "Card Captor Sakura," "Digimon," "Karakuri Sōshi Ayatsuri Sakon," "Video Girl Ai," "Jibakukun").

2260. "Animexpress." *Animerica.* 7:10 (1999), pp. 22-27. ("Lady Death," "Martian Sucessor Nadesico," "X," "Cowboy Bebop," "Maison Ikkodu, Ranma ½," "Macross Plus," "Steel Angel Kurumi," "Earth Protection Corporation Daiguard," "Ryvaius," "Arms," "Boys Be . . .").

2261. "Animexpress." *Animerica.* 7:11 (1999), pp. 24-25. ("Blue Gender," "Danger Girl," "Excel Saga," "Angel Sanctuary").

2262. " Animexpress." *Animerica.* 7:12 (1999), pp.22-26. ("Super Manga Blast," "Gundam Wing," "Anime on Cartoon Network," "Kia Asamiya Artwork," "Dirty Pair," "Rurōni Kenshin," "Gigantor," "Street Fighter Zero," "Hunter x Hunter," "Amon Devilman Chronicles," "Future Boy Canan 2").

2263. "Animexpress." *Animerica.* 8:1 (2000), pp. 22-27. ("Cosplay Encyclopedia," "Pet Shop of Horrors," "Gestalt," "Tattoon Master," "Garzey's Wing, Brain Powered," "Vampire Hunter D," "Nazca," "Sailor Moon," "Boogie-pop Phantom," "Sakura Wars," "Sen'nen Joyū," "Oh! Super Milk-chan," "Di Gi: Charot," "FICL," "The Wanderer Gekkeiran," "Weiβ Kreuz," "Macross 3D").

2264. "Animexpress." *Animerica.* 8:2 (2000), pp. 22-26.

2265. "Animexpress." *Animerica.* 8:3 (2000), pp. 25-29. ("Monster Rancher," "Sin the Movie," "Kimba the White Lion," "Macross Plus Toys," "Anime DVDs," "Ayashi No Ceres," "Attack Armor Audian," "Angelique," "Pokémon," "Rumiko Takahashi Game Designs").

2266. "Animexpress." *Animerica.* 8:4 (2000), pp. 26-28. ("Princess Mononoke," "Toonami," "Manga," "ADV Fansubs/ADV Music,"

"Japanese Snacks," "Digimon," "Kaitō Kiramekiman," "Yu-Gi-Oh Duel Monsters," "Jo Jo's Bizarre Adventures").

2267. "Animexpress." *Animerica*. 8:5 (2000), pp. 25-29. ("Cardcaptors," "Speed Racer," "Flint the Time Detective," "Gundam Wing," "Manga," "Lost Universe," "Oh My Goddess!" "Midnight Eye Goku," "The Vision of Escaflowne," "Apocalypse Zero Battle," "Aquarium," "Denshin Mamotte Shugo Getten!" "Saiyuki," "Crest of the Stars 2").

2268. "Animexpress." *"Animerica.* 8:6 (2000), pp. 27-30. ("Detective Conan," "Eagle," "Blue Submarine No. 6," "El-Hazard," "Cleopatra DC," "Dragon Ball," "Space Travelers," "Strange Dawn," "éx-D," "Devilman," "Labyrinth of Fire").

2269. "Animexpress." *Animerica*. 8:7 (2000), pp. 27-31. ("Lone Wolf and Cub," "Virtua Fighter," "Gasaraki," "Jubei-chan," "3x3 Eyes," "Legend of Hiwou," "Brigadoon Marin and Meran," "Tri-Zenon," "R.O.D.").

2270. "Animexpress." *Animerica*. 9:1 (1999), pp. 14-15. ("Magic Knight Rayearth," "Ghost in the Shell," "Anime: The History of Japanese Animated Film," "Fist of the North Star," "Prince Lightning," "Crusher Joe").

2271. "Animexpress: Dragon Ball, Gundam Wing, Gall Force, Rumic World, Chōsha Raideen, Akachan To Boku, Ani-Mayhem, Castle of Cagliostro." *Animerica*. 4:9 (1996), pp. 10-13.

2272. Arnold, Erica. "What's New in Japan." *The Rose*. February 2000, p. 20.

2273. Beam, John. "Anime." *Animato!*. Summer/Fall 1997, pp. 50-53, 64. ("Burn-Up W," "Neon Genesis Evangelion," "Crusher Joe the Movie," "Night on the Galactic Railroad," "Ushio & Tora," "Street Fighter II V," "Macross Plus the Movie").

2274. Beam, John. "Anime Reviews." *Animato!* Winter/Spring 1999, pp. 64-65. ("Kiki's Delivery Service," "Blue Seed," "Go Nagai's New Cutey Honey," "Dirty Pair Flash," "Gunbuster," "Neon Genesis Evangelion 0.9-0:11," "KEY The Metal Idol," "Ellcia," "Ranma," "Rail of the Star," "Maison Ikkoku: She's Leaving Home," "Street Fighter ZV," "Giant Robo," "Urusei Yatsura," "Slayers the Motion Picture").

2275. Beam, John and G. Michael Dobbs. "Anime." *Animato!* Spring 1997, pp. 9-10. ("M.D. Geist II: Deathforce," "Street Fighter II," "Vampire Princess Miyu," "Roujin Z," "Tenchie the Movie").

2276. "Best of the East." *Animerica*. 4:4 (1996), pp. 66-67.

2277. "Best of the East." *Animerica.* 5:2 (1997), pp. 66-67. ("Hōma Hunter Lime," "Marriage," "Natsuki Crisis Clash 1," "Lupin III: Dead or Alive").

2278. "Best of the East." *Animerica.* 5:3 (1997), pp. 62-63.

2279. "Best of the East." *Animerica.* 6:9 (1998), pp. 72-73.

2280. "Best of the East." *Animerica.* 6:10 (1998), pp. 66-67. ("Silent Moebius TV," "Ginga Hyôryû Vifam," "Lost Universe," "Galaxy Express 999: Eternal Fantasy").

2281. "Best of the East." *Animerica.* 6:12 (1998), pp. 74-75. ("Bubblegum Crisis: Tokyo 2040," "Initial D," "Lain," "Perfect Blue").

2282. "Best of the East." *Animerica.* 7:3 (1999), pp. 76-77. ("Spriggan," "DNA Sights," "Tao No Tsuki," "The End of Evangelion").

2283. "Best of the East." *Animerica.* 7:4 (1999), pp. 76-77. ("Harlock Saga," "Mobile Suit Gundam," "Getter Rono").

2284. "Best of the East." *Animerica* 7:6 (1999), pp. 80-81. ("'Turn A' Gundam," "Corrector Yui," "DT Eightron," "Cyber Team Akihabara").

2285. "Best of the East." *Animerica.* 7:7 (1999), pp. 88-89. ("Generator Gawl, Vol. 1," "Arc the Lad," "Angel Links," "Power Stone").

2286. "Best of the East." *Animerica.* June 1999, pp. 80-81. ("Pokemon," "Z-Mind," "Eatman '98," "Kareshi Kanjo no Jijo").

2287. "Best of the East." *Animerica.* 7:8 (1999), pp. 80-81. ("Dual," "A.D. Police," "Neoranga," "Betterman").

2288. "Best of the East." *Animerica.* 7:9 (1999), pp. 86-87. ("Celestial Crest Vol. 1," "Card Captor Sakura," "Himiko-Den Vol. 1," and "Samurai Spirits 2, Vol. 1").

2289. "Best of the East." *Animerica.* 7:10 (1999) pp. 84-85. ("Devilman Lady Vol. 1," "Devilman TV Series," "Ghost Sweeper Mikami," "Ge Ge Ge No Kitaro").

2290. "Best of the East." *Animerica.* 7:11 (1999), 84-85. ("D4 Princess," "Jubei-chan," "Tenshi ni Narumon," "Eden's Boy").

2291. "Best of the East." *Animerica.* 7:12 (1999), pp. 84-85. ("Master Keaton," "GTO," "Shin Hakkenden," "The Big O").

2292. "Best of the East." *Animerica.* 8:1 (2000), pp. 84-85. ("Kachō Ōji," "Psibuster," "Excel Saga," "Daiguard").

2293. "Best of the East." *Animerica.* 8:3 (2000), pp. 84-85.

2294. "Best of the East." *Animerica.* 8:5 (2000), pp. 84-85.

2295. "Best of the East Anime." *Animerica.* 8:2 (2000), pp. 84-85.

2296. "Best of the East Anime." *Animerica.* 8:4 (2000), pp. 84-85

2297. "Best of the East Anime." *Animerica.* 8:6 (2000), pp. 84-85.

2298. "Best of the East Anime." *Animerica.* 8:7 (2000), pp. 84-85.

2299. "Best of the East: Import Only Anime Reviews." *Animerica.* 6:11 (1998), pp. 70-71. ("Shin Getta Robo, Vol. 1," "Mazinger Z," "Gekiganga 3," "Chô Denji Machine Voltes V").

2300. "Best of the East: The Import Report." *Animerica.* 4:2 (1996), pp. 62-63. ("Mechancial Violator Hakaider," "Wedding Peach," "Goldoran," "Mars").

2301. "Best of the East: The Import Report." *Animerica.* 4:3 (1996), pp. 62-63.

2302. "The Best of the East: The Import Report." *Animerica.* 4:12 (1996), pp. 64-65.

2303. "Best of the East Import Report." *Animerica.* 5:4 (1997), pp. 62-63.

2304. "Best of the East: The Import Report." *Animerica.* 5.5 (1997), pp. 62-63.

2305. "Best of the East Import Report." *Animerica.* 5:7 (1997), pp. 64-65. ("Eat-Man," "Elf O Karu," "Kindaichi Shōnen no Jikenbo," "Hana Yori Dango").

2306. "Best of the East: The Import Report." *Animerica.* 5:10 (1997), pp. 64-65.

2307. "Best of the West." *Animerica.* 4:4 (1996), pp. 68-69.

2308. "Best of the West." *Animerica.* 4:9 (1996), pp. 66-67

2309. "Best of the West." *Animerica.* 4:10 (1996), pp. 65-69.

2310. "Best of the West." *Animerica.* 4:11 (1996), pp. 66-69.

2311. "Best of the West." *Animerica.* 4:12 (1996), pp. 66-69.

2312. "Best of the West." *Animerica.* 5:1 (1997), pp. 66-69.

2313. "Best of the West." *Animerica.* 5:3 (1997), pp. 66-69.

2314. "Best of the West." *Animerica.* 5:4 (1997), pp. 66-69. ("Akai Hayate," "Burn Up W," "Dark Warrior: First Strike," "Dragon Ball," "Yuna," "Here Is Greenwood," "Junk Boy," "Kizuna," "Neon Genesis Evangelion," "Atragon," "Tenchi," "Ultimate Teacher").

2315. "Best of the West." *Animerica.* 5:6 (1997), pp. 66-69.

2316. "Best of the West." *Animerica.* 5:7 (1997), pp. 66-69. ("Black Jack Clinical Chart 1," "Battle Arena Toshinden," "Dark Myth Part 1," "Darkside Blues," "Golden Boy," "Grappler Baki: The Ultimate Fighter," "Gunhed," "Lone Wolf and Cub," "Street Fighter," "Sanctuary," "Suikoden: Demon Century," "Ushio and Tora").

2317. "Best of the West." *Animerica.* 5:9 (1997), pp. 66-69. ("Adieu Galaxy Express 999," "Black Jack Clinical Chart #1," "The Dark Myth Part 2," "Gunhed," "Darkside Blues," "Key the Metal Idol Vol. 1," "Leda: The Fantastic Adventures of Yohko," "Machine Robo: The Revenge of Cronos," "Macross Plus the Movie," "Patlabor, the Mobile Police: The Original Series," "Sanctuary: The Movie," "Shadow Skill").

2318. "Best of the West." *Animerica.* 5:10 (1997), pp. 66-69.

2319. "Best of the West." *Animerica.* 7:3 (1999), pp. 66-70. ("Ninja Resurrection," "Blood Reign," "Macross," "Marriage," "Earthian: Final Battle," "Grave of the Fireflies," "Battle Athletes Victory," "Magical Project S," "Balthus: Tia's Radiance").

2320. "Best of the West." *Animerica.* 8:1 (2000), pp. 70-75. (Rio Yanez, "Ehrgeiz"; Brian Camp, "Serial Experiments Lain"; Brian Camp, "Outlaw Star"; Rio Yanez, "Silent Möbius"; Rio Yanez, "Wild Cardz"; Patrick Macias, "AWOL"; Corina Borsuk. "The Slayers Next: Phantom City").

2321. "Best of the West." *Animerica.* 8:2 (2000), pp. 69-75. (Kit Fox, "Cowboy Bebop"; Adam Rehorn, "Those Who Hunt Elves"; Rio Yanez, "Geobreeders"; Patrick Macias, "Ninja Resurrection DVD"; Adam Rehorn, "Original Dirty Pair"; Patrick Macias, "Garzey's Wing"; Patrick Macias," "City Hunter"; Adam Rehorn, "Sorcerer Hunters"; Rio Yanez. "Tattoo Master").

2322. "Best of the West." *Animerica.* 8:3 (2000), pp. 69-75. (Brian Camp, "A Chinese Ghost Story"; Rio Yanez, "Brain Powered"; Adam Rehorn, "E-Hazard: The Alternative World"; Adam Rehorn, "Nazca"; Rio Yanez, "Sakura Wars DVD"; Rio Yanez, "Spell Wars"; Adam Rehorn," "Tenchi in Tokyo").

2323. "Best of the West." *Animerica.* 8:4 (2000), pp. 69-71. (Angeline Kim, "Bubblegum Crisis: Tokyo 2040"; Adam Rehorn, "Martian Successor Nadesico"; Kit Fox, "She Sells Sorcery: Gestalt"; Rio Yanez, "Pet Shop of Horrors;" Rio Yanez, "Master of Mosquiton the Vampire"; Kit Fox, "Blue Submarine No. 6"; Brian Camp, "Power Dolls 2"; Adam Rehorn, "Outlaw Star").

2324. "Best of the West." *Animerica.* 8:5 (2000), pp. 69-76. (Rio Yanez, "Cool as Iczel: Iczelion"; Adam Rehorn, "Record of Lodoss War: Chronicles of the Heroic Knight"; Marc Hairston, "Nadia: The Secret of Blue Water: Vol. 1"; Rio Yanez, "Photon"; Corina Borsuk, "Sailor Moon R the Movie"; Adam Rehorn, "Magic Knight Rayearth"; Adam Rehorn, "Silent Möbius"; Adam Rehorn, "Trigun: Vol. 1"; Kit Fox, "Voogie's Angel").

2325. "Best of the West." *Animerica.* 8:6 (2000), pp. 69-71. (Rio Yanez, "Perfect Blue"; Kit Fox, "Jungle de Ikou"; Adam Rehorn, "Brain Powered"; Adam Rehorn, "Cowboy Bebop"; Rio Yanez, "Sol Bianca: The Legacy"; Adam Rehorn, "Outlaw Star"; Adam Rehorn, "Those Who Hunt Elves").

2326. "Best of the West." *Animerica.* 8:7 (2000), pp. 69-71. (Patrick Macias, "Neon Genesis Evangelion"; Adam Rehorn, "Dragoon"; Rio Yanez, "Sailor Moon S the Movie"; Rio Yanez, "Gundam Wing"; Dr. Brown, "Blue Submarine No. 6"; Kit Fox, "Shamanic Princess"; Adam Rehorn, "Haunted Junction Vol. 5"; Rio Yanez, "Pokémon: The First Movie DVD").

2327. Bomford, Jen. "Coming Up Next: Anime Titles To Keep an Eye On!" *Sequential Tart.* March 2001.

2328. Bomford, Jen. "Kodomo No Omocha (Child's Toy): An Actress, an Award-Winning Writer, an Angry Boy, and a Squirrel?" *Sequential Tart.* February 2001.

2329. Bomford, Jen. "The Sensitive New Age Antihero: Leading Men of Anime." *Sequential Tart.* November 2000.

2330. Brimmicombe-Wood, Lee, *et al.* "Postmortem." *Manga Mania.* July-August 1997, pp. 90-93. ("Neon Genesis Evangelion," "Tenchi Muyo in Love," "Shadow Skill," "Power Dolls," "Darkside Blues," "The Outlaw Brothers," "Blue Sonnet, "Patlabor the Mobile Police: The New Files V-3," "Battle Arena Toshinden").

2331. Brown, Urian, Kit Fox, Patrick Macias, Julie Davis, and Corina Borsuk. "AV Interface." *Animerica.* 7:7 (1999), pp. 84-87. ("Super Smash Bros.," "Cowboy Bebop Blue," "Kikaider," "Pokémon Stadium," "Sailor Moon: A Scout Is Born," "Fire Bomber: Ultra Fire!" "Pokémon Guide Books," "Brain Powered Original Soundtrack").

2332. Camp, Brian. "Manga into Anime. Two Approaches: *Sanctuary* and *Ghost in the Shell*." *Animation World Magazine.* July 1997, pp. 63-64.

2333. Carter, Lloyd. "Tenchi & Bubblegum Crisis on DVD." *The Rose.* February 2000, p. 21.

2334. "Catnapped." *Fant-Asia.* July/August 1997, p. 26.

2335. Chua, Johann, Kit Fox, Dwight R. Decker, Michael O'Connell. "Reviews." *Animerica.* 6:9 (1998), pp. 64-67. ("One-Pound Gospel," "Neon Genesis Evangelion," "Ranma ½ The Movie: Big Trouble in Nekonron, China," "Tekkaman Blade II Stage I: The New Generation").

2336. Clarke, Jeremy. "Postmortem." *Manga Mania.* March-April 1998, pp. 73-75. ("At the Movies: Memories," "Red Hawk: Weapon of Death," "Phantom Quest Corp," "Super Atragon 2," "Shadow Skill The Movie," "The Humanoid," "Burn Up W File 3," "Neon Genesis Evangelion," "Peacock King").

2337. Clements, Jonathan. "CD Reviews." *Manga Mania.* October-November 1997, p. 85.

2338. Clements, Jonathan, Fred Patten, Julia Sertori, Cathy Sterling, Jim Swallow, Lee Brimmicombe-Wood, and Bruce Lewis. "Reviews." *Manga Max.* March 1999, pp. 41-45. ("Ushio & Tora #1," "Jungle Emperor Leo," "Birdy the Mighty #2," "Magical Project S," New Cutey Honey 3," "Sexorcist," "Bondage Queen Kate," "Mobile Suit Gundam: The Movie," "The Prince of the Sun: The Great Adventure of Hols," "Bite Me! Chameleon," "Patlabor TV #4," "Slayers: The Motion Picture").

2339. Colton, Dave. "Bubblegum Crisis: AD Police and Hurricane Live 2032/2033: Squeezing More Blood from a Turnip?" *fps.* September 1993, pp. 16-19.

2340. "Coming Soon in America." *Animerica.* 3:2 (1995), p. 12.

2341. "Coming Soon in America." *Animerica.* 3:3 (1995), p. 15.

2342. "Coming Soon in America." *Animerica.* 3: 6 (1995), p. 15.

2343. "Coming Soon in Japan." *Animerica.* 2:7 (1994), p. 15.

2344. "Coming Soon in Japan." *Animerica.* 2:11 (1994), p. 19.

2345. "Coming Soon in Japan." *Animerica.* 2:12 (1994), p. 15.

2346. "Coming Soon in Japan." *Animerica.* 3:1 (1995), p. 19.

2347. "Coming Soon in Japan." *Animerica.* 3:2 (1995), p. 15

2348. "Coming Soon in Japan." *Animerica.* 3:3 (1995), p. 18.

2349. "Coming Soon In Japan." *Animerica.* 3:5 (1995), p. 17.

2350. "Coming Soon in Japan." *Animerica.* 3:6 (1995), p. 17.

2351. "The Compact View." *Animerica.* 5:1 (1997), p. 63.

2352. Courtney, Gail, *et al.* "Postmortem." *Manga Mania.* May-June 1998, pp. 74-76. ("Black Jack," "Landlock," "Pretty Sammy: Vol. 1, The Magical Girl," "Debutante Detective Corps," Neon Genesis Evangelion 0.6 and 0.7," "Burn-Up W File 4," "Takegami: Guardian of Darkness # 1," "Poltergeist Report").

2353. Cowie, Geoff. "A Dish Served Cold?" *Manga Max.* September 1999, p. 66.

2354. Davis, Julie. "The Bigger, the Better: (The Tighter the Sweater?)." *Animerica.* 7:4 (1999), p. 7.

2355. Davis, Julie, Kit Fox, and James Teal. "The Compact View." *Animerica.* 5:7 (1997), p. 63.

2356. Davis, Julie, Daniel Huddleston, and James Teal. "The Compact View." *Animerica.* 5:9 (1997), p. 62.

2357. Davis, Julie, Casey E. Van Maanen, and Daniel Huddleston. "CD Review: The Compact View." *Animerica.* 5:4 (1997), p. 64.

2358. Davis, Julie, *et al.* "The Compact View." *Animerica.* 4:10 (1996), p. 64.

2359. Davis, Julie, *et al.* "The Compact View." *Animerica.* 5: 5 (1997), p. 65.

2360. Dawe, Aaron, Rio Yanez, Daniel Huddleston, Corina Borsuk, Kit Fox, James Teal, Mark Schumann, and Julie Davis. "Best of the West." *Animerica.* 7:10 (1999), pp. 70-83. ("City Hunter, .357 Magnum," "Moon Over Tao: Makaraga." "Elf Princess Rane," "Fake," "Urusei Yatsura TV Series Vol 21," "Record of Lodoss War," "Capnapped!" "Sailor Moon R," "Saber Marionette R," "El Hazard, The Alternative World," "Mobile Suit Gundam," "Heavy Gear 2," "Evil Zone," "How To Draw Manga").

2361. Decker, Dwight and Nova Takaoka. "Best of the West. *Animerica.* 5:2 (1997), pp. 68-69. ("Armored Trooper Votoms: Vol. 1," "Burn Up W!," "Tenchi Muyo," "Akai Hayate," "Dragon Ball," "Gunbuster Vols. 1-3," "Galaxy Express 999," "Junk Boy").

2362. Dlin, Doug. "New Season File." *Mangazine.* July 1994, pp. 6-7.

2363. Duquette, Patrick, Bob Miller, John Beam, and Celina Brooks. *Animato! Anime Guide.* Summer 1996. ("Zenki Overview," pp. 54-56; "Blue Water," pp. 56-57; "Here Is Greenwood," p. 57; "Vampire Princess Miyu," pp. 57-58; "Bounty Dog," p. 58; "Miss China's Ring," pp. 58-59; "Ghost in the Shell," pp. 59, 63).

2364. "East: The Import Report." *Animerica.* 4:8 (1996), pp. 64-65.

2365. Elias, Marc, *et al.* "Reviews." *fps.* Spring 1995, pp. 32-36, 40.

2366. Evans, Peter J. "Children of the Night." *Manga Max.* March 1999, pp. 22-26.

2367. Evans, P.J., *et al.* "Video Scan." *Anime FX.* January 1996, pp. 54-55.

2368. Evans, P.J., *et al.* "Video Scan." *Anime FX.* February 1996, pp. 54-55.

2369. "Everything Old Is New Again." *Mangazine.* July 1992, pp. 36-41. ("Tetsujin 28," "Minky Momo").

2370. "Fall Anime Preview." *Animerica.* 6:9 (1998), pp. 16-19.

2371. "Fall Anime Review." *Animerica.* 7:9 (1999), pp. 22-25.

2372. Fox, Kit, James Teal, and Julie Davis. "The Compact View." *Animerica.* 4:9 (1996), p. 63.

2373. Fox, Kit, *et al.* "The Compact View." *Animerica.* 4:11 (1996), p. 63.

2374. Frants, Marina. "Studio Ghibli, a Select Filmography." *AnimeFantastique.* Fall 1999, pp. 44-45.

2375. Greenholdt, Joyce. "Viewing 'Streetfighter II' and 'The Wings of Honneamise.'" *Comics Buyer's Guide.* December 29, 1995, p. 28.

2376. Havis, Richard J. "A Samurai and a Princess." *Asiaweek.* December 26, 1997 – January 2, 1998, p. 87.

2377. Horn, Carl G. "The Compact View." *Animerica.* 4:4 (1996), p. 62.

2378. Horn, Carl G., Phil Yee, Julie Davis, and Trish Ledoux. "The Compact View." *Animerica.* 3:12 (1995), p. 63.

2379. Horn, Carl., *et al.* "The Compact View." *Animerica.* 4:8 (1996), p. 66.

2380. "Hot Off the Press." *Animerica.* 7:7 (1999), pp. 22-25. (Pokémon," "Irresponsible Captain Tylor," "Sailor Moon," "Dragon Ball Z," "Kimagure Orange Road," "Compiler," "Urusei Yatsura," "Chirality," "Anime on Action Channel," "The Vision of Escaflowne," "Mangazine," "Kaitōranma," "Breakage").

2381. "How Will It All End? U.S.M.C.'s Gall Force 3 and Project A-Ko 4, 'Final.'" *Animerica.* 2:7 (1994), p. 17.

2382. Hughes, David. "Out of Japan." *AnimeFantastique.* Fall 1999, p. 57.

2383. Hughes, David, Helen McCarthy, Jim Swallow, Fred Patten, Ben Carter, Jeremy Clarke, and Jonathan Clements. "Reviews." *Manga Max.* October 1999, pp. 48-53. ("Eat-Man #4," "The Vision of Escaflowne #3," "Mobile Suit Gundam 0083," "Kite," "Debutante Detective Corps,"

"Haunted Junction #4," "Midnight Panther," "Record of Lodoss War," "Saber Marionette J Again # 1," "Princess Rouge," "El Hazard 2," "Spawn 13-14," "Yotoden: Broken Hell," "Perfect Blue," and "Fist of the North Star TV # 4").

2384. Hughes, David, Cathy Sterling, Jim Swallow, Julia Sertori, and Jeremy Clarke. "Reviews: UK Anime." *Manga Max.* August 1999, pp. 50-51. ("Bubblegum Crisis #3," "Toshinden," "Dirty Pair Flash 2," "Fist of the North Star # 3," "Legend of Crystania: The Cave of the Sealed").

2385. "Idol Chatter: A Select List of Idols in Anime." *Animerica.* 5:2 (1997), p. 8.

2386. "The Import Report." *Animerica.* 4:4 (1996), pp. 60-61. ("Lupin III: Kutabare! Nostradamus," "Sanctuary," "Mimo O Sumaseba," "The 08th Mobile Suit Team").

2387. "The Import Report." *Animerica.* 4:5 (1996), pp. 62-63.

2388. "The Import Report." *Animerica.* 4:10 (1996), pp. 62-63.

2389. "The Import Report." *Animerica.* 5:1 (1997), pp. 64-65.

2390. "Incoming! Release Roundup." *Anime UK.* May 1995, pp. 49-51.

2391. "Incoming Release Roundup." *Anime UK.* July 1995, pp. 48-51.

2392. "It's a Wrap!" *Animerica.* 4:5 (1996), p. 14.

2393. "I Wanna Be a Star! A Select List of Anime Idols." *Animerica.* 5:2 (1997), p. 9.

2394. "Japan's Manga Top Ten." *Animerica.* 4:12 (1996), p. 61.

2395. "Japan's Manga Top Ten." *Animerica.* 5:7 (1997), p. 62.

2396. "Japan's Top Ten." *Animerica.* 2:7 (1994), p. 14.

2397. Kandy, A.J., *et al.* "Reviews." *fps.* September 1994, pp. 30-36.

2398. Kobayashi, Kumi, Julie Davis, and James Teal. "The Compact View." *Animerica.* 5:10 (1997), p. 63.

2399. Kobayashi, Kim, *et al.* "Mini Reviews." *The Rose.* October 1995, p. 33.

2400. Kohler, Chris. "Final Fantasy Anthology." *Animerica.* 8:1 (2000), pp. 76-77.

2401. Kohler, Chris, Patrick Hodges, Trish Ledoux, Mark Simmons, Julie Davis. "AV Interface." *Animerica.* 7:8 (1999), pp. 76-78. ("Guardian's Crusade," "Lunar Silver Star Story Complete," "Bubblegum Crisis as

Sekiria," "Pokémon," "Galaxy Express 'Pre-Assembled Collection' Matel," "Joe Hisaishi Works I").

2402. Kohler, Chris, Mark Simmons, Geoffrey Tebbetts, Johann Chua, Julie Davis, and Bill Flanagan. "Reviews." *Animerica.* 7:4 (1999), pp. 72-74. ("Brave Fencer Musashi," "En Fleurage," "Giren's Greed," "Kodomo No Omocha Soundtrack," "1/100 Master Grade Gundam RX-78-2," "Steam Detectives Full Color Style," "Urusei Yatsura," "Xenogears").

2403. Leavenworth, Shelley, Patrick Macias, Angeline Kim, Kit Fox, Mark Simmons, Dr. Brown, Brian Camp, and Rio Yanez. "Best of the West." *Animerica.* 7:9 (1999), pp. 70-77. ("Bubblegum Crisis," "Riki-Oh: The Story of Ricky," "Tales of Titillation and Tales of Misbehavior," "Ninja Resurrection: Hell's Spawn," "Don't Leave Me Alone Daisy," "Compiler," "Blue Submarine No. 6," "Cowboy Bebop," "Serial Experiments Lain," "Princess Rouge," and "The Dog of Flanders").

2404. Ledoux, Trish. "The Compact View." *Animerica.* 4:6 (1996), p. 61.

2405. Lew, Joshua and Lloyd Carter. "CD Reviews." *The Rose.* April 1996, pp. 32-33. ("Rhythm Emotion Gundam Wing Single," "Virtual Fighter 2," "Robotech Perfect Soundtrack," and "Goddess Family Club").

2406. Lowson, Iain. "You Got the Look." *Manga Max.* June 1999, p. 66.

2407. McCarthy, Helen, Bruce Lewis, Jeremy Clarke, Peter J. Evans, Jim Swallow, Lee Brimmicombe-Wood. "Reviews." *Manga Max.* February 1999, pp. 54-56. ("Darkside Blues," "Slayers: Explosion Army," "Angel Dust," "Giant Robo #7," "Black Jack," "Mobile Police Patlabor," "Pokemon," "Galaxy Express 999," "Eat-Man").

2408. McCarthy, Helen, Fred Patten, Jim Swallow. "Reviews: US Anime." *Manga Max.* March 2000, pp. 52-54. ("AWOL #2," "Gundam 0080: War in the Pocket," "Eat-Man 98 #3," "Ehrgeiz #2," "Brain Powered #3," "Garzey's Wing," "Master of Mosquiton 2," "Silent Möbius TV #1," "Pokémon #10").

2409. McCarthy, Helen, Jim Swallow, Lee Brimmicombe-Wood, Jeremy Clarke, Fred Patten, Julie Sertori, Cathy Sterling, Melissa Hyland. "Reviews." *Manga Max.* July 1999, pp. 50-57. ("City Hunter: The Movie," "Genocyber," "Legend of Cyrstina: A New Beginning," "Nightmare Campus: The Movie," "Pokémon," "Sorcerer Hunters #3," "Ranma ½: Tattoo You," "The Slayers Next: The Sudden Pinch," "Those Who Hunt Elves," "Bubblegum Crisis #2," "Fist of the North Star TV #2," "Slayers Dragon Slave").

2410. McCarthy, Helen, *et al.* "Video Reviews." *Anime UK.* December 1994/January 1995, pp. 44-46.

2411. Macias, Patrick, Julie Davis, and Mark Simmons. "AV Interface." *Animerica.* June 1999, pp. 76-78. ("Kamen Rider," "Hime Brain Powered," "Mario Party," "Yamato 1/1300 Die- Cast Model").

2412. Macias, Patrick, Kit Fox, Brian Camp, and Rio Yanez. "Best of the West." *Animerica.* 7:7 (1999), pp. 78-82. ("Battle Skipper the Movie," "Orochi, the Eight-Headed Dragon," "Eat-Man, Vol. 1," "Black Jack," "Kimba the White Lion: The Vow of Peace," "DNA Sights 999.9," "Hyper-Speed Grandoll").

2413. Macias, Patrick, Kit Fox, James Teal, and Trish Ledoux. "The Compact View." *Animerica.* 4:12 (1996), p. 63.

2414. Macias, Patrick, Rio Yanez, Geoffrey Tebbetts, Kit Fox, Brian Camp, and Dwight R. Decker. "Best of the West." *Animerica.* 7:8 (1999), pp. 70-75. ("Midnight Panther," "Ninja Cadets," "Tenchi Muyô!" "Video Girl Ai," "Outlaw Star," "Fist of the North Star, Vol. 3," "Revolutionary Girl Utena 1-4," "Saber Marionette J Again," "Queen Emeralda").

2415. "Manga Closeup." *Animerica.* 4:8 (1996), p. 60.

2416. "Manga Close-Up." *Animerica.* 5:7 (1997), p. 60-62. ("Black Knight Bat," "Super Street Fighter II," "Plastic Little," "Armored Trooper Votoms").

2417. Miranda, Donato, *et al.* "Toon Reviews." *Animato!* Spring 1998, pp. 86-94. ("Wig Rodeo," "Animaland," "The Black Cauldron," "Invasion America," "Beauty and the Beast: The Enchanted Christmas," "Pooh's Grand Adventure," "Batman and Mr. Freeze: SubZero," "RoboCop: The Cartoon," "Upon This Planet," "Betty Boop: The Definitive Collection").

2418. Moore, Jennifer, *et al.* "The Compact View." *Animerica.* 5:6 (1997), p. 64.

2419. "A Muppet Christmas." *Manga Max.* June 1999, p. 4.

2420. Napier, Susan J. "Making a Habit of It? Gender Boundary Crossing in *Ranma ½* and *Kuse Ni Narenai Yo.*" Paper presented at Association for Asian Studies, San Diego, California, March 11, 2000.

2421. "A Naughty Knight and a Pugnacious Princess." *Mangazine.* May 1995, p. 9.

2422. "New Animation Films." *Animag.* No. 5, 1988, p. 5.

2423. "New Anime." *The Rose.* October 1997, pp. 18-20.

2424. "New Anime." *The Rose.* February 1998, pp. 17-19.

2425. "New Anime." *The Rose.* October 1998, pp. 16-20.

2426. "New Anime." *The Rose.* February 1999, pp. 20-23.

2427. "New Anime." *The Rose.* June 1999, pp. 20-30.

2428. "New Anime." *The Rose.* October 1999, pp. 22-28.

2429. "New Anime." *The Rose.* February 2000, pp. 18-19.

2430. "New Anime." *The Rose.* June 2000, pp. 20-21.

2431. "New Anime." *The Rose.* October 2000, pp. 10-11.

2432. "New Anime." *The Rose.* February 2001, p. 9.

2433. "New Anime (From Company Ads)." *The Rose.* October 1997, p. 29.

2434. "New Release Information." *Animerica.* 5:1 (1997), p. 21.

2435. "New Releases." *The Rose.* June 1998, pp. 20-24.

2436. "News." *Animation Planet.* Spring/Summer 1998, pp. 7-13.

2437. "New Season TV Roundup!" *Animerica.* 4:4 (1996), pp. 12-15. ("Escaflowne," "Slayers Next," "Vs Knight Lamune & 40 Fire," "B'TX," "Sailor Moon Sailor Stars," "Rock Me, Aragami," "Magical Mystery Tour," "The End of the World Is Coming . . . ," "More Magic Knights," "Battle Harder").

2438. "New Vision." *Manga Max* August 1999, p. 10.

2439. "Noh Surrender." *Manga Max.* June 1999, p. 5.

2440. O'Connell, Michael, *et al.* "Best of the West." *Animerica.* 4:2 (1996?), pp. 65-66. ("Legend of the Lemnear," "The Hakkenden," "The Wings of Honneamise," "El-Hazard," "Ranma ½").

2441. O'Connell, Michael, Rio Yanez, and Kit Fox. "Best of the West." *Animerica.* 6:10 (1998), pp. 58-61. ("Silent Service," "Golgo 13: Queen Bee," "My Dear Marie," "Ghost in the Shell DVD").

2442. O'Connell, Michael, Mitch Samuels, Benjamin Wright, Dwight R. Decker, Shidoshi, Rio Yanez, Mark Simmons, Kit Fox, Urian Brown, Daniel Huddleston. "Reviews." *Animerica.* 7:2 (1999), pp. 66-74. ("Misa the Dark Angel," "Beast City," "Hurricane Polymar," "Tenchi in Tokyo," "Yû Yû Hakusho," "Tekken," "Dirty Pair Flash," "Pokémon," "Bite Me! Chameleon," "Bust a Groove," "Bushido Blade 2," "The Anime Companion," "Lain," "1/144 Temjin").

2443. Oshiguchi, Takashi. "On Idols and Anime." *Animerica.* 5:2 (1997), p. 61.

2444. Oshiguchi, Takashi. "On the American Broadcast of Sailor Moon and Dragon Ball." *Animerica.* 4:2 (1996?), p. 30.

2445. Oshiguchi, Takashi. "On the New Fall Animation." *Animerica.* 6:12 (1998), p. 64.

2446. Oshiguchi, Takashi. "On the Summer Anime Movies." *Animerica.* 5:8 (1997), p. 61.

2447. Osmond, Andrew, *et al.* "Anime Reviews." *Animato!* Spring 1998, pp. 69-73, 100-101. ("Memories," "Blue Seed," "The Irresponsible Captain Tyler," "Elicia & Elicia Part 2," "Ghost in the Shell Special Edition," "Neon Genesis Evangelion," "Shadow Skill and Shadow Skill Part 2," "Street Fighter II V, Volumes 5-8," "Ushio & Tora, Volumes 3 & 4," "Violence Jack").

2448. Pang, Stephen and David Rasmussen. "Mini Reviews: Memories, Maho Tsukaitai, Tenchi Muyo in Love, Samurai Pizza Cats, Dragon Ball Z." *The Rose.* October 1996, p. 37.

2449. Patten, Fred. "Coming (Hopefully) to Local Theaters." *Animation.* April 1996, pp. 20, 83.

2450. Patten, Fred. "15 Notable Anime Direct to Video Releases." *Animation Magazine.* December 2000, p. 69.

2451. Patten, Fred. "15 Notable Anime Features." *Animation Magazine.* December 2000, p. 69.

2452. Patten, Fred. "Who Knows Best?" *Manga Max.* December 1998, p. 54.

2453. Patten, Fred. "*Wild 7* and *Wild 7 Biker Knights.*" *Manga Max.* January 2000, p. 52.

2454. Patten, Fred, Helen McCarthy, Lee Brimmicombe-Wood, Julia Sertori, Peter J. Evans, and Melissa Hyland. "Reviews." *Manga Max.* June 1999, pp. 50-52. ("The Adventures of Kotetsu," "Dragon League #1," "Original Dirty Pair # 1," "Agent Aika # 2," "Sakura Wars," "Knights of Ramune," "Master of Mosquiton," "Revolutionary Girl Utena: The Power of Dios," "801 TTS Air Bats: 1st Strike," "Fist of the North Star TV," "Bubblegum Crisis #1," "Dirty Pair Flash Mission 2 #1").

2455. Patten, Fred, Helen McCarthy, Julia Sertori, Cathy Sterling, Ben Carter, Amos, Jeremy Clarke, Jonathan Clements, Bruce Lewis. "Reviews: Anime." *Manga Max.* November 1999, pp. 48-52, 54-55. ("City Hunter. 357 Magnum," "Catnapped," "Compiler," "Don't Leave Me Alone, Daisy #1," "Elf Princess Rane #1," "Check Into Ogenki Clinic," "Ranma ½: Eat-Drink-Man- (Who-Turns-Into)-Woman," "Saber Marionette R," "Serial Experiments Lain," "Gundam 0083 Stardust

Memory # 5," "Fist of the North Star TV #6," "Sonic the Hedgehog: The Movie," "Sakura Wars," "Memories").

2456. Patten, Fred, Helen McCarthy, Julia Sertori, Jim Swallow, Lee Brimmicombe-Wood, and Bruce Lewis. "Reviews: US Anime." *Manga Max.* September 1999, pp. 46-52. ("DNA Sights 999.9," "Queen Emeraldas," "Eat-Man #2," "Eat-Man # 3," "The Vision of Escaflowne # 1," "Escaflowne # 2," "Maison Ikkoku: Godai Come Home," "Original Dirty Pair #2," "The History of Japanese Animation 2," "Mobile Suit Gundam 0083 Stardust Memory #2," "Those Who Hunt Elves #2," "Yuna Returns," "Tales of").

2457. "Postmortem." *Manga Mania.* July/August 1998, pp. 72-78.

2458. "Radio Heads." *Manga Max.* May 1999, p. 5.

2459. "Rebirth Reborn." *Manga Max.* September 1999, p. 5.

2460. "Reviews." *Animation Buyer's Guide.* November 12, 1999, pp. 7, 10-14.

2461. "Reviews." *Animerica.* 7:1 (1999), pp. 62-69. (Michael O'Connell, "Giant Robo"; Urian Brown, "Strange Love"; Geoffrey Tebbetts, "Night Warriors: Darkstalkers' Revenge"; Geoffrey Tebbetts, "Special Duty Combat Unit Shinesman"; Kit Fox, "Sol Bianca"; Kit Fox, "Kiki's Delivery Service"; Geoffrey Tebbetts, "Fushigi Yûgi"; Geoffrey Tebbetts, "Birdy the Mighty: Double Trouble"; Michael O'Connell, "Chimera: Director's Cut"; Mark Simmons, "1/35 Tactical Armor Type 17 Raiden Armor"; Julie Davis," Sailor Moon Role-Playing Game and Resources Book"; Daniel Huddleston, "Tokimeki Memorial Drama"; Mark Simmons, "Gouf Custom"; Julie Davis, "The Four Immigrants Manga"; Chris Kohler, "Parasite Eve").

2462. "Reviews." *Manga Max.* December 1998, pp. 44-51. ("Dirty Pair Flash," "Neon Genesis Evangelion 10 & 11," "Record of Lodoss War," "Tenchi the Movie," "Armitage III Polymatrix," "Domain of Murder," "Golgo 13: Queen Bee," "Strange Love," "Rail of the Star," "The Silent Service," "Banana Fish," "The Four Immigrants Manga," "Star Wars: A New Hope").

2463. [Reviews]. *Manga Max.* March 1999, pp. 6-9. ("Jubei the Ninjette," "3, 2, 1, Let's Jam!" "God Squad," "Bouncy Bouncy," "X-rated," "Big G's Hang on to Charts," "Angel Links," "Perfect Timing," "Dope on a Rope," "Psycho Connection").

2464. "Reviews." *Manga Max.* April 1999, pp. 48-53. ("Kayoko's Diary," "El Hazard # 2," "Cool Devices #1," "Agent Aika: Naked Mission," "The Clamp School," "Ninja Resurrection," "Saber Marionette J," "Legend of Crystania," "Final Fantasy # 1," "Rail of the Star").

2465. "Reviews." *Manga Max.* May 1999, pp. 48-52. ("Panzer Dragoon" (Julia Sertori), "Legend of Crystania" (Fred Patten), "New Cutey Honey # 4" (Bruce Lewis), "Crystania # 2" (Bruce Lewis), "Gundam 0083: Stardust Memory #1" (Fred Patten), "Ninja Cadets" (Cathy Sterling), "Sorcerer Hunters # 1&2" (Fred Patten), "Revolutionary Girl Utena # 3" (Bruce Lewis), "Tenchi in Tokyo #1" (Julia Sertori), "Tenchi in Tokyo #2" (Bruce Lewis), "Final Fantasy #2" (Paul Watson), "Street Fighter IIV # 1" (Jim Swallow).

2466. "Reviews: Miscellaneous." *Manga Max.* May 2000, pp. 54-55. (Steve Kyte, "Collecting Monster Toys"; Steve Kyte, "An Unauthorized Guide to Godzilla Collectibles"; Martha Russ, "Sailor Moon: Mercury Rising"; Julia Sertori, "Japan Edge"; Helen McCarthy, "Anime vs. Traditional Comic Art"; Amos Wong, "Excel Saga Love [Loyalty]").

2467. "Reviews: Miscellaneous." *Manga Max.* June 2000, p. 54. (Jim Swallow, "Demon City Shinjuku"; Jim Swallow, "Hot Rods and Gun Bunnies"; Lee Brimmicombe-Wood, "Meet Sailor Mars: FIRE").

2468. "Reviews: Miscellaneous." *Manga Max.* July 2000, p. 54. (Julia Sertori, "Anime Trivia Quiz Book"; Ben Carter, "Pokémon GS"; Julia Sertori, "Digimon Adventure").

2469. "Reviews on Anime & Related Media." *Animeco.* No. 12, 2000, pp. 31-36. ("Sorcerer Hunters," "Tekken – The Motion Picture," "Those Who Hunt Elves," "Bubblegum Crisis 2040," "Original Dirty Pair 2," "Queen Emeraldas," "Princess Mononoke," "Lunar: Silver Star Story Complete").

2470. "Reviews: UK Anime." *Manga Max.* Summer 2000, p. 45. (Cathy Sterling, "Oh My Goddess"; Jomathan Clements, "Kimagure Orange Road #2; Jeremy Clarke, "Kimagure Orange Road #1").

2471. "Reviews: UK Anime." *Manga Max.* May 2000, p. 47. (Jeremy Clarke, "Rei Rei/The Gigolo"; Peter J. Evans, "Original Dirty Pair #1"; Peter J. Evans, "Airbats – 3rd Strike").

2472. "Reviews: UK Anime." *Manga Max.* June 2000, p. 48. (Julia Sertori, "Yotoden #2; Jeremy Clarke, "Pokémon: The First Movie"; Cathy Sterling, "Dirty Pair Flash #3.1").

2473. "Reviews: UK Anime." *Manga Max.* July 2000, p. 50. (Jim Swallows, "Bubblegum Crisis Tokyo 2040 #1"; Lee Brimmicombe-Wood, "Sakura Wars 2"; Jeremy Clarke, "Original Dirty Pair #2").

2474. "Reviews: U.S. Anime." *Manga Max.* May 2000, pp. 44-46. (Fred Patten, "Video Girl Ai # 3"; Amos Wong, "Battle Angel"; Julia Sertori, "Geobreeders"; Fred Patten, "Fist of the North Star #8"; Fred Patten,

"Bubblegum Crisis Tokyo 2040 # 4-5"; Helen McCarthy, "Maison Ikkoku: Piyo Piyo Diaries"; Fred Patten, "Green Legend Ran"; Fred Patten. "Serial Experiments Lain #3-4").

2475. "Reviews: U.S. Anime." *Manga Max.* June 2000, pp. 44-47. (Julia Sertori, "Dream Hazard/Pianist"; Julia Sertori, "Fencer of Minerva"; Fred Patten, "Nazca #1"; Jonathan Clements, "Pet Shop of Horrors"; Julia Sertori, "Photon #1"; Daren Stanley, "Ranma ½ . . . The Harder They Fall"; Jonathan Clements, "Sprite"; Fred Patten, "You're Under Arrest: Criminally Complete Collection"; Ben Carter, "Wild Cardz").

2476. "Reviews: US Anime." *Manga Max.* July 2000, pp. 46-48. (Julia Sertori, "Dragoon"; Julia Sertori, "Four Play"; Cathy Sterling, "Mama Mia"; Martin Russ, "Ranma ½: Tea For Three"; Fred Patten, "Pet Shop of Horrors # 2"; Jonathan Clements, "Shamanic Princess"; Cathy Sterling, "Maze").

2477. "Reviews: US Anime". *Manga Max.* Summer 2000, pp. 42-43. (Cathy Sterling, "Spaceship Agga Ruter"; Fred Patten, "Trigun # 1"; Cathy Sterling, "Jubei-chan the Ninja Girl").

2478. Rhee, Keith. "The Compact View." *Animerica.* 3:7 (1995), p. 66.

2479. Riddick, David, Adam Rehorn, and Julie Davis. "AV Interface." *Animerica.* 7:6 (1999), pp. 75-76. ("Metal Gear Solid," "Super Robot Generation," "1/60 AV-98 Ingram: Alphonse Special," "Ghost in the Shell Action Figure").

2480. "Rumour Mills." *Manga Max.* December 1999, p. 10.

2481. Sertori, Julia and Jeremy Clarke. "Reviews: UK Anime." *Manga Max.* March 2000, p. 55. ("Ghost in the Shell," "Metal Angel Marie," "Panzer Dragoon").

2482. Sanet, Joel. "Anime in Japan." *The Rose.* February 1999, pp. 14-15.

2483. Scott, Christine. "The Bitch Women of Anime." *Sequential Tart.* January 2001.

2484. Sertori, Julia, *et al.* "Postmortem. *Manga Mania.* January-February 1998, pp. 74-75. ("Tokyo Revelation," "Macross Plus: The Movie," "Ellicia, Vols. 1 + 2," "Yotoden: Chronicle of the Warlord Period," "Roots Search," "El Hazard 1 + 2," "Tenchi Muyo: Vol 7").

2485. Sertori, Julia, Fred Patten, Chrys Mordin, Helen McCarthy, Jeremy Clarke, Jim Swallow. "Reviews." *Manga Max.* January 1999, pp. 42-45. ("Birdy the Mighty," "Legend of Crystania," "Gatchaman," "Twin Angels # 3," "Tekken," "Beast City: Vampire Madonna," "Spriggen," "Bullet Ballet," "Neon Genesis Evangelion").

2486. Simmons, Mark, Mitch Samuels, Daniel Huddleston, Rio Yanez, Michael O'Connell, Geoffrey Tebbetts. "Reviews." *Animerica.* 7:4 (1999), pp. 66-70. ("Mobile Suit Gundam Movie 1," "Urusei Yatsura TV Series," "Legend of Crystania," "Panzer Dragoon," "The Adventures of Kotetsu," "Agent Aika," "Magical Project S," "Sorcerer Hunters").

2487. Simmons, Mark, Mitch Samuels, Rio Yanez, Patrick Macias, and Corina Borsuk. "Best of the West." *Animerica.* 7:11 (1999), pp. 70-75. ("Martian Successor Nadesico Vol. 1," "Compiler 2," "Macross Plus Vols. 1 and 2," "Megazone 23 Part 1 DVD," "Magic Knight Rayearth Vol. 1: Daybreak," "Sailor Moon S: The Movie," "Tenchi Forever: The Movie").

2488. Smith, Mike. "Assemble Insert." *The Rose.* February 1998, pp. 22-31.

2489. "Special Review." *Animerica.* 4:8 (1996), pp. 10-13.

2490. "Special Review." *Animerica.* 5:9 (1997), pp. 10-14.

2491. Spencer, John. "Live and Kicking." *Anime FX.* August 1995, p. 55.

2492. Sterling, Cathy, Fred Patten, Steve Kyte, Lee Brimmicombe-Wood, Julia Sertori, and Jim Swallow. "Reviews: US Anime." *Manga Max.* December 1999, pp. 48-50. ("Eat Man 98 #1," "Kimagure Orange Road TV #1," "Blue Submarine No. 6 #2," "Bubblegum Crisis 2040 #1," "Powderdolls 2").

2493. "Suits You, Sir." *Manga Mania.* July/August 1998, p. 6.

2494. Swallow, Jim, Lee Brimmicombe-Wood, Jeremy Clarke, Jim McLennan, and Steve Kyte. "Reviews: UK Anime." *Manga Max.* September 1999, pp. 52-55. ("Genesis Survivor Gaiarth," "Ninja Resurrection," "Pretty Sammy # 3: Super Kiss," "Street Fighter 2 V #2," "Takegami," "Tenchi the Movie 2").

2495. Swallow, Jim and Jeremy Clarke. "UK Anime." *Manga Max.* December 1999, p. 51. ("801 T.T.S. Airbats 2nd Strike," "Legend of Crystania: A New Beginning").

2496. Swallow, Jim, Julia Sertori, Jonathan Clements, and Fred Patten. "Reviews: US Anime." *Manga Max.* August 1999, pp. 46-49. ("Eat-Man #1," "Erotic Torture Chamber," "Video Girl Ai #1," "Mobile Suit Gundam 0083," "Black Jack," "Wolf Brigade").

2497. Swallow, Jim, Julia Sertori, Helen McCarthy, Jeremy Clarke. "Reviews: Miscellaneous." *Manga Max.* March 1999, pp. 50-51. ("Big Eyes, Small Mouth," "Sailor Moon RPG and Sourcebook," "Brain Powered OST 2,"

"The Worlds of Japanese Popular Culture," "Takarazuka," "Bubblegum Crisis Tokyo 2040," "Understanding Animation").

2498. Swallow, Jim, *et al.* "Postmortem." *Manga Mania.* October-November 1997, pp. 82-85. ("Zeoraima: Project Hades," "Neon Genesis Evangelion," "Gunsmith Cats Ep. 3: High Speed Edge," "Detonator Orgun," "Black Jack," "MD Geist," "Tenchi Muyo! Vols. 5, 6," "Grappler Baki," "Crying Freeman," "Robotrix").

2499. Swift, Lester. "Best of Anime." *The Rose.* October 1998, p. 27.

2500. Teal, James, Carl G. Horn, Julie Davis. "The Compact View." *Animerica.* 5:8 (1997), p. 63.

2501. Tebbetts, Geoffrey, *et al.* "Reviews." *Animerica.* 6:11 (1998), pp. 66-69. ("Kiki's Delivery Service," "Revolutionary Girl Utena, Vol. 1," "Mobile Suit Gundam 0083," "Gappa: The Triphibian Monsters," "Crimson Blade: The Mix," "The Vision of Escaflowne, Vol. 1").

2502. Thompson Maggie. "Comics Guide." *Comics Buyer's Guide.* February 14, 1997, p. 104.

2503. Thornton, Emily. "Top of the Charts." *Far Eastern Economic Review.* June 22, 1995, pp. 88-89.

2504. Tsao Sheng-Te. "Japan's Top Anime CDs." *The Rose.* October 1997, p. 30.

2505. Tsao Sheng-Te. "Japan's Top Anime TV, Videos, & Manga." *The Rose.* July 1997, pp. 18-19.

2506. "The Undiscovered Anime Country." *Animerica.* 5:8 (1997), pp. 6-7, 20-24, 28.

2507. "Upcoming Soon in Japan." *Animerica.* 3:5 (1995), p. 18.

2508. "US Anime Reviews." *Manga Max.* February 2000, pp. 48-49. (Jim Swallow, "AWOL"; Julia Sertori, "Brain Powered #1"; Helen McCarthy, "Compiler 2"; Daren Stanley, "Tenchi Forever"; Julia Sertori, "Sins of the Sisters"; Jim Swallow, "Ehrgeiz #1"; Jim Swallow, "Serial Experiments Lain #2"; Ben Carter, "Pokemon #9"; Fred Patten," Perfect Blue").

2509. "U.S. TV Report: Anime World Tour: Dragon Ball and Sailor Moon." *Animerica.* 3:10 (1995), p. 12.

2510. Vernal, David. "War and Peace in Japanese Science Fiction Animation: An Examination of *Mobile Suit Gundam* and *The Mobile Police Patlabor.* " *Animation Journal.* Fall 1995, pp. 56-84.

2511. "Video Reviews." *Protoculture Addicts.* December 1993, pp. 34-37.

2512. "Video Scan." *Anime FX.* August 1995, pp. 52-54.

2513. "Video Scan." *Anime FX.* December 1995, pp. 54-55.

2514. "Videoscan." *Anime UK.* April 1995, pp. 49-51.

2515. "Virtual Panel." *Animerica.* 5:9 (1997), p. 28.

2516. "Warren Walks." *Manga Max.* May 1999, p. 5.

2517. "What's New In America?" *Animerica.* 7:3 (1999), pp. 22-23. ("Complete Gaiarth," "Video Girl Ai," "Slayers Next," "Silent Möbius," "Blue Sub No. 6," "Agent Aika").

2518. "What's New in America? New Video Releases." *Animerica.* 5:10 (1997), p. 14.

2519. "What's New in Japan?" *Animerica.* 6:12 (1998), pp. 16-17.

2520. "What's New in Japan?" *Animerica.* 7:3 (1999), pp. 18-19. ("Turn a Gundam," "Shōjo Kakumei Utena," "Space Battleship Yamamoto Yoko," "Pet Shop of Horrors," "Powerstone," "A.D. Police," "Nanki Kiō," "Tenamonya Boy Jazz," "Meitantei Conan").

2521. "What's New in Japan?" *Animerica.* 7:4 (1999), pp. 20-23. ("Arc the Lad." "D4 Princess," "Angel Links," "Gundress," "Psibuster," "Samurai Spirits," "Kachô Ōji," "Nanako's Anatomy Report," "Sunrise Eiyûtan," "Ultraman M78 The Movie," "Ten Captains," "Saiyûki").

2522. "What's New in Japan?" *Animerica.* 9:1 (1999), pp. 16-17. ("You're Under Arrest," "Rurôni Kenshin Recollections," "Gravitation," "Duel," "Graduation M," "Gatekeepers," "Angelic Layer," "Correction Yui," "Final Fantasy," "Microman," "Betaman," "Himiko-den").

2523. Yanez, Rio, Patrick Macias, Kit Fox, Benjamin Wright, Aaron Dawe. "Best of the West." *Animerica.* June 1999, pp. 70-75. ("The Vision of Escaflowne: Best Collection," "Lupin III," "Fist of the North Star. Vol. 1," "Ranma 1/2 Outta Control: Tattoo You," "Those Who Hunt Elves," "Knights of Ramune," "Domain of Murder," "Clamp School Detectives").

2524. Yanez, Rio, Michael O'Connell, Patrick Macias, Geoffrey Tebbetts, and Kit Fox. "Best of the West." *Animerica.* 7:6 (1999), pp. 70-74. ("Big Wars DVD," "City Hunter," "Galaxy Fraulein Yuna 1&2," "Master of Mosquiton: The Vampire," "Genocyber," "Original Dirty Pair," "Haunted Junction," "Sakura Wars").

2525. Yokota, Masao. "Face Preference of Animation Characters by Japanese University Students." Paper presented at Society for Animation Studies, Utrecht, The Netherlands, October 11, 1997.

Reviews, Synopses: Individual Titles

2526. Accorsi, Diego. "La Saga de los Caballeros del *Zodiaco.*" *Comiqueando.* March 1996, pp. 11-17.

2527. "The Age of High Adventure." *Animerica.* 5:9 (1997), pp. 4-7, 18-19, 21-23.

2528. Aish, Sergei L. "AV Interface: Galaxy Maiden Sapphire." *Animerica.* 4:3 (1996), p. 64.

2529. Aish, Sergei L. "Far East of Eden: Kabuki Klash." *Animerica.* 4:2 (1996?), p. 64.

2530. "Almost Like Being in Slough." *Manga Max.* July 2000, p. 5.

2531. "Altered States." *Manga Max.* June 1999, p. 7.

2532. "Angelic Visions." *Animerica.* 6:12 (1998), pp. 11, 29-31.

2533. "Animation Comes of Age with End of Summer." *Mangazine.* January 1994, p. 3. ("End of Summer").

2534. "Anime 18 – Blue As They Wanna Be." *Mangazine.* May 1995, p. 10. ("La Blue Girl").

2535. "Another Eden." *Manga Max.* February 1999, p. 4. ("Eden's Boy").

2536. "Arc the Lad." *Manga Max.* April 1999, p. 7.

2537. "Babe Charmer." *Manga Max.* January 1999, p. 5. ("Heartbeat Memorial").

2538. "Back to Byston Well." *Animerica.* 4:6 (1996), p. 13. ("Garzey's Wing")."

2539. "Bakabon Dolls." *The Rose.* July 1997, p. 20.

2540. "Barefoot Ginrei." *Mangazine.* January 1994, p. 4.

2541. Barr, Greg. "American Anime Graffiti – Dark Warrior: First Strike." *Animerica.* 5:3 (1997), p. 68.

2542. Barr, Greg. "Rough House: Battle Royal High School." *Animerica.* 4:9 (1996), p. 69.

2543. Barr, Greg. "Violence and Viscera: Cybernetics Guardian." *Animerica*. 4:10 (1996), p. 69. ("Cybernetics Guardian").

2544. Beam, John. "Grave of the Fireflies." *The Rose*. April 1996, p. 30.

2545. "Beast Warrior Gulkiiba." *Mangazine*. May 1995, p. 14.

2546. "Beat Berates Bedhead." *Manga Max*. May 2000, p. 5.

2547. "Beckham To Spice up Soccer Kid?" *Manga Max*. July 1999, p. 6.

2548. Bernardo, Carmen. "Dub Review: Those Obnoxious Aliens." *The Rose*. July 1995, p. 10.

2549. "Blade Running." *Manga Max*. April 1999, p. 4. ("Blade Runner").

2550. "Blow Me Down." *Manga Max*. January 2000, p. 5.

2551. "Blue Genes." *Manga Max*. November 1999, p. 6. ("Genocyber").

2552. "Boys Unlimited." *Manga Max*. June 1999, p. 8.

2553. "Bra Wars." *Manga Max*. November 1999, p. 5.

2554. Brimmicombe-Wood, Lee and Motoko Tamamuro. "Deep Six." *Manga Max*. November 1999, pp. 34-38. ("Blue Six").

2555. Brimmicombe-Wood, Lee and Motoko Tamamuro. "Flight of the Condor." *Manga Max*. May 2000, pp. 14-16. ("Time Reincarnation Nazca").

2556. Brimmicombe-Wood, Lee and Motoko Tamamuro. "Masked Avenger." *Manga Max*. March 1999, pp. 38-39.

2557. Brimmicombe-Wood, Lee and Motoko Tamamuro. "Meddling Kids." *Manga Max*. March 2000, pp. 14-19. ("New Kindaichi Files").

2558. Brimmicombe-Wood, Lee and Motoko Tamamuro. "Smack My Pitch Up." *Manga Max*. April 1999, pp. 40-42. ("Red Card").

2559. Bush, Laurence. "Still Waiting and Dreaming." *The Rose*. February 2000, pp. 8-9.

2560. Bush, Laurence. *"Tokyo Revelation." The Rose*. October 1998, pp. 14-15.

2561. "Cannonball Rerun." *Manga Max*. November 1999, p. 9.

2562. "Casshan: The New Four Part OVA Series Commemorating Tatsumoko's 30th!" *Mangazine*. August 1993, p. 7.

2563. "Caves of Steel." *Manga Max*. September 1999, p. 7.

2564. "Charlie's Angel." *Manga Max*. January 2000, p. 8. ("Angelique").

2565. "China Boy." *Manga Max*. September 1999, p. 10.

2566. Cirronella, James. "Five Star Soldier Dairanger." *Anime UK*. May 1995, pp. 22-23.

2567. Clarke, Jeremy. "Schismatrix." *Manga Max*. July 1999, pp. 22-24. "The Matrix").

2568. "Classmates." *Animerica*. 2:12 (1994), p. 64.

2569. Clements, Jonathan. *"Anime UK* Gets Beastly: KO Century Beast Warriors." *Animerica*. 2:7 (1994), pp. 60-61.

2570. Clements, Jonathan. "Asatte Dance # 1: The Luckiest Boy in Tokyo." *Anime FX*. December 1995, p. 52.

2571. Clements, Jonathan. "Japan Rocks: It's a Fair Cop: Tokyo Policewoman Duo." *Anime FX*. December 1995, pp. 42-43.

2572. Clements, Jonathan. "Japan Rocks: Shonen Knife." *Anime FX*. August 1995, pp. 48-49.

2573. "Count with the Count." *Manga Max*. April 1999, p. 5.

2574. "Cowboys and Glove Puppets." *Manga Max*. August 1999, p. 8.

2575. "Crimefighting Roomies." *Manga Max*. December 1999, p. 6.

2576. "Curious Cat. Illusion of Iihatove: Kenji's Spring." *Animerica*. 5:1 (1997), p. 13. ("Illusion and Kenji's Spring").

2577. "Cyber Dream Team." *Manga Max*. January 1999, p. 5.

2578. "Cyber Saibuster." *Manga Max*. 1999, p. 4.

2579. "Dark Angel." *Manga Max*. January 1999, p. 4.

2580. "Daughters of the Otaku Revolution: Princess Maker 2." *Animerica*. 3:10 (1995), p. 15. ("Princess Maker 2").

2581. Davis, Robert L. "ReConTanimé-Ted." *Anime FX*. December 1995, pp. 39-40.

2582. "Demon Warrior Luna Varga." *Mangazine*. September 1994, pp. 8-14.

2583. "Dial 'H' for Hero." *Animerica*. 4:3 (1996), p. 11. ("Golden Hero Goldoran").

2584. "Die Hardy." *Manga Mania*. July/August 1998, p. 6.

2585. "Digital Depot." *Manga Max*. October 1999, p. 10. ("Intron Depot").

2586. Dlin, Douglas. "Who Are the VR? The World of V.R. Troopers."
 Sentai. November 1994, pp. 18-20.

2587. Dlin, Doug and Ben Dunn. "Welcome to the Cpomputerized World of
 the Superhuman Samurai Syber-Squad." *Sentai.* November 1994, pp.
 21-25.

2588. "Dodgy Digi Dub." *Manga Max.* June 2000, p. 4.

2589. Doi, Hitoshi. "Miracle Girls TV Episodes 1-6." *Anime Reference Guide.*
 2:2 (1994), pp. 59-64.

2590. Donnelly, Laura. "It's Elementary, My Dear! Part One: Fire."
 Sequential Tart. September 2000.

2591. Donnelly, Laura. "The Rane Must Fall: Elf Princess Rane." *Sequential
 Tart.* August 2000.

2592. "Don't Lose, You Loser! Makeru Na! Makendo." *Animerica.* 3:2
 (1995), p. 15.

2593. "Doom & Gloom." *Manga Max.* June 2000, p. 8.

2594. "Dub Ugly." *Manga Max.* Summer 2000, p. 7.

2595. Duffield, Patti. "Lord of Lords Ryu Knight." *Anime Reference Guide.*
 3:1 (1995), pp. 63-67.

2596. Duffield, Patti. "Yu Yu Hakusho Movie." *Anime Reference Guide.* 2:2
 (1994), pp. 107-109.

2597. "Dummy Run." *Manga Max.* June 2000, p. 5.

2598. Endresak, Dave. "A.D. Police Files #1 – The Phantom Woman." *The
 Rose.* April 1995, pp. 23, 43.

2599. Endresak, Dave. "Graduation 1 & 2." *The Rose.* January 1996, pp. 16-
 17.

2600. Endresak, Dave. "Idol Project." *The Rose.* July 1996, pp. 18-19.

2601. Endresak, Dave. "Legendary Idol Eriko." *The Rose.* April 1997, pp. 20-
 21.

2602. Endresak, Dave. "Nurse Angel Lilika S.O.S." *The Rose.* April 1996, p.
 28.

2603. "Escape from Mai Hollywood Hell." *Manga Max.* July 2000, p. 8.

2604. "Escape from Oedo: Cyber City Oedo 808." *Animerica.* 3:5 (1995), p.
 13.

2605. "Eskimo Hell." *Manga Max*. November 1999, p. 8. ("A.L.I.C.E.").

2606. Evans, Peter J. "Bleeding Hell." *Manga Max*. July 2000, pp. 18-21. ("Berserk").

2607. Evans, P.J. "Debutante Detective Corps." *Manga Mania*. May-June 1998, pp. 20-21.

2608. Evans, Peter J. "Ghost Stories." *Manga Max*. July 1999, pp. 40-44.

2609. Evans, P. J. "The Iria Connection." *Manga Max*. January 1999, pp. 40-41.

2610. Evans, Peter J. "Midnight Express." *Manga Max*. July 2000, pp. 24-26. ("Midnight Eye Goku").

2611. Evans, Peter J. "Somewhere in Time." *Manga Max*. February 2000, pp. 38-43. ("Fire Tripper").

2612. Evenson, Laura. "Cyberbabe Takes on Tokyo in 'Ghost.'" *San Francisco Chronicle*. April 12, 1996.

2613. "Exaxxion into Action." *Manga Max*. January 1999, p. 7.

2614. "Explodey Head." *Manga Max*. September 1999, p. 9. ("Jibaku-kun").

2615. "Fairy Princess Reine." *Anime FX*. December 1995, pp. 34-38.

2616. "Fancy That." *Manga Mania*. July/August 1998, p. 7. ("Magical Stage Fancy Lala").

2617. "Fandabidozey." *Manga Max*. November 1999, p. 10.

2618. "Fat Stats for Anime Cats." *Manga Max*. June 1999, p. 9.

2619. "FF9 Coked Up." *Manga Max*. June 2000, p. 6.

2620. Fischer, Dennis. "Space Adventure Cobra." *AnimeFantastique*. Summer 1999, pp. 10-13.

2621. "Five Star Stories." *Manga Max*. June 1999, p. 6.

2622. "Flatland." *Manga Max*. July 1999, p. 8.

2623. "Fly Me to the Mond." *Manga Max*. July 1999, p. 4. ("Der Mond").

2624. Fox, Kit. "Delinquent in Drag." *Animerica*. 6:12 (1998), p. 68.

2625. Fox, Kit. "Mean Motor Scooters. *Wild 7.*" *Animerica*. 7:12 (1999), p. 73.

2626. Fox, Kit. "Vampire Savior: The Legend of Vampire." *Animerica*. 6:9 (1998), p. 68.

2627. Fox, Kit. *"Variable Geo."* *Animerica.* 7:12 (1999), pp. 72-73.

2628. Frankenhoff, Brent. "Knights of Ramune: Blast Off!" *Animation Buyer's Guide.* May 7, 1999, p. 20.

2629. Friestad, Geir. "Taiho Shichau Zo!" *Anime Reference Guide.* 3:1 (1995), pp. 110-111.

2630. "Fugitive." *Manga Max.* July 1999, p. 6. ("Intrigue").

2631. "The Fury of the Elements: Elemental Masters." *Animerica.* 2:12 (1994), pp. 14-15.

2632. "Galactic Zeroes." *Manga Max.* June 1999, p. 6.

2633. "Games You Can Play. Alice in Cyberland. Quo Vadis." *Animerica.* 5:1 (1997), p. 12.

2634. Genesse, David. "The X-Files of Anime." *The Rose.* October 1996, p. 21.

2635. "Ghibli Pricks Up Its Ears." *Animerica.* 3:5 (1995), p. 16. ("Mimi o Sumaseba").

2636. "Go, Go, Gokaiser." *Animerica.* 4:6 (1996), p. 11.

2637. "Golden Eye." *Manga Max.* March 2000, p. 6.

2638. Greenholdt, Joyce. "The Adventures of Kotetsu." *Animation Buyer's Guide.* May 7, 1999, p. 20.

2639. Greenholdt, Joyce. "Ninja Cadets." *Animation Buyer's Guide.* May 7, 1999, p. 18.

2640. Greenholdt, Joyce. "Viewing 'Babel II.'" *Comics Buyer's Guide.* February 2, 1996, p. 40.

2641. "Gundress." *Animatoon* No. 22, 1999, pp. 96-97.

2642. "Gun Powder Stuff." *Manga Max.* January 2000, p. 7. ("Oh! Super Milk-chan").

2643. Guru, Grebo. "Anime Pin-Up Beauties." *Animerica.* 6:12 (1998), p. 72.

2644. "The Hakkenden." *Animerica.* 5:9 (1997), pp. 21-23.

2645. "Hamster Insertion." *Manga Max.* Summer 2000, p. 7.

2646. "Hands Off My Nuts!" *Manga Max.* November 1999, p. 8.

2647. "Hard Core." *Manga Max.* June 2000, p. 4.

2648. "A Hard Knight's Day for the 'Dragon Knight.'" *Mangazine*. January 1994, p. 3.

2649. "Hedging His Bets." *Manga Max*. August 1999, p. 5. ("Sonic").

2650. Heiskanen, Jukka. "Kaiken Maailman Sarjakuvatuksia." *Sarjainfo*. No. 94, 1/1997, p. 31.

2651. "Hermes: Love Blows Like the Wind." *The Rose*. June 1998, p. 7.

2652. Hernandez, Lea. "Pink Radio: 'A Little Night Musing.'" *Mangazine*. May 1995, p. 19.

2653. "High Spirits." *Manga Max*. May 1999, p. 9.

2654. Hilton, Robert T. and Shun Tsurugi. "Shurato." *Anime Reference Guide*. 1:1 (1991), pp. 79-80.

2655. Hiroi, Takahiro. "Demon Century Suiko Legend." *The Rose*. July 1996, p. 21. Reprinted from *NewType*. June 1993.

2656. "Hit Stabber." *Manga Max*. June 2000, p. 6.

2657. "Holy Macaroni." *Manga Max*. October 1999, p. 7. ("Wild Arms").

2658. "Honkers Bonkers." *Manga Max*. June 1999, p. 9.

2659. "Hooray for Hollywood." *Manga Max*. October 1999, p. 7. ("Now I'm There").

2660. Horn, Carl G. "Are You Experienced? Golden Boy, Vols. 1 & 2." *Animerica*. 5:4 (1997), p. 66.

2661. Horn, Carl G. "Don't Stand So Close to Me – Wait Till Later! Homeroom Affairs. Parts 1 and 2." *Animerica*. 4:3 (1996), p. 68.

2662. Horn, Carl G. "Gainax: Find, Find Your Place; Speak the Truth." *AnimeFX*. January 1996, pp. 24-29.

2663. Horn, Carl G. "I Died Yesterday (Or Was It Today?): *Coshogun: The Time Étranger.*" *Animerica*. 3:9 (1995), p. 64.

2664. Horn, Carl G. "The Sands of Chryse Planitia: Big War." *Animerica*. 4:10 (1996), p. 65.

2665. Horn, Carl G. "Sing a Song from the Good Ol' Days of Anime. Blue Sonnet. Vol. 1." *Animerica*. 3:3 (1995), p. 53.

2666. Horn, Carl G. "Ten Against One, They Were 11." *Animerica*. 3:1 (1995), p. 60.

2667. Horn, Carl G. "Zen and the Art of '50s Revival: Shonan Bakusozoku: Bomber Bikers of Shonan." *Animerica.* 2:12 (1994), p. 60.

2668. "Horn Boy in Funny Bunny Vamp Camp." *Manga Max.* June 1999, p. 8.

2669. Howell, Shon. "Tokyo Mojo." *Mangazine.* June 1993, p. 7.

2670. "Hunters Dream." *Manga Max.* December 1999, p. 9.

2671. "Hurricane Revisited." *Animerica.* 4:7 (1996), p. 11. ("Hurricane Polymer").

2672. "I Love Lum in a Brand-New Dub: Those Obnoxious Aliens." *Animerica.* 3:3 (1995), p. 14.

2673. Ishigami, Yoshitaka. "Kataku-Firehouse." *Anime Reference Guide.* 2:1 (1992), pp. 44-45.

2674. Jackman, Chris K. "Samurai Pizza Cats." *Manga Mania.* July/August 1998, pp. 59-62.

2675. Jackman, Chris K. "Warriors of the Wind." *Anime UK.* December 1994/January 1995, pp. 32-36.

2676. Jackson, Aleta. "Monkey Shines, Alakazam the Great." *Animerica.* 4:4 (1996), p. 68.

2677. Inui, Mariko. "An Analysis of the Popularity of Chibimaruko-chan in Relation to Attitude and Thinking in Contemporary Japan." MA thesis, California State University, Long Beach, 1995. 107 pp.

2678. Jang, Galen. "Kujaku-O II." *Anime Reference Guide.* 1:1 (1991), pp. 40-41.

2679. Jankowski, Joe. "Psychic Wars." *The Rose.* February 1999, p. 16.

2680. Jowett, Simon. "Gilding the Lily." *Manga Max.* November 1999, p. 66.

2681. Kadrey, Richard. "Move Over Eve, Sayonara Sharon Apple." *The Rose.* April 1997, p. 30.

2682. "The Kamen Rider That Almost Was." *Kung-fu Girl.* Summer 1995, p. 36.

2683. "Kendo Defenders." *Manga Max.* February 2000, p. 5.

2684. "Kenji." *Fant-Asia.* July/August 1997, p. 47.

2685. Kim, Andy. "Hi No Tori 2772." *Anime Reference Guide.* 1:1 (1991), pp. 60-61.

2686. Kim, Andy. "Phoenix 2772." *Anime Reference Guide.* 2:1 (1992), p. 64.

2687. Kim, Angeline. "Super-Schoolgirl Mutant Roach, The Ultimate Teacher." *Animerica.* 5:3 (1997), p. 67. ("The Ultimate Teacher").

2688. "Kindaichi Surprise." *Manga Max.* May 1999, p. 4.

2689. "King of the World." *Manga Max.* February 1999, p. 5. ("Gundam A-Project").

2690. Kobayashi, Kim. "Debut." *The Rose.* October 1995, pp. 21, 35.

2691. Kobayashi, Kim. "H2." *The Rose.* January 1996, p. 15.

2692. Kobayashi, Kim. "New Century GPX Cyber Formula Zero." *The Rose.* January 1996, p. 30.

2693. Kohler, Chris. "The Granstream Saga." *Animerica.* 6:12 (1998), p. 72.

2694. Kohler, Chris. "Marvel vs. Capcom." *Animerica.* 8:1 (2000), p. 79.

2695. "Kyoko Otonashi's Better Holiday Living." *Animerica.* 4:11 (1996), pp. 9-14.

2696. *"The Laws of the Sun."* *The Rose.* October 2000, p. 7.

2697. Leahy, Kevin. "Lamp-Lamp." *The Rose.* July 1995, p. 26. ("Arabian Genie Adventure Lamp-Lamp").

2698. Leahy, Kevin. "Wicked City." *The Rose.* October 1996, pp. 20-21.

2699. Lee, Karen. "Vampire Wars." *The Rose.* June 1999, p. 6.

2700. Lewis, Bruce. "People Like Us?" *Manga Max.* October 1999, p. 66.

2701. Lilines. "Dragon Half." *The Rose.* February 1998, pp. 20-21.

2702. "Live Invasion." *Manga Max.* February 2000, p. 6.

2703. Loo, David. "Majo no Takuyubbin." *Anime Reference Guide.* 1:1 (1991), pp. 36-39.

2704. López Ortiz, David. "Anime: Yu Yu Hakusho." *Albur.* Verano 1996, p. 10.

2705. "Lord of the 'Bungle' Makes Jump to Small Screen." *Mangazine.* October 1993, p. 7. ("Jungle King Tar-chan").

2706. "The Loser Hero." *Animerica.* 7:2 (1999), pp. 15, 34-35.

2707. *"Love Hina* Coming Soon." *Manga Max.* Summer 2000, p. 5.

2708. Lurio, Eric. "Beyond Real: The *Avartar* Conundrum." *AnimeFantastique.* Fall 1999, p. 6.

2709. Luse, Jonathan. *"Dangaioh."* *The Rose.* January 1997, pp. 18-19.

2710. "Luvvie Trouble." *Manga Max.* March 2000, p. 5.

2711. McCarter, Charles. "Crusher Police Dominion Episodes 1-2." *Anime Reference Guide.* 2:2 (1994), pp. 14-16.

2712. McCarter, Charles. "Idol Defense Team Hummingbird." *Anime Reference Guide.* 3:1 (1995), pp. 30-34.

2713. McCarthy, Helen. "Chocolate-Dipped Carrots, at the Magic Café." *Manga Max.* April 1999, pp. 24-25.

2714. McCarthy, Helen. "Cyguard – Cybernetics Guardian." *Anime FX.* February 1996, pp. 38-41.

2715. McCarthy, Helen. "Fly Peek." *Anime FX.* August 1995, p. 33.

2716. McCarthy, Helen. "Got You Under My Skin." *Manga Max.* February 1999, pp. 20-22. ("Birdy the Mighty").

2717. McCarthy, Helen. "Monkeying Around." *Manga Max.* June 2000, pp. 22-26. ("Monkey King").

2718. McCarthy, Helen. "The Pirates of Shinjuku." *Manga Mania.* October-November 1997, pp. 24-26. ("Ellcia").

2719. McCarthy, Helen. "Shadow Boxing." *Manga Mania.* July-August 1997, pp. 18-19. ("Shadow Skill").

2720. McCarthy, Helen. "Space Firebird." *Anime FX.* August 1995, pp. 28-31.

2721. McCarthy, Helen. "Starlite Express." *Manga Max.* February 1999, pp. 16-19.

2722. McCarthy, Helen. "21st Century Boys." *Manga Max.* December 1998, pp. 14-17.

2723. McCloy, Stephen. "The Rose of Versailles." *The Rose.* April 1996, pp. 22-23.

2724. "Machine Dog Corps." *Mangazine.* August 1993, p. 3.

2725. "Machine Robo – Revenge of Cronos I." *The Rose.* July 1997, p. 21.

2726. Macias, Patrick. "*Blue Submarine* No. 6, Vol. 2: Pilots." *Animerica.* 7:12 (1999), p. 75.

2727. Macias, Patrick. "Enter The Ninja." *Animerica.* 7:2 (1999), pp. 11-12, 31-33.

2728. Macias, Patrick. "Grand Master Matsumoto, *The Cockpit.*" *Animerica.* 7:12 (1999), pp. 70-71.

2729. Macias, Patrick. "Is This the End?" *Animerica.* 7:12 (1999), pp. 30-31.

2730. Macias, Patrick. "Monster Rancher." *Animerica.* 8:7 (2000), pp. 9, 35, 37.

2731. Macias, Patrick. "Space Cinema Yamato." *Animerica.* 7:3 (1999), pp. 11-13.

2732. Macias, Patrick and Andy Nakatani. "Spotlight: Trigun." *Animerica.* 8:4 (2000), pp. 19-22.

2733. McLennan, Jim. "*A.*" *Manga Max.* February 2000, p. 53.

2734. McLennan, Jim. "Bring Your Daughter to the Slaughter." *Manga Max.* November 1999, pp. 24-26. ("Baptism of Blood").

2735. McLennan, Jim. "It's Raining Yen!" *Manga Max.* September 1999, pp. 34-36. ("Weather Woman").

2736. McLennan, Jim. "Kitty Kitty Bang Bang." *Manga Max.* March 2000, p. 66.

2737. McLennan, Jim. "Live and Kicking: Zeiram." *Anime FX.* January 1996, pp. 32-33.

2738. McLennan, Jim. "1 + 2 = Paradise: Another Look at Trash Animation." *Asian Trash Cinema.* 1:5, pp. 26-27.

2739. "Mana from Heaven." *Manga Mania.* July/August 1998, p. 8. ("Steel Girlfriend").

2740. "A Man and His Machine: Godmars." *Animerica.* 2:12 (1994), p. 10.

2741. "Mars." *Animerica.* 2:7 (1994), pp. 64-65.

2742. Martin, Rick, *et al.* "Holy Akira! It's Aeon Flux." *Newsweek.* August 14, 1995, pp. 68, 70.

2743. "Mashed Swedes." *Manga Max.* June 2000, p. 7.

2744. Matsuzaki, James. "Jumping." *Anime Reference Guide.* 1:1 (1991), p. 37.

2745. Mauriello, Scott C. "A Sense of Wabi-Sabi." *AnimeFantastique.* Fall 1999, p. 62.

2746. "Mel UK Dvd." *Manga Max.* January 2000, p. 10.

2747. "Menace from the Deep." *Manga Max.* July 2000, p. 7.

2748. Meyer, Michael and Dody Tsiantar. "Ninja Turtles, Eat Our Dust." *Newsweek.* August 8, 1994, pp. 34-35.

2749. "Millennium Domu." *Manga Max.* May 1999, p. 4.

2750. Moe, Anders. "Space Opera Agga Rutaa." *The Rose.* June 1999, p. 19.

2751. Moe, Anders. "Tenchi & El Hazard." *The Rose.* February 1999, p. 27.

2752. *"Moncollé* Movie." *Manga Max.* June 2000, p. 5.

2753. "Mondo Mental." *Manga Max.* January 2000, p. 4.

2754. Moore, Jennifer. "Where the Boys Are: Kizuna, Vols. 1 & 2." *Animerica.* 5:3 (1997), p. 66.

2755. "MVM on the Move." *Manga Max.* June 1999, p. 10.

2756. "My Kung Fu Is Best! Grappler Baki: The Ultimate Fighter." *Animerica.* 5:4 (1997), p. 68.

2757. "My Roomie Is an Alien." *Manga Max.* February 2000, p. 6.

2758. "Nazi Space Elves from Planet Bandai." *Manga Max.* Summer 2000, p. 6.

2759. "Negative Buttheads." *Manga Max.* November 1999, p. 47.

2760. Nelson, Even. "Silent Mobius." *AnimeFantastique.* Summer 1999, p. 61.

2761. "Never Been First Before." *Manga Max.* March 2000, p. 7.

2762. Newell, Adam. "Spotlight on: Master of Yin and Yang." *Manga Max.* Summer 2000, p. 9.

2763. Newitz, Annalee. "Magical Girls and Atomic Bomb Sperm." *Film Quarterly.* Fall 1995, 14 pp.

2764. Ng, Ernest. "Kareshi Kanojyo no Jijyo Act 1.0." *The Rose.* February 2001, pp. 22-23.

2765. "Ninja Is as Ninja Does." *Animerica.* 7:2 (1999), p. 13.

2766. Noble, Chris. "Genesis Survivor Gaiarth." *The Rose.* July 1996, p. 9.

2767. "Norm Stars." *Manga Max.* January 1999, p. 4. ("Mini-Goddess").

2768. "Now To Conquer Earth!" *Manga Max.* January 2000, p. 10.

2769. "Null & Zoid." *Manga Max.* September 1999, p. 7.

2770. "Ny Hero." *Manga Max.* November 1999, p. 10.

2771. O'Connell, Michael. "A Nice To Visit . . . Garaga." *Animerica.* 4:4 (1996), p. 69.

2772. O'Connell, Michael. "Sex, Latex and Rock & Roll: Ogenki Clinic." *Animerica.* 5:9 (1997), p. 66.

2773. O'Connell, Michael. "A Ticket To Ride." *Animerica.* 4:7 (1996), p. 69. ("Night on the Galactic Railroad").

2774. O'Connell, Michael. "We Four Kings: *Sohryuden: Legend of the Dragon Kings."* *Animerica.* 3:12 (1995), p. 67.

2775. O'Connor, Mike. *"Landlock."* *The Rose.* October 1998, p. 9.

2776. O'Connor, Mike. "Metal Skin Panic Madox-01." *The Rose.* April 1997, p. 15.

2777. "Oda Nobunaga." *Animerica.* 5:9 (1997), p. 19.

2778. "Old Habits Dy Gard." *Manga Max.* October 1999, p. 6.

2779. "One Small Step." *Manga Max.* Summer 2000, p. 5.

2780. "On the Slab." *Manga Max.* May 1999, p. 7.

2781. Osaki, Tad. *"One Piece."* *Variety.* March 26-April 1, 2001, p. M34.

2782. Ouellette, Martin. "Fiddler of Hamelin." *Protoculture Addicts.* September- October 1997, p. 58.

2783. Ouellette, Martin. "The Movie: Characters: The Sky Dragons." *Protoculture Addicts.* September-October 1997, pp. 28-30, 35-36.

2784. "Outlanders." *A-ni-mé.* January 1991, pp. 137-146.

2785. "Paper Chase." *Manga Max.* July 2000, p. 5. ("R.O.D.").

2786. Patten, Fred. "Go to Jailed." *Manga Max.* February 1999, pp. 42-44. ("Jailed").

2787. Patten, Fred. *"Sailor Victory."* *Manga Max.* January 2000, p. 51.

2788. "Peacock King: Spirit Warrior I." *The Rose.* July 1997, p. 21.

2789. Penn-Miller, Rachel. "Shadow Lady." *Animerica.* 8:5 (2000), pp. 21-23.

2790. Penn-Miller, Rachel. "What's Michael?" *Animerica.* 8:7 (2000), pp. 20-21.

2791. Persons, Dan. "Full Speed, Uh, Ahead?" *AnimeFantastique.* Spring 1999, p. 4.

2792. Persons, Dan. "Smear That Snowman!" *AnimeFantastique.* Spring 1999, pp. 10-15.

2793. "Petrol Emotion." *Manga Max.* June 2000, p. 4.

2794. "Plastic Temples." *Manga Max.* August 1999, p.7.

2795. "Princess Making." *Manga Max.* January 1999, p. 8. ("Princess Maker").

2796. "Rally and the Road Buster." *Animerica.* 9:1 (1999), pp. 24, 26. ("Gunsmith Cats," "Riding Bean").

2797. "Red Dawn." *Manga Max.* July 2000, p. 4.

2798. Rehorn, Adam. "1/48 HG Cannon Fire-Type Aestivalis." *Animerica.* 8:1 (2000), p. 81.

2799. Rehorn, Adam. "1/100 F90 Y Cluster Gundam." *Animerica.* 7:9 (1999), p. 83.

2800. "Revelation Lugia." *Manga Max.* June 2000, p. 7.

2801. Robert, George. "Juubei Ninpocho." *Anime Reference Guide.* 3:1 (1995), pp. 52-58.

2802. Robinson, Brian. "*Megami Paradise.*" *The Rose.* January 1997, p. 31.

2803. "Robot Dawn." *Manga Max.* May 1999, p. 7.

2804. "Ronin Warriors." *Animerica.* 4:10 (1996), p. 25.

2805. "RPG-TFOS." *Protoculture Addicts.* August-September 1991, p. 10.

2806. "Sagely Advice." *Manga Max.* May 1999, p. 6.

2807. Samuels, Mitch. "Cuts Right to the Chase: Detonator Orgun." *Animerica.* 2:7 (1994), p. 61.

2808. Samuels, Mitch. "Overfiend's Drooling Idiot Cousin: Legend of Lyon: Flare I and II." *Animerica.* 3:1 (1995), p. 61.

2809. Samuels, Mitch. "Sexorcist." *Animerica.* 6:12 (1998), p. 70.

2810. "Samurai Spirits." *Manga Max.* March 2000, p. 6.

2811. "Samurai Troopers Fighting Towards American Release." *Mangazine.* March 1995, p. 5.

2812. Sanet, Joel. "Blue Submarine No. 6." *The Rose.* February 1999, p. 8.

2813. Savage, Lorraine. "Kizuna." *The Rose.* February 1999, p. 9.

2814. Savage, Lorraine. "Legend of the Forest." *The Rose.* July 1996, pp. 25, 31.

2815. Savage, Lorraine. "Night on the Galactic Railroad." The Rose. January 1997, pp. 8-9.

2816. Savage, Lorraine. "The Tale of Genji." *The Rose.* April 1996, pp. 24-25.

2817. Savage, Lorraine. "Toward the Terra." *The Rose.* April 1995, pp. 11, 33.

2818. "Say It With Flowers." *Manga Max.* February 2000, p. 5. ("First Kiss Story").

2819. Schilling, Mark. "Red Pig Rushes to the Rescue." *Japan Times.* July 28, 1992.

2820. "Seabass 123." *Manga Max.* June 1999, p. 4.

2821. "Separated at Birth?" *Animerica.* 7:1 (1999), pp. 60-61.

2822. "Seraphim Call." *Manga Max.* November 1999, p. 8.

2823. Sertori, Julia. "Angel # 2." *Anime FX.* December 1995, p. 52.

2824. Sertori, Julia. "Beyond the Valley of the Powerdolls." *Manga Mania.* July-August 1997, p. 27. ("Powerdolls").

2825. Sertori, Julia. "The Devil Inside." *Manga Mania.* March-April 1998, pp. 12-15. ("Shutendoji").

2826. Sertori, Julia. "Immortal Combat." *Manga Max.* January 1999, pp. 18-20. ("Tekken").

2827. Sertori, Julia. "Slow Step." *Anime UK.* May 1995, pp. 14-16.

2828. Sertori, Julia and Helen McCarthy. "Raven Tengu Kabuto." *Anime FX.* February 1996, pp. 22-27.

2829. "Sex Bomb." *Manga Max.* March 2000, p. 4.

2830. "Sheep Don't Push Me." *Manga Max.* January 1999, p. 8.

2831. Shidoshi. "A Different Sort of Sequel: *Legend of Crystania.*" *Animerica.* 6:12 (1998), p. 69.

2832. Simmons, Mark. "Blade of the Immortal." *Animerica.* 7:8 (1999), pp. 16-18, 36.

2833. Simmons, Mark. "Post-Holocaust Punch-Up: Suikoden Demon Century." *Animerica.* 5:5 (1997), p. 68.

2834. Simmons, Robert. "Why Has It Come To This?" *The Rose.* April 1996, pp. 6-7.

2835. "Sinister Deals." *Manga Max.* January 2000, p. 5. ("Parasyte").

2836. "'Skeleton Key' May Come to Saturday Morning TV." *Comics Buyer's Guide.* January 10, 1997, p. 8.

2837. Smith, Mike. "Slam Dunk." *The Rose*. April 1995, p. 9.

2838. Smith, Mike. "Starship Girl Yoko Yamamoto." *The Rose*. February 2001, pp. 4-5.

2839. Smith, Mike. *"To Heart."* *The Rose*. October 2000, pp. 5-6.

2840. "Snazzy Paparazzi." *Manga Max*. Summer 2000, p. 8.

2841. "Soap Duds." *Manga Max*. Summer 2000, p. 5.

2842. "Somebody Stop Me!" *Manga Max*. November 1999, p. 10.

2843. "Spotlight on: Emblem of the Star World." *Manga Max*. February 2000, p. 9.

2844. "Spotlight on Gasaraki." *Manga Max*. July 1999, p. 11.

2845. Staley, James. "Bakuretsu Hunter." *The Rose*. April 1997, p. 28.

2846. Sterling, Cathy. "Doggy Style!" *Manga Mania*. January-February 1998, p. 16. ("Hakkenden").

2847. Sterling, Cathy. "Identity Crisis." *Manga Max*. June 1999, pp. 38-39. ("Fake").

2848. Sterling, Cathy. "Some Day My Prince Will Come." *Manga Max*. September 1999, pp. 22-24. ("Midnight Panter").

2849. Sterling, Cathy. "Suffer Little Children." *Manga Max*. May 1999, p. 66. ("Rail of the Star").

2850. "Stoned Again." *Manga Max*. April 1999, p. 5. ("Power Stone").

2851. "The Strait is the Gate." *Manga Max*. February 1999, p. 10. ("Gate Keepers").

2852. "Streamline's Forbidden Fruit – Project Eden." *Animerica*. 2:7 (1994), pp. 16-17.

2853. "Surf's Up." *Manga Max*. July 1999, p. 10. ("Surfside High School").

2854. "Surrender Dorothy." *Manga Max*. February 1999, p. 5. ("Galerians").

2855. Swallow, Jim. "Manga in Focus: Rebel Rebel." *Anime UK*. December 1994/January 1995, pp. 42-43. ("The Rebel Sword").

2856. Swallow, Jim. "Megabyte." *Manga Mania*. July/August 1998, p. 66.

2857. Swallow, Jim. "Tigers of Terra." *Anime FX*. December 1995, p. 53.

2858. Swallow, Jim. "Twilight X Quarterly." *Anime FX*. December 1995, p. 53.

2859. Swallow, Jim. "Virtual World." *Anime FX.* December 1995, pp. 10-11. ("Battletech").

2860. "Sweet 16." *Manga Mania.* July/August 1998, p. 6.

2861. Switzer, Madeline. "St. Seiya." *Anime-zine.* No. 2, 1987, pp. 4-10.

2862. Takaoka, Nova. "The Art of Goofy: Art of Fighting." *Animerica.* 5:9 (1997), p. 69.

2863. Tamamuro, Motoko and Cathy Sterling. "Back to Chirality." *Manga Max.* March 1999, pp. 14-17.

2864. "Tangerine # 7." *Manga Max.* July 1999, pp. 46-47.

2865. "Teacher Wants You!" *Manga Max.* July 1999, p. 7. ("GTO").

2866. Teal, James. "Heavy Metal Mayhem." *Animerica.* 5:6 (1997), p. 69. ("Gunhed").

2867. Tebbetts, Geoffrey. "Uniquely Yuna Galaxy: Galaxy Fraulein." *Animerica.* 5:2 (1997), p. 71.

2868. "Terminated!" *Manga Max.* May 1999, p. 8.

2869. "There Goes the Neighborhood." *Manga Max.* May 1999, p. 6.

2870. "This Guy Speaks English, Too." *Mangazine.* January 1994, p. 4. ("Guy").

2871. "This Time, It's All in the Family: Akane and Her Sisters." *Animerica.* 2:11 (1994), p. 16.

2872. Thomas, Ted. "A Tale of Two Sisters: *Princess Minerva.* " *Animerica.* 3:12 (1995), p. 65.

2873. "Tokyo TV Report: Sea Quest SDF. Silent Service." *Animerica.* 3:10 (1995), p. 13.

2874. Toole, Michael. "Capri Corny." *Animerica.* 5:10 (1997), p. 68. ("Capricorn").

2875. Toole, Michael. "The Dysfunctional Family Circus." *Animerica.* 4:7 (1996), p. 70. ("The Abishiri Family").

2876. Toole, Michael. "Revenge of the Robots: Machine Robo." *Animerica.* 5:8 (1997), p. 68.

2877. "Torn Between Two Ronin." *Manga Max.* December 1999, p. 7.

2878. "Turn-a Art." *Manga Max.* February 2000, p. 8. ("Turn-a Gundam").

2879. "20/20 Sound & Vision." *Manga Max.* May 1999, p. 5.

2880. "Twisted Firestarter." *Manga Max*. April 1999, p. 8.

2881. "Ultracute." *Manga Max*. May 1999, p. 5.

2882. "Update: Virus Buster Serge." *Manga Mania*. July/August 1998, p. 9.

2883. "Unisex Worlds." *Manga Max*. February 2000, p. 7.

2884. Uyeyama, Richard. "Carol." *Anime Reference Guide*. 2:1 (1992), pp. 17-18.

2885. "Veritech Log." *Protoculture Addicts*. April 1990, pp. 13-16.

2886. "Veronica's Tofu Closet." *Manga Max*. March 2000, p. 5.

2887. "Viral Load." *Manga Max*. May 1999, p. 8.

2888. "VZones Give Anime Head." *Manga Max*. June 2000, p. 5.

2889. Wang, Albert Sze-Wei. "Queen Millennia." *Anime Reference Guide*. 2:1 (1992), pp. 72-79.

2890. "Warehouse of Pain." *Manga Max,* June 1999, p. 8.

2891. Watson, Paul. "Panzer Core." *Manga Max*. December 1999, pp. 28-30.

2892. "Weiss Wash?" *Manga Max*. June 1999, p. 10.

2893. West Laurence, Yvan and Alexandra Foucher. "Conan le Fils du Futur." *Animeland* (Paris). July 1996.

2894. "Whole Girl in His Hands." *Manga Max*. June 2000, p. 7.

2895. Wilkinson, Bryan C. "Omohide Poro Poro." *Anime Reference Guide*. 2:1 (1992), pp. 58-63.

2896. Winchester, James. *"Sasuga no Sarutobi."* *The Rose*. June 1999, p. 9.

2897. "A Wolf at the Door: Crimson Wolf." *Animerica*. 3:6 (1995), p. 13.

2898. Wong, Amos. "The Sound of Silence." *Manga Max*. July 2000, pp. 14-16. ("Resident Evil").

2899. Yamada, Toshihiro. "Kia Asamiya's 'The Corrector, Yui.'" *The Japanese Journal of Animation Studies*. 2:1A, (2000), pp. 33-39.

2900. Yates, Jolyon. "Gamera: The Guardian of the Universe." *Anime UK*. July 1995, pp. 14-15.

2901. Yates, Jolyon. "SFXPress." *Anime UK*. April 1995, pp. 16-18. ("Ultra Q").

2902. "You Sunk My Battleship! Deep Sea Battleship." *Animerica*. 3:1 (1995), p. 19.

2903. "Zaftig Zealots: Galaxy Fraulein Yuna." *Animerica.* 4:5 (1996), p. 13.

2904. "Zeno." *Manga Max.* May 1999, p. 5.

2905. "The Zion Thing." *Manga Max.* July 1999, p. 6. ("Goddess Cadets").

"Akira"

2906. "Akira." *Stripschrift.* August 1994, pp. 4-5.

2907. "Akira Production Report." *Stripschrift.* August 1994, p. 5.

2908. Bieker, Carl and Toon Dohmen. "Akira: Een Big Bang in Tokio." *ZozoLala.* June/July 1991, pp. 3-7.

2909. Chambers, James. "The Story Behind Akira the Card Set." *Card Collector's Price Guide.* July 1994, pp. 16-17.

2910. Cocks, Jay. "A Pulp-Style Pop Epic." *Time.* February 1, 1993.

2911. "Four Ways to Apocalypse: Akira." *Animerica.* 3:3 (1995), p. 14.

2912. Freiberg, Freda. *"Akira* and the Post-nuclear Sublime." In *Hibakusha Cinema: Hiroshima, Nagasaki and the Nuclear Image in Japanese Film,* edited by Mick Broderick, pp. 91-102. London: Kegan Paul, 1996.

2913. GK. "Akira." *Video.* February 1993, p. 50.

2914. Hollings, Ken. "Toys for the Boys." *Manga Max.* July 1999, pp. 12-17.

2915. "Japan's Animated 'Akira' Expands U.S. Run." Reuters release, April 20, 2001.

2916. Kawamoto, Saburo and Itō Shunji. *"Akira:* Mirai Toshi No Arushību." *Eureka.* 20:10 (1988), pp. 74-97.

2917. Macias, Patrick. "The Legacy of Akira." *Animerica.* 7:10 (1999), p. 15.

2918. Matsuzaki, James. "Akira." *Anime Reference Guide.* 1:1 (1991), pp. 1-2.

2919. Matsuzaki, James. "Akira." *Anime Reference Guide.* 2:1 (1992), pp. 1-2.

2920. Miyahara, Kojiro. "Looking Back at Akira." Paper presented at Association for Asian Studies, Honolulu, Hawaii, April 14, 1996.

2921. Moynihan, Martin. "'Akira Long' on Violence." Albany New York *Times Union.* December 25, 1990, p. C11.

2922. Rayns, Tony. "Akira." *Monthly Film Bulletin.* 58: 1991, pp. 66-67.

2923. Standish, Isolde. *"Akira,* Postmodernism and Resistance." In *The Worlds of Japanese Popular Culture: Gender, Shifting Boundaries and*

Global Cultures, edited by D. P. Martinez, pp. 56-74. Cambridge: Cambridge University Press, 1998.

2924. Townsend, Emru. "Akira." *Protoculture Addicts.* April 1990, pp. 25-28.

2925. Townsend, Emru. "Akira: Anime Comes of Age." *Sci-Fi Channel Magazine.* n.d., pp. 38, 40, 74.

2926. Van Willigen, Rein. "Akira." *Stripschrift.* June 1991, pp. 14-15.

"Alexander"

2927. "Alexander." *Animato!* Spring 1998, p. 85.

2928. "Alexander." *Manga Max.* December 1999, p. 9.

2929. Chung, Peter. "Designing 'Alexander.'" *Animation.* January 1999, p. 6.

2930. Swint, Lester. "Alexander." *The Rose.* February 1999, pp. 6-7.

"Angel Cop"

2931. Kim, Andy. "Angel Cop." *Anime Reference Guide.* 2:1 (1992), pp. 2-4.

2932. Luse, Jonathan. "Angel Cop." *The Rose.* April 1996, pp. 8-10.

2933. Matsuzaki, James and Andy Kim. "Angel Cop." *Anime Reference Guide.* 1:1 (1991), pp. 2-4.

2934. O'Connell, Mike. "A Guardian Angel: Angel Cop. Vols. 1-5." *Animerica.* 4:3 (1996), p. 67.

"A1 City"

2935. "Love (City) and Giant Robots from the Right Stuf." *Mangazine.* May 1995, p. 7.

2936. "Love Will Tear Us Apart . . . Again: A1 City." *Animerica.* 3:7 (1995), p. 13.

2937. Savage, Lorraine. *"A 1 City* (Love City)." *The Rose.* June 1999, pp. 14-15.

"Appleseed"

2938. Andersen, John. "Appleseed." *The Rose.* April 1995, p. 18.

2939. Barr, Greg. "A City Rotten to the Core: Appleseed." *Animerica.* 3:2 1995, p. 59.

2940. Staley, James. "Appleseed B-Club Film Comic." *The Rose*. April 1995, p. 19.

"Arcadia of My Youth"

2941. "My Youth in Arcadia." *Mangazine*. June 1993, p. 11.

2942. Sternbach, Rick. "A Fresh Perspective: Arcadia of My Youth." *Animerica*. 2:7 (1994), pp. 58-59.

"Area 88"

2943. "AREA 99." *Manga Max*. November 1999, p. 9.

2944. Horn, Carl G. "The Skies That Burned: Area 88 Act III. The Burning Mirage." *Animerica*. 2:11 (1994), p. 60. ("Area 88").

"Armitage III"

2945. "Armitage Sequel." *Manga Max*. Summer 2000, p. 8.

2946. "Armitage III." *Anime UK*. April 1995, pp. 27-29.

2947. "Character Spotlight: Armitage III." *Animerica*. 4:6 (1996), p. 21.

2948. Conty, Erique. "Pretty Hate Machine: Armitage III – Electro Blood." *Animerica*. 3:6 (1995), p. 63.

2949. Horn, Carl G. "Sounds Like Android Action." *Animerica*. 4:6 (1996), pp. 9, 23-25.

2950. Horn, Carl G. "Young Gun on Mars." *Animerica*. 4:6 (1996), pp. 8, 22-23.

2951. Karahashi, Takayuki. "Armitage III." *Animerica*. 4:6, (1996), pp. 6-7, 18-20.

2952. Ochi, Hiroyuki. "Babe Runner: Armitage III – Electro Blood." *Animerica*. 3:5 (1995), p. 12.

2953. "Pioneer Declares Armitage This June." *Mangazine*. May 1995, p. 8.

2954. Sertori, Julia. "Armitage." *Anime FX*. January 1996, pp. 34-41.

2955. Wong, Albert. "Armitage III." *Anime Reference Guide*. 3:1 (1995), pp. 7-9.

"Armored Trooper V.O.T.O.M.S."

2956. "Armored Trooper Votoms." *Animerica*. 5:6 (1997), pp. 23-25.

2957. "Armored Trooper VOTOMS Stage 3: Deadworld Sunsa." *The Rose.* July 1997, pp. 22-23.

2958. "Armored Trooper VOTOMS Stage 4: God Planet Quent." *The Rose.* July 1997, p. 23.

2959. Beam, John. "Armored Trooper Votoms, Stage 2." *Animation Planet.* Summer 1997, pp. 13-14.

2960. Beam, John. "Armored Trooper Votoms. Stage 2 Volume 1." *The Rose.* April 1997, p. 10.

2961. "Character Spotlight: Armored Trooper Votoms." *Animerica.* 4:9 (1996), p. 20.

2962. "Full Metal Jacket." *Animerica.* 4:7 (1996), p. 61.

2963. O'Connell, Michael. "Are You Ready for Votoms?" *Animerica.* 4:11 (1996), p. 66.

2964. Schumann, Mark. "Armored Trooper V.O.T.O.M.S." *Anime Reference Guide.* 2:1 (1992), pp. 101-104.

2965. Schumann, Mark and Darren Senn. "Armored Trooper V.O.T.O.M.S." *Anime Reference Guide.* 1:1 (1991), pp. 41-44.

2966. Teal, James. "Armored Trooper Votoms." *Animerica.* 4:9 (1996), pp. 4-5.

2967. Wright, Benjamin. "Armored Troopers Votoms BGM Vol. 1." *Animerica.* 7:3 (1999), p. 74.

"Astroboy"

2968. "Astroboy is 30!" *Mangazine.* August 1993, p. 5.

2969. "Astro Play." *Manga Max.* October 1999, p. 4.

2970. "Kimba and Astro Boy Posters." *Toon Art Times.* June 1997, p. 2.

2971. "Little Boys Lost and Found: Astro Boy, The Lost Episode." *Animerica.* 3:5 (1995), p. 12.

2972. "'Lost Episode' of *Astro Boy* from Right Stuf." *Mangazine.* March 1995, p. 6.

2973. Patten, Fred. "Astroold & Astronew." *Manga Max.* June 2000, pp. 38-42.

"Atragon"

2974. "Atragon Animated." *Kaiju Review.* 1:7 (1994), pp. 9-10.

2975. "Crimson Tide." *Animerica.* 4:7 (1996), p. 13.

"Baoh"

2976. Anderson, John. "Baoh." *The Rose.* July 1995, p. 22.

2977. "Baoh: Wow-Wow." *Animerica.* 3:5 (1995), p. 13.

2978. Barr, Greg. "Gory Story, *Baoh.*" *Animerica.* 3:12 (1995), p. 64.

2979. Beam, John. "Baoh." *The Rose.* October 1996, p. 31.

2980. Kim, Andy. "Baoh." *Anime Reference Guide.* 1:1 (1992), pp. 5-6.

2981. Kim, Andy. "Baoh." *Anime Reference Guide.* 2:1 (1992), pp. 5-6.

"Barefoot Gen"

2982. "Barefoot Gen-Video." *Comic!* December 1995, p. 4.

2983. "Barefoot in the Ruins: Barefoot Gen." *Animerica.* 3:7 (1995), p. 13.

2984. "Barefoot Gen." *LA Weekly.* July 21-27, 1995, p. 58.

2985. "Barefoot Gen." *Los Angeles Reader.* July 21, 1995, p. 23.

2986. Ferguson, P.H. "Popular Japanese Comic Portrays A-Bomb Horrors Artist Saw As a Child." *Philadelphia Inquirer.* August 6, 1995, p. H-6.

2987. Greenholdt, Joyce. "Viewing 'Barefoot Gen.'" *Comics Buyer's Guide.* December 29, 1995, p. 64.

2988. Kokmen, Ali T. "*I Saw It.*" *Comic Effect.* Autumn 1994, pp. 45-47.

2989. O'Neill, Sean. "Shock Treatment." *LA Village View.* July 21-27, 1995.

"Bastard!

2990. "The Heavy Metal Connection." *Animerica.* 7:2 (1999), p. 28.

2991. Kim, Richard. *"Bastard."* *The Rose.* January 1997, p. 16.

2992. Savage, Lorraine. *"Bastard."* *The Rose.* January 1997, pp. 14-15.

2993. Tebbetts, Geoffrey. "Monsters of Rock: Bastard!!: Resurrection." *Animerica.* 6:12 (1998), p. 68.

2994. Wright, Benjamin. "Bastard!" *Animerica.* 7:2 (1999), pp. 6-8, 25-27.

"Battle Angel Alita"

2995. Barr, Greg. "The Killer with the Face of an Angel: Battle Angel." *Animerica.* 3:5 (1995), p. 57.

2996. "Battle Angel Alita." *Mangazine.* May 1993, p. 4.

2997. Dextraze, Paul. "*Battle Angel Alita*/Gunnm." *The Rose.* January 1997, p. 22.

"Battle Arena Toshinden"

2998. "Battle Arena Toshinden." *Animerica.* 5:4 (1997), pp. 22-23.

2999. "Call Her Queen: Battle Arena Toshinden." *Animerica.* 4:5 (1996), p. 11.

3000. Frankenhoff, Brent. "Fighting To View 'Battle Arena Toshinden.'" *Comics Buyer's Guide.* February 14, 1997, p. 69.

3001. Teal, James. "Enter the Arena: Battle Arena Toshinden." *Animerica.* 5:5 (1997), p. 67.

"Battle Athletes"

3002. Decker, Dwight R. "Battle Athletes." *Animerica.* 7:11 (1999), pp. 18-21.

3003. Greenholdt, Joyce. "Battle Athletes." *Animation Buyer's Guide.* May 7, 1999, p. 18.

"Battle Royal High"

3004. Kim, Andy. "Battle Royal High." *Anime Reference Guide.* 1:1 (1991), pp. 6-7.

3005. Kim, Andy. "Battle Royal High." *Anime Reference Guide.* 2:1 (1992), pp. 6-7.

"Black Jack"

3006. "Black Jack on the Big Screen." *Animerica.* 4:7 (1996), p. 10.

3007. Chang, Wayne D. "Cold Hands, Warm Hearts?" *Animerica.* 5:6 (1997), p. 66.

3008. Merrill, Dave. "Calling Dr. Black Jack." *Mangajin.* October 1997, pp. 46-47.

3009. "Tezuka's Black Jack Returns in 3 OVA's!" *Mangazine.* August 1993, p. 4.

"Black Magic Mario-66"

3010. Evans, Peter J. "Mechanised Infantry." *Manga Max.* May 2000, pp. 36-38.

3011. Matsuzaki, James. "Black Magic Mario – 66." *Anime Reference Guide.* 1:1 (1991), pp. 16-17.

3012. Matsuzaki, James. "Black Magic Mario – 66." *Anime Reference Guide.* 2:1 (1992), p. 16.

3013. Savage, Lorraine. "Black Magic M-66." *The Rose.* July 1995, p. 23.

3014. "That Ol' Black Magic: Black Magic M-66." *Animerica.* 3:3 (1995), p. 14.

"Blue Seed"

3015. "Anime Series Roundup OAV – Blue Seed." *Animerica.* 4:12 (1996), pp. 20-21.

3016. Beam, John. "Blue Seed, Volume 1." *Animation Planet.* Summer 1997, pp. 14, 55.

3017. Beam, John. "Blue Seed Volume 8." *Animation Planet.* Fall 1997, p. 15.

3018. "Blue Seed." *Animerica.* 5:6 (1997), p. 19.

3019. "Blue Seed." *Mangazine.* November 1994, p. 10.

3020. "Blue Seed." *Mangazine.* May 1995, pp. 20-21.

3021. Dlin. Douglas. "What Makes Yūzō Blue? Yūzō Blue? Yūzō Takada's Blue Seed." *Mangazine.* May 1995, pp. 22-28.

3022. Ishigama, Yoshitaka. "Blue Seed, Bounty Dog." *Animerica.* 3:1 (1995), pp. 62-63.

3023. Sengupta, Anita. "Blue Seed." *Anime Reference Guide.* 3:1 (1995), pp. 10-16.

3024. Toole, Michael. "Call 911-Blu-Seed." *Animerica.* 4:7 (1996), p. 67.

"Bounty Dog"

3025. Barr, Greg. "Scholarly Sci-Fi." *Animerica.* 4:6 (1996), p. 68.

3026. Lew, Joshua. "Bounty Dog." *The Rose.* October 1996, p. 10.

"Brain Powered"

3027. Lamplighter, L. Jagi. "Brain Powered." *AnimeFantastique*. Summer 1999, p. 61.

3028. Simmons, Mark. *"Brain Powered."* *Animerica*. 8:2 (2000), pp. 16-21.

3029. Simmons, Mark. "Brain Powered." *Animerica*. 8:5 (2000), pp. 17-18, 38.

"Bubblegum Crisis"

3030. Adkins, Alexander. "Bubblegum Crisis: Before and After." *The Rose*. October 1997, p. 21.

3031. "Back on the Beat." *Manga Max*. April 1999, p. 5.

3032. "'Bubblegum Crisis' Becomes Role-Playing Game." *Comics Buyer's Guide*. December 29, 1995, p. 68.

3033. "Character Spotlight: Bubblegum Crisis: Tokyo 2040." *Animerica*. 7:8 (1999), pp. 34-35.

3034. Colton, Dave. "Bubblegum Crisis and Bubblegum Crash: A Promise Still Unfulfilled." *fps*. June 1992, pp. 14-17.

3035. Decker, Dwight R. "All the Bubblegum, None of the Crisis. Metal Fighters Miku Vol. 1." *Animerica*. 3:11 (1995), pp. 67-68.

3036. Matsuzaki, James, *et al*. "Bubblegum Crisis." *Anime Reference Guide.*" 2:1 (1992), pp. 7-15.

3037. Matsuzaki, James and Albert Sze-Wei Wang. "Bubblegum Crisis." *Anime Reference Guide*. 1:1 (1991), pp. 9-16.

3038. Meier, James. "Bubblegum Crisis." *Protoculture Addicts*. August-September 1991, pp. 11-17, 20-24.

3039. Oshiguchi, Takashi. "On the New Bubblegum Crisis." *Animerica*. 7:11 (1999), p. 65.

3040. Ratliff, Shauna. "A Bold New Bubblegum Crisis?" *Sequential Tart*. April 2000.

3041. Riddick, David. "Bubblegum Crisis Screensaver." *Animerica*. 2:12 (1994), p. 63.

3042. Spradley, Wade. "Bubblegum Crisis Legacy." *The Rose*. July 1996, pp. 26-27.

3043. "Stick by Your Bubblegum: Bubblegum Crash." *Animerica.* 2:11 (1994), p. 15.

3044. Swallow, Jim. "2040 Vision." *Manga Max.* September 1999, pp. 12-16.

3045. Townsend, Emru. "Bubblegum Crisis." *fps.* November 1991, pp. 12-20.

3046. Uyeyama, Richard. "Bubblegum Crisis 7: Double Vision." *A-ni-mé.* January 1991, pp. 37-46.

3047. Wang, Albert Sze-Wei. "Bubblegum Crisis – Background to the Series." *A-ni-mé.* January 1991, pp. 9-36.

3048. Wright, Benjamin. "Bubblegum Crisis: Tokyo 2040." *Animerica.* 7:8 (1999), pp. 14-15.

3049. Wright, Benjamin. "Bubblegum Crisis: Tokyo 2040." *Animerica.* 8:5 (2000), pp. 14-15.

"Burn Up W"

3050. Barr, Greg. "Mission Improbable: Burn Up W! File One: Skin Dive." *Animerica.* 5:1 (1997), p. 66.

3051. Beam, John. "Burn-Up W." *Animation Planet.* Fall 1997, pp. 15, 54.

3052. Evans, P.J. "Burn-Up W." *Manga Mania.* May-June 1998, pp. 18-19.

"Captain Harlock"

3053. "Captain Harlock Character Profiles." *Mangazine.* June 1993, p. 10.

3054. "Captain Harlock Mechanical Designs." *Mangazine.* June 1993, p. 12.

3055. "Space Pirate Captain Harlock." *Mangazine.* June 1993, pp. 8-9.

"Card Captor Sakura"

3056. Arnold, Erica. "Card Captor Sakura." *The Rose.* June 2000, p. 13.

3057. "CardCaptors Snatch Awards." *Manga Max.* July 2000, p. 4.

3058. Carter, Ben. "Wild Cards." *Manga Max.* July 2000, pp. 42-44.

3059. "WB Grab Card Captors." *Manga Max.* June 2000, p. 8.

"Castle of Cagliostro"

3060. Osmond, Andrew. "Spotlight: The Castle of Cagliostro." *Animerica.* 8:4 (2000), pp. 14-15, 17, 39-40.

3061. Savage, Lorraine. "Castle of Cagliostro." *The Rose.* June 2000, p. 5.

"Cat-Girl Nuku-Nuku"

3062. Jenkins, Ralph. "A Yarn Worth Chasing After: *All-Purpose Cultural Cat Girl Nuku Nuku." Animerica.* 3:9 (1995), p. 63.

3063. Moe, Anders. "Cat-Girl Nuku Nuku: Dash." The Rose. October 1998, p. 29.

3064. "Super Cat-Girl Nuku-Nuku." *Mangazine.* January 1994, pp. 10-17.

3065. Swallow, James. "Catgirl: Nuku Nuku." *Mangazine.* November 1994, p. 11.

"Cat's Eye"

3066. Wong, Larry and Peter. "Cat's Eye." *Anime Reference Guide.* 1:1 (1991), pp. 17-18.

3067. Wong, Larry and Peter. "Cat's Eye." *Anime Reference Guide.* 2:1 (1992), p. 19.

"Char's Counterattack"

3068. Matsuzaki, James. "Char's Counterattack." *Anime Reference Guide.* 1:1 (1991), pp. 18-20.

3069. Matsuzaki, James. "Char's Counterattack." *Anime Reference Guide.* 2:1 (1992), pp. 20-21.

"City Hunter"

3070. Brimmicombe-Wood, Lee and Motoko Tamamuro. "Cops & Robbers." *Manga Max.* July 1999, pp. 36-39.

3071. "City Hunter." *Animag.* No. 5, 1998, pp. 40-43.

3072. "City Hunter Design Page – Ryo Saeba, Kaori Makimura," *Mangazine.* April 1993, pp. 10-11.

3073. "City Hunter Episode Guide." *Mangazine.* April 1993, pp. 12-16.

3074. "The Compact View." *Animerica.* 2:7 (1994), p. 65.

3075. Guerin, Peter W. "City Hunter." *The Rose.* June 2000, p. 9.

3076. Knapp, Mark. "City Hunter Movie." *Anime Reference Guide.* 1:1 (1991), pp. 103-106.

3077. Knapp, Mark. "City Hunter Movie." *Anime Reference Guide.* 2:1 (1992), pp. 22-24.

3078. Liu, Ping-Chun. "Deconstructing the Female Character in a Japanese Cartoon, 'City Hunter' – A Feminist Perspective." Master's thesis, National Chengchi University, Communication School, 1996.

3079. McCarter, Charles. "City Hunter TV Episodes 1-6." *Anime Reference Guide.* 2:2 (1994), pp. 7-13.

"Cobra"

3080. Dubois, Robert. "Cobra Mission Exposed." *Protoculture Addicts.* December 1993, p. 19.

3081. McCarthy, Helen. "Cobra." *Anime FX.* February 1996, pp. 28-32.

"Cockpit, The"

3082. "The Cockpit: New OVA Series from Matsumoto!" *Mangazine.* October 1993, p. 6.

3083. Lee, Roderick. "The Cockpit." *Anime Reference Guide.* 3:1 (1995), pp. 17-23.

"Cowboy Bebop"

3084. "Bebop Grooves." *Manga Max.* June 1999, p. 7.

3085. Brimmicombe-Wood, Lee and Motoko Tamamuro. "Boogie Woogie Feng Shui." *Manga Max.* December 1999, pp. 38-42.

3086. Fox, Kit. "Cowboy Bebop." *Animerica.* February 2000, pp. 13-15, 30-31.

3087. "Rumour Mills." *Manga Max.* October 1999, p. 5.

3088. Swint, Lester. "Cowboy Bebop." *The Rose.* February 2000, pp. 6-7.

"Crayon Shin-chan"

3089. "Crayon Shin-chan." *Mangajin.* May 1995, pp. 60-68.

3090. "Crayon Shin-Chan by Usui Yoshito." *Mangajin.* February 1996, pp. 38-45.

3091. Penn, William. [Crayon Shin-Chan]. *Daily Yomiuri.* May 1, 1993.

3092. Penn, William. [Crayon Shin-Chan]. *Daily Yomiuri.* March 19, 1994.

3093. Schilling, Mark. "Shin-chan Falls Flat on Big Screen." *Japan Times.*
 July 27, 1993.

"Crusher Joe"

3094. Beam, John. "Crusher Joe the Movie." *The Rose.* July 1997, p. 5.

3095. "Crusher Joe – The Movie." *The Rose.* July 1997, p.21.

3096. Jang, Galen. "Crusher Joe OAV 2." *Anime Reference Guide.* 1:1 (1991),
 pp. 20-21.

3097. Jang, Galen. "Crusher Joe OAV #2." *Anime Reference Guide.* 2:1
 (1992), p. 25.

3098. Staley, James. *"Crusher Joe:* The Movie." *The Rose.* October 1998, p.
 8.

3099. Toole, Michael. "Joe Versus the Space Pirates: Crusher Joe: The
 Movie." *Animerica.* 5:9 (1997), p. 68.

"Crying Freeman"

3100. "The Boy from Brazil." *Manga Mania.* July-August 1997, p. 23.

3101. Clarke, Jeremy. "The Lady Killer." *Manga Mania.* July-August 1997,
 pp. 20-22.

3102. "Crying Freeman." *Spazz.* No. 11.

3103. Dean, Michael. "Behind Blue Eyes." *Comics Buyer's Guide.* December
 29, 1995, p. 74.

3104. "Erotic Crime and Occult Horror: Doomed Megalopolis and Crying
 Freeman." *Animerica.* 3:5 (1995), p. 15.

3105. Gentry, Clyde III. "Hong Kong vs. Japanese Animation Part III: *Crying
 Freeman (The Dragon from Russia)." Hong Kong Film Connection.*
 July 1994, pp. 4-5.

3106. Hughes, Dave. "Labor of Love." *Manga Mania.* October-November
 1997, p. 18.

3107. Matsuzaki, James. "Crying Freeman." *Anime Reference Guide.* 1:1
 (1991), pp. 21-22.

"Cutey Honey"

3108. "Cutey Honey Flashes Back into Spotlight in OVA Series." *Mangazine.*
 November 1993, p. 5.

3109. Dlin, Douglas. "Cutey Honey – More Than Just a 'Flash' in the Pan." *Mangazine*. March 1995, p. 18-20.

3110. "New Cutey Honey." *Mangazine*. March 1995, p. 21-25.

3111. Swint, Lester. "New Cutey Honey." *The Rose*. July 1996, pp. 4-5.

"Dancougar"

3112. McCarthy, Helen. "Dancougar: Super Bestial Machine God." *Anime UK*. July 1995, pp. 38-40.

3113. O'Connell, Michael. "Ten Years Ago Today . . . Dancougar Super Bestial Machine God." *Animerica*. 4:8 (1996), p. 68.

3114. "Super Bestial Machine God." *Animerica*. 4:7 (1996), p. 14.

"The Dark Myth"

3115. O'Connell, Michael. "Attention Anime Shoppers! Dark Myth Part 1." *Animerica*. 5:5 (1997), p. 69.

3116. O'Connell, Michael. "Mythology 101: The Dark Myth Part 2." *Animerica*. 5:7 (1997), p. 68.

3117. Robinson, Brian. "The Dark Myth." *The Rose*. October 1997, p. 13.

"Darkside Blues"

3118. Lamplighter, L. Jagi. "Darkside Blues." *AnimeFantastique*. Fall 1999, pp. 18-21.

3119. McCarthy, Helen and Jonathan Clements." Here Comes the Night: Darkside Blues." *Anime FX*. December 1995, pp. 15-17.

3120. O'Connell, Michael. "Dark Reflections." *Animerica*. 5:6 (1997), p. 69.

"Demon City Shinjuku"

3121. "Demon City Shinjuku." *Animag*. No. 5, 1988, p. 4.

3122. Samuels, Mitch. "Demons in the Big City: Demon City Shinjuku." *Animerica*. 2:12 (1994), p. 61.

"Devil Hunter Yohko"

3123. "Devil Hunter Yohko." *Mangazine*. September 1993, pp. 8-9.

3124. "Devil Hunter Yohko Character Guide." *Mangazine.* September 1993, p. 10.

3125. "Devil Hunter Yohko – Synopsis." *Mangazine.* September 1993, pp. 11-12.

3126. "Five Feet High and Six Feet Deep." *Animerica.* 3:6 (1995), p. 14.

3127. Greenfield, Matt. "Confessions of a Yohkoholic." *Mangazine.* September 1993, pp. 6-7.

3128. Kim, Angeline. "Buffy the Devil Slayer." *Animerica.* 4:6 (1996), p. 63.

3129. Newton, Cynthia J. "Move Over, Buffy! Yohko's Here!" *Animerica.* 2:11 (1994), pp. 59-60.

"Digimon"

3130. "Digi Re-Do. "*Manga Max.* April 1999, p. 6.

3131. Hunter, Stephen. " 'Digimon': Attack of Bugs and Jitters." *Washington Post.* October 6, 2000, p. C12.

3132. Koehler, Robert. *"Digimon: The Movie." Variety.* October 9-15, 2000, pp. 22-23.

3133. Koehler, Robert. "Tacky Animation Mars 'Digimon.'" Reuters dispatch, October 6, 2000.

3134. Koehler, Robert. "Tacky Animation Mars 'Digimon.'" Reuters dispatch, October 6, 2000.

3135. Martin, Patti. "Digi-maniacs Rule Kids' TV Domain." Nashville *Tennessean.* November 1, 2000, p. 5D.

3136. Patten, Fred. "Is *Digimon* Movie Destined for Success?" *Animation.* October 2000, pp. 73, 75.

3137. Penn-Miller, Rachel. *"Digimon." Animerica.* 8:7, (2000), p. 36.

3138. "Spotlight on: Digimon." *Manga Max.* October 1999, p. 11.

3139. Van Gelder, Lawrence. " 'Digimon': The Movie." *New York Times.* October 6, 2000, p. B20.

"Dirty Pair"

3140. "Digital Dirty Pair." *Animerica.* 5:10 (1997), p. 9.

3141. "Digital Pair Flash." *Animerica.* 6:12 (1998), pp. 18-19.

3142. Duffield, Patti. "Dirty Pair Flash." *Anime Reference Guide.* 2:2 (1994), p. 17.

3143. Guerin, Peter W. "Original Dirty Pair." *The Rose.* February 2000, p. 15.

3144. Kim, Andy. "Dirty Pair." *Anime Reference Guide.* 1:1 (1991), pp. 22-24.

3145. Kim, Andy. "Dirty Pair." *Anime Reference Guide.* 2:1 (1992), p. 26.

3146. Matthews, Ryan. "Dirty Pair: Flight 005 Conspiracy." *Protoculture Addicts.* November-December 1991, pp. 22-23.

3147. "New Dirty Pair OVA!" *Mangazine.* November 1993, p. 6.

3148. Rasmussen, David. "Dirty Pair Debate." *The Rose.* April 1996, p. 36.

3149. Patten, Fred. "Ordinary *Dirty Pair* #4." *Manga Max.* January 2000, p. 51.

3150. Swallow, Jim. "Girl Powered." *Manga Max.* June 1999, pp. 18-21.

"DNA2"

3151. "Justify Your Love: Recombinant Comedy DNA2." *Animerica.* 2:11 (1994), p. 19.

3152. Smith, Mike. "DNA2." *The Rose.* April 1997, p. 7.

3153. Swint, Lester. "OAV Review: DNA Sights 999.9." *The Rose.* October 1999, pp. 16, 34.

"Dominion"

3154. Kim, Andy. "Dominion." *Anime Reference Guide.* 1:1 (1991), pp. 24-26.

3155. Kim, Andy. "Dominion, Acts III-IV." *Anime Reference Guide.* 2:1 (1992), pp. 27-29.

"Doraemon"

3156. Brown, Urian. "Doraemon 2." *Animerica.* 7:3 (1999), p. 74.

3157. "Doraemon Birthday Bash." *Sun Magazine* (Malaysia). October 1, 1998, p. 19.

3158. Shilling, Mark. "A Look Inside Doraemon's Pouch." In *Kaboom! Explosive Animation in America and Japan,* pp. 76-85. Sydney: Museum of Contemporary Art, 1994.

3159. Shiraishi, Saya S. "Doraemon Goes Abroad." In *Japan Pop!* Edited by Timothy J. Craig, pp. 287-308. Armonk, New York: M.E. Sharpe, 2000.

3160. Shiraishi, Saya. "Japan's Soft Power: Doraemon Goes Overseas." Paper presented at Japanese Popular Culture Conference, Victoria, Canada, April 10, 1997.

3161. Shiraishi, Saya S. "Japan's Soft Power: Doraemon Goes Overseas." In *Network Power: Japan and Asia,* edited by Peter J. Katzenstein and Takashi Shiraishi, pp. 234-272. Ithaca, New York: Cornell University Press, 1997.

"Dragonball"

3162. "By Any Other Name." *Animerica.* 8:7 (2000), p. 39.

3163. Dennis, William. "Dragonball G.T." *The Rose.* April 1996, p. 30.

3164. "Dragon Ball License Shifts to Funimation." *Mangazine.* March 1995, p. 7.

3165. "Dragon Ball, Then and Now." *Animerica.* 4:11 (1996), pp. 19-20.

3166. "Dragon from Ball A to Z: Fun with Puns." *Animerica.* 4:11 (1996), pp. 21-24.

3167. Duffield, P. "Dragon Ball." *Animerica.* 8:7 (2000), pp. 15, 17-18, 38, 40-41.

3168. Fowler, Jimmy. "International Incident: Dragonball Z Is the Cartoon Network's Top-Rated Show, Thanks to a Fort Worth-Based Company That's Unleashing a Controversial American Version of This Japanese Hit." *Dallas Observer.* January 20, 2000.

3169. Lameiras, Joao M. "Dragon Ball e a Violência Televisiva" (Dragon Ball and the Violence on Television). *Bibliotecas* (Lisbon). February 1998.

3170. Lipari, Phil and Martin King. "Dragonball." *Anime UK.* May 1995, pp. 36-37, 39-43.

3171. Lipari, Phil and Martin King. "Enter the Dragonball." *Anime UK.* April 1995, pp. 40-43.

3172. Oshiguchi, Takashi. "On the Secret of Dragon Ball's Popularity." *Animerica.* 3:3 (1995), p. 19.

3173. "Seen on the Scene." *Animerica.* 5:6 (1997), p. 14.

3174. Teal, James. "Dragon Ball from A to Z." *Animerica.* 4:11 (1996), pp. 5-7, 18.

3175. Toole, Michael. "Bloody Entertaining! Dragon Ball: Curse of the Blood Rubies." *Animerica.* 5:1 (1997), p. 68.

3176. "Viz Comics: The Many Faces of Dragon Ball." *Comics Buyer's Guide.* March 6, 1998, pp. 30-31.

"Dragon Century"

3177. Rymning, Perrin. "Dragon Century." *Anime Reference Guide.* 1:1 (1991), pp. 25-29.

3178. Rymning, Perrin. "Dragon Century." *Anime Reference Guide.* 2:1 (1992), pp. 30-32.

"Dream Hunter Rem"

3179. Kim, Andy. "Dream Hunter Rem 4." *Anime Reference Guide.* 1:1 (1991), p. 29.

3180. Kim, Andy. "Dream Hunter Rem 4." *Anime Reference Guide.* 2:1 (1992), pp. 32-33.

3181. Staley, James. "Dream Hunter Rem." *The Rose.* July 1997, p. 27.

"Eat Man"

3182. "Eat Man," "Samurai Shodown." *Animerica.* 5:8 (1997), p. 61.

3183. Swallow, Jim. "*Eat-Man* 98 #2." *Manga Max.* January 2000, p. 50.

"801TTS"

3184. "It's Strictly Shojo in the Blue Sky Squadron!" *Animerica.* 2:11 (1994), p. 18. ("Blue Sky Shojo Squadron 801TTS").

3185. Kim, Angeline. "Homecoming Queen's Got a Top Gun: *801 T.T.S. Airbats.*" *Animerica.* 3:12 (1995), p. 70.

"El Hazard"

3186. Clements, Jonathan. "Trouble in Paradise." *Manga Mania.* March-April 1998, pp. 56-59.

3187. "Elhazzar, World of Mystery." *Animerica.* 2:7 (1994), p. 13.

3188. Evans, Peter. "El Hazard: The Magnificent World." *Anime FX.* August 1995, pp. 34-40.

3189. Fox, Kit. "A World Less Magnificent: *El-Hazard 2:* The Magnificent World, Vol. 1." *Animerica.* 6: 12 (1998), p. 70.

3190. Lew, Joshua. "El Hazard." *The Rose.* October 1997, p. 22.

3191. "The Old Order Changest: *El-Hazard* TV Series." *Animerica.* 3:12 (1995), p. 15.

"Famous Detective Holmes"

3192. Twersky, Nina. "Famous Detective Holmes." *Anime Reference Guide.* 1:1 (1991), pp. 78-79.

3193. Twersky, Nina. "Famous Detective Holmes." *Anime Reference Guide.* 2:1 (1992), pp. 43-44.

"Fantastic Journey of Licca"

3194. Kim, Andy. "Fantastic Journey of Licca." *Anime Reference Guide.* 1:1 (1991), pp. 44-45.

3195. Kim, Andy. "Fantastic Journey of Licca." *Anime Reference Guide.* 2:1 (1992), pp. 50-51.

"Fatal Fury"

3196. Aish, Sergei L. "Fatal Fury Special." *Animerica.* 3:1 (1995), p. 64.

3197. Aish, Sergei L. "Real Bout Fatal Fury." *Animerica.* 4:4 (1996), p. 62.

3198. "Fatal Fury Hits the Screen." *Animerica.* 2:7 (1994), p. 12.

3199. Lyon, Matt. "Fatal Fury 2." *The Rose.* January 1996, p. 7.

"Final Fantasy"

3200. "Fantasy Island." *Manga Max.* February 1999, p. 4.

3201. "Final Fantasy." *Manga Max.* May 1999, p. 9.

3202. "Final Fantasy Vol. 1, 'Chapter of Wind.'" *Animerica.* 2:7 (1994), p. 65.

3203. Gronnestad, Crystal. "Game Review: Final Fantasy III." *The Rose.* January 1996, pp. 20-21.

3204. Montgomery, Sheldon. "Final Fantasy 7." *The Rose.* October 1997, p. 9.

3205. Watson, Paul. "The Crystal Maze." *Manga Max.* April 1999, pp. 26-29.

"Fist of the North Star"

3206. Bush, Laurence. *"Fist of the North Star." The Rose*. June 1999, pp. 4-5.

3207. "Fist and Shout." *Manga Max*. January 2000, p. 7.

3208. "Fisting by the Pool." *Manga Max*. November 1999, p. 4.

3209. "Fist of the North Star." *Polyhedron*. 6/1994.

3210. Frankenhoff, Brent. "Fist of the North Star." *Animation Buyer's Guide*. May 7. 1999, p. 21.

3211. "Let's Fist Again!" *Manga Max*. October 1999, p. 9.

3212. Osmond, Andrew. *"Fist of the North Star* TV #7." *Manga Max*. January 2000, p. 53.

3213. Swallow, Jim. "Way of the Fist." *Manga Max*. March 1999, pp. 28-31.

3214. Wright, Benjamin. "Fist of the North Star." *Animerica*. 7:12 (1999), pp. 32-35.

"Fushigi Yūgi: The Mysterious Play"

3215. Decker, Dwight R. "Fushigi Yūgi: The Mysterious Play." *Animerica*. 8:2 (2000), pp. 10-11, 32-33.

3216. "Fushigi Yūgi." *Animerica*. 6:9 (1998), pp. 75-76.

3217. Greenholdt, Joyce. "Fushigi Yūgi/Mysterious Play." *Animation Buyer's Guide*. May 7, 1999, p. 18.

3218. Luse, Jonathan. "Fushigi Yuugi." *The Rose*. July 1996, pp. 6-8.

"Future Boy Conan"

3219. Amos, Walter. "Future Boy Conan TV Episode 1." *Anime Reference Guide*. 2:2 (1994), p. 18.

3220. "Conan Destroys Opposition." *Manga Max*. July 1999, p. 7.

3221. "Conan the Millenarian." *Manga Max*. December 1999, p. 7.

3222. Yates, Jolyon. "Future Boy Conan." *Anime UK*. May 1995, pp. 17-19.

"Galaxy Express 999"

3223. "Galaxy Express 999." *Animerica*. 5:9 (1997), pp. 32-56.

3224. Macias, Patrick. "Fond (of) Adieu." *Animerica*. 5:7 (1997), p. 66.

3225. Macias, Patrick. "Take the Galaxy Train: Galaxy Express 999." *Animerica.* 4:12 (1996), p. 67.

3226. Oshiguchi, Takashi. "On Galaxy Express 999." *Animerica.* 4:7 (1996), p. 62.

3227. Savage, Lorraine. "Galaxy Express: Eternal Fantasy." *The Rose.* June 1998, pp. 8-9.

"Gall Force"

3228. Decker, Dwight R. "Eternal Recurrence: Gall Force." *Animerica.* 4:10 (1996), p. 67.

3229. "Gall Force Down Under!" *Animerica.* 2:12 (1994), p. 11.

3230. Jang, Galen. "Rhea Gall Force." *Anime Reference Guide.* 1:1 (1991), p. 76.

3231. Kim, Andy. "Gall Force." *Anime Reference Guide.* 1:1 (1991), pp. 29-30.

3232. Kim, Andy. "Gall Force." *Anime Reference Guide.* 2:1 (1992), p. 33.

3233. Matsuzaki, James. "Ten Little Gall Force." *Anime Reference Guide.* 1:1 (1991), pp. 83-84.

3234. O'Connell, Michael. "Galls Just Want To Have Fun: Gall Force: New Era 1." *Animerica.* 3:11 (1995), p. 66.

3235. Samuels, Mitch. "A Force of Their Own: Rhea Gall Force." *Animerica.* 2:11 (1994), p. 61.

"Gatchaman"

3236. Evans, Peter J. "Science Ninja Team Gatchaman." *Manga Mania.* July-August 1997, p. 94.

3237. "Gatchaman." *Animerica.* June 1999, pp. 30-31.

3238. "Gatchaman 2 – The Red Specter." *The Rose.* July 1997, p. 23.

3239. McCarter, Charles. "Gatchaman." *Anime Reference Guide.* 3:1 (1995), pp. 24-29.

3240. Osmond, Andrew. "Battle of the Planets." *AnimeFantastique.* Fall 1999, pp. 52-53.

3241. Swint, Lester. "Gatchaman Graffiti." *The Rose.* January 1997, pp. 20-21.

"Ghost in the Shell"

3242. Dilworth, John R. "Do You Hear a Whisper in Your Ghost?" *Animation World.* June 1996, 5 pp.

3243. "Ghost in the Shell." *Anime FX.* August 1995, pp. 24-27.

3244. "Ghost in the Shell." *Fant-Asia.* July /August 1997, p. 42.

3245. "Ghost in the Shell." *Manga Mania.* March-April 1998, pp. 31-31.

3246. "'Ghost in the Shell' Is Ready for American Release." *Comics Buyer's Guide.* February 2, 1996, p. 62.

3247. "Ghost in the Shell – Kokaku Kidotai." In *Fantoche*, p. 74. Baden: Buag, 1997.

3248. "Ghost in the Shell: One of 'The 50 Best DVDs.'" *The Rose.* February 2001, p. 5.

3249. Harrington, Richard. " 'Ghost': Virtually Vivid." *Washington Post.* March 29, 1996.

3250. Horn, Carl G. "When We Dead Awaken." *Animerica.* 4:7 (1996), p. 68.

3251. Jenkins, Mark. "Mommas' Boy." *Washington City Paper.* March 29, 1996, p. 38.

3252. McCarthy, Helen. "Ghost in the Shell." *Anime FX.* December 1995, pp. 18-23.

3253. Savage, Lorraine. "Anime Symposium: Anime Creation and Production: The Making of Ghost in the Shell." *The Rose.* October 1999, pp. 30-31, 34.

3254. "Shell Shocked: Ghost in the Shell." *Animerica.* 3:1 (1995), p. 18.

3255. Staley, James and David Genesse. "Ghost in the Shell." *The Rose.* April 1996, pp. 20-21.

"Ghost Sweeper Mikami"

3256. Hiroi, Takahiro. "Ghost Sweeper Mikami." *The Rose.* October 1996, p. 19. Reprinted from *NewType.* June 1993.

3257. McCarter, Charles. "Ghost Sweeper Mikami TV Episodes 1-2." *Anime Reference Guide.* 2:2 (1994), pp. 19-21.

"Giant Robo"

3258. "Bring on the Beautiful Night!" *Animerica.* 3:11 (1995), p. 16.

3259. Clements, Jonathan. "Update G. Robo & G. Robo." *Manga Mania.* May-June 1998, p. 8.

3260. Fox, Kit. "Giant Robo." *Animerica.* 5:9 (1997), p. 25-27.

3261. Frankenhoff, Brent. "Viewing 'Giant Robo': The Night the Earth Stood Still." *Comics Buyer's Guide.* April 5, 1996, p. 56.

3262. "Giant Robo." *Mangazine.* January 1993, pp. 5-10.

3263. McCarthy, Helen. "Giant Robo." *Anime FX.* January 1996, pp. 16-21.

3264. Peacock, Dirk. "Giant Robo Vol. 1." *The Rose.* October 1995, pp. 27, 36.

"Gigantor"

3265. "Cartoon Robot To Go Live Action." *Kaiju Review.* 1:7 (1994), p. 9.

3266. "30th Anniversary Giganto Collection Zooming Your Way from the Right Stuf!" *Mangazine.* November 1993, p. 3.

"Godzilla"

3267. "Amerigoji (x) 2. Tales of Two Godzillas." *Kaiju Review.* 1:8 (1995), pp. 4-11.

3268. Anisfield, Nancy. "Godzilla Gojiro: Evolution of the Nuclear Metaphor." *Journal of Popular Culture.* Winter 1995, pp. 53-62.

3269. Chance, Frank L. "Meaning and Monstrosity: *Godzilla* 1954-1998." Paper presented at Mid-Atlantic Region Association for Asian Studies, Newark, Delaware, October 24, 1998.

3270. "Godzilla BC." *Manga Max.* February 1999, pp. 32-36.

3271. "Godzilla, Life & Times." *Manga Mania.* July/August 1998, pp. 14-15.

3272. "Godzilla vs. King Ghidorah." *Mangazine.* July 1992, pp. 24-35.

3273. "Godzilla vs. Mechagodzilla Goes into Production!" *Mangazine.* August 1993, p. 3.

3274. Groves, Don. " 'Godzilla' Storms Malaysian B.O." *Variety.* June 8-14, 1998, p. 14.

3275. Herskovitz, Jon. " 'Godzilla' To Bring Home Bacon to Toho." *Variety.* June 8-14, 1998, p. 13.

3276. "He's Back and He's Just as Bad." *Asiaweek.* November 12, 1999, p. 24.

3277. Hsiao, Hsiang-Wen. "The Movie about Monsters (Godzilla)." *Central Daily News.* June 29, 1998, p. 23.

3278. Kyte, Steve. "Big in Hollywood." *Manga Mania.* July/August 1998, pp. 10-13.

3279. Kyte, Steve. "G-Stuff." *Manga Mania.* July/August 1998, p. 16.

3280. Leydon, Joe. "Godzilla 2000 (Gojira Ni-sen Mireniamu)." *Variety.* August 21-27, 2000, p. 16.

3281. "New Godzilla Cartoon in the Works." *Kaiju Review.* 1:7 (1994), p. 10.

3282. Ragone, August. "Godzilla vs Mechagodzilla." *Asian Trash Cinema.* 5:1, pp. 31-33.

3283. "Spotlight on: Godzilla 2000," *Manga Max.* January 2000, p. 11.

3284. Stuever, Hank. "What Would Godzilla Say?" *Washington Post.* February 14, 2000, pp. C-1, C-7.

3285. Yates, Jolyon. "Godzilla." *Anime UK.* December 1994/January 1995, p. 37.

"Goldfish Warning"

3286. "Goldfish Warning!" *Mangazine.* November 1991, n.p.

3287. "Goldfish Warning." *Mangazine.* August 1993, p. 5.

"Golgo 13"

3288. Frankenhoff, Brent. "Golgo 13: Queen Bee." *Animation Buyer's Guide.* May 7, 1999, p. 20.

3289. " 'Golgo 13: Queen Bee.'" *Animation.* September 1998, p. 44.

"Green Legend Ran"

3290. Barr, Greg. "An Anime Legend in Its Own Time: Green Legend Ran." *Animerica.* 3:10 (1995), pp. 64-65.

3291. Johnston, Bill. "Green Legend Ran." *The Rose.* July 1995, p. 23.

3292. Luce, Eric. "Green Legend Ran Volumes 1-3." *Anime Reference Guide.* 2:2 (1994), pp. 22-29.

3293. "Think Globally, Buy Locally." *Animerica.* 2:11 (1994), p. 14.

"Grey"

3294. "Grey on Film." *Animerica.* 5:7 (1997), p. 19.

3295. Teal, James. "A Portrait in Grey." *Animerica.* 5:7 (1997), pp. 4-5, 18-19, 21.

3296. "Tech Talk." *Animerica.* 5:7 (1997), p. 20.

"Gunbuster"

3297. Boyte, Timothy. "Gunbuster: Aim for the Top." *The Rose.* April 1997, pp. 22, 31.

3298. Doi, Hitoshi. "Top wo Nerae! GunBuster Synopses: Volumes 2 and 3." *A-ni-mé.* January 1991, p. 52.

3299. Horn, Carl G. "Long Shot on a Bouncing Target: Gunbuster: Vols. 1-3." *Animerica.* 4:12 (1996), p. 68.

3300. Jang, Galen. "Gunbuster Volumes 2, 3." *Anime Reference Guide.* 1:1(1991), pp. 32-33, 35-36.

3301. Jang, Galen. "Gunbuster Volumes 2, 3." *Anime Reference Guide.* 2:1 (1992), pp. 36-38.

3302. Tatsugawa, Mike. "GunBuster – Episodes # 1, 2." *A-ni-mé.* January 1991, pp. 47-51.

"Gundam Wing"

3303. "Barrel Scraping?" *Manga Max.* Summer 2000, p. 8.

3304. Davis, Julie. "Gundam 0083 Stardust Memory: Original Soundtrack Vol. 1." *Animerica.* 6:12 (1998), p. 71.

3305. "End With a Bang." *Manga Max.* March 2000, p. 8.

3306. "G Force!" *Manga Max.* August 1999, p. 7.

3307. "Gundam Glossary." *Animerica.* 6:10 (1998), p. 26.

3308. "Gundam Lands at Toy Fair." *Manga Max.* April 1999, p. 11.

3309. Raugust, Karen. "Gundam Wing." *Animation.* January 2001, p. 18.

3310. Simmons, Mark. "1/144 Knight of Gold." *Animerica.* 6:9 (1998), p. 69.

3311. Wright, Benjamin. "*Gundam Wing.*" *Animerica.* 8:6 (2000), pp. 23-26.

3312. Wright, Benjamin and Mark Simmons. "Gundam Wing." *Animerica.* 8:5 (2000), pp. 11-13.

"Gunsmith Cats"

3313. Guerin, Peter. "Gunsmith Cats." *The Rose*. February 1999, p. 17.

3314. "Gunsmith Cats Live!?" *Manga Max*. July 1999, p. 5.

3315. Teal, James. 'Ride, Baby Ride Gunsmith Cats. Vol. 1." *Animerica*. 4:8 (1996), p. 70.

"Guyver"

3316. Ainsburg, Brenda. "The Guyver. Bio-Booster: Terminal Battle, Fall of Chronos." *Animation Planet*. Fall 1997, p. 13.

3317. Barr, Greg. "The Original Bio-Boostin' Power Hero." *Animerica*. 3:1 (1995), pp. 58-59.

3318. Barr, Greg. "Steve Wang's Dark Hero: Guyver: Dark Hero." *Animerica*. 3:1 (1995), p. 59.

3319. "Bio-Boosting Anime." *Animerica*. 4:3 (1996), p. 10.

3320. Dagg, Rob. "Guyver 2: Dark Hero." *Kaiju Review*. 1:7 (1994), pp. 16-17.

3321. Dextraze, Paul. "The Guyver." *The Rose*. February 1998, pp. 6-7.

"Hades Project Zeorymer"

3322. Evans, P. J. "Zeoraima, Project Hades." *Manga Max*. October-November 1997, pp. 10-13.

3323. Jang, Galen. "Mei Ou Project Zeorymer." *Anime Reference Guide*. 1:1 (1991), pp. 99-103.

3324. Jang, Galen. "Mei Ou Project Zeorymer." *Anime Reference Guide*. 2:1 (1992), pp. 109-110.

3325. Samuels, Mitch. "A Good, Strong Dose of What Mecha Fans Really Need: Hades Project Zeorymer, Vol. 1." *Animerica*. 2:11 (1994), pp. 58-59.

"Half a Dragon"

3326. "Half a Dragon Is Better for Fun: Dragon Half – Parts 1 and 2." *Animerica*. 3:6 (1995), p. 14.

3327. Kim, Richard. "Dragon Half." *The Rose*. July 1996, p. 27. From *NewType*, June 1993.

"Haunted Junction"

3328. Brimmicombe-Wood, Lee and Motoko Tamamuro. "Up the Junction." *Manga Max.* August 1999, pp. 26-27.

3329. "Haunted Junction." *Animerica.* 7:10 (1999), pp. 31-32.

"Hello Kitty"

3330. Bacani, Cesar. "Pretty in Pink." *Asiaweek.* March 19, 1999, pp. 52-55.

3331. Cheng, Maria. "Hello, Kitty." *Asiaweek.* March 9, 2001, pp. 44-45.

3332. "Cute Power!" *Asiaweek.* November 24, 2000, p. 92.

3333. "Hello Again, Kitty." *Manga Max.* June 2000, p. 7.

3334. "Hello Again, Kitty: Cartoon Character Goods Make a Comeback." *Focus Japan* (Tokyo). April 1998, p. 9.

3335. Matsumoto, Toshimichi. "Hello Kitty Makes Sanrio a Fat Cat." Asahi News Service. May 10, 1999.

3336. "Mickey Mouse Meets Hello Kitty." *Forbes.* May 1987, p. 70.

3337. "Much Ado Over Hello Kitty Dolls." *Straits Times.* February 25, 2000, p. 5.

3338. "Occult Kitty." *Manga Max.* November 1999, p. 7.

3339. Sakamaki, Sachiko. "Feline Fetish." *Far Eastern Economic Review.* September 25, 1997, p. 161.

3340. Shiau, Hong-Chi. "Japanese 'Kawaii' Doll: Hello Kitty in American Women's Eyes." Paper presented at Popular Culture Association, Philadelphia, Pennsylvania, April 14, 2001.

3341. Tesoro, Jose M. "'Kitty' Invasion from Japan." *World Press Review.* April 1996, pp. 45-46.

3342. "A Tycoon and His Cat." *Asiaweek.* March 19, 1999, p. 53.

3343. Yano, Christine R. "Confounding Kitty: Dual-Marketing of Japanese Cute Products." Paper presented at Association for Asian Studies, Chicago, Illinois, March 23, 2001.

"Here is Greenwood"

3344. "Anime Series Roundup OAV – Here Is Greenwood." *Animerica.* 4:12 (1996), pp. 18-19.

3345. Beam, John. "Here Is Greenwood." *The Rose.* July 1995, pp. 8-10.

3346. Guerin, Peter W. *"Here Is Greenwood."* *The Rose.* October 1998, pp. 24-25.

3347. McCarter, Charles. "This Is Greenwood Episodes 1-6." *Anime Reference Guide.* 2:2 (1994), pp. 84-93.

3348. Staley, James. "Here Is Greenwood." *The Rose.* July 1997, p. 8.

3349. Toole, Michael. "Fast Times at Ryokuto Academy: *Here Is Greenwood."* *Animerica.* 5:3 (1997), p. 69.

"Heroic Legend of Arislan"

3350. Barr, Greg. "Heroic Legend Makes a Heroic Effort: The Heroic Legend of Arislan." *Animerica.* 2:12 (1994), pp. 59-60.

3351. Flanagan, Bill. "Heroic Legend of Arslân Soundtrack." *Animerica.* 6:12 (1998), p. 73.

3352. "Heroic Legend of Arslân." *Animerica.* 6:10 (1998), pp. 20-21.

3353. Lau, Alex. "Heroic Legend of Arslân: Age of Heroes." *Animerica.* 6:12 (1998), p. 69.

3354. Ng, Ernest. "Best of *Arslan. " The Rose.* October 2000, p. 6.

3355. Patten, Fred. "Prince of Something." *Manga Max.* January 1999, pp. 32-33.

3356. Savage, Lorraine. *"Arslan: Age of Heroes." The Rose.* June 1999, p. 8.

"His Secret, Her Secret"

3357. "His & Her Stuff." *Manga Max.* January 2000, p. 4.

3358. "Spotlight on: His Secret, Her Secret." Manga Max. May 1999, p. 11.

Hyperdoll"

3359. Decker, Dwight R. "The Star Earrings . . . Make No Sense: Hyperdoll Vol. 1." *Animerica.* 4:9 (1996), p. 67.

3360. Evans, P. J. "Hyperdoll." *Manga Mania.* May- June 1998, pp. 24-26.

3361. Lew, Joshua. "Hyperdoll." *The Rose.* July 1996, p. 20.

"Iczer"

3362. Beam, John. "Iczer – 3." *The Rose*. October 1995, pp. 23, 35.

3363. Kim, Andy. "Iczer 3." *Anime Reference Guide*. 1:1 (1991), p. 36.

3364. "Remake! Iczer World: Iczer Gal Iczelion." *Animerica*. 2:11 (1994), p. 18.

3365. Wong Kam-Yim. "Iczer-One." *Anime FX*. January 1996, pp. 9-13.

"Inu-Yasha"

3366. Fox, Kit and staff. "*Inu-Yasha.*" *Animerica*. 7:10 (1999), pp. 11, 13-14.

3367. "Of Rice and Samurai." *Animerica*. 5:5 (1997), p. 5.

3368. Oshiguchi, Takashi. "On the Popularity of Rumiko Takahashi's New Work, Inu-Yasha." *Animerica*. 5:3 (1997), p. 57.

3369. "Rumiko's Feudal Fairy Tale. Rumiko Takahashi's Inu-Yasha." *Animerica*. 5:1 (1997), p. 59.

3370. "Rumiko Takahashi's *Inu-Yasha:* A Feudal Fairy Tale." *Animerica*. 5:3 (1997), pp. 8-9.

"Iria"

3371. McCarter, Charles. "Iria." *Anime Reference Guide*. 3:1 (1995), pp. 35-38.

3372. McNamara, Robin. "Bounty Hunter Blues." *Animerica*. 4:6 (1996), p. 67.

"Irresponsible Captain Tylor"

3373. Cziraky, Dan. "The Irresponsible Captain Tylor." *AnimeFantastique*. Spring 1999, pp. 22-27, 30.

3374. Fox, Kit. "Irresponsible Captain Tylor." *Animerica*. 7:3 (1999), pp. 6-9, 26.

3375. Hollander, Judd and Sue Feinberg. "The Irresponsible Captain Tylor: The Right Stuf International." *AnimeFantastique*. Spring 1999, pp. 28-33.

3376. Huynh, Roger. "Irresponsible Captain Tylor: An Exceptional Episode." *The Rose*. June 1998, pp. 18, 25.

3377. Ishigami, Yoshitaka. "Irresponsible Captain Tyler, Special Edition." *Animerica.* 2:12 (1994), pp. 64-65.

3378. Lin, Leon. "Irresponsible Captain Tylor." *Anime Reference Guide.* 3:1 (1995), pp. 39-51.

3379. Nadelman, Neil. "The Irresponsible Captain Tylor." *The Rose.* October 1997, p. 6.

3380. "News You Can Use – Hot Off the Presses!" *Animerica.* 2:7 (1994), p. 13.

3381. Ouellette, Martin and C.J. Pelletier. "Irresponsible Captain Tylor." *Protoculture Addicts.* December 1993, pp. 38-39.

3382. Ramasanta, Rodney. "Irresponsible Captain Tyler TV Episodes 1-4." *Anime Reference Guide.* 2:2 (1994), pp. 30-35.

3383. Thompson, Jeff. "Obtaining Captain Tylor." *The Rose.* October 1997, p. 7.

"Jinroh"

3384. Elley, Derek. "Jin-Roh: The Wolf Brigade." *Variety.* June 21-27, 1999, p. 80.

3385. *"Jin-Roh."* In *Atomic Sushi: A Bite of Japanese Animation,* pp. 23, 25, 27. Stanmore, Australia: Silicon Pulp Animation Gallery, 2000.

3386. Persons, Dan. *"Jinroh." AnimeFantastique.* Fall 1999, p. 58.

3387. Sertori, Julia. *"Jin-Roh* (The Wolf Brigade)." *Manga Max.* January 2000, p. 53.

"Jojo"

3388. "Jojo's Return." *Manga Max.* May 2000, p. 5.

3389. "JoJo's Strange Adventure." *Mangazine.* August 1993, p. 3.

"Judge"

3390. "May It Please the Court: Judge." *Animerica.* 2:11 (1994), p. 15.

3391. Savage, Lorraine. "Judge." *The Rose.* October 1995, p. 18.

"Jungle Emperor"

3392. "Jungle Taitei Zeppan Yohkyu Kara 'Shūkan Josei' Shazai Jiken Made" (From the Demand To Cease Publication of Jungle Emperor to the Apology by *Shūkan Josei*). *Hōsō Report.* 118, 1992, pp. 12-15.

3393. Kiriyama, Hideki. " 'Raion Kingu' Wa Tousaku Ka" (Is *The Lion King* a Rip-Off?). *Voice 203.* November 1994, pp. 204-213.

3394. "Koe" (Voice). *Asahi Shimbun.* July 29, 1994.

3395. Kuwahara, Yasue. "Japanese Culture and Popular Consciousness: Disney's *The Lion King* vs Tezuka's *Jungle Emperor.*" *Journal of Popular Culture.* Summer 1997, pp. 37-48.

3396. Kuwahara, Yasue. "The Lion King vs. the Jungle Emperor." Paper presented at Popular Culture Association, Philadelphia, Pennsylvania, April 13, 1995.

3397. "The Lion King and Kimba." *Animato!* Fall 1994, pp. 9-11.

3398. McCarthy, Helen. "The Lion King." *Anime UK.* December 1994/January 1995, pp. 6-7.

3399. "Magic Boys & Girls." *Manga Max.* April 1999, p. 8.

3400. "Minna No Hiroba" (Everybody's Plaza). *Mainichi Shimbun.* July 19, 29, 1994.

3401. Patten, Fred. "Simba vs. Kimba: Parallels Between *Kimba, the White Lion* and *The Lion King.*" Paper submitted to "The Life of Illusion: Australia's Second International Conference on Animation, Sydney, Australia, March 3-5, 1995.

3402. "Raion Kingu: "Janguru Taitei" Ni Sutori Sokkuri" (*The Lion King:* The Story Is the Same as *Jungle Emperor*). *Asahi Shimbun.* July 18, 1994.

3403. Satonaka, Machiko. "Kotoba" (Words). *Asahi Shimbun.* November 2, 1994.

3404. "Shasetsu" (Editorial). *Asahi Shimbun.* August 27, 1994.

3405. "Shujinko Mo Sujigaki Mo Sokkuri" (Hero, Storyline, the Same). *Mainichi Shimbun.* July 13, 1994.

3406. "Sukuriin Yori Saki CM De Katsuyaku 'Raion Kingu' Kyarakuta" (*The Lion King* Characters Active on Commercials Before the Screen). *Asahi Shimbun.* July 15, 1994.

"Junk Boy"

3407. Moe, Anders. "Junk Boy." *The Rose*. April 1997, p. 15.

3408. O'Connell, Michael. "Minimum Daily Requirement: Junk Boy." *Animerica*. 5:1 (1997), p. 69.

"Kekko Kamen"

3409. "Kekkō Kamen." *Mangazine*. November 1994, p. 4.

3410. McCarthy, Helen. "Kekkō Kamen." *Anime UK*. July 1995, pp. 24-25.

"Key the Metal Idol"

3411. "Character Spotlight: Key the Metal Idol." *Animerica*. 5:2 (1997), pp. 18-19.

3412. Decker, Dwight R. "Cyber-Pinocchio, Key the Metal Idol Vol. 1." *Animerica*. 5:7 (1997), p. 67.

3413. "Find: Information." *Animerica*. 5:2 (1997), pp. 7-9.

3414. "The Idol with the Heart of Metal: Key the Metal Idol." *Animerica*. 2:12 (1994), p. 15.

3415. Karahashi, Takayuki. "Weird Science with Key the Metal Idol." *Animerica*. 5:2 (1997), pp. 4-6.

"Kiki's Delivery Service"

3416. "Asian American Festival To Show the Animated Miyazaki Feature *Kiki's Delivery Service." ASIFA San Francisco*. March 1999, p. 3.

3417. Burr, Ty. "Special Delivery." *Entertainment Weekly*. September 4, 1998.

3418. Eng, Christina. "Kidding Around: More Than Typical Teen, Kiki Delivers at Asian-American Film Festival." *Oakland Tribune*. March 12, 1999.

3419. Greenholdt, Joyce. "Kiki's Delivery Service." *Animation Buyer's Guide*. May 7, 1999, p, 16.

3420. "Kiki Delivers." *Manga Max*. February 1999, p. 6.

3421. Loo, David. "Kiki's Delivery Service." *Anime Reference Guide*. 2:1 (1992), pp. 45-47.

3422. Savage, Lorraine and John C. La Rue, Jr. *"Kiki's Delivery Service." The Rose*. October 1998, pp. 5-8.

3423. Teto and Bounthavy. "Kiki's Delivery Service." *Animeland* (Paris). July 1996.

"Kimagure Orange Road"

3424. Brimmicombe-Wood, Lee and Motoko Tamamuro. "Torn Between Two Lovers." *Manga Max.* December 1999, pp. 16-19.

3425. Decker, Dwight R. "Kimagure Orange Road." *Animerica.* 8:6 (2000), pp. 16-18, 20-21.

3426. Dubreuil, Alain. "Whimsical Episode Guide." *Protoculture Addicts.* December 1993, pp. 23-31.

3427. Hahne, Bruce. "Kimagure Orange Road: That Summer's Beginning." *The Rose.* July 1997, pp. 6-8.

3428. Huddleston, Daniel. *"Kimagure Orange Road* TV Series." *Animerica.* 7:12 (1999), pp. 71-72.

3429. Lew, Joshua. "Kimagure Orange Road: I Want To Return to That Day." *The Rose.* June 1998, p. 19.

3430. Lew, Joshua. "Kimagure Orange Road: Loving Heart." *The Rose.* October 1996, p. 39.

3431. Sedita, Paul. "Orange Road TV Series Appeal." *The Rose.* October 1997, p. 31.

3432. "A Walk Down Memory Lane." *Animerica.* 4:7 (1996), p. 11.

"Kimba"

3433. Adams, Cecil. "The Straight Dope." *Washington City Paper.* December 24, 1999, p. 166.

3434. Bits, Ben. "Kimba." *Stripschrift.* September 1994, p. 21.

3435. Camp, Brian. "Kimba the White Lion." *Animerica.* 8:7 (2000), pp. 22-26.

3436. "Follow That Lion." *Manga Max.* March 2000, p. 7.

3437. Patten, Fred. " 'Hang on! Kimba Is Coming!'" *Manga Max.* February 2000, pp. 32-36.

3438. Patten, Fred. "Simba Versus Kimba: Parallels Between *Kimba, the White Lion* and *The Lion King*." Paper presented at Australia's Second International Conference on Animation, Sydney, Australia, March 4, 1995.

"Kishin Heidan"

3439. Barnes, William. "Kishin Heidan." *Tsunami.* Summer 1995, pp. 23-24.

3440. Barr, Greg. "Every Character an Archetype! Every Episode a Masterpiece! I Lo-o-ve the Corps: Kishin Corps, Vol. 1." *Animerica.* 3:3 (1995), pp. 54-55.

3441. "Kishin Tell: Corps Tell All! Kishin Corps." *Animerica.* 2:12 (1994), pp. 10-11.

3442. McCarter, Charles. "Kishin Heidan." *Anime Reference Guide.* 3:1 (1995), pp. 59-62.

3443. McCarter, Charles. "Kishin Heidan (Machine God Corps) Episodes 1-5." *Anime Reference Guide.* 2:2 (1994), pp. 36-45.

"Kite"

3444. Fox, Kit. "The French Connection?" *Animerica.* 7:6 (1999), p. 34.

3445. Guerin, Peter W. *"Kite" The Rose.* October 2000, p. 3.

"Lain"

3446. "Can't Stand the Lain." *Manga Mania.* July/August 1998, p. 5.

3447. Fox, Kit. "The Visual Experiments of Lain." *Animerica.* 7:9 (1999), pp. 6-9, 28-29.

3448. Kehoe, Tony and Cathy Sterling. "Cyberian Exile." *Manga Max.* August 1999, pp. 20-23.

3449. "Love & Lainy Days." *Manga Max.* May 2000, p. 8.

3450. Savage, Lorraine. "Serials Experiments Lain." *The Rose.* February 2001, pp. 6-7.

"Laputa"

3451. Beam, John. "Laputa – Castle in the Sky." *Animation Planet.* Fall 1997, pp. 12-13.

3452. "English Version of Laputa." *Animag.* No. 5, 1988, p. 5.

"Leda: The Fantastic Adventures of Yohko"

3453. "Leda: The Fantastic Adventures of Yohko." *The Rose.* July 1997, p. 21.

3454. Takaoka, Nova. "Sweet Stuff: Leda: The Fantastic Adventures of Yohko." *Animerica.* 5:8 (1997), p. 66.

"Legend of Fabulous Battle Windaria"

3455. Barr, Greg. "No Simple Film Where Good Triumphs Over Evil: Windaria." *Animerica.* 3:7 (1995), p. 63.

3456. Matsuzaki, James. "Legend of Fabulous Battle Windaria." *Anime Reference Guide.* 1:1 (1991), pp. 95-97.

3457. Matsuzaki, James. "Legend of Fabulous Battle Windaria." *Anime Reference Guide.* 2:1 (1992), pp. 104-106.

"Legend of the Galactic Heroes"

3458. Amos, Walter M. "Galactic Heroes: Why I Care (and Why You Should, Too!)." *Mangazine.* November 1993, p. 9.

3459. Amos, Walter. "Legend of the Galactic Heroes Character Guide." *Mangazine.* November 1993, pp. 10-13.

3460. Amos, Walter. "Legend of the Galactic Heroes Episode 1-4." *Anime Reference Guide.* 2:2 (1994), pp. 46-50.

3461. Amos, Walter M. "Legend of the Galactic Heroes: Series Review." *Mangazine.* November 1993, pp. 14-16.

3462. "Legend of the Galactic Heroes." *Animag.* No. 5, 1988, p. 4.

"Lone Wolf and Cub"

3463. Jenkins, Mark. "Samurai Babysitter." *Washington City Paper.* June 5, 1987.

3464. "Lone Wolf and Cub: Baby Cart to Hades." *The Rose.* July 1997, p. 22.

3465. O'Connell, Michael. "The Road to Hell: Lone Wolf and Cub." *Animerica.* 5:4 (1997), p. 69.

"Lupin"

3466. "Club Med for Lupin." *Manga Max.* September 1999, p. 4.

3467. "Hard-Boiled Lupin." *Animerica.* 4:3 (1996), p. 12.

3468. Horn, Carl G. "I Took Your Name." *Animerica.* 3:5 (1995), p. 56.

3469. Iwasa, Ken. "Arsene Lupin III: Origin of a Thief." *Tsunami.* Winter 1995, pp. 12-14.

3470. Iwasa, Ken. "Lupin the 3rd: Castle of Cagliostro." *Tsunami.* Winter 1995, pp. 14-15.

3471. Leahy, Kevin. "Lupin III: Kutabare! Nostradamus." *The Rose.* April 1996, p. 29.

3472. "Lupin Back in the Theatre After Ten Years." *Mangazine.* January 1995, p. 15.

3473. "Lupin 3rd – Dead or Alive." *Fant-Asia.* July/August 1997, p. 55.

3474. "Lupin the Third: Lupin Assassination Order." *The Rose.* April 1995, pp. 22, 34.

3475. McCarthy, Helen. "Lupin the 3rd: The Secret Files." *Anime UK.* April 1995, pp. 19-23.

3476. "Moroccan Nights." *Animerica.* 4:7 (1996), p. 12.

3477. Nguyen, Ilan. "Miyazaki Lupin III." *Animeland* (Paris). September 1996.

3478. "The Place Where the '70s Survived." *Animerica.* 3:6 (1995), p. 15.

"Macross"

3479. Ainsberg, Brenda. "Macross Plus, Volume 2 and 3." *Animation Planet.* Summer 1997, p. 13.

3480. Beam, John. "*Macross Plus* the Movie." *Animation Planet.* Fall 1997, p. 13.

3481. "Bullet the Blue Sky." *Animerica.* 3:11 (1995), p. 15.

3482. "The Characteristics of Macross Plus." *Animerica.* 3:1 (1995), p. 8.

3483. Clements, Jonathan. "Do You Remember MACROSS?" *Manga Mania.* May-June 1998, pp. 60-65.

3484. Davis, Julie. "Macross: Do You Remember Love?" *Animerica.* 6:12 (1998), p. 71.

3485. Davis, Julie. "Man of La Macross: Immortal Mecha Designer Shoji Kawamori." *Animerica.* 3:1 (1995), pp. 4-8.

3486. Dlin, Douglas. "Forget Robotech II! Macross II Has Landed with a Vengeance." *Mangazine.* September 1992, pp. 20-38.

3487. Evans, Peter J. "Macross: Detonation." *Anime UK.* May 1995, pp. 24-28, 44-46.

3488. Evans, Peter J. "Macross: Explosion." *Anime UK.* July 1995, pp. 8-12.

3489. Evans, Peter J. "Macross: Shockwave." *Anime FX.* August 1995, pp. 42-45.

3490. "The Highly Anticipated Macross Plus DVD Hits the Streets on October 12, 1999." *The Rose.* October 1999, p. 31.

3491. Ishiguro, Noburo. "Superdimensional Fortress Macross." *Animerica.* 4:9 (1996), pp. 8-9.

3492. "It's Macross . . . Plus!" *Animerica.* 3:2 (1995), p. 11.

3493. McCarthy, Helen and Peter Evans. "Macross, the New Generations." *Anime UK.* April 1995, pp. 30-39.

3494. McCloy, Stephen. "Superdimensional Fortress Macross." *The Rose.* July 1997, p. 8.

3495. "Macross at the Multiplex." *Animerica.* 3:11 (1995), p. 14.

3496. "Macross Plus." *Mangazine.* July 1994, p. 3.

3497. "Macross Plus Volume 4 To Be Released April 16, 1996 by Manga Entertainment." *Animation World.* April 1996, 1 p.

3498. "Macross II on DVD." *The Rose.* February 2001, p. 23.

3499. Michael, Hirtzy. "War and Love in Macross." *The Rose.* February 1998, pp. 23, 34.

3500. Nadzam, John. "The Cream Puff (Macross Plus)." *The Rose.* January 1996, p. 34.

3501. Nold, James, Jr. "Movie Review: Macross II: Lovers Again." Louisville (Kentucky) *Courier-Journal.* July 2, 1993.

3502. O'Connell, Michael. "To Fly: Macross Plus: The Movie." *Animerica.* 5:7 (1997), p. 69.

3503. O'Connor, Mike. "Macross Plus: The Movie." *The Rose.* October 1997, p. 5.

3504. Oshiguchi, Takashi. "Macross 7 and Macross Plus: A Comparison." *Animerica.* 3:2 (1995), p. 16.

3505. Pope, Mark. "Macross Plus." *Tsunami.* Summer 1995, pp. 29-30.

3506. "The Sound and the Fury." *Animerica.* 3:11 (1995), p. 15.

3507. Swint, Lester. "*Macross Plus*, 2, 3, 4." *The Rose*. April 1996, pp. 12-13.

3508. Swint, Lester. "OAV Review: Macross Plus." *The Rose*. April 1995, pp. 6-7, 33.

3509. Swint, Lester. "This Is Animation: Macross 7 and Macross Plus." *The Rose*. October 1996, pp. 16-17.

3510. "Valkyrie Redline." *Manga Max*. February 2000, p. 7.

"Mad Bull"

3511. O'Connell, Michael. "Lewd, Crude and Socially Unacceptable: Mad Bull 1 & 2." *Animerica*. 4:9 (1996), p. 66.

3512. Smith, Mike. "Mad Bull 34." *The Rose*. April 1997, p. 11.

"Magical Girl Pretty Sammy"

3513. Amano, Misao. "Magical Girl Pretty Sammy." *Mangazine*. May 1995, p. 12.

3514. Decker, Dwight R. "Invasion of the Magical Girls." *Animerica*. 4:4 (1996), p. 67.

3515. "Do You Believe in Magic? Magical Girl Pretty Sammy." *Animerica*. 3:10 (1995), p. 16.

3516. McCarthy, Helen. "Kawaii Five-Oh." *Manga Mania*. March-April 1998, pp. 26-28.

"Magic Knight RayEarth"

3517. "The Characters of Magic Knight Rayearth." *Animerica*. 5:1 (1997), pp. 25-27.

3518. "Clamp Hits the Airwaves with Rayearth." *Mangazine*. January 1995, pp. 18-20.

3519. Decker, Dwight R. "Magic Knight Rayearth." *Animerica*. 8:1 (2000), pp. 6-8.

3520. Evans, Peter J. "Ray of Light." *Manga Max*. Summer 2000, pp. 10-14.

3521. Jonte, Lisa. "Comparative Anatomy: Anime vs. Manga with Magic Knight Rayearth II." *Sequential Tart*. October 2000.

3522. "Knights in Pleated Satin: Magic Knight Rayearth." *Animerica*. 3:10 (1995), p. 16.

3523. "Magic Knight Rayearth." *Animerica*. 5:1 (1997), pp. 7, 25.

3524. "OVA Series: *Rayearth.*" *The Rose*. October 2000, p. 15.

3525. Patten, Fred. "*Magic Knight Rayearth* 1& 2." *Manga Max*. January 2000, p. 51.

"Maison Ikkoku"

3526. Fletcher, Clark. "The Real World in Tokyo: Maison Ikkoku." *Animerica*. 4:10 (1996), p. 66.

3527. "Heartbreak Hotel: Maison Ikkoku." *Animerica*. 3:11 (1995), p. 18.

3528. Keller, Chris and Robert Gutierrez. "Maison Ikkoku." *Anime Reference Guide*. 1:1 (1991), pp. 45-47.

3529. Keller, Chris and Robert Gutierrez. "Maison Ikkoku." *Anime Reference Guide*. 2:1 (1992), pp. 51-53.

3530. Ledoux, Trish. "Maison Ikkoku: Make Yourself at Home." *Animerica*. 4:4 (1996), pp. 6-7, 19-21.

3531. Lew, Joshua. "Maison Ikkoku." *The Rose*. April 1997, p. 23.

3532. McCarter, Charles. "Maison Ikkoku." *Anime Reference Guide*. 3:1 (1995), pp. 69-78.

3533. McCarter, Charles. "Maison Ikkoku TV Episodes 1-6." *Anime Reference Guide*. 2:2 (1994), pp. 53-58.

3534. "Maison Ikkoku." *Animerica*. 4:12 (1996), pp. 6-7.

3535. "Maison Ikkoku." *Animerica*. 5:6 (1997), p. 18.

3536. "Wacky Hijinks Launches a Great Romance: Maison Ikkoku Graphic Novel, Vol. One." *Animerica*. 2:12 (1994), p. 40.

"Maps"

3537. "Maps." *Animerica*. 3:3 (1995), p. 56.

3538. O'Connell, Michael. "Hold The Cheesecake Please. Maps 1 and 2." *Animerica*. 4:4 (1996), p. 66.

3539. "With No Direction Home: Maps." *Animerica*. 3:10 (1995), p. 15.

"Marmalade Boy"

3540. DeLoura, Robert. "Marmalade Boy." *Anime Reference Guide*. 3:1 (1995), pp. 79-85.

3541. Endresak, Dave. "TV Series Review: Marmalade Boy." *The Rose.* April 1995, pp. 10, 33.

3542. Kim, Richard. "Marmalade Boy." *Tsunami.* Summer 1995, p. 28.

"Martian Successor Nadesico"

3543. "Nadesico Sweeps Awards." *Manga Max.* July 1999, p. 9.

3544. Rehorn, Adam. "Martian Successor Nadesico." *Animerica.* 8:5 (2000), pp. 38-39.

3545. Rehorn, Adam. "Nadesico." *Animerica.* 8:3 (2000), pp. 6-11, 32-34.

3546. Sterling, Cathy. *"Martian Successor Nadesico #1." Manga Max.* January 2000, p. 50.

3547. Swallow, Jim. "Flower Power." *Manga Max.* November 1999, pp. 12-16.

"Master Keaton"

3548. Brimmicombe-Wood, Lee and Motoko Tamamuro. "Who Is Master Keaton?" *Manga Max.* January 1999, pp. 22-23.

3549. "Master Keaton." *Manga Max.* June 1999, p. 11.

"M.D. Geist"

3550. "Bat Out of Hell: M.D. Geist: Ground Zero." *Animerica.* 4:4 (1996), p. 8.

3551. Beam, John. *"M.D. Geist* II: Deathforce." *The Rose.* January 1997, p. 16.

3552. "Most Dangerous Zeitgeist: MD Geist." *Animerica.* 3:3 (1995), p. 15.

3553. "Universal Soldiers: M. D. Geist 2." *Animerica.* 4:3 (1996), p. 11.

"Megazone"

3554. "Fanimanga: The Art of 'Megazone 23 Part III.'" *Protoculture Addicts.* April 1990, pp. 17-20.

3555. Horn, Carl G. "What Am I Dreaming of? Megazone 23, Part One." *Animerica.* 3:10 (1995), pp. 63-64.

3556. King, Martin. "Megazone 23: Pt. II – Give the Secret." *Anime-zine.* No. 2, 1987, pp. 38-40.

3557. "Megazone 23 – Part 1." *A-ni-mé*. January 1991, pp. 53-84.

3558. "Megazone 23 Songs." *A-ni-mé*. January 1991, pp. 92-96.

3559. Tanaka, Shin. "Megazone 23 Part 2." *A-ni-mé*. January 1991, pp. 85-91.

"Metal Angel Marie"

3560. Camp, Brian. "*Metal Angel Marie.*" *Animerica*. 7:12 (1999), pp. 74-75.

3561. Sertori, Julia. "Sister Act." *Manga Max*. January 2000, pp. 22-24.

"Midnight Eye Gokuu"

3562. Kim, Andy and James Matsuzaki. "Midnight Eye Gokuu." *Anime Reference Guide*. 1:1 (1991), pp. 30-32.

3563. Kim, Andy and James Matsuzaki. "Midnight Eye Gokuu." *Anime Reference Guide*. 2:1 (1992), pp. 34-35.

"Mighty Morphin Power Rangers, The"

3564. Bacani, Cesar and Murakami Mutsuko. "Power Ranger." *Asiaweek*. April 19, 1996, 46-49.

3565. Biederman, Danny. "Those Mighty Saban Rangers Just Keep on Morphin." *Children's Business*. October 1994, p. 113+.

3566. Clements, Jonathan and Jim Swallow. "Power Rangers Head-to-Head." *Anime UK*. April 1995, p. 53.

3567. Cody, Jennifer. "Power Rangers Take on the Whole World." *Wall Street Journal*. March 3, 1994, p. B1.

3568. Crowe, David. "The Mighty Morphin Power Rangers Blast Off!" *Sentai*. April 1994, pp. 8-14.

3569. Crowe, David. "The Mighty Morphin Power Rangers Episode Guide (1-41)." *Sentai*. April 1994, pp. 15-30.

3570. Dlin, Doug. "The Power Rangers That Almost Was." *Sentai*. April 1994, p. 14.

3571. Dlin, Doug and Ben Dunn. "Where Did the White Ranger Come From?" *Sentai*. November 1994, pp. 16-17.

3572. Edwards, Leigh. "Playing Race As Camp: The Power Rangers and the Commodification of Multiculturalism." Paper presented at Popular Culture Association, Philadelphia, Pennsylvania, April 13, 1995.

3573. Elam, Christopher. "Morphin Rangers. Power Rangers: The Second Season." *Kaiju Review.* 1:7 (1995), pp. 15-16.

3574. "Morphin Controversy." *Kaiju Review.* 1:7 (1994), p. 8.

3575. "The Next Power Rangers?" *Sentai.* April 1994, pp. 4-5.

3576. Reboy, Judith. "Power Rangers Get Animated!" *Animato* Spring 1995, pp. 44-45.

3577. "The Return of the Morphinominal Episode Guide." *Sentai.* November 1994, pp. 10-15.

3578. Seiter, Ellen. "Power Rangers at Preschool: Negotiating Media in Child Care Settings." In *Kid's Media Culture,* edited by Marsha Kinder. Durham, North Carolina: Duke University Press, 1999.

"Mighty Space Miners"

3579. "I'm a Mighty Space Miner, Short and Stout." *Animerica.* 3:11 (1995), p. 16.

3580. Thomas, Ted. "Don't Hog That Oxygen Tank, Son! Mighty Space Miners." *Animerica.* 4:5 (1996), p. 68.

"Miyuki-chan in Wonderland"

3581. Hickey, Andrew. "OAV Review: Miyuki-chan in Wonderland." *The Rose.* January 1996, pp. 21, 33.

3582. "Miyuki-chan in Wonderland." *Animerica.* 5:1 (1997), p. 24.

3583. "Miyuki in Wonderland." *Mangazine.* May 1995, p. 11.

"Mobile Suit Gundam"

3584. "Big Wave on TV: V-Gundam Translated by Takahiro Hiroi." *The Rose.* October 1995, p. 25.

3585. "Character Spotlight: Mobile Suit Gundam." *Animerica.* 6:11 (1998), pp. 28-29.

3586. "Character Spotlight: Mobile Suit Gundam Wing." *Animerica.* 8:4 (2000), pp. 34-37.

3587. Christiansen, James, Hisashi Kotobuki, and Yumiko Yamamoto. "Mobile Suit Gundam: Char's Counter Attack." *Animag.* No. 5, 1988, pp. 12-21, 44-46.

3588. Dyar, Dafydd. "Mobile New Century Gundam X." *The Rose.* July 1996, p. 13.

3589. Fox, Kit. "Hell Has Officially Frozen Over: Mobile Suit Gundam I, II, III." *Animerica.* 6:12 (1998), p. 67.

3590. "Gimme Even Mo' Gundam!" *Animerica.* 3:3 (1995), p. 17.

3591. "Gimme Gundam!" *Animerica.* 3:3 (1995), p. 17.

3592. "Gundam Takes Wing Again in April." *Mangazine.* March 1995, pp. 10-13.

3593. Inomata, Kenji. *Gundam Shinwa Zeta. The Next Legend of Mobile Suit Gundam.* Tokyo: Diamond-sha, 1997. 180 pp.

3594. Jang, Galen. "Mobile Suit Gundam 0080: 'War in the Pocket.'" *Anime Reference Guide.* 2:1 (1992), pp. 39-42.

3595. Kim, Tonghyun. "Mobile Suit Gundam 0083: Stardust Memories Episodes 8-13." *Anime Reference Guide.* 2:2 (1994), pp. 65-73.

3596. Lew, Joshua. "Mobile Suit Gundam 08th MS Team." *The Rose.* July 1996, pp. 10-12.

3597. McCarter, Charles. "Zeta Gundam." *Anime Reference Guide.* 3:1 (1995), pp. 112-119.

3598. Meier, James. "Gundam F-91." *Protoculture Addicts.* November-December 1991, pp. 16-21.

3599. "Mobile Kombat." *Animerica.* 4:10 (1996), p. 13.

3600. "Mobile Suit Gundam: Part III, Episodes 26-30." *Animag.* No. 5, 1998, pp. 29-32.

3601. O'Connell, Michael. "On the Screen: Mobile Suit Gundam." *AnimeFantastique.* Fall 1999, p. 59.

3602. Oshiguchi, Takashi. "On the Popularity of Gundam Wing in Japan." *Animerica.* 8:4 (2000), p. 67.

3603. Oshiguchi, Takashi. "A Superdeformed Success Story." *Animerica.* 2:12 (1994), p. 16.

3604. Schumann, Mark. "Mobile Suit Gundam." *Anime Reference Guide.* 1:1 (1991), pp. 91-94.

3605. Simmons, Mark. "Mobile Suit Gundam." *Animerica.* 6:10 (1998), pp. 6-10, 26-27.

3606. Simmons, Mark and Benjamin Wright. "Spotlight: Mobile Suit Gundam Wing." *Animerica.* 8:4 (2000), pp. 6-9.

3607. Wright, Benjamin. "Gundam On the Side: Mobile Suit Gundam 0080: A War in the Pocket. Vols. 1-2." *Animerica.* 6:12 (1998), p. 66.

3608. "X Marks the Gundam." *Animerica.* 4:4 (1996), p. 11.

"Moldiver"

3609. Newton, Cynthia J. "Superhero or Public Nuisance? Moldiver Vol. 1." *Animerica.* 2:12 (1994), pp. 58-59.

3610. "Video Spotlight on Moldiver." *Mangazine.* June 1993, p. 5.

"My Neighbor Totoro"

3611. Hirashima, Natsuko. *"Tonari no Totoro:* Fuantaji Ga Umareru Kūkan." *Eureka.* 29:11 (1997), pp. 164-169.

3612. Holden, Stephen. "My Neighbor Totoro." *New York Times.* May 14, 1993, p. C14.

3613. Peacock, Dirk. "My Neighbor Totoro." *The Rose.* April 1995, p. 17.

3614. Sherman, Betsy. "From Japan, a Family Film That Has It All." *Boston Globe.* September 3; 1993.

3615. Shiba, Ryutaro. "A Walk in Totoro's Forest." *Weekly Asahi.* January 5 and 12, 1996.

3616. Shimizu, Yoshiyuki. "Sukoyaka Naru Bōsō *Tonari No Totoro* No Opunu Endingu o Megutte." *Pop Culture Critique.* 1, 1997, pp. 92-101.

3617. Solomon, Charles. " 'Totoro': A Charming Tale of Sisterhood." *Los Angeles Times.* May 7, 1993, p. F-14.

3618. "Trust Group Adopts Animation Character." *Yomiuri Shimbun.* February 16, 1995, p. 8.

3619. West Laurence, Yvan. "Mon Voisin Totoro: Miyasaki au Naturel." *Animeland* (Paris). May 1998.

"Nadia of the Mysterious Seas"

3620. Kim, Andy. "Nadia of the Mysterious Seas." *Anime Reference Guide.* 1:1 (1991), pp. 49-51.

3621. Kim, Andy. "Nadia of the Mysterious Seas." *Anime Reference Guide.* 2:1 (1992), pp. 56-57.

3622. "Nadia of the Mysterious Seas." *A-ni-mé.* January 1991, pp. 101-136.

"Nadia: The Secret of Blue Water"

3623. "Character Spotlight: Nadia." *Animerica.* 8:4 (2000), pp. 42-43.

3624. Hairston, Marc. "Spotlight: Nadia: The Secret of Blue Water." *Animerica.* 8:4 (2000), pp. 23-25, 41-42.

"Nausicaä"

3625. Chapman, Stepan. "Nausicaa of the Manga of the Pillbugs." *Comics Journal.* August 1994, pp. 59-60.

3626. Chūjō, Shōhei. "Tatakai no Ronri to Hishō no Kairaku: *Kaze no Tani no Nausicaä.*" *Eureka.* Special Issue: "Miyazaki Hayao no Sekai." 29:11 (1997), pp. 104-109.

3627. Evans, P. J. "Nausicaä of the Valley of the Wind." *Manga Mania.* January-February 1998, p. 78.

3628. Inaga, Shigemi. "*Nausicaä in the Valley of the Wind*: An Attempt at Interpretation." *Japan Review.* 11, 1999, pp. 113-128.

3629. Miyazaki, Hayao. "Your Special Story: Now Nausicaä Has Finished." *Yom* (Tokyo). June 1994.

3630. "Nausicaä" de la Vallee du Vent." *Animeland* (Paris). July 1996.

3631. Prioux, François. "Nausicaä: Du Manga a l'Anime." *Animeland* (Paris). July 1996.

"Neon Genesis Evangelion"

3632. "Angel's On the Silver Screen: Neon Genesis Evangelion." *Animerica.* 5:1 (1997), p. 14.

3633. "Anime Series Roundup OAV--Neon Genesis Evangelion." *Animerica.* 4:12 (1996), pp. 8-9.

3634. Arai, Hiroyuki. "Shinseiki Ebuangerion no Baransu Shiito." *Pop Culture Critique.* 0, 1966, pp. 67-79.

3635. "Avenging Angels: Neon Genesis Evangelion." *Animerica.* 4:3 (1996), p. 12.

3636. Beam, John. "Neon Genesis Evangelion: Genesis 0:1." *Animation Planet.* Summer 1997, p. 14.

3637. Beam, John. "Neon Genesis Evangelion: Genesis 0:4." *Animation Planet.* Fall 1997, pp. 13-14.

3638. Bissey, Laura. "The End of Evangelion; Or, How I Learned To Stop Worrying and Hate Hideaki Anno." *Sequential Tart.* July 2000.

3639. Brown, Dr. "Neon Genesis Evangelion." *Animerica.* 7:9 (1999), p. 80.

3640. Clements, Jonathan. "What's It All About Shinji?" *Manga Max.* February 1999, pp. 30-31.

3641. Daisuke, Miyao. "The Aesthetics of Excess in Neon Genesis Evangelion." Paper presented at "Visions, Revisions, Incorporations" Conference, Montreal, Canada, March 27, 1999.

3642. Donnelly, Laura. "When Angels Come to Earth: Neon Genesis Evangelion." *Sequential Tart.* July 2000.

3643. Driscoll, Mark. "Passionate Attachments and Traumatic Displacements in Neon Genesis Evangelion." Paper presented at Association for Asian Studies, Boston, Massachusetts, March 11, 1999.

3644. "Eva Deals." *Manga Max.* November 1999, p. 7.

3645. Evans, Peter J. "Welcome to the Apocalypse." *Manga Max.* December 1999, pp. 32-36.

3646. "Gainax Returns to Anime with Shinseiki Evangelion." *Animerica.* 3:2 (1995), p. 14.

3647. Horn, Carl G. "The Mask or The Face: Neon Genesis Evangelion." *Animerica.* 5:2 (1997), p. 70.

3648. Horn, Carl G. "Neon Genesis Evangelion: Adapting the Manga." *Animerica.* 5:8 (1997), p. 58.

3649. Kotani, Mari. "Evangelion as Immaculate Virgin: New Millenialist Perspectives on the Daughters of Eve." Paper presented at "Visions, Revisions, Incorporations" conference, Montreal, Canada, March 27, 1999.

3650. Lamplighter, L. Jagi. "End of Evangelion: The Story Ain't Over When the 17th Angel Dies." *AnimeFantastique.* Summer 1999, pp. 42-43.

3651. Lamplighter, L. Jagi. "Excerpts from Encyclopedia Evangelion." *AnimeFantastique.* Summer 1999, pp. 35-41.

3652. Lamplighter, L. Jagi. "Whon Angels Destroy: Neon Genesis Evangelion. Fighting the War for Humankind's Soul." *AnimeFantastique. Summer* 1999, pp. 32-40.

3653. Moe, Anders. *"End of Evangelion:* The Theatrical Release." *The Rose.* October 2000, p. 9.

3654. "Neon Genesis Evangelion." *Animerica.* 5:6 (1997), p. 22.

3655. "A New Direction for Robot Anime?" *Animerica.* 3:6 (1995), p. 17.

3656. Ng, Ernest. "Neon Genesis Evangelion S." *The Rose.* June 2000, pp. 24-25.

3657. Oshiguchi, Takashi. "On the Evangelion Movie." *Animerica.* 5:5 (1997), p. 59.

3658. Rehorn, Adam. "LM HG Evangelion Unit 05." *Animerica.* 7:9 (1999), p. 81.

3659. Routt, William. "Stillness and (e) Motion in Neon Genesis Evangelion." Paper presented at Society for Animation Studies, Brisbane, Australia, August 5, 1999.

3660. "Spooky Janeway." *Manga Max.* January 1999, p. 5.

3661. Tsao Sheng-Te. "Neon Genesis Evangelion." *The Rose.* October 1996, pp. 6-9.

3662. "21st Century Evangelion." *Mangazine.* May 1995, p. 14.

"New Dominion Tank Police"

3663. Barr, Greg. "Where Angels Fear To Tread: New Dominion Tank Police." *Animerica.* 3:6 (1995), p. 64.

3664. Greenholdt, Joyce. "Viewing 'New Dominion Tank Police.'" *Comics Buyer's Guide.* December 29, 1995, p. 54.

3665. Peacock, Dirk. "New Dominion Tank Police." *The Rose.* April 1995, pp. 18-19, 25.

"Night Warriors"

3666. McCarthy, Helen. *"Night Warriors: Darkstalkers Revenge* Vol. 1-4." *Manga Max.* February 2000, p. 52.

3667. "Night Warriors: Darkstalkers' Revenge." *Animerica.* 5:10 (1997), pp. 18-19.

"Ninja Scroll"

3668. Barr, Greg. "A Supernatural Ninja Fantasy: Ninja Scroll." *Animerica.* 3:7 (1995), p. 63.

3669. Hsiao, James. "Ninja Scroll: Just Where Exactly Is The Scroll?" *Indy Magazine.* No. 14, 1997, p. 21.

3670. Peacock, Dirk. "Ninja Scroll." *The Rose.* April 1996, p. 30.

3671. "You Don't Know the Power of the Dark Side . . . Ninja Scroll." *Animerica.* 3:7 (1995), p. 12.

"Ogre Slayer"

3672. Karahashi, Takayuki. "The New Anime Gothic." *Animerica.* 3:9 (1995), pp. 6-10.

3673. Lew, Joshua. "Ogre Slayer." *The Rose.* April 1996, p. 11.

3674. O'Connell, Michael. "Ogre Gore Galore: *Ogre Slayer." Animerica.* 3:12 (1995), p. 66.

"Oh My Goddess"

3675. Contino, Jennifer M. "Oh My Goddess! The Interview, Scott Simpson and Juliet Cesario." *Sequential Tart.* June 2000.

3676. "Goddess Almighty." *Manga Max.* September 1999, p. 4.

3677. "Heavenly Creatures: Oh My Goddess!" *Animerica.* 4:6 (1966), p. 10.

3678. Lien-Cooper, Barb. "Dialing for Deities: Oh My Goddess." *Sequential Tart.* June 2000.

3679. Metzger, Kim. "Four-Color Comments." *Comics Buyer's Guide.* July 5, 1996, p. 82.

3680. Nakamura, Roberta. "Too Sweet To Be Real: Oh My Goddess! Vol 1." *Animerica.* 3:2 (1995), p. 61.

3681. "911 Means 'I Love You': Oh My Goddess." *Animerica.* 4:12 (1996), p. 66.

3682. "Sleeping Beauty." *Manga Max* October 1999, p. 10.

3683. "Spotlight on: Oh! My Goddess: The Movie." *Manga Max.* June 2000, p. 9.

3684. "You're Busted. Goddess Creator's Work Busts onto OVA Scene." *Mangazine.* January 1994, p. 5.

"Orguss"

3685. "Superdimensional Century Orguss 02." *Mangazine*. September 1993, p. 4.

3686. Swint, Lester. "Super Dimensional Century Orguss 02." *The Rose*. July 1995, pp. 18-19.

"Otaku"

3687. "The Sign of Otaku, Vol. 1." *Animerica*. 3:3 (1995), pp. 56-57.

3688. Steele, Richard. "OAV Review: Otaku no Video." *The Rose*. January 1996, pp. 22-23.

"Overfiend"

3689. McCarthy, Helen. "Nightmare on Overfiend Street." *Manga Max*. December 1998, pp. 8-11.

3690. Sterling, Cathy. "Quest's End." *Manga Max*. July 1999, pp. 18-19.

"Parasite Eve"

3691. Brimmicombe-Wood, Lee and Motoko Tamamuro. "The Selfish Gene." *Manga Max*. June 1999, pp. 28-30.

3692. "Second Eve." *Manga Max*. January 2000, p. 9.

"Patlabor"

3693. Andersen, John. "Patlabor I." *The Rose*. January 1996, pp. 18-19.

3694. Arnal, Doug. "Little People." *Manga Max*. August 1999, pp. 36-42.

3695. "Beware the Black Death. Patlabor, The Mobile Police: The New Files." *Animerica*. 5:1 (1997), p. 13.

3696. Greenholdt, Joyce. "Patlabor." *Comics Buyer's Guide*. February 14, 1997, p. 70.

3697. Horn, Carl G. "It's a Show About Nothing (and Mecha). Patlabor, The Mobile Police: The New Files." *Animerica*. 5:9 (1997), p. 67.

3698. Horn, Carl G. "Throw My Gears, the Policeman Said." *Animerica*. 5:8 (1997), p. 67.

3699. Kim, Andy. "Patlabor Volume 1." *Anime Reference Guide*. 1:1 (1991), p. 60.

3700. Kim, Andy. "Patlabor Volume 1." *Anime Reference Guide.* 2:1 (1992), p. 63.

3701. "Labor Day." *Manga Max.* February 1999, p. 4.

3702. Luse, Jonathan. "Patlabor 2." *The Rose.* July 1997, p. 9.

3703. McCarter, Charles. "Patlabor – The Movie." *Anime Reference Guide.* 2:2 (1994), pp. 74-77.

3704. McCarter, Charles. "Patlabor 2 – The Movie." *Anime Reference Guide.* 3:1 (1995), pp. 87-94.

3705. McCarthy, Helen. "Patlabor the Beginning." *Anime UK.* May 1995, pp. 20-21.

3706. McCarthy, Helen. "Target: Lock On! Patlabor the Mobile Force." *Anime UK.* May 1995, pp. 30-35.

3707. "Patlabor." *Anime UK.* July 1995, pp. 20-23.

3708. "Patlabor. Character Spotlight." *Animerica.* 4:10 (1996), pp. 18-19.

3709. "Patlabor. Know Your Equipment." *Animerica.* 4:10 (1996), p. 20.

3710. "*Patlabor* on DVD." *The Rose.* October 2000, p. 17.

3711. "Patlabor the Mobile Police." *Kung-fu Girl.* Summer 1995, pp. 44-50.

3712. "Patlabor 2." *The Rose.* January 1996, p. 19.

3713. Simmons, Mark. "Labor of Love: Patlabor I: The Movie." *Animerica.* 4:5 (1996), p. 67.

3714. Simmons, Mark. "Patlabor, The Mobile Police." *Animerica.* 4:10 (1996), pp. 4-6.

3715. "Target: Locked On! Patlabor: The Mobile Police." *Kung-fu Girl.* Winter 1994, pp. 51-68.

3716. "A Very Private War." *Animerica.* 3:11 (1995), p. 17.

"Peacock King Kujaku-O"

3717. Matsuzaki, James. "Peacock King Kujaku-O." *Anime Reference Guide.* 1:1 (1991), pp. 39-40.

3718. Matsuzaki, James and Galen Jang. "Peacock King Kujaku-O." *Anime Reference Guide.* 2:1 (1992), pp. 48-50.

"Perfect Blue"

3719. "Blue Two?" *Manga Max.* January 1999, p. 4.

3720. "Blue Velvet." *Manga Max.* November 1999, p. 5.

3721. "Golden Years." *Manga Max.* January 2000, p. 10.

3722. Graham, Miyoko. "Perfect Blue." *Protoculture Addicts.* September-October 1997, p. 59.

3723. Guerin, Peter W. *"Perfect Blue."* The Rose. February 2000, pp. 4-5.

3724. Harvey, Dennis. "Perfect Blue." *Variety.* November 1-7, 1999, p. 88.

3725. McCarthy, Helen. "A Perfect World." *Manga Mania.* May-June 1998, pp. 14-15.

3726. Macias, Patrick. *"Perfect Blue."* Animerica. 7:12 (1999), p. 74.

3727. "Manga Entertainment Releases Japanese Hitchcockian Thriller Perfect Blue." *The Rose.* February 2000, p. 5.

3728. "Perfect Blue." Animerica. 7:6 (1999), pp. 8-9, 11.

3729. *"Perfect Blue."* Fant-Asia. July/August 1997, p. 64.

3730. "Perfect Blue." *The Rose.* October 1999, p. 7.

3731. "'Perfect Blue' Is New Anime." *Animation.* August 1999, p. 87.

3732. Vogel, Traci. "The Dark Side of Pop Culture: Disturbing Animation." *The Stranger.* September 30, 2000.

3733. "Will the Real Perfect Blue Please Stand Up?" *Manga Max.* March 1999, pp. 32-35.

"Phantom Quest Corp"

3734. Marmex, Timon. "Phantom Quest Corp." *Tsunami.* Summer 1995, pp. 25-26.

3735. "Phantom Quest Corp." *Animerica.* 7:10 (1999), p. 30.

3736. Sertori, Julia. "Ghost Town Girl." *Manga Mania.* January-February 1998, pp. 12-15.

3737. "Who You Gonna Call? Phantom Quest Corp. Vol. 1." *Animerica.* 4:3 (1996), p. 65.

"Plastic Little"

3738. Kim, Angeline. "Little Only in Name: Plastic Little." *Animerica*. 3:5 (1995), p. 58.

3739. "Plastic Explosive: The AD Ventures of Captain Tita." *Mangazine*. May 1994, p. 3.

"Please Save My Earth"

3740. "Animerica FAQ: Please Save My Earth." *Animerica*. 4:3 (1996), pp. 5-7, 18-21.

3741. Duffield, Patti. "Please Save My Earth." *Anime Reference Guide*. 3:1 1995, pp. 95-109.

3742. Moore, Jennifer. "Moonstruck: Please Save My Earth, Vols. 1-3." *Animerica*. 4:12 (1996), p. 69.

3743. Oshiguchi, Takashi. "On Animating Please Save My Earth." *Animerica*. 4:3 (1996), p. 30.

3744. "Please Save My Earth." *Animerica*. 4:3 (1996), pp. 4-5.

3745. "Somewhere in Time." *Animerica*. 4:7 (1996), p. 13.

3746. "Time Out of Mind: Please Save My Earth." *Animerica*. 4:5 (1996), p. 12.

"Pokemon"

3747. Adalian, Josef. "Kids' WB's 'Pokemon' Totes up Terrif Tots." *Variety*. March 29/April 4, 1999, p. 47.

3748. Adalian, Josef. "Kids WB! Take 2nd Poke at 'Pokemon.'" *Variety*. April 12-18, 1999, p. 27.

3749. Allen, Don. "Pokemon's Lessons: Retailers Hate To Say 'No.'" *Comics Retailer*. October 1999, p. 56.

3750. Allison, Anne. "Poké-mania: Enchantments of Collecting and Training Monsters." Paper presented at Association for Asian Studies Meeting, San Diego, California, March 11, 2000.

3751. "Anime Triggers Seizures in Hundreds." *Comics Buyer's Guide*. January 16, 1998, p. 6.

3752. Arnold, Gary. "'Pokemon 3' Ups Intensity." *Washington Times*. April 6, 2001, p. C9.

3753. Babington, Deepa. "As Pokemon Movie Opens, Toy Craze Shows Signs of Fading in U. S." Reuters dispatch, July 21, 2000.

3754. "Bad Feeling About This?" *Manga Max.* September 1999, p. 9.

3755. "Bag Your Beanie Babies." *Asiaweek.* November 26, 1999, p. 16.

3756. "Ban This Pokefilth." *Manga Max.* October 1999, p. 6.

3757. Barnes, Julian E. "Pokémon's House of Cards." *New York Times.* January 20, 2001, pp. B1, B14.

3758. Baylis, Jamie. "Invasion of Pokemon: Nintendo and Its Licensees Play Their Cards Right To Create a Craze." *Washington Post.* August 29, 1999, pp. H1, H4.

3759. Baylis, Jamie. "It's Child's Play and the Adults Just Don't Understand." *Washington Post.* August 29, 1999, pp. H1, H5.

3760. Bierbaum, Tom. "'Pokemon' Helps Kids' WB To Win." *Variety.* January 10-16, 2000, p. 98.

3761. Blitt, Barry. "Pokemon – Gotta Cast 'Em All." *Entertainment Weekly.* March 6, 1999, p. 14.

3762. Brennan, Chris. "Pokemon in the Eye." *Philadelphia Daily News.* November 12, 1999, p. 3.

3763. Brown, Dr. "AV Interface: Pokémon Snap." *Animerica.* 7:9 (1999), p. 79.

3764. Brown, Urian. "Pokémon." *Animerica.* 7:7 (1999), pp. 6-9, 28.

3765. Candelaria, Matthew. "Ash Ketchum, Poke-Pilgrim: The Quest for Values in the Pokemon Animated Series." Paper presented at Popular Culture Association, Philadelphia, Pennsylvania, April 13, 2001.

3766. "Card Sharp." *Manga Max.* May 2000, p. 7.

3767. Carter, Ben. "Pokemon: Past, Present and Future." *Manga Max.* October 1999, pp. 12-16.

3768. Carter, Ben. "Send in the Clones." *Manga Max.* May 2000, pp. 40-42.

3769. "Cartoon Character Pikachu Chosen in Time's Best of 1999." Japan Economic Newswire. December 12, 1999.

3770. "Cartoon 'Pocket Monsters' Causes Convulsions: Broadcasters to Set Guidelines." *NHK Broadcasting, Culture and Research.* No. 2. 1998, p. 2.

3771. Chavez, Paul. " 'Pokemon' Rocks in Box Office Open." Associated Press release, November 14, 1999.

3772. Chua-Eoan, Howard and Tim Larimer. "Beware of the Poké Mania." *Time.* November 22, 1999, pp. 80-84, 86.

3773. Corliss, Richard. "The Man Who Just Didn't Get It." *Time.* November 22, 1999, p. 82.

3774. Davis, Julie. "We Told You So." *Animerica.* 7:1 (1999), p. 7.

3775. Desowitz, Bill. "Upping the Ante." *Animation.* April 2001, p. 55.

3776. Evans, Eric. "Comics Shops Fight for Share of Pokémon Profits." *Comics Journal.* July 1999, pp. 9-10.

3777. Farusho, J., *et al.* "Patient Background of the Pokemon Phenomenon: Questionnaire Studies in Multiple Pediatric Clinics." *Acta Paediatrica Japonica.* December 1998, pp. 550-554.

3778. Flanagan, Bill. "Pokémon the Movie 2000." *Animerica.* 8:7 (2000), pp. 11-13.

3779. Flander, Scott. "The Lure of Film Is in the Cards." *Philadelphia Daily News.* November 12, 1999, p. 4.

3780. "Flashing-Light Cartoon Series To Resume." *New York Times.* March 31, 1998, p. A3.

3781. Fritz, Drew. "Flying with Pikachu!" *New Paper.* July 19, 2000, p. 3.

3782. Gleiberman, Owen. "My Little Monsters." *Entertainment Weekly.* November 19, 1999, p. 106.

3783. "Gotta Catch 'Em All!" *Animerica.* 7:11 (1999), pp. 11, 13.

3784. "Gotta Sue 'Em All." *Manga Max.* Summer 2000, p. 4.

3785. Greenholdt, Joyce. "Pokémon Draws New Audience to Comics." *Comics Buyer's Guide.* November 12, 1999, pp. 38-39.

3786. Greenholdt, Joyce. "Pokémon Movie Opens in November." *Animation Buyer's Guide.* November 12, 1999, pp. 5-7.

3787. Greenholdt, Joyce. "Will the Japanese Hit Catch on with American Kids? Pokémon." *Comics Buyer's Guide.* October 9, 1998, pp. 26-27.

3788. Greenholdt, Mike. "Pokémon." *Animation Buyer's Guide.* May 7, 1999, p. 19.

3789. Hall, Wendy Jackson. "How Pokeman [sic] Grabbed U.S. Kids." *Variety.* January 17-23, 2000, pp. N21, N26.

3790. Hasegawa, Mina. "Latest Buzzwords for Success: Cute, Cuddly Characters Pokemon and Gang Expand Market to All Age Groups." *Nikkei Weekly.* October 11, 1999, p. 1.

3791. Hayes, Dade. " 'Pokemon' Mania Hits the B.O." *Variety.* November 15-21, 1999, pp. 7, 9.

3792. Hayes, Dade. "Pokemon Pockets Monster Box Office." Reuters dispatch, November 15, 1999.

3793. Hernandez, Greg. "WB Collects 3rd 'Pokemon' Film." *The Hollywood Reporter.* August 24, 2000.

3794. Herskovitz, Jon. "New Pokemon-Type Cartoon Show Heads to American TV." Reuters release, June 14, 2001.

3795. Herskovitz, Jon. "Toon That Triggered Tokyo Illness Returns." *Variety.* March 17, 1998, p. 6.

3796. Hibino, Haruo and Yuko Sano. "Cognitive Factors Related to the Visual Stress in the Pokemon Mass Seizure Incident." *Japanese Journal of Animation Studies.* 2:1A, 2000, pp. 5-11.

3797. "Hokey Pokey." *Variety.* November 8-14, 1999, p. 6.

3798. Howe, Desson. " 'Pokemon' The Power of Duh." *Washington Post Weekend.* July 21, 2000, pp. 35, 44.

3799. Ikeda, Hiroshi. "Management of Visual Programs Through 'Pokemon' Case." *The Japanese Journal of Animation Studies.* 1:1A (1999), pp. 23-30.

3800. "Italy Makes Fake Pokemon Arrests." Associated Press dispatch, August 22, 2000.

3801. Jackson, John P. *Buying and Selling the Souls of Our Children: A Close Look at Pokemon.* Fort Worth: Streams Publications, 2000.

3802. Jenkins, Mark. " 'Pokemon': Cuddly Warriors without a Charge." *Washington Post.* November 10, 1999, pp. C1, C9.

3803. Kaplan, David A. and Adam Rogers. "It's a Pokemon Planet." *Newsweek.* March 1, 1999, p. 48.

3804. Katz, Richard. "'SpongeBob' To Battle 'Pokemon.'" *Variety.* June 7-13, 1999, p. 22.

3805. Kempley, Rita. " 'Pokemon 2000': More Power to Them." *Washington Post.* July 21, 2000, pp. C1, C12.

3806. "Kids' Stuff." *Animerica.* 7:1 (1999), pp. 8-9.

3807. Koehler, Robert. "Charizard Battles New Creature in Clunky 'Pokemon 3.'" Reuters release, April 6, 2001.

3808. Koehler, Robert. "Pic Success in Pocket." *Variety.* July 24-30, 2000, pp. 45, 52.

3809. Koehler, Robert. "Pokemon: The First Movie." *Variety.* November 15-21, 1999, pp. 88-89.

3810. Koso, J., *et al.* "Risk Factors in Evoked Neurological Disorder by Watching an Animated Program, Pokemon." *No to Hattatsu* (Brain & Development). September 1998, pp. 435-437.

3811. Levin, Rick. "Pokemon Possessed." *The Stranger.* November 4, 2000.

3812. MacDonald, Gayle. "Trading Peaks as Pokémon Bites the Dust." Toronto *Globe and Mail.* April 18, 2000.

3813. McLaughlin, Lisa. "Should Children Play with Monsters?" *Time.* November 22, 1999, p. 84.

3814. McLaughlin, Lisa, *et al.* "Show Me the Poké Money." *Time.* November 22, 1999, pp. 91-93.

3815. "Marketing Monsters." *Manga Max.* July 1999, p. 8.

3816. Mazurkewich, Karen and Ichiko Fuyuno. "Animation: Chasing Pokémon." *Far Eastern Economic Review.* August 10, 2000, pp. 54-57.

3817. "Monsters in Your Pocket." *Manga Mania.* March-April 1998, p. 65.

3818. Moore, Molly. "Turkish Broadcast Board Finds Pokemon Unfit for Children." *Washington Post.* December 12, 2000, p. A40.

3819. "Muffin Magic." *Variety.* November 15-21, 1999, p. 5.

3820. "New Titles for Hot Pokémon." *Comics International.* June 1999, p. 24.

3821. Nilsen, Don L. F. "Language Play in Y2-K: Pocket Monsters Become Pokemon." Paper presented at International Society of Humor Studies, Osaka, Japan, July 25, 2000.

3822. Osaki, Tad. " 'Pokemon' Spurs Nippon Prod'n." *Variety.* September 27-October 3, 1999, p. M-32.

3823. Oshiguchi, Takashi. "On Japan's Current Pokémon Boom." *Animerica.* 7:7 (1999), p. 76.

3824. Osmond, Andrew. "Pokemononoke: Anime for the Millennium." *Animation World.* December 1999, 8 pp.

3825. O'Sullivan, Michael. "Kids Watch the Darndest Things." *Washington Post.* November 12, 1999, pp. 49, 55.

3826. Overton, Wil. "A Pocketful of Monsters." *Manga Max.* December 1998, pp. 36-38.

3827. Patten, Fred. "Pokémon Graduates to the Big Screen." *Animation.* November 1999, pp. 12-13.

3828. Patten, Fred. "*Pokémon:* Ready for Its Next Success." *Animation.* July/August 2000, pp. 101, 106.

3829. Perez-Rivas, Manuel. "Pokémon Passion." *Washington Post.* February 6, 2000, p. C-10.

3830. "Pika Choose?" *Manga Max.* November 1999, p. 4.

3831. "Pikachu Genki De-Chu." *Animerica.* 7:12 (1999), p. 79.

3832. "Pikachu! I Sue You." *Manga Max.* February 2000, p. 8.

3833. "Pikachu! I Sue You, Too." *Manga Max.* March 2000, p. 4.

3834. "Pika Ooooh!!" *Manga Max.* April 1999, p. 9.

3835. "Pika-Pirates." *Manga Max.* January 2000, p. 7.

3836. "Piketchup." *Manga Max.* May 2000, p. 8.

3837. "Poke-con?" *Manga Max.* November 1999, p. 10.

3838. "Poke-Gold!" *Manga Max.* March 2000, p. 8.

3839. "Poke-Lingo." *Manga Max.* January 2000, p. 9.

3840. "Pokemania, What's Next." *The AWN Spotlight.* January 20, 2000, p. 5.

3841. "'Pokemon' Banned after Accidents." Reuters dispatch, December 12, 2000.

3842. "Pokemon Battles To Boost Licensing." *Discount Store News.* February 7, 2000, pp. A12-A14.

3843. "Pokemon Characters Appear on New Stamps." *Linn's Stamp News.* February 19, 2001, p. 20.

3844. "Poke Monger." *Manga Max.* May 2000, p. 5.

3845. "'Pokémon' Gets Away from Retailers." *Comics Buyer's Guide.* December 25, 1998, p. 7.

3846. "Pokemon Lands on UK Terrestrial." *Manga Max.* December 1999, p. 5.

3847. "Pokemon Set To Ride New Wave of Success." *Straits Times* (Singapore). July 18, 2000, p. 6.

3848. "Pokemon the Movie 2000: The Power of One." *Variety.* July 24-30, 2000, p. 45.

3849. "Poke-Safari." *Manga Max.* January 2000, p. 8.

3850. "Poke-Stats." *Manga Max.* January 2000, p. 5.

3851. "Pokethon." *Manga Max.* December 1999, p. 9.

3852. "Praise Pikachu." *Comics Journal.* February 2000, p. 12.

3853. Radford, Bill. "The Comic Fan: Pokemon Sparks New Generation of Comic Fans." *Colorado Springs Gazette.* December 19, 1999.

3854. "Retailers Pocketing Pokemon Sales." *Discount Store News.* February 7, 2000, p. A6.

3855. Rutenberg, Jim. "Pokemon, Unchosen." *New York Times.* June 28, 2000, p. B12.

3856. Ryan, Michael E. and Heather Won Tesoriero. "More Pokemon for Game Boys." *Newsweek.* October 30, 2000, p. 18.

3857. Salmon, Jacqueline L. "For Preteens and Parents, Hunt Is on for Pokemon." *Washington Post.* June 7, 1999, pp. B1, B7.

3858. Schneider, Michael. "'Pokemon' Finally Falls from First." *Variety.* May 8-14, 2000, p. 98.

3859. Shapiera, Ian. "From Pokemany to Poky Few?" *Washington Post.* July 31, 2000, pp. C1, C4.

3860. Simmons, Mark. "Pokémon: The First Movie." *Animerica.* 7:11 (1999), pp. 7-10.

3861. "The Sky's the Limit for Pokémon." *Comics International.* February 1999, p. 21.

3862. Snider, Mike. "Pokemania Builds as Monster Games Spawn a Hydra-Headed Empire." *USA Today.* March 17, 1999, p. 8D.

3863. Snider, Mike. "Pokemon Poised To Be Pop Culture's Next Big Phenom." *USA Today.* March 17, 1999, p. 1D.

3864. Snyder, Janet. "Cartoon Sickness Shocks Japan as Hundreds of Kids Take Ill." *Business Standard* (Calcutta). December 18, 1997.

3865. Snyder, Janet. "Japan Seeks Cause of Convulsions." *Washington Post.* December 18, 1997, p. C16.

3866. "SpongeBob v. Pikachu." *Manga Max.* August 1999, p. 9.

3867. Sprague, Jonathan. "Pokémon Power!" *Asiaweek.* December 31, 1999-January 7, 2000, pp. 72-73.

3868. Stepp, Laura S. "The 'Pokemon' Pehnomenon." *Washington Post.* April 9, 1999, C4.

3869. Stockwell, Jamie. "Taming the Pokemon Craze: The Animated Creatures Are All the Rage, but Parents Should Set Limits." *Washington Post.* August 29, 1999, p. H5.

3870. Sullivan, Kevin. "Japan's Cartoon Violence: TV Networks Criticized after Children's Seizures." *Washington Post.* December 17, 1997, pp. D1, D6.

3871. Takahashi, Corey. "Monster Madness: Pokemon's Taking Over School, Shops and the Silver Screen – and Not Everyone Is Happy About It." *Entertainment Weekly.* November 12, 1999, pp. 10-11.

3872. Takahashi, T. and Y. Tsukahara. "Pocket Monster Incident and Low Luminance Visual Stimuli: Special Reference to Deep Red Flicker Stimulation." *Acta Paediatrica Japonica.* December 1998, pp. 631-637.

3873. "Taking the Pisa." *Manga Max.* May 2000, p. 4.

3874. Thomas-Lester, Avis. "For Parents, It's No Game; Pokemon Plays Hard To Get." *Washington Post.* December 13, 1999, pp. B1, B3.

3875. Thompson, Maggie. "What's the Connection Between Pokémon, Dick Tracy, and Li'l Abner?" *Comics Buyer's Guide.* November 26, 1999, p. 4.

3876. "Too Much Pokémon." *U.S. News & World Report.* March 6, 2000, p. 12.

3877. "Turkey Warns Against Pokemon." Reuters dispatch, December 11, 2000.

3878. "12-Year-Old Boy Who Stole Pokémon Cards from Young Victim at Knifepoint Placed Under House Arrest." *National Post.* March 1, 2000, p. A12.

3879. Walk, Gary E. "Poking Fun." *Entertainment Weekly.* November 6, 1998, p. 96.

3880. Watson, Paul. "Happy Birthday Gameboy." *Manga Max.* Summer 2000, p. 58.

3881. Watts, Jonathan. "'Pocket Monsters' Fell Japanese Children." *Lancet.* January 3, 1998, p. 40.

3882. Wertheimer, Linda. "Cartoon Seizures." National Public Radio's All Things Considered. December 18, 1997.

3883. "What Are They Saying?" *Animerica.* 7:7 (1999), p. 31.

3884. Wheelwright, Geof. "Game Buy." *National Post* (Canada). July 19, 1999, p. E1.

3885. Wheelwright, Geof. "Nintendo, IBM Plug into Power Play." *National Post* (Canada). July 19, 1999, p. E1.

"Ponpoko"

3886. "Heisei Tanuki Gassen Ponpoko: Modern-Day Tanuki War 'Tum-Tum.'" *Animerica.* 3:2 (1995), p. 62.

3887. Schilling, Mark. "Ponpoko." *Japan Times.* August 2, 1994.

3888. Yamamoto, Fumiko Y. "Heisei *Tanuki*-Tassen: Pon Poko." *Post Script.* Fall 1998, pp. 59-67.

"Porco Rosso"

3889. Leahy, Kevin. "Porco Rosso." *The Rose.* October 1997, p. 10.

3890. "Porco Grosso." *Manga Max.* February 2000, p. 4.

3891. "Porco Rosso: What Is 'Cool.'" *Mangazine.* September 1992, pp. 39-41.

"Princess Mononoke"

3892. Amaha, Eriko. "A Royal Success." *Far Eastern Economic Review.* January 22, 1998, p. 37.

3893. Ansen, David. "'Princess [Mononoke] Ride: Miyazaki's Magic Spell.'" *Newsweek.* November 1, 1999, p. 87.

3894. The Art of The Princess Mononoke. Tokyo: Studio Ghibli, 1997.

3895. Berndt, Jaqueline. "Miyazaki Hayao's Princess Mononoke and Visual Japanese Identity in the Late Twentieth Century." Paper presented at "Visions, Revisions, Incorporations" conference, Montreal, Canada, March 27, 1999.

3896. Berndt, Jaqueline. "Miyazaki Hayao's 'Princess Mononoke': Visual Japaneseness in the Late 20th Century." Paper presented at Association for Asian Studies, Boston, Massachusetts, March 11, 1999.

3897. Bissey, Laura. "Reviewing Mononoke." *Sequential Tart.* February 2000.

3898. Brady, Matt. "Disney's Miramax Releases Japanese Hit Movie *Mononoke Hime* to Theaters." *Animation Buyer's Guide.* May 7, 1999, pp. 10-12, 14.

3899. Burr, Ty. "Princess Mononoke." *Entertainment Weekly.* November 5, 1999, p. 50.

3900. "Cartoon Japanese Princess Set To Beat Spielberg's E.T." *Agence France Presse.* October 29, 1997.

3901. Clark, Tanya. "Spirit Princess Moves Japan." *The Rose.* February 1998, p. 3. Reprinted from *USA Today.* August 28, 1997.

3902. Dobbs, G. Michael. "Making a Meal of Mononoke." *Manga Max.* May 2000, p. 58.

3903. Ebert, Roger. "Japanese Film 'Mononoke' Causes a Buzz." *Minneapolis Star Tribune.* December 21, 1997.

3904. Frants, Marina. "Princess Mononoke: Grave of the Fireflies." *AnimeFantastique.* Fall 1999, p. 29.

3905. Gopalan, Nisha. "Princess Mononoke." *Premiere.* November 1999, p. 30.

3906. Herskovitz, Jon. "Blockbusters Show Potential for Japan." *Variety.* April 27-May 3, 1993, p. 71.

3907. Herskovitz, Jon. "Japanese B.O. Regal." *Variety.* January 30, 1998, p. 52.

3908. "Hit Japanese Animation Film Breaks Box Office Record." *Japan Economic Newswire.* August 25, 1997.

3909. Howe, Desson. "'Princess': Hooray for Anime." *Washington Post Weekend.* November 5, 1999, p. 49, 52.

3910. Hughes, David. "Princess Mononoke: Talking the Language of Mononoke with Dubbing Director Jack Fletcher." *AnimeFantastique.* Fall 1999, pp. 36-37.

3911. Hunter, Stephen. "The Bland Violence of 'Mononoke.'" *Washington Post.* November 5, 1999, p. C5.

3912. "Japanese Princess Beats Steve Spielberg's Dinosaurs." *Agence France Press.* August 26, 1997.

3913. Jenkins, Mark. "The Myth Japan Pageant." *Washington City Paper.* November 5, 1999, pp. 42-43.

3914. Karrfalt, Wayne. " 'Mononoke' Japan's All-Time B.O. Champion." *The Hollywood Reporter*. October 31, 1997.

3915. Karrfalt, Wayne. " 'Princess' Crowned King of Japanese Box Office." *The Hollywood Reporter*. September 2, 1997.

3916. Karrfalt, Wayne. " 'Princess' Is No Fairy-Tale Sell: Disney May Find It Hard To Market Violent Japanese Ani Hit." *The Hollywood Reporter*. September 30, 1997.

3917. Klein, Andy. "God's Almighty: Princess Mononoke Is Beautiful, But Is She Worth the Wait?" *Dallas Observer*. November 4, 1999.

3918. Kyte, Steve. "Post Mortem Special: Princess Mononoke." *Manga Mania*. May-June 1998, p. 79.

3919. McCarthy, Helen. "The Nature of Love." *Manga Max*. July 1999, pp. 26-30.

3920. Mallory, Michael. "Princess Goes West." *Daily Variety*. February 13, 1998.

3921. Miyazaki, Hayao. "Araburu Kamigami To Ningen No Tatakai." Introduction to *The Art of The Princess Mononoke*. Tokyo: Studio Ghibli, 1997.

3922. Miyazaki, Hayao, *et al. Princess Mononoke: The Art of Making Japan's Most Popular Film of All Time*. New York: Hyperion, 1999. 224 pp.

3923. "Miyazaki's Mythical Mystery: Mononoke Hime." *Animerica*. 5:4 (1997), pp. 10-11.

3924. "Mononoke Hime." *The Rose*. February 1998, p. 16.

3925. "Mononoke Hime in Oscar Shock." *Manga Mania*. May-June 1998, p. 4.

3926. "*Mononokehime o Kaku Kataru*." *Comic Box* (Tokyo). No. 3, 1997.

3927. "'Mononoke' Pushes Box Office Record to 10 Bil. Yen." *Japan Economic Newswire*. November 17, 1997.

3928. "'Mononoke' Wins Japan's Best Pic." *Variety*. March 10, 1998, p. 16.

3929. Moore, Jennifer. "Princess Mononoke." *Animerica*. 7:11 (1999), pp. 15-17.

3930. Napier, Susan J. "Mononokehime: A Japanese Phenomenon Goes Global." *Persimmon*. Spring 2000, pp. 90-93.

3931. Nguyen, Ilan. "Mononoke Hime: Une Ultime Realisation en Forme de Retour." *Animeland* (Paris). May 1997.

3932. Nguyen, Ilan. "The Princess Mononoke." *Animeland* (Paris). September 1997.

3933. Oshiguchi, Takashi. "On Miyazaki's Mononoke Hime." *Animerica.* 5:9 (1997), p. 60.

3934. Osmond, Andrew. "Get Ready for Princess Mononoke." *AnimeFantastique.* Summer 1999, pp. 14-16, 19.

3935. Osmond, Andrew. "Marketing Mononoke." *Animerica.* 7:11 (1999), pp. 17, 28-29.

3936. Osmond, Andrew. "Princess Mononoke." *AnimeFantastique.* Fall 1999, pp. 24-28, 30-33, 38-41.

3937. Osmond, Andrew. "Princess Mononoke: Joe Hisaishi." *AnimeFantastique.* Fall 1999, pp. 34-35.

3938. Osmond, Andrew. "Princess Mononoke: Origins & Influences." *AnimeFantastique.* Fall 1999, pp. 42-43.

3939. Patten, Fred. "Miramax Releases Miyazaki's *Princess Mononoke.*" *Animation.* October 1999, pp. 72-73.

3940. Patten, Fred. "Princess Mononoke: The Art and Making of Japan's Most Popular Film of All Time." *Animation World.* November 1999, 2 pp.

3941. "Phantom Release Date?" *Manga Max.* August 1999, p. 7.

3942. Rea, Steven. "'Mononoke' Is Surprising Even Its Creator." *Philadelphia Inquirer.* November 7, 1999, p. 19.

3943. Sertori, Julia. "Twilight of the Gods." *Manga Mania.* July/August 1998, pp. 18-22.

3944. Sullivan, Kevin. "The Wolf-Girl of Japan: 'Princess Mononoke' Fans Fill the Movie Theaters." *Washington Post.* September 17, 1997, pp. D1, D2.

3945. Tanners, Timna. "Japanese Cartoon Hopes To Conquer America." Reuters dispatch, November 10, 1999.

3946. Vitaris, Paula. "Mononoke Hime." *AnimeFantastique.* Summer 1999, p. 58.

3947. Vitaris, Paula. "Neil Gaiman: The Master of the Sandman Brings a Literate Voice to *Mononoke's* Combatants." *AnimeFantastique.* Summer 1999, pp. 17-19.

3948. "Will the Real Princess Mononoke Please Stand Up?" *Manga Max.* January 2000, pp. 36-39.

"Project A-Ko"

3949. "A-Ko In-Jokes." *Mangazine.* August 1993, p. 18.

3950. "A-Ko OVA Character Designs." *Mangazine.* August 1993, p. 19.

3951. "A-Ko OVA Story Synopsis." *Mangazine.* August 1993, pp. 20-21.

3952. "A-Ko System A-Okay! Project A-Ko Screensaver." *Animerica.* 2:11 (1994), p. 14.

3953. Beam, John. "Project A-Ko Versus Battle Grey Side and Blue Side." *The Rose.* January 1996, p. 19.

3954. Dlin, Doug. "Translator's Notes: A-Ko." *Mangazine.* August 1993, p. 11.

3955. Maddern, Kevin. "Project A-Ko." *Anime Reference Guide.* 1:1 (1991), pp. 61-67.

3956. Maddern, Kevin. "Project A-Ko." *Anime Reference Guide.* 2:1 (1992), pp. 64-66.

3957. Nakamura, Roberta. "New A-Ko Dub Is A-OK!" *Animerica.* 2:7 (1994), pp. 59-60.

3958. "Project A-Ko." *Mangazine.* August 1993, pp. 14-17.

3959. "Project A-Ko Character Guide." *Mangazine.* August 1993, pp. 12-13.

3960. Samuels, Mitch. "The Anime Hyperguide. Vol. 1: Project A-Ko." *Animerica.* 4:10 (1996), p. 64.

3961. Wilkinson, Brian. "Project A-Ko 3." *Anime Reference Guide.* 2:1 (1992), pp. 70-71.

3962. Wilkinson, Brian. "Project A-Ko 3." *Anime Reference Guide.* 2:1 (1992), pp. 68-69.

3963. Wilkinson, Bryan C. "Project A-Ko." *Animag.* No. 5, 1998, pp. 6-10.

3964. Wilkinson, Bryan. Project A-Ko 2." *Anime Reference Guide.* 2:1 (1992), pp. 66-67.

"Queen Emeraldas"

3965. "The Fugitive." *Manga Max.* January 1999, p. 6.

3966. Staley, James. "Emeraldas & Harlock Figures." *The Rose.* June 1999, p. 19.

3967. Swint, Lester. "Queen Emeraldas." *The Rose.* February 2000, p. 3.

"Ranma"

3968. "Another Ranma?" *Manga Max.* August 1999, p. 5.

3969. "Bird Is the Word!" *Animerica.* 3:10 (1995), p. 17.

3970. Cha, Jason. "Ranma 1/2: Super Battle." *Tsunami.* Winter 1995, pp. 35-36.

3971. Decker, Dwight R. "Akane to the Rescue: Ranma 1/2." *Animerica.* 4:5 (1996), p. 66.

3972. Decker, Dwight R. "Bird on the Brain." *Animerica.* 4:6 (1996), p. 64.

3973. Decker, Dwight R. "The Devil in Miss Tendo: Ranma 1/2." *Animerica.* 4:11 (1996), p. 68.

3974. "The Devil Inside: *Ranma 1/2* ." *Animerica.* 3:12 (1995), p. 14.

3975. Doi, Hitoshi. "Ranma Nibunnoichi – Synopses." *A-ni-mé.* January 1991, pp. 223-226.

3976. Doi, Hitoshi. "Ranma Nibunnoichi Nettouhen – Synopses." *A-ni-mé.* January 1991, pp. 227-338.

3977. "Everybody Was Cat-Fu-Fightin'" *Animerica.* 3:5 (1995), p. 13.

3978. Holden, T.J.M. "ReDotPop: Mediations of Japan: Ranma." *PopMatters.* July 5, 2000.

3979. Jang, Galen. "Ranma 1/2 Nessen Uta Kassen." *Anime Reference Guide.* 2:1 (1992), pp. 86-87.

3980. "Jusenkyo Panic: Race to the Top! The Ranma 1/2 Board Game." *Animerica.* 2:12 (1994), pp. 4-7.

3981. Keller, Chris and Robert Gutierrez. "Ranma 1/2." *Anime Reference Guide.* 1:1 (1991), pp. 67-76.

3982. Keller, Chris and Robert Gutierrez. "Ranma 1/2." *Anime Reference Guide.* 2:1 (1992), pp. 80-86.

3983. Kim, Richard. "Ranma 1/2: DoCo First." *Tsunami.* Winter 1995, p. 19.

3984. Ledoux, Trish. "Ranma 1/2." *Axcess.* 5/1994.

3985. "Let Ranma Save Your Screen." *Animerica.* 3:3 (1995), p. 15.

3986. "Martial Arts on Ice Is Twice As Nice." *Animerica.* 3:3 (1995), p. 16.

3987. "More Ranma Frenzy and Fatal Fury From Viz." *Magazine.* March 1995, p. 3.

3988. "More Ranma 1/2 Releases from Viz Video!" *Magazine.* November 1993, p. 3.

3989. "New Ranma OAV Splashing onto Scene in June from Viz." *Magazine.* May 1994, p. 5.

3990. Pyson, Matt. "Ranma 1/2: Second Movie." *Protoculture Addicts.* December 1993, pp. 11-18.

3991. "Ranma Keeps on Rolling Out from Viz Video." *Magazine.* January 1994, p. 7.

3992. "Ranma Nibunnoichi – Episode # 6." *A-ni-mé.* January 1991, pp. 183-191.

3993. "Ranma 1/2." *Animerica.* 5:6 (1997), p. 20.

3994. "Ranma 1/2." *Animerica.* 7:7 (1999), pp. 17-18.

3995. "Ranma 1/2." *Magazine.* November 1994, p. 9.

3996. "Ranma 1/2-- Episodes # 1-5." *A-ni-mé.* January 1991, pp. 148-182.

3997. "Ranma 1/2-- Episodes # 7-10." *A-ni-mé.* January 1991, pp. 192-222.

3998. "Ranma 1/2 Guidebook." *Animerica.* 5:5 (1997), pp. 6-7, 22-26.

3999. "Ranma 1/2 News." *Magazine.* January 1995, p. 21.

4000. "Ranma's Going Back to China (Or Is He?)." *Animerica.* 3:2 (1995), p. 12.

4001. "Ranma 3-D." *Animerica.* 4:6 (1996), p. 12.

4002. Staley, James. "Ranma 1/2 Memorial Album." *The Rose.* January 1997, p. 34.

4003. Yang, Jeff. "Portrait of the (Martial) Artist As a Young Man." *Animerica.* 2:7 (1994), pp. 4-10.

"Record of Lodoss War"

4004. Clements, Jonathan. "Record of Lodoss War." *Manga Mania.* July/August 1998, p. 24.

4005. Evans, Peter J. "The Legacy of Lodoss." *Manga Max.* March 1999, pp. 18-20.

4006. Fox, Kit. "Record of Lodoss War: Chronicles of the Heroic Knight." *Animerica*. 7:9 (1999), pp. 12-14, 30.

4007. "Join the Quest: Record of Lodoss, Subtitled Vol. 1." *Animerica*. 3:3 (1995), p. 13.

4008. "Record of Lodoss War: Chronicles of the Heroic Knight." *Animerica*. 7:9 (1999), pp. 30-31.

4009. Samuels, Mitch. "A Series With Real Magic: Record of Lodoss War, Vol. 1." *Animerica*. 3:2 (1995), p. 60.

4010. "USMC Goes to War – *Lodoss War* – This Spring." *Mangazine*. January 1995, p. 11.

"Revolutionary Girl Utena"

4011. Corrigan, Paul. "Take My Revolution . . . Please." *Manga Max*. July 2000, p. 58.

4012. Duffield, P. and Michael Toole. "Revolutionary Girl Utena." *Animerica*. 6:12 (1998), pp. 6-9, 23.

4013. Lamplighter, L. Jagi. "Revolutionary Girl Utena. Vol. 1." *AnimeFantastique*. Summer 1999, p. 60.

4014. McCarthy, Helen. "Children of the Revolution." *Manga Max*. January 1999, pp. 35-38.

4015. Swint, Lester. "Revolutionary Girl Utena." *The Rose*. October 1999, pp. 4-5.

"RG Veda"

4016. Moore, Jennifer. "Clash of the Titans: RG Veda, Vols. 1 & 2." *Animerica*. 4:9 (1996), p. 68.

4017. "RG Veda." *Animerica*. 5:1 (1997), p. 19.

"Riding Bean"

4018. Kim, Andy and James Matsuzaki. "Riding Bean." *Anime Reference Guide*. 1:1 (1991), pp. 77-78.

4019. Kim, Andy and James Matsuzaki. "Riding Bean." *Anime Reference Guide*. 2:1 (1992), p. 88.

4020. Sternbach, Rick. "Good Sub, But Can You Dub to It?" *Animerica*. 2:7 (1994), p. 62.

"Robotech"

4021. Dlin, Douglas. "What Is 'Robotech'?" *Comics Buyer's Guide.* February 14, 1997, p. 68.

4022. O'Connell, Michael. " 'Waiting for Robo.'" *Animerica.* 6:9 (1998), p. 62.

4023. Patten, Fred. "Robotech." *Anime FX.* January 1996, pp. 46-47.

4024. "Robotech Returns." *Manga Max.* Summer 2000, p. 6.

4025. "'Robotech' Returns in New Antarctic Series." *Comics Buyer's Guide.* February 14, 1997, p. 68.

4026. "The Robotech World." *Protoculture Addicts.* April 1990, p. 29.

4027. "Sing a Song of Spacy!" *Animerica.* 3:11 (1995), p. 17.

4028. Swallow, Jim. "The Next Generation." *Manga Max.* March 2000, pp. 28-32. ("Robotech Sentinels").

"Roujin Z"

4029. O'Connell, Michael. "When I'm Sixty-Four... Roujin-Z." *Animerica.* 4:8 (1996), p. 67.

4030. "The Old Man and His Bed: Roujin Z." *Animerica.* 3:2 (1995), pp. 10-11.

4031. Rayns, Tony. "Rojin Z (Roujin Z)." *Sight and Sound.* July 1994.

4032. "Roujin – Z." In *Fantoche,* p. 75. Baden: Buag, 1997.

"Rupan"

4033. "No, No . . . Rupaul, Rupan!" *Animerica.* 3:3 (1995), p. 16.

4034. Savage, Lorraine. "Rupan III: The Fuma Conspiracy." *The Rose.* April 1995, p. 22.

"Ruroni Kenshin"

4035. "Age of Innocence: Rurôni Kenshin." *Animerica.* 4:3 (1996), p. 11.

4036. Bomford, Jen. "Rurouni Kenshin: Or the Story With Many Names." *Sequential Tart.* June 2000.

4037. Carter, Ben and Cathy Sterling. "Dojo Hobo." *Manga Max.* Summer 2000, pp. 16-20.

4038. Jeanne. "Rurouni Kenshin: Or, as the Americans Have It, Samurai X." *Sequential Tart.* June 2000.

4039. Kovalsky, Justin. "Rurōuni Kenshin." *Animerica.* 8:6 (2000), pp. 11-13, 34-37.

"Said the Gaijin"

4040. Overstreet, Kris. ". . . Said the Gaijin." *Mangazine.* January 1995, p. 23.

4041. Overstreet, Kris. ". . . Said the Gaijin." *Mangazine.* March 1995, p. 16.

4042. Overstreet, Kris. ". . . Said the Gaijin." *Mangazine.* May 1995, pp. 15-16.

"Sailor Moon"

4043. Adkins, Alexander. "Sailor Moon." *The Rose.* April 1997, p. 28.

4044. Adkins, Alexander. "Sailor Moon Playing Cards." *The Rose.* April 1997, p. 30.

4045. Allison, Anne. "Sailor Moon: Japanese Superheroes for Global Girls." In *Japan Pop!* edited by Timothy J. Craig, pp. 259-278. Armonk, New York: M. E. Sharpe, 2000.

4046. Allison, Anne. " 'Sailor Moon': Japanese Superheroes for Global Girls." Paper presented at "Japanese Popular Culture" conference, Lexington, Kentucky, February 21, 1997.

4047. Allison, Anne. "Sailor Moon: Japanese Superheroes for Global Girls." Paper presented at Japanese Popular Culture Conference, University of British Columbia, April 10, 1997.

4048. Barry, Dave. "Dave Barry." *St. Louis Post-Dispatch.* March 26, 1995, p. 2-C.

4049. Benkoil, Dorian. "Move Over, Power Rangers; It's Sailor Moon." Louisville, Kentucky *Courier Journal.* March 12, 1995, p. 7A.

4050. "Beyond Sailor Moon." *Animerica.* 5:4 (1997), pp. 5-7, 18.

4051. Borsuk, Corina. "Sailor Moon Super S: The Movie." *Animerica.* 7:12 (1999), p. 77.

4052. Brimmicombe-Wood, Lee and Motoko Tamamuro. "Hello Sailor!" *Manga Max.* July 2000, pp. 30-34.

4053. "Character Spotlight: Sailor Moon." *Animerica.* 4:8 (1996), pp. 20-21.

4054. Davis, Julie. "Pretty Soldier Sailor Moon." *Animerica.* 6:12 (1998), p. 71.

4055. Davis, Julie. "Who's That Girl?" *Animerica.* 6:11 (1998), p. 5.

4056. Decker, Dwight R. "Beyond Sailor Moon, Part 2." *Animerica.* 5:7 (1997), pp. 6-7, 22-24.

4057. Decker, Dwight R. "Beyond Sailor Moon. Part 3." *Animerica.* 6:11 (1998), pp. 6-9, 25-27, 31-34.

4058. Decker, Dwight R. "Buying Tapes by Moonlight: Sailor Moon." *Animerica.* 4:3 (1996), p. 66.

4059. Decker, Dwight R. "Sailor Moon." *Animerica.* 8:2 (2000) pp. 6-9, 30-31.

4060. Dennis, William. "The Continually Changing Splendor of Sailor Moon." *The Rose.* April 1996, p. 21.

4061. Dennis, William. "Inside Sailor Moon." *The Rose.* January 1996, pp. 15, 33.

4062. "Discontinued: Silver Moon." *Asiaweek.* February 21, 1997, p. 13.

4063. Duckett, Jodi. "Barbie Joins The Parade of Superheroes." *St. Louis Post-Dispatch.* March 16, 1995, p. 1-G.

4064. Eastham, Kim. "Moonstruck." *Tokyo Journal.* July 1994, pp. 16-17.

4065. Gelman, Morrie. "Sailor Moon." *Animation Magazine.* February 1995, p. 42.

4066. "Girl Talk with Sailor Moon." *Animerica.* 4:8 (1996), pp. 6-7, 18-19.

4067. Gliserman, Dana. "Pretty Soldier Sailor Moon: Reading Girls Reading Popular Culture." Paper presented at Popular Culture Association, San Antonio, Texas, March 29, 1997.

4068. Griffith, Clay S. "Confessions of an Adult Male Sailor Moon Fan." *Animerica.* 5:4 (1997), p. 4.

4069. Grigsby, Mary. "Sailor Moon: 'Manga' Super Heroine and Marketing Miracle." Paper presented at Popular Culture Association, Philadelphia, Pennsylvania, April 15, 1995.

4070. "Inside the Moon Kingdom: A Bluffer's Guide to Sailor Moon." *Animerica.* 5:4 (1997), p. 21.

4071. "It's All in the Name." *Animerica.* 5:4 (1997), p. 20.

4072. Kajiyama, Sumiko. "Sailor Moon Jōriku." *Asahi Shimbun Weekly Aera.* 4:17 (1995), p. 46.

4073. Kingwell, Mark. "Babes in Toyland." *Saturday Night.* February 1997, pp. 83-84.

4074. "A Moon for All Seasons." *Animerica.* 5:7 (1997), p. 24.

4075. "Moonlight Manga in America: Sailor Moon." *Animerica.* 5:1 (1997), p. 60.

4076. "Moon Over America -- *Sailor Moon* Comes to U.S." *Mangazine.* January 1995, p. 7.

4077. Newson, Victoria. "Young Females as Young Heroes: Superheroines in the Animated *Sailor Moon*." Paper presented at Popular Culture Association, New Orleans, Louisiana, April 21, 2000.

4078. Nishimura, Kunio. "Sailormoon." *Look Japan.* May 1994, p. 7.

4079. Reid, T.R. "Move Over, Morphins, Sailor Moon Is Coming." *Washington Post.* July 22, 1995, p. A16.

4080. Romasanta, Rodney. "Sailor Moon TV Episodes 2-5." *Anime Reference Guide.* 2:2 (1994), pp. 78-83.

4081. "Sailor Moon." *Animerica.* 3:12 (1995), p. 9.

4082. "Sailor Moon." *Animerica.* 4:10 (1996), p. 14.

4083. "Sailor Moon in UK." *Manga Max.* May 2000, p. 6.

4084. "Sailor Moon R Movie." *Animerica.* 5:4 (1997), p. 7.

4085. "Sailor Moon R, The Villains." *Animerica.* 5:4 (1997), pp. 18-20.

4086. "Sailor Moon Slams into the American Market." *The Rose.* April 1995, p. 27.

4087. Samuels, Mitch. "All This, and Rhubarb Pie!" *Animerica.* 5:10 (1997), p. 66.

4088. Smith, Mike. "Sailor Moon English Album." *The Rose.* April 1997, p. 28.

4089. Swett, Chris. "Bishojo Senshi Sailor Moon." *Anime Reference Guide.* 2:1 (1992), pp. 89-90.

4090. "TV Update: Sailor Moon." *Animerica.* 4:5 (1996), p. 12.

"Sakura Wars"

4091. Brimmicombe-Wood, Lee and Motoko Tamamuro. "World War Two Will Not Take Place." *Manga Max*. October 1999, pp. 22-26.

4092. "Mein Kampf!" *Manga Max*. February 2000, p. 4.

4093. "Sakura Captured for US Market." *Manga Max*. September 1999, p. 8.

4094. "Tomorrow Belongs to Sakura." *Manga Max*. January 2000, p. 6.

4095. "Update: Sakura Wars." *Manga Mania*. March-April 1998, p. 8.

4096. Watson, Paul. "Sakura Taisen (Sakura Wars)." *Manga Mania*. January-February 1998, p. 66.

4097. "We Told You!!" *Manga Max*. December 1999, p. 4.

"Samurai Shodown"

4098. "Hoedown with the Shodown." *Animerica*. 3:5 (1995), p. 15.

4099. Nguyen, Tuan. "Samurai Spirits." *The Rose*. April 1995, pp. 17, 33.

4100. Salvadore, Henry. "Samurai Shodown II." *The Rose*. April 1995, p. 16.

"Sanctuary"

4101. Macias, Patrick. "A Brave New Japan." *Animerica*. 5:6 (1997), p. 67.

4102. "Now on Home Video in Japan: A Perfect World: Sanctuary." *Animerica*. 3:10 (1995), p. 13.

4103. "'Sanctuary': The Animation. Building a Better Future . . . One Deal, One Gunshot at a Time." *Animerica*. 4:10 (1996), pp. 8-9.

"Sandman: Dream Hunters"

4104. "Dream Team." *Manga Max*. November 1999, pp. 18-21.

4105. Moore, Jennifer. "Sandman the Dream Hunters." *Animerica*. 8:1 (2000), pp. 19-21.

"Save the Wales"

4106. "Save the Wales." *Manga Max*. July 2000, p. 8.

4107. "Slayed in Wales!" *Manga Max*. July 1999, p. 8.

"Secret of Blue Water"

4108. Barr, Greg. "Steampunk Annie: The Secret of Blue Water." *Animerica.* 4:5 (1996), p. 65.

4109. McCarthy, Helen. "The Secret of Blue Water." *Anime FX.* February 1996, pp. 10-16.

"Shadow Skill"

4110. Tebbetts, Geoffrey. "Blood from Stone: Shadow Skill." *Animerica.* 5:8 (1997), p. 69.

4111. Young, Earl J. "Shadow Skill." *The Rose.* October 1997, p. 8-9.

"The Slayers"

4112. Chan, Ronald. "Slayers." *The Rose.* October 1995, pp. 10-11.

4113. Davis, Julie. *"The Slayers Try."* *Animerica.* 8:6 (2000), pp. 6-9. 38-39.

4114. Decker, Dwight. "Inverse Proportion: The Slayers." *Animerica.* 4:10 (1996), p. 67.

4115. Donnelly, Laura. "Slay You, Slay Me: A Review of the Slayers Anime Series." *Sequential Tart.* June 2000.

4116. Oshiguchi, Takashi. "On the Popularity of The Slayers." *Animerica.* 8:6 (2000), p. 66.

4117. "The Slayers." *Animerica.* 5:6 (1997), pp. 8-9.

4118. Yamazaki, Kazuo. "Tolkien or Bust." *Manga Max.* January 1999, pp. 14-17.

4119. Yanez, Rio. "The Slayers." *Animerica.* June 1999, pp. 11-12, 34.

4120. Yanez, Rio. "Slayers: Dragon Slave." *Animerica.* 6:12 (1998), p. 67.

"Sol Bianca"

4121. "Bodies & Sol." *Manga Max.* January 1999, p. 5.

4122. "Graphic Visions from The Lone Star State: Burn Up! And Sol Bianca." *Animerica.* 2:11 (1994), p. 39.

4123. Matsuzaki, James. "Sol Bianca." *Anime Reference Guide.* 1:1 (1991), pp. 80-83.

4124. Matsuzaki, James. "Sol Bianca." *Anime Reference Guide.* 2:1 (1992), pp. 90-93.

4125. "Numero Uno." *Manga Max.* November 1999, p. 4.

"The Sorcerer Hunters"

4126. "Character Spotlight: The Sorcerer Hunters." *Animerica.* 7:9 (1999), p. 32.

4127. 'The Sorcerer Hunters in Manga." *Animerica.* 7:9 (1999), p. 17.

4128. Tebbetts, Geoffrey. "The Sorcerer Hunters." *Animerica.* 7:9 (1999), pp. 15-18, 32.

"Space Cruiser Yamato"

4129. "An Anime Landmark: Space Battleship Yamato." *Animerica.* 3:11 (1995), p. 16.

4130. "Blazing Ahead." *Manga Max.* April 1999, p. 7.

4131. "Character Spotlight." *Animerica.* 7:3 (1999), p. 32.

4132. Evans, Peter J. "Space Cruiser Yamato." *Manga Mania.* October-November 1997, p. 93.

4133. Fenelon, Rob. "History of the *Yamato.*" *Mangazine.* January 1995, pp. 30-31.

4134. Fenelon, Rob. "Yamato: Fact Is Stranger Than Fiction." *Mangazine.* January 1995, p. 32.

4135. "Go Out in Glory: Final Yamato." *Animerica.* 3:6 (1995), p. 13.

4136. Handelman, Russell J. "We're Off to Okinawa: The Real Yamato (Part I)." *AnimeFantastique.* Spring 1999, p. 15.

4137. Handelman, Russell J. "We're Off to Okinawa: The Real Yamato (Part II)." *AnimeFantastique.* Summer 1999, p. 62.

4138. King, Martin and Robert Fenelon. "After the Comet Empire: Yamato 3." *Anime-zine.* No. 2, 1987, pp. 11-19.

4139. Noble, Chris. "Farewell to Space Battleship Yamato – Yamato. The New Voyage, Be Forever Yomato." *The Rose.* April 1996, pp. 26-27, 33.

4140. "The Reincarnation of the Yamato. . . Finally: Space Cruiser Yamato 2520." *Animerica.* 2:12 (1994), p. 14.

4141. "Space Battleship Yamato." *Animerica.* 7:7 (1999), pp. 20-22.

4142. "We're Off to Outer Space...." *Animerica.* 4:5 (1996), p. 10.

4143. "We're Off to Outer Space. . . on Home Video!" *Animerica.* 3:2 (1995), p. 10.

4144. "Yamato Ready To Take Off at Long Last!" *Mangazine.* January 1994, p. 6.

"Spawn"

4145. "Animation, Anime, and Spawn: Cartoons Just Grew Up." *The Rose.* June 1998, p. 17.

4146. Clarke, Jeremy. "Behind Enemy Lines: Todd McFarlane on the Japanese *Spawn.*" *Manga Max.* December 1999, pp. 12-14.

4147. "Spawn." *Fant-Asia.* July/August 1997, p. 72.

"Speed Racer"

4148. Contino, Jennifer M. "'Here He Comes . . .': Speed Racer." *Sequential Tart.* April 2000.

4149. "Here Comes Speed Racer . . . Again! Mach Go Go Go." *Animerica.* 5:1 (1997), p. 10.

4150. Horn, Carl G. "You Ain't Scared of a Little Speed, Are You, Man!? Speed Racer, 'The Man Behind the Mask.'" *Animerica.* 3:3 (1995), p. 52.

4151. Moran, Elizabeth. *Speed Racer: The Official 30ᵗʰ Anniversary Guide.* New York: Hyperion, 1997, 140 pp.

4152. Reed, Thomas E. and Elizabeth Moran. "Speed Racer: The 30ᵗʰ Anniversary Guide." *Toon.* Spring 1998, pp. 3-5.

4153. Swint, Lester. "Speed Racer: The Official 30ᵗʰ Anniversary Guide." *The Rose.* February 1998, pp. 24-25.

"Spirit of Wonder"

4154. Brimmicombe-Wood, Lee and Motoko Tamamuro. "A Sense of Wonder." *Manga Max.* October 1999, pp. 32-36.

4155. Nakumura, Dawn. "Someday, My Prince Will Come. Spirit of Wonder: Miss China's Ring." *Animerica.* 4:8 (1996), p. 69.

4156. Peacock, Dirk. *"Spirit of Wonder."* *The Rose.* January 1997, pp. 17, 37.

"Spriggan"

4157. Oshiguchi, Takashi. "'On the Spriggan Anime Movie.'" *Animerica.* 6:11 (1998), p. 64.

4158. "Spriggan Springs Ahead." *Manga Max.* January 1999, p. 9.

"Starship Troopers"

4159. Clements, Jonathan. "Above and Beyond Hollywood." *Manga Mania.* March-April 1998, pp. 20-23.

4160. Lyons, Mike. "What the Hell Is a Plasma Bug? Phil Tippett and *Starship Troopers.*" *Animato!* Spring 1998 pp. 80-82.

"Street Fighter"

4161. "Animerica Activity: Street Fighter II Paper Dolls." *Animerica.* 4:5 (1996), pp. 20-21.

4162. Beam, John and Gene Phillips. "Street Fighter II V." *The Rose.* February 1998, pp. 10-12.

4163. Camp, Brian. "The Evolution of *Street Fighter:* From Video Game to Spiritual Quest." Paper presented at Society for Animation Studies, Madison, Wisconsin, September 28, 1996.

4164. Camp, Brian. "Street Fighter – From Video Game to Anime." *Animation World.* December 1996, 5 pp.

4165. "Character Spotlight. Street Fighter II: The Animated Movie." *Animerica.* 4:2 (1996?), pp. 8-9.

4166. Ellison, David. "*Streetfighter*: Leisure Technologies and the L.A. Uprisings." Paper presented at Australia's Second International Conference on Animation, Sydney, Australia, March 5, 1995.

4167. "Fighting in the Streets Weekly." *Animerica.* 3:3 (1995), p. 18.

4168. "Flashback Fight: Street Fighter II V." *Animerica.* 5:1 (1997), p. 11.

4169. "Jean-Claude Van Damme To Star in SF II Movie." *Animerica.* 2:7 (1994), p. 16.

4170. "Kosugi To Play Ryu." *Manga Max.* December 1999, p. 5.

4171. Lew, Joshua. "Street Fighter II." *The Rose.* October 1996, p. 36.

4172. McCarthy, Helen. "Street Fighter II: The Movie." *Anime UK.* July 1995, pp. 30-36.

4173. "Marvel Super Heroes vs. Street Fighter." *Animerica.* 7:3 (1999), pp. 72-73.

4174. Montgomery, Sheldon. "Street Fighter 3." *The Rose.* July 1997, p. 17.

4175. O'Connell, Michael. "Looking for Mr. Fight: Street Fighter II V, Vol. 1." *Animerica.* 5:4 (1997), p. 67.

4176. O'Connell, Michael. "What're You Looking At?" *Animerica.* 5:10 (1997), p. 69.

4177. "Street Fighter Alpha." *The Rose.* February 2001, p. 19.

4178. "Street Fighter II." *Anime FX.* Summer 1995, pp. 14-18.

4179. "Streetfighter II. The Animation Charas: Who's Who in SFII." *Anime UK.* July 1995, pp. 44-45.

4180. "Street Fighter II: The Eight Immortals." *Animerica.* 4:5 (1996), p. 6-7.

4181. "Street Fighter II V." *Animerica.* 5:6 (1997), pp. 6-7.

4182. "Street Fighter II V." *Mangazine.* May 1995, p. 13.

4183. Watson, Paul and Amos Wong. "Street Fighting Man." *Manga Max.* April 1999, pp. 18-22.

4184. Yoshida, Toshifumi. "Street Fighter II: The Animated Movie." *Animerica.* 4:5 (1996), pp. 7, 18-19.

"Super Atragon"

4185. Clements, Jonathan. "Full Retro." *Manga Mania.* January-February 1998, pp. 62-64.

4186. Lewis, Bruce. "Run Silent, Run Deep. Super Atragon 1: Zero Hour, Annihilation." *Animerica.* 5:1 (1997), p. 67.

"Sword for Truth"

4187. Carlton, Ben. "Sword and Saucery." *Manga Mania.* May-June 1998, pp. 16-17.

4188. Jankowski, Joe. "Sword for Truth." *The Rose.* October 1998, p. 15.

"Tenji Muyo"

4189. "Anime Series Roundup OAV – Tenchi Muyō! TV and OAV." *Animerica.* 4:12 (1996), pp. 22-23.

4190. "Back to the Future." *Animerica.* 4:7 (1996), p. 12.

4191. Brown, Urian. "Tenchi: Stealth Assassins." *Animerica.* 6:12 (1998), p. 73.

4192. Decker, Dwight R. "A Boy and His Mother: Tenchi Muyo!" *Animerica.* 4:11 (1996), p. 67.

4193. Decker, Dwight R. "Tenchi Forever." *Animerica.* 7:7 (1999), pp. 10.

4194. Decker, Dwight R. "Tenchi Muyō! Boy Meets Girls." *Animerica.* 7:8 (1999), pp. 6-9.

4195. "The Ever-Expanding World of 'Tenchimuyo.'" *Mangazine.* July 1994, pp. 14-16.

4196. Kanemitsu, Dan. "The Tenchimuyo Factor." *Mangazine.* July 1994, pp. 9-12.

4197. Kanemitsu, Dan and Kuni Kimura. "Celebrating 'Tenchimuyo! Ryohki!"*Mangazine.* July 1994, p. 13.

4198. Kim, Richard. "Tenchi Muyo! Ryo Oh Ki Christmas Album." *Tsunami.* Winter 1995, pp. 18-19.

4199. Moe, Anders. "Tenchi Muyo in Love 2." *The Rose.* June 1999, p. 31.

4200. "Plant a House, Build a Tree." *Manga Max.* September 1999, p. 6.

4201. Staley, James. "Tenchi Muyo the Movie." *The Rose.* October 1996, p. 39.

4202. "Talkin' Tenchi Muyō (Times Two)." *Animerica.* 4:10 (1996), p. 24.

4203. "Tenchi Forever." *Animerica.* 7:7 (1999), p. 32.

4204. "Tenchimuyo Character Guide." *Mangazine.* July 1994, p. 8.

4205. "Tenchi's Last Wenchi?" *Manga Max.* February 1999, p. 5.

4206. "Tenchi Universe." *Animerica.* 5:6 (1997), p. 21.

4207. "Tenchi Universe: Volume 3, Tenchi on Earth." *The Rose.* July 1997, p. 21.

4208. "'TV Muyo.'" *Mangazine.* May 1995, p. 11.

"Three Beastketeers"

4209. "KO Century Three Beastketeers." *Mangazine.* August 1993, pp. 9, 12-14.

4210. "KO Three Beastketeers Character Guide." *Mangazine.* August 1993, pp. 10-11.

"3 X 3 Eyes"

4211. Davis, Julie. "3X3 Eyes Seima Densetsu: Matsuei Futanshi." *Animerica.* 6:12 (1998), p. 72.

4212. "I'll Be Seeing You . . . and Seeing You . . . and Seeing You: 3X3 Eyes." *Animerica.* 3:1 (1995), p. 18.

4213. McCarthy, Helen. "3X3 Eyes." *Anime FX.* December 1995, pp. 28-31.

4214. "3 X 3 Eyes." *Animerica.* 8:3 (2000), pp. 22-23, 35.

"Tokyo Babylon"

4215. Greenholdt, Joyce. "Viewing 'Tokyo Babylon 1.'" *Comics Buyer's Guide.* February 2, 1996, p. 40.

4216. Ishigama, Yoshitaka. "Tokyo Babylon 2." *Animerica.* 2:7 (1994), p. 64.

4217. Moore, Jennifer. "The Towering Infernal: *Tokyo Babylon.*" *Animerica.* 3:9 (1995), p, 62.

4218. Swint, Lester. "Tokyo Babylon." *The Rose.* October 1995, pp. 8-9.

4219. "Tokyo Babylon." *Animerica.* 5:1 (1997), p. 20.

4220. "Tokyo Babylon." *Animerica.* 7:10 (1999), p. 32.

"Tokyo Vice"

4221. Macias, Patrick. *"Tokyo Vice." Animerica.* 7:12 (1999), p. 77.

4222. Patten, Fred. *"Tokyo Vice." Manga Max.* January 2000, p. 52.

"To-y"

4223. Keller, Chris. "To-y." *Anime Reference Guide.* 1:1 (1991), pp. 84-86.

4224. Keller, Chris. "To-y." *Anime Reference Guide.* 2:1 (1992), pp. 94-95.

"Ultraman"

4225. Dagg, Robert. "Ultraman The Ultimate Hero Episode Guide." *Kaiju Review.* 1:8 (1995), pp. 44-46.

4226. Dubois, André. "Ultraman Great." *Protoculture Addicts.* August-September 1991, pp. 25-27.

4227. Dubois, André. "Ultraman Great vs. Ultraman Powered." *Kaiju Review.* 1:8 (1995), p. 47.

4228. Grays, Kevin. "Tsuburaya Legend: Ultra Seven." *Kaiju Review.* 1:7 (1994), pp. 24-32.

4229. "Ultraman 1966-67." *Fant-Asia.* July/August 1997, p. 82.

4230. "Ultraman vs. Coffee Monster." *Manga Max.* February 2000, p. 5.

4231. "Ultraman Tiga 1996-97." *Fant-Asia.* July/August 1997, p. 82.

4232. "Ultraman Zearth." *Fant-Asia.* July/August 1997, p. 83.

4233. "Ultra Success in China." *Kaiju Review.* 1:7 (1994), p. 9.

4234. Yates, Jolyon. "The Compleat Ultraman." *Anime FX.* December 1995, pp. 44-48.

4235. Yates, Jolyon. "The Compleat Ultraman." *Anime FX.* January 1996, pp. 42-45.

"Urotsuki Dōji"

4236. Pointon, Susan. "Transcultural Orgasm as Apocalypse: *Urotsukidōji: The Legent of the Overfiend.*" *Wide Angle.* 19:3 (1997), pp. 41-63.

4237. "Urotsukidōji." *Mangazine.* May 1994, pp. 7-21.

4238. "Urotsukidōji Goes for Triple Threat with CD-ROM Release." *Mangazine.* May 1994, p. 5.

"Urusei Yatsura"

4239. Beam, John. "Urusei Yatsura TV Series 12." *Animation Planet.* Summer 1997, p. 14.

4240. "Character Spotlight: Urusei Yatsura." *Animerica.* 7:4 (1999), p. 33.

4241. Dlin, Doug and Kuni Kimura. "A Darn Near Complete Anime Episode Guide to Urusei Yatsura, Part 2." *Mangazine.* January 1993, pp. 2-4.

4242. Dlin, Doug and Kuni Kimura. "A Darn Near Complete Anime Episode Guide to Urusei Yatsura, Part 5." *Mangazine.* April 1993, pp. 4-8.

4243. Dlin, Doug and Kuni Kimura. "A Darn Near Complete Anime Episode Guide to Urusei Yatsura." *Mangazine.* May 1993, p. 6-10.

4244. "The Electricity Comes Back On – Urusei Yatsura, TV Vol. 16." *Animerica.* 3:6 (1995), p. 15.

4245. Horn, Carl G. "AnimeEigo's Time Capsule: Urusei Yatsura TV Vol. 14." *Animerica.* 2:7 (1994), p. 62.

4246. Huddleston, Daniel. "Spotlight: Urusei Yatsura." *Animerica.* 7:4 (1999), pp. 13-15, 31-32.

4247. Staley, James. "Urusei Yatsura Complete Music." *The Rose.* October 1995, p. 28.

4248. Walker, Craig. "Urusei Yatsura in Scotland." *The Rose.* January 1997, p. 33.

"Ushio and Tora"

4249. Beam, John. "Ushio & Tora Volume One." *Animation Planet.* Fall 1997, pp. 14-15.

4250. Huddleston, Daniel. "Beastly Buddies: Ushio and Tora Vol. 1." *Animerica.* 5:5 (1997), p. 66.

4251. Lamplighter, L. Jagi. "The Secrets of Ushio & Tora: The Best Badguys Are Found in the Depths of History." *AnimeFantastique.* March 1999, p. 51.

4252. Lamplighter, L. Jagi. "Ushio & Tora: Courting the Inner Demon with the Priest and the Beast. *"AnimeFantastique.* March 1999, pp. 46-50.

4253. "Ushio & Tora." *Mangazine.* January 1994, pp. 14-21.

4254. "Ushio and Tora: Character Guide." *Mangazine.* January 1994, pp. 12-13.

"Vampire Hunter D"

4255. Coughlin, Joe. "Joe Bob's Board of Drive-In Experts: Vampire Hunter D." *The Joe Bob Report.* January 23, 1995, p. 10. (Also "The Blue Skies of Betrayal" and "3 X 3 Eyes").

4256. Elias, Marc. "Vampire Hunter D and Vampire Princess Miyu." *fps.* September 1993, pp. 23-25.

4257. Elley, Derek. "Vampire Hunter D." *Variety.* November 13-19, 2000, p. 30.

4258. Gronnestad, Crystal. "Vampire Hunter D." *The Rose.* October 1998, p. 28.

4259. Karahashi, Takayuki. "Vampire Hunter." *Animerica.* 5:10 (1997), pp. 5-7, 20.

4260. "Vampire Hunter D." *Animerica.* 7:10 (1999), pp. 20-21.

"Vampire Princess Miyu"

4261. Matsuzaki, James. "Vampire Princess Miyu." *Anime Reference Guide.* 1:1 (1991), pp. 47-49.

4262. Matsuzaki, James. "Vampire Princess Miyu." *Anime Reference Guide.* 2:1 (1992), pp. 53-55.

4263. O'Connell, Michael. "Vampire Princess Miyu." *Tsunami.* Winter 1995, p. 16.

"Venus Wars"

4264. Rymning, Perrin. "Venus Wars." *Anime Reference Guide.* 1:1 (1991) pp. 86-91.

4265. Rymning, Perrin. "Venus Wars." *Anime Reference Guide.* 2:1 (1992), pp. 96-100.

4266. "Venus Wars." *Animag.* No. 5, 1988, pp. 23-27.

"Video Girl Ai"

4267. "The Censored Video Girl." *Mangazine.* October 1993, pp. 16-17.

4268. "Character Spotlight: Video Girl Ai." *Animerica.* 7:4 (1999), p. 28.

4269. Chin, Kevin. "Hong Kong vs. Japanimation: Video Girl Ai – Summer Love." *Hong Kong Film Connection.* November 1993, pp. 3-4.

4270. Gallegos, Paul. "Video Girl Ai Episodes 2-6." *Anime Reference Guide.* 2:2 (1994), pp. 94-101.

4271. "Video Girl Ai." *Animerica.* 6:9 (1998), p. 76.

4272. "Video Girl Ai." *Animerica.* 7:4 (1999), pp. 8-10.

4273. "Video Girl Ai." *Mangazine.* October 1993, pp. 8-9, 12-15.

4274. "Video Girl Ai Character Guide." *Mangazine.* October 1993, p. 11.

"Violence Jack"

4275. Barr, Greg. "Legendary Violence: Violence Jack." *Animerica.* 4:11 (1996), p. 69.

4276. French, Todd. "You're Never Too Dead or Too Red: Rippin' Up the Future with Violence Jack." *AnimeFantastique.* March 1999, p. 56.

4277. Phillips, Gene. "OAV Review: Violence Jack." *The Rose.* April 1997, p. 6.

"The Vision of Escaflowne"

4278. Chan, Richard. *"Escaflowne." The Rose.* January 1997, p. 4-7.

4279. "Escaflowne on US TV?" *Manga Max.* May 2000, p. 5.

4280. Fletcher, Dani. "Perfect Visions: Looking at the Vision of Escaflowne." *Sequential Tart.* May 2000.

4281. Loo, Egan. "Foretelling the Future." *Animerica.* 5:3 (1997), pp. 18-19.

4282. Loo, Egan. "The Vision of Escaflowne." *Animerica.* 5:3 (1997), pp. 4-7.

4283. McCarthy, Helen. "The Other Side of the Sky." *Manga Max.* December 1999, pp. 20-26.

4284. Ng, Ernest. "CD Review: Vision of Escaflowne: Lovers Only." *The Rose.* October 2000, p. 16.

4285. Swint, Lester. "Vision of Escaflowne Memorial Collection." *The Rose.* October 1997, pp. 17, 31.

4286. "Telly Vision of Escaflowne !!" *Manga Max.* July 2000, p. 7.

4287. "The Vision of Escaflowne Character Spotlight." *Animerica.* 5:3 (1997), pp. 20-21.

"Wedding Peach"

4288. Endresak, John. "Lovely Messenger Wedding Peach." *The Rose.* October 1995, p. 24.

4289. "The Power of Love: Legend of the Angel of Love Wedding Peach." *Animerica.* 3:5 (1995), p. 17.

4290. "Wedding Peach." *Mangazine.* May 1995, p. 10.

"Whisper of the Heart"

4291. Savage, Loraine. "Whisper of the Heart." *The Rose.* July 1997, p. 11.

4292. Swint, Lester. "Whisper of the Heart." *The Rose.* July 1997, p. 10.

4293. "Whisper of the Heart." *Fant-Asia.* July/August 1997, p. 86.

"Wicked City"

4294. Dean, Michael. "Anime Comes Alive in 'Wicked City.'" *Comics Buyer's Guide.* February 2, 1996, p. 40.

4295. Gentry, Clyde III. "Hong Kong vs. Japanimation Part II: Supernatural Beast City (Wicked City)." *Hong Kong Film Connection.* December 1993, p. 5.

4296. Newton, Robert. "Wicked, Man!" *Film Threat.* August 1994, pp. 84-87.

4297. Strauss, Bob. "Explicit, Adult 'Wicked City' Not Typical Cartoon Fare." *Los Angeles Daily News.* February 25, 1994, p. 11.

4298. "Wicked City." *Los Angeles Reader.* February 25, 1994.

"Wings of Honneamise"

4299. Beam, John. "Review: Wings of Honneamise." *The Rose.* April 1995, p. 26.

4300. "Condition Blue." *Manga Max.* February 2000, p. 4.

4301. Ebert, Roger. "'Wings' a Sensational Peak at Japan's 'Anime.'" Chicago (Illinois) *Sun-Times.* May 12, 1995.

4302. Feeney, F.X. "The Wings of Honneamise." *LA Weekly.* March 10-16, 1995, p. 55.

4303. Hawxhurst, Paul. "Wings of Honneamise (Royal Space Force)." *The Rose.* July 1996, p. 28.

4304. "Honneamise on DVD." *Manga Max.* October 1999, p. 9.

4305. Horn, Carl G. "In Dreams Begin Responsibility." *Animerica.* 3:5 (1995), pp. 6-10.

4306. McCarthy, Helen. "The Wings of Honneamise." *Anime UK.* December 1994/January 1995, pp. 38-40.

4307. "Movie Reviews: Royal Space Force – Wings of Honneamise." *The Rose.* April 1995, p. 26.

4308. O'Connell, Michael. "Royal Space Force: Wings of Honneamise." *Tsunami.* Summer 1995, p. 27.

4309. "Out of the Blue and into the Black." *Animerica.* 3:6 (1995), p. 16.

4310. "A Point of Controversy." *Animerica.* 3:5 (1995), p. 10.

4311. Sherman, Betsy. "Animated 'Wings' Soars to Visual Heights." *Boston Globe.* March 31, 1995.

4312. Smith, Toren. "Wings of Oneamis." *Anime-zine.* No. 2, 1987, pp. 22-29.

4313. "'Thumbs Up' for Wings." *Animerica.* 3:7 (1995), pp. 13-14.

4314. "Winging Its Way to a Theater Near You." *Animerica.* 3:1 (1995), p. 14.

"X"

4315. Oshiguchi, Takashi. "On the Animated 'X' Movie." *Animerica.* 5:1 1997, p. 61.

4316. Wright, Benjamin. "X." *Animerica.* 8:5 (2000), pp. 6-7, 34-35.

"X/1999"

4317. Clark, Randall. "X/1999 as Fantasy *Shojo Manga.*" Paper presented at International Comics and Animation Festival, Silver Spring, Maryland, September 20, 1997.

4318. "X/1999." *Animerica.* 5:1 (1997), p. 8.

4319. "X/1999." *Animerica.* 6:9 (1998), pp. 77-78.

4320. "X/1999: The Movie." *Animerica.* 7:12 (1999), pp. 16-17.

"Yawara"

4321. Matsuzaki, James. "Yawara! A Fashionable Judo Girl." *Anime Reference Guide.* 1:1 (1991), pp. 97-98.

4322. Matsuzaki, James. "Yawara! A Fashionable Judo Girl." *Anime Reference Guide.* 2:1 (1992), pp. 107-108.

"Yoma"

4323. Kim, Andy and Grant Kono. "Yoma." *Anime Reference Guide.* 1:1 (1991), pp. 98-99.

4324. Kim, Andy and Grant Kono. "Yoma." *Anime Reference Guide.* 2:1 (1992), pp. 108-109.

"Yotoden"

4325. Brimmicombe-Wood, Lee and Motoko Tamamuro. "Men in Black." *Manga Max.* September 1999, pp. 18-21.

4326. Duffield, Patti. "Yotoden Episodes 1-3." *Anime Reference Guide.* 2:2 (1994), pp. 102-106.

4327. Moore, Jennifer. "You Go, Ninja Girl!" *Animerica*. 5:10 (1997), p. 67.

4328. "Yotoden: Chronicle of the Warlord Period, Chapter 1." *The Rose*. July 1997, p. 21.

"You're Under Arrest!"

4329. "Arrested Development." *Manga Max*. January 1999, p. 9.

4330. Kobayashi, Kim. "You're Under Arrest!" *The Rose*. July 1995, p. 17.

4331. Moe, Anders. *"Taiho Shichauzo (You're Under Arrest)* The Movie." *The Rose*. June 1999, p. 15.

4332. Moe, Anders. "You're Under Arrest. Character CDs." *The Rose*. February 1998, p. 29.

4333. Moe, Anders. "You're Under Arrest Mini-TV Series." *The Rose*. February 2000, p. 7.

4334. Peacock, Dirk. *"You're Under Arrest."* *The Rose*. January 1997, p. 23.

4335. Samuels, Mitch. "She's Got a Ticket To Ride: You're Under Arrest." *Animerica*. 3:10 (1995), p. 62.

4336. "You're Under Arrest." *Anime UK*. December 1994/January 1995, pp. 28-31.

"Zeguy"

4337. Horn, Carl G. "I'm Zeguy Your Mother Warned You About, Baby. Zeguy – Parts 1 and 2." *Animerica*. 3:6 (1995), p. 62.

4338. "USMC – Zey're Just Zese Zeguys, You Know?" *Mangazine*. March 1995, p. 4.

4339. "The Wonderful Wizard of Zeguy." *Animerica*. 3:5 (1995), p. 15.

"Zenki"

4340. "Demons, Demons, and More Demons: Zenki the Dream Prince." *Animerica*. 3:2 (1995), p. 14.

4341. Lew, Joshua. "Zenki." *The Rose*. October 1996, p. 31.

4342. "More New Anime To Welcome in the New Year." *Mangazine*. January 1995, pp. 15-17.

Manga (Comic Books) and Comic Strips
Reviews, Synopses: Multiple Titles

4343. Brimmicombe-Wood, Lee, Helen McCarthy, Jim Swallow, Melissa Hyland. "Reviews: Comics." *Manga Max*. November 1999, pp. 57-61. ("Silent Möbius # 2," "Usagi Yojimbo #30," "Dance Till Tomorrow #2," "Speed Racer," "Oh My Goddess: Terrible Master Urd," "Gold Digger #1," "Galaxy Express 999 #2," "Voyeur," "World War II: 1946 #1").

4344. Brimmicombe-Wood, Lee, Jim Swallow, Paul Watson. "Reviews." *Manga Max*. March 1999, pp. 48-49. ("Neon Genesis Evangelion #2," "Futaba-Kun Change # 6," "Hyper Dolls # 5," "Slayers," "X-Men," "Parasite Eve," "SHOGO").

4345. Carter, Ben, Lee Brimmicombe-Wood, Jim Swallow, and Julia Sertori. "Reviews: Comics." *Manga Max*. December 1999, pp. 54-56. ("Dark Angel," "Neon Genesis Evangelion #3," "Ice Blade # 2," "Intrigue," "Maison Ikkoku," "Nadesico," "Sailor Moon Super S # 2," "Valkyr").

4346. Clarke, Jeremy, Lee Brimmicombe-Wood, Jim Swallow, Steve Kyte, and Helen McCarthy. "Comics." *Manga Max*. October 1999, pp. 57-60. ("Blade of the Immortal," "Tekken 2 # 1," "Gold Digger # 50," "Harlem Beat," "Mobile Suit Gundam 0079 # 3," "Inu-Yasha # 4," "Ninja High School Summer Special # 1," "Ranma 1/2 # 8.2," "Return of the Jedi," "Shadow Lady – The Eyes of a Stranger # 2," "Silent Möebius: Into the Labyrinth").

4347. Clements, Jonathan. "Mangascan." *Anime FX*. January 1996, p. 50.

4348. Clements, Jonathan. "Mangascan in Japan." *Anime FX*. February 1996, pp. 50-53.

4349. "Comics." *Manga Max*. January 1999, pp. 16-17. ("Black Jack," "Gen 13," "Sailor Moon # 1," "Legend of the Overfiend Nos. 1-3").

4350. "Comics." *Manga Max*. April 1999, pp. 54-58. ("The Empire Strikes Back," "Dragonball," "Crusher Joe," "Robotech: Final Fire," "Legend of Lemnear," "Striker vs. The Third Reich," "Blade of the Immortal," "On Silent Wings 8," "Black Magic," "Maison Ikkoku," "No Need for Tenchi!").

4351. "Comics." *Manga Max*. May 1999, pp. 58-60. (Jim Swallow, "Ashen Victor"; Julia Sertori, "Blade of the Immortal"; Jim Swallow, "Dragon Ball Z"; Jim Swallow, "Neon Genesis Evangelion"; Lee Brimmicombe-Wood, "Sailor Moon"; Lee Brimmicombe-Wood, "Inu-Yasha # 3"; Julia

Sertori, "Legend of Lemnear"; Jim Swallow, "Shadow Lady: Dangerous Love #5"; Jim Swallow, "Night Warriors: Darkstalker's Revenge").

4352. "Comics." *Manga Max*. July 1999, pp. 55-57. ("Black Jack," "Drakuun, The Hidden War," "Geobreeders," "Ice Blade," "Maison Ikkuku Part Eight #7," "Luftwaffe 1946: Project Saucer," "Parasyte #2," "Mechanical Man Blues # 2," "Silent Möbius," "Ranma 1/2 #13," "Maison Ikkoku: Student Affairs").

4353. "Comics." *Manga Max*. February 2000, 57-59. (Martin Russ, "Oh My Goddess: Childhood's End # 1"; Jim Swallow, "Frontier Line"; Ben Carter, "Pokémon"; Jim Swallow, "Mobile Suit Gundam Blue Destiny"; Martin Russ, "Shadow Lady: Dangerous Love"; Ben Carter, Shadow Lady: The Awakening #1"; Helen McCarthy, "Steam Detective 2"; Ben Carter, "Ranma #14"; Helen McCarthy, "No Need for Tenchi: Dream a Little Scheme").

4354. "Comics." *Manga Max*. May 2000, pp. 50-52. (Jim Swallow, "Battle Chases: A Gathering of Heroes": Jim Swallow, "Dirty Pair: Run from the Future"; Helen McCarthy, "Fushigi Yuri # 2"; Lee Brimmicombe-Wood, "Heartbroken Angels"; Martin Russ, "Inu-Yasha # 5"; Martin Russ, "Panku Ponk"; Martin Russ, "Video Girl Ai # 1).

4355. "Comics." *Manga Max*. June 2000, p. 51. (Julia Sertori, "Call Me Princess"; Martin Russ, "Geobreeders #1"; Jim Swallow, "Gun Crisis: Deadly Curve"; Jonathan Clements, "No Need for Tenchi # 7"; Julia Sertori, Train # 3").

4356. "Comics." *Manga Max*. Summer 2000, pp. 50-52. (Martin Russ, "Dark Angel # 1: The Path to Destiny"; Cathy Sterling, "Aquarium # 1"; Julia Sertori, "Card Captor Sakura"; Paul Corrigan, "Card Captor Sakura"; Jonathan Clements, "Short Program"; Jim Swallow, "Gundam Wing # 1"; Julia Sertori, "Pokémon: Electric Pikachu Boogaloo").

4357. "Comics." *Manga Max*. July 2000, pp. 51-53. (Simon Jowett, "Banana Fish # 3"; Simon Jowett, "Black and White # 2"; Simon Jowett, "Voyeurs Inc. # 1"; Bruce Lewis, "Eagle"; Peter J. Evans, "Record of Lodoss War – The Lady of Pharis"; Martin Russ, "Sepia # 1"; Daren Stanley, "Sorcerer Hunters # 1"; Martin Russ, "Maxion #2").

4358. "Dragons and Devils and Airbats – Oh, My! All This and Sol Bianca 2, Too!" *Mangazine*. March 1995, p. 9.

4359. Dubreuil, Alain. "Reviews." *Protoculture Addicts*. August-September 1991, pp. 28-30.

4360. Elam, Christopher. "Reviews." *Kaiju Review*. 1:8 (1995), pp. 52-53.

4361. "The Hit List." *Animerica.* 2:12 (1994), p. 42.

4362. "The Hit List." *Animerica.* 3:1 (1995), p. 42.

4363. Hyland, Melissa, *et al.* "Postmortem." *Manga Max.* March-April 1998, pp. 78-79. ("Drakuun," "Eat-Man," "New Vampire Miyu," "Chirality," "The Encyclopedia of Japanese Pop Culture," "Anime Inter-views").

4364. "The Japanese Shelf." *Comics Buyer's Guide.* March 6, 1998, p. 54.

4365. "Japan's Manga Top Ten." *Animerica.* 2:7 (1994), p. 37.

4366. "Japan's Manga Top Ten." *Animerica.* 2:11 (1994), p. 39.

4367. "Japan's Manga Top Ten." *Animerica.* 2:12 (1994), p. 40.

4368. "Japan's Manga Top Ten." *Animerica.* 3:1 (1995), p. 40.

4369. "Japan's Manga Top Ten." *Animerica.* 3:2 (1995), p. 35.

4370. "Japan's Manga Top Ten." *Animerica.* 3:3 (1995), p. 48.

4371. "Japan's Manga Top Ten." *Animerica.* 3:5 (1995), p. 37.

4372. "Japan's Manga Top Ten." *Animerica.* 3:6 (1995), p. 20.

4373. "Japan's Manga Top Ten." *Animerica.* 3:11 (1995), p. 49.

4374. "Japan's Manga Top Ten." *Animerica.* 4:5 (1996), p. 58.

4375. "Japan's Manga Top Ten." *Animerica.* 4:7 (1996), p. 61.

4376. "Japan's Manga Top Ten." *Animerica.* 4:10 (1996), p. 58.

4377. "Japan's Manga Top Ten." *Animerica.* 4:11 (1996), p. 61.

4378. "Japan's Manga Top Ten." *Animerica.* 5:3 (1997), p. 57.

4379. "Japan's Manga Top Ten." *Animerica.* 5:5 (1997), p. 58.

4380. "Japan's Manga Top Ten." *Animerica.* 5:6 (1997), p. 60.

4381. "Japan's Manga Top Ten." *Animerica.* 5:10 (1997), p. 61.

4382. Keller, Hans. "Von Strip zu Strip" [Survey of comics characters and illustrators from Superman to Japanese manga]. *Du 3.* March 1997.

4383. Lefevere, Arnel. "Manga Mikt op Sterke Magen." *Stripschrift.* January 1995, pp. 28-29. ("Dominion Tank Police," "Tetsuo II," "Akira," "Akira Production Report," "Urotsukidoji," "Battle Angel Alita").

4384. McCarthy, Helen. "Mangascan." *Anime FX.* January 1996, pp. 51-53.

4385. McCarthy, Helen and Lee Brimmicombe-Wood. "Reviews: Comics." *Manga Max.* September 1999, p. 57. ("Blade of the Immortal: Dark Shadows # 4," "Night Warriors: Darkstalker's Revenge # 6").

4386. McCarthy, Helen, Jeremy Clarke, and Melissa Hyland. "Reviews: Comics." *Manga Max.* September 1999, pp. 58-60. ("Drakuun # 2: The Revenge of Gustav," "Geobreeders # 3," "Neon Genesis Evangelion 4:3," "Mobile Suit Gundam 0079 # 2," "Gunsmith Cats: Bean Bandit # 5," "Maison Ikkoku # 9:1," "Inu-Yasha # 3:1," "Shadow Lady: The Eyes of a Stranger # 1").

4387. McCarthy, Helen, Daren Stanley, Martin Russ, Jim Swallow. "Reviews: Comics." *Manga Max.* March 2000, pp. 58-59. ("Night Warriors: Darkstalker's Revenge," "Maison Ikkoku: Game, Set, Match," "Neon Genesis Evangelion # 4," "Oh My Goddess: Queen of Vengeance," "The Phantom Menace, Sailor Moon # 5," "Time Traveller Ai # 1," "Pokémon: Pikachu Shocks Back").

4388. "Manga Closeup." *Animerica.* 4:4 (1996), p. 56. ("Pervert Club," "Athena," "The Return of Lum," "Urusei Yatsura").

4389. "Manga Close-Up." *Animerica.* 5:2 (1997), pp. 60-61. ("Dominion Conflict No. 1," "Drakuun: Rise of the Dragon Princess," "Fist of the North Star: Night of the Jackal").

4390. "Manga Closeup." *Animerica.* 5:3 (1997), pp. 56-57. ("Chirality," "Metal Guardian Faust," "Battle Angel Alita," "No Need for Tenchi!").

4391. "Manga Close Up." *Animerica.* 5:4 (1997), pp. 58-59. ("Neon Genesis Evangelion," "Mobile Police Patlabor," "Mixx Zine," "What's Michael?").

4392. "Manga Closeup: Dark Dreams Collected." *Animerica.* 4:2 (1996?), p. 30. ("Domu: A Child's Dream," "Legend of Mother Sarah: Tunnel Town").

4393. "Manga Closeup: Reality Check, Batman Black and White, Gamera, Battle Angel Alita." *Animerica.* 4:9 (1996), pp. 58-59.

4394. "Manga Philes." *Manga Max.* March 2000, p. 6.

4395. "New Manga." *The Rose.* February 2001, pp. 16-18.

4396. "New Releases." *Protoculture Addicts.* September-October 1997, p. 11-17.

4397. Ouellette, Martin. "Manga Review." *Protoculture Addicts.* September-October 1997, p. 49.

4398. Ouellette, Martin. "Reviews." *Protoculture Addicts.* November-December 1991, p. 25.

4399. "Reviews." *Kaiju Review.* 1:7 (1994), pp. 12-29.

4400. Sertori, Julia. "Fanscene." *Manga Max.* February 1999, pp. 52-53. ("Lucy's in Deep # 5," "Cosmic Bento # 6").

4401. Sertori, Julia, Melissa Hyland, Lee Brimmicombe-Wood, Jim Swallow, and Peter J. Evans. "Reviews: Comics." *Manga Max.* June 1999, pp. 57-60. ("Shadow Lady: Dangerous Love # 7," "Record of Lodoss War: The Grey Witch # 5," "Gunsmith Cats: Bean Bandit," "Night Warriors: Darkstalkers' Revenge # 4," "Caravan Kidd # 3," "Mechanical Man Blues," "Mobile Suit Gundam 0079," "Inu-Yasha 2:7," "Slayers # 6," "Trouble Express # 2," "No Need for Tenchi 6:3," "Ranma 1/2 # 12").

4402. "Spring '97 Manga Update." *Manga Mania.* July-August 1997, p. 33.

4403. Swallow, Jim, Cathy Sterling, Melissa Hyland, and Helen McCarthy. "Reviews: Comics." *Manga Max.* August 1999, pp. 55-58. ("Blade of the Immortal #32," "Evangelion 4:2," "Survival in the Office," "Oh My Goddess!: The Fourth Goddess #1," "Gunsmith Cats: Bean Bandit," "No Need for Tenchi #1," "Call Me Princess #1," "Sailor Moon Super S").

Reviews, Synopses: Individual Titles

4404. "Actie, Humor en Sex. Dominion Tank Police." *Stripschrift.* August 1994, pp. 6-7.

4405. "Aji Ichi Monme, A Bit of Flavor, Part 2." *Mangajin.* July 1996, pp. 17-39.

4406. "Akogare Depa-Gyaru – Those Glamorous Salesgirls, Ōnuma Kaoru." *Mangajin.* April 1996, pp. 45-47.

4407. "Apu-In App-Install by Jonburi." *Mangajin.* February 1997 pp. 44-45.

4408. "Banana Fishu to Yoshida Akimi Gurafiti" (Banana Fish and Akimi Yoshida Graffiti). *Comic Box.* September 1990, pp. 23-49.

4409. Barson, Michael S. "Mangal Horde." *Heavy Metal.* March 1984, p. 6.

4410. "Beautiful Dreamer." *Animerica.* October 1999, p. 7.

4411. "Blast Off! "*Manga Max.* December 1999, p. 8.

4412. "Bow by Terry Yamamoto." *Mangajin.* No. 65, 1997, pp. 69-91.

4413. "Boys Boys Boys." *Manga Max.* October 1999, p. 8. ("Boys Be").

4414. Brady, Matt. "How Do You Make an 'Akiko'?" *Comics Buyer's Guide.* September 18, 1998, pp. 26-27.

4415. Brimmicombe-Wood, Lee. *"Banana Fish #2."* *Manga Max.* January 2000, p. 56.

4416. Brimmicombe-Wood, Lee. *"Fushigi Yugi: #1."* *Manga Max.* January 2000, p. 57.

4417. Brimmicombe-Wood, Lee. "Mr. Onizuka's Opus." *Manga Max.* February 2000, pp. 14-18.

4418. Brimmicombe-Wood, Lee. "Road Rage!" *Manga Max.* January 2000, pp. 40-43. ("Initial D").

4419. Brimmicombe-Wood, Lee. *"Strain #2."* *Manga Max.* January 2000, p. 57.

4420. Brimmicombe-Wood, Lee and Motoko Tamamuro. "Primary Colours." *Manga Max.* March 2000, pp. 22-26. ("Eagle").

4421. Brimmicombe-Wood, Lee and Motoko Tamamuro. "Salary Manga." *Manga Max.* Summer 2000, pp. 36-40. ("Division Chief Kosaku Shima").

4422. "Business Commando Yamazaki." *Mangazine.* August 1993, p. 5.

4423. Carlson, Johanna D. *"Geisha."* *Comicology.* Spring 2000, p. 5.

4424. Carter, Lloyd. "Dirty Pair: Fatal But Not Serious # 1." *The Rose.* October 1995, p. 16.

4425. "C-Class Salaryman Course by Yamashina Keisuke." *Mangajin.* September 1997, pp. 18-21.

4426. "Change Commander Goku Coming to America!" *Mangazine.* June 1993, p. 4.

4427. "Childhood Is Hell: Hell Baby." *Animerica.* 3:3 (1995), p. 49.

4428. "Church and State: Silver Cross." *Animerica.* 5:10 (1997), p. 62.

4429. "Çizgilerle Hiroşima' nin Bombalanmasi." *Karikatürk.* No. 20, 1995, p. 233.

4430. Clapin, Timothy. "Katsura Masakazu's DNA [2]." *Tsunami.* Winter 1995, p. 17.

4431. Clarke, Jeremy. "The Beat Goes On." *Manga Max.* October 1999, pp. 18-20.

4432. Clements, Jonathan. "Cyber Weapon Z # 1: Eternal Youth." *Anime FX.* December 1995, pp. 50-51.

4433. Clements, Jonathan. "Fujiko Hosono's *Judge.*" *Manga Mania.* July-August 1997, pp. 32-33.

4434. Clements, Jonathan. "Justice: The Blade of Thunder." *Manga Mania.* March-April 1998, p. 62.

4435. Clements, Jonathan. "Legend of Eternal Wind." *Manga Mania.* May-June 1998, p. 27.

4436. Clements, Jonathan. "The Lost Boys." *Manga Max.* January 2000, pp. 32-34. ("Yoake no Vampire").

4437. Clements, Jonathan. "Shark Skin Man and Peach Hip Girl." *Manga Mania.* October-November 1997, p. 80.

4438. Collins, David. "It's Anpan Man." *Mangajin.* April 1995, p. 31.

4439. "Cooking Papa by Ueyama Tochi." *Mangajin.* April 1995, p. 45.

4440. "Cop Fiction # 1." *Manga Max.* January 1999, p. 30.

4441. Craig, Keith. *"Warlands."* *Manga Max.* January 2000, p. 58.

4442. "Dai-Tōkyō Binbō Seikatsu Manyuaru." *Mangajin.* April 1995, pp. 59-62.

4443. *"Digimon: The Movie* Packs a Punch." *Animation.* April 2001, p. 58.

4444. "Does Whatever a Spider Can . . . Spider Man Manga." *Animerica.* 5:9 (1997), p. 59.

4445. Endresak, Dave. "Magical Girls, Part 2." *The Rose.* June 1998, pp. 10-11.

4446. Evans, Peter J. "A Break from the Norm." *Manga Max.* April 1999, p. 66. ("Kenji no Oshiri").

4447. "Fairytron." *Manga Max.* February 1999, p. 10.

4448. Fuertas, Agustin M. "Manga: La Escolta del Sultán." *Albur.* Verano 1996, p. 16.

4449. "Fuji Santarō by Satō Sanpei." *Mangajin.* No. 65, 1997, pp. 25-37.

4450. "Future Dreams: The Two Faces of Tomorrow." *Animerica.* 5:10 (1997), p. 61.

4451. "Galaxy Express 999." *Animerica.* 5:10 (1997), pp. 30-58.

4452. "Gal Gag World by Satō Ryōsaku." *Mangajin.* September 1996, pp. 42-45.

4453. "Get Ready To Riot: Riot." *Animerica.* 3:10 (1995), p. 44.

4454. Guerriero, Leila. "Lūpin: Un Vuelo Que Ya lleva 34 Años." *La Nación.* October 3, 1999.

4455. "Hana no Kakari-chō." *Mangajin.* November 1996, pp. 66-81.

4456. Hasegawa, Hōsei. *Genji Monogatari.* Vol. 1. *Manga Nihon no Koten* (Comic Japanese Classical Literature). Series 3. Chuō Kōronsha, 1996.

4457. Herriot, Fred. *"Gon." The Rose.* January 1997, p. 21.

4458. Hisaichi, Ishii, "Non-Cari Woman (A Non-Career Woman)." *Mangajin.* No. 66, 1997, pp. 24-29.

4459. "Honebuto-san by Fujitsubo Miki." *Mangajin.* September 1997, pp. 22-25.

4460. Hyland, Melissa. "Masaomi Kanzaki's *Ironcat #2.*" *Manga Max.* January 2000, p. 56.

4461. Hyland, Melissa. *"Ogenki Clinic 4.4." Manga Max.* January 2000, p. 57.

4462. "Illustrator Working on Opera Version of Hit 1970s Comic Book." Kyodo News Service release, April 22, 2001. ("The Rose of Versailles").

4463. Ishihara, Ikuko. *"Majo no Takyūbin:* Koko Kara Asoko e No Aida No Shōjo." *Eureka.* 29:11 (1997), pp. 193-199.

4464. Jowett, Simon. "Blade of the Immortal: On Silent Wings." Manga Max. January 2000, p. 56.

4465. "Kachō-san Shigoto Desu Yo by Matsuura Seiji." *Mangajin.* April 1995, pp. 45-46.

4466. Karahashi. Takayuki. "In the Mouth of Mythical Magic." *Animerica.* 3:10 (1995), p. 11.

4467. "Kariage-Kun, by Ueda Masashi." *Mangajin.* November 1996, pp. 82-85.

4468. "Katsushika Q." *Mangajin.* November 1995, pp. 31-47.

4469. Kawamoto, Saburô. [Interview about "Akira"]. *Eureka.* 8/1988, p. 92.

4470. "Kids These Days by Kubō Kiriko." *Mangajin.* April 1997, pp. 32-39.

4471. "The King of Monsters Is Back." *Animerica.* 3:5 (1995), p. 36. ("Godzilla").

4472. Knighton, Mary. "Kōno Taeko's Medusan Laugh: *Bishôjo.* " Paper presented at Association for Asian Studies meeting, San Diego, California, March 10, 2000.

4473. Kobayashi, Kim. "Idol Bo-Ei Tai Hummingbird." *The Rose.* April 1996, p. 31. ("Idol Defense Force Hummingbird").

4474. Kobayashi, Kim. "Kindaichi Shonen No Jikenbo." *The Rose.* October 1996, p. 36.

4475. "Kuriko-san Terashima Reiko." *Mangajin.* November 1995, pp. 52-53.

4476. Larmola, Kivi. "Barun Tarinoissa Ollaan Tien Päällä." *Sarjainfo.* No. 94, 1/1997, pp. 20-21.

4477. Leahy, Kevin. "Battle Royal High School -- Majinden." *The Rose.* October 1996, p. 11.

4478. Leahy, Kevin. "Cat's Eye." *The Rose.* July 1995, pp. 20-21, 33.

4479. Leahy, Kevin. "Hunter-Killer Mina." *The Rose.* April 1997, p. 24.

4480. Leahy, Kevin. "Jajin Densetsu Series." *The Rose.* October 1995, p. 19.

4481. Leahy, Kevin. "Manga Review: Risking [sic] Fighter Takeru." *The Rose.* April 1995, p. 23.

4482. Leahy, Kevin. "Present from Lemon." *The Rose.* July 1996, p. 20.

4483. Leahy, Kevin. "*Reika.* " *The Rose.* January 1997, pp. 7, 36.

4484. Leahy, Kevin. "War Is Hell, Even in Manga." *The Rose.* April 1995, pp. 7, 33.

4485. "Maaaad Dad." *Manga Max.* November 1999, p. 7.

4486. "Mai the Psychic Girl Perfect Collection." *Animerica.* 3:10 (1995), p. 45.

4487. "Manabe's Warrior Princesses." *Animerica.* 5:6 (1997), p. 58.

4488. "Manga Back with Siren." *Manga Max.* June 2000, p. 8.

4489. "Manga Closeup." *Animerica.* 5:5 (1997), p. 60. ("Gunsmith Cats").

4490. "Manga Top Seller for US." *Comics International.* March 1999, p. 8. ("Geobreeders").

4491. Marechal, Beatrice. "'Singular Stories of the Terashima Neighborhood': A Japanese Autobiographical Comic." Presented at International Comic Arts Festival, Bethesda, Maryland, September 14, 2000.

4492. Mason, Paul. "Margin of Error." *Manga Max.* June 1999, pp. 32-36. ("The Water Margin").

4493. "Men at Work!" *Manga Max.* December 1999, p. 6.

4494. "Middle Eastern Manga Madness! *The Rebel Sword.*" *Animerica.* 2:11 (1994), p. 38.

4495. "Mix Connection, by Usui Yoshito." *Mangajin.* October 1997, pp. 19-23.

4496. Moe, Anders. "*Cannon God Exaxxion.*" *The Rose.* June 1999, p. 30.

4497. "Move Over, Sarah Connor: Legend of Mother Sarah." *Animerica.* 3:5 (1995), p. 36.

4498. Munson-Siter, Patricia A. "Guyver: Part Two." *Anime UK.* April 1995, pp. 8-11.

4499. Ng, Ernest. "Cheerio." *The Rose.* February 2001, pp. 20-21.

4500. Ng, Ernest. "Intron Depot 2: Blades." *The Rose.* February 2001, p. 20.

4501. "Okusama wa Interia Dezainā, by Akizuki Risu." *Mangajin.* No. 65, 1997, pp. 62-67.

4502. "OL Reiko-san by Yamada Sanpei." *Mangajin.* June 1995, pp. 44-45.

4503. Ōno, Shinjirō. "Ajimantei, The Flavor-Full Café." *Mangajin.* June 1996, pp. 51-52.

4504. Ōshima, Kojī. "My Neighbor Totoro." *Mangajin.* May 1995, pp. 4, 75.

4505. Ouellette, Martin. "Jovian Chronicles." *Protoculture Addicts.* December 1993, p. 22. ("Mekton").

4506. "Our Tono-sama by Meguro Yasushi." *Mangajin.* February 1997, pp. 42-43.

4507. "Overfiend II Is Coming!" *Mangazine.* August 1993, p. 3.

4508. "*The Phantom Menace* Manga." *Animerica.* 7:12 (1999), pp. 28-29.

4509. "Pokemon Manga Tops Charts (Sort of)." *Manga Max.* September 1999, p. 8.

4510. "Poketto Sutorii, Pocket Story, by Mori Masayuki." *Mangajin.* September 1996, pp. 65-73.

4511. "The Professional: Golgo 13." *Stripschrift.* August 1994, p. 7.

4512. "Quaint Wakakusayama Story, by Terashima Reiko." *Mangajin.* August 1997, pp. 23-29.

4513. "Raijino." *Mangazine.* September 1991, pp. 37-38.

4514. "The Rakuten Family by Nitta Tomoko." *Mangajin.* February 1996, pp. 74-75.

4515. Randall, Bill. "Beyond Mere Action: *Legend of Kamui, 2 Volumes."* *Comics Journal.* September 2000, pp. 30-33.

4516. Roe, Anders. "Yokohama Kaidashi Kikou." *The Rose.* February 2000, p. 9.

4517. "Run! Run! Alcindo!! by Ōhira Kazuo." *Mangajin.* September 1995, pp. 74-77.

4518. "Sarariiman Senka by Shōji Sadao." *Mangajin.* June 1995, pp. 60-63.

4519. Savage, Lorraine. *"A, A¹."* *The Rose.* June 1998, p. 12-13.

4520. Savage, Lorraine. "Le Masque." *The Rose.* October 1995, pp. 17, 35.

4521. Sawayaka Sandā (Mr. Fresh Thunder)." *Mangajin.* December 1996, pp. 38-39.

4522. Scott, A.O. "Masochists Always Hurt The Ones They Love." *New York Times.* November 22, 2000, p. E8.

4523. "Sekai 4Komaka Keikaku." *Mangajin.* December 1996, pp. 41-42.

4524. "Selections from Deluxe Company." *Mangajin.* November 1995, pp. 54-57.

4525. "Serial Thriller." *Manga Max.* October 1999, p. 8. ("Fukida-Ken").

4526. Sertori, Julia. "Dear Diary" *Manga Max.* May 2000, pp. 26-28. ("Sakura Diaries").

4527. Sertori, Julia. "Mesozoic # 2." *Manga Max.* September 1999, pp. 44-45.

4528. Smith, Mike. "Episode Guide: Ranma 1/2 Manga Episode Perfect Guide." *The Rose.* February 1998, pp. 30-31.

4529. Smith, Mike. "I Wish." *The Rose.* June 2000, p. 17.

4530. Smith, Mike. "Love Hina." *The Rose.* June 2000, pp. 12-13.

4531. Smith, Mike. *"To Heart."* *The Rose.* October 2000, pp. 4-5.

4532. "Sore Demo Megezu! Never Say Die! by Kawabata Issei." *Mangajin.* March 1996, pp. 46-48.

4533. Spurgeon, Tom. "The Four Immigrants Manga." *Comics Journal.* December 1998, p. 29.

4534. Spurgeon, Tom. "*Sanctuary,* Vol. 6." *Comics Journal.* February 1997, p. 45.

4535. Staley, James. "I'S." *The Rose.* February 1999, p. 28.

4536. Staley, James. "*Kirara.*" *The Rose.* October 1998, p. 25.

4537. Staley, James. "Shadow Lady." *The Rose.* February 1999, p. 28.

4538. Staley, James. "Under the Dappled Shade." *The Rose.* July 1995, p. 11.

4539. Sterling, Cathy. "Malice in Wonderland." *Manga Max.* July 2000, pp. 28-29. ("Black Knight Bat").

4540. Sterling, Cathy. "State of the Art." *Manga Max.* December 1998, pp. 24-25. ("Intron Depot 2").

4541. "Stranger in a Strange Land: Tough Love." *Animerica.* 5:8 (1997), p. 60.

4542. Swint, Lester. "Mobile Police Patlabor." *The Rose.* February 1998, p. 13.

4543. Swift, Lester. "Star Blazers." *The Rose.* July 1995, p. 24.

4544. Swint, Lester. "*Star Wars: A New Hope* – Manga." *The Rose.* October 1998, pp. 21, 26.

4545. Swint, Lester and James Staley. "Drakuun: Rise of the Dragon Princess." *The Rose.* October 1997, pp. 20-21.

4546. Takatori, Ei. *Berusaiyu no Bara ei' en ni.* Tokyo: Shôbunkan, 1994. ("Rose of Versailles").

4547. "Take'emon-ke no Hitoboto (The Take'emon Clan.)" *Mangajin.* September 1996, pp. 84-85,

4548. Tamamuro, Motoko and Lee Brimmicombe-Wood. "His Secret, Her Secret." *Manga Max.* December 1998, pp. 26-27.

4549. "Tanaka-kun by Tanaka Hiroshi." *Mangajin.* June 1995, pp. 48-49.

4550. "Tetsuo II: The Body Hammer." *Stripschrift.* August 1994, p. 9.

4551. "Tokyo Babylon Part 1." *Stripschrift.* August 1994, p. 2.

4552. Tong, Ng Suat. "A Swordsman's Saga: *Blade of the Immortal.*" *Comics Journal.* November 2000, pp. 42-45.

4553. Tong, Ng Suat. "Train Keep a-Rollin': *Galaxy Express 999.*" *Comics Journal.* December 1999, pp. 41-42.

4554. "Top Picks: Comic Books: Akira." *US News & World Report.* January 8, 2001, p. 54.

4555. "Trial by Combat." *Manga Max.* August 1999, p. 8.

4556. Uchida, Shungieu. *Fuazā Fakkā* (Father Fucker). Tokyo: Bungei Shunjū, 1993.

4557. "Urotsukidoji." *Stripschrift.* August 1994, p. 3.

4558. van Melkebeke, Emmanuel. "Bridging Cultures." *Manga Mania.* May-June 1998, pp. 56-57.

4559. von Busack, Richard. "Migration Manga: Rare Rediscovered Japanese Comic Chronicles an Immigrant Saga." *Metro/Active.* June 3-9, 1999. ("The Four Immigrants").

4560. Ward, Murray R. "Thirteen ('Going on Eighteen') Index." *Hollywood Eclectern.* No. 26, 1998-1999, pp. 9-18.

4561. "What a Wonderful World." *Animerica.* 4:6 (1996), p. 56. ("Spirit of Wonder").

4562. "Wicked City." *Stripschrift.* August 1994, p. 10.

4563. "You Smell." *Manga Max.* July 2000, p. 5.

4564. "Yunbo-kun, by Saibara Rieko." *Mangajin.* December 1996, pp. 43-47.

4565. Zenta, Abe. "Aji Ichi Monme, A Bit of Flavor." *Mangajin.* June 1996, pp. 25-47.

"Adolf"

4566. "Are We Not Men? *Adolf.*" *Animerica.* 3:12 (1995), p. 40.

4567. Donahue, T.J. "Adolf: A Tale of the Twentieth Century." *Mangajin.* September 1996, p. 54.

4568. Flores & Flórez. "Adorf, para los Que Vengan Después." *El Wendigo.* No. 84, 2000, pp. 10-13.

4569. Goff, Janet. "Adolf: A Tale of the Twentieth Century." *Japan Quarterly.* April 1997, p. 105.

4570. Reyns-Chikuma, Cris. "Tezuka Osamu's *Adorufu*: WWII Manga as a Litmus Test for 'High Art.'" Paper presented at Association for Asian Studies meeting, San Diego, California, March 11, 2000.

4571. Tong, Ng Suat. *"Adolf: A Tale of the Twentieth Century."* Comics
 Journal. May 1996, p. 42.

"After Zero"

4572. "After Zero, by Okazaki Jirō." *Mangajin*. December 1996, pp. 65-81.

4573. "After Zero, by Okazaki Jirō." *Mangajin*. February 1997, pp. 17-37.

"Ai Ga Hoshii" (Longing for Love)

4574. "Ai Ga Hoshii, Longing for Love, by Nonaka Nobara." *Mangajin*.
 October 1995, pp. 56-59.

4575. "Ai Ga Hoshii Longing for Love, by Nonaka Nobara." *Mangajin*.
 July 1996, pp. 40-45.

"Akai Hayate"

4576. Greenholdt, Joyce. "Viewing 'Akai Hayate.'" *Comics Buyer's Guide*.
 December 29, 1995, p. 74.

4577. "Soul Brother Ichban: Akai Hayate." *Animerica*. 3:6 (1995), p. 14.

4578. "USMC Sees Red with *Akai Hayate*." *Mangazine*. May 1995, p. 5.

"Barefoot Gen"

4579. Lameiras, Joao M. "Descalço em Hiroshima." *Nemo Fanzine*. December
 1997.

4580. Nakazawa, Keiji. *Barefoot Gen: Out of the Ashes. A Cartoon History of
 Hiroshima*. Philadelphia, Pennsylvania: New Society Publishers, 1994.

4581. Nakazawa, Keiji. *"Hadashi no Gen* (Barefoot Gen): Volume 8, pages
 17-31." In *Japan Pop!* edited by Timothy J. Craig, pp. 154-170.
 Armonk, New York: M. E. Sharpe, 2000.

4582. Pols, Hans. "Barefoot Gen: Wat de Bom Ons Kan Leren." *Stripschrift*.
 January 1990, pp. 20-21.

"Battle Angel Alita"

4583. "Battle Angel Alita." *Stripschrift*. August 1994, p. 11.

4584. Evans, P. J. "Battle Angel Alita." *Manga Mania*. March-April 1998, p.
 69.

"Black Jack"

4585. Macias, Patrick. "Black Jack." *Animerica.* 7:9 (1999), pp. 33-35.

4586. Rust, David. *"Black Jack,* Volume One." *Comics Journal.* June 1999, p. 42.

4587. Sertori, Julia. "Jack of Shadows." *Manga Mania.* May-June 1998, pp. 10-12.

4588. Swint, Lester. "Black Jack: The Motion Picture." *The Rose.* October 1999, pp. 6-7.

"Clamp"

4589. Oshiguchi, Takashi. "Clamp's Wonderland: Four Women, One Name." *Animerica.* 5:1 (1997), pp. 4-6, 9, 18, 21, 74.

4590. Ouellette, Martin. "Manga Review." *Protoculture Addicts.* September-October 1997, p. 39.

"Crayon Shin-chan"

4591. "Crayon Shin-chan." *Mangajin.* September 1997, pp. 26-35.

4592. "Crayon Shin-chan, No. 9." *Mangajin.* September 1996, pp. 34-42.

"Dark Angel"

4593. *"Dark Angel."* *The Rose.* June 1999, p. 18.

4594. "Dark Angel: Phoenix Resurrection." *The Rose.* June 2000, p. 11.

4595. "Dark Angels." *Manga Max.* May 2000, p. 4.

4596. Savage, Lorraine. "Dark Angel: The Path to Destiny Graphic Novel." *The Rose.* June 2000, pp. 10-11.

"Devilman"

4597. Barr, Greg. "Demon-Bustin', Kick-Ass Technology: Devilman Vols. 1 and 2." *Animerica.* 3:7 (1995), p. 64.

4598. "Devil Man – The Birth." *Stripschrift.* August 1994, p. 2.

4599. "Men Who Run With The Devils." *Animerica.* 3:5 (1995), p. 14.

4600. "1987 Devilman: Birth." *Mangazine.* March 1992, pp. 32-35.

4601. Swint Lester. "Devilman." *The Rose.* July 1996, p. 17.

4602. Yoon, John. "Devilman." *The Rose.* July 1995, p. 16.

"Director Hira Namijirō"

4603. "Director Hira Namijirō Part 4." *Mangajin.* June 1995, pp. 64-89.

4604. "Torishimariyaku Hira Namijirō, Part 2" (Director Hira Namijirō). *Mangajin.* April 1995, pp. 65-91.

4605. "Torishimariyaku Hira Namijirō, Director Hira Namijirō, Part 3." *Mangajin.* May 1995, pp. 69-88.

"Doraemon"

4606. Arai, Eiko. "Doraemon: Transcendant Popularity." *Pacific Friend.* July 1996, pp. 31-32.

4607. "Capnapping." *Manga Max.* April 1999, p. 10.

4608. Natsume, Fusanosuke. "Spoiling the Boy." *Look Japan.* September 1995, pp. 20-21.

4609. Schilling, Mark. "Doraemon: Making Dreams Come True." *Japan Quarterly.* 40 (1993), pp. 405-417.

4610. Schilling, Mark. "Doraemon Saves the World." *Japan Times.* April 6, 1993.

4611. Setagaya Doraemon Kenkyū-Kai. *Doraemon Kenkyū Kanzen Jiten* (The Complete Encyclopedia of Doraemon Studies). Tokyo: Data House, 1994.

4612. Setagaya Doraemon Kenkyūkai. *Doraemon no Himitsu* (The Secrets of Doraemon). Tokyo: Data House, 1993.

4613. Shiraishi, Saya. "Japan's Soft Power: Doraemon Goes Overseas." Paper presented at Japanese Popular Culture Conference, University of British Columbia, April 10, 1997.

4614. "Umi o Koeru Doraemon" (Doraemon Goes Overseas). *Yom.* June 1993, pp. 2-23.

4615. "Who Is Doraemon?" *Education About Asia.* Winter 2000, p. 49.

"Dragon Ball"

4616. Chin, Oliver. "Dragon Ball Comics." *The Rose.* February 1998, p. 7.

4617. Evans, Peter J. "Balls of Confusion." *Manga Max.* May 2000, pp. 32-34.

4618. Greenholdt, Joyce. "From East to West: Viz Brings Bestselling 'Dragon Ball' Manga to U.S. in Its Original Format." *Comics Buyer's Guide.* March 6, 1998, pp. 30-31.

4619. Kanazawa, Oto. "Manga to 'Ikioi' Nitsuite no Kōsatsu 'Dorangonbōru' wo Sozai Nishite." In *Manga Hyôshô Bunka Kenkyû,* edited by Hyôshô Bunka Kenkyûkai, pp. 15-23. Tokyo: Waseda Daigaku, May 1998.

4620. Oshiguchi, Takashi. "On the End of Dragon Ball." *Animerica.* 4:11 (1996), p. 61.

4621. Sanders, Rik. "Manga-Maandblad Dragon Ball." *Stripschrift.* February 2001, p. 30.

4622. "Viz Translates 'Dragon Ball' Manga." *Comics Buyer's Guide.* November 21, 1997, p. 8.

"El Hazard"

4623. "Hazard Warning." *Manga Max.* July 2000, p. 4.

4624. Moe, Anders. "El Hazard." *The Rose.* February 1998, p. 21.

"Fist of the North Star"

4625. "Fist of the North Star." *Stripschrift.* August 1994, p. 8.

4626. "Follow the North Star: Fist of the North Star, Part Two." *Animerica.* 3:11 (1995), p. 48.

"Furiten-kun"

4627. "Ueda Masashi's Furiten-kun." *Mangajin.* February 1996, pp. 72-73.

4628. "Ueda Masashi's Furiten-kun." *Mangajin.* April 1997, pp. 20-23.

"Garcia-kun"

4629. Akira, Takeuchi. "Garcia-kun." *Mangajin.* March 1996, pp. 38-45.

4630. "Garcia-kun by Takeuchi Akira." *Mangajin.* April 1995, pp. 50-57.

4631. "Garcia, by Takeuchi Akira." *Mangajin.* November 1996, pp. 42-45.

"Garo"

4632. "Garo Fūunroku: Manga Ōkoku 30-nen no Kiseki" (A Record of *Garo*'s Stormy Times: The Thirty-Year Miracle of the Manga Kingdom). *Weekly Asahi Graph.* October 21, 1994, pp. 3-23.

4633. *Garo*-shi Henshū-iinkai (Garo History Committee), ed. *Garo Mandara* (Garo Mandala). Tokyo: TBS Britannica, 1991.

4634. Garo 20-nen-shi Kankō-iinkai, ed. *Monkuzō Morutaru no Ō Garo 20-nenshi* (The Wooden-Mortared Kingdom: *Garo's* 20th Memorial Issue). Tokyo: Seirindō, 1984.

4635. Nagai, Katsuichi. *Garo Henshucho.* Tokyo: Chikuma Shobo, 1987.

"Ghost in the Shell"

4636. "Coming Out of Its Shell: Ghost in the Shell." *Animerica.* 3:2 (1995), p. 34.

4637. "Ghost in the Shell." *Meniscus.* July 1995, p. 6.

4638. Greenholdt, Joyce. "Haunted by Ghost in the Shell." *Comics Buyer's Guide.* April 12, 1996, p. 34.

4639. Greenholdt, Joyce. "Just for Fun: Ghost in the Shell." *Comics Buyer's Guide.* March 22, 1996, p. 102.

"Gundam"

4640. "Scene Selection (*Gundam*)." *Animerica.* 7:12 (1999), p. 21.

4641. Swint, Lester. "Mobile Suit Gundam 0079." *The Rose.* October 1999, pp. 14-15.

4642. "Wing and Prayer." *Manga Max.* November 1999, p. 6.

"Hyaku-nen Senryū"

4643. "Hyaku-nen Senryū, by Gōda Yoshiie." *Mangajin.* July 1996, pp. 66-71.

4644. "Hyaku-nen Senryū, by Gōda Yoshiie." *Mangajin.* August 1997, pp. 30-31.

"Inu-Yasha"

4645. Chan, Ronald. "Inuyasha." *The Rose.* April 1997, pp. 8-10.

4646. Hyland, Melissa. "Inu-Yasha: A Feudal Fairy Tale." *Manga Mania.* May-June 1998, p. 79.

"Ironfist Chinmi"

4647. Brimmicombe-Wood, Lee and Motoko Tamamuro. "What the Hell Happened to Chinmi?" *Manga Max*. February 1999, pp. 24-28.

4648. Sertori, Julia. "Ironfist Chinmi." *Anime UK*. July 1995, pp. 41-43.

"Is That True?"

4649. Gladir, George. "Is That True?" *Mangajin*. April 1997, pp. 25-31.

4650. Gladir, George and Ōyama Tetsuya. "Is That True?" *Mangajin*. No. 66, 1997, pp. 54-75.

"Kachō Baka Ichidai"

4651. "Kachō Baka Ichidai by Nonaka Eiji." *Mangajin*. April 1997, pp. 40-47.

4652. "Kachō Baka Ichi-Dai, by Nonaka Eiji." *Mangajin*. October 1997, pp. 24-32.

"Kaiketsu!! Todo Kachō"

4653. "Kaiketsu!! Todo Kachō, Chief Todo, Wonderful Guy!! By Kadohashi Yasuto." *Mangajin*. August 1997, pp. 69-84.

4654. "Kaiketsu!! Todo Kachō (Chief Todo, Wonderful Guy!!), by Kadohashi Yasuto." *Mangajin*. September 1997, pp. 67-85.

"Kaji Ryūsuke no Gi"

4655. "Kaji Ryūsuke no Gi by Hirokane Kenshi." *Mangajin*. September 1996, pp. 17-37.

4656. "Kaji Ryūsuke no Gi, by Hirokane Kenshi." *Mangajin*. November 1996, pp. 17-40.

4657. "Kaji Ryūsuke no Gi (Kaji Ryūsuke's Agenda [Part 3] by Hirokane Kenshi." *Mangajin*. December 1996, pp. 17-37.

"Kasai no Hito"

4658. "Kasai no Hito, by Mohri Jinpachi and Uoto Osamu." *Mangajin*. May 1996, pp. 25-37.

4659. "Kasai no Hito, Story by Mohri Jinpachi." *Mangajin*. March 1996, pp. 73-86, 88-89.

4660. "Kasai no Hito. Story: Mohri Jinpachi." *Mangajin.* April 1996, pp. 25-39.

"Kekkon Shiyō Yo"

4661. "Kekkon Shiyōyo, Bokutachi no Shippai to Seikō (Let's Get Married, Our Failures and Successess)." *Mangajin.* September 1996, pp. 17-33.

4662. "Kekkon Shiyō Yo, Let's Get Married, by Hoshisato Mochiru." *Mangajin.* September 1996, pp. 65-83.

"Kochira Shakai-bu"

4663. "Kochira Shakai-bu (On the Lifestyle Beat), Ōshima Yasuichi." *Mangajin.* October 1997, pp. 49-67.

4664. "Kochira Shakai-bu (On the Metro Beat) Part 2, by Ōshima Yasuichi and Ōtani Akihiro." *Mangajin.* December 1997, pp. 61-83.

"Kono Hito ni Kakero" (Bet on This Woman)

4665. "Kono Hito ni Kakero – Bet on This Woman." *Mangajin.* August 1995, pp. 46-53.

4666. "Kono Hito ni Kakero – Bet on This Woman." *Mangajin.* November 1995, pp. 58-64.

4667. "Kono Hito ni Kakero" (Bet on This Woman). *Mangajin.* May 1996, pp. 46-55.

4668. "Kono Hito ni Kakero – Bet on This Woman – by Shū Ryōka." *Mangajin.* No. 51, 1995, pp. 46-52.

4669. "Kono Hito ni Kakero – Bet on This Woman – by Shū Ryōka." *Mangajin.* March 1996, pp. 50-56.

4670. "Kono Hito ni Kakero – Bet on This Woman – by Shū Ryōka." *Mangajin.* September 1995, pp. 48-57.

4671. "Kono Hito ni Kakero – Bet on This Woman, by Shū Ryōka and Yumeno Kazuko." *Mangajin.* October 1995, pp. 60-66.

4672. "Kono Hito ni Kakero – Bet on This Woman – by Shū Ryōka and Yumeno Kazuko." *Mangajin.* February 1996, pp. 46-52.

4673. "Kono Hito ni Kakero – Bet on This Woman – by Shū Ryōka and Yumeno Kazuko." *Mangajin.* April 1996, pp. 50-56.

"Living Game"

4674. "Living Game by Hoshisato Mochiru." *Mangajin.* June 1995, pp. 50-59.

4675. "Living Game by Hoshisato Mochiru." *Mangajin.* August 1995, pp. 55-73.

4676. "Living Game by Hoshisato Mochiru." *Mangajin.* September 1995, pp. 27-43.

"Lodoss War"

4677. McCarthy, Helen. "Making Do with Make-Believe." *Manga Max.* September 1999, pp. 26-30.

4678. Swint, Lester. "*Lodoss War: The Grey Witch.*" *The Rose.* June 1999, p. 7.

"Lone Wolf and Cub"

4679. Isabella, Tony. "Walk the *Road to Perdition.*" *Comics Buyer's Guide.* March 2, 2001, pp. 46, 56.

4680. Pusateri, John. "Assassins and Children: The Mythology of the Lone Wolf and Cub Films." *Asian Cinema.* Spring/Summer 2000, pp. 84-96.

4681. "Return of Lone Wolf." *Manga Max.* May 2000, p. 5.

4682. Ridout, Cefn. "Lone Wolf and Cub." *Manga Max.* November 1999, pp. 28-32.

4683. Sanderson, Peter. "Lone Wolf and Cub in America." *Comics Scene Special.* 1 (1987), pp. 23-25.

4684. "Walk Lightly on the Path to Hell." *Kung-fu Girl.* Summer 1995, pp. 37-42.

"Macross"

4685. "Macross." *Mangazine.* January 1992, pp. 36-41.

4686. "Macross (or Robotech)." *Meniscus.* July 1995, p. 7.

4687. "Macross II." *Mangazine.* August 1993, p. 4.

4688. Swint, Lester. "Macross II: The Micron Conspiracy." *The Rose.* April 1995, p. 8.

"Mammoth-Like Ojōsami!!"

4689. "Mammoth-Like Ojōsama!! By Okada Ganu." *Mangajin.* December 1996, pp. 82-85.

4690. "Mammoth-Like Ojōsama!! By Okada Ganu." *Mangajin.* April 1997, pp. 17-19.

"Mazinger Z"

4691. "Mazinger Z/Great Mazinger Versus" *Mangazine.* March 1992, pp. 40-46.

4692. "1972 Mazinger Z." *Mangazine.* March 1992, pp. 36-39.

"M.D. Geist"

4693. "Ohata Adapts 'M.D. Geist' to US Comics." *Comics Buyer's Guide.* April 21, 1995, p. 44.

4694. "The Unfriendliest Geist Around." *Animerica.* 3:6 (1995), p. 20.

4695. "War Is Hell." *Animerica.* 4:7 (1996), p. 40.

"Minori Densetsu"

4696. "Minori Densetsu – Part 2, The Legend of Minori, by Oze Akira." *Mangajin.* March 1997, pp. 67-85.

4697. "Minori Densetsu – The Legend of Minori by Oze Akira." *Mangajin.* April 1997, pp. 67-85.

"Monster"

4698. "Monster Trashes Watchmen." *Manga Max.* December 1999, p. 5.

4699. "Spotlight on: Monster." *Manga Max.* December 1999, p. 11.

"Natsuke Crisis"

4700. Luse, Jonathan. "Natsuki Crisis." *The Rose.* July 1997, pp. 16-17.

4701. Tsao Sheng-Te. "Natsuki Crisis." *The Rose.* January 1996, pp. 8-10.

"Nausicaä, of the Valley of Wind"

4702. Gomi, Yoko. "The Purifying Darkness of Miyazaki's World: The Place Where 'Nausicaä' Has Arrived." *Comic Box.* January 1995.

4703. Hairston, Marc. "Nausicaä in Academia." *Animerica.* 7:12 (1999), pp. 64-65, 67.

4704. "Kaze no Tani no Naushika" (Nausicaä, of the Valley of Wind). Special issue of *Comic Box.* January 1995.

4705. Okada, Emilio. "Thoughts of a Faithful Reader for 12 Years." *Comic Box.* January 1995.

4706. Schodt, Frederik L. "Reading the Classic Nausicaä, One Can See the Problems with Today's Manga." *Comic Box.* January 1995.

4707. Smith, Toren. "The New Miyazaki Generation: Spreading Even into English Speaking Countries." *Comic Box.* January 1995.

"Neon Genesis Evangelion"

4708. "Evangelion: The Manga." *Manga Mania.* July-August 1997, p. 17

4709. Lamplighter, L. Jagi. "Evangelion Manga." *AnimeFantastique.* Summer 1999, p. 46.

4710. "Neon Genesis Evangelion the Manga." *Animerica.* 5:8 (1997), pp. 8-9.

4711. Swint, Lester. "Neon Genesis Evangelion: Book 1 (Issues #1-6)." *The Rose.* October 1998, pp. 22-23.

"Ningen Kōsaten"

4712. "Ningen Kōsaten." *Mangajin.* August 1995, pp. 75-91.

4713. "Ningen Kōsaten by Yajima Masao and Hirokane Kenshi." *Mangajin.* September 1995, pp. 78-93.

4714. "Ningen Kōsaten by Yajima Masao and Hirokane Kenshi." *Mangajin.* October 1995, pp. 84-99.

"Nippon Cha-Cha-Cha"

4715. "Nippon Cha-Cha-Cha by Yamazaki Kōsuke." *Mangajin.* May 1995, pp. 44-47.

4716. "Nippon Cha-Cha-Cha by Yamazaki Kōsuke." *Mangajin.* April 1996, pp. 48-49.

4717. Yamazaki Kōsuke. "Nippon Cha-Cha-Cha." *Mangajin.* June 1996, pp. 48-49.

"Obatarian"

4718. "Obatarian by Hotta Katsuhiko." *Mangajin.* November 1995, pp. 50-51.

4719. "Obatarian by Hotta Katsuhiko." *Mangajin.* April 1996, pp. 40-41.

4720. "Obatarian by Hotta Kotsuhiko." *Mangajin.* September 1996, pp. 42-45.

"OL Shinkaron"

4721. "OL Shinkaron." *Mangajin.* June 1996, pp. 52-56.

4722. "OL Shinkaron. Theory of the Evolution of the OL by Akizuki Risu." *Mangajin.* April 1996, pp. 42-44.

"Otoko wa Tsurai Yo"

4723. "Otoko wa Tsurai Yo, It's Tough Being a Man." *Mangajin.* February 1996, pp. 25-37.

4724. "Otoko wa Tsurai Yo, It's Tough Being a Man." *Mangajin.* April 1996, pp. 73-89.

4725. Yoji, Yamada. "Otoko wa Tsurai Yo. Part 2." *Mangajin.* March 1996, pp. 25-37.

"Reggie"

4726. "Reggie, by Guy Jeans." *Mangajin.* No. 51, 1995, pp. 75-91.

4727. "Reggie by Guy Jeans and Hiramatsu Minoru." *Mangajin.* February 1996, pp. 77-93.

4728. "Reggie, Story by Guy Jeans, Art by Hiramatsu Minoru." *Mangajin.* October 1995, pp. 31-53.

"Sazae-san"

4729. Beck, Robert. "Warm Reflections of Japan." *Tokyo Journal.* November 1988, pp. 92-95.

4730. Clements, Jonathan. "Sazae-san." *Manga Mania.* January-February 1998, pp. 60-61.

4731. Hasegawa, Machiko. *The Wonderful World of Sazae-san.* Vol. 1. Tokyo: Kodansha, 1997. 168 pp.

4732. Lee, William. "From Sazae-san to Crayon Shin-chan: Family Anime and Social Change in Japan." Paper presented at Japanese Popular Culture Conference, Victoria, Canada, April 11, 1997.

4733. "Sazae-san Exhibit." *The Rose.* July 1997, p. 20.

4734. Shimizu, Isao. *"Sazae-san* and the History of Comic Art." *Fūshiga Kenkyū.* No. 20, 1996, pp. 12-13.

4735. Yamaguchi, Mariko. "The Generation Gap Between Sazae-san and Crayon Shin-chan." Paper presented at Japanese Popular Culture Conference, University of British Columbia, Victoria, Canada, April 11, 1997.

"Silent Service"

4736. "Chinmoku no Kantai" (Silent Service). *Comic Box.* July 1991, pp. 15-30.

4737. Tokio, Teruhiko, ed. *Chinmoku no Kantai: Kantai Shinsho* (Silent Service: A New Book of Analysis). Tokyo: Kōdansha, 1995.

"The Tale of Genji"

4738. Hirota, Akiko. "The *Tale of Genji:* From Heian Classic to Heisei Comic." *Journal of Popular Culture.* Fall 1997, pp. 29-68.

4739. Huddleston, Daniel. "The Tale of Genji in Words and Pictures." *Animerica.* 7:10 (1999), pp. 17-19, 33.

"Tenchi Muyo"

4740. "The Comic Books *(Tenchi Muyô)." Animerica.* 7:8 (1999), p. 28.

4741. "It's Tenchi Time!" *Animerica.* 4:3 (1996), p. 30.

4742. Staley, James. "Tenchi Muyo." *The Rose.* February 1998, p. 25.

4743. "Talkin' Tenchi Muyō." *Animerica.* 3:11 (1995), pp. 7-10.

"This Is the Katsushika-ku Kameari Kōenmae Police Boy"

4744. Akimoto Osamu. "This Is the Katsushika-ku Kameari Koenmae Police Box." *Mangajin.* June 1996, pp. 73-91.

4745. "'This Is the Katsushika-ku Kameari Kōenmae Police Boy,' by Akimoto Osamu." *Mangajin.* May 1996, pp. 73-91.

"3x3 Eyes"

4746. "Curse Your Eyes: 3x3 Eyes." *Animerica.* 3:10 (1995), p. 45.

4747. Davis, Julie. "In the Mouth of Manga Madness." *Animerica.* 3:10 (1995), pp. 6-11.

"Vampire Hunter D"

4748. Leahy, Kevin. "*Vampire Hunter D: Dark Nocturne.*" *The Rose.* October 2000, p. 8.

4749. Leahy, Kevin. "Vampire Hunter D Series." *The Rose.* October 1995, pp. 20-21.

"Vampire Princess Miyu"

4750. Hyland, Melissa. "*New Vampire Miyu 4.2.*" *Manga Max.* January 2000, p. 58.

4751. "The Last Vampire: Vampire Miyu." *Animerica.* 3:10 (1995), p. 44.

"What's Michael?"

4752. Mordin, Chrys. "What's Michael." *Manga Mania.* January-February 1998, p. 61.

4753. "What's Michael?" *Animatoon.* No. 31, 2001, pp. 56-57.

4754. "What's Michael?" *Mangajin.* July 1996, pp. 72-83.

4755. "What's Michael, by Kobayashi Makoto." *Mangajin.* September 1997, pp. 37-47.

4756. "What's Michael? Vol. 57." *Mangajin.* May 1995, pp. 49-59.

"X-Men"

4757. Brady, Matt. "Rogue Casting for *X-Men.*" *Comics Buyer's Guide.* July 30, 1999, p. 10.

4758. Swint, Lester. "X-Men: The Manga." *The Rose.* June 1998, pp. 9, 34.

"X/1999"

4759. "The End of the World is Coming." *Animerica.* 4:7 (1996), p. 60.

4760. "Is He the Angel of Our Salvation or the Devil of Our Destruction? X/1999." *Animerica.* 3:5 (1995), p. 37.

4761. Iwasa, Ken. "X/1999." *Tsunami.* Summer 1995, p. 30.

4762. Swint, Lester. "X/1999." *The Rose.* October 1995, pp. 8-9.

4763. Brimmicombe-Wood, Lee. *"X/1999: Serenade."* *Manga Max.* January 2000, p. 58.

"You're Under Arrest"

4764. Kobayashi, Kim. "You're Under Arrest File-X." *The Rose.* April 1996, p. 31.

4765. "Policewomen on Patrol: You're Under Arrest!" *Animerica.* 3:11 (1995), p. 48.

4766. Staley, James. "You're Under Arrest!" *The Rose.* July 1995, p. 17.

"Yūyake no Uta"

4767. "Yūyake no Uta by Saigan Ryōhei." *Mangajin.* No. 66, 1997, pp. 77-91.

4768. "Yūyake no Uta, by Saigan Ryōhei." *Mangajin.* August 1997, pp. 51-67.

Exports and Imports

4769. "ADV Snuggles up to Right Stuf." *Manga Max.* March 2000, p. 5.

4770. "All Change for Antarctic." *Comics International.* June 1999, p. 11.

4771. Ching, Leo. "Imaginings in the Empires of the Sun: Japanese Mass Culture in Asia." *Boundary.* Spring 1994, pp. 198-219.

4772. Couch, Christopher. "CPM Manga Celebrates Its 5th Anniversary." *Comics Buyer's Guide.* October 27, 2000, pp. 22-23.

4773. "CPM Manga Dives into New Adventures." *Comics Buyer's Guide.* March 10, 2000, p. 42.

4774. Grigsby, Mary. *"Sailormoon: Manga* (Comics) and *Anime* (Cartoon) Superheroine Meets Barbie: Global Entertainment Commodity Comes to the United States." *Journal of Popular Culture.* Summer 1998, pp. 59-80.

4775. "Japanese Pop Culture Is Turning into a Money Spinner Across Asia." *The Economist.* July 22, 2000.

4776. Lent, John A. *"Vignette: Anime* and *Manga* in Parts of Asia and Latin America." In *Animation in Asia and the Pacific,* edited by John A. Lent, pp. 85-88. Sydney: John Libbey & Co., 2001.

4777. Lim Yan Ling. "Japanese Merchandise in Singapore: A Study of Sanrio." Honors thesis, National University of Singapore 1998/99.

4778. "Pop Culture: A Hot Japanese Export." *Nikkei Weekly*. May 8, 2000, p. 20.

4779. Shimoharaguchi, Toru. " 'Made in Japan' Has Never Looked So Cool as Culture Sells Big in Asia. Movies, TV, Pop Music, Fashion Being Embraced by Young and Old Alike." *Nikkei Weekly*. July 10, 2000, p. 22.

4780. "Viz Collect Corrector." *Manga Max*. Summer 2000, p. 4.

Anime (Animation)

4781. "A.D. Vision Lets the Girl from Phantasia out from under the Carpet!" *Mangazine*. January 1994, p. 3.

4782. "Anime Around the World." *The Rose*. October 1995, p. 13.

4783. "Anime Around the World." *The Rose*. February 1999, p. 13. (Mexico, Indonesia, South Korea).

4784. "AnimEigo Stealing Show with World's Greatest Thief." *Mangazine*. January 1995, p. 6.

4785. "Anime News: A.D. Vision, AnimEigo, U.S. Manga Corps., Viz, Right Stuf." *Mangazine*. September 1994, pp. 4-7.

4786. "Anime News: AnimEigo, SoftCel, U.S. Renditions." *Mangazine*. November 1994, p. 7.

4787. "Another UCLA Success." *Manga Max*. August 1999, p. 5.

4788. "Antarctic Plans To Consolidate Its Line for '97." *Comics Buyer's Guide*. February 14, 1997, p. 78.

4789. Beck, Jerry. "Anime: Hollywood's Invisible Animation Genre." *Animation World*. August 1996, 3 pp.

4790. "Blazing Action and Uproarious Comedy from USMC in May!" *Mangazine*. January 1994, p. 4.

4791. Brady, Matt. "Manga Entertainment Releases First Anime DVD in July." *Comics Buyer's Guide*. July 4, 1997, p. 8.

4792. "CBG Anime News." *Comics Buyer's Guide*. December 29, 1995, p. 68.

4793. "Central Park Media: An Overview." *Comics Buyer's Guide*. December 29, 1995, p. 44.

4794. "Central Park Media Expands." *Animato!* Fall 1995, p. 8.

4795. Collins, Keith. "Anime Hot Stuff for Distribs." *Variety.* June 19-25, 1995, pp. 62, 64.

4796. "Competition with Animations in the World, Not with Japanese Works." *Animatoon.* No. 22, 1999, p. 69.

4797. "CPM Expands into New Ventures." *Comics Buyer's Guide.* December 29, 1995, p. 64.

4798. "CPM Has New Releases of Old Classics." *Mangazine.* January 1994, p. 5.

4799. "Disney Dishes Dosh." *Manga Mania.* July/August 1998, p. 4.

4800. "Disney To Distribute Features Produced in Japan by Hayao Miyazaki." *ASIFA San Francisco.* July/August 1997, p. 6.

4801. "Disney To Distribute Miyazaki's Animated Movies in U.S." *Animato!* Summer 1996, p. 13.

4802. "Disney Will Distribute Japanese Animation." *Animation World.* August 1996, 1 p.

4803. Elias, Marc. "Nemo: East Meets West To Bring McCay's Surreal Masterwork to Life." *fps.* June 1992, pp. 8-10.

4804. Furniss, Maureen and Anthony Beal. "The Adaptation of Japanese Animation Series for Use on American Television." Paper presented at Society for Animation Studies, Madison, Wisconsin, September 26, 1996.

4805. Gelman, Morrie. "Anime Makes Special Penetration in U.S. Market." *Animation.* October 2000, p. 18.

4806. "Ghost in the Disney Machine." *Manga Mania.* October-November 1997, p. 7.

4807. Goldstein, Seth. "Orion, Polygram Bring Anime to Mainstream." *Billboard.* December 24, 1994, pp. 13, 94.

4808. Gosling, John. "Anime in Europe." *Animation World.* August 1996, 4 pp.

4809. Greene, R. "Anim-Asian." *Boxoffice.* July 1994, p. 41.

4810. Haring, Bruce. "Japanese Animation Niche Expands in US." *Video Business.* September 24, 1994.

4811. Harvey, Iain. "Rotterdam Turns to Japan." *Animation World.* March 2000, 4 pp.

4812. Hirtzy, Michael. "Anime in Great Britain – Dead or Alive?" *The Rose.* June 1998, pp. 28-29.

4813. "Japanese Animation In the World." *Animatoon.* No. 22, 1999, pp. 62-63.

4814. McCarthy, Helen. "The Development of the Japanese Animation Audience in the United Kingdom and France." In *Animation in Asia and the Pacific,* edited by John A. Lent, pp. 73-84. Sydney: John Libbey & Co., 2001.

4815. "Manga Entertainment Announces Launch of U.S. Theatrical Division with Release of Cybertech Thriller Ghost in the Shell." *Animation World.* April 1996, 1p.

4816. "Manga Entertainment Call for Animated Films." *Society for Animation Studies Newsletter.* Spring/Summer 1997, p. 6.

4817. "Manga Entertainment Seeks Animation Shorts." *Comics Buyer's Guide.* February 14, 1997, p. 8.

4818. "Manga Wants To Be the Next Major International Theatrical and Home Video Distributor of Animated Shorts." *ASIFA San Francisco.* March 1997, p. 5.

4819. Miller, Bob. "Dateline: Streamline. Carl Macek on Streamline Pictures and Life After Robotech." *Animato!* Spring 1991, pp. 24-27.

4820. Miller, Bob. "U.S. Renditions: Dubbing for Dollars." *Animato!* Fall/Winter 1993, pp. 16-17, 61.

4821. O'Connell, Michael. "The Next Big Japanese Import: Animation." *Washington Post Fast Forward.* August 1995, pp. 14-15.

4822. O'Donnell, John. "International Production and Distribution." *Animation.* January 1966, pp. 128-129.

4823. Ono, Keigo. "Disney and the Japanese." *Look Japan.* July 10, 1983, pp. 6-12.

4824. Patten, Fred. "*Anime* in the United States." In *Animation in Asia and the Pacific,* edited by John A. Lent, pp. 55-72. Sydney: John Libbey & Co., 2001.

4825. Patten, Fred and Frederik Schodt. "Bridge USA: Disney Also Influenced by Japanimation." *The Rose.* February 1998, pp. 4, 31.

4826. "Pioneer Anime News." *Animerica.* 3:12 (1995), p. 20.

4827. "Pioneer Shows the Way with Multitude of Multi-Format Releases."
 Mangazine. November 1994, p. 7.

4828. Raffaelli, Luca. "Disney, Warner Bros. and Japanese Animation." In *A
 Reader in Animation Studies*, edited by Jayne Pilling, pp. 112-136.
 London: John Libbey and Co., 1997.

4829. Reaves, Michael. "American Anime?" *AnimeFantastique*. March 1999,
 p. 62.

4830. Savage, Lorraine. "The Anime Invasion." *Computer Graphics
 Magazine*. April 1998.

4831. Savage, Lorraine. "Siskel & Ebert: A Tribute to Animation." *The Rose.*
 June 1999, p. 5.

4832. Schwartz, Robert. "Global Audiences Are Tooning In–Japan."
 Hollywood Reporter. January 24, 1995, pp. S-30, S-86.

4833. Segall, Mark. "Manga Entertainment: Taking Anime to the Next Stage."
 Animation World. August 1996, 5 pp.

4834. "Sequels Galore from U.S. Manga Corps!" *Mangazine*. July 1994, p. 3.

4835. Shimizu, Isao. "Nihon Manga, Anime e no Beikokujinn no Kanshin"
 (The American's Interest in Japanese Manga and Anime: Interview
 Questions by an American TV Station). *Fūshiga Kenkyū*. January 20,
 1998, pp. 8-9.

4836. "Simitar Entertainment Launches Chroma-Cel Line." *Comics Buyer's
 Guide*. March 6, 1998, p. 54.

4837. Storey, John. "Amecomi: American Comics: Japan's Latest Fad."
 Mangajin. May 1996, pp. 58-60.

4838. "Streamline Does Distribution Deal with Orion." *Mangazine*. November
 1994, p. 3.

4839. "Streamline Hits Cable Market on Network One." *Mangazine.*
 November 1994, p. 3.

4840. "Streamline, Orion and Polygram To Channel Anime More into
 Mainstream." *Mangazine*. January 1995, p. 9.

4841. Swallow, James. "Nippon Europa: Spotlight on Kiseki Films."
 Mangazine. May 1995, p. 18.

4842. Swallow, Jim. "Anime Invasion?" *Manga Max*. January 1999, pp. 10-
 12.

4843. Townsend, Emru. "Over the Waves: Marvin Gleicher, Manga Entertainment's CEO Talks About Getting Anime on TV, U2, and *Ghost in the Shell." fps.* Summer 1996, pp. 18-23, 37.

4844. "U.S. Manga Corps." *Mangazine.* November 1994, p. 8.

4845. "U.S. Manga Corps Announces Release of *Ambassador Magma." Mangazine.* April 1993, p. 2.

4846. "US Manga Corps Warns of Final Showdown in June." *Mangazine.* May 1994, p. 4.

4847. "U.S. Theatrical Anime." *Mangazine.* August 1993, p. 4.

4848. "Video News: AnimEigo, U.S. Manga Corps." *Comics Buyer's Guide.* May 26, 1995, p. 32.

4849. Vincentelli, Elizabeth. "Tooning in: Disney Imports a Japanese Auteur-Animator." *Village Voice.* September 2, 1998.

4850. "When Is Anime Not Anime: When Disney Says It's Not." *The Rose.* June 1998, p. 17.

4851. Williams, Janice. "A.D. Vision Expands into Co-production, Live-Action Films." *Comics Buyer's Guide.* April 5, 1996, pp. 38-39.

4852. Woods, Mark. "'Toy 2' Is Tops in Japan's Tooniverse." *Variety.* March 20-26, 2000, pp. 14, 18.

4853. Yanez, Rio. "I Saw It! (Right Where I Didn't Expect It)." *Animerica.* 7:10 (1999), pp. 65-66.

4854. "Zenryaku W. Dizunisama" (Dear Mr. Walt Disney). *Asahi Shinbun.* August 27, 1994, p. 5.

Manga (Comic Books)

4855. "Antarctic Press: 10 Years and Counting." *Mangazine.* January 1995, pp. 3-4.

4856. "Antarctic Unleashes Usagi Action Figure." *Comics Buyer's Guide.* March 6, 1998, p. 54.

4857. Brady, Matt. "More Manga at Dark Horse." *Comics Buyer's Guide.* November 17, 2000, p. 38.

4858. Burress, Charles. "San Francisco's Manga Man." *San Francisco Chronicle.* February 2, 1997.

4859. Bush, Laurence. "Mandarake Invades America." *The Rose*. October 1999, p. 29.

4860. "Call Me Princess. CPM Manga." *Comics Buyer's Guide*. April 30, 1999, p. 20.

4861. "Comics & Media: U.S.A. vs. Japan." *If*. December 1983, pp. 36-37.

4862. "CPM Scores with New Manga Line." *Animerica*. 3:2 (1995), p. 35.

4863. CPM Starting Comics Line in March." *Mangazine*. January 1995, pp. 8-9.

4864. "Dark Horse Blasts into March with Manga!" *Comics Buyer's Guide*. March 10, 2000, pp. 40-41.

4865. Ervin-Gore, Shawna. "Dark Horse Manga Line Set To Explode with *Super Manga Blast!" Comics Buyer's Guide*. November 12, 1999, p. 28.

4866. Ervin-Gore, Shawna. "Making Manga at Dark Horse." *Comics Buyer's Guide*. October 9, 1998, p. 28.

4867. "Giant-Size Manga Anthology Planned by Dark Horse." *Comics International*. December 1999, p. 13.

4868. Hanna, Junko. "Manga's Appeal Not Limited to Japanese Fans." *Daily Yomiuri*. December 11, 1996, p. 3.

4869. Harrison, John. "Manga Mania Hits Oz." *Mangazine*. May 1994, p. 6.

4870. Herskovitz, Jon. "Japanese Pic Gets Disney Coin." *Variety*. April 27-May 3, 1998, p. 18.

4871. Kondo, Hisashi. "Manga Go Global." *Pacific Friend*. June 1995, pp. 2-9.

4872. "Manga Entertainment Inc. Company Overview." *Comics Buyer's Guide*. February 2, 1996, p. 44.

4873. "Manga Goes Hollywood ... Disney Style!" *Comics International*. May 1999, p. 27.

4874. "Manga Influence in Hollywood." *The Rose*. July 1997, p. 20.

4875. "Manga in Français." *Anime FX*. August 1995, p. 7.

4876. "Manga Month Marches on at Dark Horse." *Animerica*. 3:3 (1995), p. 48.

4877. "Manga Verovert Nederland." *Stripschrift*. August 1994, p. 1.

4878. "New Vizions in Manga." *Animerica.* 3:3 (1995), p. 49.

4879. "Open Shirt, Gold Chains, Hot Tub, White Wine … and Manga. Manga in Penthouse Comix." *Animerica.* 5:6 (1997), p. 59.

4880. "Pioneer Goes on a Phantom Quest in April." *Mangazine.* March 1995, p. 6.

4881. Smith, Toren. "The Growing Appeal of Japanese Comics in the United States." Speech at "Manga Madness" symposium, Woodrow Wilson International Center for Scholars, Washington, D.C., June 26, 1997. Commentary by John Whittier Treat.

4882. Starling, Jaime. "VIZualize World Comics." *Comics Buyer's Guide.* August 4, 2000, pp. 22, 24.

4883. Swallow, Jim. "Nippon Europa." *Mangazine.* January 1995, p. 22.

4884. Swallow, Jim. "Nippon Europa." *Mangazine.* March 1995, p. 17.

4885. "Texas Retailer Convicted of Selling Obscene Manga." *Comics Journal.* November 2000, p. 35.

4886. "Valentino's Image Line To Publish Manga Graphic Novel." *Comics International.* January 1998, p. 14.

4887. "Vicious Destruction and Wild Comedy from AnimEigo." *Mangazine.* March 1995, p. 8.

4888. "Viz Collects 'Manga for Grownups' in Fall." *Comics Buyer's Guide.* July 17, 1998, p. 40.

4889. "Viz Has Offerings for General Audiences, Too." *Comics Buyer's Guide.* July 17, 1998, p. 40.

4890. "Warren Back on Gen[13] Manga." *Comics International.* September 1998, p. 6.

4891. Wong, Heung Wah and Sze Ling Lai. "Japanese *Manga* Coming to Hong Kong." Paper presented at Association for Asian Studies, Washington, D.C., March 29, 1998.

Historical Aspects

4892. "Appendice 5: 20 Anni di Cartoni Giapponesi." *If.* December 1983, pp. 91-101.

4893. Feng Zikai. "Tan Riben de Manhua" (On Japanese Cartoons). *Yuzhou Feng* (Shanghai). October 1, 1936, pp. 120-127.

4894. [Hell Cartoon Scrolls]. *Fūshiga Kenkyū.* January 20, 2002, pp. 4-5.

4895. Hosokibara, Seiki. *Nihon Manga-shi* (A History of Japanese Comic Art). Tokyo: Yūzankaku, 1924.

4896. Iwasaki, Haruko. "The Preface as a Guide to 'Shuko' in Kibyoshi (Pictorial Comic Fiction)." Paper presented at Association for Asian Studies, Washington, D.C., March 27, 1998.

4897. Katayori, Mitsugu. "A Personal History of Comic Art During the Shōwa Period (8)." *Fūshiga Kenkyū.* No. 21, 1997, p. 15.

4898. Katayori, Mitsugu. "Personal History of Shōwa Cartoons (1)." *Fūshiga Kenkyū.* October 20, 1997, p. 15.

4899. Katayori, Mitsugu. "Personal History of Shōwa Cartoons Part 2." *Fūshiga Kenkyū.* July 20, 1995, p. 15.

4900. Katayori, Mitsugu. "Personal History of Shōwa Cartoons Part 3." *Fūshiga Kenkyū.* No. 16, 1995, p. 15.

4901. Katayori, Mitsugu. "Personal History of Shōwa Cartoons: Part 4 of Series." *Fūshiga Kenkyū.* January 20, 1996, p. 15.

4902. Katayori, Mitsugu. "Personal History of Shōwa Cartoons (6)." *Fūshiga Kenkyū.* No. 19 (July 20, 1996), p. 14.

4903. Katayori, Mitsugu. "Personal History of Shōwa Cartoons." *Fūshiga Kenkyū.* July 20, 1997, p. 13.

4904. Katayori, Mitsugu. "A Private History of Shōwa Cartoons (7)." *Fūshiga Kenkyū.* No. 20, 1996, p. 15.

4905. Katayori, Mitsugu. "A Private History of Shōwa Cartoons Part 9." *Fūshiga Kenkyū.* No. 22, 1997, p. 15.

4906. Katayori, Mitsugu. "A Private History of Shōwa Comic Art." *Fūshiga Kenkyū.* April 20, 1996, p. 15.

4907. Katayori, Mitsugu. "Shōwa Manga Shishi (12)" (A Personal History of Shōwa Comic Art). *Fūshiga Kenkyū.* January 20, 1998, p. 13.

4908. Katayori, Mitsugu. "Shōwa Manga Shishi (13)" (A Personal History of Shōwa Comic Art [13]). *Fūshiga Kenkyū.* April 20, 1998, p. 13.

4909. Katayori, Mitsugu. "Shōwa Manga Shishi (14)" (A Personal History of Shōwa Comic Art [14]). *Fūshiga Kenkyū.* July 20, 1998, p. 15.

4910. Katayori, Mitsugu. "Shōwa Manga Shishi (15)" (A Personal History of Shōwa Comic Art [15]). *Fūshiga Kenkyū.* October 20, 1998, p. 15.

4911. Nasu, Ryōsuke. *Manga-ka Seikatsu 50-nen* (A 50-Year-Life As a Cartoonist). Tokyo: Heibonsha, 1985.

4912. Okamoto, Rei. "Cultural Myths in Japanese Wartime Comic Art." Paper presented at Mid-Atlantic Region/ Association for Asian Studies, West Chester, Pennsylvania, October 26, 1997.

4913. Okamoto, Rei. "'Fuku-chan' Goes to Java: Images of Indonesia in a Japanese Wartime Newspaper Comic Strip." *Southeast Asian Journal of Social Science.* 25:1 (1997), pp. 111-123.

4914. Okamoto, Rei. "State Propaganda Campaign in *Fuku-chan,* Japanese Newspaper Comic Strip during the Pacific War." Paper presented at Popular Culture Association, San Diego, California, April 1, 1999.

4915. Pavia, Jack and Nancy Brcak. "Images of Asians in the Art of the Great Pacific War, 1937-1945." Paper presented at Asian Popular Culture Conference, Victoria, Canada, April 16, 1998.

4916. Séguy, Christiane. *Histoire de la Presse Japonaise: Le Développement de la Presse à l'Epoque de Meiji.* Paris: Presses Orientalistes de France, 1993. 357 pp.

4917. Shimizu, Isao. "*Japan in 1897*: A Local Edition Targeted at Foreigners in Kobe." *Fūshiga Kenkyū.* No. 20, 1996, pp. 1-2.

4918. Shimizu, Isao. "Japan's Rich Tradition of Cartoons and Comics." *Echoes of Peace.* January 1993.

4919. Shimizu, Isao. "Meiji Society in Miniature: A Comparison Figure of Daily Wages Based on Occupations." *Fūshiga Kenkyū.* October 20, 1999, p. 1.

4920. Shimizu, Isao. "Ridiculed Women: The Influence of Daumier's 'Blue Stocking Women' Series to Japan." *Fūshiga Kenkyū.* July 20, 1997, pp. 1-5.

4921. Shiokawa, Kanako. " 'The Reads' and 'Yellow Covers': Pre-Modern Predecessors of Comic Books in Japan." *Journal of Asian Pacific Communication.* 7:1/2 (1996), pp. 19-30.

4922. Sugiura, Yukio. "Mangaka 70-nen: Omoidasu Hitobito (1)" (70 Years As a Cartoonist: People in My Memory [1]). *Fūshiga Kenkyū.* October 20, 1998, p. 16.

4923. *300 Years of Japanese Comic Art.* Kawazaki City, Japan: Kawazaki City Citizens Museum, 1996. 176 pp.

4924. Tokyo 12 Channel Shakai Kyōyō-bu, ed. *Shinpen Watashi no Shōwa-shi* (New Edition, My History of the Shōwa Period: When the Military Boots Roar). Tokyo: Gakugei Shorin, 1974.

4925. Yokoyama, Kuniharu. *Yomihon no Kenkyū: Edo to Kamigata to* (Study of Reads: Edo and Osaka). Tokyo: Kazama Shobō, 1974.

4926. Yonezawa, Yoshihiro. *Sengo Gag Mangashi* (History of Gag Comics Since 1945). Tokyo: Shinpyôsha, 1981.

Anime (Animation)

4927. Anderson, Joseph L. "Spoken Silents in the Japanese Cinema, Essay on the Necessity of Katsuben." *Journal of Film and Video.* Winter 1988, pp. 13-33.

4928. Desser, David. "From 'Enka' to 'Anime': Japanese Popular Films, 1950-1990." Paper presented at "Japanese Popular Culture" conference, Lexington, Kentucky, February 21, 1997.

4929. Dunn, Ben. "The Fading of History." *Mangazine.* August 1993, p. 2.

4930. Hargreaves, Darron. "You've Come a Long Way, Baby." *Daily Yomiuri.* July 27, 2000, p. 7.

4931. Herskovitz, Jon. "Toho-Towa at 70: Bridging Culture Gap." *Variety.* May 18-24, 1998, pp. 47, 50.

4932. "The History of Animania." *Time.* November 22, 1999, p. 96.

4933. Horn, Carl G., *et al.* "Anime: Then ... and Now!" *Animerica.* 3:12 (1995), pp. 4-8.

4934. Kim, Jun-yang. "Japanimation, Masterpieces 1963-1996." *Kino* (Seoul). December 1996, pp. 130-145.

4935. McCarthy, Helen. "Heavy Metal History." *Anime UK.* July 1995, pp. 26-28.

4936. Miyao, Daisuke. "New Uses for a Bathtub: The Roots of Anime." *AnimeFantastique.* Fall 1999, p. 13.

4937. O'Connell, Michael. "The Next Big Japanese Import: Animation." *Washington Post. Video Log.* August 1995, pp. 14-15.

4938. Okamoto, Rei. "Ideological Representations and Cultural Myths in a Japanese Wartime Animated Film, *Momotaro – Divine Troops of the Sea.*" Paper presented at Society for Animation Studies, Madison, Wisconsin, September 27, 1996.

4939. Patten, Fred. "Anime 20th Anniversary." *Animation.* June 1997, p. 4.

4940. Patten, Fred. "A Capsule History of Anime." *Animation World.* August 1996, 5 pp.

4941. Patten, Fred. "Momotaro's Gods-Blessed Sea Warriors: Japan's Unknown Wartime Feature." *Animation World.* October 1996, 3 pp.

4942. Patten, Fred. "The 13 Developments in Anime 1985-1999." *Animation.* February 1999, pp. 123, 125, 127-128, 131.

4943. Persons, Dan. "Rare Early Shorts." *AnimeFantastique.* Summer 1999, p. 61.

4944. Smith, Mike. "Studio Yume's Top 50 Anime of the 20th Century." *The Rose.* February 2000, p. 23.

4945. Swallow, Jim. "Retro Futures." *Anime UK.* December/January 1995, pp. 16-17.

Caricature

4946. Iwashita, Tetsunori. "Caricature – My Recommendation (3)." *Fūshiga Kenkyū.* October 20, 1997, p. 6.

4947. Iwata, Takuko. "Caricature – My Recommendation (2)." *Fūshiga Kenkyū.* October 20, 1997, p. 6.

4948. Katayori Mitsugu. "Caricature – My Selection (1)." *Fūshiga Kenkyū.* July 20, 1997, p. 16.

4949. Kaya, Atsuko. "Fūshiga – Watashi no Ichimai (7)" (Caricature – My Selection [7]). *Fūshiga Kenkyū.* July 20, 1998, p. 16.

4950. Mizuno, Ryōtarō. "Fūshiga – Watashi no Ichimai (4)" (Caricature: My Selection [4]). *Fūshiga Kenkyū.* January 20, 1998, p. 9.

4951. Mizuno, Ryōtarō. "Fūshiga – Watashi no Ichimai (4)" (Caricature: My Selection [4]). *Fūshiga Kenkyū.* April 20, 1998, p. 9.

4952. Ōkoshi, Hisako. "Fūshiga – Watashi no Ichimai (6)" (Caricature: My Selection [6]). *Fūshiga Kenkyū.* April 20, 1998, p. 14.

4953. Ogawa, Orie. "Fūshiga – Watashi no Ichimai (5)" (Caricature: My Selection [5]). *Fūshiga Kenkyū.* January 20, 1998, p. 14.

4954. Shimizu, Isao. "Book Review: Minami, Kazuo. Edo no Fūshiga" (Caricatures of the Edo Period) (1997). *Fūshiga Kenkyū.* October 20, 1997, p. 5.

4955. Shimizu, Isao. "Creator of Caricatures During Boshin War." *Fūshiga Kenkyū.* January 20, 1996, pp. 11-12.

4956. Shimizu, Isao. "Meiji-ban 'Midai no Wakamochi'" (The Meiji Edition of the Woodblock Print Caricature, "Midai no Wakamochi"). *Fūshiga Kenkyū.* April 20, 1998, p. 13.

4957. Yokota, Yasuyuki. "*Fūshiga* – Watashi no Ichimai (8)" (Caricatures-- My Selection [8]). *Fūshiga Kenkyū Kenkyū.* October 20, 1998, p. 14.

Cartoon and Humor Magazines

4958. Okamoto, Rei. "Ideological Messages in Japanese Cartoon Magazines During the Pacific War." Paper presented at Association for Asian Studies, Chicago, Illinois, March 13, 1997.

4959. Shimizu, Isao. "A Collection of Nihon Manga Shorō kan: A List of Contents of Cartoon Magazines Published in 1946 (Showa 21)." *Fūshiga Kenkyū.* April 20, 1996, pp. 5-8.

4960. Shimizu, Isao. "Collection of Nippon Manga Shiryōkan: *Yomimono to Manga* (Novels and Cartoons): List of Cartoon Works." *Fūshiga Kenkyū.* No. 22, 1997, pp. 10-12.

4961. Shimizu, Isao. "Down-to-Earth Power of *Osaka Puck.*" *Fūshiga Kenkyū.* October 20, 1997, pp. 1-3.

4962. Shimizu, Isao. "*Puck* and Japanese Modern Comic Art (1): The U.S. Humor Magazine's Influence on Japan." *Fūshiga Kenkyū.* No. 21, 1997, pp. 1-2.

4963. Shimizu, Isao. "Puck and Modern Japanese Cartoons. Part I". *Fūshiga Kenkyū.* No. 22, 1997, pp. 1-4.

4964. Shimizu, Isao. "Quantification of the Rise and Decline of *Tōkyō Puck.*" *Fūshiga Kenkyū.* July 20, 1997, pp. 9-12.

4965. Yumoto, Gōichi. "Works That Were Not Included in the *Japan Punch.*" *Fūshiga Kenkyū.* No. 20, 1996, pp. 10-11.

Manga (Comic Books)

4966. *The Collection of Masterpiece Comics: Children's History of Showa 1-20.* Tokyo: Heibonsha, 1989.

4967. "Formative Circumstances of Nihon Manga Renmei (Japan Manga League)." *Fūshiga Kenkyū.* October 20, 1999, p. 11.

4968. Fujishima, Usaka. *Sengō Manga Minzoku-shi* (Postwar Manga Cultural Industry). Tokyo: Kawai Shuppan, 1990.

4969. High, Peter B. *Teikoku no Ginmaku* (The Silver Screen of the Imperial Japan). Nagoya: Nagoya University Press, 1995.

4970. Iizawa, Tadashi. "Bijutsu Toshite no Manga. Shōwa no Mangashi Gaikan." In *Shôwa no Manga Ten,* edited by Ryûichi Yokoyama, pp. 5-8. Tokyo: Asahi Shinbunsha, 1989.

4971. Ishiko, Jun. *Nihon Mangashi* (History of Japanese Manga). Vols. 1, 2. Tokyo: Ōtsuki Shoten, 1979.

4972. Ishiko, Junzō. *Sengo Mangashi Nōto.* Tokyo: Kinokuniya Shoten, 1994.

4973. Ishinomori, Shōtarō. *Manga Chō Shinkaron* (Comic Evolution). Tokyo: Kawade Shobō Shinsha, 1989.

4974. "Japon: Breve Historia de la Historieta en Japon." In *La Historieta Mundial,* edited by David Lipszyc, *et al.,* pp. 94-97. Buenos Aires: Instituida por la Escuela Panamericana de Arte, n.d.

4975. Jenkins, Mark. "Role Models." *Washington City Paper.* January 26, 2001, p. 46.

4976. Kure, Toniofusa. *Gendai Manga no Zentaizo* (The Whole Picture of Contemporary Comics). Tokyo: Jōhō Sentā-Shuppankyoku, 1986.

4977. *Manga Hanseikiten: Kakareta Nippon no Shakai* (What's What in This 50 Years in Japanese Comic Books). Special exhibition catalogue. Tokyo Shinbun, 1995.

4978. "'Manga No Kuni' (Manga World) Table of Contents and Content Outline." *Fūshiga Kenkyū.* October 20, 1999, p. 4.

4979. "'Manga No Kuni' (Manga World): The Truth in 'Manga-kai Jihyō (Commentary on Current Events in the World of Manga).'" *Fūshiga Kenkyū.* October 20, 1999, p. 11.

4980. Nagai, Asami. "Manga's 12th-Century Roots." *Daily Yomiuri.* September 2, 1999, p. 7.

4981. "1976-1983: Storia di Un' Invasione." *If.* December 1983, pp. 44-45.

4982. Okamoto, Rei. "Images of the Enemy in Wartime *Manga* Magazine, 1941-1945." In *Illustrating Asia: Comics, Humor Magazines, and Picture Books,* edited by John A. Lent, pp. 204-220. Richmond: Curzon Press; Honolulu: University of Hawaii Press, 2001.

4983. Otsuka, Eiji. *Sengo Manga no Hyoguen Kuukan: Kigouteki Shintai no Jubaku.* Tokyo: Houzoukan, 1994.

4984. Sakai, Tadayusi and Isao Shimizu, eds. *Nisshin Sensôki no Manga.* Tokyo: Chikuma Shobô, 1985.

4985. Shimizu, Isao. "Comic Books During the Showa Period (1955-1963)." *Fūshiga Kenkyū.* October 20, 1997, pp. 12-14.

4986. Shimizu, Isao. "From the Collection Nihon Manga Shiryōkan: *Manga Gidai* – The Era of Comics." *Fūshiga Kenkyū.* No. 16, 1995, pp. 10-11.

4987. Shimizu, Isao. "Nihon Mangashi Kakuritsu He no Keifu." In *Nihon no Mangan 300-nen,* pp. 166-167. Tokyo: Yomiuri Shinbunsha, 1996.

4988. Shimizu, Isao. "Nihon Manga Shiryô-kan Shozô: Manga Zasshi Sôkangô Collection" (From the Collection of Nihon Manga Shiryô-kan: A Collection of the First Issue of Comic Magazines." *Fūshiga Kenkyū.* January 20, 1998, pp. 1-8.

4989. Shimizu, Isao. "Nihon Manga Shiryô-kan Shozô: Shōwaki (Shōwa 39-53-nen) no Mangabon" (From the Collection of Nihon Manga Shiryō-kan (Comic Books in the Showō Period [1964-1978]). *Fūshiga Kenkyū.* April 20, 1998, pp. 3, 6-12.

4990. Shimizu, Isao. "Nihon Manga Shiryô-kan Shozô: Shōwaki (Shōwa 54-61-nen) no Mangabon" (From the Collection of Nihon Manga Shiryō-kan (Comic Books in the Shōwa Period [1979-1986]). *Fūshiga Kenkyū.* July 20, 1998, pp. 12-14, 4, 6, 11-14.

4991. Shimizu, Isao. "Red Comic Books: The Origins of Modern Japanese *Manga.*" In *Illustrating Asia: Comics, Humor Magazines, and Picture Books,* edited by John A. Lent, pp. 137-150. Richmond: Curzon Press; Honolulu: University of Hawaii Press, 2001.

4992. Sumaya, Keiichi. *Nihon Manga Hyakunen.* Tokyo: Haga Shoten, 1968.

4993. Takayama, Hiroshi. "Media Komikkusu: Wazuka 40-nen de 400-nen Zenhyōshōshi o Kakenukeru" (Media Comics: Running Through 400 Years of Total Expressive-Symbolic History in Only 40 Years). In *Komikku Media,* pp. 166-209. Tokyo: NTT Shuppan, 1992.

4994. Takeuchi, Osamu. *Sengō Manga 50-nenshi* (Fifty-Year History of Postwar Manga). Tokyo: Chikuma Shobō, 1995.

4995. Terada, Hirō, ed. *Manga Shōnen-shi* (A History of Boy's Manga). Tokyo: Shōnan Shuppansha, 1981.

4996. Thorn, Matt. "A History of Manga, Part 1 of 3." *Animerica.* 4:2 (1996?), p. 31.

4997. Thorn, Matt. "A History of Manga, Part 2 of 3." *Animerica.* 4:4 (1996), pp. 57-58.

4998. Thorn, Matt. "A History of Manga: Part 3 of 3." *Animerica.* 4:6 (1996), p. 57.

4999. "300 Years of Manga." *The Rose.* July 1997, p. 20.

5000. "The Twelfth Year in Shōwa Period (1937)." *Fūshiga Kenkyū.* October 20, 1999, p. 11.

5001. Yamaguchi, Mari. "Computer Games, Comic Books Revise Japanese History." *Washington Times.* July 1, 1994.

5002. Yokoyama, Ryûichi, ed. *Shôwa no Manga Ten.* Tokyo: Asahi Shinbunsha, 1989.

Political and Propaganda Cartoons

5003. Dower, John W. "Graphic Others/Graphic Selves: Cartoons in War and Peace." In *War and Peace: Essays on History, Culture and Race,* pp. 287-300. London: HarperCollins, 1993.

5004. Duus, Peter. "The Imperial Gaze: National Self and Other in the Meiji Political Cartoon." Lecture, Center for East Asian Studies, University of Pennsylvania, Philadelphia, Pennsylvania, September 17, 1998.

5005. Duus, Peter. "The *Marumaru Chinbun* and the Origins of the Japanese Political Cartoon." *International Journal of Comic Art.* Spring 1999, pp. 42-56.

5006. "Japanese Propaganda on Bataan." *Infantry Journal.* October 1942, pp. 34-37. (Cartoon leaflets).

5007. Minear, Richard H. "Dr. Seuss and Japan, December 1941." *Education about Asia.* Winter 1999, pp. 42-44.

5008. Mitchell, John L. "Japanese Propaganda Leaflets." *Banzai: The Newsletter for the Collector of Japanese Militaria.* May 1989, pp. 129-130.

5009. Okamoto, Rei. "Pictorial Propaganda in Japanese Comic Art, 1941-1945: Images of the Self and Other in a Newspaper Strip, Single-Panel Cartoons, and Cartoon Leaflets." Ph.D. dissertation, Temple University, 1998.

5010. Okamoto, Rei. "Rhetoric of Japanese Propaganda Leaflets." Paper Presented at Mid-Atlantic Region/Association for Asian Studies, Towson, Maryland, October 21, 1995.

5011. Okamoto, Rei "Portrayal of the War and Enemy in Japanese Wartime Cartoons." *Journal of Asian Pacific Communication.* 7:1/2 (1996), pp. 5-18.

5012. Shimizu, Isao. "Bôryaku Senden Bira (Dentan): Nicchû Sensô no Ichidanpen o Shôgensuru Setto" (Propaganda Leaflets: A Set That Testifies One Aspect of the War Between Japan and China). *Fūshiga Kenkyū.* October 20, 1998, pp. 1-2, 14.

5013. Shimizu, Isao. "Boshin Sensōki no Jōhō Bira?" (An Information Leaflet During the Boshin War Period). *Fūshiga Kenkyū.* April 20, 1998, p. 13.

5014. Tsuneishi, Shigetsugu. *Shinri Sakusen no Kaisō* (A Memoir of the Psychological Warfare). Tokyo: Tōsen Shuppan, 1978.

Personnel

5015. Anders, Lou. "Gotta Watch 'Em All." *Manga Max.* February 2000, pp. 30-31. (Roland Poindexter).

5016. Barr, Greg. "Over the Waves: Candid Discussion with Three of America's Major Importers of Japanese Animation." *fps.* September 1993, pp. 26-31.

5017. Barr, Greg. "Over the Waves: Robert Woodhead." *fps.* Spring 1995, pp. 27-31.

5018. Brady, Matt. "Dark Horse's Chris Warner: 'It's a Good Time To Be a Manga Fan.'" *Comics Buyer's Guide.* November 17, 2000, pp. 36-37.

5019. Chiba, Rieko, ed. *Hiroshige's Tokaido in Prints and Poetry.* Rutland, Vermont: Charles E. Tuttle, 1992.

5020. Deneroff, Harvey. "Fred Ladd: An Interview." *Animation World.* August 1996, 4 pp.

5021. Dubreuil, Alain. "Interview, Ben Dunn." *Protoculture Addicts.* November-December 1991, pp. 10-13.

5022. Fox, Kit. "Leah Applebaum: Interview." *Animerica.* 7:11 (1999), pp. 63-64, 67, 69.

5023. Huddleston, Daniel. "White Radish Productions." *Animerica.* 8:7 (2000), pp. 63-65. (Shawn the Touched).

5024. Hughes, Dave. "A.D. Visionary." *Manga Mania.* March-April 1998, pp. 24-25. (John Ledford).

5025. Hughes, Dave. "Live from Central Park Media." *Manga Mania.* January-February 1998, pp. 18-19. (John O'Donnell).

5026. Hughes, Dave. "The Man with the Plan." *Manga Mania.* July-August 1997, pp. 28-29.

5027. "Interview: Carl Macek." *Protoculture Addicts.* November 1990, pp. 10-11.

5028. Joris, Luc. "Eric Ledune, Juste des Sensations." *Plateau.* 19:2 (1998), pp. 6-7.

5029. Lamplighter, L. Jagi. "Scott Frazier." *AnimeFantastique.* Fall 1999, pp. 8-11.

5030. Lien, Barb. "Kung Fu Meets Star Wars: Brandon McKinney." *Sequential Tart.* January 2000.

5031. Lien, Barb. "Practicing Slowpokemon: Jen Sorenson." *Sequential Tart.* February 1999.

5032. Luu, Loan. "A Woman in the Business of Anime." *Tsunami.* Summer 1995, pp. 7-9. (Trish Ledoux).

5033. Macias, Patrick. "David Kaye." *Animerica.* 8:2 (2000), pp. 65-67.

5034. O'Connell, Michael. "American Manga Star." *Animerica.* 4:12 (1996), pp. 59-60. (Robert DeJesus).

5035. O'Connell, Michael. "From Bikinis to Bubblegum ... and Manga to Mainstream." *Animerica.* 5:2 (1997), pp. 22-25. (Adam Warren).

5036. "Robert Whiting, a.k.a. Guy Jeans." *Mangajin.* No. 51, 1995, pp. 73-74, 79.

5037. Savage, Lorraine. "Eddie Allen." *Animerica.* 8:1 (2000), pp. 64-65.

5038. Savage, Lorraine. "Interview: Antonia Levi, Author of Samurai from Outer Space." *The Rose.* April 1997, pp. 12-13.

5039. Savage, Lorraine. "Interview: Eddie Allen (Desslok)." *The Rose.* October 1999, pp. 8-9.

5040. Savage, Lorraine. "Interview: Tom Tweedy." *The Rose.* June 2000, pp. 6-8.

5041. Shimizu, Isao. "The Death of a Scholar of Bigot." *Fūshiga Kenkyū.* No. 19 (July 20, 1996), p. 13.

5042. Swallow, Jim. "The Mighty Adam." *Manga Max.* May 1999, pp. 12-16. (Adam Warren).

5043. Velasquez, Phil. "Fred Patten." *The Rose.* October 1995, pp. 22-23.

5044. Velasquez, Phil. "Fred L. Schodt." *The Rose.* January 1997, pp. 13, 37.

5045. Velasquez, Phil. "Interview: Trish Ledoux." *The Rose.* April 1995, pp. 20-21.

5046. "Writer Who Published the Study of Japanese Manga." *Asahi Shimbun.* December 11, 1996.

Animators, Cartoonists

5047. Addiss, Stephen. *Haiga: Takebe Sōchō and the Haiku-Painting Tradition.* Richmond and Honolulu: Marsh Art Gallery in association with University of Hawaii, Press, 1995. 136 pp.

5048. *Anime Interviews. The First Five Years of Animerica Anime and Manga Monthly (1992-97).* Cadence Books, 1997, 192 pp.

5049. "The Animerica Interview. Takahata and Nosaka: Two Grave Voices in Animation." *Animerica.* 2:11 (1994), pp. 6-11. (Isao Takahata, Akiyuki Nosaka).

5050. Ashby, Janet. "Readers Still Riding Kenji Miyazawa's Railway." *Japan Times.* September 4, 1992.

5051. "Barefoot in the Ashes: Keiji Nakazawa." *Animerica.* 2:11 (1994), p. 11.

5052. Brimmicombe-Wood, Lee and Motoko Tamamuro. "Renegade Master." *Manga Max.* Summer 2000, pp. 28-33. (Mitsuteru Yokoyama).

5053. Brimmicombe-Wood, Lee and Motoko Tamamuro. "Who is Naoki Urasawa?" *Manga Max.* January 1999, pp. 24-27.

5054. *Cartoonist. Festival International du Film d'Animation.* Toulon: CARTOONIST, 1999. 142 pp. (Shingo Araki, Kazuo Komatsubara, Masami Suda, Akeni Takada, Hiruhiko Mikimoto, Yōko Hanabusi, Harumo Sanazaki, Kaya Tachibana).

5055. Chin, Oliver. "Back to the Future. A Primer for Two of Manga's Returning Greats." *Comics & Games Retailer.* May 2001, p. 62.

5056. Clarke, Jeremy. "Ryuichi Sakamoto." *Manga Max.* March 2000, p. 9.

5057. Clements, Jonathan. "Shiro Sagisu." *Manga Mania.* October-November 1997, pp. 94-95.

5058. Contino, Jennifer M. "Chatting with Chu: Jerry Chu." *Sequential Tart.* March 2001.

5059. Contino, Jennifer M. "Getting into the Clique: ST's New Manga Writer, Jeanne Burdorf." *Sequential Tart.* January 2001.

5060. Contino, Jennifer M. "Guys and Guys Together: Talking Yaoi with Umbrella Studios." *Sequential Tart."* December 2000. (Lissette A.)

5061. Craig, Andrew. "Yuzo Takada Artbook." *Tsunami.* Summer 1995, pp. 43-44.

5062. "The Daily Grind." *Mangajin.* April 1997, p. 15. (Narita Akira).

5063. Davis, Julie. "Fatal Fury: Masami Obari's House of Style." *Animerica.* 3:3 (1995), pp. 6-10.

5064. Decker, Dwight R. "Animerica Interview: Hiroshi Negishi." *Animerica.* 7:7 (1999), pp. 13-15, 32.

5065. "Design Files, Kazuko Tadano, Toshihiro Kawamoto, Sachiko Kamimura, Hiromi Matsushita, Akio Takami." *Animerica.* 8:3 (2000), pp. 65-67.

5066. d'Hondt, Ivan. "Nico in Nagasaki: The Story of Nico Crama." *Plateau.* 13:2 (1992), pp. 4-5.

5067. "Died: Ishinomori Shotaro." *Asiaweek.* February 13, 1998, p. 13.

5068. Dlin, Douglas. "Kōichirō Yasunaga--The Great Unknown?" *Mangazine.* January 1995, pp. 33-41.

5069. "Ebisu Yoshikazu Tokushū" (Special Yoshikazu Ebisu Feature). *Garo.* May 1993, pp. 3-42.

5070. Ernst, Tim. *Japan Sketchbook: Chronicles of a Gaijin Cartoonist.* Tokyo: Japan Times, 1989. 135 pp.

5071. Evans, Peter J. "Legends of a Third Eye." *Manga Max.* March 2000, pp. 42-44. (Yuzo Takada).

5072. Evans, P. J. "Masami Obari." *Manga Mania.* March-April 1998, p. 81.

5073. Fallaix, Olivier and Pierre Giner. "Hommage a Yoshifumi Kondo." *Animeland* (Paris). March 1998.

5074. "Farewells: Arihiro Hase, Takeyuki Kanda." *Animerica.* 4:9 (1996), p. 14.

5075. Flórez, Florentino. "La Sirenaza." *El Wendigo.* No. 68, 1995, pp. 6-7. (Santoshi Kon).

5076. French, Calvin, *et al. The Poet-Painters: Buson and His Followers.* Ann Arbor: University of Michigan Museum of Art, 1974.

5077. Fujishima, Usaku. *Sengo Manga Minzoku-shi,* Tokyo: Kawai Shuppan, 1990.

5078. "Global Visionary [Al Kahn]." *Animation.* June 2001, p. 24.

5079. Grille, Elise. *Sesshu Toyo.* Edited by Tanio Nakamura. Rutland, Vermont: Charles Tuttle, 1959.

5080. "Hanawa Kazuichi no Sekai" (The World of Kazuichi Hanawa). *Garo.* May 1992, pp. 3-47.

5081. Hiroshi, Yaku. *Comic Baku and Tsuge Yoshiharu.* Tokyo: Fukutake Books, 1989.

5082. Horn, Carl G. "Light, Shadow, Air: A World: A Look at the Life and Works of Nobuyuki Ohnishi." *Animerica.* 3:10 (1995), p. 14.

5083. Horn, Carl G. and James Teal. "Explodin' Heads with Tetsuo Hara." *Animerica.* 4:8 (1996), p. 61.

5084. Iizawa, Tadashi. *Gendai Mangaka Retsuden. Manga 100-Nenshi.* Tokyo: Sôjusha, 1978.

5085. International and Cultural Section, Planning Department, City of Omiya, ed. *Kitazawa Rakuten: Founder of Modern Japanese Cartoon.* Omiya: Omiya City Council, 1991.

5086. "An Interview with Shon Howell." *Mangazine.* May 1993, pp. 11-18.

5087. Kanta, Ishida. "The Future of Animation Illustrated by the Master." *Yomiuri Shimbun.* August 28, 1997.

5088. Karahasi, Takayuki. "Masashi Ikeda." *Animerica.* 8:4 (2000), pp. 10-11.

5089. Karahasi, Takayuki. "O, So It's Mio!" *Animerica.* 3:1 (1995), p. 16.

5090. Karahasi, Takayuki. "Robots and Rawhide." *Animerica.* 4:9 (1996), pp. 5-7, 18-19. (Ryosuke Takabashi).

5091. "Kazuhisa Kondo." *Animerica.* 7:12 (1999), pp. 19-20.

5092. Kobayashi, Kim. "Hide Matsumoto (1964-1998)." *The Rose.* June 1998, p. 19.

5093. Kurahashi, Takayuki. "Osamu Dezaki, Part 3." *Animerica.* 7:8 (1999), pp. 19, 37-39.

5094. Lamplighter, L. Jagi. "Feather Weight." *Manga Max.* June 2000, pp. 28-30. (Hiroyuki Utatane).

5095. Leahy, Kevin. "The Works of Kaoru Shintani." *The Rose.* July 1996, pp. 22-23.

5096. Leahy, Kevin. "Works of Masakazu Yamaguchi." *The Rose.* October 1996, pp. 15, 33.

5097. Leahy, Kevin. "Works of Yoshihiro Kuroiwa." *The Rose.* October 1999, pp. 20-21.

5098. Lien, Barb. "American Manga with a Reason for Being: Will Allison." *Sequential Tart.* July 1999.

5099. Lien, Barb. "Declaration of Independents: Tak Toyoshima – The Couch." *Sequential Tart.* June 1999.

5100. Lippolis, Alessandro. "Creator Profile: Adachi Mitsuru." *The Rose.* January 1996, p. 11.

5101. Littardi, Cedric. "Interview: Isao Takahata." *Animeland* (Paris). July/August 1992.

5102. "Lone Wolf Dies." *Manga Max.* February 2000, p. 7. (Goseki Kojima).

5103. "Love To Rabu You." *Manga Max.* March 2000, p. 5. (Rabu Hina).

5104. McCarthy, Helen. "The Adjuster: Toshio Suzuki Interview." *Manga Max.* May 1999, pp. 26-30.

5105. McCarthy, Helen. "Yutaka Izubuchi." *AnimeFX.* August 1995, pp. 20-22.

5106. Maderdonner, Megumi. "Hagio Moto." In *Lexikon der Comics, Teil 2: Personen.* Meitingen: Corian-Verlag Heinrich Wimmer, 27, 1998.

5107. "Manga Artists Honored." *Mangajin.* August 1997, p. 84.

5108. Maruo Suehiro" (Suehiro Maruo). *Garo.* May 1993, pp. 3-40.

5109. "Mecha for the Coming Apocalypse: The Art of Kenji Yanobe." *Animerica.* 5:7 (1997), pp. 8-9.

5110. "Meet Haruka Takachiho." *Animerica.* 5:10 (1997), pp. 9, 24.

5111. "Mega Talks from Mangawriters." *Mega Comics.* Summer 1991, pp. 22-37.

5112. Mievis, Jean-Marie. "Roger Leloup: Met Yoko Tsuno Kan Ik Alle Kanten Uit." *Stripschrift.* August 1991, pp. 4-7.

5113. "Mika Akitaka." *Animerica.* 8:3 (2000), pp. 13-15.

5114. Miyazaki, Hayao. "Hikisakarenagara Ikite Iku Sonzai No Tame Ni" [Interview with Yamaguchi Izumi]. *Eureka.* 29:11 (1997), pp. 29-47.

5115. "Mochizuki's Manga." *Manga Max.* June 1999, p. 24.

5116. Morikuma, Takeishi. "Reaching the Age of Ninety (2)." *Fūshiga Kenkyū.* October 20, 1999, p. 14.

5117. Morse, Deanna. "Pre-Cinema Toys Inspire Multimedia Artist Toshio Iwai." *Animation World.* February 1999.

5118. "My Manga Life." *Fūshiga Kenkyū.* October 20, 1999, p. 14.

5119. Nagai, Katsuichi. "*Garo" Henshûcho.* Tokyo: Chikuma Shobô, 1989.

5120. "Naoko Takeuchi." *Animerica.* 6:11 (1998), pp. 10. 26.

5121. Natsume, Fusanosuke. *Natsume Fusanosuke no Mangagaku* (Fusanosuke Natsume's School of Manga). Tokyo: Chikuma, Shobō, 1992.

5122. Negishi, Yasuo. *Ore no Manga Michi* (My Way of Manga). Vols. 1, 2. Tokyo: Shōgakukan, 1989-1990.

5123. Ng Suat Tong. "Umezu Kazuo: Japanese Overtures to Madness and Death." *Comics Journal.* May 2001, pp. 28-32.

5124. Nihon Manga Gakuin and Tadao Kimura, ed. *Mangaka Meikan* (A Dictionary of Manga Artists). Tokyo: Kusanone Shuppankai, 1989.

5125. "Obituary: Katsuichi Nagai." *WittyWorld International Cartoon Bulletin.* 4/1996, p. 2.

5126. Ono, Kosei. "Tadahito Mochinaga: The Japanese Animator Who Lived in Two Worlds." *Animation World.* December 1999, 8 pp.

5127. Oshiguchi, Takashi. "Image Is Everything." *Animerica.* 2:7 (1994), p. 15.

5128. "Ōten Shimokawa and Foreign Cartoons." *Fūshiga Kenkyū.* October 20, 1999, p. 13.

5129. Patten, Fred. "America's Favorite Anime Directors." *Animation.* August 1997, pp. 4-5.

5130. "Point/Counterpoint!" *Animerica.* 5:10 (1997), pp. 22-23. (Noboru Ishiguro, Haruka Takachiho).

5131. Prenc, Dean and Junko Matsuura. "Mitsuhisa Ishikawa: The IG Factor." In *Atomic Sushi: A Bite of Japanese Animation,* pp. 20-22, 24. Stanmore, Australia: Silicon Pulp Animation Gallery, 2000.

5132. "Revolution Eve – Sadao Sakai." In *2. Uluslararasi Ankara Karikatür Festivali,* pp. 102-103. Ankara: Karikatür Vakfi Yayinlari, 1996.

5133. "Sailor and Lula, an Interview with Katsuhito Ishii." *Manga Max.* June 1999, p. 25.

5134. Saltz, Jerry. "Imitation Warhol." *Village Voice.* August 25, 1999. (Takashi Murakami).

5135. Samu, Charles. "Contemporary Japanese Animators Part 1." *Plateau.* 8:1, pp. 14-15.

5136. Samu, Charles. "Contemporary Japanese Animators. Part 2." *Plateau.* 7:2, p. 21.

5137. Satō, Sanpei. *The Best Selection of Fuji Santaro.* Tokyo: Asahi Shimbun, 1997.

5138. Satō Sanpei. "Fuji Santarō." *Mangajin.* No. 66, 1997, pp. 30-37.

5139. "Satoshi Urushihara's Manga Art." *Comics International.* December 1998, p. 14.

5140. Savage, Lorraine. *"Masters of Anime: Anime Filmmakers." The Rose.* October 1998, p. 28.

5141. Schodt, Frederik L. "The Hard, Cruel Life of the Manga Artist." *Mangajin.* April 1997, pp. 12-16.

5142. Schodt, Frederik L. "Masumi Muramatsu: A National Treasure." *Mangajin.* February 1997, no. 62, pp.12-14, 67.

5143. Schodt, Frederik L. "Nakayoshi and Media Mix." *Mainichi Daily News.* September 31, 1994.

5144. "A Selected Filmography of Isao Takahata." *Animerica.* 2:11 (1994), p. 12.

5145. "A Select Filmography of Shoji Kawamori." *Animerica.* 3:1 (1995), p. 9.

5146. Sheaf, Colin. "Charles Wirgman: Rediscovered in the Salesroom." *Arts of Asia.* January-February 1990, pp. 141-146.

5147. Shimizu, Isao. "Cartoonist Fusetsu Nakamura." *Fūshiga Kenkyū.*
 January 20, 1996, pp. 1-4, 10.

5148. Shimizu, Isao. "A Cartoonist, Shōtarō Koyama." *Fūshiga Kenkyū.* No.
 19 (July 20, 1996), p. 1.

5149. Shimizu, Isao. "Dai 4-Kai Nichibei Mangaka Kaigi" (The Fourth Japan-
 American Conference of Cartoonists). *Fūshiga Kenkyū.* April 20, 1998,
 p. 6.

5150. Shimizu, Isao. "International Comparison of Cartoonists' Salaries."
 Fūshiga Kenkyū. No. 20, 1996, p. 11.

5151. Shimizu, Isao. "Meiji no Manga – Fūshigaten: Kiyochika to Bigō o
 Chūshin ni" (Exhibition of Meiji Cartoons and Satirical Drawings:
 Emphasizing Works of Kiyochika and Bigot). Tokyo: Ōta Kinen
 Bijutsukan, 1980.

5152. Shimizu, Isao. "On an Exhibition of 'Seibu Line' and Cartoonists."
 Fūshiga Kenkyū. No. 20, 1996, pp. 7, 14.

5153. Shimizu, Isao. "Takahashi Kunitarō and Miyataki Gaikotsu." *Fūshiga
 Kenkyū.* No. 22, 1997, p. 14.

5154. Shimizu, Isao. "What Is a Mangaka (Manga Artist)?" *Fūshiga Kenkyū.*
 October 20, 1999, p. 3.

5155. "Shinshun Tokubetsu Taidan." *Cōmic '94, Tôkyô: Bungei Shunshû
 (Rinji Sô Kango).* 2/1994, pp. 363-373. (Fujia F. Fujiko, Banana
 Yoshimoto).

5156. Siegel, Robert. "Counter-Tenor." National Public Radio's Weekly
 Edition. February 7, 1998. (Yoshikazu Meru).

5157. Simmons, Mark. "Lives of the Mecha Makers." *Animerica.* 8:4 (2000),
 pp. 64-66.

5158. Smith, Toren. "Hisashi Sakaguchi 1946-1995." *Animerica.* 4:3 (1996),
 p. 14.

5159. Sorayama, Hajime. *Sorayama Hyper Illustrations.* Tokyo: Bijutsu
 Shuppan-shan, 1989.

5160. Sugiura, Yukio. "Seventy Years as a Manga-ka (Manga Artist) – People
 I Remember (5)." *Fūshiga Kenkyū.* October 20, 1999, p. 15.

5161. Suzuki, Daisetz Taitaro. *Sengai: The Zen Master.* Greenwich,
 Connecticut: New York Graphic Society, 1971.

5162. "Suzuki's Shakedown." *Manga Max.* August 1999, p. 9.

5163. Swallow, Jim. "Anime Expo (sed)." *Manga Mania.* January-February 1998, pp. 22-24. (Haruka Tachiho).

5164. Swallow, Jim. "Master of Many Faces." *Manga Mania.* March-April 1998, pp. 16-17. (Nobuteri Yuki).

5165. Swallow, Jim. "Shibaharo and Sato – Live in LA." *Manga Mania.* July/August 1998, p. 64. (Chiyako Shibahara and Hiroaki Sato).

5166. Swallow, Jim. "Swordplay & Slapstick." *Manga Max.* June 2000, pp. 32-36. (Director Johji Manabe).

5167. Tebbetts, Geoffrey. "Rio Natsuki." *Animerica.* 7:6 (1999), pp. 64-65.

5168. Terasawa, Buichi, Junco Itō, Scholar Editorial Staff, *et al. Macintosh no Dennō Manga Jutsu: Mac de Hirogaru Terasawa Buichi Wārudo* (Cyber Manga Techniques with the Macintosh: The World of Buichi Terasawa Expands with the Mac). Tokyo: Scholar, 1994.

5169. "That Sinking Feeling." *Asiaweek.* April 13, 2001, p. 10. (Igarashi Mikio).

5170. Thorn, Matt. "Matt's Travel Diary." *Animerica.* 2:12 (1994), p. 41. (Keiko Nishi).

5171. "Toshihiro Kawamoto." *Animerica.* 8:1 (2000), pp. 16-17, 30.

5172. "Toshihiro Ono." *Animerica.* 8:1 (2000), pp. 36-39.

5173. "Uchida Shungicu Intābyū: 'The Life of UltraDeep'" (Dhungicu Uchida Interview: The Life of UltraDeep). *Garo.* November 1992, pp. 11-32.

5174. "Ultimate Devotion." *Manga Mania.* July/August 1998, p. 8. (Fujio Akatsuka).

5175. *Viva Comic: Mangaka Daishūgō* (Viva Comic: A Grand Gathering of Manga Artists). Special edition of *Shukan Taishū.* December 27, 1984.

5176. Watson, Paul. "The Akemi Takada Interview." *Anime UK.* December 1994/January 1995, pp. 12-13.

5177. Wong, Amos. "Ghost in the Shell: Hiroyuki Kitakubo." In *Atomic Sushi: A Bite of Japanese Animation,* pp. 24, 26. Stanmore, Australia: Silicon Pulp Animation Gallery, 2000.

5178. Wong, Amos. "High Performance." *Manga Max.* Summer 2000, pp. 22-25. (Kenji Kawai).

5179. Wong, Amos. "Masters of the Madhouse." *Manga Max.* October 1999, pp. 38-42. (Rin Taro, Nobuteru Yuki).

5180. Wong, Amos. "Nostalgia Kick." *Manga Max.* July 2000, pp. 10-12. (Tatsuo Sato).

5181. Wong, Amos. "Scaremonger." *Manga Max.* May 2000, pp. 10-12. (Yoshiaki Kawajiri).

5182. Wong, Amos. "A Taste of Kurosawa." *Manga Max.* February 2000, pp. 10-11.

5183. "World Domination with Yasuhiro Imagawa." *Animerica.* 5:9 (1997), p. 24.

5184. "Yamada Murasaki Tokushū" (Special Murasaki Yamada Feature Issue). *Garo.* February/March 1993, pp. 4-67.

5185. Yamamoto, Eiichi. *Mushi Puro Kōbōki: Animēta no Seishun* (The Rise and Fall of Mushi Productions: My Youth As an Animator). Tokyo: Shinchōsha, 1989.

5186. Yokota, Masao. "Isao Takahata: The Animation Director Who Worries About the Mental Health of the Young." *The Japanese Journal of Animation Studies.* 2:1A, 2000, pp.13-18.

5187. Yokota, Masao. "Isao Takahata: The Animation Director Who Worries About the Mental Health of the Young Generation." Paper presented at Society for Animation Studies, Brisbane, Australia, August 5, 1999.

5188. Yoshida, Toshifumi. "Mizuho Nishikubo: The Director of *Video Girl Ai.*" *Animerica.* 7:4 (1999), pp. 10-11, 26-27.

5189. Yoshida, Toshifumi and Bill Flanagan. "Takemoto Mori." *Animerica.* 7:7 (1999), pp. 28-31.

5190. "Yoshihisa Tagami Mini-Bio." *Animerica.* 5:7 (1997), p. 18.

5191. Yumoto, Kōichi. "Matsudaira Yōho Fūshiga" (The Caricature of Yōho Matsudaira). *Fūshiga Kenkyū.* January 20, 1998, p. 12.

Amano, Yoshitaka

5192. Savage, Lorraine. "Anime Symposium: Yoshitaka Amano." *The Rose.* June 1999, pp. 16-17.

5193. "Storming the Walls of Time." *Manga Max.* February 2000, pp. 20-24.

5194. "Yoshitaka Amano, Creator and Designer of *A Tale of 1001 Nights.*" *The Rose.* June 1998, pp. 26-27.

Anno, Hideaki

5195. "His and Hers." *Manga Mania.* July/August 1998, p. 8.

5196. "Virtual Panel: Meet Hideaki Anno." *Animerica.* 4:9 (1996), p. 27.

Asamiya, Kia

5197. Davis, Julie and Bill Flanagan. "Kia Asamiya." *Animerica.* 8:3 (2000), pp. 17-19, 21, 37-38.

5198. Evans, P. J. "Kia Asamiya." *Manga Mania.* October-November 1997, pp. 96-97.

5199. Fletcher, Dani. "Here There Be Angels: Kia Asamiya." *Sequential Tart.* May 2000.

5200. Jeanne. "The Dark Brilliance of Kia Asamiya." *Sequential Tart.* May 2000.

5201. "Kia Asamiya." *Animerica.* 6:9 (1998), pp. 15, 29-31.

Banana, Yoshimoto

5202. "Fruits of Her Labor." *Asiaweek.* May 9, 1997, p. 51.

5203. Fujimoto, Yukari. "Atsui Ocha no Kioku: Nichijōsei no Shisō' to Yoshimoto Banana" (Memories of Hot Green Tea: 'The Ideology of the Everyday' and Yoshimoto Banana). In *Josei Sakka no Shinryū* (The New Wave of Women Writers), edited by Hasegawa Izume, pp. 303-317. Tokyo: Shibundo, 1991.

5204. Furuhashi, Nobuyoshi. *Yoshimoto Banana to Tawara Machi* (Yoshimoto Banana and Tawara Machi). Tokyo: Chikuma Shobō, 1990.

5205. Gee, Alison D. "A Taste for the Unusual." *Asiaweek.* May 9, 1997, pp. 50-51.

5206. Matsumoto, Takayuki. *Yoshimoto Banana Ron: 'Futsū to iu Muishiki* (Yoshimoto Banana: The Unconscious 'Ordinary.'). Tokyo: JICC Shuppankyoku, 1991.

5207. Mitsui, Takayuki and Koyata Washida. *Yoshimoto Banana no Shinwa.* Tokyo: Seikyûsha, 1989.

5208. Nanba, Hiroyuki. "Yoshimoto Banana: 'Manga Sedai' no Jun-Bungaku." (Yoshimoto Banana: The Pure Literature of the 'Comic Generation'). In *Josei Sakka no Shinryū,* edited by Hasegawa Izumi, p. 319. Tokyo: Shibundō, 1991.

5209. Treat, John W. "Yoshimoto Banana Writes Home: *Shojo* Culture and the Nostalgic Subject." *Journal of Japanese Studies.* 19:2 (1993), pp. 353-387.

5210. Treat, John W. "Yoshimoto Banana Writes Home: The Shōjo in Japanese Popular Culture." In *Contemporary Japan and Popular Culture,* edited by John W. Treat, pp. 275-308. Honolulu: University of Hawaii Press, 1996.

Bashō

5211. *Bashō-ten* (Bashō Exhibition). Tokyo: Keizai Shinbunsha, 1993.

5212. *Bashō to Ōmi no Monjin-tachi* (Bashō and His Pupils from Ōmi). Otsu: Otsushi Rekishi Hakubutsukan, 1994.

Beck, Jerry

5213. Amos, Walter. "The Story Behind Streamline: An Interview with Jerry Beck." *Protoculture Addicts.* November 1990, pp. 11-14.

5214. Loo, David and Mike Tatsugawa. "A-ni-mé Interview with Jerry Beck." *A-ni-mé.* January 1991, pp. 4-8.

Bigot, Georges

5215. "Biggest Oil Painting by Bigot." *Fūshiga Kenkyū.* July 20, 1995, p. 14.

5216. Shimizo, Isao. "Bigot no Inage Jidai Yusaiga." (Bigot's Oil Paintings Created in Inage). *Fūshiga Kenkyū.* April 20, 1998, pp. 1-3.

5217. Shimizu, Isao. "Bigot's Offsprings' Visit to Japan." *Fūshiga Kenkyū.* July 20, 1997, p. 14.

5218. Shimizu, Isao. "Bigot's Oil Painting, 'The Landscape of Yokohama.'" *Fūshiga Kenkyū.* No. 20, 1996, p. 14.

5219. Shimizu, Isao. "Bigot's Photographs of Sino-Japan War: Reactions of Readers and New Information." *Fūshiga Kenkyū.* January 20, 1996, p. 13.

5220. Shimizu, Isao. "The Camera Bigot Used." *Fūshiga Kenkyū.* October 20, 1997, p. 3.

5221. Shimizu, Isao. "The First Japanese Translation of *Shockin' au Japon,* Written and Illustrated by F. Ganesco (G. Bigot)." *Fūshiga Kenkyū.* April 20, 1996, pp. 1-4.

5222. Shimizu, Isao. "G. Bigot Dôbanga Sakuhin: 176-ten no Risuto Oyobi Kaisetsu" (G. Bigot's Copperplate Engravings: The List and Explanation of His 176 Works). *Fûshiga Kenkyû*. October 20, 1998, pp. 3-14.

5223. Shimizu, Isao. "G. Bigot Yusaiga (Nihon Kankei) Sakuhin: 80-ten no Risuto Oyobi Kaisetsu" (G. Bigot's [Japan-Related] Oil Paintings: The List and Explanation of His 80 Works). *Fūshiga Kenkyū*. July 20, 1998, pp. 5-11.

5224. Shimizu, Isao. "Japonisumu no Ichi Yoha: G. Bigot no Rainichi" (A Side Issue of Japonisme: The Arrival of G. Bigot in Japan). In *Japonisumu no Jidai: 19 Seiki Kohan no Nihon to Furansu* (The Era of Japonisme: Japan and France in the Late Nineteenth Century), edited by Akiyama Terukazu and Haga Tōru, pp. 15-23. Tokyo: Nichi-Futsu Bijutsu Gakkai, 1983.

5225. Shimizu, Isao. "Photograph Album of Sino-Japanese War by Bigot." *Fūshiga Kenkyū*. No. 16, 1995, pp. 1-9.

5226. Shimizu, Isao. "'Shockin' Au Japon.'" *Fūshiga Kenkyū*. October 20, 1997, pp. 4-5.

5227. Shimizu, Isao. "Shockin' au Japon. First Japanese Translation. Part 5." *Fūshiga Kenkyū*. No. 22, 1997, pp. 8-9.

5228. Shimizu, Isao. " 'Shockin' au Japon' (2), Written and Illustrated by F. Genesco (G. Bigot)." *Fūshiga Kenkyū*. No. 19 (July 20, 1996), pp. 2-4.

5229. Shimizu, Isao. "*Shockin' au Japon* (3)." *Fūshiga Kenkyū*. No. 20, 1996, pp. 8-9.

5230. Shimizu, Isao. "Shockin' au Japon (6)." *Fūshiga Kenkyū*. July 20, 1997, pp. 6-7.

5231. Shimizu, Isao. "Shockin' au Japon (8)." *Fūshiga Kenkyū*. January 20, 1998, pp. 10-11.

5232. Shimizu, Isao. "Unveiling of Bigot's Return Home Commemorative Plate, Content Revision in My Publications." *Fūshiga Kenkyū*. October 20, 1999, p. 2.

5233. Shimizu, Isao. "Works of G. Bigot Housed at Utsunomiya Art Museum." *Fūshiga Kenkyū*. October 20, 1997, pp. 7-11.

5234. "Shockin' au Japan." *Fūshiga Kenkyū*. No. 21, 1997, p. 14.

5235. "A Theory in 'Chōsō' Shūiko; Ganesco and Bigot Are Different Persons." *Fūshiga Kenkyū*. October 20, 1999, p. 4.

Dezaki, Osamu

5236. Karahashi, Takayuki. "Animerica Interview: Osamu Dezaki Part 2."
 Animerica. 7:6 (1999), pp. 15, 17-18, 36-37.

5237. Karahashi, Takayuki. "Osamu Dezaki: *Animerica* Interview."
 Animerica. June 1999, pp. 17-18, 36.

Fujiko, Fujio F.

5238. "Japanese Cartoonist Fujio F. Fujiko Dies." *Comics Buyer's Guide.*
 October 18, 1996, p. 6.

5239. "Obituary: Fujio F. Fujiko." *The Rose.* January 1997, p. 12.

Hayashi, Hiroki

5240. Lamplighter, L. Jagi and Amos Wong. "Hard Hitter." *Manga Max.* June
 2000, pp. 10-14. (Hiroki Hayashi).

5241. Tebbetts, Geoffrey. "Animerica Interview: Hiroki Hayashi." *Animerica.*
 7:8 (1999), pp. 15, 33.

Hirano Toshiki

5242. "Toshiki Hirano." *Animerica.* 8:1 (2000), pp. 9-11.

5243. "Toshiki Hirano: Selected Filmography." *Animerica.* 8:1 (2000), p. 11.

Hokusai, Katsushika

5244. *Catalogue of the Exhibition of Paintings of Hokusai.* Ernest Fenollosa.
 Tokyo: Bunshichi Kobayashi, 1901. Reprint, Geneva: Minkoff, 1973.

5245. de Goncourt, Edmond. *Hokusai.* Paris: Bibliothèque Charpentier, 1896.
 Reprint, Matthi Forrer. New York: Rizzoli, 1988; Paris: Flammarion,
 1988.

5246. Dickins, Frederick V. *Fugaku Hiyaku-kei: One Hundred Views of Fuji
 by Hokusai.* London: Batsford, 1880. Reprinted, New York: Frederick
 Publications, 1958.

5247. Hayashi, Yoshikazu. *Enpon Kenkyū: Hokusai* (Studies of Erotic Books:
 Hokusai). Tokyo: Yūkō Shobō, 1968.

5248. Hillier, Jack. *Hokusai: Paintings, Drawings and Woodcuts.* 3rd ed.
 London: Phaidon Press, 1978.

5249. Hitchcock, J. A. "An Artist of the People." *Mangajin.* No. 66, 1997, pp. 42, 79.

5250. *Hokusai and His School: Catalogue of Special Exhibition No. 1.* Museum of Fine Arts, Boston; Ernest Fenollosa, Alfred Mudge and Son, 1893.

5251. *Hokusai et Son Âge.* Paris: The Marais Culture Center, 1980.

5252. *Hokusai Kenkyū* (Hokusai Study). Nos. 1-15. Tokyo: Tokyo Hokusai-kai, 1972-1980.

5253. *Hokusai Kenkyū* (Hokusai Study and Research). Nos. 16-. Tokyo: Katsushika Hokusai Museum of Art, ed. Tōyō Shoin, 1994 -.

5254. *Hokusai Manga* (15 volumes, 1814-1878). Reproduced in 3 volumes. Tokyo: Iwasaki Bijutsusha, 1986-87.

5255. Iijima, Kyoshin. *Katsushika Hokusai Den* (A Biography of Katsushika Hokusai). 2 vols. Tokyo: Hōsūkaku 1893. Reproduction supervised by Shinichi Segi. Tokyo: Zōkeisha, 1978.

5256. Inoue, Kazuo. *Ukiyo-e Hyōjun Gashū: Hokusai* (The Standard Collection of Ukiyo-e: Hokusai) Tokyo: Takamizawa Mokuhansha, 1932.

5257. Iso, Hiroshi. "Kawamura Minsetsu No 'Hyaku Fuji' to Hokusai No Fugaku zu." *Bigaku Ronkyu.* 1(1961), pp. 67-84.

5258. *Katsushika Hokusai* (Catalogue of the *Dai Hokusai Ten* [Great Hokusai Exhibition]). Tokyo: Asahi Shimbunsha, 1993.

5259. Kikuchi, Sadao. *Nihon no Bijutsu, 74: Hokusai* (Japanese Art, 74: Hokusai). Tokyo: Shibundō, 1972.

5260. Kobayashi, Taiichirō. *Hokusai to Doga* (Hokusai and Degas). Tokyo: Zenkoku Shohō, 1971.

5261. Kondō, Ichitarō. *Hokusai.* Tokyo: Biwa Shoin, 1953.

5262. Kondō, Ichitarō. *Sekai Meiga Zenshū Bessatsu: Hokusai, Fugaku Sanjūrokkei* (Masterworks of World Art, Supplementary Volume: Hokusai's *Thirty-six Views of Mt. Fuji*). Tokyo: Heibonsha, 1960.

5263. Kondō, Ichitarō. *The Thirty-Six Views of Mount Fuji by Hokusai.* Honolulu: East West Center Press, 1966.

5264. Kuwabara, Yōjirō. *Hokusai Kaimei Kō* (A Study of Hokusai's Name Changes). Tokyo: Kyōbunkan (Matsue), 1922.

5265. Morse, Peter. *Hokusai: One Hundred Poets.* New York: George Braziller, 1989.

5266. Murayama, Shungo. *Katsushika Hokusai Nisshin Joma Chō* (Katsushika Hokusai's *Daily Warding-Off of Demons*). Tokyo: Kokkasha, 1954.

5267. Nagata, Seiji. "Bōsō No Ryokaku Katsushika Hokusai." *Ukiyo-e Geijutsu.* No. 35, 1972, pp. 20-26.

5268. Nagata, Seiji. "Hiroshige Shinshutsu-go No Hokusai." *Ukiyo-e Geijutsu.* No. 30, 1971, pp. 24-26.

5269. Nagata, Seiji. *Hokusai Bijutsukan* (The Hokusai Museum; Five Volumes). Tokyo: Shūeisha, 1990.

5270. Nagata, Seiji. *Hokusai: Genius of the Japanese Ukiyo-e.* Tokyo: Kodansha, 1995. 95 pp.

5271. Nagata, Seiji. *Hokusai Manga* (The Hokusai Sketches; three volumes). Tokyo: Iwasaki Bijutsusha, 1986-1987.

5272. Nagata, Seiji. *Hokusai no Ehon Sashie* (Hokusai's Picture Book Illustrations; three volumes). Tokyo: Iwasaki Bijutsusha, 1987.

5273. Nagata, Seiji. *Hokusai no Etehon (*Hokusai's Art Manual; five volumes). Tokyo: Iwasaki Bijutsusha, 1986.

5274. Nagata, Seiji. *Hokusai no Kyōka Ehon* (Hokusai's *Kyōka Ehon).* Tokyo: Iwasaki Bijutsusha, 1988.

5275. Nagata, Seiji. *Katsushika Hokusai Nenpu* (A Katsushika Hokusai Chronology). Tokyo: Sansai Shinsha, 1985.

5276. Nagata, Seiji. *Katsushika Hokusai-ron Shū* (Essays on Katsushika Hokusai). Tokyo: Tōyō Shoin, 1994.

5277. Nagata, Seiji. *Katsushika Hokusai: Tōkaidō Gojūsan-tsugi* (Katsushika Hokusai: *The Fifty-Three Stations on the Tōkaidō Highway*). Tokyo: Iwasaki Bijutsusha, 1994.

5278. Nagata, Seiji. *Ukiyo-e Hakka, 5: Hokusai* (Eight Ukiyo-e Masters, 5: Hokusai). Tokyo: Heibonsha, 1984.

5279. Narazaki, Muneshige. *Fugaku Sanjūrokkei. Hokusai to Hiroshige, I.* Tokyo: Kodansha, 1971.

5280. Narazaki, Muneshige. *Hokusai.* Tokyo: Kōdansha, 1967.

5281. Narazaki, Muneshige. *Hokusai Ron* (A Study of Hokusai). Tokyo: Atorie-sha, 1944.

5282. Narazaki, Muneshige. *Hokusai to Hiroshige* (Hokusai and Hiroshige). Tokyo: Kōdansha, 1964-65.

5283. Narazaki, Muneshige, Jūzō Suzuki, Gōzō Yasuda. *Zaigai Hihō* (Treasures of Japanese Art in Foreign Collections). Vol. 4: Hokusai. Tokyo: Gakushū Kenkyūsha, 1972.

5284. Narazaki, Muneshige. *Masterworks of Ukiyo-e: Hokusai Sketches and Paintings.* Tokyo: Kodansha, 1969. 96 pp.

5285. Narazaki, Muneshige. *Nikuhitsu Ukiyo-e* (Ukiyo-e Brush Paintings), Vol. 7: Hokusai. Tokyo: Shūeisha, 1982.

5286. Noguchi, Yonejirō. *Katsushika Hokusai.* Tokyo: 1930.

5287. Oda, Kazuma. *Arusu Bijutsu Sōsho* (Ars Art School), 15: Hokusai. Tokyo: Arusu, 1927.

5288. Oda, Kazuma. *Hokusai.* Tokyo: Arusu, 1926.

5289. Oda, Kazuma. *Hokusai.* Tokyo: Sōgensha, 1957.

5290. Oka, Isaburō. *Ukiyo-e Taikei* (An Ukiyo-e Compendium), Vol. 8: Hokusai. Tokyo: Shūeisha, 1974.

5291. Ozaki, Shū dō. *Nikkei Shinsho, 85: Hokusai – Aru Gakyōjin no Shōgai* (Nikkei Shinsho Library, 85: Hokusai – The Life of a Man Mad About Art). Tokyo: Nihon Keizai Shimbunsha, 1968.

5292. Sakamoto, Mitsuru. *Heibonsha Gyarari: Hokusai Manga* (The Heibonsha Gallery: The Hokusai Sketches). Tokyo: Heibonsha, 1964.

5293. Segi, Shinichi. *Gakyōjin Hokusai* (Hokusai, the Man Mad About Art). Tokyo: Kōdansha, 1973.

5294. Suzuki, Jūzō. *Genshoku Ukiyo-e Bunko* (The Ukiyo-e in Color Library), 3: *Ningen Hokusai* (Hokusai the Man). Tokyo: Ryokuen Shobō, 1963.

5295. Suzuki, Jūzō. *Katsushika Hokusai: Fugaku Hyakkei* (Katsushika Hokusai: *One Hundred Views of Mt. Fuji*). Tokyo: Iwasaki Bijutsusha, 1973.

5296. Suzuki, Jūzo, Isaburō Oka, Tadashi Kobayashi, and Nobuo Tsuji. *Hokusai Yomihon Sashie Shūsei* A Compendium of Hokusai's *Yomihon* Illustrations). Tokyo: Bijutsu Shuppansha, 1971.

5297. Suzuki, Jūzō, *et al.*, eds. *Zaigai Hihō: Hokusai.* Tokyo: Gakushū Kenkyūsha, 1972.

5298. *Taiyo Ukiyo-e Series, 2: Hokusai.* Tokyo: Heibonsha, 1975.

5299. Tsuji, Nobuo. *Bukku obu Bukkusu Nihon no Bijutsu, 31: Hokusai* (Book of Books, The Art of Japan, 31: Hokusai). Tokyo: Shōgakkan, 1982.

5300. Tsuji, Nobuo. *Nihon no Meiga, II: Katsushika Hokusai* (Famous Art Works of Japan, II: Katsushika Hokusai). Tokyo: Kōdansha, 1974.

5301. *Ukiyo-e Taika Shūsei* (A Compendium of Masters of the Ukiyo-e: Hokusai). Vol. 15. Hokusai Ukiyo-e Kenkyūkai. Tokyo: Taihōkaku Shobō, 1932.

5302. Uragami, Mitsuru, Jūzō Suzuki, Seiji Nagata, and Yoshikazu Haysahi. *Hokusai: Manga to Shunga* (Hokusai: Sketches and Erotic Works). Tokyo: Shinchōsha, 1989.

5303. Yasuda, Gōzō. *Gakyō Hokusai* (Hokusai Mad About Art). Tokyo: Yūkō Shobō, 1971.

Ippongi, Bang

5304. "Bang Ippongi -- A Profile." *Mangazine*. January 1995, pp. 13-14.

5305. "Bang-zai!" *Mangazine*. January 1995, p. 5.

5306. Ippongi, Bang. "Tales from the Inside: 'Dosa's Date.'" *Mangazine*. January 1995, pp. 12-13.

5307. Ippongi, Bang. "Tales from the Inside: 'A Field Guide to Manga Artists.'" *Mangazine*. March 1995, p. 14.

Ishiguro, Noboru

5308. "Anime Q & A with Noburo Ishiguro." *Animerica*. 4:9 (1996), p. 26.

5309. Ishiguro, Noboru. "Anime Memories: 'Airport '38.'" *Animerica*. 4:12 (1996), p. 61.

5310. Ishiguro, Noboru. "Anime Memories: More on Originality and Las Vegas." *Animerica*. 5:8 (1997), p. 62.

5311. Ishiguro, Noboru. "Noboru Ishiguro's Anime Memories: 'Before the Flood.'" *Animerica*. 5:9 (1997), p. 63.

5312. Ishiguro, Noboru. "Noboru Ishiguro's Anime Memories, 'Originality.'" *Animerica*. 5:7 (1997), p. 62.

5313. "Noboru Ishiguro's Anime Memories." *Animerica*. 4:10 (1996), pp. 59-60.

5314. "Noboru Ishiguro's Anime Memories: 'Hollywood Boulevard.'" *Animerica*. 5:3 (1997), p. 58.

5315. "Noboru Ishiguro's Anime Memories: 'Ravel's Bolero.'" *Animerica.* 5:2 (1997), p. 62.

5316. "Noboru Ishiguro's Anime Memories: School Daze." *Animerica.* 5:5 (1997), p. 60.

5317. "Noboru Ishiguro's Anime Memories: 'Singin' in the Rain.'" *Animerica.* 4:11 (1996), p. 59.

Ishii, Hisaichi

5318. "Ishii Hisaichi Senshū, Selected Works of Ishii Hisaichi." *Mangajin.* September 1996, pp. 46-47.

5319. "Ishii Hisaichi Senshū, Selected Works of Ishii Hisaichi." *Mangajin.* April 1997, pp. 48-49.

5320. Natsume, Fusanosuke. "Quiet Lives of Exploration: The Manga Sampler." *Look Japan.* December 1996, pp. 20-21.

5321. "Selected Works of Ishii Hisaichi." *Mangajin.* September 1996, pp. 38-41.

Ishiyama, Takaaki

5322. Davis, Julie. "No Gears, No Glory." *Animerica.* 3:2 (1995), pp. 4-8.

5323. Ledoux, Trish. "A Select Filmography for Takaaki Ishiyama." *Animerica.* 3:2 (1995), p. 9.

Kanzaki, Masaomi

5324. "Masaomi Kanzaki." *Animerica.* 7:11 (1999), p. 30.

5325. "Masaomi Kanzaki Mini-Bio." *Animerica.* 7:11 (1999), pp. 31-32.

Katsura, Masakazu

5326. Brimmicombe-Wood, Lee and Motoko Tamamuro. "Masakazu Katsura's Superheroes." *Manga Max.* February 1999, pp. 38-40.

5327. "Katsura's QT." *Manga Max.* December 1999, p. 9.

5328. Ng, Ernest. "4C-Masakuza Katsura Illustrations." *The Rose.* June 2000, p. 19.

5329. "Ten Things You Didn't Know About Masakazu Katsura." *Animerica.* 4:5 (1996), pp. 56-57.

Kawamoto, Kihachiro

5330. Alder, Otto. "Kihachiro Kawamoto." In *Fantoche,* pp. 50-52. Baden: Buag, 1997.

5331. "Retrospectieve Kihachiro Kawamoto." *Plateau.* January-March 1992, p. 17.

Kinoshita, Renzo

5332. Deneroff, Harvey. "Renzo Kinoshita: A Talk with Miyasan Sadao Miyamoto." *Animation World.* February 1997, pp. 50-52.

5333. Ehrlich, David. "Memory of an Animated Couple: Renzo and Sayoko Kinoshita." In *Animation in Asia and the Pacific,* edited by John A. Lent, pp. 51-54. Sydney: John Libbey & Co., 2001.

5334. "In Memoriam: Renzo Kinoshita." *Plateau.* 18:1 (1997), p. 19.

5335. "La Scomparsa di Renzo Kinoshita." *ASIFA Itlalia Notizie.* January/February 1997, p. 3.

5336. Moline, Alfons. "Sayonara, Renzo Kinoshita." *Noticies.* April/May 1997, p. 4.

5337. "Renzo Kinoshita." *ASIFA News.* 10:1 (1997), p. 2.

5338. Wright, Prescott. "Giants Pass." *ASIFA San Francisco.* February 1997, pp. 8-9.

Kobayashi, Kiyochika

5339. Itabashi Kuritsu Bijutsukan, ed. *Kobayashi Kiyochikaten Zuroku* (Catalogue of an Exhibition of Kobayashi Kiyochikaten). Tokyo: Itabashi Kuritsu Bijutsukan, 1982.

5340. Yoshida, Susugu. *Kaikaki no Eshi Kobayashi Kiyochika* (Artist of the Enlightenment Period: Kobayashi Kiyochika). Tokyo: Ryokuen Shobō, 1964.

Kobayashi, Yoshinori

5341. Heilbrunn, Jacob. "Tokyo Diarist: Cartoon History." *New Republic.* January 1999.

5342. Kure, Tomofusa, ed. *Kobayashi Yoshinori Ronjōsetsu: Gōmanizumu to wa Nanika* (Debating Yoshinori Kobayashi: What Is Arrogantism'?) Tokyo: Shuppō Shinsha, 1995.

Kon, Satoshi

5343. Osmond, Andrew. "Satoshi Kon." *Animerica.* 7:6 (1999), pp. 11, 28-29.

5344. "Perfect Blue." *Manga Max.* June 1999, pp. 13-16.

Kyōsai, Kawanabé

5345. Anderson, William. "A Japanese Artist, Kawanabé Kiōsai." *Studio Magazine.* 15:67 (1898).

5346. Briot, Alain. "Ehon Taka-Kagami, le Miroir de la Fauconnerie de Kawanabe Kyosai." *Bulletin Association Franco-Japonaise.* No. 36, 1992.

5347. Briot, Alain. "Kyosai et le Kyogen." *Bulletin Association Franco-Japonaise* (Paris). No. 43, 1994.

5348. Clark, Timothy. *Demon of Painting: The Art of Kawanabe Kyosai.* London: British Museum, 1993.

5349. *Comic Genius: Kawanabe Kyosai.* Tokyo: Tokyo Shimbun, 1996. 332 pp.

5350. Conder, Josiah. "Kyosai." *The Japan Weekly Mail.* May 18, 1889.

5351. Conder, Josiah. *Paintings and Studies by Kawanabé Kyōsai.* Tokyo: Maruzen, Hong Kong: Kelly & Walsh, 1911.

5352. Isaacs, N. "Some Original Drawings of Kawanabe Kyosai." *The Connoisseur.* No. 72, 1925.

5353. *Kawanabe Kyosai.* Catalogue. Leiden: Rijkesmuseum voor Volkenkunde, 1967.

5354. Menpes, Mortimer. "A Lesson from Khiosai." *The Magazine of Art.* April 1888.

5355. Schack, Gerhard. *Kyosais Falkenjagd.* Hamburg: Paul Parey, 1968.

5356. Shigeru, Oikawa. "Discovery or Good Fortune? Ten Years with Kyosai Paintings." *Andon* (Leiden). No. 50, 1995.

5357. Shigeru, Oikawa. "Kawanabe Kyosai's Paintings in Europe and the United States." *Andon* (Leiden). 34, 1989.

5358. Shimizu, Christine. "Diversité de l'art de Kawanabe Kyosai. *"Le Revue du Louvre.* February 1986.

5359. Strange, Edward F. "The Art of Kyōsai." *Transactions and Proceedings of the Japan Society.* Vol. 9. London, 1911.

Matsumoto, Leiji

5360. "GE 999 Q & A." *Animerica.* 4:7 (1996), pp. 7, 26-28.

5361. Karahashi, Takayuki. "Riding the Rails with Leiji (Matsumoto)." *Animerica.* 4:7 (1996), pp. 6-9, 18-19.

5362. "Leijiverse Character Relation Chart." *Animerica.* 4:7 (1996), p. 29.

5363. Macias, Patrick. "Grand Epic Eternal." *Animerica.* 7:1 (1999), pp. 11-13, 29-30.

5364. Oshiguchi, Takashi. "On the Current Leiji Matsumoto Boom." *Animerica.* 7:1 (1999), p. 60.

5365. "Who's Who in the Leijiverse." *Animerica.* 4:7 (1996), pp. 20-21, 28.

Miyazaki, Hayao

5366. Akira and Shinobu. "Hayao Miyazaki: Le Cochon Volant." *Animeland* (Paris). July/August 1992.

5367. Baricordi, Andrea and Massimiliano de Giovanni. "Hayao Miyazaki." *Mangazine* (Bologna). May 1991.

5368. Chute, David. "Organic Machine: The World of Hayao Miyazaki." *Film Comment.* November/December 1998, pp. 62-65.

5369. Colpi, Federico. "Portfolio Hayao Miyazaki." *Mangazine* (Bologna). June 1994.

5370. Feldman, Steve. "Mo' Miyazaki, Mo' Miyazaki." *Animerica.* 3:11 (1995), p. 49.

5371. Giner, Pierre. "Interview: Hayao Miyazaki." *Animeland* (Paris). March 1993.

5372. "Hayao Miyazaki, Mononoke Hime and Studio Ghibli." *Kinejun Special Issue.* February 1998.

5373. "Hayao Miyazaki Wants To Make a Modest Proposal." *Manga Max.* February 2000, p. 66.

5374. Herskovitz, Jon. " 'Mononoke' Creator Miyazaki Toons Up Pic." Reuters dispatch, December 15, 1999.

5375. Inaga, Shigemi. "Hayao Miyazaki's Epic Comic Series: An Attempt at Interpretation." Paper presented at Association for Asian Studies, Honolulu, Hawaii, April 14, 1996.

5376. "Interview with Hayao Miyazaki." *A-Club* 19 (Hong Kong). June 10, 1987.

5377. Kominz, Laurence C. "Mononoke Hime: From Animation to Environmentalism in the Works of Miyazaki Hayao." Paper presented at Association for Asian Studies, Boston, Massachusetts, March 11, 1999.

5378. "*Kurenai no Buta* in Italy: Location Hunting with Director Hayao Miyazaki." *Animage Magazine.* January 1992. Reprinted in *The Rose.* October 1997, pp. 11-12.

5379. Levi, Antonia. "Miyazaki and the Soul of Japan." *Animeco.* No. 12, 2000, pp. 22-24.

5380. Lyman, Rick. "Darkly Mythic World Arrives from Japan." *New York Times.* October 21, 1999, pp. E-1, E-9.

5381. McCarthy, Helen. *Hayao Miyazaki, Master of Japanese Animation: Films, Themes, Artistry.* Berkeley California: Stone Bridge Press, 1999.

5382. McCarthy, Helen. "The House That Hayao Built." *Manga Max.* April 1999, pp. 30-36.

5383. Meyts, Rein. "Hayao Miyazaki: Strijdend voor de Auteursfilm en Maer." *Plateau.* 21:2 (2000), pp. 7-13.

5384. Miyazaki, Hayao. "The Current Situation of Japanese Movies." *Course on Japanese Movies 7* (Iwanami Shoten). January 28, 1988.

5385. "Miyazaki." *Plateau.* 18:3 (1997), p. 15.

5386. "Miyazaki Hayao to Manga Eiga" (Hayao Miyazaki and Manga Movies). Special issue of *Comic Box.* September 1989.

5387. "Miyazaki Hits the Arthouse Circuit." *Manga Mania.* July/August 1998, p. 5.

5388. "Miyazaki's Minions." *Manga Max.* September 1999, p. 7.

5389. Moisan, David. "*Nausicaä* and *Dune:* The Intertwined Worlds of Frank Herbert and Hayao Miyazaki." *Japanese Animation News and Review: The Official Newsletter of Hokubei Anime-Kai.* July 1991.

5390. Murase, Hiromi. "Kumorinaki Sunda Manako de Mitsumeru 'Sei No Yami': Miyazaki Anime No Joseizō." *Pop Culture Critique.* 1, 1997, pp. 53-66.

5391. Ono, Kosei. "Post-War History of Japanese Animated Films and the Sense of Levitation in Hayao Miyazaki's Feature Works." Paper presented at Australia's Second International Conference on Animation, Sydney, Australia, March 3, 1995.

5392. Osmond, Andrew. "Hayao Miyazaki: A Celebration." *Animerica.* 6:9 (1998), pp. 6-10, 25-28.

5393. Osmond. Andrew. "Hayao Miyazaki: A Celebration. Part 2." *Animerica.* 6:10 (1998), pp. 13-15, 28-31.

5394. Ōtsuka, Eiji, *et al. Emu no Sedai: Bokura to Miyazaki-kun* (The M-Generation: Young Miyazaki and Us). Tokyo: Ōta Shuppan, 1989.

5395. "Panoramic Miyazaki." *Eureka.* Special Issue: "Miyazaki Hayao No Sekai." 29:11 (1997).

5396. Reid, Bruce. "Cartoons for Every Age: The Complex Beauty of Hayao Miyazaki." *The Stranger.* November 4, 2000.

5397. Rivet, Jerome. "New Feature Forthcoming from Japanese Animation Master." Agence France Presse release, June 18, 2001.

5398. Saeki, Junko. "Nijūisseiki No Onnagami, Saibogu=Goddesu." In *Hayao Miyazaki (Filmmakers* Vol. 6), edited by Yoro Takeshi. Tokyo: Kinema Junpōsha, 1999.

5399. Saitani, Ryō. "Miyazaki Hayso Rongu Intabyū: Mae Yori mo Naushikā no Koto ga Sukoshi Wakaru Yō ni Natta" (The Long Interview with Hayao Miyazaki: I Now Understand Nausicaä a Little Better Than Before). *Comic Box.* January 1995, pp. 6-37.

5400. Schilling, Mark. "Miyazaki Does Disney One Better." *Japan Times.* July 1995.

5401. Schilling, Mark. "Miyazaki Hayao and Studio Ghibli, The Animation Hit Factory." *Japan Quarterly.* January-March 1997, pp. 30-40.

5402. Toda, Mitsunori. "Animator Loses Sight of Utopia." *The Daily Yomiuri.* April 25, 1995.

5403. Wells, Paul. "Hayao Miyazaki: Floating Worlds, Floating Signifiers." *Art and Design.* No. 53, 1997, pp. 22-25.

5404. Yamada, Tadon. "Animekai No Kein To Aberu: Miyazaki To Takahata Isao Wa Fujiko Fujio Datta." *Pop Culture Critique.* No. 11, 1997, pp. 37-42.

5405. Yokota, Masao. "A Psychological Meaning of Creatures in Hayao Miyazaki's Feature Animations." *The Japanese Journal of Animation Studies.* 1:1A (1999), pp. 39-44.

5406. Yokota, Masao and Koji Nomura. "The Impact of Miyazaki Hayao's Feature Animations on Japanese Audiences." Paper presented at Society for Animation Studies, Orange, California, August 13, 1998.

5407. Yoshida, Toshifumi. "Hayao Miyazaki." *Animerica.* 7:12 (1999), pp. 6-7, 10-11, 13, 18-19.

Mizuki, Shigeru

5408. Adachi, Noriyuki. *Yōkai to Aruku: Hyōden – Shigeru Mizuki* (Walking with Goblins: A Critical Biography). Tokyo: Bungei Shunjū, 1994.

5409. "Goblins, Hobgoblins and the Folly of War." *Look Japan.* December 1995.

5410. "Mizuki Shigeru no Sekai" (The World of Shigeru Mizuki). Expanded edition of *Asahi Graph.* December 10, 1993, pp. 3-22.

5411. "Mizuki Shigeru Tekushūgo" (The Shigeru Mizuki Special Edition). *Garo.* September 1991, pp. 3-80.

5412. "Mizuki Shigeru Tokushū 2." (Shigeru Mizuki Special 2). *Garo.* January 1993, pp. 3-58.

5413. *Mizuki Shigeru to Nihon no Yôkai.* Catalogue, Exposition. Tokyo: NHK Promotion, 1993.

Monkey Punch

5414. "A Few Stolen Moments with Monkey Punch." *Mangazine.* January 1995, pp. 24-27.

5415. Horn, Carl G.. "A Glimpse of the Cosmopolitan Manga Man." *Animerica.* 3:9 (1995), pp. 44-45.

Murakami, Ryu

5416. Sertori, Julia. "Against the Clock." *Manga Max.* February 1999, pp. 46-47.

5417. "Who Is Ryu Murakami?" *Manga Max.* February 1999, p. 47.

Nagai, Gō

5418. Della Mora, Max. "Go Nagai's Terror Zone." *Kaiju Review.* 1:8 (1995), pp. 50-51.

5419. Dlin, Doug, trans. "First Screening: Go Nagai." *Mangazine.* March 1992, pp. 28-31.

5420. Kyte, Steve. "Space: 2999." *Manga Max.* May 2000, pp. 18-24.

5421. Watson, Paul. "The Go Nagai Interview." *Anime UK.* December 1994/January 1995, pp. 14-15.

5422. Wong, Martin. "Spotlight on Go Nagai." *The Rose.* July 1996, p. 5.

Ohata, Koichi

5423. "Koichi Ohata Interview." *Anime FX.* February 1996, pp. 36-37.

5424. "Rider on the Storm." *Animerica.* 4:3 (1996), p. 31.

Okada, Toshio

5425. Nadelman, Neil. "Holding Court with the Otaking: Toshio Okada." *The Rose.* October 1995, p. 27.

5426. Horn, Carl G. "The Conscience of the Otaking. The Studio Gainax Saga in Four Parts." *Animerica.* 4:2 (1996), pp. 6-7, 24-26.

5427. Horn, Carl G. "The Conscience of the Otaking: The Studio Gainax Saga in Four Parts: Part Four." *Animerica.* 4:5 (1996), pp. 8-9, 24-27.

5428. Horn, Carl G. "The Conscience of the Otaking: The Studio Gainax Saga in Four Parts: Part Three." *Animerica.* 4:4 (1996), pp. 9-10, 24-27.

5429. Horn, Carl G. "The Conscience of the Otaking: The Studio Gainax Saga in Four Parts: Part 2." *Animerica.* 4:3 (1996), pp. 8-9, 22-25.

Okamoto, Ippei

5430. Asahi Shimbunsha and Kawasaki-shi Shimin Museum, eds. *Exhibition on Ippei Okamoto: A Pioneer of Contemporary Comic Art (The 50th Anniversary of His Death).* Catalogue. Tokyo: September 1997, 100 pp.

5431. "A Letter by Okamoto Ippei in His Later Years." *Fūshiga Kenkyū.* April 20, 1996, p. 9.

5432. Shimizu, Isao. "Okamoto Ippei." *Fūshiga Kenkyū.* No. 16, 1995, p. 12.

5433. Shimizu, Isao. "Original by Okamoto Ippei, a Movie Version of 'Human Life.'" *Fūshiga Kenkyū.* No. 19 (July 20, 1996), pp. 11-13.

Oshii, Mamoru

5434. David, Harold. "The Elegant Enigmas of Mamoru Oshii." *AnimeFantastique.* Spring 1999, pp. 6-9.

5435. Horn, Carl G. "Shell Shocked. A Director's Dreamscape: The *Animerica* Interview with Mamoru Oshii." *Animerica.* 4:2 (1996?), pp. 4-5, 18-20.

5436. Ishii, Rika. "Interview with Mamoru Oshii." *Kinejun Special Issue.* July 1995.

5437. "Virtual Panel! Meet Mamoru Oshii." *Animerica.* 4:8 (1996), p. 27.

Otomo, Katsuhiro

5438. Clements, Jonathan. "Katsuhiro Otomo: Devil in the Detail." In *Atomic Sushi: A Bite of Japanese Animation,* pp. 14, 19. Stanmore, Australia: Silicon Pulp Animation Gallery, 2000.

5439. Horn, Carl G. "A Memorable Feast. Katsuhiro Otomo Meets (and Eats) with the Press in San Francisco." *Animerica*. 3:12 (1995), pp. 10-11.

5440. "Katsuhiro Otomo's Memories." *Animerica.* 3:3 (1995), p. 48.

5441. Swallow, Jim. "Manga in Focus: Otomo Revisited." *Anime FX.* February 1996, pp. 46-47.

Pope, Paul

5442. "Making of a Young Manga Artist." *Animerica.* 5:5 (1997), p. 59.

5443. Mason, Jeff. "Who Is Paul Pope?" *Comics Buyer's Guide.* November 10, 1995, pp. 22, 24.

5444. Mescallado, Ray. "Paul Pope." *Comics Journal.* November 1996, pp. 98-117.

Rintaro

5445. Karahashi, Takayuki. "Rintaro." *Animerica.* 8:5 (2000), pp. 8-10, 34.

5446. Oshiguchi, Takashi. "On the Works of Rintaro." *Animerica.* 8:5 (2000), p. 62.

Shirow, Masamune

5447. "Masamune Shirow's Dominion." *Mangazine.* August 1993, pp. 6-7.

5448. Schodt, Frederik L. "Being Digital." *Manga Max.* December 1998, pp. 18-23.

Smith, Toren

5449. Dubreuil, Alain. "Toren Smith Interview." *Protoculture Addicts.* April 1990, pp. 21-24.

5450. McPherson, Darwin. "Inside Studio Proteus: A Talk with Toren Smith."
 Amazing Heroes. July 1990, p.. 27-38.

Sōji, Ushio

5451. Shimizu, Isao. "Ushio Sōji-shi Taku Hōmonki" (A Visit to the House of
 Mr. Sōji Ushio). *Fūshiga Kenkyū*. April 20, 1998, pp. 1-8.

5452. Shimizu, Isao. "Ushio Sōji-shi Taku Hōmonki" (A Visit to the House of
 Mr. Sōji Ushio). *Fūshiga Kenkyū*. January 20, 1998, pp. 1-8.

Sonoda, Kenichi

5453. "Road Rage: Kenichi Sonoda's World of Cars, Guns, and High-Speed
 Action." *Animerica*. 9:1 (1999), pp. 6-7, 23-24.

5454. Swallow, Jim. "Life in the Fast Lane." *Manga Max*. August 1999, pp.
 12-18.

Takahashi, Rumiko

5455. Clancy, Keith. "Just When You Thought It was Safe To Go Back in the
 Water: Becoming-Other–Than-Oneself by Halves in Rumiko
 Takahashi." Paper presented at Australia's Second International
 Conference on Animation, Sydney, Australia, March 3, 1995.

5456. "A Grand Day in the Life of Rumiko." *Animerica*. 5:5 (1997), p. 19.

5457. Lien-Cooper, Barb. "Rumiko Takahashi." *Sequential Tart*. March 2000.

5458. McNiel, Sheena. "Rumiko Takahashi and Inuyasha: An Anime, a
 Manga, and a Whole Lot of Excitement!" *Sequential Tart*. March 2001.

5459. Matsuzaki, James. "Rumiko Takahashi: A Brief Biography." *A-ni-mé*.
 January 1991, p. 147.

5460. "My Rumiko Runneth Over." *Animerica*. 4:6 (1996), p. 13.

5461. "Rumiko Takahashi Special: Monsters, Martial Arts and Romance."
 Animerica. 5:5 (1997), pp. 4-5, 18-19.

Teraoka, Masami

5462. Haggerty, Gerard. "Making Great Waves." In *Masami Teraoka*, pp. 5+.
 Oakland, California: Oakland Museum, 1983.

5463. Handel, Jane. "Women in the Waves: The Archetypal Feminine in the
 Work of Masami Teraoka." *Persimmon*. Summer 2001, pp. 34-37.

5464. Hess, Lynda. "Panoramic Teraoka." *Art Asia Pacific.* 3:1 (1996), pp. 78-83.

5465. Link, Howard A. *Waves and Plagues: The Art of Masami Teraoka.* Honolulu: The Contemporary Museum, 1988.

5466. Marshall, Richard. "Preface and Acknowledgments." In *Masami Teraoka.* New York: Whitney Museum of American Art, 1979. Unpaginated.

5467. "Paintings by Masami Teraoka: Waves and Plagues." *IIAS Newsletter.* Summer 1996, p. 55.

5468. Teraoka, Masami. "Ukiyo-e and Pop Art." *Asian Art and Culture.* Fall 1994, pp. 2-11.

5469. Ulak, James T., Alexandra Munroe, Masami Teraoka, with Lynda Hess. *Paintings by Masami Teraoka.* Washington, D.C.: Arthur M. Sackler Gallery, Smithsonian Institution, in association with Weatherhill (New York), 1996. 112 pp.

Tezuka, Osamu

5470. Akita Shoten, ed. *Tezuka Osamu Manga 40-nen* (Forty Years of Osamu Tezuka Cartoons). Tokyo: Akita Shoten, 1984.

5471. "By the Grace of Tezuka: In the Beginning." *Animerica.* 3:6 (1995), p. 16.

5472. "Çocuklara Çizgilerle Adem-Havva." *Cumhuriyet Dergi.* December 6, 1992.

5473. *Comic Box* (Tokyo). Special number 5/1987. "Bokura no Tezuka Osamu."

5474. Covert, Brian. "Manga, Racism and Tezuka." *The Japan Times Weekly.* April 18, 1992, pp. 1-4.

5475. Einholz, Eveline. "Der Manga-Künstler Tezuka Osamu (1928-1989). Seine Bedeutung für die Entwicklung des Modernen Manga Unter Besonderer Berücksichtigung des Stilbildenden Frühwerks." Doctoral dissertation, Freie Universität Berlin, 1994.

5476. "Episodes from the Life of Osamu Tezuka." *Animerica.* 3:6 (1995), pp. 8-11.

5477. Evans, Peter and Cefn Ridout. "Osamu Tezuka: The God of Manga." In *Atomic Sushi: A Bite of Japanese Animation,* pp. 12-13. Stanmore, Australia: Silicon Pulp Animation Gallery, 2000.

5478. Hunt, Claire. "Japan's Great Animator Hits Local Cinema." *Moscow Times.* September 16, 1998.

5479. Ijin Monogatari 31: Tezuka Osamu (Story of Great Man 31: Tezuka Osamu)." In *Nihon To Sakai No Ijin Monogatari 55* (Stories of Great Men in Japan and the World 55), edited by Takeshi Handa, pp. 188-189. Tokyo: Gakushu Kenkyusha Co., 1986.

5480. Ishigami, Mitsutoshi. *Tezuka Osamu no Jidai* (The Age of Osamu Tezuka). Tokyo: Tairiku Shobō, 1989.

5481. Iwasaki, Yoshikazu. "The Osamu Tezuka Exhibition within the Context of Museum Activity." In *Tezuka Osamu-ten. Catalogue,* pp. 12-13. Tokyo: The National Museum of Modern Art, 1990.

5482. Koechlin, Heinrich. "Tezuka Osamu, Leben und Werk." Thesis, University of Vienna, 1993.

5483. "The Largest Selection of Osamu Tezuka Artwork Ever Seen in the West!" *Toon Art News.* November 1998, p. 2.

5484. Leahy, Kevin. "A Look at Osamu Tezuka on *Surprising 20th Century.*" *The Rose.* January 1996, p. 17.

5485. MacWilliams, Mark. "Japanese Comic Books and Religion: Osamu Tezuka's Story of the Buddha." Paper presented at Japanese Popular Culture Conference, University of British Columbia, April 10, 1997.

5486. MacWilliams, Mark. "Revisioning Japanese Religion: Osamu Tezuka's *Hi no Tori* (The Phoenix)." Paper presented at Asian Popular Culture Conference, Victoria, Canada, April 18, 1998.

5487. Matsutani, Takayuki. "A Life Spent Loving Manga: Osamu Tezuka's Legacy to His American Readers." *Animerica.* 3:6 (1995), p. 9.

5488. Nakano, Haruyuki. "Charm of Kansai Shines Through." *Daily Yomiuri.* September 21, 1993, p. 7.

5489. Nakano, Haruyuki. *Tezuka Osamu no Takarazuka* (Tezuka Osamu's Takarazuka). Tokyo: Chikuma Shobō, 1994.

5490. Natsume, Fusanosuke. *Tezuka Osamu Wa Doko Ni Iru* (Where Is Tezuka Osamu?). Tokyo: Chikuma Shobo Co., 1992.

5491. [Osamu Tezuka]. *Cartoonist PROfiles.* June 1998, pp. 47-49.

5492. [Osamu Tezuka]. *The Economist.* December 16, 1995.

5493. "Osamu Tezuka in 15 Minutes or Less." *Animerica.* 3:6 (1995), p. 12.

5494. Phillipps, Susanne. "Der 'Gott der Japanischen Comics': der Manga-Zeichner und Trickfilmproduzent Tezuka Osamu." In *Japan-Lesebuch 3: "Intelli,"* edited by Steffi Richter, pp. 258-274. Tübingen: Konkursbuchverlag Claudia Gehrke, 1998.

5495. Phillipps, Susanne. *Erzählform Manga. Eine Analyse der Zeitstrukturen in Tezuka Osamus "Hi No Tori" ("Phoenix").* Wiesbaden: Harrassowitz Verlag, 1996.

5496. Phillipps, Susanne. "Narrative Bausteine im Manga. Erzählanalyse am Beispiel von Tezuka Osamus 'Hi No Tori.'" Thesis, Freie Universität Berlin, 1995.

5497. Phillipps, Susanne. "Tezuka Osamu." In *Lexikon der Comics Teil 2: Personen.* Meitingen: Corian-Verlag Heinrich Wimmer, 26. Erg.-Lfg., 1998. 62 pp.

5498. "Remembering Osamu Tezuka." *Animerica.* 3:6 (1995), pp. 6-7.

5499. Sakura, Tetsuo. *Tezuka Osamu: Jidai to Kirimusubu Hyōgensha* (Osamu Tezuka: A Man Who Took On and Expressed His Era). Tokyo: Kōdansha, 1990.

5500. Schodt, Frederik L. "Remembering Osamu Tezuka." *Animerica.* 3:6 (1995), p. 8.

5501. Takeuchi, Osamu. *Tezuka Osamu Ron.* Tokyo: Heibonsha, 1992.

5502. Tezuka, Etsuko. "With My Husband, Osamu Tezuka." *Animerica.* 3:6 (1995), p. 12.

5503. Tezuka, Osamu. *Mitari, Tottari, Utsushitari* (Viewing, Shooting, Screening). Tokyo: Kinema Junpōsha, 1987.

5504. Tezuka, Osamu. *Mushirareppanashi* (Plucked and Nibbled Talks). Tokyo: Sinchōsha, 1981.

5505. Tezuka, Osamu. "Father of Postwar Manga Culture." *The East: Higachi.* September 1, 1995, p. 6.

5506. *Tezuka Osamu no Sekai* (The World of Osamu Tezuka). Special supplement edition of *Asahi Journal.* April 20, 1989.

5507. *Tezuka Osamu-ten* (The Osamu Tezuka Exhibition). Tokyo: National Museum of Modern Art/Asahi Shinbun, 1990.

5508. *Tezuka Osamu-ten: Kakō to Mirai no Imēji* (The Osamu Tezuka Exhibition: Images of the Past and Future). Tokyo: Tezuka Productions/ Asahi Shinbun, 1995.

5509. Tezuka Productions, ed. *Tezuka Osamu Gekijō* (The Animation Filmography of Osamu Tezuka). Tokyo: Tezuka Productions, 1991.

5510. "Tezuka's Legend of the Forest Coming to America." *Mangazine.* May 1994, p. 4.

5511. Watanabe, Yasushi. "Osamu Tezuka, Given an Honorific Title 'The God of Manga,' Had His Desire To Produce Animations." *The Japanese Journal of Animation Studies.* 1: 1A (1999), pp. 51-60.

5512. Watanabe, Yasushi. "Osamu Tezuka, 'The God of Manga,' Fascinated by Animations." *The Japanese Journal of Animation Studies.* 2:1A, 2000, pp. 61-68.

Tomino, Yoshiyuki

5513. Barr, Greg. "Over the Waves." *fps.* Summer 1995, pp. 20-24.

5514. Karahashi, Takayuki. "Interview: Yoshiyuki Tomino." *Animerica.* 8:2 (2000), pp. 12-13, 34-37.

5515. "Notes on Author and Translator of Gundam Novels – Yoshiyuki Tomino and Frederik L. Schodt." *Protoculture Addicts.* November-December 1991, p. 20.

5516. Oshiguchi, Takashi. "On the Works of Yoshiyuki Tomino." *Animerica.* 8:2 (2000), p. 67.

5517. "Selected Yoshiyuki Tomino Filmography." *fps.* Summer 1995, p. 24.

Tsuge, Yoshiharu

5518. Gondō, Susumu. "Nejishiki" *Yowa. Tsuge Yoshiharu to Sono Shûhen.* Tokyo: Hokutô Shobô, 1992.

5519. Tsuge, Yoshiharu. *Hinkonryokōki* (Journal of Impoverished Travel). Tokyo: Shōbunsha, 1991.

5520. "Tsuge Yoshiharu' Suru!" (Doing Yoshiharu Tsuge!). *Garo.* August 1993, pp. 3-59.

Tsukimura, Ryoei

5521. McCarthy, Helen and Chris Keller. "Interview: Ryoei Tsukimura." *Anime FX.* August 1995, p. 40.

5522. Oshiguchi, Takashi. "El Hazard, the Magnificent World." *Animerica.* 3:7 (1995), pp. 6-11.

Umetsu, Yasuomi

5523. Karahashi, Takayuki. "Kite: Yasuomi Umetsu: Interview. *Animerica.* 7:6 (1999), pp. 6-7, 12, 30-31, 35.

5524. "Yasuomi Umetsu: Select Filmography." *Animerica.* 7:6 (1999), p. 13.

Yamazaki, Kazuo

5525. "Convention '97: Meet Kazuo Yamazaki." *Animerica.* 5:10 (1997), pp. 8, 24.

5526. Swallow, Jim. "Kazuo Yamazaki." *Manga Mania.* July/August 1998, p. 65.

Yanase, Masamu

5527. Gōichi, Yumoto. "The Fourth Tokyo Puck and Masamu Yanase." *Fūshiga Kenkyū.* July 20, 1995, pp. 9-10.

5528. Ide, Magoroku. *Nejikugi no Gotoku: Graka, Yanase Masamu no Kiseki* (Like a Screw Nail: The Journey of an Artist, Yanase Masamu). Tokyo: Iwanami Shoten, 1996.

5529. *Neji Kugi no Gaka.* Edited by The Yanase Masamu Exhibition Organizing Committee. Tokyo: Musahino Art University, 1990.

5530. Shimizu, Isao. "Caricature of Masamu Yanase." *Fūshiga Kenkyū.* July 20, 1995, pp. 1-8.

Yokoyama, Ryūichi

5531. "50 Years Later the War Ends for Yokoyama Ryūichi." *Mangajin.* August 1995, pp. 28-29.

5532. "Fuku-chan by Yokoyama Ryūichi." *Mangajin.* August 1995, p. 30.

Voice Actors, Actresses

5533. "Akira Kamiya." *Animerica.* 6:9 (1998), pp. 60-61.

5534. "America's Sound Bites: Ward Perry." *Animerica.* 5:1 (1997), pp. 28-29.

5535. "Anime Focus: Eric Stuart." *Animerica.* 7:7 (1999), pp. 72, 75.

5536. "Catch Up With Popular Voice-Actors: Cathy Weseluck." *Animerica.* 4:3 (1996), pp. 26-27.

5537. "Catch Up With Popular Voice-Actors! Kelly Sheridan, Brad Swaile." *Animerica.* 4:8 (1996), pp. 24-25.

5538. "Catch Up With Popular Voice-Actors: Tony Sampson." *Animerica.* 4:6 (1996), pp. 26-27.

5539. "Catch Up With Popular Voice-Actors: Scott McNeil." *Animerica.* 4:11 (1996), pp. 28-29.

5540. Contino, Jennifer M. "A Grand Voice: Michael Granberry." *Sequential Tart.* February 2000.

5541. "Crispin Freeman." *Animerica.* 7:1 (1999), pp. 58-59.

5542. Davis, Julie. "Catch Up With Popular Voice Actors: Toby Proctor." *Animerica.* 4:9 (1996), pp. 22-23.

5543. Davis, Julie. "Sound Bites Special: Chiyako Shibahara." *Animerica.* 5:9 (1997), pp. 30-31.

5544. Dobson, Michael. "Catch Up With Popular Voice-Actors: Jayson Gray Stanford." *Animerica.* 4:2 (1976?), pp. 28-29.

5545. Dobson, Michael. "Catch Up With Popular Voice-Actors! Saffron Henderson." *Animerica.* 4:7 (1996), pp. 24-25.

5546. "The End of an Era: Kei Tomiyama (1942-1995)." *Animerica.* 3:12 (1995), p. 18.

5547. Fox, Kit. "Anime Focus: Rachael Lillis." *Animerica.* 6:11 (1998), pp. 62-63.

5548. Fox, Kit. "Sound Bites: Julie Maddalena." *Animerica.* 8:5 (2000), pp. 58-59, 61.

5549. Fox, Kit. "Sound Bites: Veronica Taylor." *Animerica.* 8:7 (2000), pp. 58-59, 61.

5550. Fox, Kit. "Sound Bites: Wendee Lee." *Animerica.* 8:4 (2000), pp. 60-61, 63.

5551. Fox, Kit and Toshifumi Yoshida. "Janyse Jaud." *Animerica.* 6:12 (1998), pp. 62-63.

5552. Horn, Carl G. "Animerica's Sound Bites – Apollo Smile." *Animerica.* 5:3 (1997), pp. 26-27.

5553. Horn, Carl G. "Sound Bites: Amanda Winn." *Animerica.* 5:10 (1997), pp. 26-27.

5554. Horn, Carl G. "Animerica's Sound Bites: Lisa Ortiz." *Animerica*. 5:2 (1997), pp. 26-27.

5555. Hughes, David. "Dub Be Good to Me." *Manga Max*. February 1999, pp. 12-14. (Jack Fletcher).

5556. Ledoux, Trish and Toshifumi Yoshida. "Catch Up With Popular Voice-Actors! You're Under Arrest!" *Animerica*. 4:5 (1996), pp. 22-23. (JoAnn Luzzatto and Tamara Burnham).

5557. McGuire, Paul. "Sound Bites – Terri Hawkes." *Animerica*. 5:7 (1997), pp. 26-27.

5558. Macias, Patrick. "Brian Drummond." *Animerica*. 8:6 (2000), pp. 58-59, 61.

5559. Maxwell, Joe. "Voice Actors: The People You Don't See." *The Rose*. January 1996, p. 29.

5560. Nelson, Brandon. "Animerica's Sound Bites." *Animerica*. 5:5 (1997), pp. 28-29. (Scott Simpson, Juliet Cesario).

5561. Nelson, Brandon. "Tamara Burnham and Joann Luzzato." *The Rose*. January 1997, pp. 24-25.

5562. Oshiguchi, Takashi. "On Celebrity Voice Actors." *Animerica*. 4:6 (1996), p. 58.

5563. Savage, Lorraine. "Amy Howard – Voice of Nova of *Star Blazers*." *The Rose*. February 1998, pp. 8-9.

5564. "Sound Bites – Chisa Yokoyama." *Animerica*. 4:12 (1996), pp. 26-27.

5565. "Sound Bites: Debora Rabbai." *Animerica*. June 1999, pp. 66-67.

5566. "Sound Bites: Daphne Goldrick." *Animerica*. 7:2 (1999), pp. 62-63.

5567. "Sound Bites: Myriam Sirois." *Animerica*. 7:3 (1999), pp. 62-63.

5568. "Sound Bites Focus: Brett Weaver." *Animerica*. 7:9 (1999), pp. 64-65, 67-68.

5569. "Sound Bites Focus: Nicole Oliver." *Animerica*. 7:8 (1999), pp. 66-67.

5570. Sterling, Cathy. "Chisa & Co." *Manga Mania*. May-June 1998, pp. 22-23. (Chisa Yokoyama).

5571. Swallow, Jim. "Voice of the North Star." *Manga Mania*. January-February 1998, pp. 25-26. (Akira Kamiya).

5572. Teal, James. "Animerica's Sound Bites: Katie Griffin." *Animerica*. 5:8 (1997), pp. 26-27.

5573. "Tiffany Grant." *Animerica.* 6:10 (1998), pp. 50-51.

5574. Wong, Amos. "The Girl Next Door (Kotono Mitsuishi). "*Manga Max.* March 2000, pp. 38-41.

5575. Yoshida, Toshifumi. "Ellen Kennedy 'Kyoko Otonashi." *Animerica.* 4:4 (1996), pp. 22-23.

5576. Yoshida, Toshifumi. "Jason Gray Stanford 'Yusaku Godai.'" *Animerica.* 4:4 (1996), p. 23.

5577. Yoshida, Toshifumi. "Michael Donovan." *Animerica.* 3:12 (1995), pp. 12-13.

5578. Yoshida, Toshifumi. "America's Sound Bites: Ted Cole." *Animerica.* 5:4 (1997), pp. 24-25.

Anime (Animation)
General Sources

5579. Abbasi, Azizoliah. "A Trip to the World of Dreams." *Kayhan Caricature.* October 2000.

5580. "Animania." *TV Guide.* May 21, 1994.

5581. "Animated Issues." *Asiaweek.* April 26, 1996, p. 14.

5582. *Animation no Hon* (A Book on Animation). (Bungei Shunjū Delux). Tokyo: Bungei Shanjū, October 1977.

5583. "Anime Action." *Animation.* July 1998, p. VI.

5584. "Anime Annihilation." *Comics Buyer's Guide.* January 30, 1998, p. 36.

5585. "Anime 18 Stops Wandering, Starts Adventuring." *Mangazine.* January 1995, p. 5.

5586. "Anime Gossips." *Protoculture Addicts.* August-September 1991, p. 8.

5587. *Anime Hiroingahō.* B Media Books. Tokyo: Takeshobō, 1999.

5588. "Anime Is In." *Inklings.* Fall 1995, p. 12.

5589. "Anime News." *Animerica.* 3:7 (1995), p. 12.

5590. "Anime News." *Comics Buyer's Guide.* March 6, 1998, p. 54.

5591. "Anime News." *Mangazine.* January 1993, pp. 12-13.

5592. "Anime News." *Mangazine.* May 1993, pp. 2-3.

5593. "Anime News." *Mangazine.* September 1993, pp. 3-4.

5594. "Anime News." *Mangazine.* October 1993, pp. 3-5.

5595. "Anime News." *Mangazine.* November 1993, p. 4.

5596. "Anime News." *Mangazine.* January 1994, p. 6.

5597. "Anime News." *Mangazine.* July 1994, pp. 4-5.

5598. "Anime News." *Protoculture Addicts.* December 1993, pp. 6-7.

5599. "Anime News: Right Stuf, SoftCel." *Mangazine.* January 1995, p. 10.

5600. "Anime 'Poised To Explode' (Again)." *Manga Max.* April 1999, p. 10.

5601. "Anime Q and A." *Animerica.* 2:7 (1994), p. 18.

5602. "Anime World." *Protoculture Addicts.* December 1993, p. 21.

5603. "Art Attack." *Manga Max.* May 1999, p. 11.

5604. Ashby, Janet. "Animated 'Manga' Latest Summer Treat." *Japan Times.* August 7, 1992.

5605. "Babes and Cyborgs." *Manga Max.* May 1999, p. 10.

5606. Barr, Greg. "Over the Waves." *fps.* September 1994, pp. 10-14.

5607. Beam, John. "Why Do I Like Anime?" *Animato!* Winter 1995, p. 70.

5608. Beam, John. "Why Do I Like Anime?" *The Rose.* July 1997, pp. 4, 28.

5609. Benedict, John. "Understanding Anime." *Mangajin.* March 1997, pp. 54, 75.

5610. Birchfield, Michael and Kevin Kinne. "Anime Gossips." *Protoculture Addicts.* November-December 1991, p. 9.

5611. Bomford, Jen. "Weiss Noise: A Brief Introduction to the Seiyuu of Weiss." *Sequential Tart.* February 2001.

5612. Bomford, Jen. "What You See Isn't What You Get: The Popular Anime That Hasn't Been Released in North America (Yet)." *Sequential Tart.* December 2000.

5613. Bomford, Jen. "White Wing, Black Wing, Cute Wing, Bat Wing." *Sequential Tart.* July 2000.

5614. "Books Nippan News Flash." *Mangazine.* January 1995, p. 10.

5615. Braun, Frank. "Anime – Features Films from Japan." In *Fantoche,* pp. 72-73. Baden: Baug, 1997.

5616. Brophy, Philip. "Ocular Eyes: A Semiotic Morphology of Cartoon Eyes." *Art and Design.* No. 53, 1997, pp. 26-33.

5617. Brophy, Philip. "Ocular Excess: A Semiotic Morphology of Cartoon Eyes." In *Kaboom! Explosive Animation in America and Japan,* pp. 42-58. Sydney: Museum of Contemporary Art, 1994.

5618. *Bunraku,* Japanese-Style Puppet Theatre. Monte Carlo: International Television Festival, 1962.

5619. Carlson, Bruce. "Ask 109. Got a Question?" *The Rose.* October 1996, p. 4.

5620. Chen, Allen. "Getting Around on the Net." *Tsunami.* Summer 1995, pp. 10-12.

5621. "Ciclo en el Malda de Cine Japones de Animation." *Vanguardia* (Spain). December 3, 1993.

5622. Clements, Jonathan. "The Sensual World." *Anime UK.* April 1995, p. 52.

5623. Clements, Jonathan. "Surrendering the Pink." *Anime FX.* February 1996, pp. 44-45.

5624. Clements, Jonathan. "To Live and Die in LA." *Manga Max.* February 2000, pp. 26-29.

5625. Cohen, Amy. "An Ocean of Comment." *Bikini.* February/March 1994, pp. 90-91.

5626. "Come Alive! You're in the Anime Generation." *Manga Max.* June 1999, pp. 42-43, 45-46.

5627. Corliss, Richard. "Amazing Anime." *Time.* November 22, 1999, pp. 94-96.

5628. Cotter, Holland. "Films That Keep Asking, Is It Fact or Fiction?" *New York Times.* January 19, 2001, p. B43.

5629. "Critical Mass." *Manga Max.* January 2000, p. 9.

5630. Cruz, Catherine. "Saturday Evening Cartoons." *Yolk.* Fall 1995.

5631. Dean, Michael. "Turning Japanese." *Comics Buyer's Guide.* January 31, 1997, p. 22.

5632. "De Japanse Animatiefilm." *Plateau.* January-March 1992, pp. 16-17.

5633. Dennis, William. "Living in Animeland." *The Rose.* January 1997, p. 33.

5634. Desser, David. "Why Anime?" Paper presented at Society for Animation Studies, Madison, Wisconsin, September 27, 1996.

5635. Driscoll, Mark. "Passionate Attachments and Critical Displacements: Reading Recent Japanese Anime." Paper presented at "Visions, Revisions, Incorporations" conference, Montreal, Canada, March 27, 1999.

5636. Dugdale, Timothy. "Cultural Snacks." *Metro Times.* December 12-18, 1990.

5637. "Du Neuf de Qualité: 13 Rue de l' Espair en Mangas!" *Les Cahiers Pressibus.* September 1996, p. A 4.

5638. Dunn, Ben. "Naruhodo: The World of Japanese Animation." *Mangazine.* July 1999, 4 pp.

5639. Eisentodt, Gale and Kerry A. Dolan. "Watch Out, Barbie." *Forbes.* January 2, 1995, pp. 58-59.

5640. Elias, Marc. "Anime, and He May Not." *fps.* September 1993, pp. 20-22.

5641. Evans, Peter. "Newsline Japan via Sakura Studio." *Anime UK.* December 1994/January 1995, pp. 22-23.

5642. Evans, Peter J. and Jonathan Clements. "Out of the Shadows." *Manga Max.* November 1999, pp. 40-45.

5643. "Flash News." *Protoculture Addicts.* December 1993, p. 5.

5644. Fletcher, Danielle. "The People of Anime and Why They Are Central to World Peace." *Sequential Tart.* February 2000.

5645. Fox, Kit, *et al.* "Anime Millennium. New Year's Predictions." *Animerica.* 8:1 (2000), pp. 32-34.

5646. Gamarra, Edward. "Animus, Anima, Anime: A Jungian Approach to Japanese Animation." Paper presented at Society for Animation Studies, Utrecht, The Netherlands, October 11, 1997.

5647. Gleicher, Marvin and Fred Patten. "Anime." *Animation.* December 1996, p. A58.

5648. Goodall, Jane. "Animation and Species Confusion." Paper presented at Australia's Second International Conference on Animation, Sydney, Australia, March 4, 1995.

5649. Goto, Kazuhito. "Editorial." *The Japanese Journal of Animation Studies.* Vol. 2, No 1A, 2000, pp. 2-3.

5650. Graham, Jefferson. "Syndicators Scan Japan for Cartoons." *USA Today.* January 30, 1995, p. 3D.

5651. Groves, Don. "Homevids Riding in on Lion's' Coattails." *Variety.* October 2-8, 1995, pp. 95-96.

5652. Hairston, Marc. "The Art of Totoro CD-ROM." *Animerica.* 5:7 (1997), p. 63.

5653. Handelman, Russell J. "Lore and Order: Shinto in Anime (Part I)." *AnimeFantastique.* Fall 1999, p. 7.

5654. Hanna, Junko. "Japan Pays Tribute to its Animation Heritage." *Daily Yomiuri.* July 27, 2000, p. 7.

5655. Hayden-Guest, Anthony. "Who Killed Bambi?" *World Art.* 1 (1995).

5656. Heins, Michael. "The Japanese Animation Scene." *Toon Art Times.* June 1997, p. 1.

5657. Herskovitz, Jon. "Japan." *Variety.* April 10-16, 2000, p. 59.

5658. Herskovitz, Jon. "Splitting Decision." *Variety.* March 31, 1998, p. 14.

5659. Hirsig, Andrea. "Japan." *Hollywood Reporter.* October 3, 1995, p. A-25.

5660. Hoffmann, Curtis. "Facets: Believe the Hype About Japanese Animation." *fps.* September 1994, pp. 15-17.

5661. Howell, Shon. "The Fabulous Dog and Pony Girl Show." *Mangazine.* August 1993, pp. 7-8.

5662. Hu, Gigi T. Y. "Independence in Japan." *Animation World.* December 1999, 8 pp.

5663. Hwang, Hea-lim. "Japanimation, the Dream of the End of Century." *Cine 21.* 186, pp. 22-29.

5664. "IANUS News." *Protoculture Addicts.* December 1993, p. 9.

5665. "Industrial Fights and Magic." *Manga Max.* May 2000, p. 4.

5666. "Info and Info Corner." *Animatoon.* No. 16, 1998, pp. 112-115.

5667. Isabella, Tony. "Anime and Awards Tips." *Comics Buyer's Guide.* May 14, 1999, p. 36.

5668. "It's Not Just Anime, It's Manime." *Animerica.* 8:5 (2000), pp. 64-67.

5669. "It's Superdimensional and in English." *Animerica.* 3:3 (1995), p. 13.

5670. Jackman, Chris K. "Expanding Your Anime World." *Anime FX.* December 1995, pp. 12-13.

5671. James, Walt. "Animania." *VideoScope.* Summer 1995, p. 36.

5672. James, Walt. "Animania." *VideoScope.* Fall 1995, p. 27.

5673. "Japan." *Animatoon.* 3:11 (1997), p. 44.

5674. "Japanese Animation." San Diego Comic Convention *Update.* March 1995, p. 6.

5675. "Japanese Animation in Japan." *Animatoon.* No. 22, 1999, pp. 64-65.

5676. "'Japanimation' Sure Isn't a Disney Film." *Anchorage Daily News.* July 30, 1993, p. D6.

5677. "Japanse Animatiefilmproduktie: Dagboek Van Anne Frank." *Plateau.* 16:2 (1995), p. 20.

5678. Jenkins, Mark. "Masters of Anime." *Washington City Paper.* September 10, 1999.

5679. Jones, Paul. "Sophisticated Japanese Cartoon Is Great for Older Kids." *Anchorage Daily News.* August 20, 1993.

5680. "Just Kid's Stuff?" *Manga Max.* May 1999, p. 9.

5681. Katayama, Hirako. "Lightening Up Heavy." *Forbes.* October 15, 1990, pp. 42-43.

5682. Kim, Jun-yang and Yun Seong-yong. "Japanimation: Mapping Subculture." *Kino* (Seoul). 20, pp. 74-121.

5683. Kinoshita, Sayoko. "Japon: À Coté de Goldorak...." *Sommaire.* Special Issue: "Le Cinèma d'Animation." 1993, pp. 157-163.

5684. Kinoshita, Sayoko. "New Japanese Animation." Presentation at World Animation Celebration, Hollywood, California, May 30, 2000.

5685. Kirihara, Don. "Response to 'Why Anime?'" Paper presented at Society for Animation Studies, Madison, Wisconsin, September 27, 1996.

5686. Kister, D. M. "Japanimation." *Heavy Metal.* March 1984, p. 7.

5687. Kitano, Taiitsu. *Nihon Animeshigakukenkyūjōsetsu.* Tokyo: Hachiman Shoten, 1998.

5688. Kojima, Hisako. "Gender Differences in Humor and Laughter of Japanese and American Animation." Paper presented at International Society of Humor Studies, Osaka, Japan, July 25, 2000.

5689. Lamplighter, L. Jagi. "Pet Peeves and Dangerous Thinking." *Manga Max.* February 2000, pp. 44-47.

5690. Ledoux, Trish. "Anime Ja Nai." *Animag.* No. 5, 1988, p. 22.

5691. Leonard, Andrew. "Animation." *Bay Guardian.* July 7, 1993, pp. 31-32.

5692. Leonard, Andrew. "Heads Up, Mickey." *Wired.* April 1995.

5693. Lewis, Dina. "Nihon Anime Ga Sekai e Tobu." *Newsweek Japan.* July 30, 1997, pp. 43-49.

5694. Lubich, David. "Japanimation." *The Guardian.* January 20, 1995.

5695. McLennan, Jim and Jonathan Clements. "True Romance." *Manga Max.* June 1999, pp. 22-26.

5696. Magee, Michelle. "Virtual Cebebs Fill Fantasies." *Variety.* June 24-30, 1996, p. 103.

5697. Makino, Keiichi. "A Hypothesis of Animation Artisan." *The Japanese Journal of Animation Studies.* 2:1A, 2000, p. 72.

5698. "Manga Mania." *Moving Pictures International.* September 10, 1992, p. 23.

5699. "The Manga Phenomenon: Lecture by Cuno Affolter." In *Fantoche,* p. 127. Baden: Buag, 1997.

5700. "Manga: The Drawn Japan. Documentary." In *Fantoche,* p. 123. Baden: Buag, 1997.

5701. "Manga Video of Onverantwoorde Beelden." *Plateau.* 15:3 (1994), p. 15.

5702. Matsumoto, Jon. "Tooning in to Japanimation." *Los Angeles Times Sunday.* January 14, 1996, Calendar Section, pp. 71, 93.

5703. Mazzone, André. "Blue Sky's Trip to Japan." *Animation World.* December 1999, 12 pp.

5704. Mèredieu, E.-G. "L'éveil Cinématographique du Japon." *Pour Vous.* December 27, 1928, p. 4.

5705. Merrill, David. "Is It Live Or Is It Anime?" *The Rose.* April 1995, pp. 24-25.

5706. Merrill, David. "Made in Japan?" *The Rose.* October 1995, p. 32.

5707. Merriman, Doug, comp. "Atomic Sushi Gallery." In *Atomic Sushi: A Bite of Japanese Animation,* pp. 15-18. Stanmore, Australia: Silicon Pulp Animation Gallery, 2000.

5708. Metzger, Darren. "Bambi's Revenge." *Flatron News.* Fall 1995.

5709. Minamida, Misao. "Kindai Animeshigairon." In *Nijūseikianimetaizen.* Tokyo: Futabasha, 2000.

5710. Misono, Makoto. *Zusetsu Terebianime Zensho.* Tokyo: Hara Shobo, 1999.

5711. Miyazaki, Hayao. "Here Comes Animation." *Kinejun Special Issue.* July 16, 1995.

5712. Moe, Anders. "Understanding Japanese Culture Through Anime." *The Rose.* February 1999, p. 5.

5713. Moffett, Sebastian. "Super Mario's Brothers." *Far Eastern Economic Review.* March 14, 1996, pp. 53-54.

5714. "More Japanese Animation!" *Toon Art Times* (Sydney). March 1993, p. 3.

5715. Napier, Susan J. *Anime from Akira to Princess Mononoke: Experiencing Contemporary Japanese Animation.* New York: Palgrave, St. Martin's, 2001. 304 pp.

5716. "New Anime Section." *Mangazine.* May 1993, p. 5.

5717. "News." *Protoculture Addicts.* August-September 1991, pp. 31-34.

5718. "News." *The Rose.* April 1995, pp. 12-13.

5719. "News." *The Rose.* October 1997, pp. 14-16.

5720. "News." *The Rose.* February 1998, pp. 14-16.

5721. "News." *Tsunami.* Summer 1995, pp. 4-6.

5722. "News." *Tsunami.* Winter 1995, pp. 4-5, 11.

5723. "News and Reviews." *Protoculture Addicts.* April 1990, pp. 30-33.

5724. "News and Reviews." *Protoculture Addicts.* November 1990, pp. 30-33.

5725. "Newsline." *Anime UK.* December 1994/January 1995, pp. 3-4.

5726. "Newscan." *Anime FX.* August 1995, p. 5-7.

5727. Nichols, Peter M. "At Mickey's House, a Quiet Welcome for Distant Cousins." *New York Times.* February 1, 1998, p. 37.

5728. "Now in America." *Manga Mania.* July/August 1998, p. 4.

5729. Okiura, Hiroyuki, Taro Rin, Masaaki Osumi, and Tokumitsu Kifune. "Symposium: The Front of Feature Animation in Japan." *The Japanese Journal of Animation Studies.* 2:1A, 2000, pp. 59-60.

5730. Osaki, Tad. "Comic Books Inspire Fresh Japanese Toons." *Variety.* September 25- October 1, 2000, pp. M44, M46.

5731. Osaki, Tad. "Renewing Interest in Japanese Animation." *Television Asia.* October 1999, pp. 26-27.

5732. Oshiguchi, Takashi. "Anime Déjà Vu, Or 'Didn't I See That Mecha Someplace Before?'" *Animerica.* 2:11 (1994), p. 20.

5733. Oshiguchi, Takashi. "On Action Figures in Japan. Part 2." *Animerica.* 7:4 (1999), p. 60.

5734. Oshiguchi, Takashi. "On Anime and Live Shows." *Animerica.* 5:4 (1997), p. 60.

5735. Oshiguchi, Takashi. "On Anime Publicity Events." *Animerica.* 3:6 (1995), p. 18.

5736. Oshii, Mamoru, Uedo Toshiya, and Itō Kazunori. "Eiga to Wa Jitsu Wa Animēshon Datta." *Eureka.* 28:9 (1996), pp. 50-81.

5737. Osmond. Andrew. "Critical Mass." *Manga Max.* March 2000, pp. 10-12.

5738. Ōtsuka, Eiji. "Yugama Ba Yagate Yonaoshi." *Eureka.* 20:10 (1988), pp. 68-71.

5739. Ouellette, Martin. "The Movie: Studio Clamp." *Protoculture Addicts.* September-October 1997, pp. 26-27.

5740. Parisi, Paula. "Rising Fun." *Hollywood Reporter.* October 3, 1995, pp. A-38, A-40.

5741. Patten, Fred. "The Anime Companion: What's Japanese in Japanese Animation?" *Animation World.* February 1999, 3 pp.

5742. Patten, Fred. "Anime Gets Framed." *Animation Magazine.* November 1996, p. 49.

5743. Patten, Fred. "Anime: A Look Back to 1996." *Animation.* March 1997, pp. 5, 59.

5744. Patten, Fred. "Anime Licensing Grows Up." *Animation.* June/July 1996, p. 6.

5745. Patten, Fred. "By The Numbers." *Manga Max.* July 1999, p. 66.

5746. Patten, Fred. "Japan's Anime." *Animation.* August 1995, pp. 34-36.

5747. Patten, Fred. "What Does 'Anime' Mean?" *Animation.* September 1996, p. 9.

5748. Patten, Fred and Jonathan Clements. "Anime for Beginners: Tezuka's Children." In *Atomic Sushi: A Bite of Japanese Animation,* pp. 6-11. Stanmore, Australia: Silicon Pulp Animation Gallery, 2000.

5749. "Pioneer Anime News." *Animerica.* 3:6 (1995), p. 21.

5750. "Pioneer Anime News." *Animerica.* 3:7 (1995), p. 18.

5751. Poitras, Gilles. "The Japanese Home." *Animeco.* No. 12, 2000, pp. 8-11, 27-28.

5752. "Questions and Answers." *Animag.* No. 5, 1988, p. 33.

5753. Rees, Christina. "This Cartoon Is X-Rated." *Dallas Observer.* September 3, 1998.

5754. Robinson, Gwen. "Anime Territory." *Variety.* June 19-25, 1995, pp. 35, 62.

5755. Robischon, Noah. "In 'Toon. Japanimation Rules on the Web. Can It Take Over U.S. Movie Screen?" *Entertainment Weekly.* October 29, 1999, p. 21.

5756. Root, Tom. "Be an Anime Missionary!" *Animerica.* 7:8 (1999), p. 68.

5757. Routt, William. "De Anime." Paper presented at Australia's Second International Conference on Animation, Sydney, Australia, March 4, 1995.

5758. Saito, Tamaki. *Sentobisōjo No Seishin Bunseki.* Tokyo: Ota Shuppan, 2000.

5759. Sandē Manga Karedji, ed. *Tsukurō! Dōjinshi* (Let's Make Dōjinshi!) Tokyo: Shōgakukan, 1983.

5760. Saperstein, Patricia. "Kids Warm to New Crop of Japanese Toons." *Variety.* January 17-23, 2000, p. N22.

5761. Savage, Lorraine. "Review: Anime Trivia Quizbook." *The Rose.* June 2000, p. 18.

5762. Savage, Lorraine. "The Wonders of Japan." *The Rose.* June 1998, pp. 30-32.

5763. Schilling, Mark. "Animation Wizard Makes Magic with Folklore." *Japan Times.* August 2, 1994.

5764. Schilling, Mark. "Green Guerrillas on Four Feet." *Japan Times.* August 2, 1994.

5765. Schilling, Mark. " 'Memories' May Be Beautiful, and Yet" *Japan Times.* December 19, 1995, p. 12.

5766. Shimotsuki, Takanaka. "Anime Yo Anime! Omae Wa Dare Da!?" *Pop Culture Critique.* No. 0. 1997, pp. 7-18.

5767. Smith, Dennis R. "Finally, Japanimation Standing on Its Own Two Feet." *El Vaquero.* April 8, 1994, p. 8.

5768. Smith, Toren. "News from Japan." *Anime-zine.* No. 2, 1987, pp. 35-38.

5769. Span, Paula. "Cross-Cultural Cartoon Cult." *Washington Post.* May 15, 1997, pp. B1, B4.

5770. "Square Signs with Mouse." *Manga Max.* May 2000, p. 8.

5771. "State of the Art." *Animerica.* 6:11 (1998), pp. 14-15.

5772. Strauss, Bob. " 'Anime'-ed Video." *Animation.* December 1995, p. 17.

5773. Stuever, Hank. "What Would Godzilla Say? At the Japanese Animation Festival, a Brave New World of Hot Pink and Cool Kids." *Washington Post.* February 14, 2000, p. C1.

5774. "Summer Celluloid." *Manga Mania.* October-November 1997, p. 8.

5775. Swallow, Jim. "Anime in Print: CPM Comics." *Anime FX.* August 1995, pp. 12-13.

5776. Takada, Akinori. "Animeeshon Kōzō Bunseki Hōhōron Jōsetsu." *Pop Culture Critique.* No. 0, 1997, pp. 19-39.

5777. "They Say It Was in India." *Manga Mania.* July/August 1998, p. 7.

5778. Townsend, Emru. "Lip Sync." *fps.* Summer 1995, p. 4.

5779. Townsend, Emru and Hitoshi Doi. "Nine Anime Myths." *fps.* September 1994, pp. 18-19.

5780. Ueno, Toshiya. *Kurenai No Metarusutsu Anime To Iu Senjō/Metal Suits the Red Wars in Japanese Animation.* Tokyo: Kodansha, 1998.

5781. Vidal, Jaime. "Barcelona Acogera la Primera Muestra Española de Animación Japonesa." *El Pais* (Madrid). November 26, 1993.

5782. Vrielynck, Robert. "De Tekenfilm in Japan." *Plateau.* Winter 1982, pp. 3-5.

5783. Walters, Barry. "Artful Animation from Japan." *San Francisco Examiner.* April 12, 1996.

5784. "Web Site: AnimeVillage.Com." *The Rose.* October 1998, p. 30.

5785. "Win a Tokima Watch." *Manga Max*. May 2000, p. 7.

5786. Yang, Jeff. "Anime Q and A." *Animerica*. 2:11 (1994), p. 17.

5787. Yang, Jeff. "Anime Q & A." *Animerica*. 3:1 (1995), p. 15.

Criticism

5788. Dean, Michael. "Retailers Alarmed by *Wizard* Ad for She-Male Anime." *Comics Journal*. January 2000, pp. 11-12.

5789. Evans, Peter J. "Crime and Punishment." *Manga Max*. September 1999, pp. 38-43.

5790. Geier, Thom *et al.* "Blood and Guts in Ancient Japan." *U.S. News and World Report*. October 6, 1997.

5791. Gosling, John. "Irresponsible Pictures." *Movie Collector*. May/June 1994, pp. 58-59.

5792. Hirtzy, Michael. "Is the Public's Perception Warrented? [sic]" *The Rose*. October 1998, pp. 3-4.

5793. "Kadokawa President Faces Firing Amid Drug Scandal." *Mangazine*. August 1993, p. 5.

5794. Mazurkewich, Karen. "The Dark Side of Animation." *Far Eastern Economic Review*. August 10, 2000, pp. 56-57.

5795. Oshiguchi, Takashi. "On Violence in Japanese Animation." *Animerica*. 7:6 (1999) p. 66.

5796. Pearson, Lars. "They Never Showed *This* on 'Speed Racer': Can Anime Move Into the Mainstream?" *Comics Buyer's Guide*. February 14, 1997, pp. 69-70.

5797. Rutenberg, Jim. "Violence Finds a Niche in Children's Cartoons." *New York Times*. January 28, 2001, pp. 1, 16.

5798. "Shocking Entertainment." *Asiaweek*. June 9, 2000, p. 17.

5799. Taylor, James S. "Anime Under Fire (Part 4)." *Protoculture Addicts*. September-October 1997, pp. 50-51.

5800. Webster, Andy. "Anime Attack!" *Details*. November 1999, pp. 160-165, 176.

Games and Toys

5801. Adkins, Alexander and Sheldon Montgomery. "Bubblegum Crisis Role-Playing Game and Street Fighter Alpha 2." *The Rose.* January 1997, p. 32.

5802. Aish, Sergei L. "Battle Tycoon." *Animerica.* 3:7 (1995), p. 66.

5803. Aish, Sergei L. "Dragon Force." *Animerica.* 5:2 (1997), p. 63.

5804. Aish, Sergei L. "Guardian Heroes." *Animerica.* 4:5 (1996), p. 64.

5805. Aish, Sergei L. "Keio Yūgeki-tai." *Animerica.* 4:8 (1996), p. 66.

5806. Aish, Sergei L. "Saturn Action – RPG Two-in-One Special." *Animerica.* 4:9 (1996), p. 63.

5807. Aish, Sergei L. "Shining Force." *Animerica.* 3:5 (1995), p. 62.

5808. Aish, Sergei L. "Spotlight Play: Popful Mail." *Animerica.* 3:3 (1995), p. 51.

5809. Aish, Sergei L. "Street Fighter Alpha 2." *Animerica.* 4:12 (1996), p. 63.

5810. Aish, Sergei L. "Super Puzzle Fighter 2X." *Animerica.* 5:4 (1997), p. 64.

5811. Aish, Sergei L. "Twinbee Deluxe Pack." *Animerica.* 3:11 (1995), p. 65.

5812. Aish, Sergei L. "*Virtual On* and *Psychic Force*." *Animerica.* 5:1 (1997), p. 63.

5813. Aish, Sergei L. "World Rally Fever." *Animerica.* 4:7 (1996), p. 66.

5814. "AV Interface." *Animerica.* 4:11 (1996), p. 63.

5815. Bacani, Cesar and Murakami Mutsuko. "Fun and Games." *Asiaweek.* April 18, 1997, pp. 52-56. ("Nintendo").

5816. Berard, Marc. "Ani-Mayhem: Game Review." *The Rose.* October 1996, pp. 32-33.

5817. "Bleem Trouble for Sony Boys." *Manga Max.* August 1999, p. 10.

5818. "A Boy & His Zoid." *Manga Max.* December 1999, p. 10. ("Zoids").

5819. Davis, Julie. "Anime 3D: Fist of the North Star 'Violence Action' Figures, Queen Emeraldas Action Figures." *Animerica.* 6:11 (1998), p. 73.

5820. Davis, Julie. "LM Figure: Lina Inverse." *Animerica.* 6:9 (1998), p. 70.

5821. Dawson, Chester. "Rolling Out the PS2." *Far Eastern Economic Review*. March 2, 2000, p. 15.

5822. Dawson, Chester. "Sony Plays To Win." *Far Eastern Economic Review*. March 2, 2000, pp. 10-12.

5823. "Dr. Brown's Game Crisis." *Animerica*. 8:7 (2000), pp. 76-77.

5824. "Electrosphere." *Manga Max*. August 1999, p. 4.

5825. "E3 Kings." *Manga Max*. July 2000, p. 6.

5826. Evans, P. J. "Role-Playing the Anime Way." *Manga Mania*. January-February 1998, pp. 56-57.

5827. Fox, Kit. "Video Games and Other Amusements: Quo Vadis 2." *Animerica*. 5:8 (1997), p. 63.

5828. "Games Capsule." *Anime UK*. May 1995, p. 48.

5829. "Games Capsule." *Anime UK*. July 1995, pp. 46-47.

5830. "Games, Toys & Music Reviews." *Animerica*. 8:2 (2000), pp. 77, 79, 81, 83.

5831. "Goldsmith, Jill. "Summer: Less Noise for Pic Toys." *Variety*. February 7-13, 2000, pp. 1, 70.

5832. Hamilton, Jay, IV. "Shogun Warriors." *Collectible Toys & Values*. July 1993, pp. 35-37.

5833. Johnstone, Barb. "Playing for Profit: In Sickly Japan Game Maker Thrives." *Far Eastern Economic Review*. November 19, 1992, pp. 72-73.

5834. "Jurassic Horror." *Manga Max*. October 1999, p. 8. ("Dino Crisis").

5835. Kohler, Chris. "Marvel Vs. Capcom." *Animerica*. 8:7 (2000), pp. 78-79.

5836. Kohler, Chris. "Panzer Dragoon Saga." *Animerica*. 6:10 (1998), p. 56.

5837. Kohler, Chris. "Pocket Fighter." *Animerica*. 6:11 (1998), p. 74.

5838. Kohler, Chris. "Shenmue Chapter 1: Yokosuka." *Animerica*. 8:7 (2000), p. 77.

5839. Kohler, Chris. "Shining Force III." *Animerica*. 6:11 (1998), p. 75.

5840. Korkis, Jim. "Japanimation." *Collectible Toys & Values*. July 1993, pp. 46-49.

5841. "Langrisser 2." *Animerica*. 2:11 (1994), p. 37.

5842. Lemieux, Jesse. "Press-Nukem 3D." *The Rose.* April 1997, p. 27.

5843. Luse, Jonathan. "Grandia." *The Rose.* February 1998, p. 12.

5844. Macias, Patrick. "Patrick Macias' Toyboy." *Animerica.* 8:7 (2000), pp. 81-82.

5845. Macias, Patrick. "Toy Boy." *Animerica.* 8:4 (2000), pp. 82-83.

5846. Mason, Paul. "Table Talk, Role-Playing Japanese Style." *Manga Max.* December 1998, pp. 28-31.

5847. "Metal Slug." *Animerica.* 4:6 (1996), p. 61.

5848. Montgomery, Sharon. "Suikoden." *The Rose.* April 1997, p. 30.

5849. Montgomery, Sheldon. "Game Review: Horned Owl." *The Rose.* October 1996, p. 33.

5850. "Nintendo Video Game in Multi-Media US Debut." *Comics International.* September 1998, p. 10.

5851. "Oni." *Manga Max.* September 1999, p. 11.

5852. Oshiguchi, Takashi. "On Action Figures in Japan. Part I." *Animerica.* 7:3 (1999), p. 64.

5853. Oshiguchi, Takashi. "On Adapting Video Games to Animation." *Animerica.* 4:5 (1996), p. 58.

5854. Oshiguchi, Takashi. "On the Japanese Toy Boom in America." *Animerica.* 7:8 (1999), p. 69.

5855. Oshiguchi, Takashi. "On the Popularity of Yu-gi-oh." *Animerica.* 8:7 (2000), pp. 66-67.

5856. "Playstation Panic." *Manga Max.* May 2000, p. 6.

5857. "Play the Game, Watch the Video: Panzer Dragoon." *Animerica.* 4:5 (1996), p. 13.

5858. Raugust, Karen. "Toy Fair: Anime Leads the Way." *Animation.* April 2000, pp. 104-105.

5859. Rehorn, Adam. "Haste Makes Waste! Plan the Coming Attack!" *Animerica.* 8:7 (2000), p. 80.

5860. Rehorn, Adam. "How To Customize Your Model Kits." *Animerica.* 7:11 (1999), pp. 77, 81, 83.

5861. Rehorn Adam. "Mech Works: Getting Started! The Inscrutable Choice." *Animerica.* 8:4 (2000), pp. 80-81.

5862. "Reviews: Games." *Manga Max*. April 1999, pp. 60-61. ("Metal Gear Solid," "Xenogears").

5863. "Reviews: Games, Toys, & Music." *Animerica*. 8:4 (2000), pp. 76-77, 79.

5864. "Reviews: Games, Toys, & Music." *Animerica*. 8:5 (2000), pp. 78-79, 81-83. (Julie Davis, "Star Child"; "Dance Dance Revolution"; Chris Kohler, "Silhouette Mirage"; Daniel Huddleston, "Maison Ikkoku Theme Song"; "Toy Boy"; "Adam Rehorn's MechWorks").

5865. "Reviews: Games, Toys, & Music." *Animerica*. 8:6 (2000), pp. 75-82. (Chris Kohler, "Mario Party 2"; "Dr. Brown's Game Crisis"; Chris Kohler, "Crazy Taxi"; "Patrick Macias' Toyboy"; "Adam Rehorn's "MechWorks.").

5866. Salcido, Mario A. "The Robotech Assault." *Collectible Toys & Games*. July 1993, pp. 27-28.

5867. "Second Eleven." *Manga Max*. May 2000, p. 7.

5868. Sertori, Julia. "Angel Attack." *Manga Max*. December 1998, pp. 32-34.

5869. Simmons, Mark. "1/100 Master Grade Gundam RX-78 GP02A." *Animerica*. 6:10 (1998), p. 55.

5870. Simmons, Mark. "Video Games and Other Amusements: Gundam Shop Vol. 1." *Animerica*. 5:5 (1997), p. 65.

5871. Simmons, Mark. "Video Games and Other Amusements: Gundam 0079: The War for Earth." *Animerica*. 5:9 (1997), p. 62.

5872. "Solid Prospects." *Manga Max*. July 2000, p. 7.

5873. "Spotlight on Granada." *Manga Max*. May 2000, p. 9.

5874. Swallow, Jim. "Games Capsule." *Anime UK*. April 1995, pp. 46-47.

5875. Takaoka, Nova. "Street Fighter III, 'New Generation.'" *Animerica*. 5:6 (1997), p. 64.

5876. Tanner, Ron. "Toy Robots in America, 1955-75: How Japan Really Won the War." *Journal of Popular Culture*. Winter 1994, pp. 125-154.

5877. Teal, James. "Games People Play." *Animerica*. 5:10 (1997), p. 4. ("Vampire Hunter").

5878. Teal, James. "SD Gundam G Century." *Animerica*. 5:10 (1997), p. 63.

5879. Teal, James. "Toshinden 3." *Animerica*. 5:3 (1997), p. 61.

5880. "The Tokyo Game Show." *Manga Max*. November 1999, p. 11.

5881. "Video Games and Other Amusements." *Animerica*. 2:7 (1994), p. 38.

5882. "Walk This Way." *Manga Max*. July 2000, p. 6.

5883. Watson, Paul. "Games Capsule." *Anime FX*. August 1995, p. 51.

5884. Watson, Paul. "Games Capsule: Final Fantasy Demo." *Anime FX*. December 1995, p. 27.

5885. Watson, Paul. "Game Zone." *Anime UK*. December 1994/January 1995, p. 41.

5886. Watson, Paul. "A Hedgehog's Dilemma." *Manga Max*. October 1999, pp. 28-30.

5887. Watson, Paul. "Pocket Monster!" *Manga Max*. January 2000, pp. 44-45.

5888. Watson, Paul. "True Love." *Manga Max*. July 1999, p. 60.

Genre: General Sources

5889. Greenholdt, Joyce. "Widely Available Anime Offers Many Genres." *Comics Buyer's Guide*. February 14, 1997, p. 70.

5890. Lee, William. "From *Sazae-san* to *Crayon Shin-chan:* Family Anime, Social Change, and Nostalgia in Japan." In *Japan Pop!* Edited by Timothy J. Craig, pp. 186-206. Armonk, New York: M. E. Sharpe, 2000.

5891. Lee, William. "From *Sazae-san* to *Crayon Shin-chan:* Family Anime, Social Change, and Nostalgia in Japan." Paper presented at Japanese Popular Culture Conference, University of British Columbia, April 11, 1997.

5892. Macias, Patrick, Kit Fox, and Rio Yanez. "Ghost Stories." *Animerica*. 7:10 (1999), pp. 6, 28-29.

5893. McLennan, Jim. "Get in the Ring." *Manga Max*. March 2000, pp. 46-48. (Women's wrestling).

5894. Schreiber, Dominic. "Cult Heroes and Their Secrets." *Animation World*. April 1998, 4 pp.

5895. Sertori, Julia. "Just Desserts: Eco-Anime." *Anime UK*. April 1995, pp. 14-15.

5896. Wickstrom, Andy. " 'Japanimation' Adult Cartoons Come to U. S." Albany, New York *Times Union*. October 24, 1991, p. T27.

Genre: Apocalyptic Horror, Monster

5897. Brophy, Philip. "Sonic-Atomic-Neumonic: Apocalytic Echoes in Japanese Animation." Paper presented at Australia's Second International Conference on Animation, Sydney, Australia, March 3, 1995.

5898. Cholodenko, Alan. "Apocalytic Anime: In the Wake of Hiroshima, Nagasaki and Godzilla." Paper presented at Society for Animation Studies, Brisbane, Australia, August 4, 1999.

5899. Crawford, Ben. "*Emperor Tomato-Ketchup:* Cartoon Properties from Japan." In *Hibakusha Cinema: Hiroshima, Nagasaki and the Nuclear Image in Japanese Film,* edited by Mick Broderick, pp. 75-90. London: Kegan Paul, 1996.

5900. Hiltbrand, David. "Monster Magnet." *TV Guide.* January 2, 1999, p. 46.

5901. Hollings, Ken. "Dreams of Tall Buildings and Monsters." *Anime FX.* August 1995, pp. 8-10.

5902. Kinoshita, Sayoko. "The Hiroshima Experience." In *Drawing Insight,* edited by Joyce Greene and Deborah Reber, pp. 67-68. Penang: Southbound, 1996.

5903. Leahy, Kevin. "Hideyuki Kikuchi's Talk Live: Hammer Horror Films." *The Rose.* October 1999, pp. 18-19, 29.

5904. McCarthy, Helen. "No More Hiroshimas." *Anime FX.* August 1995, p. 11.

5905. Mizenko, Matthew. "The Monster in the Self: Anime and Identity." Paper presented at Mid Atlantic Region Association for Asian Studies, Newark, Delaware, October 25, 1998.

5906. Napier, Susan J. "Panic Sites: The Japanese Imagination of Disaster from Godzilla to Akira." *Journal of Japanese Studies.* 19:2 (1993), pp. 327-351.

5907. Napier, Susan J. "Panic Sites: The Japanese Imagination of Disaster from *Godzilla* to *Akira.*" In *Contemporary Japan and Popular Culture,* edited by John W. Treat, pp. 235-261. Honolulu: University of Hawaii Press, 1996.

5908. Natsume, Fusanosuke. "Goblins, Hobgoblins, and the Folly of War." *Look Japan.* December 1995, pp. 20-21.

5909. Oshiguchi, Takashi. "Japan, Land of Demons!" *Animerica.* 7:12 (1999), p. 67.

5910. Strom, Frank E. "On the Trail of the Elusive Japanese Monster." *Anime-zine*. No. 2, 1987, pp. 30-34.

5911. "Uh?! Chronicle of the Odd and Bizarre." *Protoculture Addicts*. April 1990, p. 10.

5912. "Uh?! Chronicle of the Odd and Bizarre." *Protoculture Addicts*. November 1990, pp. 7-8.

Genre: Erotic, Porn

5913. Akagi, Akira. "Bishojo Shokogun Rorikon to luu Yokubo." In *New Feminism Review: Pornography*. Vol. 3. Tokyo: Gakuyo Shobo, 1993.

5914. "The Erotic Anime Movie Guide." *Manga Max*. December 1998, 16 pp. supplement.

5915. French, Todd. "To the Extreme: Don't Go There, Girl: Does *Cool Devices* Island Holiday Go Too Far?" *AnimeFantastique*. Fall 1999, p. 56.

5916. Funabashi, Kuniko. "Pornographic Culture and Sexual Violence." In *Japanese Women: New Feminist Perspectives on the Past, Present and Future,* edited by Kumiko Fujimura–Fanselo and Atsuko Kameda. New York: The Feminist Press, 1995.

5917. Haden-Guest, Anthony. "Who Killed Bambi? *World Art*. No. 1, 1995, pp. 42-47.

5918. Komotada, Emai. "Jissaku Onna no Erochika" (Actual Work: Women's Eroticism). In *New Feminism Review: Pornography*. Vol. 3 Tokyo: Gakuyo Shobo, 1993.

5919. Napier, Susan J. "The Frenzy of Metamorphosis: The Body in Japanese Pornographic Animation." In *Word and Image in Japanese Cinema,* edited by Dennis Washburn and Carole Cavanaugh, pp. 342-365. Cambridge: Cambridge University Press, 2001.

5920. Patten, Fred. "The Anime 'Porn' Market." *Animation World*. July 1998, 8 pp.

5921. Rosenblum, Trudi M. "Labels Fill Demand for Adult Cartoons." *Billboard*. October 9, 1993, pp. 81, 83.

5922. Sertori, Julia. "Only the Lonely." *Manga Max*. December 1998, pp. 6-7.

Genre: Girls'

5923. Bissey, Laura. "The Seductive World of Shoujo Anime." *Sequential Tart*. March 2000.

5924. Camp, Brian. "Girls in Cartoons: Japan's Pioneers." *New York Times*. September 24, 2000, p. AR4.

5925. Cooper-Chen, Anne. "An Animated Imbalance: Japan's Television Heroines in Asia." *Gazette*. 61:3/4 (1999), pp. 293-310.

5926. Endresak, Dave. "Commentary." *The Rose*. July 1995, p. 7.

5927. Goldberg, Wendy. "The Homosexual Male in Girl's (*Shouja*) Anime." Paper presented at Popular Culture Association, Philadelphia, Pennsylvania, April 14, 2001.

5928. Hamilton, Robert. "Synthetic Girls: The Seduction of Artifice in Anime, 'Kisekae' Dolls, and Kyoko Date." Paper presented at Japanese Popular Culture Conference, Victoria, Canada, April 11, 1997.

5929. Iwamura, Rosemary. "Blue Haired Girls with Eyes So Deep, You Could Fall into Them. The Success of the Heroine in Japanese Animation." In *Kaboom! Explosive Animation in America and Japan*, pp. 66-75. Sydney: Museum of Contemporary Art, 1994.

5930. Keveney, Bill. "'Girls' Tribute: If This Doesn't Beat All." *USA Today*. January 19, 2001, p. 1E.

5931. Macias, Patrick. "Seven Types of Anime Dream Girls." *Animerica*. 7:4 (1999), p. 26.

5932. Monnet, Livia. "The *Shōjo* as Spectral Double: Understanding Remediation in Recent Japanese Anime and Film." Paper presented at Association for Asian Studies, San Diego, California, March 10, 2000.

5933. Scott, Christine. "Beautiful Boys, Bishounen! The Anime Eye-Candy for Females." *Sequential Tart*. February 2001.

5934. Tobenkin, David. "Where the Girls Are." *Broadcasting and Cable*. July 24, 1995, p. 46.

5935. Zimmerman, Eve. "Tsushima Yuko's *Moeru Kaze* (Fiery Wind): The *Shōjo* Takes Flight" Paper presented at Association for Asian Studies, San Diego, California, March 10, 2000.

Genre: Robots

5936. Gilson, Mark. "A Brief History of Japanese Robophilia." *Leonardo* 31 (5, 1998), p. 367.

5937. Granveldt, Brian. "Teen-age Ninjas, Time-Traveling Heroes, and Hundreds and Hundreds of Giant Robots! The World of 'Anime.'" *Comics Buyer's Guide.* December 29, 1995, pp. 26-28.

5938. "Japantasy." *Oriental Cinema.* January 1994, pp. 17-22.

5939. Oslund, Karen. "Men, Women, and Killer Robots: Gender Identification in Japanese Animation." Paper presented at Asian Popular Culture Conference, Victoria, Canada, April 18, 1998.

5940. "Robo Heroes Phase 1: Gavan." *Oriental Cinema.* May 1994, pp. 4-8.

5941. "Robo Heroes: Phases 2, 3." *Oriental Cinema.* May 1994, pp. 9-13.

5942. Snyder, Stephen B. "Giant Robots/Distant Fathers: Size and Anxiety in Japanese Animation." Paper presented at Association for Asian Studies Meeting, San Diego, California, March 11, 2000.

5943. Teal, James. "Mecha File: A Continuing Series on the Mechanics and Robots of Japanese Animation." *Animag.* No. 5, 1988, pp. 34-35.

Governance

5944. Haring, Bruce. "Japanese Animation Tones Down for Mainstream." *USA Today.* August 15, 1995.

5945. Herskovitz, Jon. "Japan Sets New Toon Regs." *Variety.* April 14, 1998, p. 7.

5946. "J. A.I. L. E. D. Busts Dealer and Takes Pocession [sic] of 10,000 Illegal Videos." *Animato!* Fall 1995, p. 8.

5947. "Japan Moms Call for Animation Standards." *Toon.* Spring 1998, p. 8.

5948. "Seizures Spur Animation Guidelines." *Asian Mass Communications Bulletin.* September-October 1998, p. 16.

Guides, Overviews

5949. *Atomic Sushi: A Bite of Japanese Animation.* Exhibition, Stanmore, Australia, 11 August-14 October 2000. Stanmore: Silicon Pulp Animation Gallery, 2000. 32 pp.

5950. Baricordi, Andrea, Massimiliano De Giovanni, Andrea Pietroni, Barbara Rossi, Sabrina Tunesi. *Anime, Guida al Cinema d 'Animazione Giapponese.* Bologna: Granata Press, 1991.

5951. Baricordi, Andrea, Massimiliano De Giovanni, Andrea Pietroni, Barbara Rossi, Sabrina Tunesi. *Anime: A Guide to Japanese Animation (1958-1988).* Montreal: Protoculture Enr., 2000. 311 pp. English edition.

5952. Levi, Antonia. "New Myths for the Millennium: Japanese Animation." In *Animation in Asia and the Pacific,* edited by John A. Lent, pp. 33-50. Sydney: John Libbey & Co., 2001.

5953. Levi, Antonia. *Samurai from Outer Space: Understanding Japanese Animation.* Chicago, Illinois: Open Court, 1996, 169 pp.

5954. McCarthy, Helen. *The Anime! Movie Guide. Movie-by-Movie Guide to Japanese Animation Since 1983.* London: Titan Books, 1996. 285 pp.

5955. Museum of Contemporary Art, Sydney, ed. *Kaboom! Explosive Animation from America and Japan.* Sydney: Museum of Contemporary Art, 1994. 159 pp.

5956. Napier, Susan J. *Anime from Akira to Princess Mononoke.* New York: Palgrave, 2000. 311 pp.

5957. Park, In-ha. *Animega Bogosipda* (I Want To See Anime). Seoul: Kyobomungo, 1998.

5958. Park, Taegyun. *Japanimationi Sesangeul Jibaehaneun Iyu* (The Reason Why Japanimation Conquers the World). Seoul: Gilbeot, 1997.

5959. Pearl, Steve. "Anime Clubs in America." Paper presented at Japan Society Symposium on Anime, New York, January 1999.

5960. Poitras, Gilles. *The Anime Companion: What's Japanese in Japanese Animation?* Berkeley, California: Stone Bridge Press, 1999. 163 pp.

5961. Raffaelli, Luca. *Le Anime Disegnate: Il Pensiero nei Cartoon da Disney ai Giapponesi.* Rome: Castelvecchi, 1994, 1995. 183 pp.

5962. Satō, Kenji. "More Animated Than Life: A Critical Overview of Japanese Animated Films." *Japan Echo.* December 1997, pp. 50-53.

5963. Schilling, Mark. *Contemporary Japanese Film.* New York: Weatherhill 1999. 399 pp.

Impacts

5964. Endo, Tomoyoshi, Akio Kasuga, and Naomi Takano. "Symposium: Education and Animation." *The Japanese Journal of Animation Studies.* 2:1A, 2000, pp. 56-57.

5965. Evans, Peter J. "Mind Players." *Manga Max.* August 1999, pp. 30-34.

5966. Gosling, John. "The Hidden World of Anime." *Animation World.* August 1996, 4 pp.

5967. Gribbish, Irving. "Storming the Ramparts of Childhood: Personality, Cartoons and Other Considerations." In *Kaboom! Explosive Animation from America and Japan,* pp. 17-29. Sydney: Museum of Contemporary Art, 1994.

5968. Kodaira, Imaizumi. "Children Learn from Watching TV Programs: Experiences in Japan." *Broadcasting Culture and Research.* No. 7, 1999, pp. 9-13.

5969. Levi, Antonia. "The Animated Shrine: Using Japanese Animation To Teach Japanese Religion." *Education About Asia.* Spring 1997, pp. 26-29.

5970. Suen, Li-Cheng. "The Influence of Japanese Animation on Youth Culture and Consumer Culture." Master's Thesis, National Chengchi University, Communication School, 1998.

Music

5971. "CD Reviews." *The Rose.* July 1996, pp. 30-31.

5972. Clements, Jonathan. "Japan Rocks!" *Anime UK.* December 1994/January 1995, pp. 24-26.

5973. Clements, Jonathan. "Japan Rocks." *Anime UK.* May 1995, pp. 12-13.

5974. Clements, Jonathan. "Japan Rocks: The Condition of Muzak." *Anime UK.* April 1995, pp. 12-13.

5975. Clements, Jonathan. "Japan Rocks! The Frank Chickens." *Anime UK.* July 1995, pp. 16-17.

5976. Clements, Jonathan. "Japan Rocks: If You Go Down to the Woods Today." *Anime FX.* February 1996, p. 17.

5977. Clements, Jonathan. "Japan Rocks: Now That's What I Call Music." *Anime FX.* January 1996, pp. 22-23.

5978. Clements, Jonathan. "Sing Japanese." *Anime UK.* July 1995, p. 52.

5979. Clements, Jonathan. "Sounds Out East." *Manga Mania.* March-April 1998, p. 77.

5980. Craig, Mark, *et al.* "CD Reviews." *The Rose.* February 1999, p. 29. ("End of Evangelion," "Sailors Stars," "Sailor Moon Memorial Box," "Sailor Moon Complete Vocal Collection").

5981. Davis, Julie. "The Compact View." *Animerica.* 2:12 (1994), p. 65.

5982. Davis, Julie. "The Compact View." *Animerica.* 3:1 (1995), p. 63.

5983. Evans, Peter J. "Heart & Soul." *Manga Max.* July 2000, pp. 36-40.

5984. "Japan's Bestselling LDs." *Animerica.* 3:12 (1995), p. 18.

5985. Lau, John, Phil Yee, and Trish Ledoux. "The Compact View." *Animerica.* 4:5 (1996), p. 64.

5986. Leahy, Kevin. "Anime Karaoke – A New Spin." *The Rose.* April 1997, p. 29.

5987. "Lyrics." *Protoculture Addicts.* November 1990, p. 9.

5988. Nadzam, John. "Background Radiation." *The Rose.* April 1995, p. 29.

5989. "Song Lyrics." *The Rose.* April 1995, p. 30.

5990. Staley, James and Burke Rukes. "Giant Robo 1." *The Rose.* April 1997, p. 32.

5991. Torres, Rey, Jr. "Fan Music Videos: Comedy Versus Other Genres." *The Rose.* April 1997, p. 5.

5992. "Tunes from Toons." *fps.* September 1994, pp. 22-26.

Portrayals

5993. Izawa, Eri. "The Romantic, Passionate Japanese in Anime: A Look at the Hidden Japanese Soul." In *Japan Pop!* edited by Timothy J. Craig, pp. 138-153. Armonk, New York: M. E. Sharpe, 2000.

5994. Izawa, Eri. "The Romantic, Passionate Japanese in Anime: A Look at the Hidden Japanese Soul." Paper presented at Japanese Popular Culture Conference, University of British Columbia, April 10, 1997.

5995. Moore, Pauline. "Cuteness (Kawaii) in Japanese Animation: When Velvet Gloves Meet Iron Fists." Paper presented at Australia's Second International Conference on Animation, Sydney, Australia, March 3, 1995.

5996. Raffaelli, Luca. "Conflicts Between Generations in the Animated Series." Paper presented at Society for Animation Studies, Greensboro, North Carolina, October 1, 1995.

5997. Rolandelli, D. "Gender-Role Portrayal Analysis of Children's Television Programming in Japan." *Human Relations.* 44:12 (1991), pp. 1273-1299.

Studio Ghibli

5998. *Archives of Studio Ghibli.* Vols. 1-5. Tokyo: Tokuma Shoten, 1995 -.

5999. Dauphin, Gary. "Japanimation's All-Ages Show." *Village Voice.* September 15, 1999.

6000. De Giovanni, Massimiliano. "Il Ghibli Che Soffia dall' Este." *Kappa Magazine.* August 1992.

6001. *Kinema Jimpo.* Special issue on Hayao Miyazaki, Isao Takahata, and the Animation of Studio Ghibli. July 1995, 166 pp.

6002. Nguyen, Ilan. "Aux Sources du Studio Ghibli." *Animeland* (Paris). July 1996.

6003. Suzuki, Toshio. "Animation Studios 'Ghibli,' Japan." *Animatoon.* 2:4-1 (1996), pp. 42-50.

6004. Suzuki, Toshio. "Studio Ghibli of Internationally-Famous Director Miyazaki." *Animatoon.* No. 4, 1996, pp. 42-50.

6005. Suzuki, Toshio. "Ten Years of Studio Ghibli." In *Archives of Studio Ghibli 1.* Tokyo: Takuma Shoten, 1995.

Technical Aspects

6006. "Analysis: Digitization Zooms in on Japan's Film Industry." *Asia Pulse.* May 16, 1997.

6007. Bordwell, David. "Stylistic Transformations Between Live-Action and Animation in Japanese Cinema." Paper presented at Society for Animation Studies, Madison, Wisconsin, September 28, 1996.

6008. "Cartoni e Computer." *If.* December 1983, p. 48.

6009. Clements, Jonathan. "The Mechanics of the U. S. Anime and Manga Industry." *Foundation: The Review of Science Fiction.* Summer 1995, pp. 32-44.

6010. "DVDividends." *Manga Max.* January 1999, p. 6.

6011. "DVD Killed the Video Star." *Manga Max.* July 2000, p. 7.

6012. Evans, Peter J. "Tokyo Mirrorshades." *Anime UK.* December 1994/January 1995, pp. 18-21.

6013. Gomarasca, Alessandro. "Mechanized Bodies, Exoskeletons, Powered Suits: The Metaphors of Technodress in Japanese Animation." In *Re-Orienting Fashion,* edited by Brian Moeran and Lise Skov. Richmond, Surrey: Curzon Press, forthcoming.

6014. Kawaguchi, Yoichiro. "Creation of Original Survival CG Arts." *The Japanese Journal of Animation Studies.* 2:1A, 2000, p. 55.

6015. Kim, Jun-yang. "Techno-orientalism of Japanimation in the 90s." *Kino.* February 1998, pp. 106-109.

6016. Macias, Patrick. "Experimental Animé." *Animerica.* 7:6 (1999), pp. 67-69.

6017. Mangels, Andy and Richard A. Scott. "Anime DVDs Bring the Manga World to Life." *Comics Buyer's Guide.* June 29, 2001, pp. 22-23.

6018. Mangels, Andy and Richard A. Scott. "Manga-Based Anime Is Available on Many DVDs." *Comics Buyer's Guide.* June 29, 2001, pp. 36-45.

6019. Oshiguchi, Takashi. "About Animation Character Design." *Animerica.* 4:4 (1996), p. 57.

6020. Oshiguchi, Takashi. "On Computer Graphics in Anime." *Animerica.* 7:2 (1999), p. 64.

6021. Oshiguchi, Takashi. "On Mecha Design in Anime." *Animerica.* 8:3 (2000), pp. 63-64, 66.

6022. "Picture Techniques Used in Animation Programs, Etcetera." *Broadcasting Culture and Research.* Summer 1998, pp. 17-18.

6023. "Sony Imageworks Adds NT Systems." *Animation.* August 1999, p. 27.

6024. Swallow, Jim. "Dubble Impact." *Manga Max.* March 1999, p. 54.

6025. Tateishi, Ramie. "Nostalgia Technology and Giant Robot." Paper presented at Popular Culture Association, San Diego, California, April 1, 1999.

6026. Toshiya, Ueno. "Japanimation and Techno-Orientalism." *Documentary Box.* No. 9, 1996, pp. 1-5.

6027. Wales, Lorene. "Humanipulation: Theoretical Considerations in the Computer Animated Manipulation of the Human Image in Feature

Film." Paper presented at Society for Cinema Studies, West Palm Beach, Florida, April 15-18, 1999.

6028. Wexler, Barbara. "Putting Special Effects in Live Action." *Animation.* April 1997, pp. 87, 89.

6029. Wilkinson, Bryan C. "Cel Composition." *fps.* Summer 1995, pp. 18-19.

6030. Wilkinson, Bryan. "Cel Compositions: A Whimsical But Technical Look at Our Favorite Anime and Manga." *fps.* Autumn 1995, pp. 38-39.

6031. Yamamoto, Hiroki. "Research on the Cutting Technique in Animated Cartoons." *Japanese Journal of Developmental Psychology.* 4:2 (1993), pp. 136-144.

Television

6032. "Anime TV Explosion!" *Animerica.* 8:7 (2000), pp. 6-8.

6033. "Digital Satellite TV in Japan: Which Future for International Programmes?" *Animatoon.* No. 16, 1998, p. 57.

6034. "Il Sistema Televisivo Giapponese." *If.* December 1983, pp. 52-56.

6035. "Is It Real, Or Is It a Virtua Fight? *Virtua Fighter."* *Animerica.* 3:12 (1995), pp. 16-17.

6036. Leahy, Kevin. "Yat: Safe Space Travel." *The Rose.* April 1997, pp. 19-20.

6037. Morikawa, Kathleen. "Tyke TV." *Mangajin.* December 1997, pp. 30-33, 71.

6038. Moriyama, Ayumi. "24-Hour Cartoon Channel to Debut in Japan." *The Rose.* July 1997, p. 27.

6039. Morris, Mark. "Tokyo Calling: For Anyone Who Watches a Lot of TV, Japanese Culture Is an Open Book – It's All Crazy Cartoons." *Guardian.* August 4, 2000, Features, p. 13.

6040. Osaki, Tad. "TV Tokyo Readies 'Monster' Invasion." *Daily Variety.* November 10, 1998, p. 41.

6041. Oshiguchi, Takashi. "On Japan's 2000 Anime TV Series." *Animerica.* 8:1 (2000), p. 69.

6042. Patten, Fred. "TV Animation in Japan." *Fanfare.* Spring 1980, pp. 9-18.

6043. "Sizzling Summer for the Small Screen." *Manga Mania.* July/August 1998, p. 4.

6044. "TV Update." *Animerica.* 5:2 (1997), p. 14.

6045. "TV Update." *Animerica.* 5: 7 (1997), p. 13.

6046. "TV Update." *Animerica.* 5:10 (1997), p. 13.

6047. "24-Hour Cartoon Network To Launch in Japan." *Asian Mass Communications Bulletin.* July/August 1997, p. 9.

6048. "What's New in Japan? New Fall TV Season." *Animerica.* 5:10 (1997), pp. 12-13.

6049. Yuasa, Manabu. "Japanese TV Animation in the Early Years." In *Kaboom! Explosive Animation in America and Japan,* pp. 59-65. Sydney: Museum of Contemporary Art, 1994.

Theme Parks

6050. Brannen, Mary Y. "'Bwana Mickey': Constructing Cultural Consumption at Tokyo Disneyland." In *Culture of United States Imperialism,* edited by Amy Kaplan and Donald E. Pease, pp. 617-634. Durham, North Carolina: Duke University Press, 1993.

6051. Dawson, Chester. "Tokyo's Toon Town." *Far Eastern Economic Review.* November 11, 1999, p. 52.

6052. Herskovitz, Jon. "New Mouse Pagoda." *Daily Variety.* October 23, 1998, p. 6.

6053. Kristof, Nicholas D. "Disney's Tokyo Kingdom." *New York Times.* August 27, 1995.

6054. Littardi, Cedric. "Animation: Adults May Not Be Unwelcome (But Jeez, What Would They Be Doing There?)." *Animation World.* July 1999, 4 pp.

6055. "Mickey Mouse and Japan." *Education about Asia.* Spring 2000, p. 37.

6056. Nolasco, Paul. " A Slice of American Life." *Asahi Evening News.* November 26, 1993.

6057. O'Brien, T. "New Sesame Japan Themer a Hit with Tokyo Youth." *Amusement Business.* February 25, 1991, p. 38.

6058. Raz, Aviad E. "Domesticating Disney: Onstage Strategies of Adaptation in Tokyo Disneyland." *Journal of Popular Culture.* Spring 2000, pp. 77-99.

6059. Raz, Aviad E. *Riding the Black Ship: Japan and Tokyo Disneyland.* Cambridge: Harvard University Press, 1999. 240 pp.

6060. Tanikawa, Miki. "Fun in the Sun: Newly Rich Asians Help Sustain Japan's Theme Park." *Far Eastern Economic Review*. May 29, 1997, pp. 56-57.

6061. Tanikawa, Miki. "A Thrill a Minute." *Far Eastern Economic Review*. May 29, 1997, pp. 56-57.

6062. "Tokyo Disney Is a Park's Pioneer." *Japan Times*. April 14, 1994.

Comic Strips

6063. Austin, Theresa. "What's So Funny: Appreciating Japanese Humour." *Journal of Asian Pacific Communication*. 5:1/2, 1994, pp. 57-88.

6064. Bumiller, Elisabeth. "Working 9 to 5, Tokyo Style: Japan's Comic Strip of Secretaries Who Just Wanna Have Fun." *Washington Post*. June 25, 1991, pp. D1, D4.

6065. Davis, Julie. "Outer Limits." *Animerica*. 8:4 (2000), p. 4.

6066. "Japanese Show Helps Kids Develop Taste for Cooking." Albany, New York *Times Union*. October 27, 1991, p. T42.

6067. Maynard, Senko K. "Interrogatives That Seek No Answers: Exploring the Expressiveness of Rhetorical Interrogatives in Japanese." *Linguistics*. 33:3 (1995), pp. 501-503.

6068. Murata, Natsuko. "The Effects of Comic Strips as a Teaching Strategy." *Science of Reading*. December 1993.

6069. Oshiro, Y. and M. Fukuhara. "Impressions of Comic Strips and Comic Strip Heroes: A Multidimensional Scaling of Comic Strip Perceptions." *Science of Reading*. December 1990.

6070. Pols, Hans. "Strips in Japan, Een Vrijwel Onbekend Maar Eindeloos Terrein." *Stripschrift*. No. 202, 1986, pp. 13-25.

Manga (Comic Books)
General Sources

6071. *AERA Mook: Komikkugaku no Mikata*. Tokyo: Asahi Shinbunsha, 1997.

6072. Allison, Anne. *Permitted and Prohibited Desires: Mothers, Comics, and Censorship in Japan*. Boulder, Colorado: Westview Press, 1996. 225 pp.

6073. *The Analysis of Kōkakukidōtai*. Tokyo: Kodansha, Young Magazine, 1995.

6074. "Angel of Darkness." *Manga Max.* March 1999, pp. 64-65.

6075. Aramata, Hiroshi. *Manga to Jinsei* (Manga and Life). Tokyo: Shūeisha, 1994.

6076. Aufenanger,Stefan. "Zur Rezeptionssituation von Zeichentrickfilmen aus Japanischer Produktion für Kinder in der Bundesrepublik Deutschland." In Deutsches Jugendinstitut, comp. *Kinderfernsehen und Fernsehforschung in Japan und der Bundesrepublik Deutschland,* pp. 131-143. Munich, 1989.

6077. "Basic Japanese Through Comics." *Mangajin.* May 1995, pp. 38-43.

6078. "Basic Japanese Through Comics. Lesson 49." *Mangajin.* October 1995, pp. 102-107.

6079. Berndt, Jaqueline. "Bilderwelten. Popularität des Manga und Visualitätskultur." In *Ästhetik und Ästhetisierung in Japan. Referate des 3. Japanologentages OAG in Tokyo,* edited by Werner Schaumann, pp. 41-54. Munich: iudicium Verlag, 1994.

6080. Berndt, Jaqueline. "Comics in Japan." *Lexikon der Comics, Teil 3: Themen und Aspekte.* Meitingen: Corian-Verlag Heinrich Wimmer, 26. Erg. – Lfg, 1998. 75 pp.

6081. Berndt, Jaqueline. *El Fenōmeno Manga.* Barcelona: Ediciones Martinez Rosa, 1996. 204 pp.

6082. Berndt, Jaqueline. "Im Land der Bilder (Comic-Land Japan)." *Form + zweek. Zeitschrift für Gestaltung.* December 1992, pp. 14-21.

6083. Berndt, Jaqueline. "Japanische Bilderwelten. Popularität des Manga und Visualitätskultur. Comics Anno." In *Jahrbuch der Forschung zu Populär-Visuellen Medien,* Vol. 3, edited by H. Jürgen Kagelmann, pp. 228-240. Munich/Vienna: Profil, 1995.

6084. Berndt, Jaqueline. "Japanische Massenkultur in Wandel: Ästhetisch-Kulturelle Prozesse im Gegenwärtigen Japan am Beispiel Massenliterarischer Bestseller und Manga" (Japanese Mass Culture in Changing Times: Aesthetic and Cultural Processes in Comtemporary Japan – The Example of Bestseller and Manga for the Mass Literary Market). Ph. D. dissertation, Humboldt Universität zu Berlin, 1990. 170 pp.

6085. Berndt, Jaqueline. "Japanische Populärkultur als Forschungsgegen-stand." 1997, pp. 43-63.

6086. Berndt, Jaqueline. "Kunstgehduse: Über den Musealen Ort Moderner Kunst in Japan." *Japanstudien Jahrbuch des Deutschen Instituts für Japanstudien.* Vol. 9, 1997, pp. 175-198.

6087. Berndt, Jaqueline. *Manga no Kuni Nippon: Nihon no Taishû Bunka, Shikaku Bunka no Kanôsei* (A Country of Comics, Japan: The Possibilities of Japanese Popular Culture and Visual Culture). Tokyo: Kodansha, 1994.

6088. Berndt, Jaqueline. *Phänomen Manga: Comic-Kultur in Japan.* Berlin: Edition Q, 1995.

6089. Berndt, Jaqueline. "'Verkunstung' des Comics. Wo Sich Japanisch Kunstwissenschaft und Mangastudien Bislang Begegnen." *Thesis* (Wissenschaftliche Zeitschrift de Bauhaus-Universität Weimar). 6. Heft 1998, 44. Jg." Disorientiert: Japan, der Western und der Ästhetizentrismus, pp. 52-73.

6090. Berndt, Jaqueline. "Zeitgenossische Asiatische Kunst in Japan: Bericht über Einen Lernprozeß." In Steffi Richter, ed. *Modernen in Ostasien,* pp. 98-118. Leipzig: Leipziger Universitätsverlag, 1998.

6091. *Bessatsu Shinpyō: Sanryūgekiga no Sekai* (The World of Third-Rate Graphic Novels). Spring 1979. Shinpyōsha.

6092. *Bessatsu Takarajima 104: Otaku no Hon* (Takarajima Supplement 104: The Otaku Book). Tokyo: Takarajima-sha, 1989.

6093. Bijnsdorp, Léon. "Manga Mania." *Stripschrift.* November 1995, pp. 22-26.

6094. "Book Giveaway." *Manga Mania.* October-November 1997, p. 81.

6095. "Books Nippan." *Mangazine.* November 1994, p. 4.

6096. Brady, Matt. "A 'Kabuki' Kartoon." *Comics Buyer's Guide.* December 25, 1998, p. 12.

6097. Brown, Urian. "Nightmares, Monsters, and Understanding." *Animerica.* 7:10 (1999), p. 67.

6098. Buckley, Sandra. "Penguin in Bondage: A Graphics Tale of Japanese Comic Books." In *Technoculture,* edited by Constance Penley and Andrew Ross, pp. 163-196. Minneapolis: University of Minnesota Press, 1991.

6099. Burdorf, Jeanne, *et al.* "Read This or Die: Manga Manga!" *Sequential Tart.* February 2001.

6100. Bush, Laurence. "Quest for Manga." *The Rose.* February 1999, pp. 24-25.

6101. Charbonnier, Jean-Marie. "Manga: Bulles de Japon." *Beaux Arts Magazine.* December 1999, p. 34.

6102. Chung, Steve. "'Why Comics?' – From the Seventies to Now." *Sequential Tart.* February 2001.

6103. Clements, Jonathan. "Mangaka." *Comic World.* February 1995, p. 28.

6104. Coleman, Joseph. "Comics Aren't Just for the Young in Japan." *Athens Daily News/ Athens Banner-Herald* (Athens, Georgia). August 3, 1997.

6105. Coleman, Joseph. "Japan Takes Comic Books to Next Level." Albany *Times Union.* July 28, 1997.

6106. "Comic Box: Manga 1993-1994." Expanded edition of June/July *Comic Box Jr.* July 1994.

6107. Cooper-Chen, Anne. *Mass Communication in Japan.* Ames: Iowa State University Press, 1997. (Manga, pp. 20, 98-103, 139, 149, 160, 170, 178-179, 211).

6108. "Copyrighted Manga in Asia." *Japanese Book News.* 7 (1994), p. 20.

6109. Cote, Mark. "Crossed Hairs." *Intersect.* February 1993, pp. 23-26.

6110. Couch, John S. "Japan's Dreaming." *Wired.* January 1997, p. 174.

6111. *Da Vinci* (Tokyo). 6/1994: "Manga de Yomuzo! Kinmirai Nippon." 10/1994: "Manga Okoku no Tamate-bako."

6112. de Spiegeleer, Chantal. "Marc Michetz: De Stijgende Ster van de Rijzende Zon." *Stripschrift.* December 1991, pp. 4-6.

6113. "Dial M for Manga." *Asiaweek.* January 28, 2000, p. 11.

6114. "'Die Wanna Manga!'" *Manga Max.* April 1999, p. 17.

6115. "Eclectic: Japanese Manga." *The Economist.* December 16, 1995, p. 81.

6116. "El Relax Que Vino del Sol Naciente." *Trix.* November 1993, p. 79.

6117. "F.A.C.T.S. III." *Stripschrift.* September 1994, p. 30.

6118. Flores, José Ma. "Pequeñas Tragedias Cotidianas." *El Wendigo.* No. 76, 1997-1998, pp. 12-13.

6119. Flórez, Florentino. "La Madre de Todos los Mangas." *El Wendigo.* No. 74-75, 1997, pp. 8-11.

6120. French, Howard W. "Japan's Resurgent Far Right Tinkers with History." *New York Times.* March 25, 2001.

6121. Fujioka, Wakao. *Sayonara, Taishû! Kanjô Jidai o Dô Yomi Ka.* Tokyo: PHP, 1984.

6122. Fijishima, Ushaku. "Manga Kara Guga e." *Honbako* (Tokyo). No. 6, 1991, pp. 30-37.

6123. Fukushima, Akira. *Manga to Nihonjin: "Yūgai" Komikku Bokokuron o Kiru* (Manga and the Japanese: Dissecting the Myth of "Harmful Comics" Ruining the Nation). Tokyo: Nihon Bungeisha, 1992.

6124. Funck, Carolin. "Girl, Girls, Girls. Die Takarazuka-Revue als Traumfabrik." *Japan Magazin* (Bonn). 12/1993, pp. 24-28.

6125. Gendai Fūzoku Kenkyū kai, ed. *Manga Kankyō: Gendai Fūzoku '93* (The Manga Environment: Current Public Morals and Manners, 1993). Tokyo: Riburopōto, 1993.

6126. *Gendai Manga no Techō* (Handbook of Modern Manga). Special supplement of *Kokubungaku: Kaishaku to Kyōzai no Kenkyū.* April 1981.

6127. Groensteen, Thierry. *Il Mondo dei Manga, Introduzione al Fumetto Giapponese.* Bologna: Granata Press, 1991.

6128. Groensteen, Thierry and Harry Morgan. *L' Univers des Mangas: Une Introduction a la Bande Dessinée Japonaise.* 2nd Edition. Tournai: Casterman, 1996.

6129. Hammitzsch, Horst, ed. *Japan Handbuch.* Stuttgart: Franz Steiner, 1990.

6130. Helms, Shelly. "Manga Mayhem: A Brief Introduction to Super Manga Blast and Animerica Extra." *Sequential Tart.* March 2001.

6131. Hodenpilj, Willem. "Jidaimono, Achtergronden Bij de Samoeraistrip." *Stripschrift.* August 1998, pp. 14-19.

6132. Horn, Carl G. "American Manga: Why Many American Comic Artists Are 'Turning Japanese.'" *Wizard.* April 1996, pp. 52-57.

6133. Horn, Carl G. "Manga Morning Surprise." *Animerica.* 5:5 (1997), pp. 58-59.

6134. Horn, Maurice. "Comix International." *Heavy Metal.* November 1986, pp. 7, 74-78.

6135. Hughes, David and Jonathan Clements. "Arts: Manga Goes to Hollywood." *The Guardian.* April 14, 1997.

6136. Hwang, Jae Sun, trans. "The Current Tendency of Japanese Cartoon Theory/Enlightening Cartoon Theory Regarded As Authentic." *Manhwa Teah.* Winter 1995, p. 44-46.

6137. Inoue, Manbu, ed. *Manga no Yomikata.* Tokyo: Takarajimasha, 1995.

6138. "Interactive Manga." *Animerica.* 4:6 (1996), p. 14.

6139. Ishinomori, Shōtarō. *Shōsetsu: Tokiwasō, Haru* (The Chapter: Tokiwasō, Spring). Tokyo: Sukora, 1981.

6140. Ito, Kinko. "The *Manga* Culture in Japan." *Japan Studies Review.* 4 (2000), pp. 1-16.

6141. "It's a Manga New Year." *Mangajin.* No. 51, 1995, p. 34.

6142. "Japanese Doll Is Like Popeye's Face on Barbie's Body: Image Made from 2 Comic Book Icons Triggers a Big Fight Over Copyrights." *Deseret News* (Salt Lake City, Utah). March 16, 1997.

6143. "Japanese Manga: Eclectic." *The Economist.* December 16, 1995, pp. 116-118.

6144. "Japan Inc." *Animag.* No. 5, 1988, p. 35.

6145. Jenkins, Mark. "Manga: Of Sex, Sci-Fi and Salarymen." *Washington Post.* February 5, 1995, p. G-8.

6146. Jenkins, Mark. "Samurai Babysitter." *Washington City Paper.* June 5, 1987.

6147. Jonte, Lisa R. "A Beginner's Guide to Japanese Manga." *Sequential Tart.* May 2000.

6148. "Kaiju Buzz Notes." *Kaiju Review.* 1:7 (1994), pp. 3-11.

6149. "Kakioroshi Komikku: Hadokaba de Zokuzoku." (Newly Written Comics: Hardcovers in Rapid Succession). *Yomiuri Shimbun.* June 22, 1996.

6150. Kamata, Tōji. "'Nagare' to 'Chikara' No Hate Ni." *Eureka.* 20:10 (1988), pp. 54-67.

6151. Kerkhof, Robin. "Manga Manga. De Kunst van Japanse Strips." *Stripschrift.* March 2000, pp. 18-20.

6152. "The Kimono Revolt." *Asiaweek.* June 23, 1995, p. 40.

6153. Kitazawa, Noriaki. *Komikkugaku no Mikata.* Tokyo: Asahi Shimbunsha, 1997.

6154. Klauser, Wilhelm. "Mangas in Japan: Der Japanische Comic als Spiegel Einer Urbanisierten Gesellschaft." *Bauwelt.* December 6, 1996.

6155. Koike, Masaharu. "Genki na Take Shobō, Seme no Keiei wa Mi o Musubuka" (Healthy Take Shobō: Will the Aggressive Strategy Bear Fruit?). *Tsukuru.* November 1994, pp. 44-51.

6156. Komatsu, Kazuhiko. "Mori No Kamikoroshi to Sono Noroi." *Eureka.* 29:11 (1997), pp. 48-53.

6157. Komikku Hyōgen no Jiyū o Kangaerukai, ed. *Shigaisen* (Undeclared War on Publications). Tokyo: Tsukuru Shuppan, 1992.

6158. *Komikku Media: Yawarakai Jōhō Sōchi to Shite no Manga* (Comic Media: Comics as a Soft Informational System). Tokyo: NTT Shuppan, Books In-Form, 1992.

6159. Kondō, Kōtarō. "Manga Sangyō Tasogare no Hajimari: 5,500-oku En Shojō no Kyodai Media" (The Beginning of the Twilight of the Manga Industry: A Giant Medium Now Worth 550 Billion Yen). *Aera.* March 27, 1995, pp. 32-33.

6160. Kure, Tomofusa. "Bungaku wa Manga ni 'Nido' Maketal." In *1-Okunin no Manga Rensa,* edited by "da Vinci," p. 80. Tokyo: Recruit, 1998.

6161. Kure, Tomofusa. *Gendai Manga no Zentaizō. Taibō Shiteita Mono, Koeta Mono.* Tokyo: Century Press, 1986.

6162. Kure, Tomofusa. *Gendai Manga no Zentaizō: Zōhoban* (The Totality of Modern Manga: The Expanded Version). Tokyo: Shiki Shuppan, 1990.

6163. Kure, Tomofusa. "Junbungaku Manga no Yukue." *Eureka.* 2/ 1987, pp. 124-131.

6164. Kusaoi, Akiko. "Never Mind the Mishima, Here's the Manga." *Look Japan.* January 1993, p. 47.

6165. Kwan Weng Kin. "In a Nation of Readers, Manga Popularity Jumps." *Straits Times* article reprinted in *Japan Times.* January 3, 1995.

6166. Lam. S. K. S. "The Impact of Translated Japanese Comics on Hong Kong Cinematic Production: Cultural Imperialism or Local Reployment?" Master of Philosophy thesis, University of Hong Kong, 1997.

6167. Leahy, Kevin. "Manga Boom." *The Rose.* July 1997, p. 28.

6168. "L'Impériale Ascension de la BD." *Bédésup.* June 1982, p. 47. Reprinted from *Libération.* April 12, 1982.

6169. "Lonely Pleasures: Japan." *The Economist.* July 23, 1994, p. 84.

6170. Lowe, Adam. *Manga.* Catalogue for the Exhibition, "Manga, Comic Strip Books from Japan," Pomeroy Purdey Gallery, London, October-November 1991. London: Lowe Culture, 1991.

6171. Luyten, Sonia M. Bibe. *Manga: O Poder Dos Quadrinhos Japoneses.* São Paulo: Achime, 1990; Liberdade Fundação Japão, 1991.

6172. McCloud, Scott. "Understanding Manga." *Wizard.* April 1996, pp. 52-58.

6173. MacGregor, Hilary E. "Comic Books Draw Serious Attention in Japan." *Philadelphia Inquirer.* February 4, 1996, p. A-2.

6174. MacGregor, Hilary E. "Japanese Are Crazy for Comics." *Los Angeles Times.* January 30, 1996, pp. A1, A4.

6175. Macias, Patrick. "Our New Year's Resolutions." *Animerica.* 8:1 (2000), pp. 67, 69.

6176. "The Magic of Manga." *Japan Update.* Summer 1989, pp. 27-30.

6177. Makino, Keiichi. *Bannô Setchakuzai MANGA. Nikkan Wãrudo Manga-ten wo Chûshin Toshita Manga Hyôgen Hôhokusho.* Kyoto: Kyoto Seika Daigaku Jôhôkan, 1998.

6178. Makino, Keiichi. Manga, Manga, Manga. *Komikkugaku no Mikata,* pp. 82-85.

6179. Makino, Keiji, *et al.* "Why Has Literature Lost to Manga?" *Kino Review.* 1998.

6180. "Manga." *Le Collectionneur de Bandes Dessinées.* September 1994, p. 2.

6181. "Manga Closeup." *Animerica.* 3:7 1995, p. 20.

6182. "Manga Closeup." *Animerica.* 4:12 (1996), p. 58.

6183. "Manga Everywhere." *Inklings.* Fall 1995, p. 12.

6184. "Manga for 'Matured': Pulp." *Animerica.* 5:10 (1997), p. 60.

6185. Manga Hyôshô Bunka Kenkyūkai, ed. *Manga Hyôshô Bunka Kenkyû.* No. 1. Tokyo: Waseda Daigaku, May 1998.

6186. "Manga Looking for Shorts." *Animation Planet.* Summer 1997, p. 3.

6187. *Manga Manga Manga Ten.* Catalogue Exposition, *Yomiuri Shimbun.* Tokyo: *Yomiuri Shinbun,* 1993.

6188. "Manga-mania." *The Japan Times Weekly.* November 18, 1995, p. 2.

6189. "Manga Market Grows Overall But Male Market Shrinks." *Anime FX.* August 1995, p. 6.

6190. "Manga News." *Protoculture Addicts.* December 1993, p. 8.

6191. "Manga: Niet Alleen Voor Jongens." *Stripschrift.* August 1994, p. 2.

6192. "Manga Ōkoku no Kageri?" (Shadows of the Manga Kingdom?) Special issue of *The Tsukuru.* No. 10, 1995, pp. 16-105.

6193. "Manga School." *Manga Max.* March 2000, p. 6.

6194. "Manga Taikoku Nippon" (Manga Superpower Japan). Special issue of *The Tsukuru.* No. 8, 1994, pp. 18-109.

6195. "Manga-vertalers in Staking." *Stripschrift.* August 1994, p. 1.

6196. "Manga wa Bungaku" (Manga Are Literature). *Kaien.* July 1993, pp. 3-114.

6197. "Manga Zasshi Dai Kenkyū!" *Comic Box.* November 1987, pp. 92-106.

6198. "Manga-zines." *S.I.D.* September 1998, p. 14.

6199. "March Is Manga Month." *Comics International.* January 1998, p. 12.

6200. Márquez, Pablo. "¡ No Hay Crisis en el Comic!" *Circulo Andaluz de Tebeos.* No. 18, 1996, pp. 33-34.

6201. Matsutani, Takayuki. "The Present Cultural and Industrial Situation of the Japanese Comics." In *1995 International Symposium and Lecture for the Seoul International Cartoon and Animation Festival,* pp. 45-60. Seoul: SICAF 95 Promotion Committee, 1995.

6202. "Mixx Continues 'Star Wars of Japan.'" *Comics International.* December 1999 p. 20.

6203. Miyamoto, T. "The Effects of Graphic Properties of 'Pictorial Letters' in Japanese Comic Books." *Science of Reading.* July 1990.

6204. Mordin, Chrys. "Manga Anthologies." *Manga Mania.* March-April 1998, p. 63.

6205. "The More 'Manga.'" *Asiaweek.* October 3, 1997, p. 9.

6206. Morikawa, Kathleen. "More Than Mind Candy." *Japan Quarterly.* January 1997, pp. 92-94.

6207. Murray, Geoffrey. "In Japan, Comic Books Aren't for Children Anymore." *Christian Science Monitor.* August 22, 1980.

6208. Nagatani, Kunio. *Nippon Manga Meikan.* Tokyo: Data Base, 1994.

6209. Nagatani, Kunio. *Nippon Meisaku Manga Meikan.* Tokyo: Data Base, 1995.

6210. Nagatomo, Kazuhiko. *Do-It-Yourself Japanese Through Comics.* Tokyo: Kodansha, 1995.

6211. Nakatani, Masahito. "Wohnungsbau in Japan." *Bauwelt.* November 17, 1995.

6212. Natori, Motoki. "Mangas. Japanische Comics. Ihr Vielfalt und Dynamik." In *Comic Almanach,* edited by Joachim Kaps, Wimmelbach: ComicPress, 1992.

6213. Natsume, Fusanosuke. "Manga no Bunpô. Hyôgen Yôshiki no San-Yôso e, Koma, Kotoba no Yomikata." In *Komikkugaku no Mikata,* pp. 86-95.

6214. Natsume, Fusanosuke. *Manga to "Sensô."* Tokyo: Kodansha Nimiya Kazuko, 1997.

6215. Natsume, Fusanosuke. *Manga wa Naze Omoshiroi no Ka. Sono Hyôgen to Bunpô.* Tokyo: Nippon Hôsô Shuppan Kyôkai, 1996.

6216. Natsume, Fusanosuke. *Natsume Fusanosuke no Mangagaku.* Tokyo: Yamato Shobô, 1985.

6217. Natsume, Fusanosuke. *Natsume Fusanosuke no Mangagaku.* Tokyo: Chikuma Shobô, 1992.

6218. Nieuwenhuis, Jef. "De Verstilde Beelden van Moesashi." *ZozoLala.* February/March 1994, pp. 3-7.

6219. Ogasawara, Yuko. *Office Ladies and Salaried Men: Power, Gender, and Work in Japanese Companies.* Berkeley: University of California Press, 1998.

6220. Okamoto, Rei. "Violence in Japanese Comics." Paper presented at Popular Culture Association, Philadelphia, Pennsylvania, April 12, 1995.

6221. "On Animating Games." *Animerica.* 5:6 (1997), p. 60.

6222. Ono, Kosei. "Comics of Japan." *Foreign Comic Reviews.* No. 3, 1973, pp. 2-3.

6223. Ono, Kosei. "Japan's Remarkable Comic Book Culture." *Tokyo Business Today.* February 1989, pp. 32-35.

6224. Ōshiro, Yoshitake. *Manga no Bunka Kigorôn.* Tokyo: Kôbundô, 1987.

6225. Ōtsuka, Eiji. *Manga no Kōzō. Genshō. Tekisuto.* Tokyo: Shōhin, 1987.

6226. Ōtsuka, Eiji. *Sengo Manga no Hyôgen Kûkan: Kigôteki Shintai no Jubaku.* Tokyo: Hôsôkan, 1994.

6227. Pep Shuppan Editorial Department, ed. *Sugiura Manga Kenkyu: Marugoto Sugiura Shigeru.* Tokyo: Pep Shuppan, 1988.

6228. Phillipps, Susanne. "Manga für Ein Deutschsprachiges Publikum. Möglichkeiten der Übertragung von Text-Bild-Verbindungen." In *Japanstudien.* Jahrbuch des Deutschen Instituts für Japanstudien der Philipp-Franz-von-Siebold-Stiftung. Vol. 8, pp. 193-210. Munich: iudicium Verlag, 1996.

6229. "Politics Takes Flight in the World of Manga." *Asiaweek.* June 19, 1998, p. 49.

6230. "Psychology of Contemporary Manga." Special Issue. *Imago* (Tokyo). 2:10 (1991).

6231. Reader, Ian. "*Manga*: Comic Options – The Japanese Tradition for Illustrated Stories." *Japan Digest.* October 1990, p. 19.

6232. Reid, Calvin. "Manga: Comics Japanese Style." *Publishers Weekly.* June 30, 1997, p. 50.

6233. Reid, T.R. "In Japan, the Serial Addiction." *Washington Post.* April 22, 1992, pp. B1-B2.

6234. Richie, Donald. "Walkman, Manga and Society." In *A Lateral View – Essays on Contemporary Japan,* pp. 205-208. Tokyo: The Japan Times, 1987.

6235. Riley, James. "How I Learned To Stop Worrying and Love...Manga." *Big Planet Orbit.* April 2001, p. 3.

6236. "Sabetsu to Hyōgen 1" (Discrimination and Expression 1). *Comic Box.* January 1991, pp. 22-33.

6237. "Sabetsu to Hyōgen 3" (Discrimination and Expression 3). *Comic Box.* March/April 1991, pp. 134-144.

6238. Sakuma, Akira. *Dakara Manga Daisuki!* (That's Why I Love Manga!). Tokyo: Shūeisha, 1982.

6239. Sanders, Rik. "Manga in Rotterdam." *Stripschrift.* January 2000, p. 31.

6240. Sawaragi, Noi. "Manga Atoron." In *Komikkugaku no Mikata,* pp. 30-31.

6241. Swallow, Jim. "The Fighting Gallant Girls Come to Comics." *Anime UK.* July 1995, p. 19.

6242. Schodt, Fred. "Manga: Japan's New Visual Culture." Public lecture, Japanese Popular Culture Conference, University of British Columbia, April 10, 1997.

6243. Schodt, Frederik L. "American Comic Artists Visit Japan." *Animerica.* 3:1 (1995), p. 41.

6244. Schodt, Frederik L. "Comics and Social Change." *PHP*. April 1984, pp. 15-25.

6245. Schodt, Frederik L. *Dreamland Japan: Writings on Modern Manga.* Berkeley, California: Stone Bridge Press, 1996. 360 pp.

6246. Schodt, Frederik L. "Japanese Comics: *Manga* Mania." *Look Japan.* January 1989, pp. 39-41.

6247. Schodt, Frederik L. "Land of the Running Serial." *Civilization.* June/July 1998.

6248. Schodt, Frederik L. "Manga Honyaku wa Doko Made Kanōka" (What Are the Limits on Translating Comics and Cartoons?). *Honyaku Jiten.* November 1984.

6249. Schodt, Frederik L. "Manga Talk in London Causes Heatwave." *Animerica.* 3:10 (1995), p. 46.

6250. Schodt, Frederik L. "The Times, They Are a' Changin.'" *Animerica.* 4:8 (1996), p. 62.

6251. "Search for New Talent." *The Rose.* July 1997, p. 20.

6252. Shikata, Inuhiko. *Manga Genron* (The Principles of Manga). Tokyo: Chikuma Shobo, 1994.

6253. Shimizu, Isao. "The 'Manga' Entry in an Encyclopedia." *Fūshiga Kenkyū.* No. 19 (July 20, 1996), pp. 4-5, 13.

6254. Shiokawa, Kanako. "Memorable Episodes: The Use of Personal Experiences in Japanese Comic Books." Paper presented at Mid-Atlantic Region/Association for Asian Studies, Towson, Maryland, October 21, 1995.

6255. Shiratori, Chikao. *Secret Comics Japan.* San Francisco: Viz Communications/Pulp Books, 2000.

6256. Smith, Toren. "Manga 101." *Comics Buyer's Guide.* October 9, 1998, p. 27.

6257. Smith, Toren. "The World of Manga." *Japanese Book News.* 2 (1993), pp. 1-3.

6258. Soeda, Yoshiya. *Gendai no Esupuri: Manga Bunka.* Tokyo: Shinbundô, 1976.

6259. Soeda, Yoshiya. *Manga Bunka.* Tokyo: Kinokunniya Shoten, 1983.

6260. "Studio Go Is Ready To Go." *Animerica.* 3:1 (1995), p. 41.

6261. Stump, Greg. "Cultural Exchange Brings American Cartoonists to Japan." *Comics Journal.* February 1997, pp. 22-23.

6262. Swallow, Jim. "Manga in Focus: Octane and Cordite." *Anime UK.* July 1995, pp. 18-19.

6263. Swallow, Jim. "Past to Present: Manga in Focus." *Anime FX.* December 1995, pp. 32-33.

6264. Takahashi, Mizuki. "Manga Kenkyû Josetsu. Bijutsushi, Tabû, Manga." In *Manga Hyôsho Bunka Kenkyû,* edited by Manga Hyôshô Bunka Kenkyûkai, pp. 4-14. Tokyo: Waseda Daigaku, May 1998.

6265. Takatori, Ei. *Ashita no Jô no Daihimitsu.* Tokyo: Shôbunkan, 1993.

6266. Takeuchi, Natsuki. *Manga no Tatsujin: Manga to Dôjinshi no Subete ga Wakaru* (The Manga Experts: Everything You Need To Know About Manga and Dôjinshi). Tokyo: KK Best Sellers, 1993.

6267. Takeuchi, Osamu. "Japanese Manga: Research and Criticism." *Japanese Book News.* No. 15, 1996, pp. 1-3.

6268. Tanabe, Kunio F. "Letter from Tokyo." *Washington Post Book World.* November 3, 1996, p. 15.

6269. "Texas Chain Store Massacre." *Manga Max.* May 2000, p. 8.

6270. Thorn, Matthew. "Adolescent Luminality in Japanese Manga." Paper presented at 7th Annual Association of Teachers of Japanese Seminar, Washington, D.C., March 16, 1989.

6271. Thorson, Alice. "From Collection of Cultures, Artistic Unity Arises." *Kansas City Star.* January 21, 1996.

6272. *The Tsukuru* (Tokyo: Tsukuru Shuppan). 8/1992: "Comic no Hyôgen o Meguru Daigerikon." 8/1994: "Manga Taikoku Nippon."

6273. *Tsukuru* Editorial Staff, ed. *"Yūgai" Komikku Mondai o Kangaeru* (Thinking About the Issue of 'Harmful' Comics). Tokyo: Tsukuru Shuppan, 1991.

6274. Turney, Alan. "Translating Culture: The Venerable Tradition Behind Comics." *Daily Yomiuri.* May 16, 1994, p. 8.

6275. Ueno, Kōshi. "Tenkū No Shiro Raputa: Eiga No Yume, Jitsugen To Sōshitsu." *Eureka.* 29:11 (1997), pp. 158-163.

6276. "Un Kilo de Historietas ..!" *Trix.* November 1993, p. 48.

6277. Vescovi, Mario. "I Manga: (Questi Sconosciuti)." *Comics World* (Genoa). September-October 1997, pp. 13-14.

6278. von Busack, Richard. "Knowing a Nation in Comic Books: The 'Manga' Craze Says Volumes about Modern Japanese Culture." San Jose, California *Metro.* October 10, 1996.

6279. Walton, David. "Novel's Cultural Mix a Recipe for Humor." *Kansas City Star.* March 19, 1996.

6280. Yokota-Murakami, Takayuki. "The Fallen Literature: On the Creation of the Canon of Comics." Paper presented at Association for Asian Studies, Honolulu, Hawaii, April 14, 1996.

6281. "Yomota, Imuhiko. *Manga Genron* (Fundamentals of Manga). Tokyo: Chikuma Shobô, 1994.

6282. Yonezawa, Yoshihiro. *Dôjinshi Daihyakka.* Tokyo: Tatsumi Shuppan, 1992.

6283. Yonezawa, Yoshihiro. *Gendai Yôgo no Kiso Chishiki.* Tokyo: Jiyû Kokuminsha, 1992. (Manga, pp. 1234-1238).

6284. Yoshitomi, Yasuo. "Hito-koma Manga Kenkyū." In *Komikkugaku no Mikata,* pp. 34-35.

Genre: General Sources

6285. Álvarez Vaccaro, Paula. "El Cómic Japonés Hace Furor entre Chicos y Adolescentes." *Clarín.* August 23, 2000.

6286. Berndt, Caroline M. "Popular Culture as Political Protest: Writing the Reality of Sexual Slavery." *Journal of Popular Culture.* Fall 1997, pp. 177-187.

6287. Castelli, Alfredo and Gianni Bono. "Dossier: Orfani & Robot." *If.* December 1983, p. 43.

6288. Kinsella, Sharon. "Pro-Establishment Manga: Pop-Culture and the Balance of Power in Japan." *Media, Culture and Society.* July 1999, pp. 567-572.

6289. MacWilliams, Mark W. "Japanese Comic Books and Religion: Osamu Tezuka's Story of the Buddha." In *Japan Pop!* Edited by Timothy J. Craig, pp. 109-137. Armonk, New York: M. E. Sharpe, 2000.

6290. MacWilliams, Mark. "Japanese Comic Books and Religion: Osamu Tezuka's Story of the Buddha." Paper presented at Japanese Popular Culture Conference, Victoria, Canada, April 10, 1997.

6291. Malcolm-Smith, Sally. "Japan's Cruelty Comics Move in." *Sunday Telegraph* (London). April 11, 1993.

6292. Marechal, Beatrice. "'The Singular Stories of the Terashima Neighborhood': A Japanese Autobiographical Comic." *International Journal of Comic Art*. Fall 2001, pp. 138-150.

6293. "Samurai Spirit Lives on in Sports Comics." *The Rose*. February 1998, p. 32.

6294. "Saraiiman Senka, Salaryman Seminar." *Mangajin*. September 1996, pp. 74-81.

6295. Sekikawa, Natsuo. *Chishikiteki Taishū Shokun: Kore mo Manga Da* (Ah, Yee Intelligent Masses: These, Too, Are Manga). Tokyo: Bungei Shunjū, 1991.

Genre: Boys'

6296. Nishimura, Shigeo. *Saraba Waga Seishun no "Shōnen Jampu"* (Farewell to the *Shōnen Jump* of My Youth). Tokyo: Asuka Shinsha, 1994.

6297. Oshiguchi, Takashi. "On Bishōnen Manga." *Animerica*. 3:5 (1995), p. 18.

6298. Takatori, Ei. *Shônen Manga Gahô*. Tokyo: Pharaoh, 1993.

Genre: Children's

6299. Allison, Anne. *A Male Gaze in Japanese Children's Cartoons or Are Naked Female Bodies Always Sexual?* Durham, North Carolina: Duke University Press, Asian/Pacific Studies Institute, 1993.

6300. Hatano, Kanji. *Children's Comics in Japan*. Cambridge: Communications Program CENIS, Massachusetts Institute of Technology, 1956. 81 pp.

6301. Kawai, Ryozo. "Die Geschichte der Japanischen Jugendcomics nach dem Zweiten Weltkrieg, Literatur und Mediensoziologisch Betrachtet." *Massenmedien und Kommunikation*. 42 (1986).

6302. Maderdonner, Megumi. "Kinder-Comics als Spiegel der Gesellschaftlichen Entwicklung in Japan." In *Aspekte Japanischer*

Comics, pp. 1-94. Vienna: Institut für Japanologie der Universität Wien, 1986.

6303. "Susume Manga Seinen!" (Onward Manga Youths!). *Marco Polo.* May 1993, pp. 3-108.

Genre: Educational

6304. Fletcher, Dani. "The 'Truth' Is in Here: Project: Generation and Public Service." *Sequential Tart.* September 2000.

6305. Fonda, Daren, Tim Larimer, and Vicky Rainert. "Global Briefing: Comics for Businessmen. New Office Betting Pools...." *Time.* April 9, 2001.

6306. "Golf Lesson Comic." *Anime FX.* February 1996, p. 51.

6307. "Tokyo's Political Superman." *Far Eastern Economic Review.* May 11, 2000, p. 10.

6308. Tsurumi, M. "Books Recommended by Senior Nurses and by Fresh Nurses. A Comic Illustrating Students' Clinical Practice." *Kango.* March 1993, pp. 72-74.

6309. Watanabe, Toshiro. *Manga de Manabu MR no Tame no GPMSP – Shohan* ("GPMSP for MR, through Cartoons" – Japanese Drug Legislation). Tokyo: Yakugyo Jihosda, 1992.

Genre: Erotic and Adult

6310. Bachmayer, Eva. "'Gequälter Engel' – Das Frauenbild in den Erotischen Comics in Japan. Versuch Einer Psychoanalytischen und Feministischen Interpretation." In *Aspekte Japanische Comics,* pp. 95-223. Vienna: Institut für Japanologie der Universität Wien, 1986.

6311. Bladwin, Ian. "Delving into the World of Manga." *Mangajin.* December 1996, pp. 54-55, 84.

6312. *Bessatsu Takarajima 196; Media de Yokujō Suru Hon: Nippon wa Dennō Etchi no Jikkenjō Da!* (Takarajima Supplement 196: The Book of Media-Inflamed Passions: Japan Is a Testing Site for Cyber Eroticisim). Tokyo: Takarajima-sha, 1994.

6313. Bomford, Jen. "Yaoi and Shounen Ai-Or-Turnabout Is Fair Play ???" *Sequential Tart.* September 2000.

6314. Boyd, Robert. "Comics Underground Japan." *Comics Journal.* September 1996, p. 126.

6315. Chung, Jui-Ping. "The Uses and Gratification Study of Japanese Queer Comics." Master's thesis, Culture University (Taiwan), Journalism Department, 1998.

6316. Clements, Jonathan. "Flames." *Manga Max.* May 1999, pp. 33-36.

6317. Cooper-Chen, Anne. "'The Dominant Trope': Sex, Violence, and Hierarchy in Japanese Comics for Men." In *Comics & Ideology,* edited by Matthew P. McAllister, Edward Sewell, Jr., and Ian Gordon, pp. 99-128. New York: Peter Lang, 2001.

6318. Go, Tomohide. "Gendai Eromanga Tenbō" (View of Erotic Comic Books Today). *Manga Ronsō,* special issue of *Bessatsu Takarajima.* 13 (1981), pp. 260-262.

6319. Ito, Kinko. "Sexism in Japanese Weekly Comic Magazines for Men." In *Asian Popular Culture,* edited by John A. Lent, pp. 127-138. Boulder, Colorado: Westview, 1995.

6320. Jones, Sumie, ed. *Imaging/Reading Eros: Proceedings for the Conference, Sexuality and Eros Culture, 1750-1850, Indiana University, Bloomington, August 17-20, 1995.* Bloomington: Indiana University, East Asian Studies Center, 1996. 161 pp.

6321. Kinsella, Sharon. *Adult Manga: Culture & Power in Contemporary Japanese Society.* Honolulu: University of Hawaii Press, 2000. 228 pp.

6322. Kinsella, Sharon. "Change in the Social Status, Form and Content of Adult Manga, 1986-1996." *Japan Forum.* 8:1 (1996), pp. 103-112.

6323. Kondo, Tomoko. "The Making of a Corporate Elite Adult Targeted Comic Magazines of Japan." MA thesis, McGill University (Montreal), 1991. 85 pp.

6324. Lister, David. "Cartoon Cult with an Increasing Appetitie for Sex and Violence." *The Independent* (London). October 15, 1993.

6325. Ng Suat Tong. "What's So Secret? *Secret Comics Japan.*" *Comics Journal.* February 2001, pp. 32-36.

6326. Patten, Fred. "Porn in the USA." *Manga Max.* December 1998, pp. 2-5.

6327. "Poruno na Kibun" (A Porn Feeling). *CREA.* June 1994, pp. 59-107.

6328. Quigley, Kevin, ed. *Comics Underground Japan.* New York: Blast Books, 1996. 221 pp.

6329. Randall, Bill. "*Adult Manga:* May I See Some ID?" *Comics Journal.* May 2001, p. 32.

6330. Schodt, Frederik L. "The Lolita Complex." *Manga Max*. January 1999, p. 52.

6331. Shiratori, Chikao, ed. *Underground Comics Now. Secret Comics Japan.* San Francisco, California: Cadence Books, 2000. 198 pp.

6332. Swallow, Jim. "Hard Core." *Manga Max*. December 1998, pp. 12-15.

6333. Takahashi, Keiichi. "Byakuya Shobō no 'Soredemo Erobon wa Fumetsu Desu'" (Byakuya Shobō's Philosophy of "Despite All This, We Think Erotic Publications Will Last Forever"). *Tsukuru*. November 1994, pp. 80-86.

6334. "Underground Manga from FBI." *Comics Journal*. August 1995, p. 24.

6335. "Voyeur: Manga for Grownups Collection." *Comics International*. February 1999, p. 12.

Genre: Fantasy

6336. Shiokawa, Kanako. "Folklore, Mythology, and History: Japanese Fantasy Comics." Paper presented at Mid-Atlantic Region, Association for Asian Studies, South Orange, New Jersey, October 26, 1996.

6337. Yomota, Inuhiko. "On the Grotesque Trend in Japanese Post-Modern Art." In *Modernity in Asian Art,* edited by John Clark, pp. 200-206. Sydney: University of Sydney, East Asian Series No. 7, and Wild Peony Press, 1993.

Genre: Girls'

6338. Akagi, Kanko. "Aijō-busoku no Kodomo-tachi: Shōjo Manga ni Muru Gendai no Byōri to Sono Jittai" (Loveless Children: Today's Illness and Its Reality Seen in Girls' Comics). In *Komikku Media,* pp. 90-117. Tokyo: NTT Shuppan, 1992.

6339. Akisato, Wakuni. "Interview: Akisato Wakuni." *Pafu*. 10:6 (1984), pp. 7-15.

6340. Bungei Shunshû, comp. *Dai Anketô ni Yoru Shônen Shôjo Manga Besuto 100*. Tokyo: Bungei Shunshû, 1992.

6341. Endresak, Dave. "Magical Girls, Part 1." *The Rose*. February 1998, pp. 26-27.

6342. *Eureka* (Tokyo: Seidosha). Monograph 7/1981: "Shōjo Manga." 2/1987: "Manga Okoku Nihon."

6343. Fujii, Masahiko. *The Female in Airbrush*. Tokyo: Graphic-Sha, 1988.

6344. Fujimoto, Yukari. "Onnano Ryosei Guyu, Otokono Han Inyo" (Transgender Phenomenon in Comics). *Gendai no Esupuri.* 277 (1990), pp. 177-209.

6345. Fujimoto, Yukari. *Watashi no Ibasho wa Doka Ni Aru No? Shōjo Manga Ga Utsusu Kokoro no Katachi* (Where Do I Belong? The Shape of the Heart as Reflected in Girls'Comics). Tokyo: Gakuyô Shobô, 1998.

6346. Fujimoto, Yukari and Julianne Dvorak. "A Life-Size Mirror: Women's Self-Representation in Girl's Comics." *Review of Japanese Culture and Society.* December 1991, pp. 53-57.

6347. Gayton, Loran. "Cherry Blossoms Versus Chainsaws – A Meditation on the Meaning of Cute." *Sequential Tart.* July 1999.

6348. Gössmann, Elisabeth, ed. *Japan – Ein Land der Frauen?* Munich: iudicium, 1991.

6349. Hagio, Moto and Yoshimoto Ryumei. "Jikohyogen Toshiteno Shojo Manga" (Shojo Manga As Self Representation). *Eureka.* 13:9 (1981), pp. 82-119.

6350. Honda, Masuko. " 'Hirahira' no Keifu: Shōjo, Kono Kyōkaiteki Naru Mono" (A Geneaology That Flutters: Girl, This Transient Being). In *Ibunka to Shite no Kodomo,* by Masuko Honda, pp. 135-170. Tokyo: Kinokuniya Shoten, 1982.

6351. Honda, Masuko. "Senjika no Shojo Zasshi" (Magazines for Girls During the War). Otsuka, *Shojo.* 1991, pp. 7-43.

6352. Honda, Masuko. "Shojo Katari." *Shojoron.* Tokyo: Seikyusha, 1988, pp. 9-37.

6353. *Imago* (Tokyo: Seidosha). Monograph 4/1995: "Shôjo Manga."

6354. Ishida Saeko. "'Shōjo Manga' no Buntai to Sono Hōgensei" (The Grammar and Its Dialecticality of Girls' Comics). In *Komikku Media,* pp. 54-89. Tokyo: NTT Shuppan, 1992.

6355. Kakinuma, Eiko. "'Ai' wo Tsukuridasu Shôjo Mangakatachi." *Imago.* 4/1995, pp. 170-178.

6356. *Kodomo no Shōwashi – Shōjo Manga no Sekai: Shōwa 20-37-nen* (Children's History of the Shōwa Era – The World of Girls' Manga: 1945-62). Special Supplement Issue of *Taiheiyō.* Tokyo: Heibonsha, 1991.

6357. *Kodomo no Shōwashi – Shōjo Manga no Sekai II: Shōwa 38-64-nen* (Children's History of the Shōwa Era: The World of Girls' Manga II,

1962 –89). Special supplement issue of *Taiheiyō*. Tokyo: Heibonsha, 1991.

6358. Matsui, Midori . "Feminine Sexuality As a Political Site: The Widened Discursive Field of Japanese Girls' Comics." Paper presented at Association for Asian Studies, Honolulu, Hawaii, April 14, 1996.

6359. *MT Manga Tekunikku: Bokutachi no Komikku Bishōjō Densetsu* (MT Manga Techniques: The Legendary Beautiful Girls of Our Comics). Special supplement of *Bessatsu BT Bijutsu Techō*. November 1994.

6360. Napier, Susan J. "From Shojo to 'Ladies' to 'Ghosts': Problems of Female Empowerment in Manga and Animation." Paper presented at Association for Asian Studies, Chicago, Illinois, March 15, 1997.

6361. Napier, Susan. "Vampires, Psychic Girls, Flying Women and Sailor Scouts: Four Faces of the Young Female in Japanese Popular Culture." In *The Worlds of Japanese Popular Culture: Gender, Shifting Boundaries and Global Cultures,* edited by D.P. Martinez, pp. 91-109. Cambridge: Cambridge University Press, 1998.

6362. Niimiya, Kazuko. *Adaruta Chirudoren to Shôjo Manga: Hitonami ni Yattekoreta Onna no Kotachi e.* Tokyo: Kôzaidô-Shuppan, 1997.

6363. Nishiyama, Chieko. "Directions of Sexuality in Japanese Girls' Comic Books." In *Global Perspectives on Changing Sex-Role.* Translated by Martha Tocco. Tokyo: Kokuritsu Funjin Kyoiku Kaikan, 1989.

6364. Oakes, Kaya. "Shojo Manga – Not for Women Only !" *Manga Vizion.* 1:3 (1995), p. 2.

6365. Ōgi, Fusami. "Beyond *Shoujo,* Blending Gender: Subverting the Homogendered World in *Shoujo* Manga (Japanese Comics for Girls)." *International Journal of Comic Art.* Fall 2001, pp. 151-161.

6366. Ōgi, Fusami. "Beyond *Shoujo,* Blending Gender: Subverting the Homogendered World in *Shoujo Manga.*" Paper presented at Popular Culture Association, Philadelphia, Pennsylvania, April 14, 2001.

6367. Ōgi, Fusami. "Gender Insubordination in Japanese Comics (*Manga*) for Girls." In *Illustrating Asia: Comics, Humor Magazines, and Picture Books,* edited by John A. Lent, pp. 171-186. Richmond: Curzon Press; Honolulu: University of Hawaii Press, 2001.

6368. Ōgi, Fusami. "Gender Insubordination in Japanese Comics (Manga) for Girls." Paper presented at Association for Asian Studies, Chicago, Illinois, March 15, 1997.

6369. Ōgi, Fusami. "Parodying or Reinscribing?: Shoujo Manga's (Comics for Girls) Transgression, Visually and Literally." Paper presented at International Society of Humor Studies, Osaka, Japan, July 26, 2000.

6370. Ōgi, Fusami. "Reversing 'Orientalism' in Shouja Manga (Japanese Comics for Girls)." Paper presented at International Association for Media and Communication Research, Singapore, July 19, 2000.

6371. Ophüls-Kashima, Reinold. "Comics für Mädchen (Shojo Manga) und Mädchenliteratur als Phänomene der Modernen Massenliteratur – Eine Übersicht Über Neuere Publikationen," pp. 535-554. In *Japanstudien. Jahrbuch des DIJ.* Vol. 5, Munich: iudicium Verlag. 1993.

6372. Orbaugh, Sharalyn. "Grrl Power: Busty Battlin' Babes and the Shoojo-ization of Japanese Culture." Papers presented at "Visions, Revisions, Incorporations" Conference, Montreal, Canada, March 27, 1999.

6373. Otsuka, Eiji, ed. *Shojo Zasshi Ron* (Examining Magazines for Girls). Tokyo: Tokyoshoseki, 1991.

6374. Sato, Masaki. "Shoujo Manga to Homophobia" (Shoujo Manga and Homophobia). *Queer Studies '96*, pp. 161-169. Tokyo: Nanatsumori Shokan, 1996.

6375. Shiokawa, Kanako. "Cute but Deadly: Women and Violence in Japanese Comics." Paper presented at Popular Culture Association, Philadelphia, Pennsylvania, April 12, 1995.

6376. Shiokawa, Kanako. "Roses, Stars, and Pretty Boys: Symbolism in Japanese Girls' Comics." *Asian Thought and Society.* September-December 1999, pp. 206-230.

6377. Shiokawa, Kanako. "Roses, Stars, and Pretty Boys: Symbolism in Japanese Girls' Comics." Paper presented at Association for Asian Studies, Chicago, Illinois, March 13, 1997.

6378. Shiokawa, Kanako. "Symbolism in Japanese Girls' Comics." Paper presented at Popular Culture Association, Las Vegas, Nevada, March 28, 1996.

6379. Shiokawa, Kanako. "Why Do Straight Japanese Women Love Men Who Love Other Men?: Homoeroticism in Japanese Girls' Comics." Paper presented at Mid-Atlantic Region, Association for Asian Studies, Newark, Delaware, October 25, 1998.

6380. Takahashi, Hiroko. "Tôsei Shôjo Manga no Geryû o Tazunete." *Eureka.* 2/1987, pp. 178-189.

6381. *Tayyô* (Tokyo: Heibonsha). 3/1971: Monograph number, "Nihon no Manga." 7/1991: Extra monograph, "Shojo Manga no Sekai I." 8/1991: "Shojo Manga no Sekai II."

6382. "THE Shōjo Manga!" (THE Girls' Manga!) *CREA*. September 1992, pp. 71-132.

6383. Thorn, Matt. "Girls' Stuff." *Animerica*. 3:7 (1995), 21.

6384. Thorn, Matt. "The Hands That Hold (and Mold) the Texts: Comics in The Lives of Japanese Girls and Women." Paper presented at "Visions, Revisions, Incorporations" conference, Montreal, Canada, March 27, 1999.

6385. Thorn, Matt. "Girls and Women Getting Out of Hand: The Pleasures and Politics of Japan's Amateur Comics Community." Paper presented at American Anthropological Association, Washington, D.C., November 22, 1997.

6386. Thorn, Matthew. "Unlikely Explorers: Alternative Narratives of Love, Sex, Gender and Friendship in Japanese 'Girls' Comics." Paper presented at New York Conference on Asian Studies, New Paltz, New York, October 16, 1993.

6387. Thorn, Matthew. "Unlikely Explorers: An Ethnography of the Community of Japanese Girls' and Women's Comic Books." Ph. D. dissertation, Columbia University, n.d.

6388. Tsurumi, Maia. "Gender and Girls' Comics in Japan." Paper presented at Japanese Popular Culture Conference, University of British Columbia, April 11, 1997.

6389. Tsurumi, Maia. "Gender Roles and Girls' Comics in Japan: The Girls and Guys of *Yūkan Club*." In *Japan Pop!*, edited by Timothy J. Craig, pp. 171-185. Armonk: New York: M.E. Sharpe, 2000.

Genre: Heroes and Superheroes

6390. Pollack, Andrew. "Japan, a Super Power Among Superheroes." *New York Times*. September 17, 1995, pp. H32.

6391. "Pow! Argh! Manga Heroes Bust Out of Japan." *Nikkei Weekly*. March 25, 1996.

6392. "When Japanese and Kirby Monsters Collide." *Comics International*. May 1999, p. 6.

Genre: Ladies'

6393. Erino, Miya. *Lady's Comic no Joseigaku.* Tokyo: Seikyusha, 1990.

6394. Fujiwara, Yukari. "Onna no Yokubou no Katachi: Ledeezu Komikusu ni Miru Onna no Sei Gensou" (The Contours of Women's Desire: The Sexual Fantasies Found in Ladies Comics). In *New Feminism Review: Pornography.* Vol. 3. Tokyo: Gakuyo Shobo, 1993.

6395. Ito, Kinko. "Sexism in Japanese Ladies' Comics." Paper presented at Popular Culture Association, Philadelphia, Pennsylvania, April 14, 2001.

6396. Kristoff, Nicholas D. "In Japan, Brutal Comics for Women." *New York Times.* November 5, 1995, pp. 1, 6.

6397. Lent, John A. "Womanizing Japanese Women's Comics." *WittyWorld International Cartoon Bulletin.* No. 10, 1996, p. 1.

6398. Morishige, Yumi. "Do Japanese Women Really Want To Be Raped?" In *Japan Made in the U.S.A.,* edited by Zipanyu, pp. 8-9. New York: Zipanyu, 1998.

6399. Nakano, Akira. "Redisu Komikku no Yokubō o Yomu" (Reading the Desire of Ladies' Comics). *Hon no Zasshi.* 12 (1990), pp. 72-76.

6400. "Nicholas D. Kristof Talks Back." In *Japan Made in the U.S.A.,* edited by Zipanyu, pp. 29-37. New York: Zipanyu, 1998.

6401. Reid, T.R. "Comics for the Career Woman." *Mangajin.* February 1997, pp. 63-83.

6402. Saotome, Miyako. *Lady's Comic no Himitsu.* Tokyo: Data House, 1993.

6403. Thorn, Matt. "Enticing Sexual Fantasies of Japanese Women: The Meaning of Ladies' Comics." In *Japan Made in U.S.A.,* edited by Zipanyu, pp. 92-97. New York: Zipanyu, 1998.

6404. "Women's Comics in Japan." *Inklings.* Summer 1997, p. 4.

6405. Yamada, Tomoko. "Ladies' Comic no Han' i." (The Scope of the Ladies' Comics). *Fūshiga Kenkyū.* January 20, 1998, pp. 9, 11.

6406. Zipanyu, ed. *Japan Made in U.S.A.* New York: Zipanyu, 1998. 280 pp.

Genre: Samurai

6407. Ishizu, Arashi. *Mushi Puro no Samurai-tachi* (The Samurai of Mushi Productions). Tokyo: Futabasha, 1980.

6408. Mutsuko, Murakami. "The War Mangas: Evolving Battlelines in Japan's Popular Comics Hold Clues to the Social Psyche." *Asiaweek.* March 20, 1998, pp. 40-41.

Genre: Science Fiction

6409. Ihara, Keiko. "Kyōtsūgo wa SF Anime Da: Ōmu-shiki Hassō no Kagi." (Sci-Fi Animation Is Their Common Language: The Key to AUM-Style Thinking). *Aera.* April 24, 1995, pp. 19-21.

6410. Kobayashi, Yoshinori and Yoshikazu Takeuchi. *Ōmu-teki!* (AUM-ish!). Tokyo: Fangs, 1995.

Portrayals

6411. Buckley, Sandra. "Facing Race: Landscape of Identity in Japanese Comic Books," Paper presented at "Visions, Revisions, Incorporations" Conference, Montreal, Canada, March 27, 1999.

6412. Cooper-Chen, Anne. "Manga for the Masses: Portrayals of Women in Japanese Comics for Men." Paper presented at International Association for Media and Communication Research, Glasgow, Scotland, July 27, 1998.

6413. Grigsby, Mary. "The Social Production of Gender as Reflected in Two Japanese Culture Industry Products: *Sailormoon* and *Crayon Shin-Chan.*" In *Themes and Issues in Asian Cartooning: Cute, Cheap, Mad and Sexy,* edited by John A. Lent, pp. 183-210. Bowling Green, Ohio: Popular Press, 1999.

6414. "Sexism in Comics." *Japan Economic Journal.* September 12, 1992, p. 2.

6415. Shigematsu, Setsu. "Dimensions of Desire: Sex, Fantasy, and Fetish in Japanese Comics." In *Themes and Issues in Asian Cartooning: Cute, Cheap, Mad and Sexy,* edited by John A. Lent, pp. 127-164. Bowling Green, Ohio: Popular Press, 1999.

6416. Shiokawa, Kanako. "Cute but Deadly: Women and Violence in Japanese Comics." *Themes and Issues in Asian Cartooning: Cute, Cheap, Mad and Sexy,* edited by John A. Lent, pp. 93-126. Bowling Green, Ohio: Popular Press, 1999.

6417. Silverman, Laura K. ed. *Bringing Home the Sushi: An Inside Look at Japanese Business Through Japanese Comics.* Atlanta: Mangajin, 1995. 209 pp.

Technical Aspects

6418. Brophy, Philip. "Ocular Excess: A Semiotic Morphology of Cartoon Eyes." *Art and Design.* Profile 53, 1997.

6419. Ikoma, Fernando. *A Técnica Universal das Histórias em Quadrinhos.* São Paulo: Edrel, n.d.

6420. Kyte, Steve. "Drawing Japanese." *Manga Max.* May 1999, pp. 22-23.

6421. *Manga Kisō Tekunikku Kōza* (Seminar on Basic Manga Techniques). Tokyo: Bijutsu Shuppansha, 1989.

6422. *Manga Ōyō Tekunikku Kōza* (Seminar on Manga Application Techniques). Tokyo: Bijutsu Shuppansha, 1990.

6423. *Manga Supā Tekunikku Kōza* (Seminar in Manga Super Techniques). Tokyo: Bijutsu Shuppansha, 1988.

6424. Matsuoka, Masatsuna. "Komikku Tekunoroji to Henshū Kōgaku (Comic Technology and Editing Engineering). In *Komikku Media*, pp. 209-243. Tokyo: NTT Shuppan, 1992.

6425. Miyamoto, T. "The Effect of Graphic Properties of 'Pictorial Letters' in Japanese Comic Books." *Science of Reading.* July 1990.

6426. *MT Manga Tekunikku* (MT Manga Techniques). Special supplement of *Bessatsu BT Bijutsu Techō.* May 1994.

6427. *MT Manga Tekunikku* (MT Manga Techniques). Special supplement of *Bessatsu BT Bijutsu Techō.* August 1995.

Political Cartoons

6428. Duus, Peter. "Weapon of the Weak, Weapon of the Strong: The Political Cartoon of Modern Japan." Presidential address, Association for Asian Studies, Chicago, Illinois, March 23, 2001.

6429. Feldman, Ofer. "Political Caricature and the Japanese Sense of Humor." Paper presented at International Society of Political Psychology, Boston, Massachusetts, July 7, 1993.

6430. Feldman, Ofer. "Political Reality and Editorial Cartoons in Japan: How the National Dailies Illustrate the Japanese Prime Minister." *Journalism Quarterly.* Autumn 1995, pp. 571-580.

6431. "Political Cartoon." *Mangajin.* No. 51, 1995, p. 13.

6432. "Political Cartoon." *Mangajin.* March 1996, p. 13.

6433. "Political Cartoon." *Mangajin.* April 1996, p. 15.

6434. "Political Cartoon from the Asahi Shinbun." *Mangajin.* March 1995, p. 7.

6435. "Political Cartoon from the Asahi Shinbun." *Mangajin.* May 1995, p. 9.

6436. "Political Cartoon from the Asahi Shinbun." *Mangajin.* June 1995, p. 9.

6437. "Political Cartoon from the *Asahi Shimbun."* *Mangajin.* August 1995, p. 9.

6438. "Political Cartoon from the Asahi Shimbun." *Mangajin.* September 1995, p. 17.

6439. Solomon, Charles. "The 'Eagle' Has Landed: Cartoon Swoops Down on U.S. Politics." *Los Angeles Times.* October 23, 2000.

6440. Yamanoi, Norio. *Booing! Political Cartoons from Perestroika to the Gulf War.* Tokyo: The Japan Times, 1991. 151 pp.

KAZAKHSTAN
General Sources

6441. "Kazahstan-Sanje Ali Realnost." *Stripburger.* No. 19, p. 75.

KOREA, NORTH
General Sources

6442. "'Robot Tae-Kwon V' & North Korean Animations on Show." *Animatoon.* No. 22, 1999.

6443. Shin, Nelson. "The Reality of North Korean Animation Industry." *Animatoon.* 3:10 (1997), pp. 67-68.

6444. Suh Sung-rok. "The Battlefront Is Just in Front of Us: Chosun Painting in North Korea." *Art Asia Pacific.* 3:3 (1996), pp. 74-76.

KOREA, SOUTH
Cartooning, Cartoons

6445. Bai, Jung Sook. "Review of Exhibition 'Cartoon Is Alive.'" *Woori Manhwa.* 8(4), 1944, pp. 2-5.

6446. Chang, Hee Jin. "Special Editorial: 'After Discussion for the Progress of Cartoon Movement.'" *Woori Manhwa.* 4(3), 1994, pp. 14-15.

6447. "Character: Cho, Yong Jin." *Manhwa Teah.* Winter 1995, p. 19.

6448. Chung, Kyong-Jun. "Specialized Book Publishing Boom Easily Explained by Cartoons." *Dong-a Daily News.* February 20, 1996, p. 9.

6449. "Comments of Exhibition." *Woori Manhwa.* 4(3), 1994, pp. 8-13.

6450. Han, Hee Jak. "Portrait (1) 'A Man Living by Thinking.'" *Manhwa Teah.* Winter 1995, p. 32.

6451. Hatton, Denise. "World of New Issues." *Linn's Stamp News.* September 11, 1995, p. 44.

6452. "Hi! Mr. Doo Ho Lee! By Editing Department." *Woori Manhwa.* 8(4), 1994, pp. 15-16.

6453. "The Impressions of 'Members of Woori Manhwa Association' About the Exhibition by Editing Department." *Woori Manhwa.* 8(4), 1994, pp. 9-10.

6454. Kim, Ha Jung. "The Popularity of Cartoon and Artistry." *Manhwa Teah.* Winter 1995, pp. 12-18.

6455. Kim, Hyung Bai. "Greeting." *Woori Manhwa.* 4(3), 1994, p. 1.

6456. Kim, Jin Tae. "My Opinion (3) 'Taming Our Culture.'" *Manhwa Teah.* Winter 1995, pp. 30-31.

6457. Kim, Jun Bum. "My Opinion (1) 'New Future.'" *Manhwa Teah.* Winter 1995, p. 28.

6458. Kim, Sang Ho. [Poster]. *Manhwa Teah.* Winter 1995, p. 19.

6459. Kim, Sung Doo. "'Short Sentence, Long Impression' (1) 'Living and Touching.'" *Manhwa Teah.* Winter 1995, p. 36.

6460. "Knock! Knock! Do You Know This Face?" *Woori Manhwa.* 8(4), 1994, pp. 21-22.

6461. Kwon, Young Sup. "'The Proposal for Reinforcement of National Competitive Power of Korean Cartoon.'" *Manhwa Teah.* Winter 1995, pp. 5-7.

6462. Lee, Dong Soo. "Meeting with a Cartoonist." *Woori Manhwa.* 4(3), 1994, pp. 16-17.

6463. Lee, Hyun Sook. "Trash Santa." *Manhwa Teah.* Winter 1995, p. 43.

6464. Lee, Jung Moon. "Preface: 'A Crisis Is a Chance.'" *Manhwa Teah.* Winter 1995, p. 4.

6465. Lee, Kang Wook. "The Happening in Location." *Manhwa Teah.* Winter 1995, p. 42.

6466. Lee, Roma. "My Opinion (2) 'The Culture and Industry of Cartoon.'" *Manhwa Teah.* Winter 1995, p. 29.

6467. Lee, So Poong. "'Short Sentence, Long Impression' (2) 'A Handicapped.'" *Manhwa Teah.* Winter 1995, p. 37.

6468. Lee, Yong Chul. " 'A Stranger of Spring, Moerceau and I.'" *Woori Manhwa.* 8(4), 1994, pp. 11-14.

6469. Lim, Cheong-San. "The Task for Development of Korean Cartoon." In *1995 International Symposium and Lecture for Seoul International Cartoon and Animation Festival,* pp. 139-144. Seoul: SICAF 95 Promotion Committee, 1995.

6470. Lim, Eung Soon. "Portrait (2) 'An Artist Never Changing.'" *Manhwa Teah.* Winter 1995, pp. 32-33.

6471. "News of Cartoon World." *Woori Manhwa.* 8(4), 1994, pp. 23-24.

6472. "News of Cartoon World." *Manhwa Teah.* Winter 1995, pp. 48-53.

6473. Park Jae-Dong. "The Painting and Cartoon As Similar Object of Interest." In *1995 International Symposium and Lecture for Seoul International Cartoon and Animation Festival,* pp. 173-180. Seoul: SICAF 95 Promotion Committee, 1995.

6474. Park, Jin Woo. " 'Make Our Cartoon a Product of National Competitive Power.'" *Manhwa Teah.* Winter 1995, pp. 8-9.

6475. Park Se-Hyung. "Educational Function of the Cartoon." Master's thesis, Seoul National University, 1985.

6476. "The Relationship of Cartoon and Opening Market for Japan." *Woori Manhwa.* 8 (4), 1994, pp. 18-20.

6477. "Rules." *Woori Manhwa.* 4(3), 1994, pp. 4-7.

6478. "The Schedule of 'Woori Manhwa Association' and System of New Executives." *Woori Manhwa.* 4(3), 1994, pp. 2-3.

6479. "A Survey of the Visitors by Editing Department." *Woori Manhwa.* 8(4), 1994, pp. 6-8.

6480. "Visiting Cartoon School of Yeon Park." *Woori Manhwa.* 8(4), 1994, pp. 25-27.

6481. Yoo, Sa Rang. "A Proposal." *Manhwa Teah.* Winter 1995, pp. 20-21.

6482. Yoo Soh-jung. "Cartoon Fanatic a Walking Encyclopedia." *Korean Herald News.* April 6, 2001.

6483. Yu, Kie-Un. "Authorship in Korean Cartoons." Paper presented at Popular Culture Association, Las Vegas, Nevada, March 28, 1996.

Animation
General Sources

6484. "Algogyeseyo (Please, Know This) – Limited Animation." *Joongyang Ilbo.* Page from Internet, January 31, 1997.

6485. "Animated-Film making Workshop." *Animatoon.* June 2001, p. 75.

6486. "Animation News: Korea." *Animatoon.* No. 4, 1996, p. 62.

6487. "Animation-Related Information. New Release Videos, Recommendable Books and Web Sites." *Animatoon.* No. 22, 1999, pp. 104-107.

6488. "Animation Report: ANIMAFORUM That Played an Important Role for Independent Creative-Short Animations." *Animatoon.* No. 22, 1999, pp. 76-83.

6489. "Animation Terminology." *Animatoon.* 1:2 (1995), pp. 74-76.

6490. "Animation Terminology." *Animatoon.* No. 7, 1996, pp. 90-91.

6491. "Animation Yeongwhasijang 'Chambaram.'" *Korean Central Daily News Magazine.* September 15, 1997, p. 26.

6492. "Animation Yongeo Haeseol" (Animation Dictionary). *Animatoon.* 3:13 (1998), pp. 74-75.

6493. "Animatoon: Its Outstanding Success As an International and Professional Animation Journal." *Animation.* No. 6, 1996, pp. 8-9.

6494. Byun, E-M. "Local Movie Production To Reach 65; Trained Young Filmmakers Show Technical Expertise." *Korea Herald.* December 28, 1994.

6495. Choi Shin-Mook. "The Opinion for Development of Animated Film." In *1995 International Symposium and Lecture for Seoul International Cartoon and Animation Festival,* pp. 103-110. Seoul: SICAF 95 Promotion Committee, 1995.

6496. "Current Situation of the Dormant MBC's Animation Productions." *Animatoon.* No. 4, 1996, pp. 34-37.

6497. "Current Situation of the World's Children's Television Program Regulation: Recently, Korea Made a Children's Broadcasting Constitution." *Animatoon.* No. 4, 1996, pp. 10-18. (Also, France, Germany, England, Netherlands, Sweden, Japan, Australia, New Zealand, Canada, South Africa, Russia, Israel).

6498. "Cutout Animation." *Animatoon.* No. 25, 2000, pp. 94-95.

6499. "Drawing Cartoon in My Mind." *Animatoon.* No. 5, 1996, pp. 96-97.

6500. "Event Haengsa Yeolam" (Directory of Events). *Motion.* 8, 1997, pp. 162-165.

6501. "Feature-Length Animation in Korea." *Animatoon.* No. 4, 1996, pp. 73-79.

6502. Fischer, Dennis. "Korean Conquerors." *AnimeFantastique.* Spring 1999, pp. 16-19, 21,

6503. Fischer, Dennis. "Two from Korea: Sony or Goldstar? Manga Offers Up a Mixed Bag of Anime Action." *AnimeFantastique.* Spring 1999, p. 20.

6504. "'Future Art,' Which Will Lead the Animation Visual Culture." *Animatoon.* No. 4, 1996, pp. 100-101.

6505. "Issue-Animationjok Tteotda" (Issue-Animation Mania Emerging). *Chosun Daily.* May 16, 1996.

6506. Jeon, Beojun. "Network Sogeui Animation Sarang" (Love of Animation in the Network). *Animatoon.* 3:13 (1998), p. 88.

6507. Kim, Chung-Ki. "The Cobbler Should Stick to His Last." *Animatoon.* No. 8, 1997, pp. 108-109.

6508. Kim Dae Jung. "Thinking at One O'Clock in the Morning." *Animatoon.* No. 4, 1996, pp. 96-97.

6509. Kim, Gil-Woong. "Animator As a Successful Production Manager." *Animatoon.* No. 6, 1996, pp. 100-101.

6510. "Korean and American Animation Advertising." *Animatoon.* No. 5, 1996, pp. 85-89.

6511. "Korean Theater Animation." *Animatoon.* 2:4-1 (1996), pp. 73-79.

6512. Langford, Jessica. "Animation and Cultural Identity in Seoul." *Storyboard.* 3-4/1995, pp. 4-7.

6513. Lent, John A. (Trans. Tianyi Jin and Lin Lin). "The Changes of Korean Animation: 1994 to 1996." *New Film.* No. 5, 1997, pp. 49-52.

6514. Lent, John A. "Korean Animation: An Analysis of the Boom Years, 1994-96." Paper presented at Association for Asian Studies, Chicago, Illinois, March 13, 1997.

6515. Lent, John A. "Korean Animation: The Boom Years." Paper presented at Society for Animation Studies, Madison, Wisconsin, September 28, 1996.

6516. Lent, John A. "News from Korea." *Society for Animation Studies Newsletter.* Winter/Spring 1996, p. 4.

6517. Lent, John A. and Kie-Un Yu. "Korean Animation: A Short but Robust Life." In *Animation in Asia and the Pacific,* edited by John A. Lent, pp. 89-100. Sydney: John Libbey & Co., 2001.

6518. "Lotte World's Theatre Exclusively for Animation." *Animatoon.* No. 4, 1996, p. 85.

6519. McClellan, Steve. "Twinkle Set for Animation." *Broadcasting.* July 6, 1992, p. 34.

6520. "The Magic of Animation That Inspired the Drawings." *Animatoon.* No. 4, 1996, pp. 98-99.

6521. "MCS (Ministry of Culture and Sports) Program." *Korean Film News.* July 1996, p. 6.

6522. Namgung, Euijeong. "16 gnag Jinchureui Ggum 'Bulgeun Akma Kori'" (Dream of Becoming One of the 16 Countries in the World Cup "Red Devil Kori"). *Animatoon.* 3:13 (1998), p. 87.

6523. "New Animation." *Animatoon.* No. 28, 2000, p. 83.

6524. "'95 KBS Visual Art Competition Which Shows Endless Possibility of High-Tech Animation." *Animatoon.* No. 4, 1996, pp. 82-85.

6525. "'99 Korean Visual Animation Prize in Competition." *Animatoon.* No. 22, 1999.

6526. "'96 KBS Visual Contest – Animation/CG Division Winners' Collection." *Animatoon.* No. 8, 1997, pp. 60-63.

6527. Park Chung-bae. "The Changing Winds of Korean Animation." *Animation World.* February 1997, pp. 22-24.

6528. "Professor Sung-Wan Park Won a Merit Prize of Illustration in the Third NorthArtMartin *Biennale.*" *Animatoon.* No. 22, 1999.

6529. "SBS Plans High Quality Animation Film For Over-the-Air." *Animatoon.* No. 5, 1996, pp. 34-37.

6530. Shin, Dong-Hun. "Animation and Music." *Animatoon.* No. 5, 1996, pp. 90-91.

6531. Shin, Nelson. "Animation Gibeop" (Animation Skills). *Animatoon.* 3:12 (1998), pp. 80-87.

6532. Shin, Nelson. "Animation Terminology." *Animatoon.* No. 4, 1996, pp. 86-89.

6533. Shin, Nelson. "For the Development of Original Korean Animated Films." *Animatoon.* No. 24, 2000, p. 5.

6534. Shin, Nelson. "'International' Issue of ANIMATOON Magazine." *Animatoon.* 2:4-1 (1996), p. 5.

6535. Shin, Nelson. "Looking Back to Korean Animation of 2000." *Animatoon.* No. 28, 2000, p. 5.

6536. Shin, Sung-Ho. "Cartoon Book for Starting Fire." *Animatoon.* No. 6, 1996, pp. 102-103.

6537. "Special Exhibition on Paper: Winning Programs on '95 KBS's Short Animation and Film Competition." *Animatoon.* 2:4-1 (1996), pp. 82-85.

6538. "Summer Showers." *Korea Cinema.* 1996, p. 60.

6539. "TV Animation Information." *Animatoon.* 1:2 (1995), pp. 58-60.

6540. "The Underworld." *Animatoon.* No. 25, 2000, pp. 98-99.

6541. Vallas, Milt. "The Korean Animation Explosion." *Animation World Magazine.* September 1997, 6 pp.

6542. "Widehan Animation Yesul Jakpum Segye." *Animatoon.* 3:11 (1997), pp. 112-117.

6543. "Winners of Cartoon Contest Named." *Korea Herald.* July 16, 1995.

6544. Yi, Jiyeon. "Hanguk Manwha Animation Baljeoneul Wihan Moim" (Meeting for Development of Korean Comics and Animation). *Animatoon.* 4:12 (1998), pp. 68-71.

6545. Yi, Junwung. "Sinariowa Kaerikteoga Chaeksange Itseul Ttae Deouk Haengbokhada" (I Am Much Happier When Scenario and Characters Are on My Desk). *Animatoon.* 1:2 (1995), pp. 94-95.

Animation Towns and Theme Parks

6546. "Announcing the Birth of the Strategic Multi Media Animation City of Chun-Chon in the 21ˢᵗ Century, '97 Chun-Chon Cartoon Festival." *Animatoon.* 3:10 (1997), pp. 44-47.

6547. "Choon-Chun City's Project of 'Animation Image Information Center' Is Stuck." *Animatoon.* No. 22, 1999.

6548. "Chun-An 'Animation Complex' Assigned as Foreign Investment Site." *Animatoon.* No. 22, 1999.

6549. Deckard, L. "South Korea Park Set for $300 Million Expansion." *Amusement Business.* April 11, 1994, p. 1.

6550. Sklarewitz N. "Seoul Complex a World of Its Own." *Amusement Business.* June 20-28, 1994, p. 31.

6551. "Songdo Sindosie Media Park." (Media Park in the New City Songdo). *Joongyang Ilbo.* Page from Internet, March 24, 1997.

6552. "Tae-Jon City's 'Animation Town' Project on Track Next Year." *Animatoon.* No. 22, 1999.

6553. "Toonipark." *Animatoon.* No. 30, 2001, pp. 68-69.

6554. Yu Kie-Un. "Anitown and Local Government's Interest in the Korean Animation Industry." Paper presented at Mid-Atlantic Region Association for Asian Studies, Newark, Delaware, October 25, 1998.

Animators

6555. "Animationgye Saebaram Ireukigo Inneun Jeolmeunideul" (Young People Who Make New Wind in Animation Arena). *Animatoon.* 1:2 (1995), pp. 102-103.

6556. "Animation People Best 100." *Animatoon.* No. 26, 2000, pp. 72-85.

6557. "Animation People Best 100." *Animatoon.* No. 27, 2000, pp. 56-69.

6558. "Animation People Best 100." *Animatoon.* No. 28, 2000, pp. 54-69.

6559. "Animation People Best 100." *Animatoon.* No. 29, 2001, pp. 66-69.

6560. "Animation People Best 100." *Animatoon.* No. 30, 2001, pp. 48-51.

6561. "Background Artist Who Makes Animation Alive." *Animatoon.* 1:2 (1995), pp. 98-99.

6562. Bae, Jeonggil. "Jinjeonghan Jakgajeongshineul Gatja" (Let's Have Real Spirit of Creator). *Animatoon*. 3:11 (1997), pp. 122-123.

6563. "Career World: Understanding Animator – Animator's Today and Tomorrow, a Message from Seung-Chan Lee, a Producer of the Original Picture in the Field." *Animatoon*. No. 22, 1999, pp. 102-103.

6564. Im, Jeonggyu. "Jakwhajireul Sseureonaemyeo Maeume Grimeul Grinda" (I Am Drawing in My Heart …). *Animatoon*. 2:5 (1996), pp. 96-97.

6565. "Im Keok-Jung, Korean Robin Hood." *Korea Cinema*. 1997, p. 59.

6566. [Korean Animators' Profiles]. *Animatoon*. No. 25, 2000, pp. 66-83.

6567. Nangung, Euijeong. "Dongnip Animeitendeure Jakpum Segye" (Art World Of Independent Animators). *Animatoon*. 4(14): 1998, pp. 96-98.

6568. Park, Yuhyang. "Cameramene Segye" (World of Camera Men). *Animatoon*. 1:1 (1995), pp. 102-103.

6569. "The President of Shon e Shon Film Corp., Shon Kyung-woo: Successful Distribution of 'A Little Dinosaur Doolie' to Germany." *Animatoon*. No. 16, 1998, p. 110.

6570. "The Road to the Animator." *Animatoon*. No. 16, 1998, pp. 92-95.

6571. "The World of Rho Jung-duk's Characters." *Animatoon*. No. 16, 1998, pp. 98-99.

6572. Yeo Youngwook. "Animator's Square: Let's Fly the Sky." *Animatoon*. No. 7, 1996, pp. 92-93.

6573. Yi, Chunman. "Naeui Bunsln PLUS ONE" (My Incarnation, PLUS ONE). *Animatoon*. 3:12 (1998), pp. 100-101.

Chung, Peter

6574. Hughes, David. "Peter the Great." *Manga Max*. April 1999, pp. 12-16.

6575. Mallory, Michael. "Korean Animator Peter Chung of AEON FLUX." *Animatoon*. 1:2 (1995), pp. 40-41.

Shin Dong Hun

6576. Kim, Irang. "Umjigineun Manwha-e Kum" (Dreams of Moving Cartoons – Shin Brothers). In *Hanguk Manwha-e Seongujadeul* (Pioneers of Korean Cartoons), edited by Jaedong Park, pp. 49-63. Seoul: Yeolwhadang, 1995.

6577. Lent, John A. "Shin Dong Hun, An Old Warrior in Korean Animation."
 Animation World. February 1997, pp. 25-26.

6578. Lent, John A. *"Vignette:* Shin Dong Hun and Korea's 'Miserable'
 Animation Beginnings." In *Animation in Asia and the Pacific,* edited by
 John A. Lent, pp. 101-104. Sydney: John Libbey & Co., 2001.

6579. Shin Dongheon Gamdokgwa Hong Gil Dong" (Director Dongheon Shin
 and "Hong Gil Dong"). *Motion.* August 1997, pp. 166-167.

6580. Shin, Dongheon. "Daebu" (Grand Master). *Animatoon.* 1:2 (1995), pp.
 84-85.

Associations, Clubs

6581. "About Members/Post Scripts." *Manhwa Teah.* Winter 1995, p. 54.

6582. "Animation Club Series/Chasamo." *Animatoon.* 2:4-1 (1996), pp. 102-
 103.

6583. "Any Road: Professional Animation Scenario Group." *Animatoon.* No.
 4, 1996, pp. 94-95.

6584. Gungnae Animation Dongarie Hyeonjuso" (Current State of Domestic
 Animation Fan Groups). *Animatoon.* 2:7 (1996), pp. 99-101.

6585. " 'Kae. Sa. Mo.': An Animation Club Which Shows the Possibility of
 the Domestic Character Industry." *Animatoon.* No. 4, 1996, pp. 102-
 103.

6586. "Korean Animation and Cartoon Association's Foundation Symposium,
 As a Place of Distorted Truth, Lacking Academic Specialty, Research,
 and Logic." *Animatoon.* No. 8, 1997, pp. 96-99.

6587. "Korean Animation Artist Association Newly Establishes." *Animatoon.*
 No. 5, 1996, p. 68.

6588. "Korean Cartoonist Association Holds the 28th Committee Conference."
 Animatoon. 2:4-1 (1996), p. 26.

6589. "Korea Now Joins the ASIFA National Member." *Animatoon.* No. 5,
 1996, p. 68.

6590. "Manwha Animation Hakwhoe Jeonggi Haksuldaewhoe" (Comics and
 Animation Society Regular Academic Conference). *ET NEWS.* April 23,
 1998.

6591. "Saeroun Sidoro Gwansim Moeuneun Animation Dongarideul"
 (Animation Amateur Production Groups). *Animatoon.* 2:3 (1996), pp.
 102-103.

6592. "Series of Animation Clubs: 'Dal' – A Professional Club." *Animatoon.* No. 7, 1996, pp. 102-103.

6593. Yi, Jiyeon. "Hanguk Manwha-Animationeul Wihan Moim" (Meeting for Korean Comics and Animation). *Animatoon.* 3:12 (1998), pp. 68-71.

Characters and Titles

6594. "Admiral's Diary." *Korea Cinema.* 1997, p. 58.

6595. "Animation Yesure Saeroun Daejungjeok Pyohyeon Yangsik Jesihan Prodeure Moim 'Dahl'" ('Dahl,' Which Presents a New Popular Expression Style). *Animatoon.* 2:7 (1996), pp. 102-103.

6596. "Blockbuster Ani-Movie." *Animatoon.* No. 29, 2001, pp. 82-83.

6597. Clements, Jonathan. "Red Hawk: Weapon of Death." *Manga Mania.* March-April 1998, p. 73.

6598. "Dongyang Seolwhae Batangeul Dun S.F. Fantasy Cheorin Sacheonwang" (Iron Man Sacheon King, S.F. Fantasy Based on Oriental Legend). *Animatoon.* 3:13 (1998), pp. 52-53.

6599. "Empress Chung, the Movie." *Animatoon.* No. 27, 2000, pp. 44-45.

6600. "Empress Esther." *Korea Cinema.* 1996, p. 63.

6601. *"Fantastic Village Topo Topo."* *Animatoon.* No. 27, 2000, pp. 86-87.

6602. Fischer, Dennis. "Two from Korea." *AnimeFantastique.* Spring 1999, p. 20.

6603. "Geukwha-eseo Animation Jejak Dongariro Byeonmohan MYSTERY" (MYSTERY, Which Was Transformed from Comics to Animation). *Animatoon.* 3:11 (1997), pp. 124-125.

6604. "Grandma and Her Ghosts." *Korea Cinema 1998,* p. 65.

6605. "Hanguk Animation Geungan Jomyeong" (Review of Recent Korean Animation). *Motion.* June 1997, pp. 162-178.

6606. "The Hungry Best 5." *Korea Cinema.* 1996, p. 64.

6607. Jeong, Dobin. "Cel 240Maero Mandeun 'Gaemiwa Baetzangi" ("Ants and Locusts" Made with 240 Cels). *Animatoon.* 2:6 (1996), pp. 98-99.

6608. Kim, Cheonggi. "Songchungi Galipeul Meogeo Dwegenna?" (How Can Caterpillar Eat Reeds?) *Animatoon.* 3:8 (1997), pp. 108-109.

6609. Kim Tae-Woo. "Image Expressions of Characters." *Animatoon.* 1:2 (1995), pp. 62-64.

6610. "A Korean-American Joint Investment in 'Super Duper Sumos' Animation Series." *Animatoon.* No. 22, 1999, p. 42.

6611. "A Korean Animation 'Restol Teuk-Soo-Goo-Jo-Dae' (Special Relief Squad) Running on the NHK TV in Japan." *Animatoon.* No. 22, 1999, p. 42.

6612. "Korean Cartoon 'Yul-Hyul-Kang-Ho' Circulation Over 2 Millions." *Animatoon.* No. 22, 1999.

6613. "Motion Special: Jeonsa Ryan." *Motion.* August 1997, pp. 108-122.

6614. Namgung, Euijeong. "Mabeopeui Kal" (Magic Sword). *Animatoon.* 3:13 (1998), pp. 54-55.

6615. "New Animation Series 'Yally and Bong' by AKOM." *Animatoon.* 2:4-1 (1996), pp. 52-56.

6616. "'New Generation Young-Sim-I' Having New Characters." *Animatoon.* No. 22, 1999.

6617. Park, Shinyeong. "Hanguke Character Saneobgwa Geu Banghyahgseong" (Korean Character Industry and Its Direction). *Animatoon.* 4(14): 1998, pp. 80-83.

6618. "Restol Special Relief Squad (Korean)." *Animatoon.* No. 16, 1998, p. 63.

6619. "Rian." *Korea Cinema.* 1997, p. 60.

6620. "'Robot Tae-Kwon V,' on Progress of Being Developed as a Character Commodity." *Animatoon.* No. 22, 1999, p. 42.

6621. "Yalsukyi and Yalbongyi Will Be Produced As Animation Series." *Animatoon.* No. 4, 1996, pp. 52-53.

6622. "Yeoreum Banghak Guknae Manwhayeogwha Samdae Geukjang Gaebongjak" (The Three Major Animation Features in Summer Vacation). *Motion.* July 1997, pp. 116-123.

"Armageddon"

6623. "Armageddon." *Korea Cinema.* 1996, p. 62.

6624. Armageddon Production Committee White Paper Editing Department. *White Paper of Animation Armageddon.* Seoul: 1996.

6625. "Armageddon Reviewed by General Director Yi Hyeon Se." *Animatoon.* No. 4, 1996, p. 77.

6626. Clements, Jonathan. "Seoul Blades." *Manga Mania.* October-November 1997, pp. 14-15.

6627. Park, Minseong and Rakhyun Seong. "Pre-production." In *Armageddon Baekseo* (Armageddon White Book). Seoul: Armageddon Production Committee, 1996.

"Baby Dinosaur Dooley"

6628. "Baby Dinosaur Dooly: The Great Adventure of Ice Star." *Animatoon.* No. 6, 1996, pp. 86-87.

6629. "'Dooley' Drawing Two Million-Dollar Investments from Germany." *Animatoon.* No. 22, 1999, p. 42.

6630. "A Little Dinosour [sic] Doolie." *Korea Cinema.* 1996, p. 61.

"Hong Gil Dong"

6631. "Hong Gil-Dong." *Korea Cinema.* 1996, p. 65.

6632. Shin, Nelson. "Hong Gil Dong Style and Samurai Style: These Are the Problems in Hong Gil Dong Returned." *Animatoon.* No. 4, 1996, pp. 80-81.

"Ttotto and Ghost Friends"

6633. Namgung, Euijeong. "Ttottowa Yuryeong Chigudeul" (Ttotto and Ghost Friends). *Animatoon.* 3:13 (1998), pp. 84-85.

6634. Park, Shinyeong. "Eumjigime Sorireul Damneun Animation Eumakga Bang Yongseok, Ttottowa Yurgeong Chigudeul" (Ttotto and Ghost Friends). *Animatoon.* 3:13 (1998), p. 86.

Companies, Studios

6635. "Animation Creative Group, DigiArt." *Animatoon.* No. 16, 1998, pp. 108-109.

6636. "Bongyeok Clay Animation Changjage Dojeonhaneun Studio 'MARU'" (Studio 'MARU,' Which Challenges Professional Clay Animation Production). *Animatoon.* 3:8 (1997), pp. 110-111.

6637. "Dayanghan Soje Balgul Naseon ANI" (ANI Seeks Various Themes). *Animatoon.* 2:5 (1996), pp. 98-99.

6638. "C & A Han Jangreue Gukhandwoeji Anneun Dagakjeokin Whaldongeul Hago Inneun Animation Yeongu Dongari" (The

Animation Group C & A, Which Makes Various Efforts). *Animatoon*. 3:10, pp. 102-103.

6639. "Depth Analysis: MBC's Animation Production." *Animatoon*. 2:4-1 (1996), pp. 86-89.

6640. "Dongwoo Animation." *Animatoon*. No. 27, 2000, pp. 84-85.

6641. "EBS." *Animatoon*. No. 25, 2000, pp. 90-91.

6642. Fabrikant, Geraldine. "Great Expectations for Fledgling Studio." *New York Times*. January 20, 1997, pp. D-1, D-9.

6643. "FDC (Film Development Corporation) Opening Animation Scenarios Competition." *Animatoon*. No. 22, 1999.

6644. Gelman, Morrie. "Saerom Animation: Korean Studio Ready To Branch Out." *Animation*. May 2000, p. 32.

6645. Groves, Don. "Ameko Tunes Up Deals, Toons." *Variety*. February 21-27, 2000, p. 35.

6646. Gwon, Manu. "(Youngsang Camp) Mirae Youngsang Saneop Juyeok Balgul" ([Visual Camp]: Digging Up the Future Leader of the Visual Industry). *Chosun Ilbo*. Page from Internet, November 27, 1996.

6647. Hall, Wendy Jackson. "Rough Draft." *Animation*. December 1999, pp. 20-21.

6648. "Jeolmeun Animation Chanjak Dongari 'Mongsangga'" (Young Creative Animation Production Group, "Dreamers"). *Animatoon*. 3:12 (1998), pp. 102-103.

6649. Knapp, Sunja. "Sunwoo Entertainment." *Animation*. October 1999, pp. 34-35.

6650. [Korean Scientific and Educational Film Studio]. *Animatoon*. No. 30, 2001, pp. 58-59.

6651. "Koron, SBS wa Kaerikteo Saeop Jehyu" (Koron and SBS Enter into Animation Character Joint Venture). *Joongyang Ilbo*. Page from Internet, January 18, 1997.

6652. "Korong Character Saeop Bongyeok Jinchul" (Korong Group Enters Into Character Business). *Chosun Ilbo*. Page from Internet, October 9, 1996.

6653. McClellan, Steve. "Zen and the Art of Animation Production: Ex-Zodiac Executive Starts New Company." *Broadcasting and Cable*. August 22, 1994, p. 14.

6654. "MBC 'Boom-I-Dam-I-Boorung-Boorung' Program on the Air." *Animatoon.* No. 22, 1999.

6655. "'Milro's Great Adventure,' a First-Run on the 26th of November." *Animatoon.* No. 22, 1999.

6656. "Planning a Site for Animation House in Namsan Mountain." *Animatoon.* No. 22, 1999.

6657. "Production Companies Directory." *Animatoon.* 1:2 (1995), pp. 86-92.

6658. "SAC (Seoul Animation Center) 2000 – More More!" *Animatoon.* No. 25, 2000, pp. 92-93.

6659. "Seoul Animation Co., Ltd." *Animatoon.* No. 24, 2000, pp. 74-75.

6660. "Seoul Visual Venture Center: The Small but Powerful Beginning Spot of Korean Visual Industry." *Animatoon.* No. 16, 1998, pp. 96-97.

6661. "Studio 'MaaRoo,' Challenging the Creation of Authentic Clay Animation." *Animatoon.* No. 8, 1997, pp. 110-111.

6662. "Studio Visit: Han-Ho, Inc., a Leader in the High Quality Animations." *Animatoon.* No. 22, 1999, pp. 84-85.

6663. "The Today and Tomorrow of Daegyo Bangsong – Children's Cable TV Channel 17." *Animatoon.* 1:2 (1995), pp. 36-39.

6664. "The Unique Cel Animation Independent Group 'SeNN Graphics.'" *Animatoon.* 3:9 (1997), pp. 102-103.

6665. "What Is AniBS?" *Animatoon.* No. 23, 2000, pp. 70-71.

Cheil

6666. "Cheil Jedang Guknae Eumbansaeop Bongyeok Jinchul" (Cheil Jedang Company Enters into Music Disc Industry). *Joongyang Ilbo.* Page from Internet, January 18, 1997.

6667. "Cheil Jedang, Sogangdae, Multi-Media Gyoyukgwajeong Gaeseol." *Joongyang Ilbo.* Page from Internet, February 5, 1997.

6668. "Cheil To Set Up Movie Software Company in United States." *Korea Herald.* April 30, 1995.

6669. Yun, Youngshin. "Cheil Jedang Video Saeoup Jinchul" (Cheil Jedang Enters into Video Business). *Chosun Ilbo.* Page from Internet, November 12, 1996.

Computer Animation

6670. "The Advent of Live and Moving Manhwa (Animation): Digital Manhwa Having the Advantage of Both of the Cartoon's Convenience and Animation's Vividness." *Animatoon.* No. 22, 1999, pp. 72-73.

6671. "Animation C.F." *Animatoon.* 1:2 (1995), pp. 96-97.

6672. "Animation CF of Korea & U.S.A." *Animatoon.* 2:4-1 (1996), pp. 90-93.

6673. "Contemporary Image of Traditional Design – Kim Hye-Won's Computer Animation." *Animatoon.* 1:2 (1995), pp. 52-53.

6674. "Internationally Famous Computer Animation Hardware and Software." *Animatoon.* No. 4, 1996, pp. 70-72.

6675. "Korean Animation CF." *Animatoon.* No. 4, 1996, pp. 90-92.

6676. "New Job of the Digital Animation Era, Computer Animation Operator." *Animatoon.* No. 5, 1996, pp. 92-95.

6677. "THELMA Full 3D Computer Graphic Animation Project in Progress." *Animatoon.* No. 22, 1999.

Education, Training

6678. "Animation School." *Animatoon.* No. 31, 2001, pp. 26-27.

6679. "Creative and Experimental Stage of Young Animators: Animation Graduation Exhibition of the Kyewon Johyong Art School." *Animatoon.* No. 22, 1999, p. 108.

6680. "Choon-Chun City Getting High School Students Field Trips to Animation Industries." *Animatoon.* No. 22, 1999.

6681. "Domestic Educational Institutions for Animation." *Animatoon.* No. 7, 1996, pp. 94-98.

6682. Ericsson, Erling. "Kids with Action Animation in School/Workshop in Korea." *Animatoon.* 3:13 (1998), pp. 72-73.

6683. "Guknae Animation Gyoyukgigwan Annae" (Guide to Domestic Animation Educational Institutions). *Animatoon.* 3:12 (1998), pp. 88-89.

6684. "Gungnae Animation Gyoyukgigwan Annae" (Guide to Korean Animation Educational Institutions). *Animatoon.* 4:12 (1998), pp. 80-89.

6685. "Gungnae Animation Gyoyukgigwan Jipjung Annae" (Intensive Guide to the Korean Animation Educational Institutions). *Animatoon.* 2:7 (1996), pp. 94-98.

6686. Park Se-Hyung. "Educational Function of the Cartoon." Masters thesis, Seoul National University, 1995.

6687. "Syejong University Offers New Major: Animation Multimedia Major." *Animatoon.* 2:4-1 (1996), p. 26.

6688. Yu, Kie-un. "Cartoon and Animation Education in Korea." Paper presented at Popular Culture Association, Philadelphia, Pennsylvania, April 14, 2001.

Festivals

6689. "CHIAF '99." *Animatoon.* No. 20, 1999, pp. 11-13.

6690. "Children's International Film Fest To Woo Young and Old; First Such Event in Seoul To Feature Films from About 20 Nations." *Korean Herald.* June 25, 1995.

6691. "Chunchon International Animation Festival '98." *Animatoon.* No. 16, 1998, pp. 32-37.

6692. "Cyber 2000: Chunchon International Anitown Festival." *Animatoon.* No. 28, 2000, pp. 28-31.

6693. "Dibujante de Humor Premiado en Korea." *Che-Loco.* April 1999, p. 12.

6694. "The 8th Taejon Int'l Cartoon Contest." *Kayhan Caricature.* February/March, 2 pp.

6695. "Exclusive Report: Celebration of World Animation." *Animatoon.* No. 7, 1996, pp. 80-82.

6696. "An Exhibition of Artists-Manufactured Animations Being Held." *Animatoon.* No. 22, 1999, p. 42.

6697. "Family and Fantasy: The 2nd Seoul International Family Film Festival and the First Pusan Fantastic Film Festival." *Animatoon.* 3:10 (1997), pp. 51-53.

6698. "The First Annual Geum-Kang Visual Art Festival for Juniors and Teenagers Will Be Held." *Animatoon.* No. 22, 1999.

6699. "The First Annual Seoul Cyber Film Festival: A Small Door to the Future Through Film and Animation." *Animatoon.* No. 22, 1999, pp. 32-33.

6700. "The 9th Daejeon Int'l Cartoon Contest." *Kayhan Caricature.* March 2001, 2 pp.

6701. "'99 Korean Visual Animation Prize Award Ceremony Held." *Animatoon.* No.22, 1999.

6702. "PiFan 99." *Animatoon.* No. 20, 1999, pp. 17-19.

6703. "Seoul Anim Expo '97." *Animatoon.* 3:11 (1997), pp. 64-73.

6704. "Seoul International Character Show 2000." *Animatoon.* No. 27, 2000, pp. 24-25.

6705. Shin, Jina. "Chamdaun Jeongshin, Jayuroun Changjak – 98 Daehak Youngwha Chukje" (True Mind, Free Creation – 98 University Cinema Festival). *Animatoon.* 3:13 (1998), p. 36.

6706. "Special Report: Natpe International 33rd Annual Program Conference and Exhibition." *Animatoon.* No. 4, 1996, pp. 20-27. (Comment on Korea's lack of participation in animation.)

6707. "The 3rd Pusan International Film Festival: Twenty-One Animation Features Were Screened." *Animatoon.* No. 16, 1998, pp. 38-41.

AnimExpo

6708. "AnimExpo '97." *Society for Animation Studies Newsletter.* Spring/Summer 1997, p. 5.

6709. Kreck, Detelina. "AnimExpo '97: An Introduction to the Rising Tiger." *Animation World Magazine.* September 1997, 3 pp.

6710. McLaughlin, Dan. "A Report on Animexpo '97." *Society for Animation Studies Newsletter.* Summer 1997, p. 5.

6711. "'97 Seoul Segye Animation Expo" ('97 Seoul International Animation Expo). *Animatoon.* 3:10 (1997), pp. 38-42.

6712. "Seoul Animation Expo '97 Awarded Animation in Competition." *Animatoon.* 3:11 (1997), pp. 64-73.

Dong-A LG

6713. "New Age, New Trend, the First Dong-A—LG International Cartoon Festival." *Animatoon.* 3:10 (1997), pp. 48-49.

6714. "'97 Dong-A, LG International Festival of Comics and Animation." *Animatoon.* 3:11 (1997), pp. 74-78.

6715. Park, Shinyoung. "98 Dong-A LG Gukje Manwha Festival" (98 Dong A LG International Cartoons Festival). *Animatoon*. 3:13 (1998), pp. 8-11.

6716. "2000 Dong-A. LG International Festival of Comics, Animation & Games." *Animatoon*. No. 27, 2000, pp. 20-23.

Korea Short Animation Festival

6717. "98 Korea Short Animation Festival." *Korean Film News*. December 1998, p. 7.

6718. "99 Korea Short Animation Festival." *Animatoon*. No. 20, 1999, pp. 14-16.

PIFF

6719. "99 PIFF." *Animatoon*. No. 21, 1999, pp. 22-23.

6720. "Puchon International Fantastic Film Festival 98." *Animatoon*. No. 17, 1999, pp. 50-53.

PISAF

6721. "ASIFA Members in PISAF." *Animatoon*. No. 29, 2001, pp. 20-27.

6722. "Festival Spotlight PISAF 1999." *Animatoon*. No. 19, 1999, pp. 32-35.

6723. "Festival Spotlight: Puchon International Students Animation Festival (PISAF)." *Animatoon*. No. 18, 1999, pp. 8-9.

6724. [PISAF]. *Animatoon*. No. 30, 2001, pp. 54-55.

6725. "PISAF 2000." *Animatoon*. No. 29, 2001, pp. 12-14.

6726. "2000 PISAF (Puchon International Student Animation Festival)." *Animatoon*. No. 29, 2001, pp. 8-11.

SICAF

6727. Alder, Otto. "Seoul International Cartoon and Animation Festival (SICAF) 14-21 August 1996." *Animatoon*. No. 8, 1997, pp. 90-93.

6728. Cho Sang-hee. "Int'l Cartoon-Animation Festival Opens." *Korea Times*. August 11, 1995, p. 10.

6729. "Exhibition of Animation: SICAF '96 Animation Award Winners." *Animatoon*. No. 7, 1996, pp. 22-31.

6730. "A Global Cartoon Festival, the 1996 Seoul International Cartoon and Animation Festival (SICAF) Opened." *Korean Film News.* December 1996, p. 5.

6731. Kato, Masaaki. "SICAF '95." *Anime FX.* December 1995, pp. 24-26.

6732. Koh, C.M. "SICAF '95 Showing Address of World Animation." *Korea Times.* August 11, 1995, W-2.

6733. Lent, John A. "SICAF '96: You Can't Get There From Here." *WittyWorld International Cartoon Bulletin.* No. 8, 1996, p. 5.

6734. Lent, John A. "Successfully Completed '95 Seoul International Cartoon Festival." *Animatoon.* 1:2 (1995), p. 33.

6735. Nieuwendijk, Peter and Ab Moolenaar. "Seoul International Cartoon and Animation Festival." *FECO News.* Autumn/ Winter 1995, pp. 14-17.

6736. *1995 International Symposium and Lecture for Seoul International Cartoon and Animation Festival.* Seoul: SICAF 95 Promotion Committee, 1995. 180 pp.

6737. *1996 International Symposium for Seoul International Cartoon and Animation Festival.* Seoul: SICAF, 1996. 30 pp. (Includes Sadao Sakai, "Art, Violence and Sex in Cartoons," pp. 5-10; Bert Witte, "The Issue of Violence (Attitude of Dutch Government),'" pp. 11-26; Lim Chung-San, "The Issue of Creative Expression for Korean Cartoons," pp. 27-30).

6738. "Non-Governmental Festival SICAF '97." *Animatoon.* 3:10 (1997), pp. 34-37.

6739. "Je2 Whoe Seoul Gukje Manwha Festival" (Second Seoul International Cartoon and Animation Festival). *Animatoon.* 2:6 (1996), pp. 20-23.

6740. "'95 Seoul Gukje Manwhajeon" ('95 Seoul International Cartoon and Animation Festival). *Animatoon.* 1:2 (1995), pp. 24-31.

6741. "Seoul International Cartoon and Animation Festival." *Animatoon.* No. 6 (August), 1996, pp. 20-23.

6742. "Seoul International Cartoon & Animation Festival." *Animatoon.* 3:11 (1997), pp. 54-63.

6743. "Seoul International Cartoon & Animation Festival 1996." *ASIFA News.* 9:4 (1996), p. 19.

6744. *Seoul International Cartoon & Animation Festival 1996.* Seoul: SICAF, 1996. 297 pp.

6745. Shin Hye-son. "Korea's 1st Int'l Cartoon Festival To Open at KOEX." *Korea Herald.* July 22, 1995.

6746. Shin, Nelson. "'96 Seoul International Cartoon and Animation Festival: Its Problems and Solutions." *Animatoon.* No. 8, 1997, pp. 82-89.

6747. [SICAF]. *Animatoon.* No. 30, 2001, pp. 52-53.

6748. "SICAF Minganjudoro Yeolrineun Manwhagwalryeon Choedae Chukje-e Jang Seoul Gukje Manwha Festival '97" (SICAF – The Biggest Cartoon-Related Festival, Seoul International Cartoon and Animation Festival). *Animatoon.* 3:10 (1997), pp. 34-37.

6749. "SICAF '96 Animation Gongmojeon" (SICAF '96 Animation Contest). *Animatoon.* 2:7 (1996), pp. 22-31.

6750. SICAF 95 Promotion Committee. *Catalogue.* First Seoul International Cartoon and Animation Festival, Seoul, Korea, August 11-13. Seoul: SICAF 95 Promotion Committee, 1995. 292 pp.

6751. "SICAF '97 Awarded Animation in Competition." *Animatoon.* 3:11 (1997), pp. 54-63.

6752. "SICAF 1999." *Animatoon.* No. 20, 1999, pp. 8-10.

6753. "SICAF, '99." *Animatoon.* No. 21, 1999, pp. 8-22.

Foreign Influences

6754. Alford, Christopher. "Turner Toons into S. Korea." *Variety.* September 6-12, 1999, p. 31.

6755. "Haewoe Gongdongjejakchegyewa Jeolmeunideure Giwhoek Chamyeo" (International Co-Production System and Young People's Participation of Planning). *Animatoon.* 1:2 (1995), pp. 42-44.

6756. Herriot, Fred. "Anime in Korea." *The Rose.* April 1997, p. 25.

6757. "Importing Japanese Cartoon and the Christian Diagnosis Against It From Deulsori News." *Manhwa Teah.* Winter 1995, pp. 10-11.

6758. "Japanese Animation in South Korea." *Animatoon.* No. 22, 1999, pp. 66-68.

6759. Kunio Endo. "South Koreans Say Hello to Kitty, Other Japanese Cultural Exports. Eased Import Regulations Mean Big Business for Character Goods." *Nikkei Weekly.* July 24, 2000, p. 19.

6760. Oh, Gwangsu. "Guksan Manwha-youngwha 'Chanbab' Yeojeon" (The Domestic Animation Is Still Put Aside). *Kyunghyang Shinmun.* Page from Internet, March 29, 1997.

6761. Shin, Dalja. "Imi Duk-eul Neomeo-on Ilbon Manwha" (Overflowed Japanese Cartoons). *Kyunghang Shinmun.* March 5, 1994, p. 5.

6762. Shin, Nelson, Shinyoung Park, Beomjun Jeon, and Jina Shin. "Ilbon Munwha Gaebanggwa Urie Hyeonsil" (Opening to Japanese Culture and Reality). *Animatoon.* 4(14): 1998, pp. 50-57.

6763. Yoon, Sunny. "Disney Animated by the 'White' Head and 'Yellow' Hands." Paper presented at International Association for Media and Communication Research, Glasgow, Scotland, July 28, 1998.

6764. Yu, Seungchan. "Disneytado Naseon J Com" (The J Com Standing for Attack Against Disney). *Chosun Ilbo.* Page from Internet, March 15, 1997.

6765. Yu, Kie-Un. "The Synthesis of International Cultures in Korean Animation." Paper presented at Popular Culture Association, New Orleans, Louisiana, April 22, 2000.

Historical Aspects

6766. "'Animation History' – Unique World of Animation Art; Character Design Describing People of Modern Society." *Animatoon.* No. 8, 1997, pp. 100-105.

6767. "Animation History: The World of Frontier Animation." *Animatoon.* 3:10 (1997), pp. 69-77.

6768. Ghang, Hanyeoung. " 'Unjigineun Grim' 30nyeoneui Gwejeok" (30 Years of Moving Pictures). *Animatoon.* 3:11 (1997), pp. 118-121.

6769. Han, Seonghak. "Animation-Gwaeui 40 Nyeon" (40 Years with Animation). *Animatoon.* 1:1 (1995), pp. 86-87.

6770. Kim, Songpil. "Cel-eul Ssiseo Animation-eul Mandeuldeon Sijeol" (Those Days When We Made Animation by Washing the Cels). *Animatoon.* 2:3 (1996), pp. 98-99.

6771. "Korean Short Animation in the Past and Future: Observation of Identity, History, Problems and the Present Situation of Korean Short Animation Features." *Animatoon.* No. 16, 1998, pp. 64-71.

6772. "Saeroun Sidoga Dotboineun" (Animation History – Works After the Late Golden Period When New Trials Were Distinguished). *Animatoon.* 3:13 (1998), pp. 66-69.

6773. Shin, Nelson. "Celebrating the 4th Anniversary of *Animatoon*." *Animatoon*. No. 20, 1999, p. 5.

6774. Shin, Nelson. "History of Korean Animation." *Animatoon*. No. 16, 1998, pp. 90-91.

6775. Shin, Nelson. "Millennium Special Series 2 – Animation Chronological Table: Animation, Past 100 Years & Future 100 Years." *Animatoon*. No. 22, 1999, pp. 54-61.

6776. Shin, Nelson. "35 nyeongan Animation-gwa Donggodongrak" (Pains and Happiness Together with Animation for 35 Years). *Animatoon*. 2:3 (1996), pp. 70-71.

6777. Yi, Siwoo. "I Want To Go Back to the Past Days When I Was Frantically Working." *Animatoon*. 3:9 (1997), pp. 100-101.

6778. Yu, Kie-Un. "Historical Aspects of the Korean Animation Industry." *Asian Thought and Society*. September-December 1999, pp. 231-249.

Industry

6779. "The Analysis of Korean Animation Industry, Facing a Turning Point." *Animatoon*. No. 8, 1997, pp. 36-47.

6780. "The Animation Promotion Projects." *Korean Film News*. July 1996, p. 6.

6781. "Animation Saneop Jinheung Symposium" (Animation Industry Development Symposium). *Joongyang Ilbo*. Page from Internet, April 21, 1997.

6782. "Dangjeong, Bangsong Wejujejak Yeogeon Whalseongkiro" (The Party's Policy, Activation of the Broadcasting Companies' Production Environment). *Joongang Ilbo*. February 5, 1997, p. 12.

6783. "Dongnip Production Hyeonwhang mit Whalseongwha Bangan" (Current Situation of Independent Production and Development Plan). Seoul: Korean Cable Television Association, December 1994.

6784. "The Door Is Open for Financial Support for Animation and Visual Products Industry." *Animatoon*. No. 4, 1996, p. 33.

6785. Groves, Don. "Animation Industry Gets Original Prod'n." *Variety*. November 15-21, 1999, p. 35.

6786. Groves, Don. "Distrib Gets Animated." *Variety*. July 17-23, 2000, p. 63.

6787. Groves, Don and Christopher Alford. "Quotas Animate Local Industry." *Variety*. August 16-22, 1999, p. 26.

6788. Han Chang Wan. *A Study of the Korean Cartoon Animation Industry.* Seoul: Gullongrim Bat, 1995. Based on Master's thesis, Sogang University, Seoul, 1993.

6789. "Hanguksik Animation-Saeroun Tansaeng" (New Birth of Korean Style Animation). *Animatoon.* 2:3 (1996), pp. 36-37.

6790. "Jeon Myeongok Sajang – 'Sunyeonnae Changjak Manwha Suchal" (President Myeongok Jeon – Domestically-Created Animation Will Be Exported in Several Years). *Digital Chosun.* June 25, 1997.

6791. "Jeonwhangi Majeun Hanguk Bangsong Animationgae Jipjung Bunseok" (Intensive Analysis of Korean Television Animation at Turning Point). *Animatoon.* 3:8 (1997), pp. 36-47.

6792. Jung, Wook. "Manwhayoungwha Saneobeui Hyeonwhanggwa Jeonmang" (Current Situation and Prospect of Animation Industry). Paper presented at Symposium for Animation Industry Development, Seoul, Korea, December 6, 1994.

6793. Kim, Gyeongdal. "Hanguk Animation 30nyeon Choeageui Jachejejakguk" (30 Years of Korean Animation Finds Korea as Worst Country of Domestic Animation Production). *Dong-A Ilbo.* June 6, 1997, p. 12.

6794. "Korean Animation Industry: Its Current Address, Problems, and Solutions." *Animatoon.* No. 6, 1996, pp. 28-35.

6795. "The Korean Domestic Cartoons and Animation Market." *Yonhap News.* August 16, 1996, p. 13.

6796. Lee, Hanna. "Korean Turns Kidvid into Gold." *Variety.* December 7-13, 1998, p. 25.

6797. "The Letter from Dai Won Producer Association Refutes 'Problems of Korean Animation Industry' in Animatoon 15:60." *Animatoon.* No. 16, 1998, pp. 100-102.

6798. "Manwhayeongwhaeui Stardeulgwa Aewhan Damgin Animation Jakpum Segye" (The World of Animation Works Which Has Tears and Loves with Animation Stars). *Animatoon.* 3:12 (1998), pp. 72-75.

6799. Park Chung-bae. "The Changing Winds of Korean Animation." *Animation World Magazine.* February 1997, online.

6800. Park, Minyeong. "Hanguk Aeni, Doyageui Ttaega Watta" (Now Is the Time for Korean Animation). *CINE.* 21, No. 161, 1998.

6801. Park, Se-Hyung. "The Situation of Korean Animation Industry." In *1995 International Symposium and Lecture for Seoul International*

Cartoon and Animation Festival, pp. 133-138. Seoul: SICAF 95 Promotion Committee, 1995.

6802. Park, Shinyeoung, Beomjun Jeon, and Jina Shin. "Hangukeui Animation Saneopdanji Gingeup Jindan" (Urgent Diagnosis of Korean Animation Industry Complex Projects). *Animatoon.* 3:13 (1998), pp. 60-63.

6803. Shin Hye-son. "Animation Reaches Level of 'Ninth Art': High Value-Added Makes Animation Big Business." *Korea Newsreview.* September 2, 1995, pp. 24-25.

6804. Shin Hye-son. "Korean Animation Industry Cashing in on Potential of World of Make-Believe; Still in Need of Investment into Original Production." *Korean Herald.* August 25, 1995.

6805. Shin, Jina. "Gukjejeok Marketinge Seonggonghan Hanshin Corporation Choi Shinmuk Sajang" (CEO of Hanshin Corporation Who Was Successful in International Marketing). *Animatoon.* 3:13 (1998), p. 89.

6806. Shin, Nelson. "Hanguk Animationeui Eojewa Oneul, Grigo Miraereul Wihan Jeeon" (Yesterday and Today of Korean Animation and Suggestions for the Future). *Animatoon.* 2:5 (1996), pp. 79-83.

6807. *The Strategy of the Korean Animation Industry for the Future.* Seoul: Cohosted by Tooniverse and *Joong-Ang Daily News,* sponsored by Korean Ministry of Information, 1997. 65 pp.

6808. Yang, Deoksoo. "I Want To Attack the World Market with Our Creativity." *Animatoon.* 3:10 (1997), pp. 100-101.

6809. Yi, Yongbae. "Animation Jejak Productiondreui Choigun Donghyang" (Recent Situation of Animation Productions). Paper presented at Forum – Haguk Animationeui Gilchatgi (Forum – Path-Finding of Korean Animation), Seoul, Korea, December 3, 1994.

6810. Yi, Young. "The Problems and Solutions of TV Animation." *Animatoon.* 3:9 (1997), pp. 93-97.

6811. Yoon, Shin-Ae. "A Study of the Korean Animation Industry." Master's thesis, Yonsei University, 1995.

6812. Yu Kie-Un. "Anitown and Local Government's Interest in the Korean Animation Industry." Paper presented at Mid-Atlantic Region, Association for Asian Studies, Newark, Delaware, October 25, 1998.

6813. Yu, Kie-Un. "New Era of 'Korean' Animation: From Subcontinent to Self Contract." Paper presented at Mid-Atlantic Region/Association for Asian Studies, West Chester, Pennsylvania, October 26, 1997.

Overseas Service Animation

6814. Groves, Don. "Struggling Animators Seek Overseas Partners." *Variety.* April 24-30, 2000, pp. 53, 58.

6815. "Interview of RDK – Expanding Overseas Market with Solid Execution." *Animatoon.* 1:2 (1995), pp. 46-47.

6816. "Interview of Saerom Production: Coproduction with Overseas Agents and Participation of Young Blood." *Animatoon.* 1:2 (1995), pp. 40-41.

6817. Jo, Joe. "Overseas Marketing Suggestions for the Korean Animation Industry." *Animation World.* March 2000, 6 pp.

6818. Lent, John A. and Kie-Un Yu. "Oversea [sic] Marketing Strategies of Korean Animations Through AnimEast '95." *Animatoon.* No. 5, 1996, pp. 42-47.

6819. "Rapidly Changing World Broadcast Animation Industry." *Animatoon.* No.8, 1997, pp. 48-59.

6820. Rho, Gwangwoo. "Hanguk Manwhayeongwha-e Gukjehacheong-e Gwanhan Il Yeongu" (A Study of International Subcontracting of Korean Animation). Master's thesis, Korea University, Seoul, 1995.

6821. Yu Kie-Un. "Development of Korean Foreign Animation Industry: Global Division of Cultural Labor." Paper presented at Mid-Atlantic Region, Association for Asian Studies, Seton Hall University, South Orange, New Jersey, October 26, 1996.

6822. Yu, Kie-Un. "Global Division of Cultural Labor and Korean Animation Industry." In *Themes and Issues in Asian Cartooning: Cute, Cheap, Mad and Sexy,* edited by John A. Lent, pp. 37-60. Bowling Green, Ohio: Popular Press, 1999.

Tooniverse

6823. "Close Examination: Animation Cable TV Ch. 38 'Tooniverse', Korea." *Animatoon.* 2:4-1 (1996), pp. 94-99.

6824. "Minute Diagnosis: The Locomotive of Animation Industry, Tooniverse CATV 38." *Animatoon.* No. 4, 1996, pp. 28-32.

Comic Books

6825. "Autobiography of the Late Jaewha Lee." *Manhwa Teah.* Winter 1995, pp. 22-25.

6826. "A Comical Situation." *Asiaweek.* January 5, 1996, p. 38.

6827. "History of Korean Comic Art (review)." *Fūshiga Kenkyū.* No. 22, 1997, p. 14.

6828. Hyun, Daiwon. "Policy and Regulation of Korean Government Regarding Comic Art." Paper presented at International Association for Media and Communication Research, Singapore, July 19, 2000.

6829. "Korean Manga Hits US." *Comics International.* May 1999, p. 12.

6830. Kwon Young-Sup. *The First Korean Manwha Industry Art Exhibition: Manwha Poster Exhibition of Correct Living Campaign.* Seoul: Korea Cartoonist Association, 1994. 130 pp. Korean.

6831. Kwon Young-Sup, comp. *New Korean Manwha Poster Exhibition Campaign for the New Way of Thinking of Korean People.* Seoul: Korea Cartoonist Association, 1993. 37 pp.

6832. Lee, Hye Kwang. "My Teacher/ Hyang Won: 'A Lesson Through Three Years.'" *Manhwa Teah.* Winter 1995. p. 27.

6833. Lee Keon-Sang. *'95 Manwha World: The Fifth Seoul International Cartoon Festival.* Seoul: Pressville, 1995. 144 pp. Korean.

6834. Lent, John A. "The Multi-Tiered Korean Comics." *Comics Journal.* September 1998, pp. 31-34.

6835. Yi Soon Hyung, Kang Yi Lee, and Yun Joo Chyung. [Adolescents' Subscription of Japanese Comic Books and Their Envy Toward Japan]. *Korean Journal of Child Studies.* November 1993, pp. 65-78.

6836. Yokota, Kazunari. "Comics Entering New Phase." *Nikkei Weekly.* February 21, 2000, p. 19.

6837. Yu Kie-Un. "Comics Market Distribution in Korea." Paper presented at Popular Culture Association, Philadelphia, Pennsylvania, April 12, 1995.

6838. Yu, Kie-Un. "Historical Perspective of Korean Comics." Paper presented at Mid-Atlantic Region/Association for Asian Studies, Towson, Maryland, October 21, 1995.

Comic Strips

6839. Medioni, Gilles, Stacy Mosher, and Shim Jae Hoon. "Cartoonists Abroad Are 'Stirring Things Up': Comic Strips from France to Korea Skewer Society's Mores." *World Press Review.* October 1991, pp. 26-28.

"Gobau"

6840. *Gobau Kim Song-Whan's Works Exhibition*, November 25, 1996-Forever, National Central Library, Seoul. Seoul: National Central Library, 1996.

6841. Kim Song-Hwan. *Gobau Half Century Exhibition.* Seoul: Sejong Center for the Performing Arts, 2000. 95 pp.

Political Cartoons

6842. Park Jongmin and Shim Sungwook. "Presidential Candidates' Image in Newspaper Cartoons: Can Culture Make a Difference?" *Sungkok Journalism Review.* Fall 1999. pp. 29-50.

6843. Park, Jongmin and Sung Wook Shim. "The Presidential Candidates in Political Cartoons: A Reflection of Cultural Differences Between the United States and Korea." *International Journal of Comic Art.* Fall 2000, pp. 233-247.

MALAYSIA
Cartooning, Cartoons

6844. A. Samad Ismail. "Peranan Kartunis Untuk Wawasan 2020." *Watan.* August 30, 1992, p. 35.

6845. Lent, John A. "Of 'Kampung Boy,' 'Tok Guru' and Other Zany Characters: Cartooning in Malaysia." *Berita.* Fall 1994, pp. 10-21.

6846. Lent, John A. "Of 'Kampung Boy', 'Tok Guru' and Other Zany Characters: Cartooning in Malaysia." *Jurnal Komunikasi.* 10 (1994), pp. 55-77.

6847. Muliyadi Mahamood. "A Brief History of Malaysian Cartoons." In *International Cartoonists Gathering.* Kuala Lumpur: Kampung Boy Sdn. Bhd., 1990.

6848. Muliyadi Mahamood. "Dialog Kartunis Antarabangsa Malaysia 1990." *Fantasi (*Kuala Lumpur). April 1991.

6849. Muliyadi Mahamood. *Kartun dan Kartunis.* Kuala Lumpur: Univision Press, 1999. 140 pp.

6850. Muliyadi Mahamood. "Kartun Sebagai Senjata Budaya." *Dewan Budaya* (Kuala Lumpur). August 1989.

6851. Muliyadi Mahamood. *Mendekati Seni Lukis dan Seni Reka.* Kuala Lumpur: Dewan Bahasa dan Pustaka, 1993.

6852. Muliyadi Mahamood. "Menyatukan Kartunis Menerusi 'PEKARTUN.'" *Mastika* (Kuala Lumpur). Creative Enterprise Sdn. Bhd.), n.d.

6853. Muliyadi Mahamood. *Pengantar Seni Lukis Kartun.* Kuala Lumpur: Univision Press, 1999. 101 pp.

6854. Muliyadi Mahamood. "Perkembangan Awal Kartun Lerang Melayu." *Inti.* January-December 1998, pp. 34-42.

6855. Muliyadi Mahamood. *Seni Lukis dalam Peristiwa.* Kuala Lumpur: Dewan Bahasa dan Pustaka, 1995. 204 pp.

6856. Pyanhabib. "Rossem: Tiada Cincai dalam Melukis Kartun." *Mastika.* July 1989, pp. 40-41.

6857. Rais, Hishamuddin. "It's No Laughing Matter." *Men's Review* (Kuala Lumpur). July 1997, pp. 42-43.

6858. Sinar Harapan. "Orang-orang Jepun Tak Suka Kartun Berbau Kritik." *Mingguan Malaysia.* (Kuala Lumpur). January 16, 1983, p. 20.

6859. Zainal Buang Hussein. "Contemporary Cartoons in Malaysia." In *Asian Cartoon Exhibition – The Women of Asia Seen Through Cartoons,* pp. 30-31. Tokyo: The Japan Foundation Asia Center and The Japan Cartoonists Association, 1995.

Cartoonists and Their Works

6860. Abib. *Tok Aki Keluarga Canggih.* Kuala Lumpur: Media Wrappers, 1991.

6861. Kee, C.W. *Marvellous Durian Life.* Petaling Jaya: Star Publications, 1999. 134 pp.

6862. Muliyadi Mahamood. "Ibrahim Ismail: Berkomunikasi Menerusi Kartun." *Fantasi* (Kuala Lumpur). February 1992.

6863. Muliyadi Mahamood. "Malaysian Cartoonists: Artists with a Function in Society." In *Caricature, Cartoons and Comics Exhibition Catalogue.* Kuala Lumpur: National Art Gallery, 1989.

6864. Redza Piyadasa. "The Cartoonist: An Appreciation and Tribute." In *Lat 30 Years Later: Compilation of Lat Cartoons,* pp. 39-60. Petaling Jaya: Kampung Boy, 1994.

6865. Taib, Jaafar. *Jungle Jokes, Jilid 2.* Kuala Lumpur: Creative Enterprise, 1996. 86 pp.

Abdul Rahim Kajai

6866. Abdul Latiff Abu Bakar. *Abdul Rahim Kajai: Wartawa dan Sasterawan Melayu.* Kuala Lumpur: Dewan Bahasa dan Pustaka, 1984.

6867. Hashim Awang, ed. *Satira Kajai: Cerpen Pilihan Abdul Rahim Kajai.* Petaling Jaya: Penerbit Fajar Bakti Sdn. Bhd., 1985.

Lat (Mohd. Nor Khalid)

6868. Anthony, Eugene. "The Accidental 'Data.'" *Men's Review* (Kuala Lumpur). July 1997, pp. 14-22.

6869. Cheng, Maria and Irene Liow. "Malaysian Cartoonist Lat on Ulu Kenas." *Asiaweek.* June 9, 2000, p. 58.

6870. Jayasankaran, S. "Going Global." *Far Eastern Economic Review.* July 22, 1999, pp. 35-36.

6871. Lat. *Lat at Large.* Kuala Lumpur: Berita Publishing Sdn. Bhd., 1999. 142 pp.

6872. Lat. *Lat Gets Lost.* Kuala Lumpur: Berita Publishing Sdn. Bhd., 1996. 142 pp.

6873. Lat. *Lat 30 Years Later.* Petaling Jaya: Kampung Boy Sdn. Bhd., 1994.

6874. Lat. *The Portable Lat.* Kuala Lumpur: Berita Publishing Sdn. Bhd., 1998. 142 pp.

6875. "Lat." *Asiaweek.* May 9, 1997, p. 70.

6876. Lat. "Lat on Lat." In *Lat 30 Years Later: Compilation of Lat Cartoons,* pp. 1-38. Petaling Jaya: Kampung Boy, 1994.

6877. "Lat: Saya Ini Angkuh!" *HumOr* (Jakarta). March 29-April 11, 1995, pp. 46-53.

6878. "Lat 30 Years Later." *Bookbrowse.* March 10, 1995.

6879. Lent, John A. "The Varied Drawing Lots of Lat, Malaysian Cartoonist." *Comics Journal.* April 1999, pp. 35-39.

6880. Mohd. Nor Khalid (Lat). *"Vignette:* Notes of a Cartoonist Temporarily Turned Animator." In *Animation in Asia and the Pacific,* edited by John A. Lent, pp. 153-154. Sydney: John Libbey & Co., 2001.

6881. Ng Suat Tong. "Lat: Drawings from Memory." *Comics Journal*. May 1996, pp. 33-35.

6882. Rosenfeld, Megan. "Malaysians Create Hybrid Culture with American Imports Despite Government Censorship ..." *Washington Post*. October 26, 1998, p. A23.

Leee, Kit

6883. Jayasankaran, S. "Kit Leee, Malaysia: Out of Bounds." *Far Eastern Economic Review*. October 12, 1995, p. 166.

6884. Lee, Kit. *Adoi!* Singapore: Times Editions, 1995. 176 pp.

Rejabhad

6885. Provencher, Ronald. "Travels with 'The Chief': Rejab Had, A Malaysian Cartoonist." *Journal of Asian Pacific Communication*. 7:1/2 (1996), pp. 55-76.

6886. Rejabhad. *Periwira Mat Gila. Vol. 2.* Kuala Lumpur: Creative Enterprise, 1988. 118 pp.

6887. Rejabhad. *Periwira Mat Gila. Vol 3.* Kuala Lumpur: Creative Enterprise, 1988. 98 pp.

6888. Rejabhad. *PMG (Periwira Mat Gila)*. Kuala Lumpur: Creative Enterprise, 1988. 116 pp.

6889. Rejabhad. *Siri Gila-Gila Pruduksi Dengan Rejabhad.* Kuala Lumpur: Creative Enterprise, 1983, 1988. 146 pp.

Zunar

6890. Pyanhabib. "Zunar: Kita Boleh Melihat dengan Mata Kartun." *Mastika*. July 1990, pp. 52-53.

6891. Zunar. *Dari Kerana Mata*. Kuala Lumpur: Penerbitan Muttaqin Sdn. Bhd., 1999. Unpaginated.

6892. Zunar. *Koleksi Kartun Zunar. Lawan Tetap Lawan.* Kuala Lumpur: Penerbitan Muttaqin, 2000. Unpaginated.

6893. Zunar. *Kroni Mania!* Kuala Lumpur: Penerbitan Muttaqin Sdn. Bhd., 1999. Unpaginated.

Animation

6894. "Abim Wants Ban on Race-Biased Aladdin." *New Straits Times.* May 28, 1993, p. 4.

6895. "Animasi Keluang Man Hebatnya." *Keluang Man.* July 1999, pp. 30-31.

6896. "Assault on Arcades: Malaysia's Ban on Video Game Establishments Is Misguided." *Asiaweek.* October 27, 2000, p. 22.

6897. Balraj-Ambigapathy, Shanti. "An Assessment of Children's Television Programmes in Malaysia." In *Growing up with Television: Asian Children's Experience,* edited by Anura Goonasekera, pp. 157-212. Singapore: Asian Media Information and Communication Centre, 2000.

6898. Groves, Don. "Brain Storms 'Mad Monk.'" *Variety.* November 23-29, 1998.

6899. Khan, Bob. "Malay Toon Mimics Mouse Moves." *Variety.* July 24-30, 2000, p. 61.

6900. Khan, Bob. "'Spider' Teaches Lesson to Malaysian Toon Biz." *Variety.* March 5-11, 2001, p. 22.

6901. Latif, Baharuddin. " 'Prince' Banned in Malaysia." *Variety.* February 1-7, 1999, p. 17.

6902. "Matinee Entertains Malaysia on ASTRO." *Animatoon.* September 1998, p. 46.

6903. Muliyadi Mahamood. "Animation in Malaysia." Paper presented at Society for Animation Studies, Brisbane, Australia, August 5, 1999.

6904. Muliyadi Mahamood. "The History of Malaysian Animated Cartoons." In *Animation in Asia and the Pacific,* edited by John A. Lent, pp. 131-152. Sydney: John Libbey & Co., 2001.

6905. Nazrullah Rosli. "Kerjasama Membanteras Video Rakam Rompak." *Utusan Malaysia.* May 6, 1993, p. 22. (Disney).

6906. Oorjitham, Santha. "The Cartoon Network." *Asiaweek.* March 24, 2000, p. 39.

6907. Oorjitham, Santha. "Is an E-Village Enough? Malaysia Wants a Piece of the Action, Too." *Asiaweek.* April 27, 2001, p. 46.

6908. Rajah, Niranjan and Hasnul Jamal Saidon. "The Evolution of Electronic Art in Malaysia." *Art Asia Pacific.* No. 27, 2000, pp. 64-69.

"Hello Kitty"

6909. "Kitty Pair Takes Over." *Borneo Bulletin.* March 5, 2000.

6910. Maheshwari, D. "Wedding To Remember for McDonald's Employees." *New Straits Times* (Malaysia). October 4, 2000, City Diary, p. 9.

6911. Oh, Errol. "Strictly Business." *Malaysian Business.* April 1, 2000, p. 70.

"Kampung Boy"

6912. Abdullah, Firdaus. "Kampung Boy Goes to Hollywood." *Vision Kuala Lumpur.* January 1997, pp. 19-23.

6913. Latif, Baharuddin and Don Groves. "Nation on a Fast Rise." *Variety.* August 21-27, 1995, pp. 47, 58.

6914. "Lat's 'Kampung Boy' Wins Award." *New Straits Times.* June 15, 1999, p. 12.

6915. Seno, Alexandra A. "Kampung Boy Moves On." *Asiaweek.* March 28, 1997, p. 53.

6916. Sigler, Richard. "Let the Music Begin." *Animation.* July 1999, pp. 6, 49.

Comic Books

6917. "Budaya Komik: Bahana di Kalangan Anak-Anak." *Manuskrip.* July-December 1995, pp. 30-31.

6918. Chen, P.C. "Human Behavioural Research Applied to the Leprosy Control Programme of Sarawak, Malaysia" (Using cartoon tape-slides and cartoon story books). *Southeast Asian Journal of Tropical Medicine and Public Health.* September 1986, pp. 421-426.

6919. Chen, P.C. and H.C. Sim. "The Development of Culture-Specific Health Education Packages To Increase Case-Finding of Leprosy in Sarawak" (Using cartoon tape-slides and cartoon story books). *Southeast Asian Journal of Tropical Medicine and Public Health.* September 1986, pp. 427-432.

6920. Fauziah Zakaria. "Berniaga Cara Creative." *Manuskrip.* July-December 1995, p. 37.

6921. Hassan, Mazlan and Zalifah Mohd. Yatim. "Pelajar Beli Komik Lucah." *Harian Metro* (Kuala Lumpur). July 22, 2000, p. C4.

6922. Shafinar binti Salleh. "Permaparan Tema dan Isu Semasa dalam Kartun: Kajian Terhadap Empat Buah Majalah Komik" (Portrayal of Themes

and Current Issues in Cartoons: An Analysis of Four Local Comic Magazines). BA thesis, Universiti Kebangsaan Malaysia, Bangi, 1999.

Humor Magazines

6923. Provencher, Ronald. "Everyday Life in Malaysia: Representations of Social Relationships in Malay Humour Magazines." *Southeast Asian Journal of Social Science.* 25:1 (1997), pp. 11-37.

6924. Provencher, Ronald. "Malaysia's Mad Magazines: Images of Females and Males in Malay Culture." In *Illustrating Asia: Comics, Humor Magazines, and Picture Books,* edited by John A. Lent, pp. 187-203. Richmond: Curzon Press; Honolulu: University of Hawaii Press, 2001.

6925. Provencher, Ronald. "An Overview of Malay Humor Magazines: Significance, Origins, Contents, Texts, and Audiences." In *Themes and Issues in Asian Cartooning: Cute, Cheap, Mad and Sexy,* edited by John A. Lent, pp. 11-36. Bowling Green, Ohio: Popular Press, 1999.

6926. Ravindran, K. "Pupils Get Sex Story in 'Free' Magazine." *The Sun* (Malaysia). July 22, 2000, p. 3.

Political Cartoons

6927. Abdul Latif, Pelajar Roslina. "Directions and Effectiveness of Caricatures as Social Critiques. A Survey Research on Local Newspapers." BA thesis, Universiti Kebangsaan Malaysia, Bangi, 1989/1990

6928. Muliyadi Mahamood. "The Development of Malay Editorial Cartoons." *Southeast Asian Journal of Social Science.* 25:1 (1997), pp. 37-58.

6929. "Paper Apologises for Illustration of Prophet." *Straits Times* (Singapore). November 17, 1995.

MOLDOVA
Cartoonists

6930. "Valeri Kurtu." *Humour and Caricature.* July/August 1997, pp. 9-11.

6931. "Valeri Kurtu." *Humour & Caricature.* April/May 2001, pp. 6-8.

6932. "Valeri Curtu." In *Sanatta Karikatür/Cartoon in Art,* edited by Nezih Danyal, pp. 154-155. Ankara: Karikatür Vakfi Yayinlari, 1997.

MONGOLIA
Animation

6933. Ehrlich, David. *"Vignette:* The First US-Mongolian Co-Production: *Genghis Khan."* In *Animation in Asia and the Pacific,* edited by John A. Lent, pp. 121-124. Sydney: John Libbey & Co., 2001.

Cartoonists

6934. "Samandariin Tsogtbayar." *Humour and Caricature.* August/September 1997.

NEPAL
Cartooning, Cartoons

6935. Lent, John A. "Land in Zicht: Nepal." *Stripschrift.* May 2001, p. 13.

6936. Panday, Ram Kumar. *Nepalese Humor* (Himalayan Humor). Kathmandu: Muskan Prakashan, 2000. 90 pp.

6937. Panday, Ram Kumar. *Sense of Humor Series. Nepalese Cartoons.* Kathmandu: Ratna Pustak Bhandar, 1997.

Political Cartoons

6938. Panday, Ram Kumar. *Humor-Satire.* Kathmandu: Ratna Pustak Bhandar, 1995.

6939. Panday, Ram Kumar and Goh Abe. "Political Humor in Nepal: A Study of the Power of Political Cartoons." Paper presented at International Society of Humor Studies, Osaka, Japan, July 26, 2000.

6940. Singh, Ashok Man, comp. *A Portfolio of the Nepalese Comic Cartoons.* Kathmandu: HaSaNe Foundation, 2000. 56 pp.

PAKISTAN
Lodhi, Yusuf

6941. Lodi, Yusof. *The Holy Bull.* Islamabad: S. B.Ali, 1990. 175 pp.

6942. "Yusuf Lodhi." *Asiaweek.* November 1, 1996, p. 10.

PHILIPPINES
Cartooning, Cartoons

6943. Barker, Nicholas. "The Revival of Religious Rituals of Self-Mortification in Lowland Christian Philippines." Paper presented at Fifth International Philippine Studies Conference, Honolulu, Hawaii, April 15, 1996. (Cartoons, p. 16).

6944. Lent, John A. "Comic Art in the Philippines." *Philippine Studies*. 46: Second Quarter, 1998, pp. 236-248.

6945. Lent, John A. "Comic Art in the Philippines: A Long and Varied Tradition." Paper presented at Fifth International Philippine Studies Conference, Honolulu, Hawaii, April 16, 1996.

Cartoonists and Their Works

6946. Knowles, Chris. "Invasion from the Philippines: A Brief Survey of the Great '70s Filipino Artists at DC." *Comic Book Artist*. Summer 1999, pp. 92-96.

6947. Ocampo, Manuel. *Virgin Destroyer*. Introduction by Jenifer P. Borum. Honolulu: Hardy Marks Publications, 1996.

6948. "Page 1 Cartoon." *Press Forum* (Manila). April 1972, p. 5. (Pol Galvez).

6949. Rafael, Vicente L. "Taglish, or the Phantom Power of the Lingua Franca." *Public Culture*. Fall 1995, pp. 101-126. (Nonoy Marcelo).

6950. Sturgeon, Theodore. *More Than Human*. New York: Heavy Metal, n.d. (Alex Niño).

Alcala, Alfredo

6951. Alcala, Alfredo. *Voltar*. Schanes & Schanes, 1979.

6952. Auad, Manuel. "Alfredo Alcala." *Alter Ego*. Summer 2000, pp. 30-31.

6953. Auad, Manuel. "Fred Alcala: Wizard with a Brush." *Mediascene*. March/April 1977, pp. 10-11.

6954. Evanier, Mark. "Point of View." *Comics Buyer's Guide*. May 5, 2000, pp. 36-37, 43.

6955. Recan, Ali. "Büyük Ustalar: Alfredo Alcala." *Çizgi Roman Koleksiyon Dergisi*. AR Çizgi Roman Külübü Yayinlari, No. 2, p. 15.

6956. Spurgeon, Tom. "Alfredo Alcala Dead at 74." *Comics Journal.* May 2000, pp. 18-19.

Alcala, Larry

6957. Alcala, Larry. *The Best of Mang Ambo.* Vol. 1. Quezon City: New Day Publishers, 1988. 124 pp.

6958. Guillermo, Alice G. "The Filipino According to Larry Alcala." *Who.* April 4, 1984, pp. 24-25.

6959. Paulino, Roberto G. "The Filipino According to the Comics of Larry Alcala." *Philippine Star.* August 2, 1998, pp. L-6, L-7.

Gat (Liborio Gatbonton)

6960. Gatbonton, Liborio. *Jappy Days in the Philippines.* Manila: Tamarao Publications, 1946. 160 pp.

6961. "Gatbonton's Best Last Year." *Press Forum* (Manila). January/February 1972, p. 6.

Redondo, Nestor

6962. "Artist Nestor Redondo Dies." *Comics Buyer's Guide.* January 26, 1996, p. 34.

6963. Evanier, Mark. "Point of View." *Comics Buyer's Guide.* March 1, 1996, p. 66.

6964. Royce-Roll, Heather. "Nestor Redondo, Filipino Illustrator, Dies at 68." *Comics Journal.* February 1996, p. 23.

Velasquez, Antonio

6965. Erediano, Arnold and Odette Galino. "Comics Pioneer Who Committed Suicide Buried Today." *People's Journal Tonight.* April 23, 1997, p. 8.

6966. Galino, Odette and Arnold Erediano. " 'Kenkoy' Creator's 'Suicide' Baffles Police!" *People's Journal Tonight.* April 22, 1997, pp. 1-2.

Historical Aspects

6967. Castillo-Pruden, Marie. "Pop Culture: After the War, Before Martial Law. Ruben Tagalog Was a Visayan." *Filipinas.* April 1998, pp. 62-65.

6968. Fortier, Malcolm V. *The Life of a P.O.W. under the Japanese in Caricature.* Spokane, Washington: C.W. Hill Printing, 1946. 150 pp.

6969. Geraldo, Fritz Arreza. "The Laughs GI Joe Left Behind." *Kislap-Graphic.* February 11, 1959, pp. 18-19, 36.

6970. "Our Gagmen Go to Leyte." *Yank Far East.* January 1, 1945, p. 9. (Douglas Borgstedt, Charles Pearson, and Ozzie St. George).

6971. Quirino, Carlos. "How An American Master Spy Saved the Life of Amorsolo." *Philippine Panorama.* October 14, 1979, pp. 34, 36-37.

6972. Roces, Alfredo S. *Amorsolo: 1892-1972.* Manila: Filipinas Foundation, 1975. 208 pp.

6973. Serrano, Leopoldo R. "The Lighter Side of the War: The Joke's on the Japanese." *Sunday Times Magazine.* April 10, 1966, pp. 46-47.

6974. Taruc, Luis. *Born of the People.* New York: International Publishers, 1953. 286 pp. (Leaflets on p. 141).

6975. Vaughan, Christopher. "Laughing at Savages: American Humor and the Conquest of the Philippines." Paper presented at International Communication Association, Montreal, Canada, May 22-26, 1997.

6976. Vaughan, Christopher. "Negative Image: Cartoon and Photographic Representations of the Philippines, 1898-1915." Paper presented at Popular Culture Association, Las Vegas, Nevada, March 26, 1996.

Animation

6977. Espiritu, Carol. "Animators Drawn to Region." *Variety.* June 17-23, 1996, p. 46.

6978. Groves, Don. "Filipino Animator Retoons for New Role." *Variety.* July 12-18, 1999, p. 35.

6979. Groves, Don. "Top Draw Toons Up in Manila." *Variety.* November 8-14, 1999, p. 23.

6980. Jazmines, Tessa. "Pasi Initiates Artists Revenue Sharing." *Variety.* November 6-12, 2000, p. 65.

6981. Jazmines, Tessa. "PASI Retooning Animates Philippine Studio After Years in Doldrums." *Variety.* August 7-13, 2000, p. 30.

6982. Karp, Jonathan. "Get It?" *Far Eastern Economic Review.* June 22, 1995, pp. 88-89.

6983. "Manila Targets Violent Cartoons." *Asian Mass Communications Bulletin.* November-December 1995, p. 21.

6984. "Notes from the Philippines." *Animation.* January 1999, p. 15.

6985. O'Brien, T. "Enchanted Kingdom, the Philippines' Largest Park To Open in November." *Amusement Business.* July 18-24, 1994, pp. 38-41.

6986. "Philippines Makes Bid To Become Cartoon Capital." *Asian Mass Communications Bulletin.* September/October 1995, p. 20.

6987. *A Profile on Film Animation.* Makati: Bureau of Export Trade Promotion, Department of Trade and Industry, 1989. 15 pp. (Product Profile Series, 11).

6988. Rice, John W. "The Making of Child Soldiers." *Animation World.* March 1997, 4 pp.

6989. Tolentino, Rolando. "Animating the Nation: Animation and Development in the Philippines." In *Animation in Asia and the Pacific,* edited by John A. Lent, pp. 167-180. Sydney: John Libbey & Co., 2001.

6990. Tolentino, Rolando. "Animating the Nation: Animation and Development in the Philippines." Paper presented at Society for Animation Studies, Brisbane, Australia, August 5, 1999.

Fil-Cartoons

6991. "Cartoon News, the Official Fil-Cartoon Newsletter." *ASIFA San Francisco.* September 1995, p. 8, 10.

6992. "Congratulations to Fil-Cartoons." *ASIFA San Francisco.* July/August 1996, p. 5.

6993. "Fil-Cartoons Gave Everybody on the Staff a Well Produced Yearbook." *ASIFA San Francisco.* February 1996, p. 7.

6994. "Fil-Cartoons in Manila Is Animating, Inking, Painting the Cartoons of the Future." *ASIFA San Francisco.* April 1996, p. 8.

6995. "Fil-Cartoons Pitches in To Help People Left Homeless by Typhoon Rosing." *ASIFA San Francisco.* January 1996, p. 6.

Comic Books

6996. "Appendix D: Philippine Codes." In *Pulp Demons: International Dimensions of the Postwar Anti-Comics Campaign,* edited by John A.

Lent, pp. 288-293. Madison, New Jersey: Fairleigh Dickinson Press; London: Associated University Presses, 1999.

6997. Burton, John W. "How I Came To Know the Philippines and Rizal." *Kinaadman.* 1982, pp. 127-145.

6998. David, Joel. *Fields of Vision: Critical Applications in Recent Philippine Cinema.* Quezon City: Ateneo de Manila University Press, 1995. (*Komiks,* pp. 15-16, 63-64, 105.).

6999. David, Joel. *The National Pastime: Contemporary Philippine Cinema.* Manila: Anvil Publishing, 1990. 238 pp. ("Underground, in the Heat of the Night," pp. 154-157.)

7000. De Vera, Ruel. "Comic Fairy Tale." *Asiaweek.* September 15, 2000, pp. 46, 48.

7001. Dionnet, Jean-Pierre. "La Bande Dessinée Philippine." *Phenix.* No. 36, n.d., pp. 18-25.

7002. Jones, Clayton. "Filipino Comics Are More Than Laughing Matter." *Christian Science Monitor.* August 12, 1987, pp. 1, 8.

7003. Pacheco, Esther M. "The Komiks: The 'National Book,' Aspects of Book Publishing in the Philippines." *Singapore Book World.* 26 (1996), pp. 5-18.

7004. "Pilipino 'Komiks': Sex and Deviation." *Press Forum* (Manila). July 1969, pp. 5, 12.

7005. Reyes, Soledad S. "The Philippine *Komiks:* Text As Containment." *Southeast Asian Journal of Social Science.* 25:1 (1997), pp. 79-91.

7006. Roces, Joaquin P. "Magazine Publishing in the Philippines." *Press Forum* (Manila). March 1969, pp. 3-4.

7007. Soriano, D.H. "Now, the Magazine Field." *Press Forum* (Manila). October 1967, pp. 3, 6.

7008. Torres, Amaryllis T. "Decisions, Aspirations and Media Preferences of Rural Out of School Youth." *Philippine Journal of Psychology.* 15-16 (1982-1983), pp. 28-55.

Comic Strips

7009. Medina, Pol, Jr. *Pugad Baboy Eight. Ang Hiwaga ng Dueñas.* Pasig City: Anvil Publishing, 1997, 74 pp.

7010. Rebosura, Alexander. "Tisoy and Its Readers." *Press Forum* (Manila). October 1968, p. 5.

Political Cartoons

7011. Isaac, Norman. "Toons Regarded 'Inferior' and Masterpieces Discarded as Garbage." *WittyWorld International Cartoon Bulletin.* No. 5, 1996, p. 2.

SINGAPORE
Cartooning, Cartoons

7012. Lee, Adam. "Greetings from Malaysia." *FECO News.* No. 26, 1998, pp. 24-25.

7013. Lee Weng Choy. "Representation as Detour: Three Anecdotes about Singapore Art." *Art AsiaPacific.* No. 25, 2000, pp. 57-61.

7014. Lent, John A. "Singapore Cartooning: Only a Few Bright Spots." *Berita.* Spring/Summer 1995, pp. 2-9.

7015. Tan Hui Leng. "How Book on SM Lee Was Born." *The New Paper.* June 20, 2000, p. 10.

7016. "What Are Cartoons Really For?" *New Paper.* August 29, 1999, p. 5.

Cartoonists and Their Works

7017. Koh Choon Teck. *Growing up with Lee Kuan Yew.* Singapore: Educational Publishing House, 2000. 103 pp.

7018. Lee, C.C. *Life's Like This!* Singapore: East Asia Book Services, 1994.

7019. *1999: The Year in Cartoons. By the Straits Times Cartoonists.* Singapore: Landmark Books, 1999. 95 pp.

7020. Yeoh, Joe. *To Take a Tiger: The Singapore Story.* Singapore: Wiz-Biz, n.d. Unpaginated.

Chua, Morgan

7021. Chua, Morgan. *My Singapore: Sketches.* Singapore: SNP Editions, 2000. 118 pp.

7022. Chua, Morgan. "My Sunday." *Asia Magazine*. December 27, 1987, p. 34.

7023. Husain, Nazir. "My Hometown: From Disney to the Singapore Story." *Big O*. July 2000, pp. 10-11.

7024. Lee, Karen. "For Kids: A Cartoon Version of SM's Memoirs." *Sunday Times*. June 25, 2000, p. 29.

7025. Lim Cheng Tju. "Return of the Native Wit." *Sunday Times* (Singapore). July 30, 2000, p. 49.

7026. "Morgan's World." *Far Eastern Economic Review*. July 3, 1997, pp. 45-48.

7027. Plott, David. "Irreverent and Humorous." *Far Eastern Economic Review*. December 14, 2000, p. 99.

Goh, Colin

7028. Goh, Colin. *Orchard Road III: Tongues for the Memories*. Singapore: Times Books International, 1993. 136 pp.

7029. Goh, Colin. *I Was a Teenage Sex Slave*. Singapore: Times Editions, 1995. 112 pp.

7030. Goh, Colin. *Orchard Road: The Restricted Zone*. Singapore: Times Books International, 1990. 132 pp.

7031. Goh, Colin and Lawrence Low. *The Buaya Handbook*. Singapore: Times Editions, 1995. 128 pp.

Miel, Deng Coy

7032. Chua Chin Hon. "The Perfect Icon." *Straits Times*. July 20, 2000, p. 40.

7033. Lim, Cheng Tju. "Talking with the Pro: An Interview with Dengcoy Miel." *Aporia*. July 1998, pp. 15-20.

7034. *Miel: Cartoons and Illustrations*. Singapore: Miel, 2000. 28 pp.

Tan Wee Lian

7035. Tan Wee Lian. *Love and Hamburgers: Teen Life*. Singapore: Times Editions, 1995. 112 pp.

7036. Tan Wee Lian. *Wake Up Your Ideas! – The Recruits' Handbook*. Singapore: Times Editions, 1995. 184 pp.

Censorship

7037. Lee Weng Choy. "Misunderstanding Art." *Art AsiaPacific.* No. 64, 1994, pp. 42-43.

7038. Lenzi, Iola. "Process and Politics: ARX5: The Fifth Artists' Regional Exchange." *Art AsiaPacific.* No. 64, 1999, pp. 40-42.

Animation

7039. "Digital Animation Seminar Draws Good Response." *Asian Mass Communications Bulletin.* January-February 1999, p. 2.

7040. Heidt, Erhard U. *Mass Media, Cultural Tradition, and National Identity: The Case of Singapore and Its Television Programmers.* Saarbrücken: Verlag Breitenbach Publishers, 1987. (Japanese cartoons on Singapore TV, pp. 197-200).

7041. Hong Lee Tiam. "Colorland Animation Launches IPO in Singapore." channelnewsasia.com, May 25, 2001.

7042. Hu, Gigi. "Animation in Singapore." *Animation World.* February 1997, pp. 32-35.

7043. Hu, Gigi. "Review: *The Life of the Buddha in Animation.*" *Society for Animation Studies Newsletter.* Summer 1995, p. 5.

7044. Laybourne, Geraldine. "Kids Deserve To Be Heard." In *Drawing Insight,* edited by Joyce Greene and Deborah Reber, pp. 74-77. Penang: Southbound, 1996.

7045. Leong Chan Teik. "Twelve Say Sorry for Violating Disney Rights." *Straits Times.* June 2, 1994, p. 21.

7046. Lin Ai-Leen. "An Assessment of Children's Television Programmes in Singapore." In *Growing up with Television: Asian Children's Experience,* edited by Anura Goonasekera, pp. 272-299. Singapore: Asian Media Information and Communication Centre, 2000.

7047. "Pioneer Disney Slows Incursion." *Variety.* July 29-August 4, 1996, p. 40.

7048. Ray, S. "Sequoia Completes 15.5 Mil Dark Ride for Singapore's Clark Quay Village." *Amusement Business.* January 3-9, 1994, p. 17. (Theme park).

7049. Soon, Lilian. "Animation in Singapore." In *Animation in Asia and the Pacific,* edited by John A. Lent, pp. 155-166. Sydney: John Libbey & Co., 2001.

7050. "Too Many Cartoons, Too Few Current Affairs Shows." *Straits Times* (Singapore). August 28, 1996.

7051. "Walt Disney To Set Up Satellite Earth Station in S'pore." *Asian Mass Communications Bulletin.* Winter 1995, p. 21.

"Aladdin"

7052. *"Aladdin* Dijangka Cipta Sejarah Box Office." *Berita Harian.* May 20, 1993, p. 27.

7053. "Aladdin Hiburkan Kanak-Kanak Yatim." *Berita Harian.* May 24, 1993, p. 18.

7054. "Call To Ban *Aladdin* Because of 'Racial Slurs.'" *Straits Times.* May 29, 1993, p. 25.

7055. "Disney Cartoon *Aladdin* To Open at 17 Cinemas." *Straits Times.* May 3, 1993, p. 25.

7056. "Disney Charged with Racial Slurs in 'Aladdin.'" *The Star.* May 22, 1993, p. 27.

7057. Lau, Joan. "Aladdin's a Winner and a Movie for the Adults Too." *New Straits Times.* May 29, 1993, p. 24.

7058. "The Magic of Aladdin Draws Huge Audiences." *New Straits Times.* June 5, 1993, p. 5.

"Hello Kitty"

7059. Ho Ka Wei. "There's No Money in This Kitty." *Straits Times* (Singapore). January 23, 2000, p. 35.

7060. Ho, Michelle. "Hello Kitty, What's Cooking This Time?" *Straits Times* (Singapore). April 23, 2000, Sunday Plus, p. 2.

7061. "The Kitty in the Middle." *Asiaweek.* January 14, 2000, p. 41.

7062. Lai Hau Boon. "Awww, They're So Cute!" *Straits Times* (Singapore). February 13, 2000, p. 16.

7063. Ng, Irene. "Craze Spits at the Spirit of Singapore 21." *Straits Times* (Singapore). January 22, 2000.

7064. Seah, Lynn. "Grrr, Fake Kitty's Features Look Funny." *Straits Times* (Singapore). January 30, 1999, p. 2.

7065. "Seven Hurt in Kitty Riot." *Manga Max.* February 2000, p. 6.

7066. Shameen, Assif. "Frenzy in (Gasp!) Singapore." *Asiaweek.* January 28, 2000, p. 55.

7067. "Singapore's Hello Kitty Frenzy Touches Off Parliamentary Concerns." *Deutsche Presse Agentur.* January 18, 2000.

7068. Stephens, Jacintha. "In a McKitty Frenzy." *Asiaweek.* February 18, 2000, p. 42.

7069. Wee, Lea. "Hello, What's Fuss All About?" *Straits Times* (Singapore). January 16, 2000, Sunday Plus, p. 2.

Singapore Animation Fiesta

7070. Hu, Gigi. "Personal Reflections." *Society for Animation Studies Newsletter.* Summer 1996, pp. 3, 8.

7071. Hu, Gigi. "Singapore Animation Fiesta, June 15-16." *Society for Animation Studies Newsletter.* Winter/Spring 1996, p. 3.

7072. Langer, Mark. "Singapore Animation Fiesta." *Animation World.* August 1996, 4 pp.

7073. Langer, Mark. "Singapore Animation Fiesta '98." *Animation World.* August 1998, 4 pp.

7074. McNamara, Martin. "Fiesta Report." *Society for Animation Studies Newsletter.* Summer 1996, pp. 3, 8.

Comics

7075. Chiang, Joseph. "Note from Singapore." *Comics Journal.* September 1996, p. 6. (Comic strips).

7076. "Comics Fair Sign of Big Market." *Straits Times.* September 23, 1993, p. 3.

7077. "From the Gongfu to Astro Boy." *Sunday Times* (Singapore). October 24, 1999.

7078. Ho, Karl. "Condor Heroes on the Warpath." *Sunday Times* (Singapore). October 24, 1999.

7079. Khoo, Eric. *Unfortunate Lives: Urban Stories and Uncertain Tales.* Singapore: Times Editions, 1995. 104 pp.

7080. Lim, Cheng Tju. "It Was a Chance Meeting." *Aporia.* July 1998, pp. 2-3.

7081. Ming Moh Yu and Pao Pei Yu. "Impact of Manga on Singaporean Youths." In *Memory and Identity,* pp. 115-119. Singapore: Author, 1998.

7082. Ng, Benjamin Wai-ming. *Research Report. Japanese Video Games and Comics in Singapore: Issues in Popularization, Localization and Their Implications.* Singapore: Sumitomo Foundation Research Grant, 1999. 73 pp.

7083. Ng, Wai-ming. "Japanese Comics in Singapore." *Asian Culture.* June 2000, pp. 1-14.

7084. "So Sorry." *Inklings.* Fall 1995, p. 12.

7085. "Spiderman Gets Stuck as the Crowd Thins Out." *Sunday Times* (Singapore). October 24, 1999.

7086. Teo Pau Lin. "They're Simply Mad About Manga." *Sunday Times* (Singapore). October 10, 1999.

"Mr. Kiasu"

7087. Bachtiar, Ida. "Mr. Kiasu Goes Big Time; The Kuppies Unveiled." *Straits Times.* January 12, 1993, pp. 1-2.

7088. Fuller, Linda K. "Singapore's *Mr. Kiasu, Kiasu Krossover, Kiasu Max,* and *Kiasu the Xtraman:* Comics Reflecting a Nation's Personality and Popular Culture." In *Themes and Issues in Asian Cartooning: Cute, Cheap, Mad and Sexy,* edited by John A. Lent, pp. 77-90. Bowling Green, Ohio: Popular Press, 1999.

7089. Fuller, Linda K. "When a National Characteristic Becomes Popular Culture: The Case of Singapore's 'Kiasuism.'" Paper presented at Northeast Popular Culture Association, Quinnipiac College, Hamden, Connecticut, 1996.

7090. George, Cherian. "Ta-ta Mr. Kiasu." *Straits Times.* August 15, 1993, pp. 1-2.

7091. "Is Mr. Kiasu Running Amok?" *Straits Times.* September 19, 1993, pp. 1+.

7092. Koh Buck Song. "Over-Cautious Publishers Taking Kiasuism to Ridiculous Lengths." *Straits Times.* January 15, 1996.

7093. Lai, Fanny. "Mr. Kiasu Ad Not Meant To Make Fun of S'poreans." *Straits Times.* June 3, 1993, p. 29.

7094. Lau, Johnny. "Introduction: You Have Just 'Krossed-Over' the Kiasu Zone!" In *Kiasu Krossover.* Singapore: Comix Factory, 1994.

7095. Lau, Johnny, Yu Cheng, and James Suresh. "K.S.X. Publisher's Note." Singapore: Comix Factory, 1994.

7096. Le Blond, Raoul. "Cheap Burgers, But Where's the Kiasu Rush?" *Straits Times.* May 24, 1993, p. 48.

7097. Lent, John A. "'Mr. Kiasu,' 'Condom Boy,' and 'The House of Lim': The World of Singapore Cartoons." *Jurnal Komunikasi.* Vol. 11, 1995, pp. 73-83.

7098. Lent, John A. "Mr. Kiasu: A Singular, Singapore Success Story." *Comics Journal.* August 1996, pp. 43-45.

7099. Wong, Jesse. " 'Kiasu' Cartoon Figure Strikes a Chord by Making Fun of Singaporean Mentality." *Asian Wall Street Journal.* February 20, 1996, pp. 1, 15.

Political Cartoons

7100. Cheah, Michael and Philip Cheah. "Read All About It." *Big O Magazine.* April 1990, pp. 7+.

7101. George, Cherian, ed. *1997. The Year in Cartoons by the Cartoonists of The Straits Times: Adrian Albano, Cheah Sin Ann, Ludwig Ilio, Adam Lee, Lee Chee Chew, Prudencio Miel, Dario Noche and Noel Rosales.* Singapore: Landmark Books, 1997. 131 pp.

7102. Langenbach, Ray. "History Through Prints: Singapore." *Art AsiaPacific.* No. 28, 2000, p. 91.

7103. Lee Hup Kheng. "Political Cartoonists in Singapore: Are They Brain Dead?" *New Paper.* August 29, 1999, p. 4.

7104. Lim Cheng Tju. "Cartoons of Our Lives, Mirrors of Our Times: History of Political Cartoons in Singapore, 1959-1995." B.A. honors thesis, National University of Singapore, 1995/1996. 99 pp.

7105. Lim Cheng Tju. "Cartoons Zoom in on Current Affairs." *Straits Times* (Singapore). December 6, 1997, p. 3.

7106. Lim Cheng Tju. "More Moments of Anguish? The Critical Use of Political Cartoons in the Teaching of Singapore's History." *Teaching and Learning.* January 2000, pp. 40-48.

7107. Lim Cheng Tju. "No Laughing Matter." *Arts and Society: The Arts Magazine.* March-April 1997, pp. 43-45.

7108. Lim Cheng Tju. "Political Cartoon Books in Singapore." Paper presented at International Association for Media and Communication Research, Singapore, July 19, 2000.

7109. Lim Cheng Tju. "Political Cartoons in Singapore: Misnomer or Redefinition Necessary." *Journal of Popular Culture.* Summer 2000, pp. 77-83.

7110. Lim Cheng Tju. "Singapore Political Cartooning." *Southeast Asian Journal of Social Science.* 25:1 (1997), pp. 125-150.

7111. Lim Cheng Tju. "Some Notes on the Consideration of Political Cartoons as Visual Arts." *Aporia.* July 1998, pp. 4-14.

7112. Miel, Deng Coy. "The Singapore Ink-sperience: A Filipino Cartoonist in Singapore." Paper presented at International Association for Media and Communication Research, Singapore, July 19, 2000.

SRI LANKA
Cartooning, Cartoons

7113. Lent, John A. "Cartooning in Sri Lanka." In *Illustrating Asia: Comics, Humor Magazines, and Picture Books,* edited by John A. Lent, pp. 81-99. Richmond: Curzon Press; Honolulu: University of Hawaii Press, 2001.

Comics

7114. Kurunanayake, Nandana. *Broadcasting in Sri Lanka: Potential and Performance.* Sri Lanka: Centre for Media and Policy Studies, 1990. ("Comics Chithrakatha").

Political Cartoons

7115. Constable, Pamela. "Blacked Out in Sri Lanka." *Washington Post.* May 16, 2000, p. A14.

7116. Hettigoda, Winnie. *Halt.* Colombo: n.p., ca. 1991. 99 pp.

7117. Lent, John A. "Sri Lanka Cartooning: A Precarious Profession." Paper presented at Mid-Atlantic Region/Association for Asian Studies, West Chester, Pennsylvania, October 26, 1997.

7118. Rifas, Leonard. "Cartooning in Sri Lanka: A Precarious Tightrope Act." In *Asian Popular Culture,* edited by John A. Lent, pp. 109-126. Boulder, Colorado: Westview, 1995.

TAIWAN
Artistic Aspects

7119. Hong, Wenqiong. *Taiwan Ertong Wenxueshi* (History of Children's Literature in Taiwan). Taipei: Chuanwen, 1994.

7120. Huang, Wen-ling. "Door Gods Stand Guard Protecting Peace of Mind." *Free China Journal.* February 28, 1997, p. 5.

7121. Jose, Nicholas and Yang Wen-i. *The Contemporary Art of Taiwan.* Sydney: G + B Arts International in association with Museum of Contemporary Art, 1995. 134 pp.

7122. Lin, Diana. "Illustrations Galore at Festival." February 20, 1998, p. 5.

7123. Wei, Shu-chu. "Shaping a Cultural Tradition: The Picture Book in Taiwan, 1945-1980." *Children's Literature Association Quarterly.* Fall 1995, pp. 116-120.

Cartooning, Cartoons

7124. Branegan, Jay. "Ask Dr. Notebook" [Taiwan cartoon contest]. *Time.* September 11, 2000, p. 22.

7125. Chen, Yi-Chin. "A Cognitive Processing Model of Understanding Messages in Cartoons." Master's thesis, Culture University (Taiwan), Journalism Department, 1997.

7126. Foreman, William. "Taiwan Company Uses Cartoon Hitler [in Advertising]." Associated Press release, November 22, 1999.

7127. Foreman, William. "Taiwanese Company Pulls Hitler Ads." Associated Press release, November 23, 1999.

7128. Lai, Ching-Fong. "A Study of Consumer Behavior: How Cartoon Icons Affect Buying Motivations of Consumers." Master's thesis, Chen-Kung University, Business School, 1999.

7129. "Taiwan Hitler [caricature] Ad for German Heaters Provokes Storm." Reuters dispatch, November 23, 1999.

7130. Tsai, Tso-wu. "What Cartoon Characters Are Taiwanese Children Modeling On?" Master's thesis, National Taipei Normal College, 1998.

7131. Wei, Shu-chu. "Shaping a Cultural Identity: The Picture Book and Cartoons in Taiwan, 1945-1980." In *Illustrating Asia: Comics, Humor Magazines, and Picture Books,* edited by John A. Lent, pp. 64-80. Richmond: Curzon Press; Honolulu: University of Hawaii Press, 2001.

7132. Zu, Zola. "Cartoons from Formosa." *FECO News.* No. 20, 1996, pp. 10-11.

Cartoonists and Their Works

7133. Goodman, Jonathan. "Sign Language: Sex, Politics and Culture in the Works of Te-Cheng Lien." *Art AsiaPacific.* No. 19, 1998, pp. 60-67.

7134. Hsiao, Hsiang-Wen. "Releasing the Clamps: Taiwanese Cartoonists Speak Out." *Journal of Asian Pacific Communication.* 7:1/2, 1996, pp. 77-86.

7135. Li Chan. "Introducing Children's Cartoonist Wang Jinxuan." *Zhongguo Manhua.* No. 4, 2000, pp. 26-27.

7136. Li Chan. "Introducing Taiwan Cartoonist Xiao Yan: Often Finds His Own Shadows in His Cartoon Works." *Zhongguo Manhua.* No. 10, 2000, pp. 26-27.

7137. Li Chan. "Introducing a Woman Cartoonist of Taiwan." *Zhongguo Manhua.* No. 5, 2000, pp. 26-27. (Ye Zhu).

7138. Li Chan. "The Person and His Work: Zhu De Yong." *Zhongguo Manhua.* No. 8, 2000, pp. 26-27.

7139. Lin, Wenyi. "Shei Chuan Zhongguo Manhua de Xiayiba Xinhuo?: Jieshao Shiyi Wei Xinku er Zhoyue de Zhongguo Manhuajie" (Who Is To Carry on the Torch for the Chinese Cartoon?: An Introduction of Eleven Hard-Working and Outstanding Chinese Cartoonists). *Shuping Shumu* (Book Reviews and Bibliography). No. 75, 1979, pp. 2-33.

7140. "New Comic Artists Introduce Their Works." *World Journal.* August 9, 1998.

7141. Underwood, Laurie. "Four Years of Funny Stuff; A Taiwan Cartoonist Draws Praise and Ire." *Asiaweek.* June 13, 1997, p. 46.

7142. Wang, Jane. [Kid Jerry]. *Sinorama.* September 1995, pp. 16-17.

7143. Zhang Bin. "Taiwanese Cartoonist Wang Ping's Life Cartoons." *Zhongguo Manhua.* No. 1, 1999. pp. 28-29.

Tsai Chih-Chung

7144. Ku Pi-ling. "Tsai Chih Chung: A New Lease of Life for the Chinese Classics." *IIAS Newsletter.* June 2000, p. 37.

7145. Mufson, Steven. "Simple Images, Great Ideals: Chinese Cartoonist Brings Classics to Whimsical Life." *Washington Post.* April 6, 1998, p. A18.

7146. Qiu, Jiayi. "Tsai Chih-chung: Manhua Shijie Duxingxia" (Tsai Chih-chung: The Independent Warrior in the World of Cartoons). *Zhanlue Shengchanli.* 439, 1992, pp. 118-120.

7147. Tsai Chih-chung. *Renzhe de Dingning, Kongzi Shuo* (A Humanitarian's Admonition, Confucius Speaks). Taipei: Shibao Wenhua, Manhua Congshu 27, 1987.

7148. Tsai Chih-chung. *Ruzhe de Zhengyan, Lunyu* (Confucian Advice, the Analects). Taipei: Shibao Wenhua, Manhua Congshu 57, 1988.

7149. Tsai Chih-chung. *The Tao Speaks: Lao-tzu's Whispers of Wisdom.* Translated by Brian Bruya. New York: Doubleday, 1995.

7150. Tsai Chih-chung. *Zhizde de Diyu, Laozi Shuo* (Whispers of Wisdom, Laozi Speaks). Taipei: Shibao Wenhua, Manhua Congshu 18, 1987.

7151. Tsai Chih-chung. *Zhizde de Diyu, Laozi Shuo 2* (Whispers of Wisdom, Laozi Speaks 2). Taipei: Shibao Wenhua, Manhua Congshu 167, 1993.

7152. Tsai Chih-chung. *Zhuangzi Speaks: The Music of Nature.* Translated by Brian Bruya. Princeton, New Jersey: Princeton University Press, 1992.

7153. Tsai Chih-chung. *Ziran de Xiaosheng, Zhuangzi, Shuo* (The Music of Nature, Zhuangzi Speaks). Taipei: Shibao Wenhua, Manhua Congshu 14, 1986.

7154. Wei, Shu-chu. "Redrawing the Past: Modern Presentation of Ancient Chinese Philosophy in the Cartoons of Tsai Chih-Chung." In *Illustrating Asia: Comics, Humor Magazines, and Picture Books,* edited by John A. Lent, pp. 153-170. Richmond: Curzon Press; Honolulu: University of Hawaii Press, 2001.

Animation

7155. Bernstein, Paula. "'Tiger' Snares Toon." Reuters release, June 1, 2001.

7156. Deckard, L. "Battaglia To Design $362 Mil Taiwan Theme Park." *Amusement Business*. October 28, 1991, p. 1.

7157. "Disney Debuts in Taiwan." *Asian Mass Communications Bulletin*. January-February 1995, p. 8.

7158. Eisner, Ken. "Grandma and Her Ghosts." *Variety*. November 2-8, 1998, p. 52.

7159. Fang, Rita. "Glove Puppetry Alive and Well." *Taipei Journal*. April 28, 2000, p. 5.

7160. Hsieh, Hsu-Chou. "Cartoon Violence Viewing and Children's Aggression: A Study on Taiwanese Primary School Students." *Journal of Radio and Television Studies* (Taipei). February 1997.

7161. Lent, John A. "Animation in Taiwan." Paper presented at Mid-Atlantic Region, Association for Asian Studies, Newark, Delaware, October 25, 1998.

7162. Lent, John A. "James Wang and Taiwan's Cuckoo's Nest." *Animation Journal*. Fall 1995, pp. 85-89.

7163. Lent, John A. "James Wang and His Crazy Climb to Taiwan's Cuckoo's Nest." In *Animation in Asia and the Pacific,* edited by John A. Lent, pp. 125-130. Sydney: John Libbey & Co., 2001.

7164. Lin Ting-ling. *A Pentadic* [sic] *Approach to Television Cartoons*. Taipei: National Science Committee, n.d., 1996 or 1997. 112 pp.

7165. Lin Yuh-yow. "A Study About Taipei's Elementary School Students' Motivation and Gratification Which Come From Watching Japanese Cartoons." Dissertation, Ming Chuan College, n.d. (1996 or 1997). 108 pp.

7166. Pai, Maggie. "Taiwan at Venice." *Asian Art News*. November-December 1999, pp. 66-67.

7167. Wang, Tse-Lan. "A Study of TV Viewing Behavior: What TV Program Kids Are Watching?" Master's thesis, Culture University (Taiwan), Journalism Department, 1997.

"Hello Kitty"

7168. Chang, Amanda. "McDonald's Breaks No Laws by Selling Toy Kitty: MOEA." Central News Agency. August 10, 1999.

7169. Ganz, Susanne. "Hello Kitty Fever Grabs Taiwan." Japan Economic Newswire. July 8, 1999.

7170. Ganz, Susanne. "Taiwan Couple Nabbed for Swindled Hello Kitty Goods." Japan Economic Newswire. August 12, 1999.

7171. "Hello Kitty Helps Taiwanese Bank Boost Business." Japan Economic Newswire. July 1, 1999.

7172. Huang, Annie. "The Cartoon Character Has Touched Off a Frenzy: Kitten Shakes up Taiwan." *Philadelphia Inquirer.* September 12, 1999, p. A23.

7173. Huang, Annie. "Cartoon Doll Creates Frenzy and Fighting in Taiwan." Associated Press, August 19, 1999.

7174. Lu, Myra. "Ad Campaign Places Hello Kitty at Center of Debate on Society." *Free China Journal.* November 11, 1999, p. 8.

7175. "Stampede of Hello Kitty Fans Overwhelms Ronald McDonald." *China News.* August 11, 1999.

7176. "Taiwan Bank Issues 'Hello Kitty' Cash, Credit Cards." Japan Economic Newswire. January 19, 1999.

7177. "The Two Faces of Taipei." *Mainichi Daily News.* July 14, 2000, p. 11.

7178. Wu, Sofia. "Fake 'Hello Kitty' Products Seized at CKS Airport." Central News Agency (Taipei). September 10, 1999.

Comic Books

7179. Ai Lei-dyi. "The Current Situation in Taiwan That Combines Comics with Literature." *Youth Literary.* March 1997.

7180. Chang, Linda. "Enthusiasts of Comic Books Given Their Own Library in Taipei." *Free China Journal.* July 31, 1998, p. 4.

7181. Chen, Jackie. "There's Something Funny About These Comics ... Adult Views of What Today's Kids Are Reading." *Sinorama.* September 1995, pp. 19-21.

7182. Cheng, Chun-Huang. "The Research of the Comics on the Vision – Taking the Sound Words and Reading Order as a Key." Master's thesis,

Yu-Ling Technology University, Visual Communication Department, n.d.

7183. Cheng Kuo-sin. "Change, Adjustment, and Breakthrough – The 1995 Comics' Ecology." *Publishing Information.* 1996, pp. 62-63.

7184. *Comics Encyclopedia.* Taipei: Male Lion Fine Art Publishing Co., 2000. 96 pp.

7185. [Comics Library]. *Central Daily News.* (Overseas Edition). July 20, 1998.

7186. "Comic Library Established in Taipei." *World Journal.* August 2, 1998.

7187. [Comics Museum]. *World Journal.* July 12, 1998, p. 1.

7188. *Dogma Information* [Catalogue]. Taipei: Dogma, 1995. 32 pp.

7189. "'A Dollar Per Minute' Comics Rental House Provides Diverse Services to Readers." *Central Daily News* (Overseas Edition). December 27, 1996, p. 5.

7190. Fan Wan-nan. "An Analysis of Comics Market." *Publication Almanac.* 1996, pp. 24-34.

7191. Fang, Rita. "Tickling the Social Funny Bone." *Taipei Journal.* September 1, 2000, p. 5.

7192. French, Howard W. "In Reinventing Past, Japan's Nationalists Find a Comic Book Ally." *International Herald Tribune.* March 26, 2001.

7193. Hsiao, Hsiang-Wen. "The Consuming Behavior of Comics Fans in Taiwan." Paper presented at Popular Culture Association, Philadelphia, Pennsylvania, April 14, 2001.

7194. Hsiao, Hsiang-Wen. "Exposure to Queer Comics and Readers' Sexual Identity." *Public Opinion Research Quarterly* (Taiwan). April 2000, pp. 89-111. Chinese.

7195. Hsiao, Hsiang-Wen. *The Influence of Japanese Comic Books on Children's Value.* Taipei: Culture University and Executive Yuan, July 1997. 61 pp. Chinese.

7196. Hsiao, Hsiang-Wen. "The Persuasion of Comics Commercials." *The Journal of Advertising* (Taipei). March 1997, pp. 114-127. Chinese.

7197. Hsu Shu-ching. "Apocalypse Regarding Taiwanese Comics' Future." *China Times.* March 13, 1997, p. 38.

7198. Hu Ying-ming. "Talking About Comics." *New Horizon: Bimonthly for Teachers in Taipei.* August 1995, pp. 58-59.

7199. Huang, Chui-Bi. "Reading Comics: Entertainment, Ecstasy and Social Practice." Master's thesis, Shi-Shin University, Communication School, 1997.

7200. Huang Hui-chen, *et al.* "A Research About the Opinions of Children in the Fourth Grade and Their Parents Towards Comics – Using 'Crayon Hsiao-shin' as an Example." *Teaching and Learning.* April 1996, pp. 13-40.

7201. Huang, Ya-Fan. "An Investigation of Taiwan Comic Cultural Industry." Master's thesis, National Taiwan Normal University, School Education Department, 1997.

7202. Ku Kuei-ling. "There's Still a Long Road for Comics Censorship." *Central Daily News.* August 23, 1995, p. 21.

7203. Ku Tsai-yen. "Taiwanese Comics Industry: From Political and Economic Perspectives." Dissertation, National Chung Cheng University, 1997. 198 pp.

7204. Lai, I-Ling. "A Textual Analysis: The Development of Taiwan Girl's Comics." Chen-Kung University, Art School, 1999.

7205. Landler, Mark. "Cartoon of Wartime 'Comfort Women' Irks Taiwan." *New York Times.* March 2, 2001, p. A3.

7206. Lee Ming-ling. "GO! GO! To See Taipei's Cartoon Festival – The Phenomena of Taiwanese Comics." *Central Daily News.* August 13, 1997, p. 21.

7207. Li, Hsiu-Mei. "The Relevance Between the Development of Child's Schema Development and the Interpretation of the Violence in Comic Books." Master's thesis. National Chengchi University, Communication School, 1998.

7208. Lin, Chih-Chan. "Comic, Ideology and Pleasure: The Comic Book and Its Readers." Master's thesis, National Taipei Normal College, 2000.

7209. Lin, Jeng-Yi. "The Study of the Relevance Between the Exposure to Violent Comics and Violent Behavior – Taking Taiwanese High School Students as Example." Master's thesis, Culture University (Taiwan), Journalism Department, 1998.

7210. Lin, Joyce. "Keeping 'X' Books Away from Young Readers." *Taipei Journal.* April 27, 2001, p. 4.

7211. Lin Shu-jeng. "The Juvenile Effect Caused by Comics." *A Place for Chinese Literature.* May 1996, pp. 70-76.

7212. Lin, Yi-Hsuan. "The Personality, Self-Concept and Behavior Pertaining to Members of Comic Fans' Club." Master's thesis, Culture University (Taiwan), Journalism Department, 1997.

7213. Ling Hui-chuan. "The Influences of Comics." *Education in Taipei County.* September 1995, pp. 25-28.

7214. Lu, Myra. "Comic Book Sparks Anger." *Taipei Journal.* March 23, 2001, p. 1.

7215. Lu Yu-jia. "Domestic Comics in Taiwan." *China Times.* January 12, 1995, p. 42.

7216. Mufson, Steven. "Let a Thousand Books Bloom." *Washington Post Book World.* August 20, 1995, pp. 1, 10.

7217. Sun Song-tang. "Comics Ecology." *Central Daily News.* September 3, 1997, p. 21.

7218. "Taiwan Envoy Says Japan Comic Distorted History." Reuters release. March 12, 2001.

7219. "Taiwan Lifts Ban on Japanese Artist." *Financial Times.* March 23, 2001.

7220. "Taiwan Mission in Japan Reiterates Government Stance on 'Comfort Women.'" *China Times.* March 14, 2001.

7221. "Taiwan's Comics Enters into Japanese Market." *World Journal.* March 21, 1999.

7222. *Tong Li Comics Book Catalog 95.* Taipei: Tong Li, 1995. 62 pp.

7223. Wang, Hsiao-Ling. "Deconstructing the Power in the Romance Comics Overwhelming Girls' High School." Master's thesis, National Taipei Normal College, 1999.

7224. Wang, Jane. "Welcome to Comic Book Paradise." *Sinorama.* September 1995, pp. 11-15.

7225. Wang Tsai-yan. "An Exploration of Comics Media." *Brain.* January 1997, pp. 48-54.

7226. Wu Chun-yao. "Comics and Literature." *Youth Literary.* April 1997.

7227. Wu Mei-hui, *et al.* "Regarding Comics." *New Horizon: Bimonthly for Teachers in Taipei.* August 1995, pp. 60-63.

7228. Yeh, Sandy. "Government Was Right To Bar Author." *Taipei Times.* March 11, 2001.

7229. Yen Ai-ling. "A New Genre: Comics in Terms of Cooking." *Central Daily News.* November 29, 1995, p. 21.

7230. Yen Ai-ling. "A Report in Terms of Comics Reading Habits." *Literature Information.* January 1997, pp. 44-47.

Comic Strips

7231. *China Times. China Times Publishing Company Catalogue.* Taipei: China Times Publishing Co., 1995.

7232. Dickie, Mure. "Comic Strip Adds to Taiwan Leader's Woes." *Financial Times.* February 27, 2001.

7233. Shen, Deborah. "Comic Strips Make Test Fun." *Free China Journal.* June 16, 1995, p. 4.

Political Cartoons

7234. Chang Shu-fen. "A Study Regarding How Comics of Current Events in Newspapers Create Politicians' Images." Dissertation, Ming Chuan College, Taipei, n.d. (1996 or 1997). 71 pp.

7235. Chen, Hui-Ting. "A Social-Cultural Analysis of Satire of Media in Taiwan." Master's thesis, Shi-Hsing University, Communication School, 1998.

7236. "De Strip als Politiek Instrument." *Stripschrift.* Nos. 8/9, n.d., p. 5.

7237. Hsiao, Hsiang-Wen. "An Exploratory Study on Readers' Comprehension Toward Editorial Cartoons in Newspapers: The Construction of an Index for Measuring Comprehension." *Public Opinion Research Quarterly* (Taipei). January 2000, pp. 95-122. Chinese.

7238. Hsu, Wen-ru. "A Content Analysis About Comics of 'Presidential Election' in Political Magazines." Dissertation, Ming Chuan College, Taipei, n.d. (1996?). 57 pp.

7239. Ku, Frances. *Memoirs of a Love-Hate Relationship with Taiwan.* Taipei: Classic Communications, 1997. 253 pp.

THAILAND
Cartooning, Cartoons

7240. *Cartoon Exhibition.* Vol. 2, 1981.

7241. "Cartoon – The Art of Laughing." *Prachachart Magazine*. March 13, 1975, pp. 36-49.

7242. Kalasri, P. "The Influence of Cartoon on Children." Paper presented at 1997 Cartoon Conference, Bangkok.

7243. Lent, John A. "Eastern Approaches: Cartooning in Thailand Thrives Amid Paradoxes." *AAEC Notebook*. Summer 1997, p. 25.

7244. Lent, John A. "Thai Cartooning: Free But Shaky, Lucrative But Limited." *Comics Journal*. April 1997, pp. 47-49.

7245. Lent, John A. "The Uphill Climb of Thai Cartooning." *Southeast Asian Journal of Social Science*. 25:1 (1997), pp. 93-109.

7246. Nakpaijit, S. *Cartoon*. Bangkok: Srinakarinvirot University, 1987.

7247. Newspaper Association of Thailand. *1979 Cartoon Conference*. December 1, 1979.

7248. Vetchnukror, V. "Looking Back on Thai Cartoon." Vol. 2. Bangkok: Cartoon Library and Rare Book Project, 1992.

7249. "What Price a Laugh in Hard Times?" *The Nation*. March 3, 1998.

Cartoonists and Their Works

7250. Watcharasawat, Arun. *Arun's Collection: When Kreukrit Was Prime Minister*. Bangkok: Piyasarn Publishing, 1978.

Chai (Chai Rachawat)

7251. Chai Rachawat, the Long-Time Greatest Cartoonist of the Era." *Street of Book Magazine*. November 5, 1984.

7252. Lent, John A. "Thai Cartoonist Chai, A Worker in Many Fields." *WittyWorld International Cartoon Bulletin*. No. 5, 1996, pp. 3-4.

7253. Ponjareunsawat, Chatri. "Analysis of Chai Ratchawat's Cartoons: 'Villager Ma and Ma-Meun-Field' During 1978-1980." Thesis, Srinakarinwirot University, March 1986.

Animation

7254. Amnachareonrit, Bamrung. "Animators Look Forward to Copyright Enforcement." *The Nation*. January 5, 1997.

7255. Danutra, Pattara. "An Animated Character." *Bangkok Post.* September 23, 1998, Outlook, p. 1.

7256. "Hmm, I Smell a Rat." *Asiaweek.* May 18, 2001, p. 8.

7257. Lent, John A. " 'A Screw Here, a Crank There': Payut Ngaokrachang and the Origins of Thai Animation." *Animation World.* April 1997, pp. 39-41.

7258. Lent, John A. "Thai Animation, Almost a One-Man Show." In *Animation in Asia and the Pacific,* edited by John A. Lent, pp. 185-192. Sydney: John Libbey & Co., 2001.

7259. "Saksiri Koshpasharin." *Animatoon.* No. 26, 2000, p. 17.

7260. Sarobol, Parichart Sthapitanonda and Arvind Singhal. " 'Glocalizing' Media Products: Investigating the Cultural Shareability of the 'Karate Kids' Entertainment—Education Film in Thailand." *Media Asia.* 25:3 (1998), pp. 170-175.

7261. "Soodsakorn." In *The First Annual Bangkok Film Festival,* program, p. 12. Bangkok, 1998.

7262. Uabumrungjit, Chalida. "Much Ado about Animation." *The Nation* (Bangkok). September 20, 1996, p. C-1.

Theme Parks

7263. Deckard, L. "Forrec Intl. Working on Two Bangkok Projects." *Amusement Business.* January 3-9, 1994, p. 17.

7264. Deckard, L. "Thailand's Future World Set To Open in 1995." *Amusement Business.* August 1-7, 1994, pp. 51-55.

Comic Books

7265. Baikasuyee, J. "The Academic Value of Thai Comic Books." In *Handbook of Thai Cartoon Development.* Bangkok: Ministry of Education, 1991.

7266. "Belgian Boyscout." *Kayhan Caricature.* December 2000, 3 pp.

7267. Carroll, Mimi. "The Ultimate Letter." *Comics Journal.* April 1996, p. 3. (Censorship).

7268. "Comic Magazine." *1979 Cartoon Conference.* Bangkok: Association of Mass Media for Children, 1979.

7269. Masrangsarn, Pravit. "The Experiment of Using Comic Books To Help the Education and Study of the Environment." Thesis, Mahidol University, n.d.

7270. Matzner, Andrew. "Not a Pretty Picture: Images of Married Life in Thai Comic Books." *International Journal of Comic Art.* Spring 2000, pp. 57-75.

7271. Moylan, Brian. "Comings and Goings." *Washington Blade.* March 9, 2001, p. 38.

7272. Premchaiporn, J. "The Current Situation of Children's Comic Books in Thailand." M.A. thesis, Thammasat University, 1989.

7273. Sankatiprapa, S. "Reading Behavior and Selection of Japanese Comic Books by Thai Children in Bangkok Metropolis." M.A. thesis, Thammasat University, 1989.

7274. Shepherd, Catherine. "No Respite from Vigilance." *Asiaweek.* August 2, 1996, pp. 44-45.

7275. Somboon, Singkamanan. "Other Voices: Manga in Thailand." *Bookbird.* Fall/Winter 1995, pp. 46-47.

7276. Sriwittayapaknam School. "Proindustry: Japanese Comic Books in Thailand." Online http://www.sriwittayapaknam.ac.th/class6-1/subjects.html, 1995.

7277. Thammapakkul, Anutra. "Comic Capers." *Nation Junior* (Bangkok). August 1-15, 2000, pp. 24, 26.

7278. [*Tintin* in Thailand]. *Asiaweek.* March 2, 2001, p. 9.

7279. "Tintin's Twisted Thai Adventure." *Far Eastern Economic Review.* March 1, 2001, p. 12.

Political Cartoons

7280. Janyawong, Sudrak. "Cartoon and Political Cartoon." *Ban-Mai-Ru-roil Journal.* November 1987.

7281. Kitichaiwan, Annop. *Political Cartoon* [sic] *by Add Daily News.* Bangkok: Bangkok Post, 1990 (?). 179 pp.

7282. Korwattanasakul, J. "Political Cartoon During the Communism Era." M.A. thesis. Chieng Mai University, 1992.

7283. Reungnarong, Naruemol. "Political Cartoons During October 14, 1973-October 6, 1976." Thesis, Chulalongkorn University, 1990.

7284. "Thailand." *Human Rights Watch/Asia.* November 1995, p. 37.

UZBEKISTAN
General Sources

7285. Aktchourina, Ella. "Succession de Générations: Notes sur le Cinéma d'Animation d'Ouzbékistan." *Plateau.* Autumn 1989, p 18.

VIETNAM
General Sources

7286. Aghion, Anne and John Merson. "Emerging Vietnam." *Animation World.* August 1998. (Animation).

7287. *As Seen by Both Sides: American and Vietnamese Artists Look at the War.* Boston: Indochina Arts Project and the William Joiner Foundation, 1991. 116 pp.

7288. Daum, Paul. "National Liberation Front Combat Art: The Works of Huynh Phuong Dong and Lam Tam Pai." Paper presented at Popular Culture Association, Las Vegas, Nevada, March 27, 1996.

7289. Deneroff, Harvey. "Vietnamese Animation: A Preliminary Look." In *Animation in Asia and the Pacific,* edited by John A. Lent, pp. 193-198. Sydney: John Libbey & Co., 2001.

7290. Hessler, Peter. "Counter-Revolution Seeks To Stop Subversion by Book." *Times Educational Supplement.* January 17, 1997, p. 17. (Comic books).

7291. Keenan, Faith. "Licensed To Laugh." *Far Eastern Economic Review.* September 4, 1997, pp. 44-46. (Humor magazine).

7292. Kunzle, David. "Killingly Funny. US Posters of the Vietnam Era." In *Vietnam Images. War and Representation,* edited by Jeff Walsh and James Aulich, pp. 112-122. London: Macmillan, 1989.

7293. Lent, John A. "The Invisible Art: Comics and Cartooning in Vietnam and Cambodia." *Comics Journal.* April 1996, pp. 25-26.

7294. Van Oudhensden, Pieter. "Vink: Het Leven op Papier." *Stripschrift.* No. 213, 1987, pp. 12-17. (Vink, Vinh Khoa).

4

AUSTRALIA AND OCEANIA

REGIONAL AND INTER-COUNTRY PERSPECTIVES

General Sources

7295. Burrows, Toby and Grant Stone, eds. Comics in Australia and New Zealand: The Collections, the Collectors, the Creators. New York: Haworth Press, 1994, 115 pp.

7296. Edera, Bruno. "Un Survol du Film d'Animation aux Antipodes." *Plateau.* Winter 1980, pp. 9-16.

7297. Foster, John. "Comics in Australia and New Zealand." *Australian Academic and Research Libraries.* June 1995, pp. 140-141.

7298. Gordon, Ian. "Comics in Australia and New Zealand: The Collections, the Collectors, the Creators." *Inks.* February 1996, p. 42.

7299. Ohasio, Campion. "A Solomon's 'Voice.'" *Pacific Journalism Review.* November 1996, pp. 149-155.

7300. Teninge, Annick. 'Réunion Island: A New Land for Cartoon Production." *Animation World.* January 1999. 7 pp.

7301. Wilson, Jada. "Jada and the Phantom." *Pacific Journalism Review.* November 1997, pp. 143-149.

AUSTRALIA
Cartooning, Cartoons

7302. Applegate, Joanne. "Future Art Shock." *Inkspot.* Spring 1997, p. 9.

7303. "Aussie Cartooning Books." *Toon Art Times.* October 1996, p. 4.

7304. Beiman, Nancy. "U.S. Cartoonists in Australia." *Cartoonist PROfiles.* March 1999, pp. 22-29.

7305. Burrows, Toby. "Australian Comics and Comic Strips: An Introductory Bibliography." *Australian and New Zealand Journal of Serials Librarianship.* 4:3 (1994), pp. 111-115.

7306. Burrows, Toby. "Comics Nostalgia: A Review Essay." *Serials Librarian.* 24:1 (1993), pp. 87-89.

7307. "Caught in the Act." *Inkspot.* Summer 1994, pp. 61-64.

7308. "Caught in the Act." *Inkspot.* Summer 1995, pp. 19-20.

7309. deVries, David. "State of the Art: South Australia." *Inkspot.* Spring 1997, p. 13.

7310. Foster, John. "The Image of Australia and Australians in Locally Produced Comics." *Papers.* 1:1 (1990).

7311. Foster, Peter and James H. Kemsley. *Ballantyne # 1.* Sydney: Balcom Books, 1996 (?).

7312. Gordon, Ian. "Searching for an Australian Identity." Paper presented at National Museum of Australia Seminar, September 1996.

7313. "Got Any Weird Friends?" *Toon Art Times.* December 1996, p. 1.

7314. Heimann, Rolf. "Australia." *WittyWorld International Cartoon Magazine.* Spring 1997, pp. 6-7.

7315. Heimann, Rolf. "It's a WittyWorld." *Inkspot.* Summer 1995, pp. 42-43.

7316. Heins, Michael. "An Investment in Laughter." *Toon Art Times* (Sydney). May 1992, p. 1.

7317. Hilton, Craig. "State of the Art: Western Australia." *Inkspot.* Spring 1997, p. 8.

7318. Hirst, George, ed. *Black N' White 'N' Green.* Sydney: Enviobooks, 1993. 127 pp.

7319. Kerr, Joan, Craig Judd, and Jo Holder. *Australians in Black & White. (The Most Public Art)*. Exhibition Guide. State Library of New South Wales, 1999.

7320. Lumsden, Glenn. "Aussie War Stories Set Shelves Alight." *Inkspot*. Summer 1994, p. 59.

7321. McCall, Ian and Vane Lindsay. "State of the Art: Victoria." *Inkspot*. Spring 1997, p. 10.

7322. McCulloch, Allan. *Encyclopedia of Australian Art*. Victoria: Hutchinson of Australia, 1984.

7323. McInerney, Sally. "Moira, Black Knox and Flame Man." *Sydney Morning Herald*. August 6, 1983.

7324. McPhee, John. "The Most Public Art." *Art and Australia*. 37:1 (1999), p. 149.

7325. *Mambo: Still Life With Franchise*. Rushcutters Bay: Mambo Graphics, 1998. 218 pp. (Humorous illustration).

7326. Moffitt, I. "Australia's Great Cartoon Carnival." *Bulletin*. September 11, 1976.

7327. "Movement at the Bunker." *Inkspot*. Spring 1997, p. 22.

7328. Murray, Kristen. "A Cross-Cultural Comparison of Cartoon Perception." *Australian Journal of Comedy*. 3:1 (1997), pp. 43-51.

7329. "News from Australia." *FECO News*. No. 22, 1997, p. 19.

7330. Nicholls. "The Professionals' Tips." *The Cartoonist*. July 1999, p. 3.

7331. "The 1995 Annual Report." *Inkspot*. Summer 1996, pp. 32-33.

7332. "Once Upon a Time" *Toon Art Times* (Sydney). May 1992, p. 1.

7333. "1996 – Year of The Phantom." *Inkspot*. Summer 1995, p. 8.

7334. Panozzo, Steve. "Chromed Pickup Trucks and Other Observations." *Inkspot*. Summer 1994, pp. 22-24.

7335. Panozzo, Steve. "Conference Sketched the Future." *Inkspot*. Summer 1995, p. 31.

7336. Panozzo, Steve. "The Stanleys: Leak Grabs Gold in Record Stanleys Win." *Inkspot*. Summer 1995, pp. 24-30.

7337. "Paraphernalia." *Inkspot*. Summer 1994, p. 67.

7338. "Paraphernalia." *Inkspot*. Autumn 1996, p. 17.

7339. Richardson, Donald. *Art and Design in Australia: A Handbook.* Sydney: Longman Australia, 1995 (?).

7340. Roeder, Romy. *Celluloid Dolls: Kewpies and Other Cuties.* Sydney: Kangaroo Press, 1986.

7341. Ross, Buddy. "Cartooning Conference an Inspiration." *Inkspot.* Spring 1997, p. 48.

7342. "Rotary National and International Cartoon Awards 1994." *Inkspot.* Summer 1994, pp. 32-35.

7343. "Rotary National and International Cartoon Awards 1995." *Inkspot.* Summer 1995, pp. 34-38.

7344. "Rotary National and International Cartoon Awards 1996." *Inkspot.* Spring 1997, pp. 46-47.

7345. "Sculpture Student Wins Bill Mitchell." *Inkspot.* Autumn 1996, p. 7.

7346. Seeger, Colin. "Is There a Right To Satirise?" *Inkspot.* Summer 1994, pp. 30-31.

7347. Seeger, Colin. "Plagiarism: 'It's My Cartoon, But I Didn't Draw It.'" *Inkspot.* Spring 1995, p. 28.

7348. "Smocks, Speakers and Awards." *Inkspot.* Spring 1997, p. 11.

7349. "Southern Exposure for Stanleys?" *Inkspot.* Summer 1995, p. 9.

7350. "State of the Art, Queensland." *Inkspot.* Spring 1997, p. 9.

7351. "VI$COPY Launched." *Inkspot.* Summer 1995, p. 7.

7352. "Your View on ...Birthdays and Anniversaries." *Inkspot.* Spring 1995, p. 31.

7353. "Your View on Magicians." *Inkspot.* Autumn 1996, pp. 30-31.

7354. "Your View on Poverty." *Inkspot.* Summer 1994, pp. 46-47.

Black and White Club

7355. "Brisbane Backs Black and White." *Inkspot.* Autumn 1996, p. 6.

7356. Foyle, Lindsay. "The Old Order Changeth" *Inkspot.* Summer 1994, pp. 44-45.

7357. Lindesay, Vane. *Drawing from Life: A History of the Australian Black and White Artists' Club.* Strawberry Hills, Australia: Australian Black and White Artists' Club, 1995.

7358. "New Gallery To Promote B & W Art." *Inkspot.* Summer 1994, p. 11.

7359. "The Stanleys Anniversary Awards Spring Leak to Victory." *Inkspot.* No. 16, 1995, pp. 37-41.

Historical Aspects

7360. Coleman, Peter. *Cartoons of Australian History.* Melbourne: Nelson, 1967.

7361. Craig, Clifford. *Mr. Punch in Tasmania – Colonial Politics in Cartoons 1866-1879.* Hobart: Blubber Head Press, 1980.

7362. Journalists' Club. *Fifty Years of Australian Cartooning.* Sydney: Journalists Club, 1964.

7363. Osborne, Graeme. *Communication Traditions in 20th Century Australia. Australian Retrospectives.* Melbourne: Oxford University Press, 1995. (Comics debate, pp. 88, 99).

7364. Rolfe, Patricia. *The Journalistic Javelin 1880-1980: An Illustrated History of the Bulletin.* Sydney: Wildcat Press, 1979.

Cartoonists and Their Works

7365. "Arthur Horner." *Inkspot.* Spring 1997, p. 20.

7366. "Australian Artists." *Toon Art Times.* (Sydney). May 1992, p. 4.

7367. Australian Black and White Artists' Club. *The 102 Collection of Australia's Leading Cartoonists.* Sydney: Lilyfield Publishers, 1988.

7368. "Cartoonists Help Kids Feel at Home." *Inkspot.* Summer 1995, p. 6.

7369. "Cartoonists Help Raise $20,000 for Sick Kids." *Inkspot.* Spring 1995, p. 5.

7370. "Cartoonists US Tour Sequel!" *Inkspot.* Summer 1994, p. 12.

7371. Chai, Kae. "Chai Kae-O's the Old Dart." *Inkspot.* Spring 1995, p. 12.

7372. David, Mark. "M. David—Filling in the Spaces." *Inkspot.* Spring 1995, pp. 24-27.

7373. Emmerson, Ron. *Emmersaurus: Cartoons with a Bite.* Rockhampton, Queensland: Author, 1995.

7374. Fullerton, Peter, ed. *Norman Lindsay War Cartoons.* Carlton, Victoria: Melbourne University Press, 1983.

7375. "Get To Know the Artist: Ken Dove." *Inkspot.* Summer 1994, p. 71.

7376. Heimann, Rolf. "Caricaturist John Spooner's Method: To Disturb, To Subvert, To Undermine." *WittyWorld International Cartoon Bulletin.* 4/1996, pp. 3-4.

7377. Heimann, Rolf. "A Personal View of Cartooning and How an Overweight Tongan Chief Changed My Life Forever." *WittyWorld.* December 1998, pp. 10-11.

7378. Hopkins, Dorothy J. *Hop of the Bulletin.* Sydney: Angus and Robertson, 1929. (Livingston Hopkins).

7379. "John Champion." *Inkspot.* Spring 1997, p. 21.

7380. "Jolliffe at 90." *Inkspot.* Spring 1997, p. 13. (Eric Jolliffe).

7381. "Know the Artist." *Inkspot.* Spring 1995, p. 35. (Gus Gordon, Brett Paterson, Will Pearce).

7382. "Know the Artist: Antonio Lemos." *Inkspot.* Spring 1997, p. 23.

7383. "Leak Basks in White Light." *Inkspot.* Spring 1997, p. 9. (Bill Leak).

7384. "Leak, Shakes in Walkleys Triumph." *Inkspot.* Summer 1995, p. 7. (Bill Leak and John Shakespeare).

7385. Leunig, Mary. *There's No Place Like Home: Drawings by Mary Leunig.* Ringwood, Australia: Penguin Books Australia, 1982. Unpaginated.

7386. Leunig, Michael. *Ramming the Shears.* Ringwood: Dynamo, 1985, Penguin, 1990. Unpaginated.

7387. Lindesay, Vane. "The Cat Man – D.H. Souter (1862-1935)." *Inkspot.* Autumn 1996, pp. 20-22.

7388. Lindesay, Vane. "The Piped Piper: Jim Bancks (1889-1952)." *Inkspot.* Spring 1997, pp. 30-33.

7389. Lindesay, Vane. "Stan Cross 1888-1977: Legend in Black and White." *Inkspot.* Spring 1995, pp. 20-24.

7390. Lindesay, Vane. "Ted Scorfield (1884-1968): A Virtual Unknown." *Inkspot.* Summer 1995, pp. 20-22.

7391. "Löbbecke Wins Media Award." *Inkspot.* Autumn 1996, p. 5.

7392. "Media Watch Apology for Kev." *Inkspot.* Spring 1995, p. 9. (Kev Bailey).

7393. Motion, Andrew. *The Lamberts: George, Constant and Kit.* London: Chatto and Windus, 1986.

7394. Nicholls, Susan. "The Line and the Word: Socio-Political Critique in the Cartoons of Geoff Pryor." In *Australian Communication Lives,* edited by Graeme Osborne and Deborah Jenkin, pp. 95-107. Canberra: University of Canberra, Division of Communication and Education, 1999.

7395. Nicholson, Peter. *Nicholson's Jabs.* Sydney: Reed Books Australia, 1995 (?).

7396. Panozzo, Steve. "Freelance Genius." *Inkspot.* Spring 1997, pp. 18-19. (Cole Buchanan).

7397. "Puzzling Good Fun!" *Inkspot.* Spring 1997, pp. 40-43. (Dave Allen).

7398. Ross, Buddy. "A Buddy Sore Back!" *Inkspot.* Autumn 1996, p. 32. (Buddy Ross).

7399. "Rowe the Vote." *Inkspot.* Summer 1995, p. 7. (David Rowe).

7400. Ryan, John. "Bidgee." *Strips* (Auckland). No. 9, 1978, pp. 16-20.

7401. Ryan, John. "A Great Man Passed this Way." *Strips.* No. 3, 1977 (?), pp. 15-19. (Syd Nicholls).

7402. Ryan, John. "Hart Amos." *Strips* (Auckland). No. 4/5, 1977, pp. 37-41.

7403. Schroeder, Darren. "From Australia: Eddie Campbell." *Silver Bullet Comics.* October 28, 2000. (Censorship of "From Hell").

7404. Scorfield, Ted. *A Mixed Grill.* Sydney: *Bulletin,* 1943. 66 pp.

7405. Scott, Nik. "The Internet for the Cartoonist—A Brief Paddle." *Inkspot.* Autumn 1996, p. 14.

7406. "Spooner's Double Walkley Win." *Inkspot.* Summer 1994, p. 12.

7407. "The Stanleys: Gold Leaks Eternal." *Inkspot.* Spring 1997, pp. 36-39.

7408. "Step by Step: Captions Courageous." *Inkspot.* Summer 1994, pp. 53-56. (Dean Alston).

7409. "Sydney Smocks Sprod; a Treat for Tainsh." *Inkspot.* Summer 1994, p. 11. (Doug Tainsh, George Sprod).

7410. Tanner, Les. "The Black-and-White Maestros." *The Bulletin.* January 29, 1980.

7411. "Vale: John Proudfoot 1910-1994." *Inkspot.* Spring 1995, p. 6.

7412. "Vane Lindesay's Inked in Images: Finey, 1895-1987." *Inkspot.* Summer 1994, pp. 50-52. (George Edmond Finey).

7413. West, Richard S. "Oliphant in Washington, Rigby in New York: Two Australians Loose in America, Embassy of Australia, Washington, DC, 22 June-10 August 1995." *Inks.* February 1996, pp. 48-49.

7414. *Who's Who of Australian Visual Artists.* 2nd Edition. Sydney: D.W. Thorpe/NAVA, 1995 (?).

Gurney, Alex

7415. Gurney, John and Keith Dunstan. *Gurney & Bluey & Curley – Alex Gurney and His Greatest Cartoons.* South Melbourne: Macmillan, 1986.

7416. Kendig, Doug. "Alex Gurney." *The Funnies Paper.* November/December 2000, pp. 24-26.

Knight, Mark

7417. Emmerson, Ron. "A Hard Day's Knight." *Inkspot.* Autumn 1996, pp. 24-27.

7418. "Knight Thumbs His Way to Extended Break." *Inkspot.* Spring 1995, p. 6.

Mitchell, Bill

7419. "Bill Mitchell Originals." *Toon Art Times.* October 1996, p. 4.

7420. Birnbaum, Phil. *The World of Mitchell.* Chatswood, NSW: Janet's Art Books, distributor for Emperor Publishing, 1995. 216 pp.

7421. "Vale Bill Mitchell." *Inkspot.* Summer 1994, pp. 25-29.

Petty, Bruce

7422. McGregor, Craig. "Petty and the Squiggly Line." *The National Times.* February 10, 1979, p. 19.

7423. Starkiewicz, Antoinette. "Petty." *Cinema Papers.* July-August 1979, pp. 414-417.

Russell, Jim

7424. Russell, Jim. "A Record Hard To Top ...An Aussie Success Story." *Cartoonist PROfiles.* September 1998, pp. 72-81.

7425. "A Wonder Down Under." *Inklings.* Winter 1998, p. 8.

Animation

7426. Alder, Otto. "3rd Brisbane International Animation Festival." *Animatoon.* No. 25, 2000, pp. 10-13.

7427. Begg, Jane. "Silicon Pulp." Paper presented at Society for Animation Studies, Brisbane, Australia, August 4, 1999.

7428. "'Blinky Bill.'" *Toon Art Times* (Sydney). December 1992, p. 2.

7429. "Blinky Bill, The Mischievous Koala." *Toon Art Times* (Sydney). March 1993, p. 1.

7430. Bradbury, Keith. "Australian and New Zealand Animation." In *Animation in Asia and the Pacific,* edited by John A. Lent, pp. 207-224. Sydney: John Libbey & Co., 2001.

7431. Cahill, Phillippe. "Oz Gov't Toons Up for Tax Incentives." *Variety.* May 24-30, 1999, p. 18.

7432. "The Cartoon Gallery Questionnaire." *Toon News.* October 1996, pp. 2, 5.

7433. "Cartoon Men Walk Off." *The Age.* August 16, 1979.

7434. "Cartoon Row No Laughing Matter." *Australian.* August 16, 1979.

7435. "Celluloid Briefs, the First Brisbane Animation Festival." *Animation World.* October 1996, 1p.

7436. "Children and Media." *Media International Australia.* August 1995, pp. 193-194.

7437. Cholodenko, Alan. "Australia." *Society for Animation Studies Newsletter.* Summer 1995, p. 9.

7438. "Chuck's Daughter Opens Gallery." *Inkspot.* Autumn 1996, p. 5.

7439. Collins, Alison. "F/X Festival Draws Crowds." *Inkspot.* Autumn 1996, p. 32.

7440. Crogan, Patrick. "Perspectives in 3D Animation in Australia." Paper presented at Society for Animation Studies, Brisbane, Australia, August 3, 1999.

7441. Dermody, Susan and Elizabeth Jacka. *The Screening of Australia.* 2 Volumes. Sydney: Currency Press, 1987.

7442. Edgar, Patricia. *Children's Television: The Case for Regulation.* North Melbourne: Australian Children's Television Foundation, 1984.

7443. Eyley, John. "Animation School: Queensland College of Art." *Animatoon.* No. 28, 2000, pp. 36-37.

7444. Farley, Rebecca. "Animation in Australia: What Industry?" BA honors thesis, University of Queensland, Brisbane, 1992.

7445. "Film Cartoonists Seek Prize U.S. Market." *Telegraph.* December 4, 1977.

7446. "The First W.B. Store in Oz." *Toon News* (Sydney). July 1996, p. 4.

7447. Gelman, Morrie. "Energee Entertainment: *Crocadoo* Catapults Australian Production Company." *Animation.* December 1999, p. 21.

7448. Gillard, Patricia. "The Demise of the CPC." *Media Information Australia.* August 1992, pp. 63-65.

7449. Groves, Don. "Animation Distrib Opens U.K. Office." *Variety.* September 14-20, 1998, p. 29.

7450. Groves, Don. "Duet Toons Sales." *Variety.* March 26-April 1, 2001, p. 38.

7451. Groves, Don. "Icon Gets a Taste of 'Pudding.'" *Variety.* May 17-23, 1999, p. 22.

7452. Groves, Don. "Store Wars Flaring Up in Oz." *Variety.* November 27-December 3, 1995, p. 60.

7453. "Hard Sell Key to Film's Success." *Age.* November 27, 1982, pp. 26-27.

7454. Heins, Michael. "Be Afraid: Silly Season is Here!" *Toon Art Times.* December 1997, p. 1.

7455. Heins, Michael. *The Catalogue of Toon Art.* Sydney: The Cartoon Gallery, 1993/1994. 24 pp.

7456. "High Tack, the Computer Animated Logo." *Cinema Papers.* May 1988, p. 62.

7457. Hollander, Judd and Suzy Spirit. "Moose and Squirrel in the Land of Kangaroos." *FFFFF.* June 1994, pp. 8-9.

7458. "'Koala' for BBC Holidays." *Daily Variety.* November 10, 1998, p. 41.

7459. "MCA Hosts Top Animators." *Inkspot.* Summer 1994, p. 10.

7460. Mellor, Bruce. "Sydney Pens Draw World Famous TV Characters." *Sun Herald.* August 19, 1979.

7461. Mendham, Tim and Keith Hepper. "Special Report: Animation in Australia." In *Industrial and Commercial Photography 1978 Yearbook,* pp. 51-74. Sydney: Publicity Press, 1978.

7462. Mendlessohn, Johanna. "Cartoons That Move." *The Bulletin.* November 20, 1990.

7463. Monahan, Craig. *Animated.* Video-recording. Sydney: Pointblank Films, 1989.

7464. Morrison, Mike. "Multimedia Down Under." *Animation World.* December 1997, 5 pp.

7465. "Oscar for Aust Film Failure." *Sydney Morning Herald.* March 30, 1977.

7466. Palmer, Roger. "Australia's Second International Conference on Animation, *The Life of Illusion,* March, 1995." *Society for Animation Studies Newsletter.* Spring 1995, p. 3.

7467. Palmer, Roger. "Recent Animation from Australia." Paper presented at Society for Animation Studies, Greensboro, North Carolina, September 28, 1995.

7468. Paterson, Karen. "Crocadoo Entertains with Energee." *Animation World.* September 1996, 4 pp.

7469. "The RMIT Centre for Animation and Interactive Media." *Media International Australia.* August 1996, pp. 126-127.

7470. Robertson, Peter. "Computer Animation: Concepts and Preoccupations." *Artlink.* 9:4 (1989/1990), pp. 30-31.

7471. "Victorian College of the Arts School of Film and Television – Australia's Animation Capital." *Animatoon.* No. 24, 2000, pp. 28-31.

7472. Woods, Mark. "Brisbane Fest Features Animation, WWII Retro." *Variety.* June 12-18, 1995, p. 22.

7473. Woods, Mark. "Kid Toons Drive Vid Sell-Through Boom." *Variety.* April 29-May 5, 1996, pp. 112-113.

7474. Woods, Mark. "Oz Partnerships Bear Fruit." *Variety.* September 25-October 1, 2000, p. M40.

7475. Woods, Mark. "Oz's 'Ocean Girl' Gets Animated." *Variety.* September 27-October 3, 1999, p. M-32.

7476. Woods, Mark. "Shops Move 'Pyjamas' Products." *Variety.* April 8-14, 1996, p. 53.

7477. Woods, Mark. "YG Leads Active Oz Player Slate." *Variety*. June 19-25, 1995, pp. 46, 64.

7478. Woods, Mark and Don Groves. "Oz's Moppet Market Spawns Local Kidpix." *Variety*. January 10-16, 2000, pp. 36, 38.

7479. Wulf, Junia. "Voice Actors: Are They Being Heard in the Animation Industry?" Paper presented at Society for Animation Studies, Brisbane, Australia, August 5, 1999.

7480. Zurbrugg, Nicholas. "Linda Dement and Graham Harwood: De-Animation and Re-Animation." *Art and Design*. No. 53, 1997, pp. 82-85.

Animators

7481. Cahill, Phillippe. "Oz Animator Rolls Out Fall Sked." *Variety*. September 13-19, 1999, p. 38.

7482. Dawson, Jonathan. "A Regional Life – Images of Queensland and the Animation of Max Bannah." Paper presented at Society for Animation Studies, Brisbane, Australia, August 4, 1999.

7483. "Gary Clark." *Toon Art Times* (Sydney). May 1992, p. 2.

7484. Lynch, Stephen. "Keith Scott: Down Under's Voice over Marvel." *Animation World*. July 2000, 6 pp.

7485. "New Cartoonists!" *Toon Art Times*. September 1992, p. 2.

7486. "Nick Hilligoss Is Australia's Nick Park." *ASIFA San Francisco*. July/August 1999, p. 5.

Gross, Yoram

7487. Groves, Don. "A History of Yoram Gross-EM.TV." *Variety*. April 30-May 6, 2001, p. 54.

7488. Groves, Don. "Telling His Life Story in Toons." *Variety*. April 30-May 6, 2001, p. 53.

7489. Groves, Don. "Yoram Gross-EM. TV Thrives at 30." *Variety*. April 30-May 6, 2001, pp. 52, 55.

7490. Lynch, Stephen. "Marsupial Madness: The Success of Yoram Gross." *Animation World*. October 1999, 4 pp.

7491. Starkiewicz, Antoinette. "Two Animators: 1. Yoram Gross." *Cinema Papers*. October/November 1984, pp. 335-338, 380-381.

7492. Woods, Mark. "Oz Partnership Has Gross Repercussions." *Variety.* April 12-18, 1999, p. 61.

Julius, Harry

7493. Bradbury, Keith. "Australian Animation before Disney in Australia – Harry Julius." Paper presented at Society for Animation Studies, Orange, California, August 15, 1998.

7494. Ure Smith, Sydney. "The Late Harry Julius." *Art in Australia.* August 15, 1938, pp. 33-34.

Porter, Eric

7495. "The Australian Walt Disney." *Film News.* February 9, 1939, p. 15.

7496. [Eric Porter]. *Film Weekly.* March 17, 1938, p. 38; October 12, 1944.

7497. [Eric Porter]. *People.* December 15, 1954, p. 26.

7498. "Eric Porter Is Young Australian Walt Disney." *The Australasian Exhibitor News.* April 20, 1939.

Disney in Australia

7499. "Australia's First Disney Fan Club!" *Toon Art Times* (Sydney). March 1993, p. 4.

7500. "Disney Australië." *Stripschrift.* May 1989, p. 35.

7501. "Disney Channel Opens." *Toon News* (Sydney). July 1996, p. 4.

7502. "First Disney Store Opens." *Toon News* (Sydney). December 1995, p. 4.

Historical Aspects

7503. Anderson, Chris. "Aust Company Sells TV Cartoons to U.S." *Sun.* September 20, 1970.

7504. "Animated Artransa Film Has Hit Jackpot." *Radio and Television News.* July 19, 1957.

7505. Bertrand, Ina, ed. *Cinema in Australia: A Documentary History.* Sydney: South Wales University Press, 1989.

7506. Bradbury, Keith. "An Ambivalent Industry: How Australian Animation Developed." Master of Arts thesis, University of Queensland, Brisbane, 1997. 187 pp.

7507. Caban, Geoffrey. *A Fine Line: A History of Australian Commercial Art.* Sydney: Hale and Iremonger, 1983.

7508. "Cosmo Gang Ready To Take on the World." *The Sunday Mail.* September 22, 1966, p. 23.

7509. "Hitler Satirized as a Child in Color Cartoon." *Daily News.* May 16, 1940, p. 6.

7510. Howard, John. "Our Cartoons: A $1m. Export Business." *TV Times.* September 16, 1970, p. 8.

7511. "The Image Makers." *Daily Mirror.* August 12, 1976.

7512. "Is TV Animation on the Wane?" *Broadcasting and Television.* August 27, 1964, pp. 11, 17.

7513. Jolley, S. "Felix, You've Come a Long Way." *TV Times* (Australia). November 12, 1977, p. 22.

7514. "Local Color Cartoon Advertising Impresses." *The Film Weekly.* March 17, 1938, p. 28.

7515. "A Lovable Wombat Called Bimbo." *People.* December 15, 1954, pp. 23-26.

7516. *The Photoplayer and Talkies.* March 4, 1939, pp. 24-25.

7517. Pike, Andrew and Ross Cooper. *Australian Feature Film 1900-1977: A Guide to Feature Film Production.* Melbourne: Oxford University Press and Australian Film Institute, 1980.

7518. "Results from Artransa Animation." *Broadcasting and Television.* April 6, 1961.

7519. Shirley, Graham and Brian Adams. *Australian Cinema: The First Eighty Years.* Hong Kong: Currency Press, 1983.

7520. "Tariff Board Inquiry Final Hearings: Film Industry Under Heavy Attack." *Film Weekly.* December 11, 1972, p. 1.

7521. "Teamwork Plus Quality." *Script Screen and Stage.* 4:5 (1971), pp. 12-16.

7522. "Top Animator Sees Growing Sales Potential in US Markets." *Broadcasting and Television.* September 26, 1963, p. 18.

7523. "Unusual AGM Commercial." *Broadcasting and Television.* July 1963, p. 24.

Southern Star

7524. Groves, Don. "Sales Ventures Take New Route." *Variety.* September 21-27, 1988, pp. 96, 101.

7525. Groves, Don. "World's Largest Library." *Variety.* September 21-27, 1998, pp. 85, 92.

7526. "Southern Star Timeline." *Variety.* September 21-27, 1998, p. 86, 88.

7527. Woods, Mark. "Saunders' Pacific Unit Not Child's Play." *Variety.* September 21-27, 1998, pp. 98, 103.

Comic Books

7528. Allstetter, Rob. "An Australian Wolverine?" *Comics Buyer's Guide.* November 12, 1999, p. 6.

7529. "Audience ACEd by Comic Book Show." *Inkspot.* Spring 1995, p. 10.

7530. Brady, Matt. "'From Hell' Barred from Campbell's Country of Residence." *Comics Buyer's Guide.* November 17, 2000, p. 6.

7531. Carter, Derek. "Comic Art Down Under." *The New Captain George's Whizzbang.* No. 14, 1972, pp. 12-13.

7532. Chaloner, Gary. "We Need Editors." *Comics Journal.* April 1998, pp. 6-7.

7533. Clements, John. "Comics Future Banks on A C E." *Inkspot.* Spring 1997, p. 14.

7534. Dean, Michael. "*From Hell* to Australia." *Comics Journal.* December 2000, pp. 10-12.

7535. Dickinson, Pauline. "The Comic Collection at the University of Sydney Library." *Australia and New Zealand Journal of Serials Librarianship.* 4:3 (1994), pp. 87-98.

7536. Docker, J. "Culture, Society and the Communist Party." In *Society, Communism and Culture. Australia's First Cold War 1945-1953,* edited by A. Curthoys and J. Merritt, Vol. 1. Sydney: Allen and Unwin, 1984.

7537. Foster, John. "The Slow Death of a Monochromatic World: The Social History of Australia as Seen Through Its Children's Comic Books." *Journal of Popular Culture.* Summer 1999, pp. 139-152.

7538. Gerritson, Craig. "Exegesis, or the Fine Art of Australian Comics." *Funtime Comics Presents.* July 1997, unpaginated.

7539. Hill, Michael. "Outside Influence/Local Colour." Paper presented at International Comic Arts Festival, Bethesda, Maryland, September 17, 1999.

7540. "Lejos y Cerca. Clint Q-ray (Q-ray) de Australia." *Mi Barrio.* September 2000, p. 14.

7541. McGee, Graham. "Confessions of a Long Distance Collector." *Australian and New Zealand Journal of Serials Librarianship.* 4:3 (1994), pp. 99-103.

7542. "Major Comic Book Tour Announced." *Inkspot.* Summer 1994, p. 10.

7543. Miller, John J. "Down Under and Underwater." *Comics Buyer's Guide.* August 23, 1996, p. 10.

7544. "Oblagon." *Toon Art Times* (Sydney). May 1992, p. 2.

7545. Rosenthal, N. *Films and Comics.* Melbourne: Victorian Council for Children's Films and Television, 1952.

7546. Ryan, John. "With the Comics: Down Under." *Australian and New Zealand Journal of Serials Librarianship.* 4:3 (1994), pp. 25-39.

7547. Scudamore, Ian. "Citee Comique: Western Australia's Greatest Comics Magazine." *Australian and New Zealand Journal of Serials Librarianship.* 4:3 (1994), pp. 67-69.

7548. Shiell, Annette, ed. *Bonzer: Australian Comics 1900s-1990s.* Redhill: Elgua Media, 1998. 188 pp.

7549. St. Lawrence, Gary. "Eddie Campbell Schedules Collected *From Hell.*" *Comics Buyer's Guide.* October 8, 1999, p. 6.

7550. Stone, Richard. "Achieving Fandom: John Ryan and the Australian Comics in the National Library of Australia." *Australian and New Zealand Journal of Serials Librarianship.* 4:3 (1994), pp. 71-85.

7551. Thompson, Mark. "Censorship in Australia." *Comics Journal.* August 1995, pp. 28-29.

Comics Debate

7552. Bartlett, N. "Culture and Comics." *Vol. 13 (1954).*

7553. Beasley, F. "The Censorship and Exclusion of Ideas." *Australian Quarterly.* 24, 1934, pp. 20-27.

7554. Borchardt, D. "Ideas, Books and the Censor." *The Australian Quarterly.* 26:4 (1954), pp. 79-80.

7555. Brannigan, A. "Crimes from Comics: Social and Political Determinants of Reform of the Victoria Obscenity Law 1938-54." *Australian and New Zealand Journal of Criminology*. March 1986, pp. 23-42.

7556. Coleman, P. *Obscenity, Blasphemy, Sedition, Censorship*. Brisbane: Jacarandah Press, n.d. [1963].

7557. [Comics Debate]. *Meanjin*. 13:1 (1954), p. 4.

7558. Duncan, W.G.K. "Comics." *Current Affairs Bulletin*. November 21, 1949, pp. 70-83.

7559. Finnane, M. "Censorship and the Child: Explaining the Comics Campaign." *Australian Historical Studies*. 23, 92, 1989, pp. 220-240.

7560. Fitzpatrick, B. "The Comics, the Censorship and the Law." *The Australian Library Journal*. 3:3 (1954), pp. 87-88.

7561. Metcalfe, J. "The Comics. Funny Ha Ha or Funny Peculiar." *The Australian Library Journal*. 1:6 (1952), pp. 122-126.

7562. Morris, N. "Films, Comics and Delinquency." *Visual Arts Review*. 1:4 (1953), pp. 4-8.

7563. Osborne, Graeme. "Comics Discourse in Australia and Fredric Wertham's *Seduction of the Innocent*." In *Pulp Demons: International Dimensions of the Postwar Anti-Comics Campaign*, edited by John A. Lent, pp. 179-214. Madison, New Jersey: Fairleigh Dickinson University Press; London: Associated University Presses, 1999.

7564. Osborne, G. and G. Lewis. *Communication Traditions in 20th Century Australia*. Melbourne: Oxford University Press, 1995. (Cartoons, pp. 81-82).

7565. Rosenthal, N. *Films and Comics*. Melbourne: The Victorian Council for Children's Films and Television, 1952.

7566. "Seduction of the Innocent." Editorial. *Visual Aids Review*. 1:7 (1954), pp. 3-4.

Oz Con

7567. "Club Maintains OzCon Commitment." *Inkspot*. Summer 1994, p. 58.

7568. Hale, Stuart. "Biggest Con of All." *Inkspot*. Spring 1995, p. 8.

7569. Hale, Stuart. "Conventioneering in the Land of the Australian Comic Book Convention." *Inkspot*. Summer 1994, p. 57.

7570. Hale, Stuart and Gerald Carr. "Double Scoop of OzCon!" *Inkspot.* Autumn 1996, p. 8.

7571. "OzCon Comes of Age." *Inkspot.* Spring 1997, p. 10.

7572. "OzCon 5 Shapes Up!" *Inkspot.* Summer 1995, p. 8.

7573. "OzCon '93!" *Toon Art Times* (Sydney). September 1992, p. 4.

7574. "OzCon '92." *Toon Art Times* (Sydney). May 1992, p. 2.

Underground, Alternative

7575. "Australian Underground Comics." *Strips* (Auckland). No. 14, 1980, pp. 24-26.

7576. Danko, Tim. "Why the Australian Small Press Make Eskimo Comics." In *Savage Pencils.* Exhibition Catalogue, Silicon Pulp Animation Gallery, Sydney, February 2-April 1, 2001, pp. 10-13. Sydney: Grabber Hill/Silicon Pulp Animation Gallery, 2001.

7577. Hill, Michael. "Outside Influence/ Local Color: The Australian Small Press." *International Journal of Comic Art.* Spring 2000, pp. 117-132.

7578. Hill, Michael. "Postmodern Dark Romantiks: Chthonik Gothik Comiks of the Emerald City." *Angst & Ankhs.* Winter 1999, Unpaginated.

7579. Hill, Michael, ed. *Savage Pencils.* Exhibition Catalogue, Silicon Pulp Animation Gallery, Sydney, February 2-April 1, 2000. Sydney: Grabber Hill/Silicon Pulp Animation Gallery, 2001. 60 pp.

7580. Hill, Michael. "Sick Puppies with Pencils." In *Savage Pencils.* Exhibition Catalogue, Silicon Pulp Animation Gallery, Sydney, February 2-April 1, 2001, pp. 15-19. Sydney: Grabber Hill/Silicon Pulp Animation Gallery, 2001.

7581. Kidd, Courtney. "Beyond the X Factor." *Sydney Morning Herald.* March 26, 2001.

7582. Pinder, Phil, compiler. *Down Underground Comix.* Ringwood, Australia: Penguin Books Australia, 1983. 144 pp.

Comic Strips

7583. "Cartoonist Goes for Record." *Inkspot.* Autumn 1996, p. 9.

7584. Clements, John. "Bluey, Les Dixon and Curley." *Inkspot.* Spring 1995, pp. 16-19.

7585. Emmerson, Rod. "Swamp by Gary Clark." *Inkspot.* Summer 1994, pp. 18-21.

7586. Foster, John. "Truth, Justice and the Australian Way." *Westerly: A Quarterly Review.* Summer 1992, pp. 55-66.

7587. Hilton, Craig. *Downunderground.* Collie: Craig Hilton and Collie Mail Printing, 1996.

7588. King, Terry. "Social and Historical Aspects of the Australian Comic Strip." B.A. (Honors) thesis, History, Monash University, Melbourne, 1973.

7589. "Movement at the Station." *Inkspot.* Summer 1994, p. 10.

7590. Ryan, John. "Star Hawks." *Strips* (Auckland). No. 6, 1977, pp. 10-13.

7591. Stivins, D. "The Social Significance of Comic Strips." *Meanjin.* 6:2 (1947), pp. 90+.

7592. Trengrove, Alan. "The Granddaddy of Them All." *Sydney Sun.* April 27, 1967.

"Ginger Meggs"

7593. Bancks, J.C. *The Golden Years of Ginger Meggs, 1921-1952.* Medindie: Souvenir Press/Brolga Books, 1978.

7594. Horgan, John, ed. *The Golden Years of Ginger Meggs 1921-1952.* South Australia: Souvenir Press/Brolga Books, 1978.

7595. Kemsley, James. *Some Days You're a Legend ...Some Days You Ain't: A Ginger Meggs Collection.* Mosman, Australia: Allen and Kemsley, 1995. 96 pp.

7596. Norris, Don. "Ginger Meggs: Cartoonist James Kemsley Is The Talent Behind 'Ginger Meggs,' Australia's Most Popular Comic Strip." Adobe.com: http://www.adobe.com/print/gallery/kemsley/main.html.

7597. Seeger, Colin. "Cartoon Characters." *Inkspot.* Spring 1997, p. 44.

"The Potts"

7598. Dunstan, Keith. "Pottering Around for 50 Years." *Sydney Sun.* October 31, 1970.

7599. Loos, Rachel. "A Golden Year for Potts Cartoonist." *Sydney Sun-Herald.* March 12, 1989.

7600. "Potty Strip Hits 75." *Inkspot*. Spring 1995, p. 6.

Political Cartoons

7601. Foyle, Lindsay. "Cartooning's Proud Tradition of Sexism." *The Western Australian*. June 12-13, 1999.

7602. "House Down but Not Out." *Inkspot*. Spring 1997, p. 15.

7603. Macklin, Jenny. "Are Political Cartoonists Sexist? The Evidence Is the Naked Truth." *The Australian*. June 9, 1999, p. 13.

7604. Mahood, Marguerite. "The Australian Political Cartoon in Victoria and New South Wales: 1855-1901." Dissertation, University of Melbourne, 1965.

7605. Mahood, Marguerite. *The Loaded Line: Australian Political Caricature 1788-1901*. Melbourne: Melbourne University Press, 1973.

MALDIVES
General Sources

7606. "Prince of Egypt Banned." *ASIFA San Francisco*. February 1999, p. 4.

NEW ZEALAND
Animation

7607. Palmer, Roger. "The National Style: A Case Study of 'Footrot Flats.'" Paper presented at Society for Animation Studies, Brisbane, Australia, August 4, 1999.

Lye, Len

7608. Cavalcanti, Alberto. "Presenting Len Lye." *Sight and Sound*. Winter 1947/48, pp. 134-136.

7609. Curnow, Wynstan and Roger Horrocks. *Figures of Motion: Len Lye Selected Writings*. Auckland: Len Lye Foundation, 1984.

7610. Ulver, Stanislav. "Len Lye: 30 Years after Particles in Space." *ASIFA News*. 9:2 (1996), pp. 8-9.

7611. Vrielynck, Robert. "Len Lye 1901-1980." *Plateau*. Summer 1981, p. 15.

7612. Watson, Paul. "True Lye's: (Re)animating Film Studies." *Art and Design.* No. 53, 1997, pp. 46-49.

Cartooning, Cartoons

7613. Curnow, Wystan. "Speech Balloons and Conversation Bubbles." *And 4.* October 1985, p. 141.

7614. "Expedition South." *Funtime Comics Presents* (Christchurch). June 1995, Unpaginated. (Comics workshop).

7615. Harris, Lee. "Cartoonists Gather for Workshop." *Otago Daily Times.* April 3, 1995.

7616. Rees, Peter. "The New Amorality – A Fashion To Pan?" *Injury to the Eye* (Christchurch). April-May 1991, pp. 2-5. (Censorship).

Anthologies

7617. Brockie, Bob. *Brockie's Bones of Contention.* Wellington: Fourth Estate Group, n.d. Unpaginated. (Political),

7618. Bromhead, Peter. *The Best of Bromhead Cartoons 1975-78.* Auckland: Island, 1978. Unpaginated. (Political).

7619. Evans, Malcolm. *Edna.* Vol. 3. Auckland: MOA-MERC Press, 1983. Unpaginated.

7620. Hodgson, Trace. *Dismembered! 1984 to 1988.* Wellington: Listener, 1988. Unpaginated.

7621. *Ian Wishart's Vintage Winebox Guide.* Auckland: Howling at the Moon, 1996. 96 pp. (Political).

7622. Paterson, A.S. *Knight After Knight.* Auckland: Hodder and Stoughton, 1970. Unpaginated.

7623. Linton, Barry. *Chok! Chok!* Auckland: Barry Linton, 1994.

7624. Scott, Tom. *The Daily News. 1993 Cartoon Annual.* Lower Hutt: Inprint New Zealand, 1993. 88 pp.

7625. Scott, Tom. *Overseizure. The Saga of a New Zealand Family Abroad.* Christchurch: Whitcoulls, 1978. 48 pp.

7626. Slane, Chris. *"Let Me Through, I Have a Morbid Curiosity": Cartoons by Chris Slane.* Auckland: Chris Slane, 1998.

7627. Slane, Chris and Robert Sullivan. *Maui. Legend of the Outcast. A Graphic Novel.* Auckland: Godwit, 1996.

7628. Stewart, Niki and Stephen Higginson, eds. *The NZ Cartoon Manual.* Dunedin: Pilgrims South Press, 1983. 96 pp. (Political).

7629. *Strip Club. A Compilation of New Zealand Women's Cartoons and Comic Strips.* No. 1, September 1993. Wellington: Women's Cartoon Collective, 1993. 34 pp.

7630. Tremain, Garrick. *Best of '95. Garrick Tremain Cartoons.* Dunedin: Garrick Tremain, 1996 (?).

Cartoonists and Their Works

7631. Astor, David. [England Dwelling/New Zealand Native Kim Casali Has Died] Was the Creator of 'Love Is....'" *Editor & Publisher.* June 28, 1997, p. 50.

7632. Bollinger, Tim. *Tim Bollinger's Over-Developed Sense of Injustice.* Wanganui, New Zealand: Tim Bollinger, 2000.

7633. "Chris Knox." *Injury to the Eye.* April/May 1991, pp. 6-10.

7634. *David Low. Kiwi Cartoonist on Hitler's Blacklist, A New Zealand Cartoon Archive Trust Exhibition, 1995-1998.* Wellington: National Library of New Zealand, 1995(?). 20 pp. (Includes Susan Foster, "David Low—Kiwi Cartoonist on Hitler's Blacklist"; Colin Seymour-Ure, "David Low: The Roots of a Reputation"; John Roberts, "David Low: The Influence of the New Zealand Years"; "Sir David Low (1891-1963)"; "Catalogue").

7635. Gerritson, Craig. "A Brief Interview with Dylan Horrocks." *Funtime Comics Presents.* July 1997, unpaginated.

7636. *Gruesome! The Influence of Comics on Contemporary New Zealand Artists.* Christchurch: McDougall Contemporary Art Annex, 1999. 37 pp. (Warren Feeney, "Born under a Bad Sign," pp. 1-20; Tim Bollinger, "Why Art Is '@*#!' and Comics Are So Fantastic," pp. 21-27; Renee Jones, "Art Is Easy, Comics Are Hard," pp. 28-32).

7637. Haag, Greg. "Murray Ball." *Strips* (Auckland). No. 17, 1981, pp. 18-19.

7638. Herrick, Linda. "Comic Artists Serious About Funny Business." *Sunday Star Times.* January 14, 1996.

7639. "Interview with Al Nisbet, Editorial Cartoonist for 'the Press.'" *The Cartoonist.* July 1999, pp. 4-5.

7640. Jewell, Stephen. "Married to the Mob." *Injury to the Eye*. April-May 1991, pp. 11-12.

7641. Jones, Renee. "Art Is Easy; Comics Are Hard: Auckland Comic Book Artist Renee Jones Interviews Artists Violet Faigan and Saskia Leek." *Gruesome!* April-May 1999, pp. 28-33.

7642. "Kr2a." *Striprofiel*. March 1981, pp. 48-49. (Joe Wylie).

Minhinnick, Gordon

7643. Minhinnick, Gordon. *It's That Min Again! 1968-69*. Auckland: Wilson and Horton, 1969. 56 pp.

7644. Minhinnick, Gordon. *Min's Sauce. Cartoons from The N.Z. Herald.* Auckland: Wilson and Horton, 1976. 56 pp.

Wilson, Colin

7645. Drewes, Jac. "Colin Wilson, Een Gevangen Tekenaar." *Stripschrift*. Nos. 159/160, 1982, pp. 14-16.

7646. van Eijck, Rob and Mat Schifferstein. "Colin Wilson: Science-Fiction en Western." *Stripschrift*. No. 188, 1984, pp. 18-24.

Comic Books

7647. Bollinger, Tim. "Why Art is '@*#!' and Comics Are So Fantastic." *Gruesome!* April-May 1999, pp. 21-27.

7648. Clark, Russell. "Scomix." *The Listener*. November 12, 1954, pp. 10-11.

7649. *A Collection of Comics of AIT Students Past and Present*. No. 1 (July-August 1995). *Mainstream*. Auckland: Tuatara Press, 1995.

7650. *Contemporary New Zealand Comics*. Catalogue, exhibition. Fisher Gallery, 12 January- 11 February 1996. Aotearoa: Fisher Gallery, 1996. 54 pp. (Includes Dylan Horrocks, "Tuhituhi Noa: Mapping a Path Through New Zealand Comix"; profiles of 42 cartoonists).

7651. Dalziel, Margaret. "New Zealand." *Landfall*. March 1955, p. 43.

7652. Elley, Warwick B. and Cyril W. Tolley. "Children's Reading Interests: A Wellington Survey." Wellington, New Zealand: International Reading Association, 1972.

7653. Feeney, Warren. "Born Under a Bad Sign." *Gruesome!* (Christchurch). April-May 1999, pp. 1-20.

7654. Feeney, Warren. *Gruesome: The Influence of Comics on Contemporary New Zealand Artists.* Exhibition Catalogue. Christchurch: Robert McDougall Art Gallery and Annex, 1999.

7655. Hewiston, Michael. "Wham, Bam, Striking a Blow for Art." *The New Zealand Herald.* September 7, 1995, 4:1.

7656. Horrocks, Dylan. "On New Zealand Comics." Lecture presented at International Comics and Animation Festival, Bethesda, Maryland, September 26, 1998.

7657. Horrocks, Dylan, ed. *Nga Pakiwaituhi o Aotearoa: New Zealand Comics.* Auckland: Hicksville Press, 1998. Unpaginated.

7658. Kreiner, Rich. "*Hicksville,* by Dylan Horrocks." *Comics Journal.* April 1999, pp. 13-16.

7659. Kreiner, Rich. "Comics 'Way Down Under: Dylan Horrocks on New Zealand Cartooning." *Comics Journal.* November 1998, pp. 39-40.

7660. Lee-Smith, David. "Comics in New Zealand Libraries." *New Zealand Libraries.* September 1994, pp. 213-214.

7661. Lee-Smith, David. "Kiwis and Comics: A Glimpse." *Australian and New Zealand Journal of Serials Librarianship.* 4:3 (1994), pp. 105-109.

7662. Schroeder, Darren. "Land in Zicht -- Nieuw-Zeeland." *Stripschrift.* September 2000, p. 9.

7663. Watson, Chris and Roy Shuker. *In the Public Good? Censorship in New Zealand.* New Zealand: Dunmore Press, 199? (Chapter on comic books).

7664. Wilson, Colin. "The Birth of an Eco-Superhero." *Strips* (Auckland). No. 12, 1979, pp. 24-27.

7665. Yska Redmer. *All Shook Up. The Flash Bodgie and the Rise of the New Zealand Teenager in the Fifties.* Auckland: Penguin, 1993. 224 pp. (Chapter 4, "Beneath the Covers," pp. 87-106).

Alternative

7666. Boyask, Ruth. "Reading Community in *Funtime Comics:* A New Zealand Narrative." *International Journal of Comic Art.* Fall 2000, pp. 152-163.

7667. Gerritson, Craig. " 'Survey of Contemporary NZ Comix.'" *Funtime Comics Presents.* July 1996, unpaginated.

7668. Little, Jim. "Underground Comics in N.Z." *Strips* (Auckland). No. 9, 1978, pp. 22-23.

7669. Mark One, Christchurch. *The New Zealand Comics Register.* Christchurch: n.d.

7670. "The New Comic Register." *Funtime Comics Presents* (Christchurch). June 1995, unpaginated.

7671. "The New Zealand Comic Register." *Funtime Comics Presents.* July 1997, unpaginated.

7672. "The New Zealand Comic Register." *Funtime Comics Presents.* May 1998, unpaginated.

7673. "The New Zealand Comic Register." *Funtime Comics Presents.* January 1999, unpaginated.

7674. "The New Zealand Comics Register." *Funtime Comics Presents.* July 1996, unpaginated.

7675. Schroeder, Darren. "ICONZII July 1995." *Funtime Comics Presents.* July 1996, unpaginated.

7676. Stefan. "Spotlight on: Oats Comics." *The Cartoonist* (Christchurch). July 1999, p. 1.

"Pickle"

7677. Beaty, Bart. "Pickle, Poot and the *Cerebus* Effect." *Comics Journal.* September 1998, pp. 1-2.

7678. Groth, Gary. "A Publisher's Partisan Response." *Comics Journal.* September 1998, pp. 3-4.

Comic Strips

7679. Ball, Murray. *Footrot Flats 19.* Lower Hutt: Imprint, 1993. 80 pp.

7680. Ball, Murray. *Footrot Flats 23.* St. Kilda West, Australia: Orin Books, 1996. 80 pp. (Footrot Flats Series includes 22 other *Footrot Flats; They've Put Custard with My Bone!; The Cry of the Grey Ghost; I'm Warning You, Horse; It's a Dog's Life; Let Slip the Dogs of War!; The Footrot Flats "Weekender," 1-6; Footrot Flats Collector's Edition 1-3; The Footrot Flats "Weekender"*).

7681. "Footrot Flats." *Stripschrift.* July 1999, p. 29.

5

CENTRAL AND SOUTH AMERICA

REGIONAL AND INTER-COUNTRY PERSPECTIVES

Resources

7682. "Humoris Causa." *Humoris Causa.* March 1999, pp. 2-3.

7683. Orovio, Helio. "Editorial ¿ Por Qué *Humoris Causa*?" *Humoris Causa.* March 1999, p. 1.

Periodical Directory

7684. *Che-Loco.* Published as fanzine at Julián de Cortazar 1436, Bº Alem, Cordoba, Argentina. Mainly about Argentine comics. No. 7, April 1999.

7685. *La Piztola.* Organo de Penetración Humorística. Published monthly by Sociedad Mexicana de Caricaturistas, Sociedad de Gestión Colectiva de Interés Público (Donceles 99, Col. Centro, CP 06020 Mexico, D.F.). Articles of historical and contemporary aspects of primarily Mexican cartooning, as well as columns, cartoon galleries, news notes reviews. No. 100, February 2001. 34 pages.

7686. *Mi Barrio.* Publication of irregular frequency, featuring Cuban cartoons and strips, with occasional articles on Cuban and other countries' comics scene. Director, Francisco Blanco, Coordinación Nacional de los CDR, Calle Linea #157, e/L y K, Plaza, Havana, Cuba. No. 0, September 1996.

7687. *Quadreca.* Periodical published by students of University of São Paulo, with cartoons and articles about Brazilian cartoons. Since late 1970s.

7688. *Revista de Cultura* (Rio de Janeiro). March 1972. Articles about quadrinhos and superheroes.

Animation

7689. Barnard, Timothy and Peter Rist. *South American Cinema: A Critical Filmography, 1915-1994.* New York: Garland, 1996. (Animated films, pp. 5-6, 296).

7690. Bolton, Dan. "Latin America: Television Expansion Drives Animation Industry." *Animation.* November 1997, pp. 17-19.

7691. Burton, Julianne. "Don (Juanito) Duck and the Imperial-Patriarchal Unconscious: Disney Studios, the Good Neighbor Policy, and the Packaging of Latin America." In *Nationalisms and Sexualities,* edited by Andrew Parker, Mary Russo, Doris Sommer, and Patricia Yaeger, pp. 21-41. New York: Routledge, 1992.

7692. Gelman, Morrie. "Reaching South of the Border: NATPE Gets That Latin Flavor." *Animation.* February 1999, pp. 7-9.

7693. Harrison, Suzanne. "Nick Latino Plays Catchup with Cartoon Network." *Variety.* June 8-14, 1998, p. M17.

7694. Joosen, Leon and José Carlos Cuentas-Zavala. " *Maximo.* " In *Drawing Insight,* edited by Joyce Greene and Deborah Reber, pp. 108-110. Penang: Southbound, 1996.

7695. Kaufman, J.B. "Norm Ferguson and the Latin American Films of Walt Disney." In *A Reader in Animation Studies,* pp. 261-268. London: John Libbey and Co., 1997.

7696. "Latin American Animation Companies." *Animation.* November 1997, pp. 18, 24.

7697. "LocoMotion." *Animation.* March 1998, p. 69.

7698. Paxman, Andrew. "Cartoon Licensing Trail Leads to Latin America." *Variety.* June 24-30, 1996, p. 86.

7699. Paxman, Andrew. "Latins Gobble Up Animated Product." *Variety.* June 24-30, 1996, pp. 104, 110.

7700. Sutter, Mary. "Weak Signal." *Variety.* March 26-April 1, 2001, pp. 123, 136. (Cartoon Network in Argentina, Mexico).

7701. "Turner's Toons Top Ratings." *Daily Variety.* December 22, 1988, p. 7.

7702. "24-Hour, All-Animation Network Launched for Latin America and the Caribbean." *Society for Animation Studies Newsletter*. Summer 1996, p. 8.

Cartooning, Cartoons

7703. Caceres, German. "Latin America." *WittyWorld International Cartoon Bulletin*. Spring 1997, pp. 8-9.

7704. *El Tercer Milenio*. Madrid: Fundación General de la Universidad de Alcalá, 1999. 94 pp.

7705. "Entrevistas: Garci (México), Mingote (España), Calarcá (Colombia), Lailson (Brasil), Ermengol (Argentina), Peridis and Máximo (España), Banegas (Honduras), Apebas (México)." *Quevedos*. March 2001, pp. 10-14.

7706. "Fin de Milenio Año 2000." *Humoris Causa*. March 1999, pp. 22-23.

7707. *La Picaresca desde Quevedo hasta Nuestros Días*. Prologue by Manuel Vasquez Montalban. Madrid: Ministerio de Educación y Cultura, Dirección General del Libro, Archivos y Bibliotecas, 1997. 131 pp.

7708. Lent, John A. "Latin America: An Historical and Contemporary Overview." *International Journal of Comic Art*. Fall 2001, pp. 1-22.

7709. "Rolando." *Humour and Caricature*. April/May 1996, pp. 10-11.

7710. Sullivan, Edward, ed. *Latin American Art in the Twentieth Century*. London: Phaidon, 1996. 352 pp. (Includes Diego Rivera, Frida Kahlo).

7711. "Vazquez de Sola." *Humoris Causa*. March 1999, pp. 18-19.

Comics

7712. Cavalcanti, Ionaldo. *O Mundo dos Quadrinhos*. São Paulo: Editora Símbolo, 1977. (Europe, U.S., Latin America).

7713. Conde Martin, Luis. "Panoramica de la Historieta Sudamericana (1)." *Circulo Andaluz de Tebeos*. No. 13, 1992, pp. 27-30.

7714. "Editorial: Reconocimiento a la Caricatura Iberoamericana." *La Piztola*. January 2001, p. 1.

7715. Faur, Jean-Claude. *À la Rencontre de la Bande Dessinée*. Marseilles: Bédésup, 1983. (Includes, "Idéologie: La BD Latino-Américaine à Cuba," pp. 129-133).

7716. Lefèvre, Pascal. "Als er Maar Geen Revolutie Wordt Uitgebroed! Latijns-Amerika in het Beeldverhaal" (Latin America as Depicted in Comics). *America Ventana.* June 1996.

7717. McCarty, Denise and Michael Schreiber. "Guyana Reproduces Comic Book in Booklet." *Linn's Stamp News.* November 16, 1998.

7718. Pérez, Janet and Genaro J. Pérez, eds *Hispanic Marginal Literatures: The Erotics, the Comics, Novela Rosa.* Odessa, Texas: University of Texas, Permian Basin, 1991.

7719. Pertocoli, Domenico, ed. *Historietas: Storia, Personaggi e Percorsi del Fumetto Latinoamericano.* Milan: Edizioni Mazzotta, 1997.

7720. Tatum, Chuck. "From Sandino to Mafaldo: Recent Works on Latin America Popular Culture." *Latin American Research Review.* 29:1 (1994), pp. 198-214.

7721. Williams, Jeff. "Homosexuality and Political Activism in Latin American Culture: An Arena for Popular Culture and Comix." *Other Voices.* September 1998, 7 pp.

7722. Willis, Meredith S. "Spin-Offs: The Fotonovela and the Marriage of Narrative and Art." *Teachers and Writers Collaborative.* 8:1 (1976) pp. 43-51.

ARGENTINA
Cartooning, Cartoons

7723. "Greetings from Argentina." *FECO News.* No. 30, 2000, p. 23.

7724. Gutierrez Vinuales, Rodrigo. "Presencia de Espana en la Argentina: Dibujo, Caricatura y Humorismo (1870-1930)." *Cuadernos de Arte de la Universidad de Granada.* 28 (1997), p. 113.

7725. "Humor Net Made in Cordoba." *Che-Loco.* April 1999, p. 12.

7726. "La A.H.I. Cordoba." *Che' Loco Fanzine.* November 1999, p. 10.

Cartoonists and Their Works

7727. Accorsi, Andrés. "Carlos Meglia." *Comiqueando.* October 1994.

7728. Accorsi, Andrés. "Eduardo Risso." *Comiqueando.* July 1996.

7729. "Astrovista: Francisco Solano López." *Brújula.* May 1999.

7730. "Astrovista: Juan Zanotto." *Brújula.* October 1999.

7731. Betanzos, Miguel. "Crítica Sobre Humor: Sergio Langer (Buenos Aires) 1959." *Humoris Causa.* March 1999, pp. 9-10.

7732. "A Brush with Greatness: An Interview and Demonstration with the Argentine Master of the Brush Ricardo Villagran." *Draw!* Spring 2001, pp. 31-44.

7733. Cáceres, Germán. "Escape en Tren (entrevista a Leopoldo Durañona)." *Charlando con Superman.* Buenos Aires: Fraterna, 1988.

7734. Cepeda, Laura. "Oski (Oscar Conti)." *Bang!* No. 12, 1974, p. 56.

7735. Herman, Leon. *99 Silencios.* Buenos Aires: Ed. Pensir y Pensar, 1967.

7736. "Humberto Pollo." *Comiqueando.* March 1996, pp. 42-46.

7737. Leenders, Mike. "De Midlife-Crisis van Oscar Zarate en Alan Moore." *ZozoLala.* April/May 1992, pp. 3-6.

7738. Legaristi, Francisco. "Entrevista Félix Bravo: 'La Aventura de Vivir de Sueños.'" *Trix.* November 1993, pp. 20-22.

7739. Lucio, Oscar V. "Liotto: Fue un Dibujante con Altura, Pero de Perfil Bajo." *Che-Loco.* August 2000, p. 3. (José Liotto).

7740. "Mazzone, Verdadero Ejemplo de Constancia y Dedicación." *Dibujantes.* January/February 1954. (Adolfo Mazzone).

7741. "Megaman." *Comiqueando.* March 1996, pp. 23-27. (Fernando Calvi).

7742. Piglia, Ricardo. "Osvaldo Lamborghini, Guionista de Historietas." *Fierro.* January 1986.

7743. "Sendra." *Comiqueando.* August 1994. (Fernando Sendra).

7744. "Tejada, Humorista ... Dibujante ... Buen Tipo." *Che' Loco Fanzine.* November 1999, p. 4. (Juan Fernando Tejada).

7745. "10 Preguntas a Tulio Lovato." *Dibujantes.* October 1957.

7746. "Trío de Ases: Manara, Giménez y Bilal." *DA.* February 7, 1999, p. 37.

7747. "Un Argentino del Gremio." *Mi Barrio.* January/March 2001, p. 29. (Horacio Altuna).

7748. "Villarruex." *Che-Loco.* April 1999, p. 5.

Breccia, Alberto

7749. "Alberto Brecchia Overleden." *Sherpa Courant* (Amsterdam). December 1993, p. 1.

7750. "Alberto Breccia Overleden." *Stripschrift.* December 1993, p. 22.

7751. Arbesú, Faustino R. "Alberto Breccia: Nunca He Leído Comics, Sólo Me Gusto Dibujarlos." *La Nueva España.* November 17, 1987.

7752. Berniere, Vincent. "Pratt/Breccia: La Connexion Argentine." *Beaux Arts Magazine.* October 1999, p. 82.

7753. "Breccia." *Le Collectionneur de Bandes Dessinées.* September 1994, p. 30.

7754. "Breccia. Bibliographie Française." *Le Collectionneur de Bandes Dessinées.* September 1994, p. 34.

7755. Groensteen, Thierry. "Propos d' Alberto Breccia." *Le Collectionneur de Bandes Dessinées.* September 15, 1994, pp. 31-33.

7756. "In Memoriam Alberto Breccia." *ZozoLala.* February/March 1997, p. 18.

7757. Jans, Michel. "Alberto Breccia." *Stripschrift.* September 1991, pp. 10-14.

7758. Lameiras, Joao M. "Alberto Breccia: A Obra ao Negro" (Alberto Breccia: A Work in Black). *Nemo* Fanzine. March 1994.

7759. Lefèvre, Pascal. "Alberto Breccia en de Wonden van Een Dictatuur." *ZozoLala.* August/September 1992, p. 7.

7760. Roach, David A. "The Genius of Alberto Breccia: The Life and Work of the Ever-Changing Argentinian Cartoonist." *Comic Book Artist.* May 2000, pp. 108-111.

7761. Rosalés, L. "Breccia." *HOP!* 3rd Trim., 1993, p. 60.

7762. Sasturain, Juan. "Breccia, el Maestro (2.ª Parte)." *H2.* Spring/Summer 1989, pp. 20-21.

7763. Ureña, F.M. "Breccia o el Profesional." *Bang!* No. 11, 1974, pp. 55-56.

Bróccoli, Alberto

7764. "Bróccoli: de lo Cotidiano al Humor." *Esquiú.* November 12, 1978.

7765. Caloi. "Carta Abierta a Bróccoli." In *Cuanto Más Bróccoli, Mejor.* Buenos Aires: Hyspamérica Ediciones, 1988.

Fontanarrosa, Roberto

7766. Brufman, Gustavo and Mariana Hernández. "Roberto Fontanarrosa: El Oficio de Hacer Reír." *Chasqui.* 44 (1993), pp. 70-75.

7767. "MaesTrazos." *Dedeté.* No. 9, 2001, p. 6.

Freixas, Carlos

7768. Rosalés, Luis. "Carlos Freixas, Maestro de la Historieta." *Circulo Andaluz de Tebeos.* No. 18, 1996, pp. 4-5.

7769. Rosalés, Luis. "Carlos Freixas, Tebeografía: Cronología Argentina Abreviada." *Circulo Andaluz de Tebeos.* No. 18, 1996, pp. 11-24.

7770. Tadeo Juan, Francisco. "Carlos Freixas, el Recordado." *Circulo Andaluz de Tebeos.* No. 18, 1996, pp. 6-10.

Giménez, Juan

7771. Cepeda, Laura. "Entrevista a Juan Gimenez." *Comix Internacional* (Barcelona). Nos. 46, 47, 1984.

7772. Giménez, Juan. *The Art of Juan Giménez. Overload.* Rockville Centre, New York: Heavy Metal, n.d. (ca. 1999). Unpaginated.

Mordillo, Guillermo

7773. "Guillermo Mordillo." *Karikatür.* No. 35, 1996, pp. 14-15.

7774. Mordillo, Guillermo. *The Collected Cartoons of Mordillo.* New York: Crown, 1971.

7775. Mordillo, Guillermo. *Mordillo.* Istanbul: Meta Yayinlari, Ünlü Karikatüristler Dizisi 1, 1976.

Muñoz, José

7776. Accorsi, Andrés and Diego. "Reportajes: José Muñoz." *Comiqueando.* December 1994.

7777. Keller, Hans. "Muñoz en Sampayo: Spelen Met Duister en Licht." *ZozoLala.* October/November 1990, pp. 3-7. (And Carlos Sampayo).

7778. Lameiras, Joao M. "Alack Sinner: Um Homem na Cidade." *Quadrado.* October 1996.

7779. Pols, Hans. "Alack Sinner: Een Pessimistische Optimist." *Stripschrift.* November 1990, pp. 14-17.

7780. Sampayo, Carlos. "Alack Sinner – Dos o Tres Cosas Que Yo Se de El." *Totem-Calibre* (Madrid). No. 8, 1983.

Oesterheld, Héctor G.

7781. Caceres, German. *Oesterheld.* Buenos Aires: Ediciones del Dock, 1992. 68 pp.

7782. de Blas, Juan A. "Hector G. Oesterheld." *Historia de los Comics.* No. 25, n.d., p. 701.

7783. Merino, Ana. "Oesterheld the Literary Voice of Argentine Comics." *International Journal of Comic Art.* Fall 2001, pp. 56-69.

7784. "Todo Oesterheld." *Trix.* November 1993, p. 96.

7785. Trillo, Carlos. "Hector G. Oesterheld, Un Escritor de Aventuras." *Historia de los Comics.* No. 23, n.d., pp. 637-644.

Palacio, Lino

7786. Pauls, Alan. *Lino Palacio. La Infancia de la Risa.* Buenos Aires: Espasa, 1995.

7787. Vazquez Lucio, Oscar. "Lino Palacio." *Che-Loco.* April 1999, pp. 2-3.

Quino

7788. de Sousa, Osvaldo. "Quino em Portugal." *Semanário.* November 24, 1984.

7789. Evora. "Quino." *Palante.* No. 5, p. 37.

7790. Flores, José Ma. "Entrevista con un Maestro del Humor, Quino." *El Wendigo.* No. 85, 2000/2001, pp. 10-14.

7791. Fregoso, Beatriz Isela. "Quino Premio Quevedos 2000." *La Piztola.* January 2001, p. 3.

7792. Moreno Santabárbara, Federico. "Quino." *Historia de los Comics.* No. 8, n.d., p. 223.

7793. "'Padre' de Mafalda Gana Premio Quevedo." *El Tiempo Latino* (Washington, D.C.). December 22, 2000, p. A16.

7794. Quino. *Exposición Personal.* Havana: Instituto Cubano del Libro, 2000. 6 pp.

7795. "Quino." *Kayhan Caricature.* June/July 2000, 5 pp.

7796. "Quino, Catedrático del Humor." *Quevedos.* March 2001, p. 7.

7797. "Quino, Nuevo Premio Quevedos 2000." *Quevedos.* March 2001, p. 6.

Salinas, José Luis

7798. Sasturain, Juan. "José Luis Salinas: Un Argentino en la Corte del King Features." *Superhumor.* November/December 1980.

7799. Vázquez de Parga, Salvador. "Jose Luis Salinas." *Historia de los Comics.* No. 28, n.d., p. 785.

Sampayo, Carlos

7800. "Astrovista: Carlos Sampayo." *Brújula.* May 2000.

7801. Cordero, Moncho. "Carlos Sampayo." *Historia de los Comics.* No. 2, n.d., p. 57.

Animation

7802. Barnard, Timothy. "El Apóstol." In *South American Cinema: A Critical Filmography, 1915-1994,* edited by Timothy Barnard and Peter Rist, pp. 5-6. New York: Garland, 1996.

7803. Bendazzi, Giannalberto. "Quirino Cristiani, The Untold Story of Argentina's Pioneer Animator." *Animation World.* July 1996, 7 pp.

7804. Bendazzi, Giannalberto. "Quirino Cristiani, The Untold Story of Argentina's Pioneer Animator." *Plateau.* 16:4 (1995), pp. 8-11.

Comic Books and Strips

7805. Acciarressi, Huberto. "El Creador Que Perdura en la Memoria Colectiva." *La Prensa.* July 25, 1999.

7806. Accorsi, Andrés. "La Crisis de la Historieta Argentina." *Comiqueando.* December 1995.

7807. Ascari, Giancarlo. "Buenos Aires, Capital of the Comic Strip." *Abitare.* July/August 1995, pp. 39-40.

7808. "Argentina." In *La Historieta Mundial,* edited by David Lipszyc, *et al.,* pp. 5-34. Buenos Aires: Instituida por la Escuela Panamericana de Arte, n.d.

7809. Barreiro, Roberto. "Locos por el Cómic." *Nueva.* November 14, 1999, pp. 52-53.

7810. "Blanco y Negro Sergio Langer (Argentina)." *Justo Medio.* July 2000, p. 23.

7811. Brest, Jorge Romero. "Las Artes Visuales y las Historietas." *Artes Visuales.* June/August 1979, pp. 23-24.

7812. Bunge, Mario. "Perfil del Chanta." *La Nación.* September 13, 1999.

7813. Cáceres, Germán. *Así se Lee la Historieta.* Buenos Aires: Beas Ediciones, 1994.

7814. Cáceres, Germán. *El Dibujo de Aventuras.* Buenos Aires: Editorial Almagesto, 1996. 197 pp. (Also Belgium, Cuba, France, Spain, and U.S.).

7815. Della Costa, Pablo. "La Edad Dorada de la Historieta." *El Arca.* May 2000.

7816. De Santis, Pablo. "Dibujantes Con Una Misión Secreta." *Cultura y Nación, Clarín.* December 30, 1993.

7817. De Santis, Pablo. *La Historieta en la Edad de la Razón.* Buenos Aires: Paidós, 1998,

7818. "Eterno Eternauta." *Trix.* November 1993, p. 97.

7819. Fernández L'Hoeste, Hector D. "From Mafalda to Boogie: The City and Argentine Humor." In *Imagination Beyond Nation: Latin American Popular Culture,* edited by Eva P. Bueno and Terry Caesar, pp. 81-106. Pittsburgh: University of Pittsburgh Press, 1998.

7820. Fossati, Franco. *Il Fumetto Argentino.* Genoa: Pirella Editore, 1980.

7821. García Canclini, Néstor. *Culturas Híbridas. Estrategias para Entrar y Salir de la Modernidad.* Buenos Aires: Sudamericana, 1995.

7822. García, Fernando and Hernán Ostuni. "Los Rescatadores." *Comiqueando.* September 1997.

7823. Gociol, Judith. "El Comicsario." *Viva.* July 30, 2000.

7824. Gociol, Judith. "Es Posible Que Algún Día No Tenga Nada Que Contar." *La Maga.* December 13, 1995.

7825. Gociol, Judith. "Pasó por Buenos Aires un Campeón de la Historieta." *Clarín.* November 4, 1999.

7826. Gociol, Judith and Diego Rosemberg. "Las Historietas Que Hicieron Historia." *Todo Es Historia.* June 1991.

7827. "Gustavo Sala Contraataca." *Comiqueando.* March 1996, pp. 35-36.

7828. Gutiérrez, José María. *La Historieta Argentina. De la Caricatura Política a las Primeras Series.* Buenos Aires: Ediciones Biblioteca Nacional y Página/12, 1999.

7829. Gutiérrez, José María. "Land in Zicht – Argentinë." *Stripschrift.* December 2000, p. 15.

7830. "Historieta Bajo Tierra." *Che' Loco Fanzine.* November 1999, p. 12.

7831. "Humor a Primera Vista, Nuevo Libro de Humor en Argentina." *Quevedos.* March 2001, p. 23.

7832. "Imperdible ...!!" *Trix.* November 1993, p. 96.

7833. "La Caceria del Lobo." *Che' Loco Fanzine.* November 1999, p. 10.

7834. *La Coupe Déborde, Vidéla!* Paris: Comité pour le Boycott de l'Organisation par l'Argentine de la Coupe du Monde de Football, 1978.

7835. "Las Dos Muertes de Jeremias." *Che-Loco.* August 2000, p. 10.

7836. Lipszyc, David. "Argentina, Comics Hasta los Años 40. Patoruzú, un Superhéroe de las Pampas." *Historia de los Comics.* No. 15, n.d., pp. 393-398.

7837. Palacio, Jorge (Faruk). *El Humor en el Tango.* Buenos Aires: Corregidor, 1996.

7838. "Para los Chicos el Papá de Chifuleta." *7 Días.* January 9, 1980.

7839. Perez, Genaro J. "A Note on Julio Cortazar's Fantomas contra los Vampiros Multinacionales" [Comic strip and Argentinian literature]. *Monographic Review.* 7 (1991), pp. 382-385.

7840. Polosecki, Fabián. "Humor de Multitudes." *Hora Cero* (Buenos Aires). No. 2.

7841. "Reportaje a Miguel Rep. Charlamos a Fondo con el Creador de Joven Argentino, Gaspar y el Caramonchón." *Comiqueando.* March 1996, pp. 18-22.

7842. Rivera, Jorge. "La Leyenda en el Mundo de la Historieta." *Cultura y Nación, Clarín.* July 1981.

7843. Saccomanno, Guillermo. "Los Comics Argentinos Buscan su Identidad." *Historia de los Comics.* No. 23, n.d., pp. 617-622.

7844. Saccomanno, Guillermo and Carlos Trillo. *Historia de Historieta Argentina.* Buenos Aires: Record, 1980.

7845. Santa Cruz, Abel. "Ferro llevó a Sus Dibujos Más Allá del Papel." *Dibujantes.* June 1954.

7846. Sasturain, Juan. *"El Domicilio de la Aventura.* Buenos Aires: Colihue, 1995.

7847. Sasturain, Juan. "Ferro, Dibujate Algo." *Superhumor.* September/October 1980.

7848. Sasturain, Juan. "Treinta Años de Milico y Ningún Ascenso." *Superhumor.* July 1981.

7849. Sasturain, Juan. "Un Clásico de la Historieta Nacional." *Clarín.* December 7, 1989.

7850. "Solano Estuvo en Córdoba." *Che' Loco Fanzine.* November 1999, p. 2.

7851. Tadeo Juan, Francisco. "Fantasia Histérica." *Che' Loco.* November 1999, p. 5.

7852. Vázquez Lucio, Oscar. "Domingo Mirco Repetto." *Che' Loco Fanzine.* November 1999, p. 9.

7853. Williams, Jeff. "Argentine Comics Today: A Foreigner's Perspective." *International Journal of Comic Art.* Fall 2001, pp. 44-55.

Historical Aspects

7854. Accorsi, Andrés. "Argentine Comics." *International Journal of Comic Art.* Fall 2001, pp. 23-43.

7855. García, Fernando and Hernán Ostuni. "La Historia de la Historieta Gauchesca." Catalogue. Museo de Motivos Argentinos José Hernández, 1992.

7856. Gociol, Judith and Diego Rosemberg. *La Historieta Argentina: Una Historia.* Buenos Aires: Ediciones de la Flor S.R.L., 2000. 606 pp.

7857. Scolari, Carlos. *Historietas para Sobrevivientes. Cómic y Cultura de Masas en los Años 80.* Buenos Aires: Colihue , September 1999. 339 pp. (Argentina, pp. 248-339).

7858. *Sexta Bienal. 100 Años de Humor e Historieta Argentinos.* Córdoba: Municipalidad de Córdoba, 1986.

7859. Vázquez Lucio, Oscar (Siulnas). *Aquellos Personajes de Historieta (1912-1959)*. Buenos Aires: Puntosur Editores, 1986.

Characters and Titles

7860. Barreiro, Ricardo and Juan Zanotto. *Bárbara*. Buenos Aires: Record, n.d.

7861. Birmajer, Marcelo. "La Bofia." *Fierro*. March 1987.

7862. Breccia, Patricia. *Sin Novedad en el Frente*. Buenos Aires: Colihue, 1999.

7863. De Santis, Pablo. *El Último Espía*. Buenos Aires: Sudamericana, 1998.

7864. De Santis, Pablo. *Rico Tipo y Las Chicas de Divito*. Buenos Aires: Espasa Calpe, 1994.

7865. Gandolfo, Elvio. "Las Aceitunas." *El Libro de Clemente*. Buenos Aires: Edíciones de la Flor, 1996.

7866. García, Fernando and Hernán Ostuni. *Cazador, Archivos Secretos*. Buenos Aires: Edíciones de la Urraca, 1996.

7867. Ghiano, Juan Carlos. "La Presencia." *La Renguera del Perro*. Buenos Aires: Emecé, 1973.

7868. Gociol, Judith. "Boogie Bajo la Lupa." *Todo Boogie*. Buenos Aires: Ediciones de la Flor, 1999.

7869. Gociol, Judith. "Historia de Felipe." *Clarín*. April 23, 1995.

7870. Gociol, Judith and Miguel Russo. "La Gente No Necesita Citar la Biblia: Tiene al *Martin Fierro*." *La Maga*. May 1, 1998.

7871. Guerriero, Leila. "Lúpin: Un Vuelo Que Ya lleva 34 Años." *La Nación*. October 3, 1999.

7872. Guerrriero, Leila. "Mirco Repetto: El Papá de la Vaca Aurora." *La Nación*. October 3, 1999.

7873. Javierdo, O'Kif and Pancu. *El Peor*. Buenos Aires: Doedytores, 1994.

7874. Marcucci, Carlos. "Cómo Me Convertí en Un Personaje de Historieta." *La Maga*. May 27, 1992.

7875. Monaco, Steve. "Buenos Aires Cop." *Four Color Magazine*. January-February 1987. (*Evaristo*).

7876. Muñoz, José. "Sudores." *Sudor Sudaca*. Barcelona: Ediciones La Cúpula, 1990.

7877. Muñoz, José and Carlos Sampayo. *Sophie*. Barcelona: Ediciones La Cúpula, 1984.

7878. Pancu. *Historias de Familia*. Buenos Aires: Doedytores, 1997.

7879. Pérez Rasetti, Carlos. "Alack Sinner: Crisis y Evolución de la Serie Negra." *Historietas para Sobrevivientes*. Buenos Aires: Colihue, 1999.

7880. Roveta, Mariana. "Isidoro Cañones." *Playboy*. May 1995.

7881. Saccomanno, Guillermo. "A Buscavidas." *Alberto Breccia*. Buenos Aires: Doedytores, 1994.

7882. Saccomanno, Guillermo. "Carlito Luna vs Charlie Moon." *Superhumor*. August 1980.

7883. Sasturain, Juan. "Bull Rockett o la 'Aventura Moderna.'" *Bull Rockett*. Buenos Aires: Colihue, 1995.

7884. Sasturain, Juan. "Evaristo Meneses. Un Policía de Papel y Hueso." *Fierro*. November 1984.

7885. Sasturain, Juan. "Perramus III." *Perramus. La Isla del Guano*. Córdoba: Ediciones B., 1993.

7886. Sebreli, Juan José. *Los Oligarcas*. Buenos Aires: Centro Editor de América Latina, 1971.

7887. Siulnas. *Aquellos Personajes de Historieta (1912-1959)*. Montevideo: Puntosur, 1987.

7888. Slavich, Walter. "Prólogo." In *Nekrodamus*. Buenos Aires: Ediciones Record, 1993.

7889. Steimberg, Oscar. "Dos Producciones Desviantes de Historieta Negra: Marc y Husmeante." *Zona 84* (Barcelona). 1984.

"El Eternauta"

7890. García, Fernando and Hernán Ostuni. "El Eternauta." *Comic Magazine*. November 1989.

7891. García, Fernando and Hernán Ostuni. "Rolo, el Eternauta Adoptivo." *Comiqueando*. September 1999.

"El Loco Chávez"

7892. Altuna, Horacio and Carlos Trillo. *El Loco Chávez. Profésion: Reportero*. Barcelona: Norma Editorial, 1991.

7893. López, Alberto. "Del 'Loco' Chávez al 'Negro' Blanco." *El Periodista.* April 14-20, 1989.

7894. Marchetti, Pablo. "Había Mucha Croqueta Alrededor del Loco Chávez." *La Maga.* November 25, 1992.

7895. Morandini, Norma. "Chau Loco." *Página/12.* November 19, 1987.

7896. Ulanovsky, Carlos. "Fue Hermoso Mientras Duró." *Clarín.* October 21, 1987.

"Hijitus"

7897. Accorsi, Andrés. "Hijitus." *Comiqueando.* August 1994.

7898. Olmedo, Gustavo. "Hijitus, Nacido para ser Argento." *Clarín.* March 24, 1995.

"Inodoro Pereyra"

7899. Mazzocchi, Mirtha. "Inodoro Pereyra y los Chistes de Gauchos." In *Ciudad/Campo en las Artes de la Argentina y Latinoamérica.* Buenos Aires: Colihue, 1991.

7900. Merino, Ana. *"Inodoro Pereyra,* A 'Gaucho' in the Pampa of Paper and Ink: Folklore and Literary Intertextuality and Its Reformations in Argentinean Comics." *International Journal of Comic Art.* Spring 2000, pp. 190-197.

"Mafalda"

7901. Arbesú, Faustino R. "'Mafalda,' Mucho de Muchos." *La Nueva España.* May 31, 1987.

7902. Gottlieb, Liana. *Mafalda Vai à Escola: A Comunicação Dialógica de Buber e Morena na Educação, nas Tiras de Quino.* São Paulo: Iglu/Núcleo de Comunicacães e Educação: CCA/ECA-USP, 1996.

7903. Guerreiro, Leila. "Quino, Mafalda, Felipe: Todo Queda en Familia." *La Nación.* October 3, 1999.

7904. Lavado, Joaquin S. *Mafalda.* Bueno Aires: Ediciones de la Flor, 1967-1974.

7905. Mackey, Jorge. "Padres con Humor." *Planetaweb.* June 2000.

7906. "Mafalda die Unbequeme." *If.* 1:3 (1971), p. 59.

7907. Ravoni, Marcelo. "I Vent' anni di Mafalda." In *Lucca 16,* 28 Ottobre-4 Novembre 1984, pp. 14-15. Lucca: I' Assessorato alla Cultura del Comune di Lucca, 1984.

7908. Rep. *Toda Mafalda.* Buenos Aires: Ediciones de la Flor, 1996.

7909. Samper Pizano, Daniel. *Mafalda: Mastropiero y Otros Gremios Paralelos.* Buenos Aires: Ediciones de la Flor, 1986.

 "Patoruzú"

7910. Garcia, Fernando and Hernán Ostuni. "La Verdadera Historia de Patoruzú." *Comiqueando.* January/February 1996.

7911. Malatesta, Parisina. "A Southern Cone Superman." *Americas.* March 1997, pp. 46-51.

BRAZIL
Cartooning, Cartoons

7912. *Álvaro.* Introduction by Jorge de Salles. N.p.: Ed. C.E.F., 1983.

7913. Amorim. *Canastra Suja.* N.p.: Ed. Circo Sampa, 1991.

7914. "Brasil Special." *Atlantis* (Air Portugal). November/December 2000, pp. 36-39.

7915. Cortez, Jayne. *Curso Completo de Desenho.* São Paulo: Div. Artísta, n.d. 4 volumes.

7916. de Sousa, Osvaldo. "Brazil, um Encontro de Humores." *Diário de Notícias.* December 10, 1989.

7917. de Sousa, Osvaldo. "Encontro Luso-Brasileiro de Humor." *Jornal de Letras.* December 26, 1989.

7918. de Sousa, Osvaldo. "Humor Luso-Brasileiro Está em Festa." *Diário de Notícias.* December 26, 1989.

7919. "Escola Panamericana de Arte-São Paulo-Brazil." *Phenix.* No. 14, 1970, p. 77.

7920. Faria, L. *Enriqueça Aprendendo Ilustração.* São Paulo: Novo Mundo, 1961.

7921. "Greetings from Brasil." *FECO News.* No. 26, 1998, p. 26.

7922. Gumery-Emery, Claude. "Le Bresil dans la Bande Dessinée de Gerard Lauzier." *Cahiers du Monde Hispaique et Luso-Bresilien/Caravelle.* 57 (1991), pp. 99-111.

7923. *Humor no Futebol.* Introduction by Jorge de Salles. N.p.: Ed. Correios, 1994.

7924. Lapi. *An Urbiwalker Anarkist.* N.p.: Ed. Codecri, 1983.

7925. Lapi. *Instalações e Objectos de Humor.* N.p.: Ed. Corde Iurbano, 1990.

7926. *Lapi 1969/73.* N.p.: Ed. Ouvidor, 1973.

7927. *Memórias da República – Humor nas Eleições 1889-1989.* N.p.: Ed. Fund. Roberto Marinho, 1989.

7928. Moliterni, Claude. "Carnet de Voyage." *Phenix.* No. 16, 1971, pp. 75-86. (Festival).

7929. *Plano Cruzado Tem Que Dar Certo.* N.p.: Ed. J.O., 1986.

7930. Rodrigues, Suzana B. and David L. Collinson. "'Having Fun?': Humor as Resistance in Brazil." *Organizational Studies.* 16:5 (1995), pp. 739-768.

7931. Santos, I. *Desenho para Comunicação.* Rio de Janeira: MM, 1975.

7932. "Viva Brazil." *Keverinfo.* No. 24, 1998, pp. 18-19.

Cartoonists and Their Works

7933. Bagchus, Tijs. "De Valse Vriend van José Alberto Lovetro." *Stripschrift.* December 1997, pp. 10-13.

7934. Chico. *Natureza Morte e Outros Desenhos.* N.p.: Ed. Muro, 1980.

7935. Coelho, Ronaldo Simões and Osmani Simanca. *Vampirilampo.* Belo Horizonte: Maza, 1999. 20 pp.

7936. d' Assunçao, Otacílio. *O Quadrinho Erótico de Carlos Zéfiro.* Rio de Janeiro: Record, 1984.

7937. Dean, Michael. "Andre Le Blanc: Staying Alive." *Comics Buyer's Guide.* January 2, 1998, p. 12.

7938. de Moraes, Dênis. *O Rebelde do Traço: A Vida de Henfil.* Rio de Janeiro: José Olympio, 1996.

7939. de Oliveira, Reinaldo. "Quien Es Quien en la Historieta." *Che-Loco.* April 1999, pp. 6-8. (Jose Delbo).

7940. "Gabriel Bá & Fábio Moon. Rolando Pelo Mundo Dos Quadrinhos." *Quadreca.* February 2001, pp. 24-32.

7941. Geszti, Gábor. "Mulatto Girls, Soccer Helped Lan Make Brazil His Home." *WittyWorld International Cartoon Bulletin.* No. 3, 1996, pp. 3-4. (Lanfranco Aldo Ricardo Veselli Cortelini Rossi).

7942. *Jorge de Salles, 25 Anos de Arte.* N.p.: Ed. Atelier Carioca de Humor, 1995.

7943. "Lailson (Brasil)." *Quevedos.* March 2001, p. 12.

7944. "Por Flávio Luiz." *Jornal Soterópolis.* October/November 1999, p. 22.

7945. [Ronaldo]. *Kayhan Caricature.* April/May 1997.

7946. Sanders, Rik and Harry Wibier. "Léo." *Stripschrift.* December 1994, pp. 4-7. (Léo, Luiz Eduardo de Oliveira).

7947. "Santiago-Brasil." *Justo Medio.* July 2000, p. 23.

7948. *Só Doi Quando Fico Sério—Homenagem a Nássara.* Introductions by Millor Fernandes, Sérgio Cabral, and Jorge de Salles. N.p.: Ed. C.C. Laura Alvim, 1987.

7949. *Szabo, Joe.* "Snapshot: Mauricio Pestana." *WittyWorld International Cartoon Bulletin.* No. 5, 1996, p. 3. (Political).

Carlos, J.

7950. Cotrim, Álvaro. *J. Carlos: Época, Vida, Obra.* Rio de Janeiro: Nova Fronteira, 1985.

7951. *J. Carlos.* Introductions by Jorge de Salles, Renato Gouveia, Alvaro de Moya. N.p.: Ed. Escritório de Arte, 1991.

7952. *J. Carlos Homenagem.* N.p.: Ed. C.C. Laura Alvim, 1988.

7953. *O Brasil Galante de J. Carlos (1884-1950). 50 Anos de Trabalho do Mestre da Caricatura Brasileira. Desenhos.* São Paulo: Renato Megalhães Gouvêa Escritório de Arte, 1991.

Cortez, Jaime

7954. Cortez, Jayme. *A Arte de Jayme Cortez.* São Paulo, Press Editorial Ltda., 1986.

7955. de Moya, Alvaro. "La Più Grande Exposizione della Carriera di Un Portoghese-Basiliano: Jayme Cortez." In *Lucca 20 Anni,* International

Salon Comics, Animated Film, Illustration, October 26-November 2, 1986. Program, pp. 64-65. Rome: Segreteria di Lucca 20 Anni, 1986.

De Sousa, Mauricio

7956. "Animators: Mauricio de Sousa, São Paulo, Brazil." *Animation.* February 1996, p. 34.

7957. "Mauricio." *Phenix.* No. 14, 1970, pp. 62-63.

7958. "The Walt Disney of Brazil." *Success.* June 1996, pp. 43-44.

Santiago

7959. Santiago. *Povaréu.* Porto Alegre: L&PM, 1994. 32 pp.

7960. "Santiago." *Humoris Causa.* March 1999, p. 7.

Zéfiro, Carlos

7961. D'Assunção, Otacílio. *O Quadrinho Erótico de Carlos Zéfiro.* 4th Edition. Rio de Janeiro: Record, 1987.

7962. Kfouri, Juca. "O Fim de 30 Anos de Mistério." *Playboy.* November 1991, pp. 94-96, 159.

7963. Marinho, Joaquim. *A Arte Sacana de Carlos Zéfiro.* Editora Marco Zero, 1983.

Animation

7964. "Anima Mundi." *Plateau.* 20:4 (1999), p. 27.

7965. Barreiros, Edmundo. "Anima Mundi: The Audience Is Key." *Animation World.* September 1998, 3 pp.

7966. "Brazil Bans Violent Video Games." *ASIFA San Francisco Newsletter.* January 2000, p. 3.

7967. Cajueiro, Marcelo. "Globo, Top Cartoonist Ink Contract." *Daily Variety.* December 15, 1998, p. 14.

7968. "Globo To Broadcast Nick Toons in Brazil." *Animation.* March 2001, p. 10.

7969. Lazaretti, Wilson. "An Animation Adventure in the Limits of the Amazon Rainforest." *Animation World.* April 1998. 3 pp.

7970. Magalhães, Marcos. *"Eight Point Star:* A Mind Experience in Animation." *Animation World.* May 1998. 4 pp.

7971. Moritz, William. "Anima Mundi 4." *Animation World.* September 1996. 3 pp.

7972. Zagury, Lea Beatriz. "Retrospective: Brazilian Animation." In *Ottawa 98 International Animation Festival.* Program, p. 93. Ottawa: 1998.

Comic Books

7973. Acevedo, Juan. *Como Fazer Histórias em Quadrinhos.* São Paulo: Global, 1990.

7974. *Almanaque de Fanzines: o Que São Pôr Que São Como São.* Rio de Janeiro: Arte de Ler, n.d.

7975. Anselmo, Zilda A. "Histórias em Quadrinhos e Adolescentes: Uma Pesquisa Junto a Ginasianos da Cidade de Santo André." Doctoral thesis, Instituto de Psicologia da Universidade de São Paulo, 1972.

7976. *Bar.* Introductions by Paulo Mendes Campos and Jorge de Salles. N.p.: Ed. Cauzzi, 1988.

7977. Bar. "Calazans Divulga HQs Brasileiras nos EUA." *A Tribuna.* February 2, 1996.

7978. Bibe Luyten, Sonia M. "Land in Zicht—Brazilë." *Stripschrift.* August 1999, p. 13.

7979. Boyd, Robert. "I'm a Comics Freak: The Stat of Mini-Comics Part One: An Interview with Fabio Zimbres." *Comics Journal.* July 1996, pp. 71-73.

7980. "Brazilian Comic Books." *The Economist.* May 6, 1995, p. 86.

7981. Cagnin, Antonio Luiz. *Os Quadrinhos.* São Paulo: Ática, 1975.

7982. Calazans, Flávio M. de Alcantara. *As Histórias em Quadrinhos no Brasil: Teoria e Prática.* São Paulo: Intercom, 1997. 176 pp.

7983. Calazans, Flávio M. de Alcantara. *Cartilha de Direito Autoral.* São Paulo: Associação de Quadrinhistas e Caricaturistas de São Paulo, 1986.

7984. Calazans, Flávio M. de Alcantara. "Histórias em Quadrinhos Segundo o Paradigma de Peirce." *Leopoldianum* (UNISANTOS). 16:47 (1990), pp. 77-86.

7985. Calazans, Flávio M. de Alcantara. "Para Entender as Histórias em Quadrinhos." *Comunicação e Arte.* 12:16 (1995), p. 204.

7986. Calazans, Flávio M. de Alcantara. *Propaganda Subliminar Multimedia.* São Paulo: Summus, 1996.

7987. *Cau Gomez. Un Humorista Brasileño Suelto en la Habana.* Exhibition. Havana, March 29-April 25, 1999. Havana: Centro de Desarrollo de las Artes Visuales, 1999. 6 pp.

7988. Cavalcanti, Ionaldo. *O Mundo dos Quadrinhos.* São Paulo: Símbolo, 1977.

7989. Cirne, Moacy. *A Explosão Criativa dos Quadrinhos.* Petropolis: Vozes, 1970.

7990. Cirne, Moacy. *História e Crítica dos Quadrinhos Brasileiros.* Rio de Janeiro: Fundação Nacional de Arte, Edição Europa, 1990.

7991. Cirne, Moacy. *Uma Introdução Política aos Quadrinhos.* Rio de Janeiro: Angra, Achiamé, 1982.

7992. Cortez Martins, Jayme, Reinaldo de Oliveira, and Alvaro de Moya. "Brasil." In *La Historieta Mundial,* edited by David Lipszyc, *et al.,* pp. 35-36. Buenos Aires: Instituida por la Escuela Panamericana de Arte, n.d.

7993. da Silva, Diamantino. *Quadrinhos para Quadrados.* Rio Grande do Sul: Editora Bels. 1976.

7994. da Silva, Nadilson M. "Brazilian Adult Comics: The Age of Market." *International Journal of Comic Art.* Spring 1999, pp. 187-204.

7995. da Silva, Nadilson M. "Brazilian Adult Comics: The Age of Market." Paper presented at International Association for Media and Communication Research, Glasgow, Scotland, July 29, 1998.

7996. de Melo, José Marques. *Comunicação Social: Teoria e Pesquisa.* Petrópolis: Vozes, 1977. ("Quadrinhos no Brasil," pp. 173-230).

7997. de Moya, Álvaro. *História da História em Quadrinhos.* São Paulo: Brasiliense, 1993. 2nd Ed. First edition, Porto Alegre: L & M, 1986.

7998. De Moya, Alvaro. "Protofumetti Brasiliani." *Expo Cartoon.* June 1996, pp. 32-33.

7999. "Dibujante Cordobes Premiado en Brasil." *Che-Loco.* April 1999, p. 12.

8000. Furtado Rahde, Maria Beatriz. "The Value of Comics as Media Communication and Pedagogical Reflection." Paper presented at International Association for Media and Communication Research, Glasgow, Scotland, July 28, 1998.

8001. "Glass House Graphics Merges with Animation Studio." *Comics Journal*. November 1994, p. 36.

8002. Holanda Cavalcanti, Lailson. "Cinco Dibujantes Brasileños Retratan el Fin de Siglo." *Quevedos*. March 2001, p. 20.

8003. *H.Q. Brasil.* 1° Concurso Nacional de Quadrinhos de 12 de Setembro a 8 de Outubro de 1995. Central Cultural São Paulo. São Paulo: Central Cultural São Paulo, 1995.

8004. Iannone, Leila Rentroia and Roberto A. Iannone. *O Mundo das Histórias em Quadrinhos*. São Paulo: Moderna, 1994. 2nd Ed.

8005. *Ique, Brasileiras, Brasileiros*. Introduction by Jô Soares. N.p.: Ed. Lumiar, 1989.

8006. Lameiras, Joao M. "Dois Europeus no Sertão." *Nemo* Fanzine. September 1997.

8007. Luchetti, Marco Aurélio. *A Ficção Científica Nos Quadrinhos*. São Paulo: GDR, 1991.

8008. Luyten, Sonia M.B. *Histórias em Quadrinhos: Leitura Crítica*. São Paulo: Paulinas, 1985. 2nd Ed.

8009. Luyten, Sonia M.B. *O Que é História em Quadrinhos*. São Paulo: Brasiliense, 1985.

8010. Maffesoli, Michel. *O Tempo das Tribos: O Declinio do Individualismo na Sociedade de Massas*. Rio de Janeiro: Forense-Universitaria, 1986.

8011. Magalhães, Henrique. *O Que é Fanzine*. São Paulo: Editora Brasiliense, 1993.

8012. Marny, J. *Sociologia dos Quadrinhos*. Rio de Janeiro: Civilização Brasileira, 1970.

8013. Marquezi, Dagomir. *Auika!: Algumas Reflexões Sobre Cultura de Massas; Arte: Lu Gomes & Flávio Del Carlo*. São Paulo: Proposta Editorial, 1980. (Underground comix).

8014. "Memorial: Assim Nasce UM GT." *GTHQ*. March 1999, p. 1.

8015. "Por Que o Quadrinho Nacional Não Vai para Frente? Tony de Marco Aponta Problemas do Quadrinho Nacional." *Quadreca*. February 2001, pp. 10-11.

8016. Rabaça, Carlos A. and Gustavo Guimarães. *Dicionário de Comunicação*. São Paulo: Ática, 1987. (Comics, pp. 314-316, 574-575).

8017. Salvat, Biblioteca de Grandes Temas. *O Humorismo.* São Paulo: Editora Salvat do Brasil, 1980.

8018. "São Paulo 1951." *Phenix.* No. 16, 1971, p. 69.

8019. Thomaz, Aylton. *Desenho Cómico.* São Paulo: Bentivegna, 1971.

8020. Velloso, Wilson. "Brazil's Cuddly Comics." *Americas.* July/August 1986, pp. 22-27.

8021. Vergueiro, Waldomiro C.S. "Brazilian Pornographic Comics: A View on the Eroticism of a Latin American Culture." Paper presented at Popular Culture Association, Philadelphia, Pennsylvania, April 13, 2001.

8022. Vergueiro, Waldomiro C.S. "Brazilian Pornographic Comics: A View on the Eroticism of a Latin American Culture in the Work of Artist Carlos Zéfiro." *International Journal of Comic Art.* Fall 2001, pp. 70-78.

8023. Vergueiro, Waldomiro C.S. "Brazilian Superheroes in Search of Their Own Identities." *International Journal of Comic Art.* Fall 2000, pp. 164-177.

8024. Vergueiro, Waldomiro C.S. "Brazilian Superheroes in Search of Their Own Identity." Paper presented at Popular Culture Association, New Orleans, Louisiana, April 20, 2000.

8025. Vergueiro, Waldomiro C.S. "Children's Comics in Brazil: From *Chiquinho* to *Mônica,* A Difficult Journey." *International Journal of Comic Art.* Spring 1999, pp. 171-186.

8026. Vergueiro, Waldomiro C.S. "Comic Book Collections in Brazilian Public Libraries: The Gibitecas." *New Library World.* 95 (1117) (1994), p. 14.

8027. Vergueiro, Waldomiro C.S. "Histórias em Quadrinhos: Seu Papel na Indústria de Comunicação de Massa." Master's thesis, Escola de Comunicações e Artes da Universidade de São Paulo, 1985.

8028. Vergueiro, Waldomiro C.S. "Histórias em Quadrinhos e Identidade Nacional: O Caso 'Pererê.'" *Comunicações e Artes* (São Paulo). 15:24 (1990), pp. 21-26.

8029. Vergueiro, Waldomiro C.S. "The Image of Brazilian Culture and Society in Brazilian Comics." Paper presented at Popular Culture Association, San Diego, California, April 2, 1999.

8030. Walty, Ivete Lara Camargos and Maria H. Rabelo. "De Quadrinhos e Quadrados." *Cadernos de Linguistica e Teoria da Literatura.* December 1985, pp. 57-82.

8031. "Y Ahora Juna Pirata." *Che-Loco.* August 2000, pp. 5-8.

"Monica"

8032. "Cartoons from Brazil: Monica's Brood." *The Economist.* May 6, 1995, pp. 126-127.

8033. "Monica of Brazil." *Inklings.* Spring 1995, p. 5.

CHILE
Animation

8034. "Animators: Alvaro Arce, Santiago, Chile." *Animation.* February 1996, p. 34.

Comic Books

8035. Eco, Umberto. "Historieta Politica en el Chile de Allende." *Bang!* No. 12, 1974, pp. 46-52.

8036. Kunzle, David. "Art of the New Chile: Mural, Poster, and Comic Book in a 'Revolutionary Process.'" In *Art and Architecture in the Service of Politics,* edited by Henry Millon and Linda Nochlin. Boston: MIT Press, 1978.

8037. Vergara, Robert A. "Humanizing Mass Media: Alternative Approaches to Comic Books During Allende's Chile, 1970-1973." Ed. D. dissertation, Northern Illinois University, 1990. 320 pp.

COLOMBIA
Cartooning, Cartoons

8038. "Calarcá (Colombia)." *Quevedos.* March 2001, p. 11.

8039. *Festival Mundial de Caricatura.* Medellín, Colombia. Medellín: Turcios, 2000. Unpaginated.

8040. "La Dibujante Colombiana Consuelo Lago Expone a Su Personaje 'Nieves.'" *Quevedos.* March 2001, p. 22.

8041. "Magola, la Feminista Colombiana, Llega a Éspaña." *Quevedos.* April 1998, p. 12.

8042. "Nueva Exposición en Alcalá del Humorista Colombiano Turcios." *Quevedos.* March 2001, p. 20.

8043. Ocampo, Jorge. *Mamarrachos de Ocampo.* Medellín: Unión Ibero-americana de Humoristas Graficos, n.d. Unpaginated.

8044. Paris, Esteban and Jorge Ocampo. *Humor de los Cuernos.* N.p: n.d. Unpaginated.

8045. "24 Horas...con Turcios." *Quevedos.* April 1998, p. 24. (Omar Figueroa).

8046. "Yayo." *Humoris Causa.* March 1999, p. 6.

COSTA RICA
General Sources

8047. Földvári, Kornel. "Svetoví Karikaturisti Očami Kornela Földváriho: Stano Kochan." *Pravda/Sobota Plus* (Bratislava). July 8, 1995.

ECUADOR
Cartooning, Cartoons

8048. Pilozo, Enrique. *The Collected Cartoons of Pilozo.* Costa Mesa, California: E. Pilozo, 1993. 130 pp. (Political cartoonist).

8049. Preston, Catherine L. "A Great Sensation of Something Real: Fotonovela Readers in Quito, Ecuador." MA thesis, University of Pennsylvania, 1987.

EL SALVADOR
Comics

8050. Ruiz, Carlos A. *La Tercera Gracia de Ruz.* San Salvador: *El Diario de Hoy,* 1999. 112 pp.

HONDURAS
Darío Banegas, Angel (Banegas)

8051. *Banegas, en Su Tinta.* Prologue by Carlos Roberta Reina. Madrid: Fundación General de la Universidad de Alcalá, 1999.

8052. "Banegas (Honduras)." *Quevedos.* March 2001, p. 14.

8053. Darío Banegas, Angel. *Comica: Las Mejores Caricaturas de 1995.* Tegucigalpa: Centro Editorial, 1995. 32 pp.

8054. Darío Banegas, Angel. *Thin Black Lines Rides Again.* Birmingham, England: Development Education Centre, 1994.

8055. Darío Banegas, Angel. *Y Reir Es de Sabios.* Tegucigalpa: Editorial Paradiso, 1989.

8056. "Entrevista: Ángel Darío Banegas: Humorista Hondureño." *Quevedos.* April 1998, pp. 19-20.

MEXICO
Cartooning, Cartoons

8057. *Album Taller de Gráfica Popular* (A Record of 12 Years of Collective Work). Mexico City: 1949.

8058. Cole, Richard R., ed. *Communication in Latin America: Journalism, Mass Media, and Society.* Wilmington, Delaware: Scholarly Resources, 1996. 260 pp. (Cartoons in Mexico's *El Iris* (1826), pp. 118-119, and *El Hijo del Ahuizote* (mid-1800s), p. 121.

8059. de la Uz, Maritza. "Peregrinación Humorística." *Justo Medio.* August 2000, p. 18.

8060. "Editorial: La Valiosa Labor y la Frescura de los Caricaturistas Jóvenes." *La Piztola.* June 2000, p. 1.

8061. *Estampas de la Revolución Mexicana, 85 Grabados de los Artistas del Taller de Gráfica Popular.* Mexico City: 1947.

8062. Haab, Armin. *Mexican Graphic Art.* Teufen, Switzerland: 1957.

8063. Heras. "La Caricatura en la Publicidad." *La Piztola.* January 2001, p. 22.

8064. "Humor, Cachondeo, Crítica y Esparcimiento." *Justo Medio.* February 2001, pp. 19-22.

8065. "Humor en Serio: Suplemento Humorístico." *Justo Medio.* September 2000, pp. 19-22.

8066. Maby. "Cómics Cibernéticos." *La Piztola.* March 2001, p. 8.

8067. Maby. "Una Pagina Sólo para Chavos." *La Piztola.* February 2001, p. 9.

8068. Masuoka, Susan N. "Joking with Death." *Print.* May/June 1984, pp. 78-83. (Political).

8069. "Mexicaans Paginaatje." *Sic.* No. 7, n.d., p. 24.

8070. Musi, Pablo P. "Cartoons in Mexico." *Skipping Stones.* February/March 1996, p. 19.

8071. Ojeda-Cardenas, R. "The Quiet War: Nonverbal Portrayal of Sex Roles in the Mexican Fotonovela." Doctoral dissertation, Boston University, 1983.

8072. "Por Mi Raza Hablará el Espíritu." *La Piztola.* January 2001, p. 20.

8073. "Seis Candidatos Tras la Silla Perdida." *La Piztola.* June 2000, p. 3.

8074. Sol, Pedro. "Miscelánea Humorística." *La Piztola.* June 2000, p. 26.

8075. "Tiliches 2000 Cachivaches." *Chocarreros.* February 2000, pp. 34-35.

8076. Zepeda, Martina. "La Cultura de Luto." *La Piztola.* February 2001, p. 21.

Exhibitions, Festivals

8077. "Cuarta Bienal José Guadalupe Posada." *La Piztola.* January 2001, p. 16.

8078. "Exclusivo: Bienal Internacional del Justo Medio." *Justo Medio.* September 2000, p. 14.

8079. "Exclusivo. Jurado del Salón Internacional de Humorismo Gráfico." *Justo Medio.* July 2000, p. 14.

8080. "Exclusivo: Jurado del Salón Internacional de Humorismo Gráfico." *Justo Medio.* August 2000, p. 14.

8081. "Ganadores de la Bienal José Guadalupe Posada." *La Piztola.* January 2001, p. 3.

8082. "La Fiesta de los Caricaturistas. Suplemento Humoristico." *Justo Medio.* July 2000, pp. 17-24.

8083. Pohle, Marlene. "Justo en Medio." *Justo Medio.* July 2000, p. 20.

8084. "Resultados de la Primera Bienal Internacional del Justo Medio." *Justo Medio.* August 2000, pp. 17-24.

Historical Aspects

8085. Fragoso, Beatriz Isela. "Los Caricaturistas le Pegan al 'Gordo.'" *La Piztola.* March 2001, p. 3.

8086. *La Caricatura en la Historia, Historia de la Caricatura. Colección Permanente.* Mexico City: Museo de la Caricatura, n.d. (ca. 2000). 16 pp.

8087. "La Caricatura en Tiempos de Juárez." *La Piztola.* March 2001, p. 1.

8088. López Casillas, Mercurio. "Benito Juárez en la Caricatura de Su Tiempo." *La Piztola.* March 2001, pp. 4-5.

Cartoonists and Their Works

8089. "Alberto Huici." *The NCS Cartoonist.* June 1966, 4 pp.

8090. "Alfredo Valdez Kaskabel." *Chocarreros.* February 2000, pp. 28-29.

8091. "David Carrillo Estrella del Zodiaco." *La Piztola.* February 2001, p. 3.

8092. González, José C. "Entrevista con Carlos Monsivais." *Artes Visuales.* June/August 1979, pp. 25-29.

8093. "Homenaje a Maestros del Cómic." *La Piztola.* February 2001, p. 3.

8094. "Homenaje en México al Dibujante Ángel Rueda." *Quevedos.* March 2001.

8095. Jis [José Ignacio Solórzano]. *Sepa la Bola.* Mexico: Editorial Grijalbo, 1996. 268 pp.

8096. Maby. "Premio Mayor con Ernesto Guasp." *La Piztola.* February 2001, p. 3.

8097. Marnham, Patrick. *Dreaming with His Eyes Open. A Life of Diego Rivera.* New York: Alfred A. Knopf, 1998. 350 pp.

8098. "Nerílícón (Antonio Neri Licon, Mexico)." *Humoris Causa.* March 1999, pp. 16-17.

8099. Pols, Hans. "Laura Esquivel De Wetten van de Liefde." *Stripschrift.* January 1997, p. 13.

8100. "Rius y Aragonés." *Humoris Causa.* March 1999, p. 11.

8101. "Sketchbook: Jose L. Solorzano." *Comics Journal.* March 1995, pp. 111-115.

8102. "Un Año de Muerto, y Sigue Tan Campante." *Chocarreros.* May 1998. pp. 18-19.

8103. Winchester, Güicho. "Escalante, Hernández y Villasana." *La Piztola.* March 2001, p.9.

Garci

8104. "El Mexicano Garci Nieto Ganó el Premio Pages Llergo de Periodismo." *Quevedos.* March 2001, p. 19.

8105. "Garci (Mexico)." *Quevedos.* March 2001, p. 10.

Kemchs, Arturo

8106. "Cartones Reciclados, Una Obra para Hacer Conciencia." *Justo Medio.* June 1999, p. 23.

8107. "El Mejor Amigo del Hombre Kemchs." *Chocarreros.* February 2000, pp. 18-19.

8108. Kemchs, Arturo. *Fin de Siglo. End of Century Cartoons.* Mexico: Iztapalapa, 1994.

Posada, José Guadalupe

8109. Charlot, Jean. "José Guadalupe Posada, Printmaker to the Mexican People." *Magazine of Art.* Vol. 38, 1945.

8110. *José Guadalupe Posada, Illustrador de la Vida Mexicana.* Mexico City: 1963.

8111. Kuh, Katherine. "Posada of Mexico." *Art Institute of Chicago Bulletin.* Vol. 38, 1944.

8112. *Las Obras de José Guadalupe Posada, Grabador Mexicano.* Mexico City: 1930.

8113. Rothenstein, Julian, ed. *Posada: Messenger of Mortality.* Mt. Kisco, New York: Moyer Bell Ltd., 1989. 188 pp.

8114. Secker, Hans F. *José Guadalupe Posada.* Dresden: 1961.

Quezada, Abel

8115. Fregosa, Beatriz Isela. "Diez Años sin Abel Quezada." *La Piztola.* February 2001, pp. 6-7.

8116. Heras. "Mi Maestro Fue Pompeyito: Abel Quezada." *La Piztola.* February 2001, p. 26.

8117. Rivera, Cecilia. "Abel Quezada: 'El Mejor de los Mundos Imposibles.'" *Justo Medio.* December 2000, p. 23.

Trino

8118. "Perdió el Gano Aclas Trino." *La Piztola.* June 2000, p. 3.

8119. Trino [José Trinidad Camacho Orozco]. *Fábulas de Policías y Ladrones Volumen 1.* Mexico: Editorial Grijalbo, 1994. 96 pp.

Animation

8120. Baisley, Sarah. "Party Time." *Animation.* April 2001, p. 79.

8121. Bolton, Don. "Promexa: Government Support Boosts Mexican Animation Industry." *Animation.* November 1997, p. 20.

8122. Heras. "Una Estrella de la Publicidad en el Cine." *La Piztola.* March 2001, p. 8. (Alberto Isaac).

8123. Hillis, Scott. "Disney To Change Mexican in Video Game after Protest." Reuters dispatch, December 11, 1999.

8124. McCracken, Harry and Kip Williams. "The Catinflas Chronicles." *Animato!* Summer/Fall 1997, pp. 18-19.

8125. McSorley, Tom. "Contemporary Mexican Animation." In *Ottawa 96 International Animation Festival.* Program, pp. 104-105. Ottawa: Canadian Film Institute, 1996.

8126. Martinez Garcia, Jésus and Ignacio Montes de Oca Martinez. "Estudio Cinematográfico de Dibujos Animados en la Ciudad de México" (Cinematographic Study of Animated Drawings in Mexico City). Thesis, Instituto Politécnico Nacional, Escuela Superior de Ingeniería y Arquitectura, 1965.

8127. Molina y Vedia, Silvia. "Disney in Mexico: Observations on Integrating Global Culture Objects into Everyday Life." Paper presented at International Association for Media and Communication Research, Glasgow, Scotland, July 28, 1998.

8128. Moline, Alfons. "Cuautli: La Historia de México en Animación." *Noticies.* September/October 1997, p. 4.

8129. Pesusich, Julie. "Liquid Light Studios Says, 'Olé!' to Mexico's *Pronto."* *Animation World.* January 1998.

8130. Sutter, Mary. "Azteca Nabs Rights to Disney Product." *Daily Variety.* November 9, 1998, p. 12.

Caricature

8131. "Amenaza de Muerte a Un Caricaturista Español." *Chocarreros.* April 1998, p. 31.

8132. "David Carrillo y su Libro *Algo de Historia en Caricature II."* *Chocarreros.* May 1997, p. 14.

8133. "Los Caricaturistas con Checo Valdez." *Chocarreros.* April 1998, p. 22.

8134. Rich, Paul and Guillermo De Los Reyes. "Mexican Caricature and the Politics of Popular Culture." *Journal of Popular Culture.* Summer 1996, pp. 133-145.

Comic Books

8135. Aberson, Sarah, John Cavanagh, and Thea Lee. "We Can Fight, We Can Win: Effective Protest Efforts Range from Comic Books to Boycotts." *The Nation.* December 1999.

8136. "Analizan a Lectores de 'La Familia Burrón.'" *La Piztola.* June 2000, p. 3.

8137. "Apebas (México)." *Quevedos.* March 2001, p. 14.

8138. Arbesú, Faustino R. "'Tomen, Pillos, Sí': Aquellos Tebeos Mexicanos." *La Nueva España.* May 24, 1987.

8139. Aureocoechea, Juan M. and Armando Bartra. *Puros Cuentos: La Historieta en México,* Vols. I, II. Mexico: Grijalbo, 1988, 1994.

8140. Ayuso, Mariano. "SUNDAY Tambien Estuvo en México." *Sunday.* December 1981, p. 36.

8141. Bartra, Armando. "The Seduction of the Innocents: The First Tumultuous Moments of Mass Literacy in Postrevolutionary Mexico." In *Everyday Forms of State Formation,* edited by G. Joseph and D. Nugent. Durham, North Carolina: Duke University Press, 1994.

8142. Biederman, Marcia. "The Story of Olé: X-Rated Comic Books from Mexico Are Making Time Fly on the Train." *New York Magazine.* October 11, 1999, p. 20.

8143. Couch, N.C. Christopher. "Rius and Politics." Paper presented at Northeastern Conference on Latin American Studies, Williams College, March 1996.

8144. de Valdés, Rosalva. "La Bande Dessinée Mexicaine." *Phenix.* No. 37, n.d., pp. 30-39.

8145. "Gente de Tesoros." *Tesoros.* Nos. 28-35 (March 7-May 3, 1952).

8146. Giardino, Alex. "Strip Tease: Mexico's Softcore Comics Craze." *Village Voice.* February 10, 1999.

8147. Helfand, Glen. "Heaven's Corner." *Artweek.* April 12, 1990, p. 11.

8148. "A Mexican Comic Book for Birth Control." *Cartoonews.* July 1975, pp. 36-37.

8149. "Publican Libro de 'La Familia Burrón.'" *La Piztola.* January 2001, p. 3.

8150. "Quinta Convention de Historietas de la Ciudad de México." *Chocarreros.* May 1998, pp. 2-3.

8151. Rubenstein, Anne G. *Bad Language, Naked Ladies, and Other Threats to the Nation: A Political History of Comic Books in Mexico.* Durham, North Carolina: Duke University Press, 1998. 210 pp.

8152. Rubenstein, Anne G. "Leaving 'The Old Nest': Morality, Modernity, and the Mexican Comic Book at Mid-Century." *Studies in Latin American Popular Culture.* Vol. 16, 1997, pp. 115-125.

8153. Rubenstein, Anne. G. "Mexican Magazine Censors Versus the United States Marines: A Case Study of Transnational Reception." *International Journal of Comic Art.* Fall 1999, pp. 41-55.

8154. Rubenstein, Anne G. "Mexico 'Sin Vicios': Conservatives, Comic Books, Censorship and the Mexican State, 1934-1976." Ph.D. dissertation, Rutgers University, 1994.

8155. Rubenstein, Anne G. "Post-Modernity, Anti-Modernity, and Mexican Graphic Narrative (With or Without a Tijuana Bible)." Paper presented at International Comic Arts Festival, Bethesda, Maryland, September 17, 1999.

8156. "¡Santa Batisorpresa, Batman!" *La Piztola.* February 2001, p. 26.

8157. Scott, David C. "Mexico's Literature for the Masses." *Christian Science Monitor.* February 8, 1993.

8158. Vidal, Noele. "La Vie Quotidienne au Mexique en Bande Dessinée: La Familia Burron, por Gabriel Vargas." *Les Langues Modernes.* 76:3 (1982), pp. 301-309.

8159. [Vincente Fox, a possible Mexican presidential candidate for the conservative PAN (National Action Party), has secured rights to enlist comic book hero Kaliman in his campaign]. *La Jornada.* April 13, 1999, p. 1.

Humor Magazines
Chocarreros

8160. "De Mexico, *Chocarreros.*" *Mi Barrio.* December 1999, p. 17.

8161. "The Mexican Magazine Chocarreros 2000." *Kayhan Caricature.* June/July 2000, 1 p.

8162. "2 Años de *Chocarreros.*" *Chocarreros.* April 1998, pp. 20-21.

La Piztola

8163. Fregosa, Beatriz Isela. "La Piztola Cien Numeros, Nueve Años y Una Expo." *La Piztola.* March 2001, pp. 6-7.

8164. "La Piztola en Fechas." *La Piztola.* February 2001, p. 5.

8165. "¡Llegamos al Número Cien!" *La Piztola.* February 2001, p. 1.

8166. López Casillas, Mercurio. "Cien Disparos de *La Piztola.*" *La Piztola.* February 2001, p. 4-5.

Political Cartoons

8167. Jardón, Jose P. "De Caricaturistas Políticos a Políticos Caricaturistas." *La Piztola.* June 2000, p. 5.

8168. "Las *Pingaderas* de Pingo." *La Piztola.* June 2000, p. 3.

8169. López, Mercurio. "Jerónimo, a 40 Años de Su Natalicio." *La Piztola.* June 2000, pp. 4-5.

8170. "Politicartones." *La Piztola.* June 2000, pp. 14-19.

8171. "Politicartones." *La Piztola.* January 2001, pp. 12-15.

8172. "Politicartones." *La Piztola.* February 2001, pp. 14-19.

8173. "Politicartones." *La Piztola.* March 2001, pp. 14-15.

NICARAGUA
Political Cartoons and Humor

8174. *El Humor Como Arma de la Lucha Ideológica* (Humor As a Weapon in the Ideological Struggle). First International Contest of Anti-Imperialist Cartoons. Managua: Tribunal Antimperialista de Nuestra América, 1984. 111 pp.

8175. Kunzle, David. *The Murals of Revolutionary Nicaragua: 1979-1992.* Foreword by Miguel D' Escoto. Berkeley: University of California Press, 1995. 203 pp.

8176. Parker, Richard H. " 'El Humor como Arma de la Lucha Ideológica.'" *Soberania.* No. 12, 1984, pp. 56-61.

8177. Róger. *Dos de Cal, Una de Arena, Muñequitos.* Managua: Editorial El Amanecer, for Association of U.S. Internationalists and Barricada, 1986.

PANAMA
General Sources

8178. "Los Humoristas Se Unen en Defensa del Dibujante Panameño RAC." *Quevedos.* March 2001, p. 8.

Cartoonists and Their Works

8179. "Galardón para el Dibujante Panameño Peña Moran." *Quevedos.* March 2001, p. 25. (Peña Moran).

8180. "La Intolerancia Tras el Humor." *La Piztola.* February 2001, p. 20. (Julio Briceño).

PARAGUAY
General Sources

8181. Simi, Paolo. "Robin Wood Cittadino del Mundo." *Expo Cartoon.* June 1996, p. 46.

PERU
Comics

8182. Cooke, Jon B. "Pablo's Amazing Journey." *Comic Book Artist.* May 2001, pp. 104-108. (Pablo Marcos).

8183. Lucioni, Mario. *Historia de la Historieta en el Peru 1873-1944* (History of Peruvian Comics 1873-1944). Lima: Universidad Lima, forthcoming.

URUGUAY
Cartoonists and Their Works

8184. Dobrinin, Pablo. "El Ismael de José Rivera." *Balazo.* August 1999, pp. 21-27.

8185. Dobrinin, Pablo. "Emilio Cortinas, El Maestro de la Aventura." *Balazo* (Montevideo). September 1999, pp. 12-14.

8186. Dobrinin, Pablo. "Entrevista: Ángel Umpiérrez: Un Niño de Ochenta Años." *Balazo.* July 1999, pp. 34-39.

Comics

8187. Dobrinin, Pablo. "Panorama Actual del Comic Uruguayo." *Balazo.* June 2000, p. 34.

8188. Errico, Gabriela. "Del Cómic Celeste y *no Tonto*: *Guacho* y *Balazo*: Una Aspuesta a la Historieta Oriental." *Cultura.* September 2, 1999, pp. 23-24.

8189. Gandolfo, Elvio E. "Revistas de Historieta Uruguaya: El Regreso del Cuadrito." *El Pais* (Montevideo). October 8, 1999, pp. 10-11.

8190. Puch, Daniel. "Cartooning in Uruguay: Not Yet the White Flag." *International Journal of Comic Art.* Fall 2001, pp. 116-126.

8191. Tomeo, Humberto. "Notizie dall' Uruguay." *Comics.* November 1971, p. 23.

VENEZUELA
General Sources

8192. Gil-Egui, Gisela. "Venezuela's Alonso and the Art of Leaving It All to Art." *International Journal of Comic Art.* Fall 2001, pp. 127-137.

8193. "Government Paper To Launch Comic Hero." Reuters dispatch, January 31, 2000. ("The Patriot").

8194. "Locomotion: The Animation Network." *Animation World.* September 1996.

8195. "Zapata." *Humoris Causa.* March 1999, p. 7.

6

CARIBBEAN

REGIONAL AND INTER-COUNTRY PERSPECTIVES

Cartooning

8196. Jardel, Jean-Pierre. "La Bandes Dessinée 'Antillaise' comme Moyen de Communication, d' Information et d' Education." *Etudes Creoles.* 15:2 (1992), pp. 126-137.

8197. Lent, John A. "Cartooning and Development in the Caribbean." In *Latin America, the Caribbean and Canada in the Hood: The Reordering of Culture,* edited by Alvina Ruprecht and Cecilia Taiana, pp. 409-416. Ottawa: Carleton University Press, 1995.

BARBADOS
Cartooning

8198. Sandiford, Robert E. "Caribbean Cartoonists Inspire Bellylaugh." *Comics Journal.* January 2000, p. 16.

BERMUDA
Political Cartoons

8199. Woolcock, Peter. *Peter Woolcock's Woppened Eleven. Cartoons from the Royal Gazette 1998-99.* Hamilton: *Royal Gazette,* 1999. 58 pp.

8200. Woolcock, Peter. *Woppened-1987-88. A Selection of Royal Gazette Cartoons.* Hamilton: *Royal Gazette,* 1988. 64 pp.

CUBA
Cartooning, Cartoons

8201. Beck, Chip. "Beck Invades Cuba with Pen, Not Sword." AAEC Website. Fall 1998, 3 pp.

8202. Betán. "Tres Expos y Otra de Ñapa." *Palante.* July 1998.

8203. Blanco, Caridad. "Culpable de Honradez." *Revolución y Cultura* (Havana). July-August 1995, pp. 57-58.

8204. Blanco, Caridad. "Historia de Cajones." Catalogue. *II Salón de Arte Cubano Contemporáneo.* Centro de Desarrollo de las Artes Visuales. Havana. November 1998.

8205. Blanco, Caridad. "Para no Dejar Morir al Topo." *La Gaceta de Cuba* (Havana). May/June 1996, pp. 56-57.

8206. Blanco, Caridad de la Cruz. [Article on Comics]. In *Las Artes Plásticas en Cuba.* Habana: Editorial Letnas Cubanas, 1995 (?).

8207. "Boceto Oral el 2000." *Juventud Rebelde.* February 13, 2000, p. 16.

8208. Cénovas Fabelo, Alexis Mario. (III Esa Categoria llamada lo Cómico." *UPEC.* No date, pp. 34-43.

8209. Constantin, Elio E. "Breve Historia de la Prensa Prerevolucionaria." *UPEC.* March 1985, pp. 1-5.

8210. "Cuatro Cubanos Premiados en Belgica." *Palante.* April 1998, p. 11.

8211. "Cuba, La Ville del Humor." *Humoris Causa.* March 1999, pp. 12-15.

8212. "Ecos del Encuentro de Historietistas Tradición Entusiasta." *Mi Barrio.* September 2000, p. 48.

8213. Fell, Paul. "Paul Fell in Cuba." *Cartoonist PROfiles.* June 1999, pp. 67-71.

8214. Ganahl, Jane. "Zippy Goes Cuba – Revolutionary." *San Francisco Examiner.* March 20, 1995.

8215. Isabella, Tony. "From Cuban Cartoons to Column Comments." *Comics Buyer's Guide.* May 4, 2001, pp. 34-35.

8216. "Küba Karikatür Sergisi Açildi." *Karikatürk.* No. 75, 2000, pp. 4-5.

8217. Lent, John A. "Cuba's Comic Art Tradition." *Studies in Latin American Popular Culture.* No. 14, 1995, pp. 225-244.

8218. Lent, John A. "Fighting for Survival." *Kayhan Caricature.* August-September 2000, pp. 2-7.

8219. Lent, John A. "Humor: La Misión Principal." *Dedeté.* July 1998, p. 2.

8220. Lent, John A. "Survival Is Name of Game for Cuban Cartoonists." *Comics Journal.* May 2001, pp. 41-42.

8221. "Lent a la Cuarta." *Juventud Rebelde.* February 20, 2000, p. 12.

8222. Lopez Oliva, Manuel. "Dibujos con Humor y sin Él." Catalogue. *Humor Gnosis, Ninguno, Otro.* Sala de Esposiciones del Periódico *Granma.* Havana, September 1975.

8223. "Los Dibujos del Ché." *Che-Loco.* April 1999, p. 9.

8224. "Luz Verde en Transito 98." *Palante.* December 2, 1998, p. 12.

8225. *Melaito* Staff. *Humor Erotico. A Filando la Punta. Colectivo de Melaito.* Santa Clara: Ediciones Capiro, 1997. 89 pp.

8226. Méndez, Janler Castillo. *Antidiertro.* Havana: Taller de Serigrafía del I.S.A., 2000.

8227. Ocasio, Rafael. "In Search of a Socialist Identity in Revolutionary Cuban Children's Literature." In *Imagination, Emblems and Expressions: Essays on Latin American, Caribbean, and Continental Culture and Identity,* edited by Helen Ryan-Ranson, pp. 89-98. Bowling Green, Ohio: Popular Press, 1993.

8228. *1/4 de Humor.* Prologue by Enrique Núñez Rodríguez. Villa Clara, Cuba: Ediciones Capiro for Colectivo de "Melaito," 1993.

8229. Piñero, Jorge A. "El Humor del Próximo Siglo." *Juventud Rebelde.* October 10, 1999, p. 13.

8230. Piñero, Jorge A. "'El Humor Es Un Refugio para la' Inteligentsia." *Juventud Rebelde.* June 28, 1998, p. 11.

8231. Piñero, Jorge A. "The Importance of Being a Humorist." *Habanera.* n.d., p. 99.

8232. "Rey Mago para Caricaturistas llega del Oriente." *Palante.* December 2, 1998, p. 12.

8233. Rodríguez S., Jorge and Aristides Hernández G. *Psicoterapia: Una Relacion de Ayuda.* Guatemala: Empretec, 1999. 112 pp.

8234. "Salon Internacional de Satira Politica La Deuda Externa." *Dedeté.* No. 13, 1986, pp. 1-8.

8235. "Salon Juan David, en Cuba." *Quevedos.* March 2001, p. 24.

8236. "Salón Nacional del Humorismo." *Juventud Rebelde.* October 13, 1999, p. 16.

8237. Tamayo, Evora. *Breve Muestra de Humorismo Gráfico Cubano.* Havana: Editorial Pablo de la Torriente, 1993. 72 pp.

8238. Tamayo, Evora. "'El Títere." *UPEC.* January/April 1982, p. 30.

8239. "Un Quincenario de Humor Joven pero con Experiencia." *Dedeté.* No. 390, 1985, p.1.

8240. Vega, Verónica. "Se Créo la Asociación Iberoamericana de Humoristas Gráficos, Presidida por *Kemchs*." *Chocarreros.* May 1997, p. 27.

8241. Veigas, José. "El Humor Nueztro de Todos los Dias." *Revolución y Cultura.* No. 60, 1977, pp. 20-27.

Bienal Internacional del Dedeté

8242. "A Cargo de Gabriel." *Juventud Rebelde.* June 7, 1998.

8243. Betán. "Fin de Siglo con Buen Humor." *Palante.* July 1998.

8244. Blayro. "Los Ruidos y las Nueces de la Humoranga 98." *Palante.* May 1998, p. 8.

8245. Castellanos León, Israel. "Sonreír con Cierto Complejo de Culpa." *Juventud Rebelde.* May 7, 1998, p. 13.

8246. "Fin de Siglo con Sabor a *Dedeté*." *Dedeté.* June 20, 1998, p. 2.

8247. "Humor de Fin de Siglo." *Opciones.* June 7, 1998.

8248. "Humor de Fin de Siglo. Catalogo." *Dedeté* Special Edition. June 1998.

8249. Nieuwendijk, Peter. "Fiesta Cubana: Segunda Bienal del Dedeté." *FECO News.* No. 30, 2000, pp. 3-4.

8250. "Noti-ratón." *Dedeté*. March 22, 1998.

8251. Piñera, Toni. "Humor de Fin de Siglo, a Salón." *Granma*. June 20, 1998, p. 6.

8252. "Premios de Fin de Siglo." *Dedeté*. June 28, 1998, p. 16.

8253. "Segunda Bienal del Dedeté." *Dedeté*. January 1999, p. 7-8.

8254. "Segunda Bienal Internacional Dedete 2000." Edición Especial, 2000, 8 pp.

8255. "Segunda Bienal Internacional *Dedeté* 2000 Premiados." *Juventud Rebelde*. February 20, 2000, p. 12.

8256. "Uluslararasi Politik Mizah Sergisi Kuba." *Karikatürk*. March 1998, p. 10.

8257. Vázquez, Omar. "Salón Internacional Humor de Fin de Siglo." *Granma*. June 9, 1998, p. 6.

8258. Venereo, Ricardo Alonso. "Habaneros en Humor de Fin de Siglo." *El Habanero*. June 19, 1998, p. 6.

8259. "Ya Empezó el Salón Internacional Humor de Fin de Siglo!" *Dedeté*. June 21, 1998, p. 12.

Bienal Internacional de Humorismo

8260. "Are Fue Premiado por la Bienal Entre Otros Acontecimientos." *Juventud Rebelde*. April 3, 2001, p. 6.

8261. "Aviso en Preparación la Proxima Bienal del Humor." *Mi Barrio*. September 2000, p. 15.

8262. "X Bienal Internacional del Humor." *Chocarreros*. May 1997, p. 26.

8263. Castillo, Héctor Antón. "Humor a la Vista: XII Bienal de San Antonio de los Baños." *Noticias de Arte Cubano*. March 2001, p. 6.

8264. *Cuarta Bienal Internacional de Humorismo 1985*. Prague: International Organisation of Journalists, 1987. Unpaginated.

8265. *VIII Bienal Internacional de Humorismo 1993*. Havana: 1995. Unpaginated.

8266. Figueredo, Janett. "Vas Bien, Andrea." *Juventud Rebelde*. April 1, 2001, p. 16.

8267. "La Bienal del Humor." *Palante*. March 2001, p. 7.

8268. *Memorias Bienals Internacionales de Humorismo 1979-1981-1983.* Prague: International Organisation of Journalists, n.d. (1983?). Unpaginated.

8269. Pérez, Jorge L. "San Antonio de Los Baños; la Villa del Humor." *UPEC.* January/February 1981, pp. 4-11.

8270. Pérez Pereira, Rafael. "II Biennial." *UPEC.* January/February 1979, pp. 41-43.

8271. Piñera, Toni. "Premios, Entre Humor y Reflexión." *Gramma.* April 2, 2001, p. 6.

8272. "Premios de 'La Picúa.'" *Mi Barrio.* September 2000, pp. 2-3.

8273. "Primer Premio del Certamen Cederista." *Mi Barrio.* January/March 2001, pp. 24-25.

8274. *Quinta Bienal Internacional de Humorismo 1987.* Prague: International Organisation of Journalists, no date (1987?). Unpaginated.

8275. *Sexta Bienal Internacional de Humorismo 1989.* Prague: International Organisation of Journalists, n.d. (1989?). Unpaginated.

8276. Tamayo, Evora. "Hablan los Humoristas Sobre la II Bienal Internacional de Humor." *UPEC.* November/December 1980, pp. 47-48.

Historical Aspects

8277. Avilés, Cecilio. "La Historieta Cubana después de 1959." Periodical unknown. 1989, pp. 95-112.

8278. de Juan, Adelaida. "Pintura Cubana: El Tema Histórico." *Universidad de La Habana.* No. 195, 1-1972.

8279. Menéndez González, Aldo. "San Antonio de la Magia." *Revolución y Cultura.* No. 60, 1977, pp. 4-19.

8280. Mogno, Dario. "Parallel Lives: Comics and Animated Cartoons in Cuba from Beginning to Present." *International Journal of Comic Art.* Fall 2001, pp. 82-105.

8281. Pérez Alfaro, Manolo. "Taller del Aficionado." *Mi Barrio.* December 1999, pp. 26-31.

Cartoonists and Their Works

8282. "Angel Rivero Sierra." Catalogue. Havana: Galería La Acacia, 1998. 6 pp.

8283. Betán. "Blanco en Su Media Rueda." *Palante.* April 1998, p. 11. (Francisco Blanco).

8284. Henríquez Lagarde, Manuel. "En Busca del Muñe Perdido: Entrevista con Norma Martinez Pineda Directora de Estudios Peliculas Animación I CAIC." *El Caiman Barbudo.* No. 295, pp. 12-14.

8285. "Juan Padrón." *Cine Cubano.* No. 110, 1984, p. 42.

8286. "Maes Trazos." *Nueva Generación Dedeté.* No. 8, 2001, p. 6, (Conrado W. Massaguer).

8287. Montes de Oca, Danny and Cristina Padura. "La Dimensión Más Profunda de la Caricatura: Conversación con Rafael Fornés." Catalogue. *De José Dolores a Sabino. Retrospectiva a Rafael Fornés.* Galería-Taller René Portocarrero. Havana. June 1996.

8288. M.P. "Premios de Humorismo a Jerez." *Mi Barrio.* January/March 2001, pp. 4-5.

8289. Núñez Rodríguez, Enrique. "El Otro Manuel...Digo, el Nuestro." *Matanzas.* No. 3, 1999, pp. 32-33.

8290. Núñez Rodríguez, Enrique. "Marcos Behmaras." *Mi Barrio.* September 1996, p. 23.

8291. Pérez, Manolo. "Homenaje al Che." *Mi Barrio.* March-April 1997, pp. 34-37. (Orestes Suarez).

8292. Pérez Pereira, Rafael. "No Solo Hacer Reir Sino Tambien Pensar." *UPEC.* September/October 1988, pp. 29-33. (Carlucho).

8293. "Polito, Jose Polo." *Kayhan Caricature.* January 2000, pp. 12-13.

8294. Tamayo, Evora. "'Criollitas' de Wilson." *UPEC.* July/August 1980, pp. 48-49.

Abela, Eduardo

8295. Carpentier, Alejo. *Catálogo de la Exposición Retrospectiva de Abela.* La Habana, March 1964.

8296. Leyva, Armando. "Con Eduardo Abela, Creador del Bobo. Dos Minutos de Charla." *Información.* February 27, 1931, p. 1.

Ares (Aristides Esteban Hernández Guerrero)

8297. Ares. *Gente de Meio-Tom. Ares Cartuns.* Bahia, Brazil: Universidade do Estado da Bahia, 1996. 72 pp.

8298. "Ares." *Kayhan Caricature.* November-December 1999. 4 pp.

8299. Blanco de la Cruz, Caridad. "Ares: An Undomesticated Humorist." *International Journal of Comic Art.* Fall 2001, pp. 106-115.

8300. "Chambelona ™Made in USA por Ares." *Mi Barrio.* January/March 2001, pp. 32-33.

8301. Hernández, Aristides (Ares). *Cuba com Humor.* Havana: Amaral, 1993. 52 pp.

8302. "Lennon y Ares." *Quevedos.* March 2001, p. 22.

Armada, Santiago (Chago)

8303. Blanco, Caridad. "Always the Other One: Salomón." *International Journal of Comic Art.* Spring 2000, pp. 178-189.

8304. Blanco de la Cruz, Caridad. "Chago-Salomón, el Inquietante Umbral de lo Simbólico." In *Catalogo Salon de Arte Contemporaneo,* pp. 134-142. Havana: Centro de Desarrollo de Las Artes Visuales, 1998.

8305. Chago. *Sa-lo-mon.* Exhibition. Havana, February-March 2000. Havana: Centro de Desarrollo de las Artes Visuales, 2000. 18 pp.

8306. Feijóo, Samuel. "Chago el Gráfico." *Signos.* No. 21, 1978, pp. 536-537.

8307. Fernández, Antonio E. (Tonel). "Brillo de Chago: 'Salomón' Compartido." *Arte Cubano* (Havana). No. 1, 1998, pp. 13-19.

8308. Fernández, Antonio E. (Tonel). "Ráfagas de Chago." Catalogue. *Ráfagas de Garabatos de Pequeño Formato o Serie de los Anhelos y Esperanzas sin Piedad.* Galería del Humor Juan David. Habana. August/September 1986.

8309. Fernández, Antonio E. (Tonel). "Tonel sobre Chago." Catalogue. *Humor: Chago y Tonel.* Galería de Arte del Cerro. Havana. November 1982.

8310. Földvári, Kornel. "Chago." *Národná Obroda,* August 4, 2000, p. 28.

8311. Földvári, Kornel. "Svetoví Karikaturisti Očami Kornela Földváriho: Chago." *Pravda/Sobota Plus* (Bratislava). December 9, 1995.

8312. Hernández, Orlando. "Chago: La Portañuela Abierta de la Libertad." Catalogue. *Eyaculaciones con Antecedentes Penales.* Galería Espacio Aglutinador. Havana. January 1995.

8313. Mosquera, Gerardo. "Chago: Existir en el Cosmos." Catalogue. *Nace el Topo.* Galería Espacio Aglutinador. Havana. April 1995.

8314. Suárez, Ezequiel. "Levántate Lázaro, No Jodas Chago." Catalogue. *Levántate Chago, No Jodas Lázaro.* Galería Espacio Aglutinador. Havana. February 1996.

Boligán, Ángel.

8315. Boligán, Ángel. *Fútbol, Luego Existo.* Havana: Editorial Unicornia, 2001. 110 pp.

8316. "Premio Nacional para Boligán." *Quevedos.* March 2001, p. 21.

Lauzán, Alen

8317. "Alen Lauzán." *Kayhan Caricature.* November 1998.

8318. "Alen Lauzan Falcon: Greetings from Cuba." *FECO News.* No. 28, 1999, pp. 16-17.

8319. "Cartoongalerij." *Keverinfo.* No. 26, 1998, p. 30.

Lázaro Fernández Moreno

8320. Blanco de la Cruz, Caridad. "The Engineering of Humor." *International Journal of Comic Art.* Fall 1999, pp. 191-194.

8321. Blanco de la Cruz, Caridad. "The Engineering of Humor." *Kayhan Caricature.* December 2000, pp. 20-22.

8322. Blanco de la Cruz, Caridad. "Mizah Mühendisliği." *Karikatürk.* No. 82, 2001, pp. 6-7.

Manuel

8323. Betán. "Esta Vez Fue para Manuel." *Palante.* March 2001, p. 7.

8324. Manuel. (Manuel Hernández). *El Otro Libro de Manuel.* Havana: Ediciones UNIÓN, 1997. Unpaginated.

De la Nuez, René

8325. Arteaga, Luisa Mariana. "'El Humorismo Es Un Arma de Combate." *UPEC.* January/February 1983, pp. 3-6.

8326. Tamayo, Evora. "El Humor Subversivo de Nuez." *UPEC.* May/June 1978, p. 41.

Prohias, Antonio

8327. Adams, Noah. "Prohias Obit." (Interview with *Mad* editor Nick Meglin). National Public Radio's All Things Considered. February 26, 1998.

8328. [Antonio Prohias]. *Cartoonist PROfiles.* December 1970, pp. 38-56.

8329. "Antonio Prohias Passes Away." *Penstuff.* April 1998, p. 5.

8330. Dean, Michael. "'Spy vs. Spy' Creator Antonio Prohias Dies." *Comics Buyer's Guide.* March 20, 1998, p. 8.

8331. Grice, Bonnie. "Remembering Cartoonist of 'Spy vs. Spy.'" National Public Radio's Anthem, February 28, 1998.

8332. Prohias, Antonio. *The Fourth Mad Declassified Papers on Spy vs. Spy.* New York: Warner Books, 1974.

8333. Prohias, Antonio. *Mad's Big Book of Spy vs. Spy Capers and Other Surprises.* Edited by Albert B. Feldstein with Jerry DeFuccio. New York: Warner Books, 1982.

8334. Prohias, Antonio. *Mad's Spy vs. Spy.* New York: New American Library, 1965.

8335. Prohias, Antonio. *Mad's Spy vs. Spy Follow-Up File.* Edited by Albert B. Feldstein. New York: New American Library, 1968.

8336. Prohias, Antonio. *Spy vs. Spy. The Updated Files.* New York: Warner Books, 1989.

8337. Prohias, Antonio. *Third Mad Dossier of Spy vs. Spy.* Edited by Albert B. Feldstein. New York: Paperback Library, 1972.

8338. Stump, Greg. *"Spy Vs. Spy* Creator Antonio Prohias Dies." *Comics Journal.* April 1998, pp. 26-27.

Tomy (Tomás Rodríguez Zayas)

8339. Lent, John A. "Cuba's Tomy, Expert in Coping." *FECO News.* No. 30, 2000, pp. 8-9.

8340. López, Félix. "De Barajagua al Habana Libre." *Granma.* March 31, 2001, p. 6.

8341. Nuñez Rodriguez, Enrique. "Tomy." *Mi Barrio.* March-April 1997, pp. 45-48.

8342. Tomy. (Tomás Rodríguez Zayas). *El Que Inventó La Trampa Hizo la Ley. Caricaturas de Tomy.* Havana: Pablo de la Torriente, 1995. 22 pp.

8343. Tomy. (Tomás Rodríguez Zayas). "(Entre Paréntesis)." *Dedeté.* January 1999, p. 3.

8344. Tomy. (Tomás Rodríguez Zayas). *Humor Exposicion sin Fronteras.* Jornada de la Cultural Cubana en Colombia, 9-20 October 1996, Santafé de Bogotá. Bogota: 1996. 8 pp.

8345. Tomy. (Tomás Rodríguez Zayas). *La Otra Cara de la Baraja.* Havana: Pablo de la Torriente, Editorial, 1997. 32 pp.

8346. "Tomy. O Grito da Terra." Catalogue. Rio de Janeiro: Instituto de Pesquisas, Jardim Botânico de Rio de Janeiro, 1998. 6 pp.

8347. Ziraldo. "Tomy Só Dói Quando Eu Rio." *Palavre.* September 1999, pp. 127-130.

Characters and Titles

8348. "Aniversarios: 'El Mago Ahmed,' 'Cecilín y Coti' and 'Elpidio Valdés.'" *Mi Barrio.* December 1999, p. 47.

8349. "¡ Ay Vecino!" *Mi Barrio.* September 1996, pp. 34-35.

8350. Carbó, Ulises. "Don Centino." *Prensa Libre.* July 16, 1959, p. 1.

8351. "Felicitamos a Péglez."*Mi Barrio.* January/March 2001, p. 29.

8352. "Me Llaman Baboso Porque Te Defiendo. En Defensa de 'don Cizaño' y 'El Loquito.'" *Revolución.* July 17, 1959, p. 1.

"El Bobo"

8353. Abela, Eduardo. "Memorias de El Bobo." *Bohemia.* December 3, 1965, pp. 84-86.

8354. "El Bobo Soñador del Ariguanabo." *Revolución y Cultura.* No. 60, 1977, pp. 38-45.

8355. Riccardi, A. "El Bobo Nació Sobre la Mesa de Un Café," *Crónica.* June 15, 1949, p. 39.

"Elpidio Valdés"

8356. Merino, Ana. "La Historia a Través de la Historieta: Una Reinterpretación de la Independencia de Cuba en 'La Historia de Elpidio

Valdés.'" Paper presented at 'Transforming Cultures' Conference, Ithaca, New York, February 1998.

8357. Padrón Blanco, Ernesto. "No Tuve Superman Tengo a Elpidio Valdés." *Cultura.* January 3, 1998, p. 11.

8358. Perera Robbio, Alina. "Me Emociona Que Elián Recuerde a Elpidio." *Juventud Rebelde.* February 13, 2000, p. 3.

Animation

8359. "Breve Resena Historica del Dibujo Animado Cubano." *Plateau.* Winter 1985, pp. 4-12.

8360. Cobas Amàte, Roberto. "El Dibujo Animado en Cuba: Un Sueño de Poetas." *Cine Cubano.* December 1998, pp. 71-75.

8361. Coelho, Cesar. "The Havana Connection." *Animation World.* February 1998. 3 pp.

8362. Cotas, Roberto. "De la Talla em Madera al Cine de Animacion." *Cine Cubano.* No. 116, 1986, pp. 7-17.

8363. "Palmares." *Plateau.*. Winter 1985, pp. 13-15.

8364. Vrielynck, Robert. "Editorial." *Plateau.* Winter 1985, p. 3.

8365. Zagury, Léa. "A Chat with Hernán Henriquez." *Animation World.* April 1999. 8 pp.

8366. Zagury, Léa. "Latin American Animation in Havana." *Animation World.* April 1999. 3 pp.

Comic Books and Strips

8367. "A Las Puertas del Tercer Milenio en la Habana." *Mi Barrio.* December 1999, p. 48.

8368. Alfaro, Manuel Pérez. "La Historieta Cubana." *El Wendigo.* No. 55, 1992, pp. 32-33.

8369. Arbesú, Faustino R. "Cuba Lucha por Crear un Comic Criollo Latino-Americano." *El Comercio.* May 12, 1974.

8370. Avilés, Cecilio. *Historietas: Reflexiones y Proyecciones.* Havana: Editorial Pablo de la Torriente, 1989.

8371. Avilés, Cecilio. "La Historieta" *UPEC.* May/June 1980, pp. 45-48.

8372. Barros-Lémez, Alvaro. "Comics: Una Invasion no Tan Comica." *UPEC.* November/December 1976/1977, pp. 17-21.

8373. Bertieri, Claudio. "Fumetti a Cuba (2). Quelli di 'P-ele.'" *Sgt. Kirk.* September/October 1976, pp. 504-507.

8374. Blanco, Caridad. *The Unknown Face of Cuban Art.* Sunderland, U.K.: Northern Centre for Contemporary Art, 1992. (Includes Antonio Eligio Fernández [Tonel], "Alternative Humour and Comic Strips: Notes on the Cuban Case").

8375. Bona, Luigi F., Dario Mogno, and Nessim Vaturi. *Fumetti a Cuba.* Milan: Liberia dell'Immagine, 1992. 95 pp.

8376. Maby. "Historieta Cubana." *La Piztola.* January 2001, p. 4.

8377. "Novedad. *Mi Corneta Pepito.*" *Mi Barrio.* September 2000, p. 15.

8378. "A Nuestros Lectores." *Mi Barrio.* January/March 2001, p. 17.

8379. "Otra para la Historieta Cubana." *Mi Barrio.* January/March 2001, p. 29.

8380. Pérez, Manolo. "Homenaje al Che." *Mi Barrio.* March/April 1997, pp. 34-37.

8381. Pérez, Ramón F. "C-Linea y el Comic Cubano." *El Wendigo.* No. 3, 1976.

8382. Rojas Mix, Miguel. "Los Héroes Estáa Fatigados: El Cómic Cien Años Después." *Casa de las Américas.* April-June 1997, pp. 5-24.

Humor Magazines

8383. "Desde Trinidad, *La Anguila* Cerrera." *Mi Barrio.* September 2000, p. 15.

8384. R.A.V. "El Perfume Bueno, en Frasco Chiquito." *Quevedos.* March 2001, p. 21.

Dedeté

8385. Manuel. "*Dedeté.* Con el Mismo Humor." *Dedeté.* June 20, 1998, p. 2.

8386. Piñero, Jorge A. "Dedeté; el Regreso." *Dedeté.* January 1999, p. 2.

8387. Tamayo, Evora. "XV Aniversario de DDT." *UPEC.* May/June 1983, p. 24.

Mi Barrio

8388. "Buzón de Mi Barrio." *Mi Barrio.* December 1999, pp. 16-17.

8389. "Concurso *Mi Barrio.*" *Mi Barrio.* September 1996, front cover.

8390. Núñez Rodríguez, Enrique. "Mi Barrio." *Mi Barrio.* September 1996, p. 1.

8391. Ortega, Víctor Joaquín. "Editorial: Mi Barrio Creció y ¡ Crecerá!" *Mi Barrio.* September 2000, p. 1.

8392. "Taller de Mi Barrio." *Mi Barrio.* January/March 2001, p. 28.

8393. "Taller de *Mi Barrio.*" *Mi Barrio.* September 2000, pp. 28-29.

Palante

8394. Betán. "40 Aniversario. Recordar Es Volver a Reír." *Palante.* March 2001, p. 6.

8395. Betán. "Se Anota *Palante* un Ermengol." *Palante.* May 1998, p. 8.

8396. Betán. "Torre de Babel en Palante." *Palante.* July 1998.

8397. Iscajim. "Palante: Se Puso los Palantalones Largos." *Palante.* March 2001, p. 10.

8398. "Mono Sapiens en Palante." *Palante.* December 2, 1998, p. 12.

CURAÇAO
Political Cartoons

8399. Lent, John A. "Curaçao's Incognito Cartoonist." *WittyWorld International Cartoon Bulletin.* 1/1996, p. 5.

8400. Lent, John A. "A Guessing Game: Curaçao's Incognito Cartoonist." *FECO News.* No. 20, 1996, p. 24.

HAITI
Animation

8401. DeForest, Ray. "Mickey Mouse Comes to Haiti." *Democratic Communique.* Winter 1996, pp. 23-25.

MARTINIQUE
General Sources

8402. "Histoire Caraïbe." *Livres/Hebdo.* December 8, 1981, p. 112.

PUERTO RICO
Cartooning

8403. Rivas, John. "Bonzzo." *Cartoonist PROfiles.* December 1999, pp. 30-37.

8404. Rodríguez, Myrna. "Diseño Gráfico en Puerto Rico." *Print.* March/April 1984, pp. 47-57.

VIRGIN ISLANDS
Animation

8405. "Enter the Virgin Islands International Animated Film Festival...." *ASIFA San Francisco Newsletter.* April 2001, p. 8.

7
ADDENDUM

INTER-REGIONAL PERSPECTIVES

8406. "Asya-Afrika Halklarinin Antiemperyalist Karikatürlerinden Seçmeler."
Günaydin Ustura. No. 57, 1970, p. 6.

8407. "Cartoons from UNICEF." In *Thai Anima 2003. The First International
Animation Festival 11-15 Jan. 2003*, pp. 60-70. Bangkok: Thai Anima,
2003.

8408. "A Critical Note on the Arab Cartooning." *Kayhan Caricature*. February
2002, pp. 4-5.

8409. Hafez, Kai, ed. *Islam and the West in the Mass Media*. Cresskill, New
Jersey: Hampton Press, 2000. ("The Campaigns Against 'Aladdin' and
'True Lies'").

8410. Kishtainy, Khalid. *Arab Political Humor*. London: Quartet, 1985.

8411. Lent, John A. *Comic Art in Africa, Asia, Australia, and Latin America:
A Comprehensive, International Bibliography*. Westport, Connecticut:
Greenwood Press, 1996. 518 pp.

8412. Yaqub, Reshma M. "Insult and Injury: Harmful Portrayals in Cartoons
Are No Laughing Matter to Arabs." *Chicago Tribune*. March 11, 1994.

AFRICA
General Sources

8413. Beez, Jigal. *Geschosse zu Wassertropfen: Sozio-religiöse Aspekte des Maji-Maji Krieges*. Magisterarbeit im Fachbereich Sozialwissenschaften der Universität Mainz.

8414. Dale, Penny. "'Justice for Zongo' Campaign Hits African Press." One World Africa dispatch, December 12, 2001.

8415. Lasekan, Akinola. "Problems of Contemporary African Artists." *Kurio Africana: Journal of Art Criticism* (Ile-Ife, Nigeria). 1:1, 1989, pp. 31-32.

Cartooning, Cartoons

8416. Eko, Lyombe. "Freedom of the Press in Africa" (Political Liberalization and the African Satirical Comic Strip). In *Encyclopedia of International Media and Communications. Volume 2*, edited by Donald H. Johnston, pp. 109-111. New York: Academic Press, 2003.

8417. Lent, John A. "African Cartooning: An Overview of Issues and Problems." In *Cartooning in Africa*, edited by John A. Lent. Cresskill, New Jersey: Hampton Press, 2003.

8418. Lent, John A. *Cartooning in Africa*. Cresskill, New Jersey: Hampton Press, 2003.

8419. Lent, John A. "Comic Art 'In Bounds' – The Case of Southern Africa." Paper presented at ICAF, Bethesda, Maryland, September 5, 2002.

8420. Lent, John A. "Southern Africa: Hardly a Cartoonist's Eden." In *Cartooning in Africa*, edited by John A. Lent. Cresskill, New Jersey: Hampton Press, 2003.

8421. Manyire, Wilson. "The Brain Behind Kingo Cartoon." *New Vision* (Kampala). January 17, 2002.

8422. Mason, Andy. "Africa Ink: Cartoonists Working Group, Towards an Association of African Cartoonists: Report of an International Workshop on Cartoon Journalism and Democratisation in Southern Africa." *International Journal of Comic Art*. Spring 2001, pp. 191-197.

8423. Russell, Robert. "*Vignette*: Cartoonists Rights Network, Free Speech, and Cartooning in Africa." In *Cartooning in Africa*, edited by John A. Lent. Cresskill, New Jersey: Hampton Press, 2003.

8424. Watremez, Emmanuel. "*Vignette*: The Satirical Press in Francophone Africa." In *Cartooning in Africa*, edited by John A. Lent. Cresskill, New Jersey: Hampton Press, 2003.

Comics

8425. Barnett, Barbara. "Emma Says: A Case Study of the Use of Comics for Health Education Among Women in the AIDS Heartland." Paper presented at Association for Education in Journalism and Mass Communication, Washington, D.C., August 2001.

8426. Beez, Jigal. "They Are Crazy These Swahili: *Komredi Kipepe* in the Footsteps of Astérix; Globalization in East Africa Comics." *International Journal of Comic Art*. Spring 2003, pp. 95-114.

8427. Braeckman, Colette. "Barly Baruti: Dessiner Envers et Contre Tous à Kinshasha." *Le Soir*. n.d. (1992?).

8428. François, Edoard. "Raoul et Gaston, le Mythe Africain." *Phénix*. No. 13, 1970, pp. 31-35.

8429. Jannone, Christian. "Les Hommes-Léopards et Leurs Dérivés dans la Bande Desinée." In *L'Autre et Nous: Scènes et Types*, edited by Pascal Blanchard, *et al.*, pp. 197-200. Paris: Association Connaissance de l'Histoire de l'Afrique Contemporaine and Syros, 1995.

8430. Lent, John A. "Comics for Development and Conscientization." In *Cartooning in Africa*, edited by John A. Lent. Cresskill, New Jersey: Hampton Press, 2003.

8431. Martirossiantz, Anouche. "L'Afrique Centrale Vue par la Bande Dessinée: Notes de Lecture." In *Papier Blanc, Encre Noire: Cent Ans de Culture Francophone en Afrique Centrale (Zaire, Rwanda, et Burundi)*, vol. 2, edited by Marc Quaghebeur, E. van Balberghe, *et al*, pp. 627-641. Brussels: Editions Labor, 1992.

8432. Pierre, Michel. "Un Certain Rêve Africain." *Les Cahiers de la Bande Dessinée*. February-March 1984, pp. 83-86.

Algeria
Cartooning, Cartoons

8433. Douglas, Allen and Fedwa Malti-Douglas. "The Algerian Strip and Bilingual Politics." In *Cartooning in Africa*, edited by John A. Lent. Cresskill, New Jersey: Hampton Press, 2003.

8434. Douglas, Allen and Fedwa Malti-Douglas. "*Vignette*: 'A' Is for Algeria (or Afghanistan)." In *Cartooning in Africa*, edited by John A. Lent. Cresskill, New Jersey: Hampton Press, 2003.

8435. Lent, John A. "*Vignette*. The Horrors of Cartooning in Slim's Algeria." In *Cartooning in Africa*, edited by John A. Lent. Cresskill, New Jersey: Hampton Press, 2003.

Angola
Comics

8436. Andersson, Per A.J. "Oh La La!" *Bild & Bubbla*. No. 1, 1994, p. 42.

8437. Mantlo, Bill. "*Vignette*: From Slavery to Freedom: A Comic Book from Angola." In *Cartooning in Africa*, edited by John A. Lent. Cresskill, New Jersey: Hampton Press, 2003.

Cameroon
Political Cartoons

8438. Nyamnjoh, Francis B. "Press Cartoons and Politics: The Case of Cameroon." In *Cartooning in Africa*, edited by John A. Lent. Cresskill, New Jersey: Hampton Press, 2003.

8439. Russell, Robert. "Cartoonist Attacked at Police Check Point." *Yeni Akrep*. March 2003, p. 6.

Congo
Comics

8440. Baruti, Barly and Jean-Pierre Jacquemin. [Brief essays.] In *Un Diner à Kinshasha: Concours BD 96 Bruxelles-Kinshasha*. Brussels: Édition Ti Suka asbl, 1996.

8441. Chanson, Philippe. *Tintin au Congo, c'est Quand Même un Peu GROS! Une Relecture Critique de l'Imagerie Nègre en Perspective Créole*. Cartigny: Tribune Libre, 1995.

8442. Halen, Pierre. "Le Congo Revisité: Une Décennie de Bandes Dessinées 'Belge' (1892-1992)." *Textyles*. No. 9, 1992, pp. 291-306.

8443. Halen, Pierre. "Tintin, Paradigme du Héros Colonial Belge? (A Propos de 'Tintin au Congo')." In *Tintin, Hergé et la Belgité*, edited by Anna Soncini Fratta. Bologna: Cooperativa Libraria Universitaria Editrice Bologna, 1994.

8444. Herman, Paul. "Bande Dessinée et Congo: De la Passion au Flirt Discret." In *Zaïre 1885-1985: Cent Ans de Regards Belges*. Brussels: Coopération par Éducation et la Culture, 1985.

8445. Hunt, Nancy R. "Tintin and the Interruptions of Congolese Comics." In *Images and Empires: Visuality in Colonial and Postcolonial Africa*, edited by Paul S. Landau and Deborah D. Kaspin, pp. 90-123. Berkeley: University of California Press, 2002.

8446. Jacquemin, Jean-Pierre. "BD Africaine: Masques, Perruques." In *L'Année de la Bande Dessinée 86-87*, edited by Stan Berts and Thierry Groensteen. Grenoble: Éditions Glénat, 1986.

8447. Maurin Abomo, Marie Rose. "'Tintin au Congo,' ou la Stratégie d'une Démarche Coloniale." In *Tintin, Hergé et la Belgité*, edited by Anna Soncini Fratta, pp. 57-73. Bologna: Cooperativa Libraria Universitaria Editrice Bologna, 1994.

Egypt
General Sources

8448. Armbrust, Walter. "Bourgeois Leisure and Egyptian Media Fantasies." In *New Media in the Muslim World: The Emerging Public Sphere*, edited by Dale F. Eickelman and Jon W. Anderson, pp. 106-132. Bloomington: Indiana University Press, 1999.

8449. Douglas, Allen and Fedwa Malti-Douglas. "Egyptian Comic Strips as Indigenous and Western Phenomena." *In Cartooning in Africa*, edited by John A. Lent. Cresskill, New Jersey: Hampton Press, 2003.

8450. "Egypt the 2nd International Cartoon Contest." *Iran Cartoon.* September 2001, p. 57.

8451. "Greeting of FECO Egypt." *Al-Pharaennah.* March 2003, p. 3.

8452. "International Cartoon Exhibition at Alexandria-Egypt." *Yeni Akrep.* January 2003, p. 5.

Cartoonists and Their Works

8453. "Case Study: Essam Hanafy." *Borderline.* December 2002, p. 17.

8454. "Ellabbad/Egypt." *Kayhan Caricature.* May 2002, 2 pp.

8455. Rageh, Rawya. "Mustafa Hussein's Cartoons: Drawing What Egyptians Are Thinking." Associated Press dispatch, January 30, 2003.

8456. "Word of Issue by EFFAT." *Al-Pharaennah.* March 2003, p. 2.

Ghana
General Sources

8457. Wolfe, Ernie, III. *Extreme Canvas: Hand-Painted Movie Posters from Ghana*. Los Angeles: Dilettante Press/Kesho Press, 2000. 305 pp.

Kenya
Cartooning, Cartoons

8458. Lent, John A., with Levi Obonyo and Dorothy Njoroge. "Foreignness and Kenyan Cartooning." In *Cartooning in Africa*, edited by John A. Lent. Cresskill, New Jersey: Hampton Press, 2003.

Mozambique
Cartoons, Comics

8459. Packalén, Leif. "Cartooning in Mozambique: An Overview." In *Cartooning in Africa*, edited by John A. Lent. Cresskill, New Jersey: Hampton Press, 2003.

8460. Wibier, Harry. "Jan Kruis in Mozambique." *Stripschrift*. No. 342, 2002, pp. 12-13.

Nigeria
General Sources

8461. Anikulapo, J. and O. Uhakhene. "There Is Tyranny in Curating, Says Jegede." *The Guardian* (Lagos). January 25, 1999, p. 66.

8462. Ogundeji, A. "Life in a Laugh." *The Guardian* (Lagos). March 9, 1996, p. 12.

Cartooning, Cartoons

8463. Medubi, Oyin. "Cartooning in Nigeria: Large Canvas, Little Movement." In *Cartooning in Africa*, edited by John A. Lent. Cresskill, New Jersey: Hampton Press, 2003.

8464. Olaniyan, Tejumola. "Cartooning Nigerian Anticolonial Nationalism." In *Images and Empires: Visuality in Colonial and Postcolonial Africa*, edited by Paul S. Landau, and Deborah D. Kaspin, pp. 124-140. Berkeley: University of California Press, 2002.

Political Cartoonists

8465. Lent, John A. "*Vignette*: Nigerian Cartooning Pro and Con: An Exchange Between an Editor and Two Cartoonists." In *Cartooning in Africa*, edited by John A. Lent. Cresskill, New Jersey: Hampton Press, 2003.

8466. Udechukwu, O. "Nigerian Political Cartoonists in the 1970s." *New Culture*. September 1979, pp. 13-20, 25.

South Africa
Cartooning, Cartoons

8467. Mason, Andy, "Black & White in Ink: Discourses of Resistance in South African Cartooning." In *Cartooning in Africa*, edited by John A. Lent. Cresskill, New Jersey: Hampton Press, 2003.

8468. Mason, Andy, "Black & White in Ink: Discourses of Resistance in South African Cartooning." Paper presented to FESCARY 2002 (Festival of Cartooning), Younde, Cameroon, April 2002.

8469. Mason, Andy. "Local vs Global: South African Cartooning in the Context of Media Convergence." Paper presented to International Seminar on Convergence, Technology and Social Impacts, University of Natal, May 2002.

Cartoonists and Their Works

8470. Glueck, Grace. "Apartheid and Its Bitter Aftertaste." *New York Times*. June 8, 2001, pp. 27, 30. (William Kentridge).

8471. Lent, John A. "*Vignette*: South Africa's Napier Dunn – Have French Horn (or Pencil), Will Travel." In *Cartooning in Africa*, edited by John A. Lent. Cresskill, New Jersey: Hampton Press, 2003.

8472. Myers, Holly. "The Personal and the Political: William Kentridge, Straight Out of South Africa." *LA Weekly*. September 13-19, 2002, p. 32.

8473. Sheets, Hilarie M. "In a Kaleidoscope of Remembering and Forgetting." *New York Times*. June 17, 2001, p. 30. (William Kentridge).

8474. van der Hoeven, Erik. "Ina van Zyl." *Stripschrift*. June 2002, pp. 16-17.

Animation

8475. Chumbler, Christine. "Muppets Take South Africa." *USAID in Africa*. Fall 2002, p. 5.

8476. Roja, Genevieve. "Sesame St. HIV." *Action*. September 2002, p. 3.

Comics

8477. Shariff, Patricia Watson and Hilary Janks. "Changing Stories: The Making and Analysis of a Critical Literacy Romance Comic." *International Journal of Comic Art*. Fall 2001, pp. 222-238.

Tanzania
Comics

8478. Beck, Rose Marie. "Comic in Swahili or Swahili Comic?" *AAP*. 60 (1999), pp. 67-101.

8479. Packalén, Leif. "Tanzanian Comic Art: Vibrant and Plentiful." In *Cartooning in Africa*, edited by John A. Lent. Cresskill, New Jersey: Hampton Press, 2003.

Political Cartoons

8480. *Art in Politics – Sanaa Katika Siasa: The First East African Competition on Political Caricatures and Cartoons*. Dar es Salaam: Friedrich Ebert Stiftung, 2001.

8481. Kipanya, Masoud. "Kipanya ni Nani?" *Femina*. February-April 2001, pp. 4-7.

8482. Kipanya, Masoud. "The Rough Path of Political Caricatures – Vikwazo na Mwelekeo wa Katuni za Kisiasa." In *Art in Politics – Sanaa Katika Siasa: The First East African Competition on Political Caricatures and Cartoons*. Dar es Salaam: Friedrich Ebert Stiftung, 2001.

Tunisia
Comics

8483. Douglas, Allen and Fedwa Malti-Douglas. "Tradition Viewed from the Maghrib: Tunisia." In *Cartooning in Africa*, edited by John A. Lent. Cresskill, New Jersey: Hampton Press, 2003.

MIDDLE EAST

General Sources

8484. "A Critique on Arab Cartoons." *Kayhan Caricature*. May 2002, 4 pp.

8485. "Greeting of Arab Cartoonist." *Al-Pharaennah*. March 2003, p. 6.

8486. "Greeting to Mahmoud Khuiel." *Al-Pharaennah*. March 2003, p. 5.

8487. "Hamed Ata." *Kayhan Caricature*. May 2002, 2 pp.

8488. Keys, Lisa. "Drawing Peace in the Middle East: Super Men Replace Superman as the Israeli-Palestinian Conflict Invades Comics." *Forward*. April 11, 2003.

8489. Rifas, Leonard. "Ugly Cartoons, Ugly Generalizations." *Comics Journal*. October 2002, pp. 38-40.

Iran
General Sources

8490. Haji, Majid. "Terrorist of a Subjective Kind." *Iran Cartoon*. September 2001, pp. 46-49.

8491. "How the Titles of the Kid's Program Was Made." *Kayhan Caricature*. November 2002, 3 pp.

8492. Najafe, Mohsen Nuri. "Peace and Reconciliation with Shadows." *Ketâb-e. Mâh* (The Arts). No. 33, 34, 2002 (?).

Cartooning, Cartoons

8493. "Ankido at the Cartoon House." *Kayhan Caricature*. November 2001, pp. 14-18.

8494. "Creativity in Cartoons." *Kayhan Caricature*. November 2002, 1 p.

8495. "Educating Citizenship." *Kayhan Caricature*. December 2001, pp. 20-26.

8496. Gravett, Paul. "World Comics." *Borderline*. November 2001, pp. 12-13. (Cartoon book).

8497. Hafezi, Parisa. "Iran Leader's Brother Rejects Caricature Criticism." Reuters dispatch, January 12, 2003.

8498. *Iran Cartoon*. Cartoon & Caricature Specialized Magazine. In Farsi and English, with interviews, news, cartoons of Iranian and other cartoonists. First issue, September 2001.

8499. Lent, John A. "Land in Zicht – Iran." *Stripschrift*. September 2001, p. 25.

8500. Niroumand, M.H. "Spring Dreams and Three Seasons of Absence." *Kayhan Caricature*. June 2001, pp. 49-50.

8501. Tabatabai, Massoud Shojai. "Editorial." *Iran Cartoon*. September 2001, p. 4.

Cartoonists

8502. "[Bahram Azimi]." *Kayhan Caricature*. December 2001, pp. 3-8.

8503. "Bahram Azimi." *Kayhan Caricature*. December 2001, inside back cover.

8504. "Caricaturist Ecologist." *Kayhan Caricature*. March 2003, 4 pp.

8505. "CRN's Russell Hears from Nik Kowsar." *AAEC Notebook*. June 2002, p. 12.

8506. "An Interview with Ali Jahanshahi." *Iran Cartoon*. September 2001, pp. 18-19.

8507. "An Interview with Hamid Bahrami." *Iran Cartoon*. September 2001, pp. 40-42.

8508. "An Interview with Jarad Alizadeh." *Ketâb-e. Mâh* (The Arts). No. 33, 34, 2002(?).

8509. "An Interview with Sayyid Masud Shojai ye Tabatabai." *Ketâb-e. Mâh* (The Arts). No. 33, 34, 2002(?).

8510. "An Interview with Touka Neyestani." *Iran Cartoon*. September 2001, pp. 50-52.

8511. "Iranian Caricature (An Interview with Kiyumarth Saberi Fumani)." *Ketâb-e. Mâh* (The Arts). No. 33, 34, 2002 (?).

8512. [Kavianrad]. *Kayhan Caricature*. January 2003.

8513. "The Role and Importance of Caricature: An Interview with Muhamnmad Hosian Nirumand." *Ketâb-e. Mâh* (The Arts). No. 33, 34, 2002 (?).

8514. Tabatabai, Massoud Shojai. "Hurdle Race." *Iran Cartoon*. September 2001, pp. 24-27. (Touka Neyestani).

8515. "The Works of Jamal Rahmati Is Exhibited in the Iranian House of Cartoon." *Iran Cartoon*. September 2001, p. 57.

Exhibitions, Festivals

8516. "Caricature Exhibition of Afshin Sabouki 6-13 Dec. 2001." *Kayhan Caricature*. December 2001, pp. 44-45.

8517. "The Cartoon Exhibition of the City Without Police." *Iran Cartoon.* September 2001, p. 58.

8518. "End of Fifth Festival." *Kayhan Caricature.* December 2001, pp. 38-41.

8519. "The Festival of Cartoons of Mountain Echo-system." *Kayhan Caricature.* March 2003, 15 pp.

8520. "The 5th Tehran International Cartoon Biennial." *Iran Cartoon.* September 2001, pp. 53-57.

8521. "The 5th Tehran International Cartoon Biennial." *Iran Cartoon.* November 2001, pp. 4-5.

8522. "Tehran International Cartoon Biennial." *Kayhan Caricature.* November 2001, pp. 8-10.

8523. Vladermersky, Nag. "My Trip to Tehran." *Animation World.* April 2001, pp. 55-57.

8524. "What Happened at the Forum?" *Kayhan Caricature.* December 2001, pp. 33-37.

Caricature

8525. Akrami, Ali. "Sports Caricature in Iran." *Ketâb-e. Mâh* (The Arts). No. 33, 34, 2002 (?).

8526. "Caricature." Special number. *Ketâb-e. Mâh* (The Arts). No. 33, 34, 2002 (?).

8527. Iranmanesh, Muhammad. "The Art of Caricature and the Need for Revising Its Education." *Ketâb-e. Mâh* (The Arts). No. 33, 34, 2002 (?).

8528. Rafiziyai, Mohammad. "Caricature in the Past (Iran)." *Kayhan Caricature.* March 2003, 2 pp.

8529. Tabatabai, Masoud Shojai. "Caricature and Cartoon in Iran." http://www.irancartoon.com/HISTORY/HISTORY.HTM. Accessed March 5, 2003.

Iraq
Cartooning

8530. "Stuck in the Iraqi Kurdestan." *Kayhan Caricature.* February 2002, 2 pp.

Israel
General Sources

8531. Beaty, Bart. "Actus Tragicus: The Case for Considering Israel a European Country." *Comics Journal*. August 2001, pp. 105-108.

8532. "News from FECO Israel." *FECO News*. No. 33, 2001, p. 11.

Cartoonists and Their Works

8533. Atterbom, Daniel and Gabriel Stein. "Ya'akov Kirschen, Israelisk Societecknare: Från Schizofren till 'Dubbelt Dum.'" *Bild & Bubbla*. No. 3/4, 1985, pp. 53-57.

8534. Pace, Eric. "Yaskov Farkas, Cartoonist, Is Dead at 79." *New York Times*. October 19, 2002.

8535. "Yaacov 'Zeev' Farkas Dies at Age 79." *FECO News Bulletin*. November 2002, p. 4.

8536. "Yaacov 'Zeev' Farkas, Israeli Cartoon Pioneer." *Cleveland Plain Dealer*. October 17, 2002.

Animation

8537. Oren, Tsvika. "Israel's Film Festivals." *Animation World*. September 2000, pp. 45-47.

8538. Oren, Tsvika. "Jewish Rabbits." *Animation World*. September 2000, pp. 41-44.

8539. Oren, Tsvika. "News from ASIFA Israel." *ASIFA San Francisco*. December 2001, pp. 6-7.

8540. Oren, Tsvika. "The 19th Jerusalem Film Festival." *ASIFA San Francisco*. September 2002, p. 5.

8541. Siegel-Itrzkovich, Judy. "DISKCOVERY: Easy English?" *Jerusalem Post*. October 10, 2002.

Comics

8542. Davis, Barry. "Think Young, Think Fink." *Jerusalem Post*. October 17, 2002.

Palestine
Cartoonists

8543. Al-Khanjare, Mona. "Palestinian Struggle in Cartoons." Gulf News Online, August 31, 2001. (Naji Al Ali).

8544. Kowsar, Nik Ahang. "Palestine and American Caricaturists." *Kayhan Caricature*. March 2003, 1 pp.

8545. "Moutaz Ali/Palestine." *Kayhan Caricature*. May 2002, 2 pp.

Saudi Arabia
Cartoonist

8546. Al Maeena, Khalid. "Arab News Cartoonist Kahil Dies in London." *http://www.arabnews.com/Article-asp?ID=22712* Posted February 12, 2003.

Syria
Cartoonists and Their Works

8547. Biedermann, Ferry. "Damascus Feeds Anti-War Fever." Radio Netherlands Wereldomroep. April 4, 2003. (Ali Ferzat).

8548. "Fares Garabet/Syria." *Kayhan Caricature*. May 2002, 2 pp.

8549. "*Muhammad* First U.S./Middle Eastern Animated Co-Production." *Animation*. August 2001, p. 34.

8550. "Syrian Cartoonist in Hot Water over anti-Saddam Cartoons." *Comics Journal* website. April 3, 2003. (Ali Ferzat).

ASIA
General Sources

8551. Lent, John A. "Cartooning in Malaysia and Singapore: The Same but Different." *Berita*. Fall/Winter 2002, pp. 14-34.

8552. Ratuva, Steven. "The Social Construction of Humour." *Pacific Journalism Review*. September 2001, pp. 119-125.

Animation

8553. "'Animation in Asia and the Pacific' Is an Important Book." *ASIFA San Francisco*. November 2001, p. 6.

8554. Kan, Wendy. "Mickey's Mission." *Variety*. September 9-15, 2002, p. 25. (Disney Channel, India, China).

8555. Koehler, Robert. "The Prince of Light: The Legend of Ramayana." *Variety*. November 12-18, 2001, p. 28. (Japan, India, U.S.).

8556. Koehler, Robert. "Tacky Animation Not Fit for a 'Prince.'" *Variety*. November 9, 2001. (India, Japan).

8557. Lent, John A. "Asian Animation: Adoption, Adaptation, and Reinterpretation." *New Films*. 6/2001, pp. 34-39.

8558. Lent, John A., ed. "Asian Animation: Commercial and Artistic Perspectives." Symposim of 13 articles. *Asian Cinema*. Spring 2003, pp. 1-137.

8559. Lent, John A. "The New Age of Asian Animation." *Asian Cinema*. Spring 2003, pp. 3-12.

8560. Lent, John A. "Three Giant Gaps Left in Asian Cartooning." *Comics Journal*. February 2003, pp. 89-91. (Abu Abraham, India; Rejab Had, Malaysia; Nonoy Marcelo, Philippines).

8561. Lent, John A. and Xu Ying. "Animation in Southeast Asia." *World Affairs Pictorial*. 11, 2001, pp. 34-39.

8562. Mollman, Steve. "No-Fly Zones." *Asiaweek*. November 30, 2001, p. 41. (Video games).

8563. Neal, Alan. "Animation in Asia and the Pacific." *Animation World*. January 2002, pp. 58-60.

8564. "Run-Dim." *Animatoon*. No. 34, 2001, pp. 72-73.

8565. Thompson, Pamela Kleibrink. "Inside Job: The Overseas Supervisor." *Animation*. November 2001, pp. 43-44.

8566. Webb, Pat Raine. "Animation in Asia and the Pacific, edited by John A. Lent." *Animatoon*. No. 33, 2001, pp. 78-79.

8567. "World Animation News." *Animatoon*. No. 34, 2001, pp. 62-79. (Japan, Korea).

8568. Wozniak, Lara. "Zip-a-Dee-Doo-Dah.*" Far Eastern Economic Review*. January 23, 2003, p. 26.

Comics

8569. Kwon, Jae-Woong. "Asian History in the 'Historia.'" Paper presented at Popular Culture Association, Toronto, Canada, March 14, 2001.

8570. Lent, John A., ed. *Illustrating Asia: Comics, Humor Magazines and Picture Books*. Honolulu: University of Hawaii Press, 2001. 249 pp.

8571. Noguchi, Irene. "'Asian Girl': Comic Strip of a Different Stripe." *Washington Post*. August 27, 2001, pp. C1, C7.

8572. Noh Sueen. "The Relationship Between Korean and Japanese Girls' Comics." MA thesis, Ewha Woman's University, Seoul, 2000.

8573. Reid, Calvin. "Asian Comics Delight U.S. Readers." *Publishers Weekly*. December 23, 2002.

8574. Seybert, Tony. "Asian Stereotypes in the Comics, 1937-1956: From Fu Manchu to Jimmy Woo." *Comic Effect*. Winter 2002, pp. 31-37.

Afghanistan
Political Cartoons

8575. Gall, Carlotta. "Afghan Editors Test Freedom's Boundaries with Cartoons." comics_news@yahoogroups.com. January 12, 2003.

Azerbaijan
Political Cartoons

8576. "Police Confiscates Newspaper." April 22, 2003. http://www.cascfen.org/modules.php?name=News&file=article&sid=331

8577. Tucker, Ernest. "The Newspaper Mullah Nasr al-Din and Satirical Journalism in Early Twentieth Century Azerbaijan." Unpublished paper, Chicago, 1987.

Bangladesh
General Sources

8578. Du Correspondent. "JCD Activists Set Fire to 'Anti-Communal' Cartoons in City." Bangladesh *Daily Star*. September 23, 2001.

8579. "Workers from a Disney Sweatshop in Bangladesh Are Touring America To Let the Public Know How Bad Conditions Are There." *ASIFA San Francisco*. November 2002, p. 4.

Brunei
Cartoonist

8580. Hasib Azaraimy Hj and Lyna Mohamad. "More Cuboi Antics, Laughter in Sequel." *Borneo Bulletin*. November 2, 2002. (Brunei's Abang Rahim).

Burma
Political Cartoons

8581. Mockenhaupt, Brian. "Wordsmithery." *Far Eastern Economic Review.* September 20, 2001, pp. 72-75.

China
General Sources

8582. Cao Juan, comp. *Facial Makeup in Traditional Chinese Operas.* Beijing: The Institute of Traditional Chinese Operas, Art Academy of China, 2000. 159 pp.

8583. Hansson, Cecilia. "Tidiga Kinesiska Serier – Ett Samtal med Christoph Harbsmeier." *Bild & Bubbla.* No. 2, 1987, pp. 28-31.

8584. Landsberger, Stefan. *Chinese Propaganda Posters: From Revolution to Modernization.* Amsterdam: The Pepin Press, 1995. 216 pp.

8585. Liu Jilin. *Chinese Shadow Puppet Plays.* Beijing: Morning Glory Publishers, 1988. 112 pp.

8586. *The Style and Features of Guangzhou. 100 Years. Wan Zhao Quan Statue Works Collection.* Guangzhou: Guangdong Folk Art Museum, 2001. 208 pp.

8587. Wang Shucun. *Paper Joss. Deity Worship Through Folk Prints.* Beijing: New World Press, 1992. 190 pp.

8588. Wang Tianyi, comp. *Underground Art Gallery: China's Brick Paintings 1,700 Years Ago.* Beijing: New World Press, 1989. 131 pp.

8589. Ye Yu Sun. *Rong Yuan Bamboo Carving.* Singapore: Singapore Cultural Association, 2000. 76 pp. Introduction by Feng Yiyin.

8590. Zhang Shuxian. *The Art of Chinese Folk Papercuts.* Beijing: China Today Press, 1996. 226 pp.

8591. Zhou Ping. *Creation and Appreciation of Decorative Art.* Harbin: Heilongjiang Arts Press, 1999. 126 pp.

Cartooning, Cartoons

8592. Bi Keguan. *The Words and Pictures of Cartoons: 100 Years Cartoon Reflections.* Beijing: China Literature & History Press, 2002. 314 pp.

8593. Bi, Wanying. "Looking for Materials from the Details of Life." *Chinese Cartoon Selection Journal.* No. 2, 1999, p. 18.

8594. Bi, Wanying. "More Miserable than Pigeon's Cage." *Chinese Cartoon Selection Journal*. No. 2, 1999, p. 18.

8595. *Cartoon in History. Special Edition of Old Cartoon.* Jinan: Shandong Pictorial Press, 2002. 252 pp.

8596. "Chinese Cartoon Industry Steps Out of Depression." *People's Daily Online*. November 17, 2000.

8597. Eckholm, Erik. "Chinese Prosecutors Deal a Full Deck of Warnings." *New York Times*. March 25, 2002, p. A4.

8598. Fang Cheng. *The Humor of Cartoon*. Beijing: Peoples Literature Press, 2002. 177 pp.

8599. Fang Cheng. "Looking for the Taste of Cartoon." *Chinese Cartoon Selection Journal*. No. 2, 1999, p. 8.

8600. *50 Years of Beijing Workers' Cartoons.* Beijing: Beijing Workers' Union, Beijing Artists' Association, Beijing Laborers Palace, 1999.

8601. *50 Years of Chinese Cartoon.* Wuhan: Changjiang Arts Press, 2001.

8602. He Wei. "Getting a High Taste When Drawing Wonderfully." *Yuanyuan Caricature*. No. 2, 2002, pp. 2-3.

8603. He Wei,. "John Lent: Asking and Answering Record." *Humor and Satire*. July 20, 2001, p. 5.

8604. He Wei. "Very Interesting." *Chinese Cartoon Selection Journal*. No. 1, 1999, pp. 32-33.

8605. *History in Cartoon. Special Edition of Old Cartoon.* Jinan: Shandong Pictorial Press, 2002. 250 pp.

8606. Hua Junwu. "Several Words – Talking About Cartoon – Every Four Years' Astronomic Phenomenon." *Chinese Cartoon Selection Journal*. Original No. 1, 1998, p. 6.

8607. Huang Yuanlin. "All Leaves Are Full of Emotion." *Yuanyuan Caricature*. No. 2, 2002, pp. 2-3.

8608. Huang Yuanlin. "One Hundred Year's Cartoon No. 1 & No. 2." *Chinese Cartoon Selection Journal*. Original No. 1, 1998, p. 32.

8609. Huang Yuanlin. "One Hundred Year's Cartoon No. 3 and No. 4." *Chinese Cartoon Selection Journal*. No. 1, 1999, p. 48.

8610. Huang Yuanlin. "One Hundred Year's Cartoon No. 5 and No. 6." *Chinese Cartoon Selection Journal*. No. 2, 1999, p. 48.

8611. "Introduction of 'Miss Bee.'" *Chinese Cartoon Selection Journal.* No. 2, 1999, pp. 24-25.

8612. Lent, John A. and Xu Ying. "Chinese Cartooning: The Veteran Artists' Views." Paper presented at Popular Culture Association, Toronto, Canada, March 14, 2001.

8613. Ma Gualiang. *Memory of The Young Companion – A Pictorial and a Time.* Beijing: Life, Reading and New Knowledge Press, 2002.

8614. Miao Yin Tang. *Exquisite Selection of Chinese Ancient Jokes.* Hainan: South Press, 2001. 337 pp.

8615. Sen Zhe Lang. *Zhongguo Kangri Manhuashi* (Chinese Anti-Japanese Cartoon History). Guangzhou: Shantong Pictorial Press, 1999. 232 pp.

8616. Sima Ding. "Telephone and Laughing." *Chinese Cartoon Selection Journal.* No. 2, 1999, pp. 30-31.

8617. "Some Preliminary Notes on Chinese Jokes and Cartoons." In *China in the 1980's – and Beyond,* edited by B. Arendrup, C.B. Thogesen, and A. Wedell-Wedellsborg. Copenhagen: Studies on Asian Topics No. 9, Scandinavian Institute of Asian Studies, 1986.

8618. "Tongxiang Becomes China's Cartoon Hometown." *Yuanyuan Caricature.* December 2001, p. 2.

8619. Toru Kono. "Comics and Animation Hot with Young Chinese." Kyodo News Service dispatch, October 3, 2002.

8620. Wang Fuyang. *Cartoons' New Plight.* Beijing: Chinese Tourist Press, 1997. 108 pp.

8621. Wang Jun Cai, ed. *Tu Quan Cartoon Selections.* Huhehaote: Inner Mongolia People's Press, 1997. 168 pp.

8622. Wen Dalin. "The Position of Five Organs on Face." *Yuanyuan Caricature.* No. 2, 2002, pp. 11-12.

8623. Wen Dalin. "What Is Cartoon?" *Yuanyuan Caricature.* No. 2, 2002, pp. 11-12.

8624. Wen Dalin. "When the Drum's Sounding." *Yuanyuan Caricature.* No. 1, 2002, pp. 12-13.

8625. Xue Shan and Liu Zhi. *Cartoon Love Songs.* Beijing: People's Literature Press, 2000.

8626. Yu Ling. "The Art of Chinese Cartooning." *China Today.* May 1996, pp. 47-50.

8627. "Zhejiang Primary School Students' Works." *Yuanyuan Caricature.* December 2001, pp. 27-29.

Military Cartoons

8628. Zheng Hua Gai, ed. *Analysis of the Foreign Armies Caricatures.* Beijing: Liberation Army Press, 2001. 238 pp.

8629. Zheng Hua Gai, ed. *Collection of Humor Cartoons of the Military Base.* Beijing: People's Liberation Army Art Press, 1994. 119 pp.

8630. Zheng Hua Gai, Chun Yu, and Bao Yue-ping, eds. *The World's Cartoons of Military.* Wuhan: Hubei Arts Press, 1999. 156 pp.

Cartoonists and their Works

8631. Anderson, Sara. "No Longer Hidden." *USA Weekend.* August 10-12, 2001, p. 12. (Zhang Ziyi).

8632. Sima Ding. "Introduction of Zhang Jing." *Chinese Cartoon Selection Journal.* No. 1, 1999, pp. 4-5.

8633. He Wei. "Jiang Fan's Recent Works Are Wonderful." *Chinese Cartoon Selection Journal.* Original No. 1, 1998, p. 3.

8634. He Wei. "The Pioneer of Chinese Modern Cartoon – Huang Wennong." *Chinese Cartoon Selection Journal.* No. 2, 1999, pp. 2-3.

8635. Hua Junwu, Ding Cong, Liao Binxiong, Fang Cheng, Yong Fei, eds. *China Contemporary Cartoonists Dictionary.* Beijing: Zhejiang Peoples Press, 1997. 617 pp.

8636. Hu Kao. *Two Kinds of Cartoons of Hu Kao.* Jinan: Shandong Pictorial Press, 1998.

8637. Kan, Wendy. "Chinese 'Hero' Draws Comic." *Variety.* August 5, 2002.

8638. Lent, John A. and Xu Ying. "Timeless Humor: Liao Bingxiong and Fang Cheng, Masters of a Fading Chinese Cartoon Tradition." *Persimmon.* Winter 2003, pp. 1-6.

8639. Liao Yin Tang. *Liao Yin Tang Cartoons; Chinese Ancient Jokes Selection.* Haikou City: Southern Press, 2000. 337 pp.

8640. "Other Cartoonists' Works." *Yuanyuan Caricature.* December 2001, pp. 14-26.

8641. *The Series of Chinese Cartoons. Wang Fu Yang Volume.* Hebei: Hebei Education Press, 1994. 150 pp.

8642. Xu Ying and John A. Lent. "The Women of Chinese Cartooning." Paper presented at Popular Culture Association, New Orleans, Louisiana, April 17, 2003.

8643. Yu Bao Xun. "Training of Cartoonists Should Start at Childhood." *Yuanyuan Caricature*. September 2001, p. 26.

8644. Zhang Leping. *Sanmao To Be a Soldier*. Shanghai: Children Press, 2000. 132 pp.

Ding Cong

8645. Ding Cong. *Cartoons, Illustrations, Sketches, Portraits, Designs Collection*. Shijiazhuang: Hebei Education Press, 1996. 147 pp.

8646. *Satires – The Cartoon Series of Ding Cong. No. 1*. Beijing: Life, Reading, New Knowledge Press, 1999.

8647. *Satires – The Cartoon Series of Ding Cong. No. 2*. Beijing: Life, Reading, New Knowledge Press, 1999.

Fang Cheng

8648. *Fang Cheng Cartoon Collection*. Shanghai: Shanghai Science and Technology Documentary Press, 2001.

8649. Lu Jien. *Endless Entertainment: Fang Cheng's Cartoon Life*. Beijing: Hu Yi Press, 2001. 265 pp.

Fang Tang

8650. Fang Tang. *Cartoon Collection of Fang Tang*. Zhongshan; Xiao Lan Town Government, 2002. 172 pp.

8651. Fang Tang. *Fangtang Shijie* (Fang Tang's World). Guangzhou: Ling Nan Art Press, 1999. 215 pp.

8652. Fang Tang. *The Wild History of Mister He. Cartoon Selection*. Hubei: Art Press, 2001. 151 pp.

Feng Zikai

8653. Barmé, Geremie. *An Artistic Exile: A Life of Feng Zikai (1898-1975)*. Berkeley: University of California Press, 2002.

8654. Bi Keguan. "Learn from Feng Zikai." *Yuanyuan Caricature*. No. 1, 2002, pp. 2-3.

8655. Feng Chang. "Feng Zikai's Cartoons." *Yuanyuan Caricature*. December 2001, pp. 3-4.

8656. Feng Cheng Bao and Feng Yiyin. *Dad's Paintings*. Shanghai: Huadong Normal University Press. Volume 1, 1999, 203 pp.; Volume 2, 1999, 203 pp.; Volume 3, 2000, 209 pp.; Volume 4, 2000, 205 pp.

8657. Feng Cheng Bao and Feng Yiyin, eds. *Feng Zikai Cartoon Collection*. Beijing: Jinghua Press, 2001. Vol.1, 263 pp.; Vol. 2, 287 pp.; Vol. 3, 421 pp.; Vol. 4, 395 pp.; Vol. 5, 461 pp.; Vol. 6, 437 pp.; Vol. 7, 460 pp.; Vol. 8, 375 pp.; Vol. 9, 239 pp.

8658. Feng Yiyin. *God of Wind with Grace and Ease. My Father Feng Zikai*. Shanghai: Eastern Normal University Press, 1998. 351 pp.

8659. Feng Yiyin. *Hu Sheng Calligraphy & Painting Collection. Feng Zikai Original Collection Imitated and Colored by Feng Yiyin*. Shanghai: Antique Book Press, 2001. 200 pp.

8660. *Feng Zikai Memorial Museum*. Tongxiang: n.d. 8 pp.

8661. Feng Zikai Memorial Museum and Feng Zikai Research Institute. *Feng Zikai Hometown Cartoons*. Tongxiang: 1996, 1998, 2001. 200 pp.

8662. Feng Zikai. *Feng Zikai Autobiography*. Jiangsu: Jiangsu Cultural and Art Press, 1996. 373 pp.

8663. Feng Zikai. *Perspectives on Life Silently*. Changsha: Hunan Arts Press, 1993. 365 pp.

8664. Feng Zikai. *A Treasury of Feng Zikai's Favourite Works*. Singapore: Seck Kong Hiap, 1988. 256 pp.

8665. Feng Zikai and Hong Yi (Master). *Hu Sheng Painting Collection. Feng Zikai Drawing*. Fujian: Fujian Putian Guang Hua Temple, 1996. 114 pp.

8666. Hung Chang-Tai. "War and Peace in Feng Zikai's Wartime Cartoons." *Modern China*. January 1990, pp. 39-84.

8667. Lu Song Xin. "Feng Zikai Cartoon School." *Yuanyuan Caricature*. June 2001, pp. 20-29.

8668. Lu Weiluan, ed. *Paintings of Famous Modern Chinese Artists: Feng Zikai, Victory*. Hong Kong: Han Mo Xuan Publishing Co., Ltd., 2000. 144 pp.

8669. Ma Guoliang. "Memory and Pose of Feng Zikai." *Memory of the Young Companion*. pp. 168-173.

8670. Tongxiang City Feng Zikai Memorial Museum. *Zikai Scenery Painting*. Tongxiang: 2000. 100 pp. Preface by Feng Yiyin.

8671. To Pui-yee, Perry. *Feng Zikai's (1898-1975) Manhua on the Theme of Children*. Hong Kong: University of Hong Kong, 1999.

8672. Xie Qi Zhang. "Interests of Looking for Zikai's Book Cover Paintings." *Yuanyuan Caricature.* December 2001, p. 5.

8673. Yi Yu Sun. "Zikai Cartoon Virtues, Morals, and Talents." *Yuanyuan Caricature.* September 2001, pp. 4-5.

8674. Yu Zhi Da. "The Symposium about Feng Zikai's Cartoons and Trends in Chinese Cartoon Development." *Yuanyuan Caricature.* June 2001, pp. 10-12.

8675. Zheng Peng Nian. *Cartoon Master Feng Zikai.* Beijing: Xinhua Press, 2001. 323 pp.

8676. Zhong Gui Song. *Feng Zikai Teenager Years.* Guangzhou: Huacheng Press, 1998. 63 pp.

8677. Zhong Gui Song and Ye Yu Son, eds. *Impressions about Feng Zikai.* Zhejiang: Zhejiang Culture and Art Press, 1998. 322 pp.

Hua Junwu

8678. *Chinese Caricature Works of Hua Junwu.* Exhibit Catalogue. Hong Kong: Hong Kong Institute for Promotion of Chinese Culture, 1991. Unpaginated.

8679. Hua Junwu. *Satire and Humour from a Chinese Cartoonist's Brush: Selected Cartoons of Hua Junwu ('83-'89).* Beijing: China Today Press, 1991. 276 pp.

8680. Zheng Hua Gai, ed. *Hua Junwu Talking about Cartoons.* Henan: Henan Arts Press, 1998. 102 pp.

8681. Zheng Hua-gai. "6 Stages of Hua Junwu's Cartoon Development." Beijing: Unpublished manuscript, 2002.

Liao Bingxiong

8682. Guangdong Museum of Art, ed. *Liao Bingxiong Caricatures Drawn in Hong Kong. 1947-1950.* Guangzhou: Guangdong Museum of Art, 2000. 296 pp.

8683. Liao Bingxiong. *The Age of the Cat Kingdom.* Guangzhou: Shandong Pictorial Press, 1999. 99 pp.

8684. Liao Bingxiong. *Bingxiong Talking Freely.* Shijiazhuang: Hebei Educational Press, 1997. 286 pp.

8685. Liao Bingxiong. *Selected Cartoons of Liao Bingxiong.* Edited by Yeung Wai-pong. Hong Kong: Hong Kong Cartoon Institute, 1984.

8686. Liao Bingxiong. *Years in Cat's Kingdom*. Jinan: Shandong Pictorial Press, 1999.

8687. Pan Jia Jun and Liang Jing, eds. *Bingxiong in My Eyes*. Guangzhou: Lingnan Art Press, 1992. 350 pp.

8688. Zhang Hong Miao and Liao Linger. *Liao Bingxiong Picture Biography. Wash the World's Face*. Guangzhou: Huacheng Press, 2002. 249 pp.

Miao Yin Tang

8689. Miao Yin Tang. *Miao Yin Tang Man Hua Xuan. Life, Humor, Cartoon*. Beijing: Knowledge Press, 1992. 123 pp.

8690. Miao Yin Tang, ed. *Going to the Door of Cartoon Art*. Beijing: Peoples Art Press, 2000. 145 pp.

8691. Miao Yin Tang and Zhu Yong Hua. *The Limits of the Earth: Cartoon Collection*. Beijing: Chinese Population Press, 2001. 92 pp.

8692. Miao Yin Tang and Zhu Yong Hua. *Love My Home Cartoon Collection*. Zhengzhou: Elephant Press, 1999. 104 pp.

8693. Miao Yin Tang, *et al. Good-bye to the Foolish; Forward to Science. Cartoon Collection*. Beijing: Science Press, 2002. 154 pp.

Xu Bing

8694. Gopnick, Blake. "Xu Story: An Artist's Absurd Cast of Characters." *Washington Post*. October 28, 2001, pp. G-1, G-4.

8695. O'Sullivan, Michael. "Xu Bing's Verbal Cure." *Washington Post Weekend*. November 2, 2001, pp. 53-54.

Exhibitions, Festivals

8696. "Awards of Children's Cartoon Competition." *Yuanyuan Caricature*. December 2001, pp. 6-13.

8697. Cartoon Art Committee. *Feng Zikai Cup. The Fourth National Chinese Cartoon Exhibition*. Hong Kong: Hong Kong Tian Ma Books Ltd., Co., and Tongxiang City Government, 2002. 100 pp.

8698. Cartoon Art Committee, ed. *2000 National Cartoon Exhibition. Cartoon Eyes Focused*. Hefei: Anhui Arts Press, 2001. 90 pp.

8699. "Cartoon Show To Enliven Shanghai Fans." Xinhua News Agency dispatch, July 20, 2002.

8700. "China To Host 6th World Cartoon Conference in October." *Peoples Daily*. March 8, 2003.

8701. "Feng Zikai Cartoon Exhibition in Beijing." *Yuanyuan Caricature*. September 2001. p. 1.

8702. "First Feng Zikai Hometown Cartoon Week Selected Works." *Yuanyuan Caricature*. June 2001, pp. 18-19.

8703. "First Zikai Cup National Children's Cartoon Competition." *Yuanyuan Caricature*. September 2001, pp. 6-18.

8704. "First Zikai Cup National Children's Cartoon Competition." *Yuanyuan Caricature*. December 2001, p. 1.

8705. "'Kentucky Fried Chicken' Award for Children's Cartoon Competition." *Yuanyuan Caricature*. June 2001, pp. 14-17.

8706. *National Admiring Science – Breaking the Superstitions, Clearing the Devil Religions Cartoon Competition, Beijing, September 2001*. Selection of Works. Beijing: 2001.

8707. "Report of Feng Zikai Cartoon Exhibition in Beijing." *Yuanyuan Caricature*. September 2001, pp. 2-3.

8708. "Report of First Zikai Cup National Children's Cartoon Exhibition." *Yuanyuan Caricature*. December 2001, p. 2.

8709. *Selection of Works Winning the First Zikai Cup for National Children's Caricature Competition*. Tongxiang: China Artists Association Cartoon Art Commission and Zhejiang Province, Tongxiang City Government, 2001. 102 pp.

8710. "3rd National Cartoon Exhibition Selected Best Works." *Yuanyuan Caricature*. June 2001, pp. 4-9.

Animation

8711. A Da. "Director Thinking and Working Method of 'Three Monks.'" *China Film Yearbook 1982*, pp. 465-466.

8712. Animation Department of Shanghai Science and Educational Film Studio. "Creation Summary of 'Crying King.'" *Chinese Film Year Book 1995*. Beijing: China Film Press, 1996, pp. 156-157.

8713. *Animation Film Creation Research*. Beijing: China Film Press, 1984. 196 pp.

8714. Bao Jigui. "My Opinion about the Reform of Animation Films." *Chinese Film Year Book 1994*. Beijing: China Film Press, 1995, pp. 181-182.

8715. Bao Jigui. "Report of the Second Shanghai International Animation Film Festival." *Chinese Film Year Book 1993*. Beijing: China Film Press, 1994, pp. 207-208.

8716. Bao Jigui and Liang Ping. "One Hundred Series Animation 'Heroes Come from Juniors Originally' Starts To Be Produced." *Chinese Film Year Book 1996*. Beijing: China Film Press, 1997, pp. 193-194.

8717. Bao Jigui and Liang Ping. "69 Years of Chinese Animation Films." *Chinese Film Year Book 1996*. Beijing: China Film Press, 1997, pp. 186-190.

8718. Bing Fu. "The Theme, Poetic Atmosphere, Illusion, and Character Development: Talking about Animation Scripts. 'Fire Child.'" *China Film Yearbook 1986*, pp. 7-11 to 7-14.

8719. Chen Jianyu. "From Three Words to a Film: Critique, Animation, 'Three Monks.'" *China Film Yearbook 1982*, pp. 459-464.

8720. Chen Xiaoli. "Shanghai Animation Film Studio Got Double Harvests of Two Benefits." *Chinese Film Year Book 1996*. Beijing: China Film Press, 1997, p. 175.

8721. Cheng Jihua, Li Shaobai, Xing Zuwen. "Chinese Cinema. Catalogue of Films, 1905-1937: Feature Films, Operas, and Cartoons." *Griffithiana*. October 1995, pp. 4-54.

8722. China Animation Society. "The Difficulties and Hopes in Advancing Chinese Animation Industry." *Chinese Film Year Book 1989*. Beijing: China Film Press, 1990, pp. 92-93.

8723. China Animation Society. "'96 National Committee's Conference Report." *Chinese Film Year Book 1997*. Beijing: China Film Press, 1998, pp. 156-158.

8724. "Chinese Hope Ancient Shadow Art Will Animate Cartoon Industry." *Peoples Daily*. March 8, 2003.

8725. Chong Song Lin. "Unique Water and Ink Animation." *China Film Yearbook 1982*, pp. 454-458.

8726. Clements, Jonathan. "Out of the Shadows: China's Hidden Animation Industry." *Nickelodeon Far East Film*. No. 99-100 (April 2002), pp. 6-11.

8727. Dovnikovic, Vesna. "Beijing Broadcasting Institute." *Animatoon*. No. 33, 2001, pp. 44-47.

8728. Ehrlich, David. "The Birth of Animation in the People's Republic of China." In *Ottawa 00 International Animation Festival*, pp. 67-73. Ottawa: Ottawa International Animation Festival, 2000.

8729. Film Administration Bureau. "Catalogue of Animation Film in 1990." *Chinese Film Year Book 1991*. Beijing: China Film Press, 1992, pp. 201-211.

8730. Film Administration Bureau. "Catalogue of Animation Film in 1991." *Chinese Film Year Book 1992*. Beijing: China Film Press, 1993, pp. 227-238.

8731. Film Administration Bureau. "Catalogue of Animation Film in 1992." *Chinese Film Year Book 1993*. Beijing: China Film Press, 1994, pp. 212-220.

8732. Film Administration Bureau. "Catalogue of Animation Film in 1993." *Chinese Film Year Book 1994*. Beijing: China Film Press, 1995, pp. 185-190.

8733. Film Administration Bureau. "Catalogue of Animation Film in 1995." *Chinese Film Year Book 1996*. Beijing: China Film Press, 1997, pp. 176-185.

8734. Film Administration Bureau. "Catalogue of Animation Film in 1996." *Chinese Film Year Book 1997*. Beijing: China Film Press, 1998, pp. 162-173.

8735. Film Administration Bureau. "Catalogue of Animation Film in 1994." *Chinese Film Year Book 1995*. Beijing: China Film Press, 1996, pp. 159-166.

8736. Ghahremani, Yasmin. "Multiplayer Mania." *Asiaweek*. November 30, 2001, p. 42. (Video games).

8737. Gladstone, Frank. "A Lessening Dichotomy: China." *Animation World*. November 2000, pp. 69-73.

8738. Hao Yin. "Whether Animation Film Can Get Into the Market? – Thinking from the Second Shanghai International Animation Film Festival." *Chinese Film Year Book 1993*. Beijing: China Film Press, 1994, p. 209.

8739. He Yu Wen. "Animation Film Brief – 1984-1988." *China Film Yearbook 1986,* pp. 7-27 to 7-28, 7-16.

8740. He Yu Wen. "Like Dream, Like Illusion – Introducing Papercut Series 'Hulu Brothers.'" *Chinese Film Year Book 1987*. Beijing: China Film Press, 1988, pp. 6-16 – 6-17.

8741. He Yu Wen. "Reflections of Chinese Cartoon Animation Outside China Since 1978." *China Film Yearbook 1984*, pp. 437-438.

8742. He Yu Wen and Qiang Xiao Bai. "Emotional Poem Build for Picture: Talking about Art Characters of Water and Ink Papercut Animation 'Snipe Grapple with Clam.'" *China Film Yearbook 1986*, pp. 7-17 to 7-20.

8743. Hermelin, Francine G. "Multimedia Impresario: From Tunes to Toons." *Working Woman*. July 1994, p. 39.

8744. "Hit Cartoon To Make Profit." *Shanghai Daily News*. February 23, 2003.

8745. Hu Xiaolong. "Ma Kexuan Talks About the Creation of 'Twelve Mosquitoes and Five Men.'" *Chinese Film Year Book 1993*. Beijing: China Film Press, 1994, p. 206.

8746. Hu Yihong. "Watching A Da Overcome Himself from Short Animation 'Door Bell' and 'Super Soap.'" *Chinese Film Year Book 1987*. Beijing: China Film Press, 1988, p. 6-10 – 6-13.

8747. Jia Fou and Lu Shengzhang. *Conception of Animation*. Beijing: Beijing Broadcasting Institute Press, 2002. 85 pp.

8748. Jin Baisong. "Modern Themes and Modern Ideas in Chinese Animation Films." *Chinese Film Year Book 1988*. Beijing: China Film Press, 1989, pp. 6-7 – 6-9.

8749. Jin Baisong. "Talking about Physical Affection in Animation – Exploring Factors of Material and Technology." *Chinese Film Year Book 1987*. Beijing: China Film Press, 1988, pp. 6-7 – 6-10.

8750. Jin Yan Yu. "Talking about Children's Taste of Animation." *China Film Yearbook 1984*, pp. 408-431.

8751. Lent, John A. and Xu Ying. "Animation in China Yesterday and Today – The Pioneers Speak Out." *Asian Cinema*. Fall/Winter 2001, pp. 34-49.

8752. Lent, John A. and Xu Ying. "Six Oldtimers and a Couple of Youngsters: Interviews with Chinese Animators." Paper presented at Society for Animation Studies, Montreal, Canada, October 25, 2001.

8753. Lent, John A. and Xu Ying. "Te Wei and Chinese Animation: Inseparable, Incomparable." *Animation World*. March 2002, pp. 28-33.

8754. Lin Wenxiao. "Researching Child Psychology, Trying Innovation – Creative Ideas of 'A Coat Isn't Afraid of Cold.'" *Chinese Film Year Book 1987*. Beijing: China Film Press, 1988, pp. 6-15 – 6-16.

8755. Liu Jing Sheng. "Talking about Art Reality of Animation Films." *China Film Yearbook 1986*, pp. 7-23 to 7-27.

8756. Liu-Lengyel, Hongying and Alfonz Lengyel. "A Monkey King Story: Chinese Animation Film in the 1960s and 1990s." Paper presented at Popular Culture Association, Toronto, Canada, March 14, 2001.

8757. Lu Chengfa. "Creation Experience of 'Cloth with Hundreds Birds.'" *Chinese Film Year Book 1997*. Beijing: China Film Press, 1998, pp. 158-159.

8758. Lu Shengzhang. *TV Advertisement Creation*. Beijing: China Broadcasting & TV Press, 2000. 395 pp.

8759. Lu Xiaoming. "A Different Test – Comment on Animation Film 'Bison and Bull.'" *Chinese Film Year Book 1990*. Beijing: China Film Press, 1991, pp. 119-121.

8760. Lu Yinghong. "Proposing Adopted Classical Novels by Animation." *Chinese Film Year Book 1995*. Beijing: China Film Press, 1996, pp. 157-158.

8761. Mao Li Lian. "Limitation Is Character: Talking from Folded Animation." *China Film Yearbook 1986*, pp. 7-20 to 7-23.

8762. Mei Bing. "Summary of Shanghai Animation Film Studio's Creation and Production in 1993." *Chinese Film Year Book 1994*. Beijing: China Film Press, 1995, pp. 180-181.

8763. "Nickelodeon Launches in China." *Asian Mass Communications Bulletin*. May/June 2001, p. 9.

8764. Nie Xinru. "A Child without Mom – Thinking of the Theory of Animation Itself." *Chinese Film Year Book 1990*. Beijing: China Film Press, 1991, pp. 124-127.

8765. Page, Jeremy. "Meet 'Chyna' – Beijing's Answer to Lara Croft." Reuters dispatch, September 10, 2001.

8766. "Phoenix Media Group Secures North American Rights to Cartoon Series." Business Wire, July 16, 2001.

8767. Qian Yunda. "Artistic Characters of 'Selection of Beauty.'" *Chinese Film Year Book 1988*. Beijing: China Film Press, 1989, p. 6-3.

8768. Qian Yunda. "Why Children Like 'Black Cat Police Chief.'" *Chinese Film Year Book 1987*. Beijing: China Film Press, 1988, pp. 6-13 – 6-15.

8769. Rist, Peter, Zhang Yuan, and Tammy Smith. "Chinese Water-Colour Animation." Paper presented at Society for Animation Studies, Montreal, Canada, October 25, 2001.

8770. Rogers, Shannon. "*Havoc in Heaven*: Bridging the Gap Between Tradition and Modernization." Paper presented at Society for Animation Studies, Montreal, Canada, October 23, 2001.

8771. Shan Chun and Ke Xuan. "At the New Starting Point." *Chinese Film Year Book 1989*. Beijing: China Film Press, 1990, pp. 81-82.

8772. Shan Fang, "Exquisitely Creating Chinese Style Animation Heroes – Analysis of One Hundred Animation Series 'Heroes Come from Juniors Originally.'" *Chinese Film Year Book 1996*. Beijing: China Film Press, 1997, pp. 190-192.

8773. Shi Dwi. "Time Animation Company Established in Guangzhou." *Chinese Film Year Book 1987*. Beijing: China Film Press, 1988, p. 6-20.

8774. Song Lin. "Comment of Animation Creation in 1985." *China Film Yearbook 1986*, pp. 7-1 to 7-7.

8775. Song Lin. "Comment on 'The First National Film of Television Animation Program Exhibition.'" *Chinese Film Year Book 1990*. Beijing: China Film Press, 1991, pp. 128-129.

8776. Song Lin. "Developing the Tradition, Efforting for Innovation – Retrospective of the Recent Decade of Animation Films." *China Film Year Book 1987*. Beijing: China Film Press, 1988. pp. 6-1 – 6-6.

8777. Song Lin. "Exploration of Animation Art Rules." *China Film Yearbook 1984*, pp. 421-427.

8778. Tang Jia. "Talking about Wins and Losses of 'Deer Bell.'" *China Film Yearbook 1984*, pp. 434-436.

8779. Tang Jiaren. "Records About Animation Films." *Chinese Film Year Book 1988*. Beijing: China Film Press, 1989, pp. 6-4 – 6-7.

8780. Te Wei. "Animation Should Pay More Attention to Quality." *Chinese Film Year Book 1992*. Beijing: China Film Press, 1993, pp. 223-224.

8781. Te Wei. "Talking About Chinese Animation Film Creation." *China Film Yearbook 1982*, pp. 449-453.

8782. Te Wei, Yan Dingxian, and Lin Wenxiao. "Directors' Ideas about Animation: 'Golden Monkey Beats Monsters.'" *China Film Yearbook 1986*, pp. 7-8 to 7-11.

8783. Teng Jinxian. "Fruitful Effects from Development and Creation. Celebrate the Birth of Long Animation Series 'Panda Jingjing.'" *Chinese Film Year Book 1996*. Beijing: China Film Press, 1997, pp. 192-193.

8784. Tianyi and Shen Yi. "Interview with Chang Guang-xi: New Graph for Animation Production Concept." *New Films*. May 1999, pp. 43-47.

8785. Wang Yongjun. "Summary of Shanghai Animation Film Studio's Production in 1992." *Chinese Film Year Book 1993*. Beijing: China Film Press, 1994, p. 205.

8786. Wu Qingxin. "Comment on Animation Film 'Tall Woman and Her Short Husband.'" *Chinese Film Year Book 1990*. Beijing: China Film Press, 1991, pp. 121-123.

8787. Xiang Hua, Hu Yi Hong, and Tianyi. "Innocent Age: Talking about Animation – 'I Am Crazy for Singing.'" *New Films*. June 2002, pp. 30-37, 55.

8788. Yan Dingxian. "Retrospective of Animation Film Creation in 1987." *Chinese Film Year Book 1988*. Beijing: China Film Press, 1989, pp. 6-1 to 6-2.

8789. Yan Dingxian and Lin Wenxiao. "A Pleasant Song—Creation Experiences of 'Songs in Spring.'" *Chinese Film Year Book 1997*. Beijing: China Film Press, 1998, pp. 160-161.

8790. Yan Dingxian and Lin Wenxiao. "Creation Ideas and Art Pursuit of 'White Egg.'" *Chinese Film Year Book 1995*. Beijing: China Film Press, 1996, pp. 154-155.

8791. Yan Dingxian and Lin Wenxiao. "New Test of Animation Series Director's Work – Primary Summary of 'Shuke and Beita.'" *Chinese Film Year Book 1991*. Beijing: China Film Press, 1992, pp. 212-213.

8792. Yan Dingxian and Lin Wenxiao. "Talking about the Creation of 'Deer Girl.'" *Chinese Film Year Book 1994*. Beijing: China Film Press, 1995, pp. 183-184.

8793. Yan Shanchun. "Devoted Beauty to Children – Creation Ideas of 'Small Snail Has His Birthday.'" *Chinese Film Year Book 1997*. Beijing: China Film Press, 1998, pp. 159-160.

8794. Yang Xiang. "Chinese First Long Animation Series 'Adventures of Panda' Starts to Be Produced." *Chinese Film Year Book 1993*. Beijing: China Film Press, 1994, p. 211.

8795. Yang Xiang. "Present Situation of Chinese Animation Producing Companies." *Chinese Film Year Book 1991*. Beijing: China Film Press, 1992, pp. 199-200.

8796. Yang Xiang. "Summary of Animation Films in 1994." *Chinese Film Year Book 1995*. Beijing: China Film Press, 1996, pp. 153-154.

8797. Yang Xiang. "Talking about Animation in 1993." *Chinese Film Year Book 1994*. Beijing: China Film Press, 1995, pp. 177-179.

8798. Ye Yonglie. "Creation Notes of 'Crying King.'" *Chinese Film Year Book 1995*. Beijing: China Film Press, 1996, pp. 155-156.

8799. Yin Yan. "The Development of 'Chinese School.'" *Chinese Film Year Book 1989*. Beijing: China Film Press, 1990, pp. 87-91.

8800. Yu Shi. "Sixty Years' Cartoon Career of 'Wan Brothers' – Report of Celebration for 'Sixty Years of Wan Brothers' Animation Film Career.'" *Chinese Film Year Book 1987*. Beijing: China Film Press, 1988, pp. 6-18 to 6-20.

8801. Yu Yin. "Developing New Fields of Animation Themes." *China Film Yearbook 1984*, pp. 432-433.

8802. Yu Yin. "Summary of Animation Production in 1991." *Chinese Film Year Book 1992*. Beijing: China Film Press, 1993, p. 221.

8803. Yu Yin. "Summary of the Development of Foreign Financial Animation Companies in Mainland China." *Chinese Film Year Book 1992*. Beijing: China Film Press, 1993, pp. 222-223.

8804. Zahed, Ramin. "Evolving in China: Colorland Animation." *Animation*. November 2002, p. 22.

8805. Zhan Xin. "New Space for Free Exertion of Sounds Creation: Talking about Sound Production of 'Lotus Lantern.'" *New Films*. May 1999, pp. 48-50.

8806. Zhang Hui Lin. *Ershi Shui Zhongguo Donghua Yishushi* (20th Century Chinese Animation Art History). Xian: Shanxi Peoples Art Press, 2002. 236+ pp.

8807. Zhang Songlin. "Brief of the Second National Film & TV Animation Exhibition and Awards." *Chinese Film Year Book 1993*. Beijing: China Film Press, 1994, pp. 210-211.

8808. Zhang Songlin. "Chinese Animation Production Industry Must Be Recovered." *Chinese Film Year Book 1992*. Beijing: China Film Press, 1993, pp. 224-226.

8809. Zhang Songlin. "Comments on 88' Shanghai International Animation Festival." *Chinese Film Year Book 1989*. Beijing: China Film Press, 1990, pp. 82-86.

8810. Zhang Songlin. "General Situation of Animation Development in 1990." *Chinese Film Year Book 1991*. Beijing: China Film Press, 1992, pp. 197-198.

8811. Zhang Songlin. "Reflections After Chinese Animations Failing at Annecy Animation Film Festival." *Chinese Film Year Book 1988*. Beijing: China Film Press, 1989, pp. 6-10 to 6-12.

8812. Zhang Songlin. "Report about Chinese Animation Films in 1995." *Chinese Film Year Book 1996*. Beijing: China Film Press, 1997, pp. 173-174.

8813. Zhang Songlin. "Summary of Chinese Animation Development in 1996." *Chinese Film Year Book 1997*. Beijing: China Film Press, 1998, pp. 155-156.

8814. Zhong Quan. "Developing Animation Creation of Changchun Film Studio." *Chinese Film Year Book 1991*. Beijing: China Film Press, 1992, pp. 198-199.

8815. Zhong Quan. "Summary of Changchun Film Studio Animation Branch's Production in 1992." *Chinese Film Year Book 1993*. Beijing: China Film Press, 1994, pp. 205-206.

8816. Zhou Keqin. "'Animation's' Unforgetable 1989." *Chinese Film Year Book 1990*. Beijing: China Film Press, 1991, pp. 117-118.

8817. Zhou Keqin. "Looking for Developments from Competitions – Retrospective of Animations in 1988." *Chinese Film Year Book 1989*. Beijing: China Film Press, 1990, pp. 79-80.

Comic Books

8818. Boissier, J.L., P. Destenay, M-Ch. Piques, eds. *Bandes Dessinées Chinoises*. Paris: CCI/Centre G. Pompidou et Centre de Recherche de l'Université de Paris VIII, 1982.

8819. "China Challenges Manga Supremacy." *Comics Forum*. Autumn 1996, p. 4.

8820. *Comic in Revolt: The Shanghai Comics in the 30s and 40s.* Hong Kong: Hong Kong Arts Center, 1995.

8821. De Vries, Kim. "Comic Books in the PRC: A New Beginning." *Sequential Tart.* November 2002.

8822. Farquhar, Mary Ann. *Children's Literature in China: From Lu Xun to Mao Zedong.* Armonk, New York: M.E. Sharpe, 1999. (Chapter 5, "Comic Books and Popularization," pp. 191-248).

8823. Hansson, Cecilia and Mats Persson. "Tintin in Kina. Ding-Dings Äventyr." *Bild & Bubbla.* No. 1, 1986, p. 12.

8824. Kunzle, David. "I Fumetti di Mao." *Artforum.* 1973, pp. 71-72.

8825. Yu Zhong. "Tintin Har Lämnat Oss." *Bild & Bubbla.* No. 1, 1986, p. 13.

Comic Strips

8826. Wang Guan Qing and Li Ming Hai, eds. *New China Comic Strips: Lianhuanhua: 1950-1960.* Shanghai: Pictorial Press, 2001. 284 pp.

8827. Wang Guan Qing and Li Ming Hai, eds. *Old Comic Strips: 1920s-1940s.* Shanghai: Pictorial Press, 1999. 212 pp.

Hong Kong
Cartoonists and Their Works

8828. *Farewell Kiddy Cheung: A Tribute to the Hong Kong Cartoonist Yuan Bou-wan (1922-1995).* Hong Kong: Hong Kong Arts Center, 1996.

8829. *Hong Kong Comic Artists, 1990.* Hong Kong: Tin-ha Publishing, 1990.

8830. Ma Long. *Manhua Classroom.* Hong Kong: 1990.

8831. *Manhua News: The Retrospect of 50 Years of Cheng Ka-chun's Works.* Hong Kong: Hong Kong Cartoon Institute, 1988.

8832. Seung-gun Siu-bo. *Seung-gun Siu-bo Autobiography.* Hong Kong: 1988.

Ma Wing-shing

8833. Ma Wing-shing. *Painting the Rainbow: The Biography of Ma Wing-shing.* Hong Kong: Yau-woo Publishing Co., 1990.

8834. Ma Wing-shing. *The Works of Ma Wing-shing.* Hong Kong: Tin Ha, 1989.

8835. Ng Ka-keung. *The Critics of Wind and Cloud.* Hong Kong: 1993.

Wong Yuk-long

8836. Wong Yuk-long. *Dream of Ten Billion*. Hong Kong: 1994.

8837. Wong Yuk-long. *Tiger in the Cage*. Hong Kong: 1994.

8838. *WOW! Wong Yuk-long*. Hong Kong: Hong Kong Cartoon Institute, 1984.

Animation

8839. Atkin, Hillary. "Star Power and Smarts Fuel Thesp's Toon, Biz Ventures." *Variety*. December 3-9, 2001, pp. A-12, A-14. (Jackie Chan animation).

8840. Elley, Derek. "My Life as McDull." *Variety*. December 23, 2002-January 5, 2003, p. 26.

8841. Hansen, Jeremy. "'Monsters' Scares Off Local Fare." *Variety*. March 4-10, 2002, p. 10.

8842. Hu, Gigi Tze Yue. "Hong Kong Animation: My Life as McDull." *Asian Cinema*. Spring 2003.

8843. "'Li Li' Offers Hip Quips." *Variety*. October 8-14, 2001, p. A4.

8844. McMillan, Alex Frex. "'Spader-man' Prowls Hong Kong's Streets." CNN dispatch, May 15, 2002.

8845. Swanson, Tim. "John Woo Preps 'Turtles' Toon." Reuters dispatch, June 21, 2001.

8846. Tan Ee Lyn. "Hong Kong Roots Run Deep in 'Shrek' Animator." Reuters dispatch, May 24, 2002.

8847. "Woo To Produce CGI Turtles Toon." *Animation*. August 2001, p. 34.

8848. Wozniak, Lara. "Crouching Tigger." *Far Eastern Economic Review*. January 23, 2003, pp. 24-25.

8849. Ziggiotti, Maria. "Piccolo, Ottuso e Rosa." *FMM Daily* (Udine, Italy). April 23, 2002, p. 4. ("My Life as McDull").

Cartoons

8850. *The Cartoons Exhibition of Hong Kong*. Hong Kong: Hong Kong Arts Center, 1981.

8851. *Cartoon Works Exhibition of Hong Kong*. Hong Kong: Cartoons Exhibition Organizing Committee, 1981.

8852. *Contemporary Hong Kong Columnist Cartoon*. Hong Kong: Hong Kong Arts Center and Hong Kong Cartoon Institute, 1989.

8853. Ngai Nam-shan. *How To Draw Cartoons*. Hong Kong: Nam-shan Publishing, ca. 1960s.

Comic Books (*Manhua*)

8854. Campos, Mark. "Manhua! Manhua! *Hong Kong Comics*." *Comics Journal*. November 2002, pp. 33-34.

8855. Chandler, Clay. "Hong Kong Loves a Fight." *Washington Post*. August 18, 2001, pp. E1, E8.

8856. "Comic Book Heroine Back in Fashion." *South China Morning Post*. February 13, 2003. ("13 Dots").

8857. Lai Ba-lun. *Manhua on Capitalism*. Hong Kong: 1990.

8858. Lai Ba-lun. *The Trends of Hong Kong Manhua*: Hong Kong: 1990.

8859. Leung, Andrew Tsung-Yan. "Cut-Throat Comics: Publishers Stick with Free Knives in Comics." *South China Morning Post*. January 8, 2000.

8860. Lo, Alex. "No Comic Relief for Broom-head." *South China Morning Post*. July 18, 2002.

8861. Melby, Nathan. "Batman Goes Overseas: The Dark Knight Visits Hong Kong." *Comics Buyer's Guide*. February 21, 2003, p. 13.

8862. Pak-muk. *The Chinese Comics Collection*. Hong Kong: Yau-woo Production Co., 1990.

8863. To Mei-tse. *The Comics Are Bad*. Hong Kong: 1991.

Historical Aspects

8864. Cheng Ka-chun. *The Records of Hong Kong Manhua*. Hong Kong: 1992.

8865. *The Good or the Bad: Textbook and Comic Book of Hong Kong (30s to 70s) Exhibition*. Hong Kong: Hong Kong Arts Center, 1994.

8866. "Hong Kong Cinema & Popular Culture: Popular Songs & Comics." *Pro Folio*. August-September 2002, pp. 8-11.

8867. Ng Sum-yi. "An Unforgettable Experience." *Hong Kong Film Archive Newsletter*. No. 21, 2002, pp. 8-9.

8868. *Violence and Sex in Children's Comic Books, Hong Kong 1973-74*. Hong Kong: non-government social groups, 1974.

8869. Wong, Wendy Siuyi. *Hong Kong Comics*. Princeton, New Jersey: Princeton Architectural, 2001. 188 pp.

Lianhuantu

8870. Lau Ding-gin. *The Scandals of the Lianhuantau Industry*. Hong Kong, 1991.

8871. Lau Ting-kin. *The Storms of Lianhuantu*. Hong Kong (?): 1989.

8872. Yuan Kin-toa. *The Language of Lianhuantu: The Birth of a Manhua*. Hong Kong: 1992.

Comic Strips

8873. Kluver, R. "Comic Effects: Postcolonial Political Mythologies in *The World of Lily Wong*." *Journal of Communication Inquiry*. April 2000, pp. 195-215.

India
General Sources

8874. Grossberg, Josh. "MTV Apologizes for Gandhi Goofing." *E! Online*. January 31, 2003.

8875. "MTV Apologizes for Show's Gandhi Lampoon." Associated Press dispatch, January 31, 2003.

8876. Pal, Pratapaditya. *Indian Painting. A Catalogue of the Los Angeles County Museum of Art Collection. Volume I. 1000-1700*. Los Angeles: Los Angeles County Museum of Art, 1993. 383 pp.

Cartoonists and Their Works

8877. "Cartoons Come from Chaos: R.K. Laxman." *Times of Oman*. March 1, 2003.

8878. "Case Study: Irfan Hussein." *Borderline*. December 2002, p. 17.

Vijayan, O.V.

8879. Vijayan, O.V. "Dialogue: O.V. Vijayan & Balraj Puri, at the Crossroads." *The Illustrated Weekly of India*. March 18, 1990.

8880. Vijayan, O.V. *Kurippukal*. Kottayam: D.C. Books, 1983.

8881. Vijayan, O.V. "My Mentor K. Shankar Pillai." *The Illustrated Weekly of India*. January 21, 1990.

8882.	Vijayan, O.V. "The Power of Truth." *The Illustrated Weekly of India.* Weekend. December 15-16, 1990.

8883.	Vijayan, O.V. "Requiem for a Foot Soldier." *The Illustrated Weekly of India.* February 12, 1984.

8884.	Vijayan, O.V. "The Tragic Idiom." *The Illustrated Weekly of India.* July 28, 1985.

8885.	Vijayan, O.V. *Vijayan: A Cartoonist Remembers.* New Delhi: Rupa Co., 2002.

Animation

8886.	"Ambitious Indian Animated Feature Ends L.A. Run." Reuters dispatch, November 16, 2001.

8887.	"Animation in India." *ASIFA San Francisco.* May 2002, p. 5.

8888.	Arackaparambil, Rosemary. "India Seeks To Star in Animation Scene." Reuters dispatch, September 18, 2001.

8889.	Badam, Ramola Talwar. "Hindu God Hanuman Is Star of India's First Animated Feature Film." Associated Press dispatch, November 20, 2002.

8890.	Deneroff, Harvey. "Famous's House of Animation." *Animatoon.* No. 42, 2003, pp. 52-55.

8891.	Deneroff, Harvey. "Famous's House of Animation – Creativity and Independence in Indian Animation." *Asian Cinema.* Spring 2003, pp. 120-132.

8892.	Deneroff, Harvey. "Masters Animation Celebration – India." *Animatoon.* No. 34, 2001, pp. 44-47.

8893.	Fine, David. "My Week in India as a Master of Animation." *Animation World.* December 2000, pp. 52-55.

8894.	Gelman, Morrie. "Color Chips India Ltd." *Animation.* January 2001, p. 16.

8895.	Harz, Christopher. "Pentamedia Graphics." *Animation.* October 2001, p. 25.

8896.	Jokinen, Heikki. "Indian Animation Industry Catches Tail-Wind." *Animatoon.* No. 37, 2002, pp. 44-49.

8897.	Mathur, Arti. "Sony Toons in for Kids." *Variety.* March 3-9, 2003, p. 39.

8898. Nagel, Jan. "Tales from India: Toonz Animation Refocused." *Animation*. September 2002, p. 28.

8899. Sen, Jayanti. "India's Expanding Horizons." *Animation World*. May 2000, pp. 41-46.

8900. Ravichandran, R. "India Could Be Next Animation Powerhouse." *Financial Express* (India). October 12, 2002.

8901. Sugar, Ellen. "Murder and Exploitation of Women: Animation by Kireet Khurana." Paper presented at Society for Animation Studies, Montreal, Canada, October 23, 2001.

8902. "3ʳᵈ Week with the Masters in India." *ASIFA San Francisco*. October 2001, p. 7.

8903. Tikoo, Rajiv and Nivedita Mookerji. "Film Industry Talks in Animated Mode." *Financial Express* (India). October 12, 2002.

8904. Vogelesang, Joan. "Animating for a Better World." *Animation*. July 2002, p. 14.

Comics

8905. Desai, Chetan. "The Krishna Conspiracy." *International Journal of Comic Art*. Spring 2003, pp. 325-333.

8906. Falk, Bertil. "I Indien är Serierna en Bra Affär." *Bild & Bubbla*. No. 3/4, 1985, pp. 40-42.

8907. Sharma, Rajnish. "Amar Chitra Katha's Westward Voyage." *Little India*. May 2002, pp. 28-30.

8908. "Vedische Strips." *Stripschrift*. November 2001, p. 29.

8909. World Comics-Finland. *India, Workshop Report, September 2002.* Vantaa, Finland: World Comics-Finland, 2002. 20 pp.

Indonesia
Cartooning, Cartoons

8910. "Cigarette Maker Pulls Ad Cartoon." *Jakarta Post*. December 14, 2001.

8911. "Indonesia Strips in Leiden." *Stripschrift*. August 2002, p. 31.

8912. Kan, Wendy. "Mickey Mouse Setting up New House." *Variety*. July 22-28, 2002, p. 21. (Animation).

8913. Sen, Hai and Rizky Wasisto Sen. *Garlands of Moonlight*. Hong Kong: Shoto Press, 2002. (Graphic novel).

Political Cartoons

8914. Ostrom, Richard. "Bali's Transition from a Traditional to a Modern Society: Some Op-Art Warnings about the Trade-offs." *International Journal of Comic Art*. Fall 2002, pp. 229-240.

8915. Ostrom, Richard. "The Changed Function of Political Cartoonists in Indonesia: From Challenging a Repressive Regime to Promoting Democratic Reforms." *International Journal of Comic Art*. Spring 2003, pp. 231-243.

Japan
General Sources

8916. McLelland, Mark J. "Kamingu Auto: Homosexuality & Popular Culture in Japan." *IIAS Newsletter*. November 2002, p. 7.

8917. Maynard, Michael L. "Friendly Fantasies in Japanese Advertising: Persuading Japanese Teens Through Cartoonish Art." *International Journal of Comic Art*. Fall 2002, pp. 241-260.

8918. Mostow, Joshua S., Norman Bryson, and Maribeth Graybill, eds. *Gender and Power in the Japanese Visual Field*. Honolulu: University of Hawaii Press, 2003. 368 pp.

Resources

8919. "The Activities of Japan Society for Animation Studies (April 2000 to March 2001)." *Japanese Journal of Animation Studies*. 3:2A, 2002, p. 67-71.

8920. Craig, Timothy J. and Richard King, eds. *Global Goes Local: Popular Culture in Asia*. Vancouver: University of British Columbia Press, 2002. 309 pp. (Includes Mark W. MacWilliams, "Revisiting Japanese Religiosity: Osamu Tezuka's *Hi no Tori* (The Phoenix)," pp. 177-210; Nancy Brcak and John Pavia, "Images of Asians in the Art of the Great Pacific War, 1937-45," pp. 211-225.

8921. Davis, Jessica Milner. "Understanding Humour in Japan." Special issue. *Australian Journal of Comedy*. 7:2 (2001).

8922. Ehriander, Helene. "Manga på Museum." *Bild & Bubbla*. No. 2, 1999, pp. 38-39.

8923. *The Floating World of Ukiyo-e. Shadows, Dreams, and Substance*. Exhibit. Library of Congress. Fall 2001. Washington, D.C.: 2001. 24 pp.

8924. Fumio, Anabuki. "Japonya Karikatürü: Opinions in Pen and Ink." In *Karikatür ve Bilsim/Cartoon and Informatics*, 10 pp. Ankara: Karikatür Vakfı, 2002.

8925. Hibbett, Howard and Nihon Bungaku to Warai Kenkyūkai, eds. *Warai to Sōzō, Vol 1*. Tokyo: Bensei Shuppan, 1998, pp. 353-382; Vol. 2 (2000), pp. 297-304.

8926. Klompmakers, Inge. *Japanese Erotic Prints: Shunga by Harunobu & Koryūsai*. Leiden: Hotei Publishing, 2001. 160 pp.

8927. Wichmann, Siegfried. *Japonisme: The Japanese Influence on Western Art Since 1858*. New York: Thames & Hudson, 1999. 432 pp.

Academic and Educational Aspects

8928. Akita, Takahiro. "Towards a Manga Database." *Manga Studies*. Vol. 1, 2002, pp. 50-56.

8929. Berndt, Jaqueline. "'Expressing with Manga' – The Aesthetics of Comics as Seen Through the New Junior High School Art Curriculum." *Manga Studies*. Vol. 1, 2002, pp. 80-85.

8930. Koide, Masashi. "Tentative Plan for Establishment of Technical Animation Training Course in Art and Design Universities." *Japanese Journal of Animation Studies*. 3:2A, 2002, pp. 27-32.

8931. Koike, Ryuta. "What Lies Beneath: Methodological Self-Questioning in the Analysis of the Form of Comics." *Manga Studies*. Vol. 1, 2002, pp. 69-74.

8932. Kure, Tomofusa. "Manga Studies: Between Criticism and Research. Summary of Panel Discussion." *Manga Studies*. Vol. 1, 2002, pp. 40-41.

8933. Murakami, Tomohiko. "Experiences with the Edition of 'The Anthology of Manga Criticism.'" *Manga Studies*. Vol. 1, 2002, p. 44-49.

8934. Nagatani, Kunio. "Negligence and Surplus of Meaning." *Manga Studies*. Vol. 1, 2002, pp. 42-43.

8935. Naiki, Toshio. "On Collecting and Preserving Manga Material." *Manga Studies*. Vol. 1, 2002, pp. 57-61.

8936. Natsume, Fusanosuke and Tomofusa Kure. "Manga Discourse, Manga Criticism, Manga Studies." *Manga Studies*. Vol. 1, 2002, pp. 6-39.

8937. Ogi, Fusami. "Manga and Academia: Experiences in the U.S. and Japan." *Manga Studies*. Vol. 1, 2002, pp. 75-79.

8938. Takahashi, Mizuki. "Manga and Manga Studies as a 'Mediator' from the Perspective of Contemporary Art in Japan." *Manga Studies*. Vol. 1, 2002, pp. 62-68.

Animators and Cartoonists

8939. Abramowitz, Jack. "Kevin Smith: Chasing Manga." *Comics Buyer's Guide*. June 21, 2002, p. 39.

8940. Akiyama, Mitsuru. *COM no Seishun* (The Youth of COM). Toyko: Heibonsha, 1990. 238 pp.

8941. Bomford, Jen. "Piece of Heaven: A Fangirl Makes Contact." *Sequential Tart*. November 2001.

8942. Elley, Derek. "Chiyoko: Millennium Actress." *Variety*. December 17-23, 2001, p. 40.

8943. Flórez, Florentino. "Hiroshima Hadashi no Gen." *El Wendigo*. Nos. 93/94, 2002, p. 35. (Keiji Nakazawa).

8944. Furudate, Kenji. "Demon of a Cartoonist: Fallen War Comrades Inspire My Work." *Shukan Asahi*. July 1, 2002. (Shigeru Mizuki).

8945. Hashimoto, Osamu. *Hana-saku Otometachi no Kinpira-gobō* (Blossoming Maidens' Kinpira-gobō). 2 vols. Tokyo: Kawade Shobō Shinsha, 1984. Vol. 1, 222 pp.; Vol. 2, 327 pp.

8946. Hellman, Bror. "Moshi, Moshii!" *Bild & Bubbla*. No. 2, 2001, pp. 44-45. (Goseki Kojima, Kazuo Koike).

8947. Hill, Kevin. "What Is Manga?" *Borderline*. January 2002, p. 29. (Miwa Ueda).

8948. Ishinomori, Shotaro. *Mangaka Nyumon* (How To Become a Comics Artist). Tokyo: Akita Shoten, 1998.

8949. Kaoru, Kumi. "Kamikakushi – Anime Master Miyazaki's New Ambition." *Animation World*. December 2001, pp. 14-17.

8950. McGill, Nichole. "Koji Yamamura." In *Ottawa 01 International Student Animation Festival, October 18-21, 2001*, pp. 18-19. Ottawa: Ottawa International Animation Festival, 2001.

8951. Makino, Keiichi. "Cartoonist and Animater [sic]." *Japanese Journal of Animation Studies*. 3:2A, 2002, p. 66.

8952. Makino, Mamoru. "Lecture: The Four Cineasts on Silhouette Animation in Japan." *Japanese Journal of Animation Studies*. 3:2A, 2002, pp. 55-61.

8953. Motomiya, Hiroshi. *Tennen Mangaka* (Naturally a Manga Artist). Tokyo: Shueisha, 2001. 249 pp.

8954. Murakami, Mutsuko. "The End of a Fantasy." *Asiaweek.* October 12, 2001, pp. 34-36. (Hironobu Sakaguchi).

8955. Nagai, Katsuichi. *"Garo" Henshūchō* ("Garo"'s Chief Editor). Tokyo: Chikuma Shobō, 1987. 321 pp.

8956. Ōizumi, Mitsunari. *Kieta Mangaka* (Manga Artists That Have Disappeared). 3 vols. Tokyo: Ōta Shuppan, August 1996, 189 pp.; June 1997, 191 pp.; December 1997, 189 pp.

8957. O'Neill, Eithne and Lorenzo Codelli. "Isao Takahata." *Positif.* April 2001, pp. 30-36.

8958. Randall, Bill. "Concerning Yuko Tsuno." *Comics Journal.* February 2003, pp. 109-114.

8959. Randall, Bill. "'Screw-Style' by Yoshiharu Tsuge." *Comics Journal.* February 2003, pp. 135-157.

8960. "Retrospective: Renzo Kinoshita." In *Thai Anima 2003: The First International Animation Festival 11-15 Jan 2003*, pp. 53-59. Bangkok: Thai Anima, 2003.

8961. Robinson, Chris. "East Meets Too Much West?: A Chat with Sayoko Kinoshita." *Animation World.* December 2000, pp. 56-59.

8962. Rozental, Izel. "A Portrait from Contemporary Cartoon Art: Norio Yamanoi (Japan)." *Yeni Akrep.* 1:3 (2002), pp. 4-5.

8963. Ryan, Will. "Mitsuhisa Ishikawa: On Vampires and Other Weirdos." *Animation World.* April 2002, pp. 29-31.

8964. Sakamaki, Sachiko. "Manga Mania: Japanese Cartoonists Eye America." *Washington Post.* September 5, 2002, p. C01.

8965. Sakurai Shōichi. *Boku wa Gekiga no Shikake-nin Datta* (I Was the Mastermind Behind Gekiga. 2 Vols.). Saītama: Tōkōsha, 1985. 142 pp.

8966. Schaefer, Gary. "Japan Dubbers Make Themselves Heard." Associated Press release, June 14, 2001.

8967. Shibata, M. "My Autobiography with Focus on Film" (Eiga wo Omo to Shita Watashi no Jijoden). *Eiga-shi Kenkyu.* Vol. 3, 1974, pp. 45-59.

8968. Takatori, Ei, ed. *"Kajiwara Ikki" o Yomu* (Reading "Kajiwara Ikki") Tokyo: Farao Kikaku, 1994. 255 pp.

8969. Thompson, Jason. "Kazuo Umezu's *Fourteen.*" *Comics Journal.* November 2002, pp. 115-117.

8970. Tinsley, Ben. "Cartoon Converts Librarian to Hero." *Fort Worth Star-Telegram.* August 24, 2001. (Monika Antonelli).

8971. Tsugata, Nobuyuki. "Research on the Achievements of Japan's First Three Animators." *Asian Cinema.* Spring 2003, pp. 13-27.

8972. Tsugata, Nobuyuki. "Research on the Achievements of Japan's First Three Animators." *Japanese Journal of Animation Studies.* 3:2A, 2002, pp. 7-20.

8973. Tsuge, Yoshiharu and Gondō Susumu. *Tsuge Yoshiharu Manga Jutsu* (The Art of Tsuge Yoshiharu's Manga). 2 Vols. Tokyo: Waizu Shuppan, 1993. Vol. 1, 305 pp.; Vol. 2, 426 pp.

8974. Yanase Masamu Kenkyū-kai. *Yanase Masamu: Hankotsu no Seishin to Jidai o Mitsumeru Me* (Yanase Masamu: The Spirit of Defiance and the Eye for Looking Hard at a Period. Exhibition Catalogue). Tokyo: Yanase Masamu Kenkyū-kai, 1999. 130 pp.

8975. Yokota, Masao. "The Japanese Puppet Animation Master: Kihachiro Kawamoto." *Asian Cinema.* Spring 2003.

8976. Yokota, Masao and Masashi Koide. "Economic Failure and Success in Feature Animations of Mamoru Oshii." Paper presented at Society for Animation Studies, Montreal, Canada, October 23, 2001.

Amano, Yoshitaka

8977. Fritz, Steve. "Yoshitaka Amano Redeems Marvel." *Comics Buyer's Guide.* November 30, 2001, pp. 14-15.

8978. Johnson, Ken. "Yoshitaka Amano." *New York Times Art in Review.* July 5, 2002, p. B35.

Asamiya, Kia

8979. Hill, Kevin. "What Is Manga?" *Borderline.* October 2001, p. 27.

8980. Hill, Kevin. "What Is Manga?: Kia Asamiya." *Borderline.* November 2001, p. 14.

8981. Sangiacomo, Michael. "Artist Makes His Point." *Cleveland Plain Dealer.* November 2, 2002.

Takashi, Murakami

8982. Cotter, Holland. "Carving a Pop Niche in Japan's Classical Tradition." *New York Times*. June 24, 2001, pp. 31-32.

8983. Murakami, Takashi. *Takashi Murakami: Summon Monsters? Open the Door? Heal? Or Die?* Tokyo: Museum of Contemporary Art, 2001. 168 pp.

8984. Smith, Roberta. "Takashi Murakami." *New York Times*. April 6, 2001, p. E38.

Tezuka, Osamu

8985. Cowan, James. "Honouring the God of Comics." *National Post* (Toronto). May 25, 2002.

8986. Natsume, Fusanosuke. *Tezuka Osamu no Bōken* (The Adventures of Tezuka Osamu). Tokyo: Chikuma Shobō, 1995. 291 pp.

8987. Nilsson, Peter. "Osamu Tezuka – Manga no Kami-sama." *Bild & Bubbla*. No. 2, 1999, pp. 28-37.

8988. Onoda, Natsu. "Drag Prince in Spotlight: Theatrical Cross-Dressing in Osamu Tezuka's Early *Shojo Manga*." *International Journal of Comic Art*. Fall 2002, pp. 124-138.

8989. Onoda, Natsu. "Osamu Tezuka and the Star System: Importing Hollywood Film into Manga." Paper presented at ICAF, Bethesda, Maryland, September 5, 2002.

8990. Onoda, Natsu. "Tezuka Osamu and the Star System." *International Journal of Comic Art*. Spring 2003, pp. 161-194.

8991. Shimotsuki, Takanaka, ed. *Tanjō! "Tezuka Osamu"* (The Birth! "Tezuka Osamu"). Tokyo: Asahi Sonorama, 1998. 278 pp.

8992. Tekeuchi, Osamu. *Tezuka Osamu Ron* (On Tezuka Osamu). Tokyo: Heibonsha, 1992. 254 pp.

8993. "Tezuka's Animation To Be Shown on Internet." Kyodo News dispatch, June 27, 2001.

Uchida, Shungiku

8994. Shamoon,Deborah. "Focalization and Narrative Voice in the Novels and Comics of Uchida Shungiku." *International Journal of Comic Art*. Spring 2003, pp. 147-160.

8995. Shamoon, Deborah. "Focalization and Narrative Voice in the Novels and Comics of Uchida Shungiku." Paper presented at ICAF, Bethesda, Maryland, September 5, 2002.

Characters and Titles: *Anime*

8996. Ball, Ryan. "Of Machines and Men: Robotech Is Back!" *Animation*. September 2002, pp. 14-15.

8997. Choo, Kukhee. "The Reemergence of Conservative Womanhood in Fruits Basket: Backlash or Reaffirmation?" Paper presented at Society for Animation Studies, Glendale, California, September 27, 2002.

8998. "Fox Acquires Live-Action Theatrical Rights to 'Dragonball.'" *Entertainment Wire*. March 12, 2002.

8999. Goldberg, Wendy. "This Isn't Your Mother's Mecha: The Adolescent's Story in *Utena* and *Evangelion*." Paper presented at Popular Culture Association, New Orleans, Louisiana, April 17, 2003.

9000. Harvey, Dennis. "Revolutionary Girl Utena: The Movie." *Variety*. July 29-August 4, 2002, p. 25.

9001. Hill, Kevin. "What Is Manga?" *Borderline*. September 2002, p. 39. (*Nausicaä of the Valley of Wind*).

9002. Hu, Gigi Tze Yue. "Usurping the Cinematic Screen – 'The Prince of the Sun: Hols Great Adventure.'" *Japanese Journal of Animation Studies*. 3:2A, 2002, pp. 21-26.

9003. Jandoc, Wilma. "'Escaflowne' Anime Packs in Plenty." *Honolulu Star Bulletin*. August 18, 2002.

9004. Kubin, Jacquie. "Gundam Wing: America's Next Pokemon?" *Animation World*. June 2000, pp. 60-63.

9005. Kunimoto, Trisha and Yoshiko Noda. "Ping Pong: Taiyo Matsumoto's Popular Manga Ping Pong Comes Alive on the Big Screen as a Live Action Movie." *http://www.akadot.com/article/article-pingpong-01.html*

9006. Leong, Anthony. "The Legacy of Starblazers Twenty Years Later." *Asian Cult Cinema*. No. 29, 2000, pp. 34-39.

9007. Linderström, Jenny. "Gästpennan." *Bild & Bubbla*. No. 4, 2001, p. 43. ("Sailor Moon").

9008. Mitchell, Elvis. "It Would Have Been Much Easier If He'd Just Misplaced His Keys." *New York Times*. April 2, 2003. ("Missing Gun").

9009. Noh Sueen. "A Blind Person and a Guide Dog Changed Darkness to Freedom – Hama Nobuko's 'Happy!'" *Hankyoreh*. August 30, 2000, p. 12.

9010. Noh Sueen. "Censorship of Obsceneness in Comics: It Is Like the Blind Men Who Touched Only One Part of an Elephant and Claimed That What It Was Like – Narita Minako's 'Cipher.'" *Hankyoreh*. April 19, 2000, p. 12.

9011. Noh Sueen. "The Challenge to the Eternity Cast by Cooled Love – Hara Hidenori's 'Come To My Home.'" *Hankyoreh*. June 28, 2000, p. 12.

9012. Noh Sueen. "The Complete Translation of 'Narcotic-Related Action Comics' Is Finally Made – Yoshida Akimi's 'Banana Fish.'" *Hankyoreh*. June 7, 2000, p. 12.

9013. Noh Sueen. "Happiness in Poor Days – Akimoto Naomi's 'Ensemble.'" *WebToon* (Korea). February 2, 2001.

9014. Noh Sueen. "Homosexual, Divorce, Remarriage…It's OK If They're Happy – Ima Ichiko's 'Problems of Adults.'" *Hankyoreh*. December 5, 2000, p. 12.

9015. Noh Sueen. " 'Hostesses' Are Your Sisters -- Rika (Drawing) and Shizuka Kidokuchi (Story)'s 'Flower of Night.'" *Hankyoreh*. February 29, 2000, p. 26.

9016. Noh Sueen. "Is Marriage Without Love True Marriage? – Koyama Yukari's 'Engagement of Ring'" *Hankyoreh*. May 3, 2000, p. 10.

9017. Noh Sueen. "I Want To Be 30 Years Old Soon – Osaka Mieko's 'Belle Epoque.'" *Hankyoreh*. April 4, 2000, p. 12.

9018. Noh Sueen. "Our Everyday Life Described Delicious – Tochi Ueyama's 'Cooking Papa.'" *Hankyoreh*. March 21, 2000, p. 12.

9019. Noh Sueen. "Pleasure Not Only from Successive Victories in Matches, But Also from Description of Complicated Relationships – Hotta Yumi (Story) and Obata Takesi (Drawings)'s 'Ghost Paduk King.'" *Hankyoreh*. November 15, 2000, p. 12.

9020. Noh Sueen. "The Power of World Revolution! Kanatsu Kumi's 'OL Visual Tribe.'" *WebToon*. April 2, 2001.

9021. Noh Sueen. "Professionals Are Beautiful – Kamoi Masane's 'Sweet Delivery.'" *WebToon*. December 7, 2000.

9022. Noh Sueen. "Reiko's Innocence or Dare – Suzuki Yumiko's 'Her Way of Love.'" *WebToon*. March 2, 2001.

9023. Noh Sueen. "Sexual Fantasy of Girls – Yamada Nanpei's 'Princess of Tea.'" *WebToon*. November 2, 2000.

9024. Noh Sueen. "There Are More Important Things Than Blood To Be a True Family – Yoshimura Akemi's 'More Deeply Than Sea.'" *Hankyoreh*. October 18, 2000, p. 12.

9025. Noh Sueen. "Wanna Be a Good Girl? – Nakayama Noriko's 'Mambo Girl Kiku.'" *WebToon*. January 7, 2001.

9026. Patten, Fred. "Which Is the Real Kimba?" *Animation World*. June 2000, pp. 70-73.

9027. Prunes, Mariano. "Having It Both Ways: Making Children Films an Adult Matter in Miyazaki's *My Neighbor Totoro*." *Asian Cinema*. Spring 2003, pp. 45-55.

9028. Prunes, Mariano. "Having It Both Ways: Making Children Films an Adult Matter Through Subjective Point of View in Hayao Miyazaki's *My Neighbor Totoro*." Paper presented at Society for Animation Studies, Glendale, California, September 27, 2002.

9029. Ragone, August. "Who Was That Masked Man? The Making of Kamen Rider." *Asian Cult Cinema*. No. 26, 2000, pp. 71-78.

9030. Rungfapaisarn, Kwanchai. "Doraemon Aims at US, Europe." *The Nation* (Bangkok). October 12, 2002.

9031. "*Transformers* Comes to *Toonami*." *Comics Buyer's Guide*. July 2002, p. 12.

9032. Yamamoto, Fumiko Y "Heisei Tanuki-gassen: Pon Poko." *Post Script*. Fall 1998, pp. 59-67.

"Akira"

9033. Beck, Jerry. "The Akira DVD Special Edition: An Anime Classic." *Animation World*. August 2001, pp. 13-14.

9034. Bernardin, Marc. "Akira: The Special Edition." *Entertainment Weekly*. July 27, 2001, p. 51.

9035. Desowitz, Bill. "DVD Spotlight: *Akira* Returns with a Digital Assist." *Animation*. October 2001, p. 47.

9036. Hill, Kevin. "What Is Manga? Katsuhiro Otomo's *Akira*." *Borderline*. March 2002, p. 31.

"Astroboy"

9037. "Astro Boy a Birthday Star." *The Age* (Australia). March 8, 2003.

9038. "Astro Boy Gold Coins To Be Sold in Japan." Agence France Press dispatch, March 8, 2003.

9039. "Astro Boy Strips Come to U.S." *Comics Buyer's Guide.* February 22, 2002, p. 31.

9040. Brodesser, Claude. "Sony Shoots for 'Astro Boy.'" *Variety.* December 10, 2001.

9041. Brooke, James. "Heart of Japanese Animation Beats in a Robot Boy." *New York Times.* April 7, 2003.

9042. Chin, Oliver. "The Ascension of Astro Boy: Even Manga Goes Retro." *Comics and Games Retailer.* June 2002, pp. 34-35.

9043. "50 Years of Tetsuwan-Atom (Astro Boy)." *Penstuff.* April 2003, p. 1.

9044. "Japanese Celebrate Cartoon Hero Astro Boy's Birth Date." AFP dispatch, April 7, 2003. Other articles: Yuri Kageyama, Associated Press, March 24, 2003; *Asahi Shimbun,* April 6, 7, 2003.

9045. Kageyama, Yuri. "Limping Japan Celebrates Birth of Robot from Bygone Boom Days." Associated Press dispatch, March 24, 2003.

9046. Osaki, Tad. "'Astro Boy' Remake Takes Off in Japan." Reuters dispatch, March 21, 2003.

"Blood: The Last Vampire"

9047. "*Blood*: Bull Digital Anime from Japan." *Animation.* September 2001, p. 18.

9048. Greenholdt, Joyce. "Anime Action: *Blood: The Last Vampire.*" *Comics Buyer's Guide.* August 10, 2001, p. 21.

9049. Holden, Stephen. "Mystery Girl vs. Creepy Vampires? Scary." *New York Times.* August 17, 2001, p. B20.

9050. Patten, Fred. "Blood: The Last Vampire – Anime's First Digital Feature." *Animation World.* October 2001, pp. 31-35.

"Cowboy Bebop"

9051. Axmaker, Sean. "Japanese Anime Film 'Cowboy Bebop' Is Flashy but Surprisingly Entertaining." *Seattle Post-Intelligencer.* April 4, 2003.

9052. Ball, Ryan. "Space Cowboys: Bandai Anime Hit *Cowboy Bebop* Saddles up for the Large Screen." *Animation*. March 2003, p. 44.

9053. Collins, Max A. "Cowboy Bebop." *Asian Cult Cinema*. No. 35, 2002, pp. 48-50.

9054. Koehler, Robert. "Cowboy Bebop: The Movie." *Variety*. August 19-25, 2002, p. 39.

9055. Patten, Fred. "Anime Goes Mainstream with 'Cowboy Bebop.'" *Animation*. September 1999, p. 45.

9056. Wilson, Alyce. "Cowboy Bebop." *Otakon 2002*, pp. 40-41.

"Hamtaro"

9057. "Japan's Hottest Hamster, Hamtaro ™, To Make U.S. Debut in San Francisco at Zeum." PRNewswire dispatch, May 17, 2002.

9058. Spreier, Jeanne. "Adventure-loving Rodents Rule on 'Hamtaro.'" *Dallas Morning News*. June 9, 2002.

9059. "Worldwide TV Update: Hamtaro." *Animation*. June 2002, p. 16.

"Jin-Roh"

9060. Hoberman, J. "Night and the Cities." *Village Voice*. June 14, 2001.

9061. Mitchell, Elvis. "An Alternate Reality Made of Cartoons." *New York Times*. June 22, 2001, p. E12.

"Lupin"

9062. Collins, Max Allan. "Foreign Crimes." *Asian Cult Cinema*. No. 36, 2002, pp. 38-39.

9063. "'Lupin the Third' Cartoon Set for TV Debut in United States, Canada." Associated Press dispatch, May 28, 2002.

"Metropolis"

9064. Carini, Stefania. "Dal Cinema al Fumetto, dal Femetto al Cinema: Le Due Metropolis." *Millimetri*. December 2002, pp. 42-49

9065. Covert, Colin. "'Metropolis' Anime Has Classical Feel." *Minneapolis Star Tribune*. March 15, 2002.

9066. Desowitz, Bill. "*Metropolis* Pushes Digital Boundaries of Anime." *Animation*. February 2002, pp. 40-41.

9067. Elley, Derek. "Metropolis." *Variety*. September 3-9, 2001, p. 45.

9068. Howe, Desson. "Our Guide to Holiday Movies: Osamu Tezuka's Metropolis." *Washington Post*. December 14, 2001, p. WE36.

9069. Jenkins, Mark. "Metropolis." *Washington City Paper*. January 25, 2002, p. 40.

9070. "'Metropolis' by Chris Lanier." *ASIFA San Francisco*. March 2002, p. 3.

9071. Nichols, Peter M. "Japan's Artistry, New and Classic." *New York Times*. April 19, 2002.

9072. Patten, Fred. "A Retro-future Metropolis." *Animation World*. February 2002, pp. 29-32.

9073. Schilling, Mark. "Metropolis: A Tribute to Pioneer Animator Osamu Tezuka." *Persimmon*. Spring 2002, pp. 86-88.

9074. Scott, A.O. "Dark Doings Proliferate in a World of Vivid Colors." *New York Times*. January 25, 2002, p. B31.

"Pokemon"

9075. "America Braces for Next Huge Pokemon Wave." *Business Wire*. March 17, 2003.

9076. Everschor, Franz. "Invasion der Pokémon. Cartoon–Monster Erobern die Herzen und das Taschengeld der Kinder." *Film-dienst* (Germany). December 1999, pp. 48-49.

9077. "First U.S. Pokemon Center Opens Its Doors in Rockefeller Center." PRNewswire press release, November 16, 2001.

9078. Gates, Anita. "Emotional Shutdown, I Choose You!" *New York Times*. April 6, 2001, p. E26. ("Pokémon 3").

9079. King, Loren. "Movie Review: 'Pokemon 4ever.'" *Chicago Tribune*. October 11, 2002.

9080. Koehler, Robert. "Pokemon 4Ever." *Variety*. October 7-13, 2002, p. 23.

9081. Mundell, E.J. "Pokemon Points to More Complex Learning in Kids." Reuters dispatch, June 19, 2001.

9082. "The 'Pokemon' Phenomenon." *Animatoon*. No. 22, 1999, pp. 52-53.

9083. Rogers, Brett. "Give Us Your Money: 4Kids Entertainment Attains Poké-Momentum." *Animation World*. October 2000, pp. 24-28.

9084. Servaes, Jan and Rico Lee. "Media Versus Globalisation and Localisation." *Media Development*. 3/2001, pp. 19-24.

9085. Talbot, Margaret. "Pokémon Hegemon." *New York Times Magazine.* December 15, 2002.

9086. Van Gelder, Lawrence. "A Reminder of Last Year's Playground Fad." *New York Times.* October 11, 2002.

9087. Warren, Steve. "Pokemon Goes Gay." *Washington Blade.* October 18, 2002, p. 57.

"Princess Mononoke"

9088. Collins, Max Allan. "Foreign Crimes (Princess Mononoke)." *Asian Cult Cinema.* No. 26, 2000, pp. 68-70.

9089. Hagiwara, Takao. "Anime East and West: Hayao Miyazaki's Mononoke Hime." Paper presented at Society for Animation Studies, Glendale, California, September 28, 2002.

9090. McCay, Mary. "Princess Mononoke and Nausicaa: Becoming an Adult Through Remembering Childhood: Anime's Integration of the Child and the Adult." Paper presented at Society for Animation Studies, Glendale, California, September 27, 2002.

"Spirited Away"

9091. Abel, George. "DVD Review: Spirited Away." *Hollywood Reporter.* April 29, 2003.

9092. Andersen, Soren. "All Ages 'Spirited Away' by Magical Movie." *Tacoma News Tribune.* November 1, 2002.

9093. Beacham, Greg. "Anime Magnetism: Miyazaki's Spirited Away Pulls You into a Completely Unique Animated World." *Salt Lake City Weekly.* October 17, 2002.

9094. Beifuss, John. "Crossing Over: Spirited's Anime Wonders Touch Emotions." *Memphis Commercial Appeal.* October 12, 2002.

9095. Bloom, David. "U.S. a Bust for Oscar Toon." *Variety.* February 17-23, 2003, p. 6.

9096. Breznican, Anthony. "Disney Will Adapt Anime Film for American Viewers." Philadelphia *Metro.* September 26, 2002, p. 16.

9097. Cheng, Scarlet. "High-Spirited." *Far Eastern Economic Review.* February 28, 2002, p. 56.

9098. "Critics Say Miyazaki's 'Spirited Away' Is a Masterpiece." *ASIFA San Francisco.* November 2002, p. 3.

9099. "Current Box Office Figures." *ASIFA San Francisco*. November 2002, p. 3.

9100. "Disney Will Not Release Miyazaki's 'Spirited Away.'" *ASIFA San Francisco*. October 2001, p. 8.

9101. Dunkley, Cathy. "Disney Acquires Japanese Hit 'Spirited Away.'" *Variety*. April 12, 2002.

9102. Ebert, Roger. "Miyazaki's 'Spirited Away.'" *Chicago Sun-Times*. September 20, 2002.

9103. Elley, Derek. "Spirited Away." *Variety*. February 25 - March 3, 2002, pp. 72-73.

9104. Elley, Derek. "Spirited Away." *Variety*. September 23-29, 2002, pp. 25-26.

9105. Fritz, Steve. "Pixar Brings Latest Miyazaki Epic to U.S." *Comics Buyer's Guide*. October 11, 2002, p. 13.

9106. Germain, David. "Japanese Fantasy 'Spirited Away' Wins Animated-Feature Oscar." Associated Press dispatch, March 23, 2003.

9107. Hartlaub, Peter. ["Spirited Away"]. *San Francisco Chronicle*. September 22, 2002.

9108. Horwitz, Jane. "An Animation Sensation: 'Spirited Away' into Wonderland." *Washington Post*. September 20, 2002, p. CO5.

9109. Howe, Desson. "'Spirited': Weird, Wonderful, Did We Mention Weird?" *Washington Post Weekend*. September 30, 2002, p. 47.

9110. Kakuchi Suvendrini. "Spirit Master." *Asiaweek*. October 19, 2001, pp. 62-63.

9111. Krolicki, Kevin. "Japan Director Miyazaki Offers Complex Kids Tale." Reuters dispatch, September 18, 2002.

9112. Lanier, Chris. "*Spirited Away* to the Working World." *Animation World*. October 2002, pp. 56-60.

9113. MacDonald, Heidi. "The Spirit of *Spirited Away*." *Comics Buyer's Guide*. April 25, 2003, p. 10.

9114. Meza, Ed. "Japanese Cartoon, U.K. Drama Share Berlin Kudos." *Variety*. February 18, 2002.

9115. Miller, Bob. "Avoiding Speed Race: Adapting Spirited Away." *Animation World*. September 2002, pp. 11-12.

9116. "Miyazaki's 'Spirited Away' Passes 'Titanic' as the Record Holder for the Film Seen by the Most People in Japan." *ASIFA San Francisco.* November 2001, p. 5.

9117. Nevius, C.W. "Japanese Preteen Girl Wins Hearts in Animated 'Spirited Away.'" *San Francisco Chronicle.* September 20, 2002.

9118. Patten, Fred. "Hayao Miyazaki's *Spirited* Trip to the US." *Animation World.* October 2002, pp. 3-8.

9119. Petkovic, John. "Japanese Animator Strikes with Familiar Fantasy Tale." *Cleveland Plain Dealer.* October 13, 2002.

9120. Schilling, Mark. "*Spirited Away.*" *Cinemaya.* Autumn 2001, pp. 28-29.

9121. Schwarzacher, Lukas. "Japan Box Office 'Spirited Away.'" *Variety AFM 2002.* February 18-24, 2002, p. 24.

9122. Schwarzacher, Lukas. "'Spirited' Box Office in Japan." Reuters dispatch, September 18, 2001.

9123. Solomon, Charles. "Discovering the Spirit Within: Miyazaki's *Spirited Away.*" *Animation.* September 2002, pp. 34-36, 38.

9124. "'Spirited Away.'" *Animatoon.* No. 33, 2001, pp. 80-83.

9125. "'Spirited Away' Will Be Shown...." *ASIFA San Francisco.* April 2002, p. 1.

9126. "'Spirited Away' Wins Best Film at Animation Industry Awards." Associated Press dispatch, February 6, 2003.

9127. Turan, Kenneth. "Under the Spell of 'Spirited Away.'" *Los Angeles Times.* September 20, 2002.

"Vampire Hunter D"

9128. Kehr, Dave. "A Clint Eastwood Loner in a Vampire Cartoon." *New York Times.* September 21, 2001, p. E16.

9129. Moondaughter, Wolfen. "The Two Faces of Vampire Hunter D." *Sequential Tart.* November 2001.

9130. Patten, Fred. "Vampire Hunter D Comes to America." *Animation World.* October 2001, pp. 43-47.

9131. Patten, Fred. "Vampire Hunter D: The New Anime Hit in America?" *Animation World.* December 2000, pp. 20-24.

9132. Siegel, Joel E. "Vampire Hunter D: Bloodlust." *Washington City Paper.* December 14, 2001, p. 42.

"Weather Girl"

9133. Kadrey, Richard. *"Weather Girl [Otenki Onesan]* (1993)." *Asian Cult Cinema.* No. 16. 1997, pp. 34-36.

9134. Lewis, Graham R. *"Weather Girl* and *To Die For*: A Cultural Chasm." *Asian Cult Cinema.* No. 16, 1997, pp. 35-39.

Characters and Titles: *Manga*

9135. Boyd, Robert. "On Second Thought, There Is a Need for Tenchi." *Comics Journal.* October 2001, pp. 93-99.

9136. Contino, Jennifer. "Marvel's X-manga: X-Men Ronin." *Pulse.* December 9, 2002.

9137. "Dark Horse's Super Manga Blast!: Go into Manga Overload." *Comics Buyer's Guide.* October 5, 2001, p. 40.

9138. Dresner, Jonathan F. *"The Four Immigrants Manga."* *Education about Asia.* Fall, 2001, pp. 63-64.

9139. Fletcher, Dani, *et al.* "Read This or Die: Blade of the Immortal." *Sequential Tart.* December 2001.

9140. Hill, Kevin. "Dragon Ball." *Borderline.* February 2002, pp. 28-29.

9141. Hill, Kevin. "What Is Manga? Boy or Astro Boy." *Borderline.* April 2002, pp. 27-28.

9142. Hill, Kevin. "What Is Manga? *Eagle* and *Sanctuary*." *Borderline.* May 2002, p. 30.

9143. Hill, Kevin. "What Is Manga? *Evangelion*." *Borderline.* July 2002, p. 40.

9144. Hill, Kevin. "What Is Manga? Masamune Shirow's Stunning *Appleseed*." *Borderline.* August 2002, p. 41.

9145. Kreiner, Rich. "In the Toilet of the Senses: *Ultra Gash Inferno*." *Comics Journal.* November 2001, pp. 24-25.

9146. Liu Ping-Chiun. "An Interpretation of City Hunter from a Feminist Viewpoint." Master's thesis, National Chengchi University, Department of Journalism, Taipei, 1996.

9147. Marechal, Beatrice. "'The Singular Stories of the Terashima Neighborhood': A Japanese Autobiographical Comic." *International Journal of Comic Art.* Fall 2001, pp. 138-150.

9148. "Marvel Mangaverse: New Dawn #1." *Borderline.* February 2002, pp. 51-52.

9149. Molotiu, Andrei. "Masashi Tanaka's *Gon* Series." *Comics Journal.* April 2002, pp. 71-74.

9150. Moondaughter, Wolfen. "Lost in Translation: Ranma vs. His Other Half." *Sequential Tart.* November 2001.

9151. "Powderpuff DVD Spreads Funlove Virus." *Comics Buyer's Guide.* November 23, 2001, p. 16.

9152. Randall, Bill. "Achieving Godhead with Pen and Ink." *Comics Journal.* September 2002, pp. 109-113. ("Phoenix").

9153. Randall, Bill. "'Of Course…We Wouldn't Want a Mushroom Cloud.'" *Comics Journal.* October 2002, pp. 121-124. ("Bakune Young").

9154. "Screening Room." *Comics Buyer's Guide.* March 22, 2002, p. 18.

9155. Tong, Ng Suat. "Hisashi Sakaguchi's *Ikkyu.*" *Comics Journal.* February 2002, pp. 36-39.

9156. Ueda, Masashi. *Kobo, The Li'l Rascal.* Vols. I, II, III. Tokyo: Kodansha, 2001. 144 pp.

"Lone Wolf and Cub"

9157. Collins, Max Allan. "The Translated Baby Cart Series: Sword of Vengeance." *Asian Trash Cinema.* No. 4, 1993, pp. 22-26.

9158. Doran, Michael and Matthew Brady. "Lone Wolf and Cub: Back to the Future." *Comics Buyer's Guide.* January 25, 2002, p. 14.

9159. "Wagner Covers Lone Wolf." *Comics Buyer's Guide.* March 8, 2002, p. 15.

"Shonen Jump"

9160. Garger, Ilya. "Look, Up in the Sky! It's Shonen Jump…." *Time.* February 24, 2003.

9161. Kelly, Keith J. "Japanese Comic To Launch in U.S." *New York Post.* June 10, 2002.

9162. Sato, Kenichi. "Editor Wants To Fill U.S. with Manga." *Yomiuri Shimbun.* January 12, 2003.

9163. "*Shonen Jump* Hops to U.S. via Viz." *Comics Buyer's Guide.* July 5, 2002, p. 1.

9164. Stone, Susan. "Japan's Comic Book Export: 'Shonen Jump' Appeals to U.S. Kids Raised on Pokemon." *National Public Radio's* "All Things Considered," January 9, 2003.

"X/1999"

9165. McNeil, Sheena. "Under a Microscope – X/1999: Overture." *Sequential Tart.* December 2001.

9166. McNeil, Sheena. "Under a Microscope – X/1999: Prelude." *Sequential Tart.* November 2001.

Exhibitions, Festivals

9167. Glabicki, Paul. "The Following Is a Brief Excerpt from 'Festival Report: Hiroshima 2002.'" *ASIFA San Francisco.* November 2002, p. 5.

9168. *Otakon 2000. Convention of Otaku Generation.* Baltimore: Anthony N. Palumbo, 2000. 64 pp.

9169. Patten, Fred. "Confirming a New Tradition: Cal State Long Beach's 2nd Annual Japanese Animation Festival." *Animation World.* July 2001, pp. 44-47.

9170. "The 23rd Yomiuri International Cartoon Contest." *Kayhan Caricature.* June 2001, p. 19.

9171. Wilson, Keri. "Anime Weekend Atlanta 2001." *Sequential Tart.* November 2001.

9172. "Yubari International Fantastic Film Festival 2002." *Animatoon.* No. 36, 2002, pp. 12-13.

Historical Aspects

9173. Akiyama, Masami. *Bessatsu Taiyō: Kodomo no Showa-shi, Shōwa Gannen-20nen 'Meisaku Komikku-shū* (Taiyō Supplemental Volumes: Shōwa Children's History, Shōwa Years 1-20 (1925-1945) 'Collection of Manga Masterpieces'). Tokyo: Heibonsha, 1989. 176 pp.

9174. Akiyama, Masami, ed. *Maboroshi no Sensō Manga no Sekai* (The Rarely Seen World of Wartime Manga). Tokyo: Natsume Shobō, 1998. 318 pp.

9175. "Charlton's '60s Manga." *Comics Buyer's Guide.* November 22, 2002, p. 27.

9176. Duus, Peter. "Japan's First Manga Magazine." *Impressions.* 21 (1999), pp. 30-41.

9177. Furuta, Shōkin. *Sengai, Master Zen Painter*. Tokyo: Kodansha International, 2000. 293 pp.

9178. Haga, Toru and Isao Shimizu. *Kindai Manga (1): Bakumatsu Isshinki no Manga* (The Modern Cartoon (1): The Late Tokugawa and Restoration Period). Tokyo: Chikuma Shobo, 1985.

9179. Hibbett, Howard. *The Chrysanthemum and the Fish: Japanese Humor Since the Age of the Shoguns*. Tokyo: Kodansha, 2002. 208 pp.

9180. Hosokibara, Seiki. *Nihon Manga-shi* (A History of Japanese Manga). Tokyo: Yūzankaku, 1924. 235 pp.

9181. Ingaki, Shin'ichi. *Edo no Asobi-e*, (Puzzle Pictures of the Edo Period). Tokyo: Tokyo Shohan, 1988.

9182. Ishiko, Junzō. *Sengo Manga-shi Nōto* (Notes on Postwar Manga History). Tokyo: Kinokuniya Shoten, 1994. 202 pp.

9183. Kajii, Jun. *Tore, Yōchō no Jū to Pen* (Pick Up! The Gun and the Pen for the Justice). Tokyo: Waizu Shuppan, 1999. 217 pp.

9184. Katayori, Mitsugu. *Sengo Manga Shisō-shi* (A History of Postwar Manga Thought). Tokyo: Miraisha, 1980. 196 pp.

9185. Kawasaki City Museum. *Nihon no Manga Sanbyaku-nen* (Three Hundred Years of Japanese Manga. Exhibition Catalogue). Kanagawa: Kawasaki City Museum, 1996. 176 pp.

9186. Matsumoto, Leiji and Hidaka Satoshi, eds. *Manga Rekishi Dai Hakubutsukan* (A Giant Museum of Comic History). Tokyo: Buronzusha, 1980. 397 pp.

9187. Minami, Kazuo. *Bakumatsu Isshin Fushiga* (Satirical Art of the Bakumatsu and Restoration Period). Tokyo: Yoshikawa Kobunkan, 1999.

9188. Minami, Kazuo. *Edo no Fushiga* (Satirical Art in the Edo Period). Tokyo: Yoshikawa Kobunkan, 1997.

9189. Miyatake, Gaikotsu. *Hikkashi* (A History of Slips of the Brush). Tokyo: Asakaya Shoten, 1926.

9190. Ōtsuka, Eiji. *Sengo Manga no Hyōgen Kūkan* (The Space of Expression of Postwar Manga). Kyoto: Hōzōkan, 1994. 393 pp.

9191. Shimizu, Isao. *Kindai Manga no Hyakusen* (One Hundred Modern Cartoons). Tokyo: Iwanami Shoten, 1997.

9192. Shimizu, Isao. *Zusetsu Manga no Rekishi* (The Illustrated History of Manga). Tokyo: Kawade Shōbō Shinsha, 1999. 127 pp.

9193. Shimizu, Isao. "A Study of Handdrawn 'Hell Cartoons' in Edo Era (1601-1868)." *Manga Studies*. Vol. 1, 2002, pp. 86-93.

9194. Steele, M. William. "Representations of Self and Other in Late Tokugawa Woodblock Prints." *Asian Cultural Studies*. March 1996, pp. 27-42.

9195. Stewart, Ron. "Temporality and the Making of Difference in Early Twentieth-Century Japanese Cartoons." Paper presented at Popular Culture Association, New Orleans, Louisiana, April 17, 2003.

9196. Takeuchi, Osamu. *Sengo Manga Gojūnen-shi* (Post-war Manga's 50 Year History). Tokyo: Chikumashobō, 1995. 238 pp.

9197. Tomii, Reiko. "Akasegawa Genpei's The *Sakura Illustrated*: When the Good Old Man Makes a Dead Tree Flower and the Bad Old Man Throws a Fire Bomb." *International Journal of Comic Art*. Fall 2002, pp. 209-223.

9198. Yonezawa, Yoshihiro. *Sengo Shōjō Manga-shi* (The History of Postwar Girl's Manga). Tokyo: Shinpyōsha, 1980. 253 pp.

Kawanabe Kyōsai

9199. Clark, Timothy. *Demon of Painting: The Art of Kawanabe Kyosai*. London: British Museum Press, 1993. 192 pp.

9200. Oikawa Shigeru. *Saigo no Ukiyoeshi: Kawanabe Kyōsai to Sono Hankotsu Bigaku* (The Last Ukiyoe Artist: Kawanabe Kyosai and His Subversive Aesthetic). Tokyo: NHK Books, 1992.

9201. Yamaguchi Seiichi and Oikawa Shigeru. *Kawanabe Kyōsai Gigashu* (The Comical Pictures of Kawanabe Kyōsai). Tokyo: Iwanami Shoten, 1988.

Kuniyoshi Utagawa

9202. Inagaki, Shin'ichi and Isao Toshihiko. *Kuniyoshi no Kyōga* (The Crazy Pictures of Kuniyoshi). Tokyo: Tokyo Shohan, 1991.

9203. Iwashita, Tetsunori. "Political Information and Satirical Prints in Late Tokugawa Japan: The Popular Image of Government Officials in Utagawa Kuniyoshi's *Kitaina mei'i nanbyō ryōji*." *Asian Cultural Studies*. March 1996, pp. 17-26.

9204. Takeuchi, Melinda. "Kuniyoshi's *Minamoto Raikō and the Earth Spider*: Demons and Protest in Late Tokugawa Japan)." *Ars Orientalis*. 17 (1987), pp. 5-38.

Marumaru Chinbun

9205. Kimoto, Itaru. "*Marumaru Chinbun*," "*Kibidango ga Yuku*" (The *Marumaru Chinbun* and the *Kibidango*). Tokyo: Hakusuisha, 1989.

9206. Yamaguchi Eiyu, ed. *Marumaru Chinbun*. 48 volumes. Tokyo: Honpō Shokan, 1981-1986.

Anime and *Manga*

9207. Clements, Jonathan. "The Mechanics of the US Anime and Manga Industry." *Foundation – The Review of Science Fiction*. No. 64, 1995, pp. 32-44.

9208. Fritz, Steve. "Anime and Manga: Starting a New Line from Scratch." *Comics and Games Retailer*. June 2002, p. 30.

9209. Fritz, Steve. "Anime and Manga Taking the Pulse: What Will the Industry Be Like in 2003?" *Comics and Games Retailer*. February 2003, pp. 16-19.

9210. Iwabuchi, Koichi. *Recentering Globalization: Popular Culture and Japanese Transnationalism*. Durham, North Carolina: Duke University Press, 2002. (Animation and comics, 1, 23, 76, 202, 216-217, 34, 69-70, 163, 170, 211, 30, 38, 119, 47, 31-33, 27-28, 94-95, 37).

9211. Minkel, Walter. "Anime? Manga? Huh?" *School Library Journal*. 47:1 (2001), pp. 36-40.

9212. "Newtype USA Sets Date for Launch Party...." PRNewswire dispatch, October 10, 2002.

9213. Schamberger, Jennifer. "Anime and Manga as Art: An Examination of a Pop Culture Movement as an Art Form." Paper presented at Popular Culture Association, Toronto, Canada, March 16, 2001.

9214. Wolk, Douglas. "Manga, Anime Invade the U.S." *Publishers Weekly*. 248:11 (2001), pp. 35-36.

Anime (Animation)
Resources

9215. "The Activities of Japan Society for Animation Studies (April 2000 to March 2001)." *The Japanese Journal of Animation Studies*. 3:1A (2001), pp. 103-111.

9216. Clements, Jonathan and Helen McCarthy. *The Anime Encyclopedia: A Guide to Japanese Animation Since 1917*. Berkeley, California: Stone Bridge Press, 2001. 545 pp.

9217. Drazen, Patrick. *Anime Explosion: The What? Why? & Wow! Of Japanese Animation.* Berkeley: Stone Bridge, 2003. 369 pp.

9218. Grissom Harriette D. "*The Anime Companion.*" *Education about Asia.* Fall 2001, pp. 69-70.

9219. Lyons, Michelle and Lucien Soulban. *Trigun Ultimate Fan Guide #1.* Guelph, Ontario: Guardians of Order, Inc., 2002. 107 pp.

9220. Neal, Alan. "The Anime Encyclopedia." *Animation World.* January 2002, pp. 61-63.

9221. Patten, Fred. "Fan Books Get Serious: *Trigun.*" *Animation World.* August 2002, pp. 60-61.

9222. Sito, Tom. "The Ghibli Museum: Miyazaki's Genius on Display." *Animation World.* July 2001, pp. 9-11.

9223. "Za Manga – Manga from Z to A." *Borderline.* March 2002, p. 26.

General Sources

9224. [Animation]. *Katsudo no Sekai.* September 1917, p. 27.

9225. "Big Fat Greek Anime." *Animation.* March 2003, p. 10.

9226. Camhi, Leslie. "The Future of Cuteness Has a Dark Side." *Village Voice.* August 30, 2001.

9227. Chan, Yuk Ting. "Animation and the Cinematic." Paper presented at Society for Animation Studies, Montreal, Canada, October 25, 2001.

9228. Chin, Oliver. "The Americanization of Anime." *Comics and Games Retailer.* November 2002, pp. 14-15.

9229. Chong, Doryun. "A Super-Flat Reality." *Art Asia Pacific.* No. 32, 2001, pp. 20-22.

9230. Considine, J.D. "Making Anime a Little Safer for Americans." *New York Times.* January 20, 2002.

9231. Cooper-Chen, Anne. "An Animated Imbalance: Japan's Television Heroines in Asia." *Gazette.* July 1999, pp. 293-310.

9232. Cotter, Holland. "Becoming Immersed in Japan's Wired Pop Culture." *New York Times.* August 3, 2001, p. B34.

9233. Dawley, Kourtney. "Truth in Anime?" *Sequential Tart.* December 2001.

9234. Desser, David. "Consuming Asia: Chinese and Japanese Popular Culture and the American Imaginary." In *Multiple Modernities: Cinemas and Popular Media in Transcultural East Asia,* edited by

Jenny Kwok Wah Lau, pp. 179-199. Philadelphia: Temple University Press, 2003.

9235. Franks, Alexis. "He Said, She Said: Gender, Power, and Community in Shojo Anime." Paper presented at Society for Animation Studies, Glendale, California, September 27, 2002.

9236. Hammer, Esther. "Exhibit Explores Japanese Animation's Influence on Art." *Tampa Tribune*. April 18, 2002.

9237. Higuinen, Erwan. "Mangas: au Pays de l'Animé." *Cahiers*. February 2000, pp. 36-39.

9238. "Indulge in Anime with On-campus Events." *Lansing* (Michigan) *State Journal*. September 26, 2002.

9239. Johnson, Ken. "The Innocent Yet Sinister Aspects of Japanese Animation." *New York Times*. August 24, 2001, p. B32.

9240. Kim, Kyu Hyun. "Girl (and Boy) Troubles in Animeland: Exploring Representations of Gender in Japanese Animation Films." *Education about Asia*. Spring 2002, pp. 38-46.

9241. King, Brad. "More Anime on the Way." Wired News dispatch, March 2, 2002.

9242. Lee, Diana K. "What I Did This Summer." *Animation World*. September 2002, pp. 8-10.

9243. McKinley, Jesse. "Anime Fans Gather, Loudly and Proudly Obsessed." *New York Times*. September 3, 2002.

9244. Meyers, Ric. "Ric & Infamous." *Asian Cult Cinema*. No. 33, 2001, pp. 20-23.

9245. Min Lee. "Coke Pulls Swastika-Bearing Figurine." Associated Press dispatch, April 30, 2003.

9246. Mollman, Steve. "Playing the Field." *Asiaweek*. November 30, 2001, pp. 36-41.

9247. Napier, Susan J. "The Frenzy of Metamorphosis: The Body in Japanese Pornographic Animation." In *Word and Image in Japanese Cinema*, edited by Dennis Washburn and Carole Cavanaugh, pp. 342-365. Cambridge: Cambridge University Press, 2001.

9248. Newitz, A. "Anime Otaku: Japanese Animation Fans Outside Japan." *Bad Subjects*. 13:1 (1994), pp. 1-14.

9249. NHK. *Broadcasting in Japan: The Twentieth Century Journey from Radio to Multimedia.* Tokyo: NHK, 2002. 365 pp. (Animation, 169, 310).

9250. Osmond, Andrew. "The Anime Debate." *Animation World.* December 2000, pp. 25-33.

9251. Osmond, Andrew. "Anime Magic." *Sight & Sound.* November 2001, pp. 24-26.

9252. Patten, Fred. "The Anime Trivia Quizbook: Fun Fan Fare or More?" *Animation World.* June 2000, pp. 74-75.

9253. "Peruvian Teenagers 'Possessed' by Japanese TV Cartoon." *Anova.* November 4, 2002.

9254. Poulos, Gerry. "Making a Break into Anime Voice Acting." *Animation World.* August 2002, pp. 20-27.

9255. Rubinoff, Joel. "Anime Returns to Waterloo." Waterloo *Record.* October 30, 2002.

9256. Sato, Kenji. "More Animated Than Life." *Kyoto Journal.* No. 41, 1999.

9257. Schaub, Joseph C. "Kusanagi's Body: Gender and Technology in Mecha-anime." *Asian Journal of Communication.* 11:2 (2001), pp. 79-100.

9258. Schifferle, Hans. "Von Prinzessinnen und Supergirls, von Wunderwelten und Megacities: Einige Notizen zum Japanischen Anime-Kino." *EPD Film.* August 2000, pp. 34-37.

9259. Schneidmill, Chris. "'Toons with an Attitude; Anime: It's Not Just for Kids." (Northern Virginia) *Journal.* September 13, 2002, p. E18.

9260. "Since Hiroshima." *Animation World.* October 2000, pp. 51-53.

9261. Sumi, Shigemasa. "Editorial." *Japanese Journal of Animation Studies.* 3:2A, 2002, pp. 2-4.

9262. Walser, Sandra. "Von Apokalypsen und Waldgeistern." *Film (Zoom).* March 2000, pp. 8-10.

9263. Wu Chi-Hsien. "How Children Make Sense of Totoro – A Study of Children's Cognitive Process of Comprehending Animated Programs." *Journal of Primary Education* (Taiwan Normal College). 6 (1997), pp. 131-168.

9264. Yomota Inuhiko. "Stranger Than Tokyo: Space and Race in Postnational Japanese Cinema." In *Multiple Modernities: Cinemas ad Popular Media*

in Transcultural East Asia, edited by Jenny Kwok Wah Lau, pp. 76-89. Philadelphia: Temple University Press, 2003.

Disney

9265. Brannen, Mary Yoko. "'Bwana Mickey': Constructing Cultural Consumption at Tokyo Disneyland." In *Re-Made in Japan: Everyday Life and Consumer Taste in a Changing Society*, edited by Joseph Tobin. New Haven, Connecticut: Yale University Press, 1992.

9266. Canemaker, John. "Un-Disney." *Print*. 54:3 (2000), pp. 94-99.

9267. Doyle, Wyatt. "Disney Turning Japanese." *Asian Cult Cinema*. No. 21, 1998, pp. 25-28.

9268. Guider, Elizabeth. "Disney Cuts Japan Deal." *Variety*. January 21-27, 2002, p. 28.

9269. "How Original Is Disney's 'Atlantis'? Fans of Japanese Animation Find It Disturbingly Similar to 'Nadia.'" *ASIFA San Francisco*. September 2001, p. 6.

9270. "'Nadia: The Secret of Blue Water' (1990), the Film That Seems To Have 'Influenced' Disney's 'Atlantis,' Is Available on Video and DVD." *ASIFA San Francisco*. October 2001, p. 5.

Historical Aspects

9271. "Anime Style Has a Long History." *Washington Post*. April 9, 2003, p. C15.

9272. Hu, Gigi Tze Yue. "Understanding Japanese Animation – From Miyazaki and Takahata Anime." Ph.D. dissertation, University of Hong Kong, 2001. 297 pp.

9273. Hu, Gigi Tze Yue. "Usurping the Cinematic Screen – Prince of the Sun: *The Great Adventures of Hols* (1968)." Paper presented at Society for Animation Studies, Montreal, Canada, October 25, 2001.

9274. Kitayama, S. "How To Make Animated Films" (Sen-Eiga no Tsukurikata). In Zen-nihon Katuei Kyoiku Kenkyukai. *Basic Facts for Film Education* (Eiga Kyoiku no Kiso Chishiki), pp. 321-341. Tokyo: Kyoiku-syokan, 1930.

9275. Kouchi, J. "Contemporary Animation" (Gendai Manga Eiga ni Tsuite). *Toyo*. October 1936, pp. 101-103.

9276. Midorikawa, M. "Beginnings of Japanese Animation" (Nihon Anime Kotohajime). In *Studies on Animated Cartoon. Vol. 0* (Manga Eiga Kenkyu. Vol. 0), pp. 1-42. Tokyo: self publication, 1993.

9277. Neal, Alan. "From Akira to Princess Mononoke? Don't Think So." *Animation World.* July 2001, pp. 54-55.

9278. Richie, Donald. *A Hundred Years of Japanese Film: A Concise History with a Selective Guide to Videos and DVDs.* Tokyo: Kodansha, 2001. (Anime, pp. 223-224, 246-253).

9279. Shimokawa, O. "Memoirs of the First Animation Production in Japan" (Nihon Shaisyo no Manga Eiga Seisaku no Omoide). *Eiga Hyoron.* July 1934, p. 39.

9280. "So...What Are Ukiyo-e?" *Asian Cult Cinema.* No. 19, 1998, p. 8.

9281. Terasaki, K. "Animated Cartoon and Kinema Colour" (Dekobo Shingacho to Kinema Colour). *Katsudo no Sekai.* January 1916, pp. 100-103.

9282. Watanabe, Yasushi. "A Study of Possibly the First Animation Film in the World Shown in Japan." *The Japanese Journal of Animation Studies.* 3:1A (2001), pp. 17-24.

9283. Yamaguchi, K. "Animators Throughout History" (Rekishijo no Animator wo Tazunete). *Animation.* November 1978, pp. 14-16.

9284. Yamaguchi, K. and Y. Watanabe. *The History of Japanese Animation* (Nihon Animation Eiga-shi). Tokyo: Yubunsha, 1977.

9285. Yokota, Masao, Masashi Koide, and Koji Nomura. "Psychological Dependence in Japanese Animation Films: A Case of Rin Taro." *The Japanese Journal of Animation Studies.* 3:1A (2001), pp. 49-52.

Industry

9286. "ADV Films Acquires Japanese Anime Sensation 'The Voices of a Distant Star.'" PRNewswire dispatch, July 25, 2002.

9287. "ADV FILMS Acquires Steel Angel: Kurumi." PRNewswire press release, November 15, 2001.

9288. "ADV FILMS Acquires the Anime Hit Noir for Home Video Release." PRNewswire, April 24, 2002.

9289. "Anime Ambassador ADV Films Gives Fans Their Fix." *Animation.* December 2002-January 2003, p. 10.

9290. Chin, Oliver. "Add a Third Dimension: Anime-inspired Toys Are Taking Flight." *Comics and Games Retailer.* November 2001, pp. 42-44.

9291. Chin, Oliver. "Anime Attractions: 2003 May See High Honors for Genre." *Comics and Games Retailer*. March 2003, pp. 46-47.

9292. Chin, Oliver. "Anime Roundup: The Real Entertainment This Summer's on Your Store Shelves." *Comics and Games Retailer*. August 2002, pp. 64, 73.

9293. Clements, Jonathan. "Kids or Kudos? The Future of Anime." *Nickelodeon Far East Film*. No. 99-100 (April 2002), pp. 12-15.

9294. Fitzpatrick, Eileen. "Manga Entertainment Strikes a Deal with Pathe To Distribute Japanese Animation Products." *Billboard*. 113:14 (2001), pp. 94-98.

9295. Fritz, Steve. "Renting Anime: A Retailer Shows How It's Done." *Comics and Games Retailer*. August 2002, p. 60.

9296. Gardner, Chris. "DreamWorks Casts Anime 'Actress.'" *The Hollywood Reporter*. July 17, 2002.

9297. Herskovitz, Jon. "Japan Gamer Seeks New Reality with Final Fantasy." Reuters dispatch, July 11, 2001.

9298. Holden, Stephen. "Machines, Noir Mood and Mayhem." *New York Times*. January 10, 2003.

9299. "I Tawt I Taw a Hello Kitty Cat: Warner Bros. Consumer Products and Sanrio Enter Agreement To Develop Co-Branded Merchandise Featuring Lovable Icons Tweety and Hello Kitty." Entertainment Wire press release, November 15, 2001.

9300. "Japan Animation Shines in New York." Reuters dispatch, October 26, 2001.

9301. Laing, Jennifer. "'Japanimation' Grows Up." *New York Times*. January 12, 2003.

9302. Leach, Justin. "Japan: A View from Inside Production I.G." *Animation World*. April 2002, pp. 25-28.

9303. Maynard, Micheline. "The Ancient Art of Kabuki Made New, with Computer Animation." *New York Times*. May 2, 2002.

9304. Nichols, Peter M. "Japan's Artistry, New and Classic." *New York Times*. April 19, 2002.

9305. Osaki, Tad. "Television Prod'n, B'cast Part of Diversification Plan." *Variety*. December 17-23, 2001, pp. A7-A8.

9306. Patten, Marc. "Anime Candidates for 'Next Big Thing' Line Up." *Comics and Games Retailer*. August 2002, p. 8.

9307. Patten, Marc. "How an Import Distributor Brings in the Goods." *Comics and Games Retailer*. August 2002, pp. 66-69.

9308. Sabulis, Jill. "Store, Convention Animate Devotees of Japanese Style." *Atlanta Journal-Constitution*. July 10, 2002.

9309. Schwarzacher, Lukas. "Pumped-up Prod'n Slates Feature Samurai Pix, Toons." *Variety*. April 15-21, 2002, p. 20.

9310. Schwarzacher, Lukas. "Toei Co. at 50: Toons Animate Bottom Line." *Variety*. December 17-23, 2001, pp. A4, A8.

9311. Slott, Mira. "'Japanime' Is a Monster in Licensing." *Home Textile Today*. 37:1 (2000), pp. 1-14.

9312. Straub, Joseph C. "Kusanagi's Body: Gender and Technology in Mecha-anime." *Asian Journal of Communication*. 11:2 (2001), pp. 79-100.

Reviews, Synopses

9313. "Bandai Entertainment Sets January 25, 2002 for Theatrical Release of Anime Feature 'Escaflowne.'" PRNewswire press release, November 9, 2001.

9314. Besher, Kara. "You've Come a Long Way, Atom Boy." *The Japan Times*. November 22, 1998.

9315. Cashen, Norene. "Still Life Anime: Japanese Animation Figures Brought to Life." Chicago *Metro Times*. October 17, 2000.

9316. Chin, Oliver. "The DVD Department." *Comics Buyer's Guide*. November 30, 2001, p. 19. ("The Big O," "Oh My Goddess! DVD").

9317. "Cosmic Baton Girl COMET." *Animatoon*. No. 32, 2001, pp. 64-66.

9318. Gearing, Julian and Yoko Shimatsuka. "Ultraman Fights Back." *Asiaweek*. November 30, 2001, pp. 56-57.

9319. Greenholdt, Joyce. "Anime Action." *Comics Buyer's Guide*. July 27, 2001, p. 60.

9320. Hiltbrand, David and Mark Lasswell. "The 10 Best New Kids' Shows." *TV Guide*. October 27, 2001, pp. 34-40.

9321. "The Legend of Blue." *Animatoon*. No. 34, 2001, p. 89.

9322. "Move Over Pokemon, Yugi in Town." *Amarillo Globe-News*. November 2, 2002.

9323. Oei, Lily. "Toons from Japan Score in Sat. Pack." *Variety*. November 5-11, 2001, p. 8.

9324. Patten, Fred. "Anime Film Reviews." *Animation World.* March 2002, pp. 65-69.

9325. Patten, Fred. "Anime Film Reviews." *Animation World.* July 2002, pp. 63-67.

9326. Patten, Fred. "Anime Film Reviews." *Animation World.* April 2001, pp. 60-64.

9327. Patten, Fred. "Anime Theatrical Features." *Animation World.* September 2000, pp. 17-20.

9328. Patten, Fred. "15 Notable Anime TV Series." *Animation Magazine.* December 2000, p. 60.

9329. Patten, Fred. "New from Japan: Anime Film Reviews." *Animation World.* October 2002, pp. 61-66.

9330. Patten, Fred. "New from Japan: Anime Film Reviews." *Animation World.* November 2002, pp. 34-39.

9331. Patten, Fred. "New from Japan: Anime Film Reviews." *Animation World.* January 2001, pp. 67-71.

9332. Patten, Fred. "New from Japan: Anime Film Reviews." *Animation World.* February 2001, pp. 48-52.

9333. Patten, Fred. "New from Japan: Anime Film Reviews." *Animation World.* March 2001, pp. 47-52.

9334. Patten, Fred. "New from Japan: Anime Film Reviews." *Animation World.* May 2001, pp. 53-57.

9335. Patten, Fred. "New from Japan: Anime Film Reviews." *Animation World.* June 2001, pp. 31-35.

9336. Patten, Fred. "New from Japan: Anime Film Reviews." *Animation World.* August 2001, pp. 43-48.

9337. Patten, Fred. "New from Japan: Anime Film Reviews." *Animation World.* September 2001, pp. 33-36.

9338. Patten, Fred. "New from Japan: Anime Film Reviews." *Animation World.* November 2001, pp. 48-54.

9339. Patten, Fred. "New from Japan: Anime Film Reviews." *Animation World.* December 2001, pp. 53-58.

9340. Patten, Fred. "New from Japan: Anime Film Reviews." *Animation World.* January 2002, pp. 50-55.

9341. Patten, Fred. "New from Japan: Anime Film Reviews." *Animation World*. April 2002, pp. 74-78.

9342. Patten, Fred. "New from Japan: Anime Film Reviews." *Animation World*. May 2002, pp. 63-67.

9343. Pereira, Joseph. "From the Folks Who Brought You Pokemon, Here Comes Yu-Gi-Oh; Kids Card Game Will Tie in with a New Cartoon Show...." Associated Press dispatch, *Wall Street Journal*. June 12, 2001.

9344. Rivet, Jerome. "New Feature Forthcoming from Japanese Animation Master." Agence France Presse dispatch, June 18, 2001.

9345. "R.O.D. (Read or Die)." *Animatoon*. No. 32, 2001, pp. 67-68.

9346. "Screening Room." *Comics Buyer's Guide*. February 22, 2002, p. 22.

9347. "Screening Room." *Comics Buyer's Guide*. May 24, 2002, p. 18. (US, Japan).

9348. "Screening Room." *Comics Buyer's Guide*. July 5, 2002, p. 30.

9349. Stancavage, Sharon. "Mister Roboto." *Entertainment Design*. 35:2 (2001), pp. 16-17.

9350. Williams, Bruce. "Without *Habeas Corpus*: The Discourse of the Absent Body." *Kinema*. Fall 2002, pp. 29-42. (Seiji Arihara's "On a Paper Crane: Tomoko's Adventure").

9351. "Writ Large on the Small Screen." *Japan Times*. September 23, 2001. ("Black Jack").

9352. Yadao, Jason S. "'End of Eva' Brings No End to Series' Muddle." *Honolulu Star Bulletin*. October 6, 2002.

Comic Strips

9353. Horowitz, Janice M. "Yu-Gi-Oh! Comes to America." *Time*. June 10, 2002.

9354. Shimizu, Isao. *Sazae-san no Shōtai* (Sazae-san's True Colors). Tokyo: Heibonsha, 1997. 254 pp.

Manga (Comic Books)
Resources

9355. International Institute for Children's Literature Osaka, ed. *Nihon Jidō Bungaku Dai-jiten* (Encyclopedia of Children's Literature). 3 vols. Tokyo: Dainihon Tosho, 1993. 518 pp., 629 pp., 215 pp.

9356. Kure, Tomofusa. *Gendai Manga no Zentai-zō* (An Overall Picture of Modern Manga). Tokyo: Jōhō Sentā Shuppankyoku, 1986. 286 pp.

9357. Minamoto, Tarō. *Manga no Meiserifu* (Great Lines from Manga). Tokyo: Rippū Shobō, 1991. 326 pp.

9358. Pafu Editorial Team in Zassōsha, ed. *Pafu* (Puff. Monthly). Tokyo: Zassōsha, 1st of every month. 146 pp.

General Sources

9359. Andersson, Mikael. "Det Går Undan På Mangafronten." *Bild & Bubbla*. No. 4, 1990, pp. 14-15.

9360. Andersson, Mikael. "Många Manga Är Det." *Bild & Bubbla*. No. 3, 1990, pp. 22-28.

9361. Andreasson, Lars and Lars Larsson. "Manga! Japaner, Japaner Överallt!" *Bild & Bubbla*. No. 1, 1989, pp. 26-28.

9362. Burgdorf, Paul. "Japans Serievärld." *Bild & Bubbla*. No. 4, 1978, pp. 22-24.

9363. Chalfen, Richard and Mai Murui. *"Print Club Photography in Japan: Framing Social Relationships."* *Visual Sociology*. 16:1 (2001), pp. 55-73.

9364. "Eastern Promise." *Borderline*. March 2003, pp. 54-55.

9365. Frödin, Ulf. "Manga Serier i Japan." *Bild & Bubbla*. No. 3/4, 1985, pp. 51-52.

9366. Fujimoto, Yukari. *Watakushi no Ibasho wa Doko ni Aru no?* (Where Do I Belong?). Tokyo: Gakuyō Shobō, 1998. 334 pp.

9367. Giles, Keith. "Nut in the Shell: Manga Nation." http://www.slushfactory.com/content/EpupyEuFlyHLupbnaZ.php Posted November 26, 2002.

9368. Gravett, Paul. "The Other Manga." *Borderline*. January 2002, pp. 21-22.

9369. Hellman, Bror. "Moshi, Moshi!" *Bild & Bubbla*. No. 2, 2000, pp. 48-49.

9370. Hellman, Bror. "Moshi, Moshi!" *Bild & Bubbla*. No. 3, 2000, pp. 126-127.

9371. Hellman, Bror. "Moshi, Moshi!" *Bild & Bubbla*. No. 4, 2000, pp. 80-81.

9372. Hellman, Bror. "Moshi, Moshi!" *Bild & Bubbla*. No. 3, 2001, pp. 42-43.

9373. Henshū Kōgaku Kenkyū-jo, eds. *Komikku Media* (Comic Media). Tokyo: NTT Shuppan, 1992. 309 pp.

9374. Hill, Kevin. "Eastern Promise: Everyone Can Draw Manga." *Borderline*. December 2002, pp. 60-61.

9375. Hill, Kev. "Eastern Promises." *Borderline*. October 2002, p.32.

9376. Hill, Kevin. "Eastern Promises." *Borderline*. November 2002, pp. 58-59.

9377. Hill, Kevin. "Manga Seen." *Borderline*. March 2003, p. 50.

9378. Hill, Kevin. "What Is Manga?" *Borderline*. August 2001, p. 27.

9379. Hill, Kevin. "What Is Manga? Clamped Up." *Borderline*. December 2001, pp. 19-20.

9380. Hill, Kevin. "What Is Manga? Who To Blame?" *Borderline*. June 2002, pp. 34-35.

9381. Isabella, Tony. "Samurai, Slayers, and Sexual Situations, Oh My!" *Comics Buyer's Guide*. November 22, 2002, pp. 16-17.

9382. Isabella, Tony. "A Tidal Wave of Manga." *Comics Buyer's Guide*. February 28, 2003, pp. 16-17.

9383. Ishikawa, Jun. *Manga no Jikan* (Manga Time). Tokyo: Shōbunsha, 1995. 309 pp.

9384. Keating, Patrick. "Smoo Operator." *Hogan's Alley*. No. 10, 2002, pp. 72-74.

9385. Kinsella, Sharon. "Manga: From Deviance to National Culture." *Comics Forum*. Summer 1998, pp. 48-49.

9386. Koyama, Masahiro. *Manga no Tamatebako* (Manga Box Forbidden To Open). Tokyo: Riiberu Shuppan, 1992. 197 pp.

9387. "Manga." *Borderline*. August 2002, pp. 59-60.

9388. "'Manga' Enthusiasts Set Up Comic Book Study Society." Kyodo News Service. July 27, 2001.

9389. Miyadai, Shinji, Ishihara Hideki, and Ōtsuka Akiko. *Sabu-karuchā Shinwa Kaitai* (Dismantling Subculture Myths). Tokyo: PARCO Shuppankyoku, 1993. 311 pp.

9390. Mizuno, Ryutaro. *Manga Bunka No Uchimaku* (The Inside of Manga Culture). Tokyo: Kawade Shobo Shinsha, 1991.

9391. Monthly *Tsukuru* Editorial Offices, ed. *"Yūgai" Komikku Mondai o Kangaeru* (Thinking About the "Hazardous" Comics Books Issue). Tokyo: Tsukuru Shuppan, 1991. 223 pp.

9392. Natsume, Fusanosuke. *Manga Sekai Senryaku* (Manga-World-Strategy). Tokyo: Shōgakukan, 2001. 253 pp.

9393. Pulse. "Western Hands, Eastern Souls: A Look at Marvel Comics and the Influences of Manga in the Past Year." *Otakon 2002*, pp. 24-26.

9394. Randall, Bill. "Built to Self-Destruct." *Comics Journal*. December 2002, pp. 54-58.

9395. Randall, Bill. "Lost in Translation: It's a Tokyo Thing." *Comics Journal*. May 2002, pp. 91-95.

9396. Saitō, Nobuhiko, ed. *Nihon Ichi no Manga o Sagase!, Bessatsu Takarajima* (Search for Japan's No. 1 Manga!, Takarajima Separate Volume). Tokyo: Takarajimasha, 1997. 319 pp.

9397. Satō, Tadao. *Manga to Hyōgen* (Manga and Expression). Tokyo: Hyōronsha, 1984. 258 pp.

9398. Siverbo, Olof. "Gen – Pojken Från Hiroshima." *Bild & Bubbla*. No. 2, 1986, p. 30.

9399. Sivier, Mike. "Turning Japanese." *Borderline*. March 2003, pp. 12-13.

9400. Uryū, Yoshimitsu. *Manga o Kataru Koto no Genzai* (The Actuality of Talking About Manga) in *Media Sutadiizu* (Media Studies). Tokyo: Serika Shobō, 2000. 310 pp.

9401. von Zedtwitz-Liebenstein, Sangrid. "Svindel med Sangrid." *Bild & Bubbla*. No. 4, 1997, p. 2.

Criticism and Research

9402. Natsume, Fusanosuke. *Manga to Bungaku, Shūkan Asahi Hyakka: Sekai no Bungaku #110* (Manga and Literature, Asahi Weekly Encyclopedia: World Literature No. 110). Tokyo: Asahi Shimbun Publishing, 2001. 121 issues in 13 volumes, each issue approximately 330 pp.

9403. Natsume, Fusanosuke. *Manga wa Naze Omoshiroi no ka* (Why Are Manga Interesting?). Tokyo: Nihon Hōsō Shuppan Kyōkai, 1997. 279 pp.

9404. Takeuchi, Osamu. *Manga no Hihyō to Kenkyū + Shiryō* (Manga Criticism and Research + Reference Material). Nishinomiya City: Takeuchi Osamu, 1997. 198 pp.

9405. Tsurumi, Shunsuke. *Sengo Nihon no Taishū Bunka-shi: 1945-1980* (A History of Post-War Japanese Popular Culture: 1945-1980). Tokyo: Iwanami Shoten, 1984. 272 pp.

9406. Yonezawa, Yoshihiro, ed. *Manga Hihyō Sengen* (A Manga Criticism Declaration). Tokyo: Aki Shobō, 1987. 199 pp.

Genres

9407. Devlin, Tom. "King of Shit: The Comics of Enomoto: *New Elements That Shake the World.*" *Comics Journal*. October 2001, pp. 65-67.

9408. Hau Boon Lai. "Young Japanese Lap Up Ultra-Nationalist Comic." Straits Times Japan Bureau. July 4, 2002.

9409. Hill, Kevin. "Eastern Promise: Sex-you-al-it-ee." *Borderline*. January 2003, pp. 62-63.

9410. Keenapan, Nattha. "Japanese 'Boy-Love' Comics a Hit Among Thais." Kyodo News dispatch, August 31, 2001.

Genre: *Gekiga*

9411. Randall, Bill. "'Hey Kids! Gekiga!' Part Two." *Comics Journal*. August 2002, pp. 107-111.

9412. Randall, Bill. "Lost in Translation: 'Hey Kids! Gekiga!' Part One." *Comics Journal*. August 2002, pp. 91-95.

Genre: Ladies' Comics

9413. Erino, Miya. *Rediisu Komikku no Josei-gaku* ("Ladies' Comics" from a Women's Studies Perspective). Tokyo: Kōsaido Shuppan, 1993. 221 pp.

9414. Ito, Kinko. "Japanese Ladies' Comics as Agents of Socialization." Paper presented at Popular Culture Association, New Orleans, Louisiana, April 17, 2003.

9415. Ito, Kinko. "The World of Japanese Ladies' Comics: from Romantic Fantasy to Lustful Perversion." *Journal of Popular Culture*. Summer 2002, pp. 68-85

Genre: *Shōjo*

9416. Fujimoto, Yukari. "The Meaning of 'Boys' Love' in Girls' Comics." *Feminism Review*. March 1991.

9417. Levi, Antonia. "American *Shoujo*: *Sailor Moon, Buffy the Vampire Slayer*, and What Women Really Want To See." Paper presented at Popular Culture Association, Toronto, Canada, March 15, 2001.

9418. Murakami, Aki. "Super-sensational Shoujyo Explosion!" *Dialogue*. May 2002, p. 53.

9419. Ogi, Fusami. "Beyond Shoujo, Blending Gender: Subverting the Homogenized World in Shoujo Manga (Japanese Comics for Girls)." *International Journal of Comic Art*. Fall 2001, pp. 151-161.

9420. Ogi, Fusami. "Reading, Writing, and Female Subjectivity: Gender in Japanese Comics (*Manga*) for Girls (*Shoujo*)." Ph.D. dissertation, State University of New York at Stony Brook, 2001.

9421. Ogi, Fusami. "*Shoujo Manga* (Japanese Comics for Girls) Grows Up: Writing Women and Young Ladies' Comics." Paper presented at Popular Culture Association, Toronto, Canada, March 14, 2001.

9422. Okamoto, Yoshie. "Panel Arrangement in *Shojo Manga* in the Light of Hideko Tachikake 'Hanaburanko Yurete.'" *Manga Studies*. Vol. 1, 2002, pp. 117-120.

9423. Onoda, Natsu. "Drag Prince in Spotlight: Theatrical Imagery in Tezuka Osamu's Early Shojo Manga." Paper presented at Popular Culture Association, Toronto, Canada, March 13, 2001.

9424. Ōtsuka, Eiji. *"Ribon" no Furoku to Otome-chikku no Jidai* ("Ribon" Magazine's Giveaways and Girlish Days). Tokyo: Chikuma Shobō, 1995. 247 pp.

9425. Saitō, Tamaki. *Sentō Bishōjo no Seishin Bunseki* (Beautiful Young Fighting Girls, a Psychological Analysis). Tokyo: Ōta Shuppan, 2000. 286 pp.

9426. Sasamoto, Jun. "Layered Narration in *Shojo Manga*, Focusing on Taku Tsumugi's Works." *Manga Studies*. Vol. 1, 2002, pp. 121-125.

9427. Shamoon, Deborah. "The Glass Mask: Shojo Manga and Japanese Television Drama." Paper presented at Popular Culture Association, New Orleans, Louisiana, April 18, 2003.

9428. Takemiya, Keiko. "How I Experienced the Changes in Girls' Manga." *Manga Studies*. Vol. 1, 2002, pp. 126-130.

9429. Wei Yaa-Ping. "The Development and Transitions of Japanese Shoujo Manga in the Post-War Era." Fu-Jen University, Department of Japanese Literature, Taipei, 1998.

9430. Yokomori, Rika. *Ren'ai wa Shōjo Manga de Osowatta* (I Learned Love from Girls' Manga). Tokyo: Shūeisha, 1999. 253 pp.

Genre: *Shōnen*

9431. Fujiko Fujio. *Futari de Shōnen Manga Bakari Kaite Kita* (We Always Created Boy's Manga). Tokyo: Mainichi Shimbunsha, 1977. 298 pp.

9432. Nishimura, Shigeo. *Saraba Waga Seishun no 'Shonen Jump'* (Good-bye to My Youth "Boys' Jump"). Tokyo: Asuka Shinsha, 1994. 284 pp.

Industry

9433. "Adult Manga: Cultural Power in Contemporary Japanese Society." *Japan Quarterly.* 48:1 (2001), pp. 103-110.

9434. "Asian Manga Summit Opens." Kyodo News dispatch, October 12, 2002.

9435. Brady, Matt and Mike Doran. "Marvel Readies Mangaverse." *Comics Buyer's Guide.* August 3, 2001, p. 6.

9436. Cohen, Howard. "Made in Japan 'Manga' Capturing Comic Book Fans in the U.S." *Miami Herald.* January 20, 2003.

9437. Eddy, Melissa. "Manga Mania Goes Global." *Japan Times.* December 2, 2002, p. 15.

9438. "Editorials: The Cost of Making Manga." Posted August 23, 2003. *http//anime-tourist.com/article.php?sid=302*

9439. Fritz, Steve. "Make Mine Manga! Publishers Poised To Hit American Market." *Comics Buyer's Guide.* April 19, 2002, pp. 1, 12.

9440. "Go Gets Popularity Boost from Comic." *Yomiuri Shimbun.* September 22, 2001.

9441. Isabella, Tony. "Visions of Viz." *Comics Buyer's Guide.* June 21, 2002, pp. 18-19.

9442. "Japanese Comics Weekly To Publish English Version in U.S." Kyodo News Service dispatch, May 16, 2002.

9443. "Japan Publishing Heavyweights Roll Out U.S. Comic." Reuters dispatch, August 1, 2002.

9444. Kageyama, Yuri. "Japanese Comic-Book Hero Headed for Hollywood." Associated Press dispatch, February 25, 2003.

9445. "Manga: Eastern Influences, Universal Profits. Suggestions on How Retailers Can Animate Their Sales with Manga." *Diamond Dialogue.* March 2003, pp. 34-35.

9446. Mitsuya, Keiko and Sachiko Nakano. "Job-Holders Working Longer Hours in the Economic Downturn." *Broadcasting Culture and Research.* Autumn 2001, pp. 5-20. ("Magazines/Comics, Books," pp. 15-16).

9447. Mori, Akiko and Cyntia Barrera Diaz. "Japan's Best Selling Comic Eyes U.S. Market." Reuters dispatch, December 18, 2002.

9448. Otsuka, Eiji. "Comic-Book Formula for Success." *Japan Quarterly.* July-September 1988, pp. 287-291.

9449. "Publisher Allegedly Evaded 70 Yen Mil in Tax." *Yomiuri Shimbun.* September 27, 2002.

9450. Reid, Calvin. "At Comics' BEA, Talk of Manga and Book-Trade Permeate." *Publishers Weekly.* August 5, 2002.

9451. Schwarzacher, Lukas. "Comix Look for Play in Pix, TV, Toys." *Variety.* April 8-14, 2002, p. 10.

9452. Wolk, Douglas. "The Manga Are Coming." *Publishers Weekly.* June 17, 2002.

9453. Wolk, Douglas. "Tokyopop Goes Left." *Publishers Weekly.* March 18, 2002.

9454. Yonezawa, Yoshihiro. "Personal Report on Section 2 [Manga and Industry]." *Manga Studies.* Vol. 1, 2002, pp. 105-116.

Otaku

9455. Azuma, Hiroki. *Dōbutsu-ka Suru Posuto-modan* (The Animalizing Postmodern). Tokyo: Kōdansha, 2001. 193 pp.

9456. Editorial Team of Bessatsu Takarajima in JICC Shuppankyoku. *Otaku no Hon, Bessatsu Takarajima* (A Book on Otaku, Takarajima Separate Edition). Tokyo: JICC Shuppankyoku, 1989. 272 pp.

9457. "Got Teen Readers? Manga Does." *Publishers Weekly.* January 6, 2003.

9458. Hasegawa, Yutaka. *Kashihon-ya no Boku ha Manga ni Muchū Datta* (As the Son of a Book Rental Store Owner, I Was Crazy About Manga). Tokyo: Sōshisha, 1999. 245 pp.

9459. Kure, Tomofusa. *Manga-kyō ni Tsukeru Kusuri* (Medicine for the Manga-Crazed). Tokyo: Rikurūto, 1998. 227 pp.

9460. Nakajima, Azusa. *An Account of Manga's Youth.* Tokyo: Shūeisha, 1986. 263 pp.

9461. Okada, Toshio. *Otaku-gaku Nyūmon* (An Introduction to the Study of Nerds). Tokyo: Ōta Shuppan, 1996. 235 pp.

Technical Aspects

9462. Aihara, Kōji and Takekuma Kentarō. *Saru Demo Kakeru Manga Kyōshitsu* (Manga School That Even Monkies Can Draw). 3 vols. Tokyo: Shōgakukan, Vol. 1, November 1990; Vol. 2, November 1991; Vol. 3, June 1992.

9463. Editorial Team of "Comickers" in Bijutsu Shuppansha, ed. *Komikkāzu, Bessatsu Bijutsu Techō* (Comickers. Quarterly, Art Journal BT Extra Issue). Tokyo: Bijutsu Shuppansha, 12th of January, April, July, October. 153 pp.

9464. Ishinomori, Shōtarō. *Ishinomori Shōtarō no Manga-ka Nyūmon* (Ishinomori Shōtarō's Manga Artist Course). Tokyo: Akita Shoten, 1998. 287 pp.

9465. Okamoto, Ippei. *Ippei Manga Kōza* (Ippei's Manga Course). Kanagawa: Sōshisha, 1981. 262 pp.

9466. Yomota, Inuhiko. *Manga Genron* (The Principles of Manga). Tokyo: Chikuma-Shobō, 1994. 296 pp.

Political Cartoons

9467. Anabuki Fumio. "Opinions in Pen and Ink: Norio Yamanoi." *FECO News Magazine*. No. 35, 2002, pp. 12-14.

9468. Duus, Peter. "Presidential Address: Weapons of the Weak, Weapons of the Strong – The Development of the Japanese Political Cartoon." *Journal of Asian Studies*. November 2001, pp. 965-997.

Korea
General Sources

9469. Kim Jung Min. "Altered Egos." *Far Eastern Economic Review*. January 24, 2002, p. 40.

9470. "A Smile from Korea: Cartoonist Il Goo Kang." *FECO News Magazine*. No. 36, 2002, p. 15.

9471. Yoo, Jae-Suk. "S. Korea Freezes Japan Exchanges." Associated Press dispatch, July 12, 2001.

Animation

9472. "Animatoon Report: ASIFA Korea." *Animatoon*. No. 41, 2003, pp. 28-29.

9473. "Animation Report KIPA." *Animatoon*. No. 40, 2002, pp. 40-41.

9474. "Animatoon School." *Animatoon*. No. 34, 2001, pp. 58-60.

9475. "Animation School." *Animatoon*. No. 37, 2002, pp. 62-63.

9476. "Animation School." *Animatoon*. No. 38, 2002, pp. 60-63.

9477. "Animation School, Kyungmin." *Animatoon*. No. 35, 2002, pp. 42-44.

9478. "Commuting the Pacific, Unseating *The Simpsons*." *Korea Society Quarterly*. Summer/Fall 2002, p. 77.

9479. Deneroff, Harvey. "Richard Kim: Korea Animation Artists Worked on the Character of 'Rain.'" *Animatoon*. No. 38, 2002, p. 73.

9480. "Empress Chung." *Animatoon*. No. 38, 2002, pp. 18-19.

9481. "Independence Digital Visual Effects Studio." *Animatoon*. No. 41, 2003, pp. 60-61.

9482. Kim Jung Min. "Animation: Making Movies." *Far Eastern Economic Review*. September 27, 2001, p. 35.

9483. Kim Jung Min. "Quest for a Perfect Play." *Far Eastern Economic Review*. August 23, 2001, p. 50.

9484. Kim, Mi Hui. "'Wave' Is Washing over Asia." *Variety*. February 4-10, 2002, p. 31.

9485. Kitchens, Susan. "Axis of Animation." Forbes.com. March 3, 2003. (North Korea).

9486. Kwan Oh Lim. "A View from Korea." *Animation*. April 2002, p. 46.

9487. Larkin, John. "Winning the Monster Game." *Far Eastern Economic Review*. September 5, 2002, pp. 32-34.

9488. Nagel, Jan. "East Meets West: C-Cubed Entertainment, Inc." *Animation Magazine*. October 2002, p. 36.

9489. "New Animation." *Animatoon*. No. 40, 2002, pp. 41-44.

9490. "People." *Animatoon*. No. 35, 2002, pp. 66-67.

9491. "People." *Animatoon*. No. 38, 2002, pp. 82-83.

9492. "Seoul Character Show." *Animatoon*. No. 33, 2001, pp. 42-43.

9493. Shin, Nelson. "Growing of Korean Film Industry." *Animatoon*. No. 39, 2002, p. 3.

9494. "Studio KAAB." *Animatoon*. No. 42, 2003, pp. 56-57.

9495. "Tin House." *Animatoon*. No. 40, 2002, pp. 26-27.

9496. "Turtle Hero." *Animatoon*. No. 32, 2001, p. 56.

9497. "Wonderful Days." *Animatoon*. No. 40, 2002, pp. 24-25.

Exhibitions, Festivals

9498. "CAF 2001. Chuncheon Anitown Festival 2001." *Animatoon*. No. 34, 2001, pp. 36-39.

9499. "Festival Spotlight: DIFECA 2002." *Animatoon*. No. 39, 2002, pp. 32-33.

9500. "Festival Spotlight: Jeonju International Film Festival." *Animatoon*. No. 37, 2002, pp. 12-15.

9501. "Festival Spotlight: PISAF." *Animatoon*. No. 40, 2002, pp. 14-15.

9502. "Festival Spotlight: Seoul Micro Movie Festival." *Animatoon*. No. 41, 2003, p. 35.

9503. "Festival Spotlight: SICAF 2002." *Animatoon*. No. 40, 2002, pp. 18-19.

9504. "Festival Spotlight: SIFF." *Animatoon*. No. 41, 2003, p. 34.

9505. "Festival Spotlight: The 6th Chuncheon Anitown Festival." *Animatoon*. No. 39, 2002, pp. 28-31.

9506. Harvey, Iain. "Travels with My Film." *Animation World*. August 2002, pp. 53-54.

9507. "International iFlash Animation Festival." *Animatoon*. No. 36, 2002, pp. 14-15.

9508. "Market & Screening: DICON 2002 & BCWW 2002." *Animatoon*. No. 40, 2002, pp. 28-31.

9509. "MIP-COM 2001." *Animatoon*. No. 34, 2001, pp. 48-51.

9510. "PISAF 2001 (Puchon International Student Animation Festival 2001)." *Animatoon*. No. 34, 2001, pp. 6-9.

9511. "PISAF 2002. *Animatoon*. No. 40, 2002, pp. 16-17.

9512. "Puchon Choice (Shorts)." *Animatoon*. No. 32, 2001, p. 16.

9513. "SIAF 2002." *Animatoon*. No. 37, 2002, pp. 6-11.

9514. "SICAF 2001 Animation Award." *Animatoon*. No. 33, 2001, pp. 12-13.

9515. "SICAF 2001. Seoul International Cartoon and Animation Festival." *Animatoon*. No. 33, 2001, pp. 6-11.

9516. "2001 Pusan International Film Festival." *Animatoon*. No. 34, 2001, pp. 18-21.

9517. "2001 SICAF." *Animatoon*. No. 34, 2001, pp. 40-43.

9518. Yoo Chang-yup. "Seoul Int'l Cartoon and Animation Festival To Open Aug. 11." Yonhap News Agency/*Korean Times*. July 29, 2001.

Comic Books

9519. Choi Jie-ho. "When Comic Books Get Old, They Come Here To Live." *Joong Ang Ilbo*. September 25, 2002. (Museum).

9520. "Comic Book about Hiroshima A-Bombing Translated into Korean." Kyodo News Service, September 14, 2002.

Girls' Comics

9521. Kim, Minkyung. "We Don't Like Conventional Girls' Comics." *News Plus*. January 23, 1997.

9522. La, Hyunsook. "Analysis of the Mechanism of Gay Boom in Girls' Comics I." *Cookie*. August 1996.

9523. La, Hyunsook. "Analysis on the Gay Boom in Girls' Comics II." *Cookie*. September 1996.

9524. La, Hyunsook. "Homosexuality in Girls' Comics." *Ewha Weekly Newspaper*. May 29, 1995.

9525. Nah, Kyungmin. "YAOI – There Is No Homosexuality." *BUDDY*. April 1998.

9526. Noh, Sueen. "Auspiciousness of New 'Auteurism' Described in Desperate Mood – Byun Byungjoon's 'Princess Anna.'" *Hankyoreh*. May 10, 2000, p. 12.

9527. Noh, Sueen. "Dreams of Girls Are Heroines of Girls' Comics? – Park Eunah's 'Sweetie Gem.'" *Hankyoreh*. March 14, 2000, p. 12.

9528. Noh, Sueen. "Happy To Be a Comic Artist Though It Is Humble and Poor – Kim Nakyung's 'Sagak Sagak.'" *Hankyoreh*. July 19, 2000, p. 12.

9529. Noh, Sueen. "Korean Sensibility, Giving Familiar Feeling – Kim Daewon's 'Red Tears.'" *Hankyoreh*. May 31, 2000, p. 12.

9530. Noh, Sueen. "Lots of Fun To Enjoy the Unusual Characters – Kang Eunyoung's 'Ya Ya.'" *Hankyoreh*. November 1, 2000, p. 12.

9531. Noh, Sueen. "Reading YAOI Comics: An Analysis of Korean Girls' Fandom." Paper presented at Korean Society for Journalism and Communication Studies, Seoul, Fall 1998.

9532. Noh, Sueen. "Six Fruits with Each Fragrance – Han Hyeyoun's 'Fruits Cocktail.'" *Hankyoreh.* August 23, 2000, p. 12.

9533. Noh, Sueen. "Special. Medium Standing Artists on Girls' Comics – Hwang Mina." *Goguma.* (Webzine). March 2001.

9534. Noh, Sueen. "Special. Medium Standing Artists on Girls' Comics – Kim Hyerin." *Goguma.* (Webzine). March 2001.

9535. Noh, Sueen. "Special. Medium Standing Artists on Girls' Comics – Kim Jin." *Goguma.* (Webzine). March 2001.

9536. Noh, Sueen. "'Worthwhile Derailment' Exciting Maniacs – You Sijin's 'Closer.'" *Hankyoreh.* October 4, 2000, p. 12.

9537. Park, Inha. "Reconsidering the Girls' Comics I." *White.* October 1995.

9538. Park, Misook. "Pleasant Revolution in Girls' Comics." *Monthly Mal.* April 1998.

9539. Shin, Woomi. "Dangerous Love in Girls' Comics I." *White.* May 1998.

9540. Song, Lakhyun. "The Forty-Year History of Japanese Girls' Comic Magazines: The Last Section." *Issue.* February 15, 1996.

Political Cartoons

9541. Jung Hyung-mo. "Strokes of Ingenious." *JoongAng Ilbo.* December 27, 2002. (Jeong Un-gyung).

9542. Khang, Hyoungkoo and Eyun-Jung Ki. "Framing the Presidential Candidates in Editorial Cartoons." Paper presented at Association for Education in Journalism and Mass Communication, Miami Beach, Florida, August 2002.

9543. Kwon, Jae-Woong. "Korean Cartoonists' Reactions to Bush's 'Axis of Evil.'" *International Journal of Comic Art.* Fall 2002, pp. 276-286.

Laos
Animation

9544. Tsugata, Nobuyuki. "The Situation of Film and Animation in Laos." *Asian Cinema.* Spring 2003.

9545. Tsugata, Nobuyuki. "The Situation of the Film and Animation in Laos." *Japanese Journal of Animation Studies.* 3:2A, 2002, pp. 45-46.

Malaysia
Cartooning, Cartoons

9546. Lent, John A. "Cartooning in Malaysia and Singapore: The Same, but Different." *International Journal of Comic Art*. Spring 2003, pp. 256-289.

9547. Muliyadi Mahamood. "An Overview of Malaysian Contemporary Cartoons." *International Journal of Comic Art*. Spring 2003, pp. 292-304.

Cartoonists

9548. Yeang Soo Ching. "Is This Really Dicky Cheah?" *New Sunday Times Style*. July 23, 2000, pp. 12-13.

Rejab Had

9549. Provencher, Ron. "Remembering 'The Chief,' Rejab Had: Cartoonist, Story Teller, Teacher, and Philosopher." *Berita*. Fall/Winter 2002, p. 35.

9550. Provencher, Ron. "Remembering 'The Chief,' Rejab Had: Cartoonist, Story Teller, Teacher, and Philosopher." *International Journal of Comic Art*. Spring 2003, pp. 290-291.

Animation

9551. Lent, John A. "Development of Malaysian Animation from the Perspective of Pioneer Animator Hassan Muthalib." *Asian Cinema*. Spring 2003, pp. 107-115.

9552. Lent, John A. "Malaysian Animation: Historical and Contemporary Perspectives." Paper presented at Popular Culture Association, New Orleans, Louisiana, April 17, 2003.

9553. Liaw, Cait. "Digital House POV Shares 'Secrets' with U.K. Firms." *Variety*. December 9-15, 2002, p. 34.

9554. Tan, David. "Teo Guan Lee To Franchise Kiki Lala and Cartoon Planet." *Malaysia Star*. April 6, 2000.

Humor Magazines

9555. Hamedi Mohd. Adnan. "Majalah-Majalah Humor Melayu dan Cabaran Pemasarannya." *Jurnal Komunikasi*. Vols. 13-14, 1997, pp. 93-114.

9556. Hamedi Mohd. Adnan. "Majallah-Majallah Humor Sebelum Gila-Gila." Kertas Penyelidikan Yang Belum Diterbitkan, 1997.

9557. Sabri Said. "Kelangsangan dan Fungsi Sosial dalam Penerbitan Kartun: Tumpuan Kepada Kartun-Kartun di Majalah Gila-Gila." Thesis, Sarjana Pengajian Penerbitan, Universiti Malaya, 1996.

Mongolia
Animation

9558. Ehrlich, David. "Ganghis Khan: Two Animated Studies from *The Secret History of the Mongols*." Paper presented at Society for Animation Studies, Montreal, Canada, October 23, 2001.

Nepal
General Sources

9559. Dixit, Mani. *Nonsense Verses from Nepal*. New Delhi: Adarsh Enterprise, 2000. 164 pp.

9560. Shakhya, Manikratna. *Sispunaniookhan*. Kathmandu: Sispunani, 2000.

Cartooning

9561. Aryal, Kundan. *Nepali Press Cartoon*. Kathmandu: Indrieni Offset Press, 2001. 88 pp.

9562. Aryal, Kundan. "Prabhavshali Abhimat Nirmata." *Khabar: Bichaar Ra Bishleshan*. May-June 2001, pp. 5-6.

9563. Biwash, Gyanendra. "Chitra Bichitra ko Byangachitra." *Indreni: Rajdhani*. September 3, 2002, p. 1. (Artistic and fantastic cartoons).

9564. Biwash, Gyanendra. "Nepali Kalapatrakarita: Ek Tippani" (Nepali Art Journalism: A View). *Khabar: Bichaar Ra Bishleshan*. May-June 2001, pp. 14-15.

9565. Ghimire, Rochak. "Hasyabyanga ko Bikasma Nepali Patrakarita ko Yogadaan" (Role of Nepali Media in the Development of Humor and Satire). *Madhuparka*. August-September 2000, pp. 27-29.

9566. Kundan, Aryal. *Nepali Press Ma Cartoon*. Kathmandu: Nepali Press Institute, 2001.

9567. Lent, John A. "Cartooning on the Top of the World." *Comics Journal*. April 2002, pp. 107-108.

9568. Lent, John A. "Cartooning on the Top of the World—Nepal." *Kayhan Caricature*. February 2002, pp. 2-3.

9569. Lent, John A. "Cartoon in the Altitudes of Everest." *Kayhan Caricature.* February 2002, 3 pp.

9570. Mainali, Laya. "Chitratmak Abhibyakti Ma Byanga Shilpa: Cartoon Kala" (Satirical Skills in Artistic Expression: Cartoon Art). *Rajdhani: Batika.* September 19, 2001, p. 11.

9571. Panday, Ram Kumar. *Sense of Humour Series. Nepalese Cartoons.* Kathmandu: Ratna Pustak Bhandar, 1997. 94 pp.

9572. Panday, R.K. "A Study of Contemporary Cartoons Against Corruption. Humor of Politics and Politics of Humor in Nepal." Paper presented at International Society of Humor Studies, Bartinoro, Italy, July 6, 2002.

9573. Ranjit, Sharad. "Nepali Press Cartoon Haru ko Ek Dirshya Chitra" (A Glimpse of Nepalese Press Cartoon). *Khabar: Bichaar Ra Bishleshan.* May-June 2001, p. 10.

Cartoonists and Their Works

9574. Gaule, Shiva. "Char Dashak Laamo Cartoon Yatra: Durga Baral Aatmakatha" (Four Decades Long Journey of Cartoon: Durga Baral's Story). *Khabar: Bichaar Ra Bishleshan.* May-June 2001, pp. 1-4.

9575. "Interview with Rabin Saymi and Rajesh K.C." *Khabar: Bichaar Ra Bishleshan.* May-June 2001, pp. 7-8.

9576. Manandhar, Razen. "Book Review: A Bird's Eye View of Nepali Cartoons and Cartoonists." *Kathmandu Post.* July 13, 1997.

9577. Panday, R.K. *Ram Kumar ko Kalam* (Ram Kumar's Pen). Publication, date unknown, pp. 5-19.

Historical Aspects

9578. Ghimire, Rajesh. "Itihaas ko Khoji Tara Bartamaan ko Upekchha" (Quest for History But Negligence of Present). *Khabar: Bichaar Ra Bishleshan.* May-June 2001, p. 9.

9579. Jigyashu, Bhim Rana. "Byangyachitra ko Itihaas Ra Nepali Byangyachitra" (History of Cartoons and Nepali Cartoons). *Madhuparka.* December 1999-January 2000, pp. 5-9.

9580. *Nepal Ma Cartoon Chitra ko Bikas Kram* (Development Progress in Nepalese Cartoon). Maadhyam: YAAG, n.d.

9581. Panday, R.K. "Nepali Byangyachitra ko Itihaas: Ek Bihangaaklokan" (A Reflection on the History of Nepali Cartoons). *Samacharpatra.* 2000.

9582. Singh, Narayan, Bahadur Singh. *Samasamayik Nepali Chitrakala ko Ithihaas*. Kamaladi, KTM: Nepal Pragya Pratisthan, 1997. (General art history of Nepal).

Animation

9583. Fudong, Fungma. "Animation in Nepal." *Asian Cinema*. Spring 2003, pp. 133-135.

Pakistan
Cartoonist

9584. Schmidt, Brad. "Artist Draws Attention to Her Culture: Nigar Nazar, Whose Popular Cartoon 'Gogi' Gained Fame in Pakistan and Then the World, Will Host a Workshop Tonight at the UO Bookstore." *Oregon Daily Emerald*. October 17, 2002.

Philippines
Cartoonists and Their Works

9585. Arpon, Yasmin Lee. "Nonoy Marcelo, 63." abs-cbnNews.com. October 22, 2002.

9586. Cooke, Jon B. "The Romantic Stylings of Mr. Jesse Santos." *Comic Book Artist*. October 2002, pp. 88-97.

9587. Defeo, Ruben. "ARTWEB." *Philippine Star*. July 1, 2002. (Larry Alcala).

9588. Lent, John A. "Larry Alcala and the Depiction of Filipinos as They Are." *International Journal of Comic Art*. Fall 2002, pp. 287-291.

9589. Nilsson, Peter. "Alfredo Alcada Död." *Bild & Bubbla*. No. 2, 2000, p. 96.

Animation

9590. "Fil-Cartoons Designed Their Own Cartoon and Sold It Worldwide." *ASIFA San Francisco*. October 1995, p. 5.

9591. Harz, Christopher. "Playing with pasi: A Studio with Heart." *Animation*. April 2002, p. 34.

9592. Jazmines, Tessa. "PAS Taps Home Market for Toons Amid Gloom." *Variety*. January 7-13, 2002, p. 43.

9593. Jimenez, Cher. "Upset by Cartoon but Not by Bakat." *Today*. September 16, 2002.

9594. Sullican, Maureen. "Disney Sets Philippines Cable Channel." *Variety*. February 19, 1998, p. 30.

9595. "Vermin, Italian-Style: pasi's *Rat's Amore*." *Animation*. April 2003, p. 44.

Komiks

9596. Arcellana, Juaniyo. "The King of Komiks." *Philippine Star*. December 17, 2001. (Francisco Coching).

9597. *Komiks: Katha at Guhit ni Francisco V. Coching*. Manila: Coching Foundation, 2001. (Essays by Patrick Flores, Alice Guillermo, Justino Dormiendo, José Tenco Ruiz).

"Darna"

9598. Ladaw, Dennis. "From Screen to Stage; But Not in Single Bound." *Manila Times*. March 23, 2003.

9599. Sipin, Larry V. "Darna for President." *Manila Times*. March 3, 2003.

9600. Sitoy, Lakambini A. "Magic Stones and Bondage Dreams." *Manila Times*. March 23, 2003.

Singapore
Cartooning, Cartoons

9601. Lee Weng Choy. "Distinctions: Paintings by Vincent Leow and Ian Woo." *Art Asia Pacific*. No. 34, 2002, pp. 52-57.

9602. Lenzi, Iola. "Wang Guangyi: Singapore." *Art Asia Pacific*. Issue 33 (2002), pp. 89-90.

9603. Lim Cheng Tju. "Chinese Cartoons in Singapore – Images of Politics, Polarity and Plurality." Paper presented at Popular Culture Association, Toronto, Canada, March 16, 2001.

9604. Lim Cheng Tju. "'*Sister Art*' – A Short History of Chinese Cartoons and Woodcuts in Singapore." *International Journal of Comic Art*. Spring 2001, pp. 59-76.

9605. Nonis, George. *Raffles: The Untold Story*. Singapore: Angsana Books, 1993.

Sri Lanka
Cartoonists

9606. "Case Study: Jiffry Yoonoos, Sri Lanka." *Borderline*. December 2002, p. 16.

Taiwan
Comic Art

9607. "Cartoon Contest Opens." *Taipei Times*. November 3, 2002.

9608. The Dummies Alliance. *The Journal for Comic Comrades I*. Taipei: Blue Whale, n.d.

9609. The Dummies Alliance. *The Journal for Comic Comrades II*. Taipei: Blue Whale, n.d.

9610. Hong, Tongli. "Promoting Comic Art as a Subject of Study." In *2001 Animation Comic*, pp. 214-216. Taipei: Blue Whale, 2001.

9611. "Introduction of Taiwan Cartoonist Huang Shi." *Chinese Cartoon Selection Journal*. No. 2, 1999, pp. 34-35.

9612. Koo Tsai-Yang. "What's So Funny About the Comics? – On the Visual Presentation in Comic Art (1)." *Baby Lion Art Review*. 84:1 (1997), pp. 87-91.

9613. Koo Tsai-Yang. "What's So Funny About the Comics? – On the Visual Presentation in Comic Art (2)." *Baby Lion Art Review*. 84:2 (1997), pp. 86-90.

9614. Ku, Francis. *Memoirs of a Love-Hate Relationship with Taiwan*. Taipei: Classic Communications, 1997. (Political cartoon).

9615. Lee Hsing-Cheng. "Where Is the Position of Comic Art Located in Popular Culture?" Paper presented at Conference of the Dialogue Between Literature and Comic Art, Taipei, Taiwan, 1996.

9616. Lee, I-Yun. "Transformation of the Comics in the Cultural Field of Taiwan." *The Bulletin of the Institute of Socio-Information and Communication Studies, The University of Tokyo*. No. 62, 2002, pp. 191-216.

9617. Lee Man-Ming. "A Study of the Consuming Space of Comic Books in Taiwan." National Normal University, Geology Department, Taipei, n.d.

9618. Lim, Benjamin Kang. "Taiwan Pop Culture Invades China." Reuters dispatch, August 10, 2002.

9619. Ou Hsio-Yu. "A Study of the Value Systems Embedded in Taiwan Popular Comic Books." Master's thesis, Fu-Jen University, Communications Department, Taipei, 1997.

9620. "Taiwan's Ruling Party Defends Hitler TV Commercial." Reuters dispatch, July 13, 2001.

9621. "Teng Shen Wang Chia" (The Playful Place). *Liberty Times*. One-half page devoted to articles about cartooning every Wednesday.

9622. Tiffany. *Comic Art and Its Counter-Arguments*. Taipei: Infant Lion, 1998.

9623. Yang Ai-Ling. *Comic Noses*. Taipei: Explore Culture, 1998.

9624. Yuan Cheng-Tao. *An Exploration of the New Comic Language*. Taipei: Chiang-Duan, n.d.

Animation

9625. Chiu Yueh-wen. "Spring House Creates Cartoon Friends." *Taipei Journal*. June 28, 2002, p. 8.

9626. Chu, H. "'South Park's' Trash-Talking Tots Have Become Widely Popular in Taiwan." *Los Angeles Times*. December 20, 2000.

9627. The Dummies Alliance. *Animation Comics 2000*. Taipei: Blue Whale, 2000.

9628. The Dummies Alliance. *Animation Comics 2001*. Taipei: Blue Whale, 2001.

9629. Huang Yu-Shan and Yu Wei-Cheng, eds. *An Exploratory Study of Animated Films*. Taipei: Yuan-Liou, 1997.

9630. Lee, L. F. "Special-Effects Wizard Puts in Cameo at Taipei Film and Animation Seminar." *Taipei Journal*. November 8, 2002, p. 4.

9631. Li, Francis. "Soft-World Takes Chinese Gaming to Next Level." *Taipei Journal*. November 23, 2001, p. 8.

9632. Lu, Myra. "Taiwan Logs in to Online Gaming Phenomenon." *Taipei Journal*. November 15, 2002, p. 8.

9633. Lu, Myra. "Taiwan Scores in Chinese Gaming Market." *Taipei Journal*. November 25-December 1, 2002, p. 8.

9634. Shiau, Hong-Chi. "American Imported Animation in Taiwan: A Case Study of *South Park*." *International Journal of Comic Art*. Fall 2002, pp. 315-326.

9635. Shiau, Hong Chi. "The Historical Development of Taiwanese Animation Industry: An Analysis of Institutional Processes." Paper presented at Popular Culture Association, New Orleans, Louisiana, April 17, 2003.

9636. Shiau, Hong-Chi. "The Production and Consumption of Animation in Taiwan – The Interplay of Global Political and Economic Forces." Ph.D. dissertation, Temple University, 2002. 231 pp.

9637. Shiau, Hong-Chi and John A. Lent. "Taiwan's Cuckoo's Nest and the New Labor Situation." *Asian Cinema.* Spring 2003, pp. 90-106.

9638. *2000 Animation Comic.* Taipei: Blue Whale, 2000. 328 pp. (Japan, Taiwan).

9639. *2001 Animation Comic.* Taipei: Blue Whale, 2001. 341 pp. (Japan, Taiwan).

9640. "Wang Shaudi and Huang Liming (Taiwan), In Conversation with *Kinema.*" *Kinema.* Fall 2002, pp. 75-84.

9641. Wu, Nelson H. "Hot Internet Toon Moves into Film and Merchandise." *Variety.* October 7-13, 2002, p. 9.

9642. Wu, Nelson H. "On Rebound, Central Announces '03 Slate." *Variety.* March 10-16, 2003, p. 21.

9643. Wu, Nelson H. "Toon Houses Draw Coin from Gov't." *Variety.* October 14-20, 2002, p. 8.

9644. Yu Sen-Lun. "Going Native: In Remaking South Park, a Trash-Talking U.S. Cartoon, a Couple of Taiwanese Scriptwriters Have Created More Than a Hit Show. They've Invented a New Street Language." *Asiaweek.* September 28, 2001, pp. 44-46.

Comics
General Sources

9645. Fang, Rita. "Yuyu Yang's Art Revealed in Comic Strips." *Taipei Journal.* March 22, 2002, p. 5.

9646. "Making Picture Books for Adults." *Taipei Times.* January 10, 2003, p. 4. (Jimmy Liao).

9647. Wu Taijing. "Manga on Life of Chen Launched at Taipei Book Fair." *Taiwan News.* February 12, 2003.

Industry

9648. "Comic Book Convention Comes to Taipei." *Taiwan News.* August 2, 2002.

9649. Haou Di. "Some Thinking About the Comic Market in Taiwan." *The Scent of Book Monthly*. 51 (1998), pp. 128-131.

9650. Huang Cheng-Ho. "A Comic Editor's Monologue: On the International Exchange of Comics." *Art Literature Monthly*. 135 (1997), pp. 39-41.

9651. Koo Tsai-Yang. "An Analysis of Taiwan Comic Industry from the Perspective of Political Economy." National Cheng-Chen University, Telecommunications Department, 1997.

9652. Lee, Abby. "High Hopes of Hearkening Back to Comic Book Heyday." *Taipei Journal*. December 13, 2002, p. 4.

9653. Lee Yi-Yun. "Departure and Incarnation: A Primary Study of the Production of Comics in Taiwan." Master's thesis, National Taiwan University, Sociology Department, n.d.

9654. Phipps, Gavin. "Taiwan's Comic Saga." *Taipei Times*. February 24, 2002.

Literature

9655. Hong Tom. "Comic Literature and Literature Comic." *United Literature*. 14:10 (1998), pp. 128-131.

9656. Su His-Wei. "The Integration Between Manga and Literature in Taiwan." Paper presented at Conference of the Dialogue Between Literature and Comic Art, Taipei, Taiwan, 1996.

9657. Yang Ai-Ling. "Who Will Bridge the Gap Between Comic and Literature?" *Literature Monthly*. 135 (1997), pp. 34-36.

Readership

9658. Chang Jwu-Chyun. "A Study of Child Development: Appreciation and Comprehension of Humorous Comics." Master's thesis, National Taiwan Normal University, Education Department, n.d.

9659. Cheng Jui-Ping. "A Study of the Relationship Between Queer Manga and the Characteristic of Its Readers." Master's thesis, Culture University, Department of Journalism, Taipei, n.d.

9660. Huang Chih-Yun. "What's Hot Now? Some Observations About the Trends of Popularity of Comics in Taiwan." *Dong-Neau*. 243 (1996), pp. 78-81.

9661. Ko Fong-Lang. "An Analysis of Children's Preference over Comics Genres." *Electronic Education*. 21:3 (1979), pp. 12-15.

9662. Lin Juno. "When Children Meet Comics – Chan Hong-Chih on the Strategies Employed by Children To Use Comics." *Central News*. June 28, 1995, Sec. 21.

9663. Su Herng. "A Study of Children's Motivations and Behaviors of Reading Comics." *Journalism Research* (National Chengchi University). 48 (1994), pp. 123-145.

9664. Tong Chi-Shen. "A Survey of Children's Behaviors of Reading Comics." *Literature Monthly*. 135 (1997), pp. 44-52.

Thailand
Animation

9665. "Best of Thai Animation 1997-2001." In *Thai Anima 2003. The First International Animation Festival 11-15 Jan 2003*, pp. 42-45. Bangkok: Thai Anima, 2003.

9666. Boonruang, Sasiwimon. "National Institute for Animation Industry To Be Created." *Bangkok Post*. January 29, 2003.

9667. Danutra, Pattara. "An Animated Character." *Bangkok Post*. September 23, 1998.

9668. "Directory." In *Thai Anima 2003. The First International Animation Festival 11-15 Jan 2003*, pp. 71-77. Bangkok: Thai Anima, 2003.

9669. "Homage to Thai Anima Master: Payut Ngaokrachang." In *Thai Anima 2003. The First International Animation Festival 11-15 Jan 2003*, pp. 40-41. Bangkok: Thai Anima, 2003.

9670. "Joint Venture To Sell Thai Cartoons." *Bangkok Post*. August 19, 2002.

9671. Jokinen, Heikki. "Anime 2003 Combined Screening and Festival." *Animatoon*. No. 42, 2003, p. 18.

9672. Lent, John A. "Thai Animation's Great Strides: A Report." *Asian Cinema*. Spring/Summer 2003, pp. 118-119.

9673. Rithdee, Kong. "Animated Identities." *Bangkok Post*. October 25, 2002.

9674. Suwanpantakul, Kreangsak. "Entertainment: Animated Ambitions." *The Nation* (Bangkok). January 17, 2003.

9675. *Thai Anima 2003. The First International Animation Festival 11-15 Jan 2003*. Catalogue. Bangkok: Thai Anima, 2003. 80 pp.

9676. "Thailand Showcase." In *Thai Anima 2003. The First International Animation Festival 11-15 Jan 2003*, pp. 48-52. Bangkok: Thai Anima, 2003.

9677. Thalang, Ping na. "Animation in Thailand Comes of Age." *Bangkok Post*. October 23, 2002.

Comics

9678. Arthit, Khwankhom. "Gay Comic Books Stir Controversial Emotions." *Nation* (Bangkok). July 19, 1997.

9679. "CCG Portfolio – Chatri Ahpornisiri." *Comics Forum*. Summer 1998, pp. 30-31.

9680. Cheuyjanya, Pachanee and Manisa Pisalbuk. "Patterns of Images of Women Appearing in Humorous Cartoons." In *Images of Women in the Mass Media* (Paplak Ko'ng Phuying Nai Su'muanchon), edited by Kanjana Kaewthep. Bangkok: Chulalongkorn University, 1992.

9681. Chindahporn, Pichayanund. "Manga Goes on a Gender-Bender." *Asiaweek*. November 16, 2001, p. 16.

9682. Costa, Lee Ray M. and Andrew Matzner. "Abusing Images: Domestic Violence in Thai Cartoon Books." *Intersections* (Murdoch University). October 2002, 21 pp.

9683. Thai Farmer's Research Center, Co. Ltd. "Cartoon Books: Creative Media or Corrupting Influence?" Electronic document, 1997.

9684. "Tintin Porn Gang Smashed." *The Express* (London). February 16, 2001.

9685. Ukrit, Kungsankhom. "Poison Penned." *Bangkok Post*. January 28, 2001.

Political Cartoons

9686. Barmé, Scot. "Visually Challenged: Graphic Critiques of the Royal-Noble Elite." In *Woman, Man, Bangkok: Love, Sex & Popular Culture in Thailand*, pp. 97-132. New York: Rowman & Littlefield, 2002.

Vietnam
Comic Books

9687. Elliston, Jon. "Counterinsurgency Comics." http://www.parascope.com/articles/0497/phoenix.htm. Accessed December 9, 2002.

AUSTRALIA AND OCEANIA

Australia
Cartooning, Cartoons

9688. Cooke, Kaz, ed. *Beyond a Joke: An Anti-Bicentenary Cartoon Book*. Fitzroy, Victoria: McPhee Gribble, and Ringwood, Victoria; Penguin, 1988.

9689. Fabian, Suzanne, ed. *Mr. Punch Down Under: A Social History of the Colony from 1856 to 1900 Via Cartoons and Extracts from Melbourne Punch*. Richmond, Victoria: Greenhouse Publications, 1982.

9690. Groenewegen, David. "Australia's Funniest Cross To Bear." *Comics Journal*. March 2003, pp. 50-51.

9691. Kennedy, Simon. "Cartoons As a Catalyst for Therapeutic Change." *Australian Journal of Comedy*. 2:1 (1996), pp. 129-144.

9692. King, Jonathan. *The Other Side of the Coin: A Cartoon History of Australia*. Revised edition. Stanmore, New South Wales: Cassell Australia, 1979.

9693. King, Jonathan. *Stop Laughing, This Is Serious: A Social History of Australia in Cartoons*. North Ryde, New South Wales and North Melbourne: Cassell Australia, 1980.

Cartoonists

9694. Bloomfield, Lin, ed. *The World of Norman Lindsay*. South Melbourne, Victoria: Sun Books, 1983.

9695. Eales, Jay. "From Eddie." *Borderline*. August 2002, p. 18. (Eddie Campbell).

9696. Kerr, Joan. *Artists and Cartoonists in Black and White: The Most Public Art*. Sydney: National Trust/S.H. Ervin Gallery, 1999.

9697. McMullin, Ross. *Will Dyson: Cartoonist, Etcher and Australia's Finest War Artist*. London, Sydney, Melbourne: Angus & Robertson, 1984.

9698. Sharp, Martin. *Martin Sharp Cartoons: A Selection from Oz, The Australian, The Sydney Morning Herald, Honi Soit, Tharunka etc*. North Sydney: Scripts Pty. Ltd., 1966.

9699. Turner, Ann, ed. *In Their Image: Contemporary Australian Cartoonists*. Canberra: National Library of Australia, 2000.

9700. "Young Guns: Steve Griffin." *Borderline*. August 2002, pp. 64-65.

Russell, Jim

9701. Cannon, Mark. "Creator of Australia's Favourite Cartoon Strips Dies." *Borderline*. September 2001, p. 5.

9702. Crawford, Barclay. "After 61 Years, Cartoonist Draws His Last." *The Australian*. Edition 1. August 16, 2001.

9703. Cunningham, James. "Taken Over by Uncle Dick, James Newton (Jim) Russell, 1909-2001." *Sydney Morning Herald*. August 16, 2001.

Animation

9704. Boland, Michaela. "Disney Makes Inroads in Oz." *Variety*. February 4-10, 2002, p. 51.

9705. Groves, Don. "ABC Pursues New Generation of Viewers." *Variety*. October 7-13, 2002, p. B4.

9706. Groves, Don. "Made-for-Video Toons Cash in Across Globe." *Variety*. September 2-8, 2002, p. 18.

9707. Groves, Don. "Toon Firm Unveils Slate." *Variety*. December 17-23, 2001, p. 33.

9708. Groves, Don. "Toon House Goes Live." *Variety*. September 30-October 6, 2002, p. 23.

9709. Groves, Don. "Toon Top 'Banana' with New Slate." *Variety*. May 6-12, 2002, p. B21.

9710. Hill, Michael. "Cross-Cultural Animation: Japanese Punks Versus the Lizards of Oz." *Perfect Beat*. July 2000, pp. 42-55.

9711. Lynch, Stephen. "The Australian Effects and Animation Festival 2001." *Animation World*. May 2001, pp. 25-27.

9712. Lynch, Stephen. "Brisbane International Animation Festival." *Animation World*. May 2000, pp. 67-69.

9713. Lynch, Stephen. "The Magic Pudding: Making a Feature in Oz." *Animation World*. May 2001, pp. 28-30. (Robbert Smit).

9714. Lynch, Stephen. "Special Effects from Down Under: A Growing Proposition." *Animation World*. May 2001, pp. 31-33.

9715. Oberg, Terry. "From BAF to BIAF and Beyond!" *ASIFA News*. Fall 2001, pp. 28-30.

9716. Palmer, Roger. "Is Academy and Graphic Art Training Still Relevant in the Now Booming Australian Animation Industry?" Paper presented at Society for Animation Studies, Montreal, Canada, October 25, 2001.

9717. Quigley, Marian. "Delineated, Digitised, Down-Under? Australian Women Animators." Paper presented at Society for Animation Studies, Glendale, California, September 27, 2002.

9718. Swain, Bob. "Wonder Downunder: Yoram Gross/EM.TV." *Animation.* September 2002, p. 20.

Comics

9719. Allen, Jeremy. "A Virtual Revolution: Australian Comic Creators and the Web." *International Journal of Comic Art.* Spring 2001, pp. 22-37.

9720. "Bye-bye Bacchus." *Borderline.* October 2001, p. 38.

9721. Gordon, Ian. "Stop Laughing This Is Serious: The Comic Art Form and Australian Identity, 1880-1960." BA honors thesis, University of Sydney, Department of History, 1986.

9722. Hendriksson, Marie. "Han Skämdes för 'Träsket.'" *Bild & Bubbla.* No. 2, 1995, p. 42.

9723. Juddery, Mark. "Badge of Honour: An Australian Artist Is Reviving One of the Lost American Comic Book Heroes of the 1940s...." *Weekend Australian.* August 3-4, 2002.

9724. Mules, Warwick. "Lines, Dots, and Pixels: The Making and Unmaking of the Printed Image in Visual Culture." *Continuum.* 14:3 (2000), pp. 303-316.

9725. Naylor, Dillon. "Australian Comic Distribution: Who's Laughing?" In *Zeen 21/2: Megazeen Australian Fanzine and Comic Book Directory*, edited by Anna Kay and Jay Kranz. St. Kilda, Victoria: Melbourne Fringe, 1997.

9726. O'Keely, Joss. "They Came from Down Under." *Borderline.* September 2002, pp. 26-27.

9727. "Pacific Publications Captures Younger Readers." *The Age.* October 7, 2002.

Underground Comics

9728. Caleo, Bernard. "Comics in Zineland." In *Zeen 21/2: Megazeen Australian Fanzine and Comic Book Directory*, edited by Anna Kay and Jay Kranz, pp. 19-22. St. Kilda, Victoria: Melbourne Fringe, 1997.

9729. Hill, Michael. "The Australian Underground." In *14^{th} International Biennial of Drawings: The Comics*. Exhibition Catalogue (1998), Moderna Galerija, Museum of Modern Art, Rijeka, Croatia, 17 December 1998-20 March 1999.

9730. Hill, Michael. "cOZmix #2: Emphasising the OZ in Australian Independent Comics." In *cOZmix #2* Exhibition Catalogue (1998), TAP Gallery, Sydney/1998 Sydney Fringe Festival, 26 January-1 February 1998.

9731. Hill, Michael. "Drawing in the Margins: Sydney's Underground Comics Scene." *Sydney City Hub*. October 1998.

9732. Hill, Michael. "Reshaping the Screen: Good Ideas from Mindrot." *Form/Work 2*. April 1998.

9733. Hill, Michael J. "A Study of Contemporary Australian Alternative Comics 1995-2000 with Particular Reference to the Work of Naylor, Smith, Danko and Ord." Ph.D. dissertation, MacQuarie University, Sydney, 2002.

9734. Rogers, Elizabeth. *Megazeen 2. Megazeen Australian Fanzine and Comic Book Directory*. St. Kilda, Victoria: Melbourne Fringe, 1996.

9735. Woolley, Pat, ed. *The Wild & Woolley Comix Book: Australian Underground Comix*. Sydney: Wild & Woolley, 1977.

New Zealand
General Sources

9736. Lent, John A. "New Zealand – Exporter of Mainstream Cartoonists, Haven for Alternative Comics." *International Journal of Comic Art*. Spring 2002, pp. 170-204.

9737. Paterson, Alan S. *The Bull Pen*. Los Angeles: Australasian American Services, 1973. (Gag cartoons).

Cartoonists and Their Works

9738. Nilsson, Peter. "Colin Wilson." *Bild & Bubbla*. No. 2, 2000, p. 35.

9739. "Secrets from the Artist's Portfolio: Roger Langridge." *Borderline*. December 2001, pp. 62-64.

Horrocks, Dylan

9740. "Dylan Horrocks Sketchbook." *Comics Journal*. May 2002, pp. 88-89.

9741. Spurgeon, Tom. "Sweeping out the Lighthouse: The Dylan Horrocks Interview." *Comics Journal*. May 2002, pp. 46-87.

Animation

9742. Desowitz, Bill. "WETA Digital Tackles Tolkien's *Lord of the Rings*." *Animation*. December 2001, pp. 27-28.

9743. Singer, Greg. "Force of Hobbit, Mythmaking at Weta." *Animation World*. March 2002, pp. 7-14.

Lye, Len

9744. Bell, Leonard. "Len Lye: A Personal Mythology." *Art New Zealand*. No. 17, 1980, p. 26.

9745. Blakeston, Oswell. "Len Lye's Visuals." *Architectural Review*. July 1932, p. 25+.

9746. Bouhours, Jean-Michel and Roger Horrocks, eds. *Len Lye*. Paris: Centre Pompidou, 2000.

9747. Broom, Maureen Hill. "A New Zealander's Contribution to Message of Peace." *New Zealand Free Lance*. October 21, 1959, pp. 3-4.

9748. Cavalcanti, Alberto. "Presenting Len Lye." *Sight and Sound*. Winter 1947/1948, pp. 134-135.

9749. "Close Look at Len Lye, Kinetic Artist." *The Press*. June 26, 1973, p. 4.

9750. "Coloured Novelty." *Daily Express* (London). September 22, 1935.

9751. Curnow, Wystan. "An Interview with Len Lye." *Art New Zealand*. No. 17, 1980.

9752. Curnow, Wystan. "Len Lye at the Govett-Brewster." *Art New Zealand*. April-May 1977, pp. 23-25.

9753. Curnow, Wystan and Roger Horrocks, eds. *Figures of Motion: Len Lye, Selected Writings*. Auckland: Auckland University Press and Oxford University Press, 1984.

9754. Curnow, Wystan and Roger Horrocks. "The Len Lye Lists." *Bulletin of New Zealand Art History*. Vol. 8, 1980.

9755. Curtis, David. *Experimental Animation: A Fifty-Year Evolution*. New York: Dell Publishing, 1971.

9756. Del Tredici, Robert. "Len Lye Interview." *The Cinema News* (San Francisco). Nos. 2-4, 1979, p. 35.

9757. "The First Swing Film." *Melody Maker*. September 18, 1937.

9758. Horrocks, Roger. *Len Lye: A Biography*. Auckland: Auckland University Press, 2001.

9759. "In Arcadia People Are Talking About…Len Lye." *Spleen* (Wellington). No. 7, 1977, pp. 4-7.

9760. Kennedy, Joseph. "Len Lye – Composer of Motion." *Millimeter*. February 1977.

9761. "Len Lye – The English Disney." *Sunday Referee*. November 10, 1935.

9762. "Len Lye Speaks at the Film-maker's Cinematheque." *Film Culture*. Spring 1967.

9763. "Len Lye – Through the Eyes of His 'Kid Brother.'" *Auckland Star*. August 4, 1980.

9764. Lye, Len. "Slow but Sure." In *Len Lye: A Personal Mythology*. Auckland City Art Gallery, 1980.

9765. "Made a Film Without a Camera." *Daily Express* (London). September 1935.

9766. Mancia, Adrienne and Willard Van Dyke. "The Artist as Film-maker: Len Lye." *Art in America*. July-August 1966, p. 105.

9767. Maxwell, Susan. "An Artist with a Whirring Mind." *New Zealand Herald*. August 6, 1980, Section 2, p. 1.

9768. Maxwell, Susan. "NZ Art Maverick Dies in His Adopted Home." *New Zealand Herald*. May 16, 1980.

9769. "New Zealand Boy Makes Good." *St. John's Evening Telegram*. November 12, 1937.

9770. "Ray Thorburn Interviews Len Lye." *Art International*. April 1975, pp. 64-68.

9771. Riding, Laura. *Len Lye and the Problem of Popular Film*. London: Seizin Press, 1938.

9772. "The Visionary Art of Len Lye." *Craft Horizons*. May-June 1961, p. 30+.

9773. Weinberg, Gretchen. "Interview with Len Lye." *Film Culture*. Summer 1963, p. 40.

Comics

9774. Brown, Jo-Marie. "Footrot Flattery after Many Years." *New Zealand Herald*. June 3, 2002.

9775. Silver, Burton. *Bogor*. Christchurch: Whitcoulls Publisher, 1979.

Reunion
Animation

9776. Detheux, Jean. "Standing at the Crossroads." *Animation World*. March 2001, pp. 67-73.

Tahiti
Animation

9777. "Animo Travels to Tahiti." *Animation*. August 1999, p. 27.

CENTRAL AND SOUTH AMERICA
General Sources

9778. de Sousa, Osvaldo Macedo. "Conceptos, Humor e Iberoamericanidad (I)." *Quevedos*. June 2002, p. 4.

9779. Díaz Granados, Martha, *et al*. "Humor y Mujer: Ellas Tienen la Palabra." *Quevedos*. February 2002, pp. 18-19. (Nuria Pompeya, Spain; Adriana Mosquera Soto, Colombia; María José Mosquera Beceiro, Spain; Amparo Camarero Amador, Spain; Rayma Isabel Suprani Migliaccio, Venezuela; Consuelo Lago, Colombia; Mariana Weschler, Argentina; Míriam Margarita Alonso Cabrera, Cuba; Debra Figgis, U.S.; Marisa Babiano Puerto, Spain; Raquel Orjuz, Uruguay; Elena Ospina Mejía, Colombia).

9780. Giménez, Felicidad Añaños. "Opinión." *Quevedos*. July 2001, p. 4.

9781. *Latino Americano Karikatürler/Cartoons*. Istanbul: Schneidertempel Art Center, 2001. 48 pp.

9782. Lent, John A., ed. *Cartooning in Latin America*. Cresskill, New Jersey: Hampton Press, 2003.

9783. Lent, John A. "Latin American Comic Art: An Historical and Contemporary Overview." *International Journal of Comic Art*. Fall 2001, pp. 1-22.

9784. Lent, John A. "Latin American Comic Art: An Overview." In *Cartooning in Latin America*. Cresskill, New Jersey: Hampton Press, 2003.

9785. Lent, John A. "Latin Amerika Mizah Sanati: Kendi Başina Bir Dram" (Latin American Comic Art: High Drama Itself). In *Karikatür ve Bilisim/Cartoon and Informatics*, 7 pp. Ankara: Karikatür Vakfi, 2002.

9786. Lent, John A. "Latin Amerika Mizah Sanati: Kendi Başina bir Dram" (Latin American Comic Art: A High Drama Itself). In *Latino Americano Karikatürler/Cartoons*, pp. 10-15. Istanbul: Schneidertempel Art Center, 2001.

9787. Merino, Ana. "Fantomas contra Disney." *Revista Latinoamericana de Estudios Sobre la Historieta.* December 2001, pp. 203-224.

9788. "Moneros Latinoamericanos en Italia." *Chocarreros.* September 2002, p. 22.

9789. "Nueva Revista Latinoamericana Sobre la Historieta." *Quevedos.* July 2001, p. 23.

9790. Pohle, Marlene. "'Latin America Karikatürü' Sergisi Hakkinda" (About the Latin American Cartoon Exhibition). In *Latino Americano Karikatürler/ Cartoons*, pp. 5-9. Istanbul: Schneidertempel Art Center, 2001.

9791. Pohle, Marlene. "Latinoamericano Karikatürler/ Cartoons." *FECO News Magazine.* No. 35, 2002, pp. 10-11.

9792. *Revista Latinoamericana de Estudios sobre la Historieta.* Official organ of Observatorio Permanente Sobre la Historieta Latinoamericana. Published three times yearly, beginning in April 2001, *Revista* features indepth overviews of comics, profiles of cartoonists, and historical pieces. Illustrated; in Spanish. Irma Armas Fonseca, director; Manuel Pérez Alfaro and Dario Mogno, editors. Calle 11#160 e/K y L-Vedado, La Habana, Cuba.

9793. Rozental, Izel. "Neden Latin Amerika Karikatürü?" (Why Latin American Cartoon?). In *Latino Americano Karikatürler/Cartoons*, pp. 3-4. Istanbul: Schneidertempel Art Center, 2001.

Argentina
General Sources

9794. Bartolomé, Andrés. "Guillermo Mordillo: 'En Casi Todos los Lugares se Ríen de las Mismas Cosas.'" *Quevedos.* January 2003, pp. 13-14.

9795.　"'Cartoons' en el Día Internacional de los Museos." *Quevedos*. June 2002, p. 24.

9796.　"FECO Argentina 1st International Cartoon Exhibition." *FECO News Bulletin*. November 2002, pp. 2-3.

9797.　"Humor y Salud Mental en Buenos Aires." *Quevedos*. January 2003, p. 25.

9798.　Kappel/Nando. "Eventos de Humor en Argentina." *Quevedos*. January 2003, p. 22.

9799.　"Libro de Huertas en Clave de Humor." *Quevedos*. January 2003, p. 29.

9800.　"'Zapping de Humor Gráfico', Nueva Revista en Argentina." *Quevedos*. June 2002, p. 28.

Cartoonists

9801.　Alcatena, Quique. *Alcatena. Hallucinations. Drawings*. Buenos Aires: A.A.A.A., 1999. Unpaginated.

9802.　Belmont, Fernando. "En Estos Momentos el Humor Es Un Producto de Primera Necesidad en AL: Fontanarrosa." *Chocarreros*. September 1996, p. 15.

9803.　Buscaglia, Norberto. "Comienza una Historia." *Revista Latinoamericana Estudios sobre la Historieta*. April 2001, pp. 55-64. (Alberto Breccia).

9804.　Cooke, Jon B. "Delbo's Authentic Artistry." *Comic Book Artist*. December 2002, pp. 78-87. (José Delbo).

9805.　"Diogenes Taborda." *Karikatürk*. No. 91, 2001, p. 3.

9806.　Hall, Phil. "On the Outside Looking in: The Big Fabian Nicieza Interview, Part One." *Borderline*. November 2001, pp. 37-43.

9807.　"Se Publica 'Humor a la Cordobesa' del Argentino Claudio Furnier." *Quevedos*. July 2001, p. 25.

9808.　Tadeo Juan, Francisco. "Grandes de la Historieta Argentina: Carlos Casalla y su Cabo Savino." *Comicguia*. No. 49, 2002, pp. 10-24.

9809.　Zanotto, Juan. *The Juan Zanotto Sketchbook*. Buenos Aires: Ancares Editora, 2001. 48 pp.

Discépolo, Enrique Santos

9810.　"Aguantà Argentina." *Comicguia*. No. 50, 2002-2003, pp. 17-18.

9811. "Remembranzas: La Filosofía." *Comicguia*. No. 50, 2002-2003, p. 16.

Oesterheld, Héctor

9812. Arnaut, Daniel. "Dossier Oesterheld." *Paredón*. No. 9, 1st sem., 1998.

9813. Merino, Ana. "Oesterheld, the Literary Voice of Argentine Comics." In *Cartooning in Latin America*, edited by John A. Lent. Cresskill, New Jersey: Hampton Press, 2003.

9814. Merino, Ana. "Oesterheld, the Literary Voice of Argentine Comics." *International Journal of Comic Art*. Fall 2001, pp. 56-69.

9815. Saccomanno, Guillermo and Carlos Trillo. "Héctor Germán Oesterheld, Una Aventura Interior." *Revista Latinoamericana de Estudios Sobre la Historieta*. December 2001, pp. 237-256.

9816. Saccomanno, Guillermo and Carlos Trillo. "Héctor Germán Oesterheld, Una Aventura Interior 2." *Revista Latinoamericana de Estudios Sobre la Historieta*. March 2002, pp. 52-60.

Quino

9817. "Graphic Art with Intellectual Qualities." *FECO News Magazine*. No. 36, 2002, p. 18.

9818. "Quino: Dedicated to Your Kind Heart!" *Kayhan Caricature*. June 2001, pp. 39-46.

9819. "Quino Expone en Roma." *Quevedos*. January 2003, p. 24.

9820. "Quino Recibió el Premio Quevedos de Humor Gráfico." *Quevedos*. February 2002, pp. 6-11.

9821. Varona, José-Ma. "Ché." "A Conversation with Quino." *FECO News Magazine*. No. 36, 2002, p. 19.

von Rebeur, Ana

9822. "Ana von Rebeur." *Humour & Caricature*. March/April 2002, 2 pp.

9823. "Ana von Rebeur: Greetings from Argentina." *FECO News*. No. 34, 2001, p. 23.

9824. "Argentina FECO: Ana Von Rebeur." *Al-Pharaennah*. March 2003, p. 8.

Zaffino, Jorge

9825. Williams, Dylan. "All That Could Have Been: Jorge Zaffino." *Comics Journal*. November 2002, pp. 121-124.

9826. Williams, Dylan. "Jorge Zaffino Dies." *Comics Journal*. September 2002, p. 19.

Animation

9827. Newberry, Charles. "TBS Bunny Hops to It for Sponsor." *Variety*. June 17-23, 2002, p. 20.

Comic Books

9828. Accorsi, Andrés. "Argentina Comics." *International Journal of Comic Art*. Fall 2001, pp. 23-43.

9829. Accorsi, Andrés. "Argentina Comics: A History." In *Cartooning in Latin America*, edited by John A. Lent. Cresskill, New Jersey: Hampton Press, 2003.

9830. Barrero, Manuel. "Viñetas Desarraigadas la Hégira de Historietistas Latinoamericanos a Otros Mercados: El Caso de Argentina." *Revista Latinoamericana de Estudios sobre la Historieta*. June 2002, pp. 93-104.

9831. Carrizo, César. "La Historia Argentina en Pedazos de Historietas." *Revista Latinoamericana de Estudios sobre la Historieta*. June 2002, pp. 114-124.

9832. Falaschini, Leonardo M. "Fuga de Lápices." *Revista Latinoamericana de Estudios sobre la Historieta*. September 2001, pp. 187-192.

9833. García, Fernando and Hernán Ostuni. "Historieta & Sociedad: *El Eternauta*." *Revista Latinoamericana de Estudios sobre la Historieta*. September 2002, pp. 125-152.

9834. García-Carrillo, Antonio Pérez. "Recuerdos. Análisis e Historias sobre el Mundo del Cómic." *Círculo Andaluz de Tebeos*. No. 23, 2002, pp. 17-19.

9835. "Nueva Revista de Humor del Argentino Sergio Más." *Quevedos*. February 2002, p. 25.

9836. Williams, Jeff. "Argentine Comics Today: A Foreigner's Perspective." In *Cartooning in Latin America*, edited by John A. Lent. Cresskill, New Jersey: Hampton Press, 2003.

9837. Williams, Jeff. "Argentine Comics Today: A Foreigner's Perspective." *International Journal of Comic Art*. Fall 2001, pp. 44-55.

Comic Strips

9838. Merino, Ana. "'Inodoro Pereyra,' a 'Gaucho' in the Pampa of Paper and Ink." In *Cartooning in Latin America*, edited by John A. Lent. Cresskill, New Jersey: Hampton Press, 2003.

Brazil
Cartooning, Cartoons

9839. Arquivo em Imagens. *No. 3 Série Última Hora: Ilustrações*. São Paulo: Arquivo do Estado de São Paulo, 1999.

9840. *Brasil-Argentina: I Encontro Latino-Americano de Humor. Catálogo*. São Paulo: Fundação Memorial da América Latina, 1990.

9841. *Caricaturas dos Tempos*. São Paulo: Melhoramentos, 1948, 1982.

9842. *Caricaturas Econômicas*. Rio de Janeiro: Museu da Fazenda Federal, 1986.

9843. Carneiro, Newton. *O Paraná e a Caricatura*. Curitiba: Universidade Federal do Paraná/Fundação Teatro Guaíra, 1975.

9844. Cedraz, Antonio. *A Turma do Xaxado 2*. Salvador: Ed. e Estúdio Cedraz, 2001.

9845. Cruz, Gutemberg. *O Traço do Mestre: Humor Gráfico na Bahia*. Salvador: Arembepe, 1993.

9846. da Fonseca, Joaquim. *Caricatura – Imagen Gráfica do Humor*. Porto Alegre: Artes e Ofícios, 1999.

9847. da Silva, Antônio Fernandes. *O Brasil na Caricatura Portuguesa*. Rio de Janeiro: Biblioteca Nacional, 1965.

9848. de Moya, Alvaro. "Quadrinhos Conquistan Novos Espaços." *Revista Abigraf*. November-December 2002.

9849. Fraga, Guaraci. *Antologia Brasileira do Humor*. Porto Alegre: L&PM, 1976.

9850. Galuzzai, Tania. "São Paulo Museu dos Artes Graficas." *Revista Abigraf*. November-December 2002.

9851. Grupo Coquetel de Palavras Cruzadas. *Caricaturas de Gente Famosa*. Rio de Janeiro: Tecnoprint, [1987?].

9852. Lemos, Renato, comp. *Uma História do Brasil Através da Caricatura 1840-2001*. Rio de Janeiro: Bom Texto Editora and Produtora de Arte and Editora Letras & Expressões, 2001. 168 pp.

9853. Nildao. *Bahia: Odara ou Desce*. Salvador (?): Atelier Gráfico VIP Ltda., n.d. Unpaginated.

9854. *No Mundo da Caricatura*. São Luiz: Museu Histórico e Artístico do Maranhão, Fundação Cultural do Maranhão, 1976.

9855. *O Rio na Caricatura*. Catalogue Seção de Exposiçôes da Biblioteca Nacional. Rio de Janeiro: 1965.

9856. Vazques, Edgar. *Caras Pintadas*. Porto Alegre: L&PM, 1993.

Historical Aspects

9857. de Ipanema, Rogéria Moreira. *A Idade da Pedra Ilustrada: Litografia: Um Monólito na Gráfica e no Humor do Jornalismo do Século XIX no Rio de Janeiro*. Rio de Janeiro: Escola de Belas-Artes, 1995.

9858. de Moya, Alvaro. *Anos 50, 50 Anos*. Opera Graphica, 2001.

9859. Leite, Silvia Helena. *Chapéus de Polha, Panamas, Plumas, Cartolos: A Caricatura na Literatura Paulina 1900-1920*. São Paulo: Fundação Editora da UNESP, 1996.

9860. *Sucessão: Charges no Jornal do Brasil*. Rio de Janeiro: Jornal do Brasil, 1983.

9861. Weber, Hilde. *O Brasil em Charges: 1950-1985*. São Paulo: Circo Editorial, 1986.

Cartoonists

9862. Andersson, Per A.J. "Oh La La!" *Bild & Bubbla*. No. 2, 1995, pp. 54-55.

9863. Appe. *Blow Appe: Un Documentário em Tempo de Humor*. Rio de Janeiro: RioArte, 1983.

9864. *Calixto Cordeiro. Catálogo de Exposição no Museu Nacional de Belas Artes*. Rio de Janeiro: 1987.

9865. "Caricatura e Caricaturistas." *Revista de Cultura Vozes* (Petropolis). April 1970.

9866. Chichorro, Alceu. *Alceu Chichorro: Charges*. Org. by Wilson Bóia. Curtibia: Secretaria da Cultura, 1994.

9867. Clériston, Lailson, Samuca, *et al. Humor no Fim do Século: O Ano 2000 no Traço de 5 Cartunistas Pernambucanos*. Recife: ACAPE (Associação dos Cartunistas de Pernambuco), 2000.

9868. Corrêa do Lago, Pedro. *Caricaturistas Brasileiros 1836-2001.* 2nd Rev. Ed. Rio de Janeiro, Contra Capa, 2001. 215 pp.

9869. Cotrin, Álvaro. *Pedro Américo e a Caricatura.* Rio de Janeiro: Pinakotheke, 1983.

9870. de Macedo, F. R180pardense. "O Premeiro Caricaturista no Brasil." *Caderno de Artes I* (Porto Alegre). June 1980.

9871. de Moya, Alvaro. "Pioneering in Brazilian Quadrinhos, as a Cartoonist and Researcher." *International Journal of Comic Art.* Spring 2002, pp. 23-25.

9872. do Lago, Pedro Corrêa. *Caricaturistas Brasileiros: 1836-1999.* Rio de Janeiro: Sextante, 1999.

9873. "Drawing Board Special: Mike Deodato Jr." *Borderline.* March 2002, pp. 52-53.

9874. Fenandes, Millôr, *et al. Dez em Humor.* Rio de Janeiro: Expressão e Cultura, 1968.

9875. Jaguar. *Átila, Você é Bárbaro.* Rio de Janeiro: Civilização Brasileira, 1968.

9876. Lent, John A. "On the Wing: A Cartoonist's Change of Country." *FECO News Magazine.* No. 36, 2002, pp. 12-13. (Osmani Simanca).

9877. *Les Humoristes 1830-1930.* Les Éditions de l'Amateur, 1999.

9878. "Mike Deodato from Brazil to the Burgh." Pittsburgh Comiccon program. April 26-28, 2002, p. 5.

9879. *Millôr Fernandes: Desenhos.* São Paulo: Raízes, 1981.

9880. Pimentel, André. "A Arté de Cau Gomez." *Palavra.* August 1999, pp. 127-130.

9881. Ralfo. *8 Anos de Humor.* São José do Rio Preto, SP: Verbo, 1984.

9882. *Raphael Bordallo Pinheiro. O Português Tal e Qual: da Caricatura à Cerâmica. O Caricaturista.* Curated by Emanoel Araujo. São Paulo: Pinacoteca do Estado, 1996.

9883. "A Selective Who's Who of Brazilian Comics Creators." *Borderline.* February 2002, pp. 41-42.

9884. Silva, Leonardo D. "Pioneiros da Caricatura em Pernambuco." In *Humor Diário: A Ilustração Humoristica do Diário de Pernambuco (1914-1996).* Recife: Ed. Universitária da Universidade Federal de Pernambuco, 1996.

9885. Trimano, Luís. *Desenhos 1968-1990*. Organized by Cássio Loredano. São Paulo: Mil Folhas, 1993.

9886. Vergueiro, Waldomiro. "El Caso del Artista Brasileño Lourenço Mutarelli." *Revista Latinoamericana de Estudios sobre la Historieta*. June 2002, pp. 105-113.

9887. Vergueiro, Waldomiro and Lucimar Ribeiro Mutarelli. "Forging a Sustainable Comics Industry: A Case Study on Graphic Novels as a Viable Format for Developing Countries, Based on the Work of a Brazilian Artist." *International Journal of Comic Art*. Fall 2002, pp. 157-167.

9888. Vivenas, Ricardo. "Daniel Messias: A Melhor Dimensão do Arte em Cartoon." *Abigraf*. July-August 2002.

Belmonte

9889. Belmonte. *Caricatura dos Tempos*. São Paulo: Melhoramentos/Círculo do Livro, 1982.

9890. *Belmonte 100 Anos*. São Paulo: Editora SENAC, 1996.

Caruso, Chico

9891. Caruso, Chico. *Diablo Mon Amour*. Rio de Janeiro: Companhia Industrial de Papel Pirahy, 1986.

9892. Caruso, Chico. "Fora Collor: O *Fenômeno em Decomposição*. São Paulo: Ed. Globo, 1992.

9893. Caruso, Chico. *Full Collor: O Fenômeno em Caricaturas*. São Paulo: Mil Folhas, 1991.

9894. Caruso, Chico. *Natureza-Morta e Outros Densenhos do Jornal do Brasil (1978 a 1980)*. Rio de Janeiro: Muro, 1980.

de Sousa, Mauricio

9895. Hall, Phil. "Brazil, Brazil." *Borderline*. October 2001, pp. 8-9.

9896. "I Don't Know Art, But I Know What I Like." *Borderline*. November 2001, p. 29.

Fred (Federico Ozanam)

9897. Fred (Federico Ozanam), comp. *Paraíba e Piauí no Cartum. Com Todo o Risco!* João Pessoa: UNPB/Editora Universitária, 2000. 72 pp.

9898. Fred. *Rio de Lágrimas: Uma Visão Muito Seca do Nordeste*. Campina
 Grande: Cover Consultoria & Comuniçacão, 1999/2000.

Henfil

9899. Henfil. *Cartas da Mãe*. 3rd Ed. Rio de Janeiro: Codecri, 1981.

9900. Henfil. *Diário de um Cucaracha*. Rio de Janeiro: Record, 1983.

9901. Henfil. *Diretas Já!* Rio de Janeiro: Record, 1984.

9902. Henfil. *Fradim, No. 17 a 27*. Rio de Janeiro: Codecri, 1980.

9903. Henfil. *Gráuna Ataca Outra Vez*. São Paulo: Geração Editorial, 1994.

9904. Henfil. *Henfil na China: Antes da Coca-cola*. 2nd Ed. Rio de Janeiro:
 Codecri, 1980.

9905. Henfil. *Henfil nas Eleições*. Aparecida: Ed. Santuário, 1994.

9906. Henfil. *Hiroshima, Meu Humor*. São Paulo: Geração Editorial, 1994.

J. Carlos

9907. Arestizábal, Irma. *J. Carlos 100 Anos*. Rio de Janeiro: Funarte/M.E.C.,
 1984.

9908. Carlos, J. *O Basil Galante de J. Carlos (1884-1950): 50 Anos de
 Trabalho do Mestre da Caricatura Brasileira*. São Paulo: Renato
 Magalhâes Gouveia Escritório de Arte, 1991.

9909. Cotrin, Álvaro. *J. Carlos, Vida e Obra*. Rio de Janeiro: Nova Fronteira,
 1985.

9910. *J. Carlos: Época, Vida, Obra*. Rio de Janeiro: Nova Fronteira, 1985.

9911. Loredano, Cássio. *O Rio de J. Carlos*. Rio de Janeiro: Lacerda
 Ed./Prefeitura do Rio de Janeiro, 1998.

9912. Lustosa, Isabel. "The Art of J. Carlos." *The Journal of Decorative and
 Propaganda Arts: Brazil Theme Issue* (Miami). 1995, pp. 108-125.

Klixto

9913. *Klixto: O Humor Demolidor*. Rio de Janeiro: Programão Funarte, 1987.

9914. Nunes, Ângela C. *Klixto: Ironia Fina e Dura na Virada do Século*. Rio
 de Janeiro: Programão Funarte, 1987.

Loredano, Cassio

9915. Loredano, Cássio. *Guevara e Figueroa: Caricatura no Brasil Nos Anos 70*. Rio de Janeiro: Instituto Nacional de Artes Gráficas, 1988.

9916. Loredano, Cássio. *Loredano: Caricaturas*. São Paulo: Globo, 1994.

9917. Loredano, Cássio. *Nássaro: Desenhista*. Rio de Janeiro: Instituto Nacional de Artes Plásticas, 1985.

9918. "Maestrazos: Loredano Cássio Silvio Filho." *Dedeté*. No. 13, 2001, p. 4.

Mendez

9919. Mendez. *Caricaturas e Caricaturados*. Rio de Janeiro: Technoprint, ca. 1986.

9920. Mendez. *Como Fazer Caricaturas*. Rio de Janeiro: Technoprint, 1979.

Zéfiro, Carlos

9921. Vergueiro, Waldomiro C.S. "Brazilian Pornographic Comics: A View on the Eroticism of a Latin American Culture in the Work of Artist Carlos Zéfiro." *International Journal of Comic Art*. Fall 2001, pp. 70-78.

9922. Vergueiro, Waldomiro. "Historieta Pornográfica Brasileña. Una Visión del Erotismo en la Cultura Latinoamericana en las Obras del Artista Carlos Zéfiro." *Revista Latinoamericana de Estudios sobre la Historieta*. September 2001.

Ziraldo

9923. Hall, Phil. "Brazil, Brazil – Ziraldo." *Borderline*. November 2001, pp. 15-16.

9924. Pinto, Ziraldo Alves. "Ninguém Entende de Humor." *Revista de Cultura Vozes*. April 1970.

9925. Pinto, Ziraldo Alves. *The Supermãe*. Bela Horizonte: Jornal Estado de Minas, 1996.

9926. Pinto, Ziraldo Alves. *Ziraldo*. Rio de Janeiro: Salamandra, 1988.

9927. Ziraldo. *Ziraldo, 40/55*. Rio de Janeiro: Salamandra, 1988.

9928. Ziraldo. *1964-1984: 20 Anos de Prontidão*. Rio de Janeiro. Record, 1984.

Exhibitions, Festivals

9929. Alves, Ceci. "Humor e Dominó." *A Tarde*. July 4, 2002, p. 6.

9930. "Bahia International Humor Contest." *FECO News*. No. 35, 2002, p. 2.

9931. "Bahia Salão Internacional de Humor." *Kayhan Caricature*. December 2001, pp. 12-14.

9932. "Brezilya'dan Ödüller." *Karikatürk*. No. 91, 2001, p. 1.

9933. Castro, Giovanna. "Formas e Conceitos, do Belo ao Humorístico." *Correio da Bahia*. June 28, 2002, p. 6. (Bahia festival).

9934. de Holanda Cavalcanti Lailson. "III Festival Internacional del Humor e Historieta de Pernambuco." *Quevedos*. July 2001, p.24.

9935. "IV Festival Internacional de Historietas de Pernambuco." *Quevedos*. June 2002, p. 24.

9936. Magalhães, Marcos and Léa Zagury. "Anima Mundi: 10 Years of a Festival in Carnival Style." *ASIFA News*. Spring 2002, pp. 30-32.

9937. Pohle, Marlene. "Salao Internacional de Humor da Bahia." *FECO News Magazine*. No. 35, 2002, p. 16.

9938. Simanca, Osmani, comp. *A Música do Cartum – The Music of Cartoon. Salão Internacional de Humor da Bahia.* Salvador: Museu de Arte Moderna da Bahia, 2001. 126 pp.

Animation

9939. "Brazil Has a Cow over 'Simpsons.'" E! Online. April 8, 2002.

9940. Faiola, Anthony. "The Cartoon That Riled Rio." *International Herald Tribune*. April 18, 2002, pp. 1,5.

9941. Faiola, Anthony. "Simpsons Go Home! Rio Takes Spoof Very Seriously." *Washington Post*. April 16, 2002, pp. C1, C7.

9942. "Rio Irked by 'Simpsons' Portrayal." Reuters dispatch, April 8, 2002.

9943. "'Simpsons' Producer Brooks Apologizes to Rio." Reuters dispatch, April 12, 2002.

Comic Books

9944. "British Explorers and Political Extremists." *Borderline*. February 2002, p. 43.

9945. Cirne, Moacy. *História e Crítica Dos Quadrinhos Brasileiros*. Rio de Janeiro: Ed Europa, Funarte, 1990.

9946. Cirne, Moacy. "Quadrinhos Infantis Brasileiros: Uma Breve Leitura." *Cultura*. April-September 1979, pp. 31-37.

9947. Cotrim, Álvaro. "Era Uma Vez um...'Tico Tico.'" *Cultura*. 4:15 (1974), pp. 82-91.

9948. da Silva, Diamantino. *Quadrinhos para Quadrinhos*. Porto Alegre: Bels, 1976.

9949. da Silva, Nadilson Manoel. "Brazilian Adult Comics: The Age of Market." In *Cartooning in Latin America*, edited by John A. Lent. Cresskill, New Jersey: Hampton Press, 2003.

9950. dos Santos, Roberto Elisio. "Zé Carioca y la Cultura Brasileña." *Revista Latinoamericana de Estudios sobre la Historieta*. September 2002, pp. 177-188.

9951. "Edições Tonto – Mini Comics with a Difference." *Borderline*. February 2002, p. 44.

9952. Feijó, Mario. *Quadrinhos em Ação: Un Século de História*. São Paulo: Editora Moderna, 1997.

9953. Hall, Phil. "Brazil, Brazil Independent Voices." *Borderline*. February 2002, p. 38.

9954. "Literatura de Tradición Oral en Forma de Historieta." *Quevedos*. June 2002, p. 28.

9955. "Made in Brazil Comics – 10 Years 4 Issues." *Borderline*. February 2002, pp. 42-43.

9956. "Pindorama, la Otra Historia del Brasil." *Quevedos*. February 2002, p. 27.

9957. Vergueiro, Waldomiro C.S. "Brazilian Pornographic Comics: Eroticism in the Work of Carlos Zéfiro." In *Cartooning in Latin America*, edited by John A. Lent. Cresskill, New Jersey: Hampton Press, 2003.

9958. Vergueiro, Waldomiro C.S. "Brazilian Superheroes in Search of Their Own Identities." In *Cartooning in Latin America*, edited by John A. Lent. Cresskill, New Jersey: Hampton Press, 2003.

9959. Vergueiro, Waldomiro C.S. "Children's Comics in Brazil: From *Chiquinho* to *Mônica*, a Difficult Journey." In *Cartooning in Latin America*, edited by John A. Lent. Cresskill, New Jersey: Hampton Press, 2003.

9960. Vergueiro, Waldomiro C.S. "Desarrollo y Perspectivas de la Historieta Infantil Brasileña. Las Incógnitas de un Nuevo Siglo." *Revista Latinoamericana de Estudios sobre la Historieta*. April 2001, pp. 3-14.

9961. Vergueiro, Waldomiro. "Historias em Quadrinhos e Identidade Nacional: O Caso Pereré." *Comunicações e Artes*. 15:14 (1990), p. 21.

9962. Vergueiro, Waldomiro. "Historieta Brasileña Actual y Sus Perspectivas." *Revista Latinoamericana de Estudios sobre la Historieta*. March 2002, pp. 23-32.

9963. Zimbres, Fabio. "A History of the Brazilian Comics Publishing Scene." *Borderline*. February 2002, pp. 39-40.

Chile
Cartoonists

9964. "La Huemul-Entrevista con Percy Eaglehurst, Dibujante del Comics Chileno 'Pepe Antártico.'" *Huemulin Comics*. December 2002, pp. 6-7.

9965. "La Huemul-Entrevista con Themo Lobos, Dibujante del Comics Chileno 'Mampato.'" *Huemulin Comics*. December 2002, pp. 22-23.

Jodorowsky, Alejandro

9966. Barrero, Manuel. "Jodorowsky, el Chileno Ecléctico (1)." *Revista Latinoamericana de Estudios sobre la Historieta*. June 2001, pp. 91-107.

9967. Barrero, Manuel. "Jodorowsky, el Chileno Ecléctico (2)." *Revista Latinoamericana de Estudios sobre la Historieta*. September 2001, pp. 167-181.

9968. "Comics and Filmworks of Jodorowsky." *Borderline*. March 2002, pp. 24-25.

9969. Hernáez, Salvador. "Alejandro Jodorowsky. Soñador de Universos, Hacedor de Leyendas." *Año Cero* (Madrid). June 1994.

9970. Kleiner, Rick, Jules Siegel, and Richard Ballard. "Alejandro Jodorowsky." *Penthouse*. June 1973.

9971. Kutscher, Karin. "Jodorowsky y el Cine." *Trauko* (Santiago de Chile). May 1991.

9972. Lennon, Tom. "Alexander Jodorowsky Metabaron." *Borderline*. March 2002, pp. 21-24.

9973. Mayo, José A. "Alejandro Jodorowsky. Escándalo Público Número Uno." *Primera Linea* (Barcelona). October 1985.

9974. Romo, Manuel. "Alejandro Jodorowsky o el Malditismo por Bandera." *Flash-back* (Valencia). Autumn 1992.

9975. Stik, Jelo. "El Comic Es la Literatura del Futuro." *Trauko* (Santiago de Chile). May 1991.

Pepo (René Rios)

9976. Bengtsson, Mattias. "Plop! Pepo Är Död – 'Condorito' Lever." *Bild & Bubbla*. No. 1, 2001, p. 94.

9977. Montealegre Iturra, Jorge. "Chile's Pepo, Much More Than a Condorito." In *Cartooning in Latin America*, edited by John A. Lent. Cresskill, New Jersey: Hampton Press, 2003.

9978. Montealegre Iturra, Jorge. "Pepo, Mucho Más Que un Condorito." *Revista Latinoamericana de Estudios sobre la Historieta*. April 2001, pp. 46-50.

Animation

9979. Koehler, Robert. "Ogu and Mampato in Rapa Nui." *Variety*. January 27-February 2, 2003, p. 30.

Comic Books

9980. Díaz Castro, Cristian Eric. "La Historieta en Chile." *Revista Latinoamericana de Estudios sobre la Historieta*. June 2002, pp. 75-92.

9981. Díaz Castro, Cristian E. "La Historieta en Chile." *Revista Latinoamericana de Estudios sobre la Historieta*. September 2002, pp. 153-176.

9982. Gutiérrez, Christian. "Historieta Chilena Post Dictadura Renaciendo en la Década del Ochenta." *Revista Latinoamericana de Estudios sobre la Historieta*. March 2002, pp. 33-42.

9983. Ivonne. "Condorito." *La Piztola*. November 2001, p. 9.

9984. Kunzle, David. "Art of the New Chile: Mural, Poster, and Comic Book in a 'Revolutionary Process.'" In *Art and Architecture in the Service of Politics*, edited by Henry Millon and Linda Nochlin, pp. 162-187. Cambridge: MIT Press, 1975.

9985. Kunzle, David. "Chile's *La Firme* Versus ITT." In *Cartooning in Latin America*, edited by John A. Lent. Cresskill, New Jersey: Hampton Press, 2003.

9986. Kunzle, David. "The Comic Book in a 'Revolutionary Process': Chile in 1973." In *Cartooning in Latin America*, edited by John A. Lent. Cresskill, New Jersey: Hampton Press, 2003.

9987. Kunzle, David. "The Worker as Mythic Hero: The Ankles of Juan." *Praxis*. Winter 1976, pp. 200-219.

9988. Montealegre, Jorge. "Historieta de Chile: Entre la Diáspora y la Nostalgia." *Con Eñe: Revista de Cultura Hispanoamericana*. No. 1, 1997, pp. 20-24.

9989. Montealegre Iturra, Jorge and John A. Lent. "*Vignette*: El Condor Pasa (The Passage of the Condor)." In *Cartooning in Latin America*, edited by John A. Lent. Cresskill, New Jersey: Hampton Press, 2003.

9990. "Nuevo Libro con los Trabajos del Dibujante Chileno Krahn." *Quevedos*. February 2002, p. 26.

Colombia
Cartoonists and Their Works

9991. Campo, José. *Klan-destinos III*. Cali: Tercer Milenio Comics, 2000.

9992. "E. Ruldan, Colombia." *Kayhan Caricature*. December 2001, p. 1.

9993. "Exposición de Jorge Ocampo en Nueva York." *Quevedos*. June 2002, p. 26.

Exhibitions, Festivals

9994. "Feria del Libro de Bogotá." *Quevedos*. July 2001, pp. 10-11.

9995. "Tercer Festival Cero para Ilustradores en Colombia." *Quevedos*. July 2001, p. 23.

Comic Books
General Sources

9996. Consuegra, David. *Comics: Otra Visión*. Bucaramanga: Museo de Arte Moderno de Bucaramanga, 1994.

9997. López, Orlando. "'Rastreando Rostros' en Colombia." *Quevedos*. June 2002, p. 11.

9998. Mejía G., Perucho. *Semiótica del Comic*. Santiago de Cali: Bellas Artes, 2001.

9999. "Nueva Página Web para Magola." *Quevedos*. July 2001, p. 21.

10000. Ossa, Felipe. *Los Héroes de Papel*. Bogota: Altamir Ediciones, 1996.

10001. Rabanal, Daniel. "Comics Production in Colombia." In *Cartooning in Latin America*, edited by John A. Lent. Cresskill, New Jersey: Hampton Press, 2003.

10002. Rabanal, Daniel. "Panorama de la Historieta en Colombia." *Revista Latinoamericana de Estudios sobre la Historieta*. April 2001, pp. 15-30.

10003. Sanín, Camilo. "Impresiones Personales sobre el Cómic Colombiano." *Revista Latinoamericana de Estudios sobre la Historieta*. September 2001, pp. 182-186.

Historical Aspects

10004. Bedoya, Silvio. *Historia de la Historieta en Colombia*. Cali: Inédito, 1997.

10005. Mejía G., Perucho. "Comic Art in Colombia: A Short Historical Journey." *International Journal of Comic Art*. Fall 2001, pp. 79-82.

10006. Mejía G., Perucho. "*Vignette*: Comic Art in Colombia: A Short Historical Journey." In *Cartooning in Latin America*, edited by John A. Lent. Cresskill, New Jersey: Hampton Press, 2003.

10007. Ossa, Felipe. *La Historieta y Su Historia*. Bogota: Editorial La Rosa, 1986.

10008. Peña, Jorge. *Cronología de la Historieta en Colombia. KLAN-destinos 3*. Cali: Tercer Milenio Comics, 2000.

Costa Rica
General Sources

10009. "La Caricatura en la Prensa de Costa Rica." *Quevedos*. June 2002, p. 10.

10010. "La Pluma Cómic Realiza 'La Semana de la Historieta.'" *Bulletin of the International Society for Luso-Hispanic Humor Studies*. Summer 2002, p. 12.

10011. Sierra Quintero, Óscar. "La Pluma Cómic Realiza 'La Semana de la Historieta.'" *Quevedos*. February 2002, p. 22.

10012. Sierra Quintero, Óscar. "La Tardía Evolución del Arte de la Historieta en Costa Rica." *Revista Latinoamericana de Estudios sobre la Historieta.* March 2002, pp. 43-51.

Cartoonists and Their Works

10013. "Encuentro de Humoristas e Historietistas en Costa Rica." *Quevedos.* June 2002, p. 10.

10014. Sierra Quintero, Oscar. "Fallece Destacado Caricaturista Costarricense." *Quevedos.* July 2001, p. 26.

Exhibitions, Festivals

10015. "Nueva Exposición del Cosarricense Oki." *Quevedos.* February 2002, p. 22.

10016. Sánchez, Ana. "'Figuras Públicas': Exposición de Gilberto Ramírez en Costa Rica." *Quevedos.* June 2002, p. 11.

Honduras
Cartoonists and Their Works

10017. "Extremadura Acogió 'Los Grandes Inventos' y a 'Banegas en Su Tinta.'" *Quevedos.* June 2002, p. 27.

Mexico
General Sources

10018. Espinosa, Jorge Luis. "Los Amantes de las Musas...." *Chocarreros.* September 1996, p. 14.

10019. Matos, Waldo. "In Guns They Trust." *La Piztola.* November 2001, p. 11.

10020. Mena, Juan Carlos, with Óscar Reyes. *Sensacional! Mexican Street Graphics.* New York: Princeton Architectural Press, 2002. 347 pp.

10021. Winchester, Güicho. "Copia Pirata." *La Piztola.* November 2001, p. 9.

Cartooning, Cartoons

10022. Apebas, Alejandro Pérez Basurto. *Historia del Humor Gráfico en México.* Lleida: Editorial Milenio, 2001. 227 pp.

10023. *Chocarreros. Los Amantes de las Musas. Tomo I. Coleccion Completa 96.* Mexico City: Editorial Carton, 1996.

10024. Heras. "En la Publicidad: el Talento de los Caricaturistas." *La Piztola.* November 2001, p. 8.

10025. *Humor Mexicanus. Zemun International Salon of Caricature.* Zemun: Trag, 2002. 12 pp.

10026. "Inaugurada la Bienal de Humor Gráfico en México." *Quevedos.* January 2003, p. 24.

10027. Larrea, Ricardo. "Propiedad Intellectual la Gestión Colectiva de las Sociedades de Autores y la Ejecución Pública." *La Piztola.* November 2001, p. 8.

10028. "Mexican Cartoons Exhibition [in Korea]." *Animatoon.* No. 40, 2002, pp. 50-51.

10029. Peláez, Ricardo. "La Onomatoepopeya." *Revista Latinoamericana de Estudios sobre la Historieta.* June 2002, pp. 68-74.

10030. "Politi Calaveras." *La Piztola.* November 2001, p. 20.

10031. Sánchez, Agustín. "El Humor como Arma de la Contrarrevolucíon. El Presidente al Que lo Acabó la Risa." *La Piztola.* November 2001, p. 6.

10032. Uh Su-woong. "Mexican Cartoon Festival Opens." *Chosun Ilbo.* September 24, 2002.

Cartoonists

10033. Berggren, Mats. "Kane, Hole & Cruz." *Bild & Bubbla.* No. 5, 1993, pp. 24-26.

10034. "El Dibujante Mexicano Pedro Sol, da la Suerte." *Quevedos.* July 2001, p. 24.

10035. "El Mexicano José Hernández, Premio Nacional de Periodismo en Caricatura." *Quevedos.* July 2001, p. 25.

10036. "Exposición 'A Lara con Humor.'" *Quevedos.* February 2002, p. 27.

10037. Matus, Waldo. "Homenaje a Agustín Lara." *La Piztola.* November 2001, p. 21.

10038. Merino, Ana. "Abel Quezada and El Fisgón: Critical Perceptions of the Socio-Economic and Political Aspects of Mexican Reality Through Cartoons." Paper presented at Popular Culture Association, Toronto, Canada, March 15, 2001.

10039. Orozco, José Clemente. *José Clemente Orozco: An Autobiography.* Mineola, New York: Dover Publications, 2001. 171 pp. Originally published by University of Texas Press, ca. 1962.

10040. Páez, Pino. "Macarroni." *La Piztola*. November 2001, pp. 18-19. (Oscar Zermeño Cruz).

10041. "People and Places in the News." Associated Press dispatch, November 16, 2002. (Dionisio Ceballos).

10042. Priego, Ernesto. "Taller del Perro: Por Una Historieta de Autor." *Revista Latinoamericana de Estudios sobre la Historieta*. June 2002, pp. 63-67.

10043. "III Congreso de Caricatura, 'Chamaco Covarrubias.'" *Bulletin of the International Society for Luso-Hispanic Humor Studies*. Summer 2002, pp. 11-12.

10044. Thompson Ginger. "His Mood Seems Mellow; His Cartoons Are Not." *New York Times*. May 18, 2002. (Rafael Barajas).

Beltran Garcia, Alberto

10045. "Alberto Beltran Garcia." *Washington Post*. April 24, 2002, p. B6.

10046. "Alberto Beltran Garcia of Mexico Dies at 81." *AAEC Notebook*. June 2002, p. 16.

Kemchs, Arturo

10047. "Arturo Kemchs Davila: Mexican Cartoons for Peace." *FECO News Magazine*. No. 35, 2002, p. 21.

10048. "11 de Septiembre por Kemchs." *Chocarreros*. September 2002, pp. 16-19.

10049. Kemchs, Arturo. *Chiapaz. Caricaturas por la Paz Kemchs*. Mexico: Editorial Carton, 2001. 64 pp.

10050. Kemchs, Arturo. *El Sexo Sentido*. Mexico: Uno Más Uno, 1995. 49 pp.

10051. Kemchs, Arturo. *Los Torcidos*. Mexico: Uno Más Uno, 1988. 78 pp.

10052. "Nuevo Libro del Mexicano Kemchs." *Quevedos*. July 2001, p. 20.

Posada

10053. "Declaran 2002 el Año de Posada." *Chocarreros*. February 2002, pp. 16-19.

10054. López Casillas, Mercurio. "112 Años con Calaveras de Posada." *La Piztola*. November 2001, pp. 4-5.

10055. R.A.V. "Posada, en Revolución y Cultura." *Quevedos*. July 2001, p. 23.

Rueda, Ángel

10056. Rruizte. "En Memoria de Ángel Rueda." *Quevedos*. June 2002, p. 22.

10057. "Un Ángel Que Hace Caricaturas." *Chocarreros*. June 2002, pp. 26-27.

Comic Books

10058. Bartra, Armando. "Debut, Beneficio y Despedida de Una Narrativa Tumultuaria (1). Piel de Papel. Los Pepines en la Educación Sentimental del Mexicano." *Revista Latinoamericana de Estudios sobre la Historieta*. June 2001, pp. 67-90.

10059. Bartra, Armando. "Debut, Beneficio y Despedida de Una Narrativa Tumultuaria (2). Fin de Fiesta. Gloria Declive de Una Historieta Tumultuaria." *Revista Latinoamericana de Estudios sobre la Historieta*. September 2001, pp. 147-166.

10060. Bartra, Armando. "Debut, Beneficio y Despedida de Una Narrativa Tumultuaria: Globos Globales: 1980-2000." *Revista Latinoamericana de Estudios sobre la Historieta*. December 2001, pp. 225-236.

10061. Bartra, Armando and Gisela Gil-Egui. "Dawn, Noon, and Dusk of a Tumultuous Narrative: The Evolution of Mexican Comic Art." In *Cartooning in Latin America*, edited by John A. Lent. Cresskill, New Jersey: Hampton Press, 2003.

10062. Cook, Greg. "Harvard Panel Divided on the Value of Lurid Mexican Historietas." *Comics Journal*. April 2002, p. 26.

10063. Fernández L'Hoeste, Héctor D. "The Mystery of Kalimán, el Hombre Increíble: Race and Identity in Mexican Comics." *International Journal of Comic Art*. Spring 2003, pp. 220-230.

10064. Fernandez L'Hoeste, Héctor. "The Ultimate Mexican Alterity: The Case of Kalimán, el Hombre Increíble." Paper presented at ICAF, Bethesda, Maryland, September 6, 2002.

10065. Johns Hopkins University School of Public Health. *Final Report Summary, Mexico. Comic Books in Mexico*. Baltimore, Maryland: Johns Hopkins Center for Communication Programs, 1990.

10066. Merino, Ana. "*La Perdida*: A Space To Find Perceptions." *Comics Journal*. January 2002, p. 32.

10067. "Politica y Viñetas." *Chocarreros*. September 2002, pp. 12-13.

10068. Priego, Ernesto. "Report from Conque 2001, 8th Mexico City Comic Book Convention." *Comics Journal*. September 2001, pp. 32-33.

Nicaragua
Róger

10069. Collinson, Helen. *Women and Revolution in Nicaragua*. London: Zed Books, 1990.

10070. Kunzle, David. "Róger Sánchez's 'Humor Erótico' and the *Semana Cómica*: A Sexual Revolution in Sandinista Nicaragua?" In *Cartooning in Latin America*, edited by John A. Lent. Cresskill, New Jersey: Hampton Press, 2003.

10071. Kunzle, David. "Róger Sánchez's 'Humor Erótico' and the *Semana Cómica*: A Sexual Revolution in Sandinista Nicaragua?" *Latin American Perspectives*. July 1998, pp. 89-120.

10072. Montenegro, Sofía. "Róger el Sexo y la Política." *Gente*. November 9, 1990, p. 4.

10073. Sánchez, Róger. *Humor Erótico*. Managua: Vanguardia, 1986.

10074. Sánchez, Róger. *Muñequitos del Pueblo: Dos Años en la Lucha Ideológica*. 2 Vols. Managua: FSLN, 1981.

Panama
Legal Aspects

10075. "Former Panama President Sues Newspaper Cartoonist." Associated Press dispatch, June 4, 2002.

10076. "Panama's Ex-President Sues Cartoonist Ramos over 'Damage to Reputation.'" *AAEC Notebook*. June 2002, p. 12.

Briceño, Julio

10077. "Aplazamiento del Juicio a Rac." *Quevedos*. February 2002, p. 28.

10078. "Caso Briceño." *Quevedos*. July 2001, p. 27.

10079. Gonzalez, David. "Panama Is Putting Journalists on Trial." *New York Times*. October 28, 2001, p. A14.

Peru
General Sources

10080. Bonavia, Duccio. *Mural Paintings in Ancient Peru*. Bloomington: Indiana University Press, 1985. 224 pp.

Cartoonists

10081. Lent, John A. and Teresa Archambeault. "Conversations with Three Peruvian Cartoonists." In *Cartooning in Latin America*, edited by John A. Lent. Cresskill, New Jersey: Hampton Press, 2003.

Comic Books

10082. "El Humorista Peruano Acevedo Presenta su Nueva Entrega de la 'Historia de Iberoamérica desde los Niños.'" *Quevedos*. July 2001, p. 26.

10083. Lucioni, Mario. "La Historieta Peruana." *Revista Latinoamericana de Estudios sobre la Historieta*. December 2001, pp. 257-264.

10084. Lucioni, Mario. "Peruvian Comics: The Early Years." In *Cartooning in Latin America*, edited by John A. Lent. Cresskill, New Jersey: Hampton Press, 2003.

Uruguay
Cartoons, Comics

10085. Alcuri, Ignacio. "A Letter from Uruguay." *Borderline*. November 2002, p. 62.

10086. Federici, Carlos M. "Desventuras en el Páramo. Una Visión Personal (ista) del Cómic en Uruguay." *Revista Latinoamericana de Estudios sobre la Historieta*. June 2001, pp. 119-130.

10087. Federici, Carlos M. "(Mis)Fortune in a High Barren Plain: A Personal View of Comics in Uruguay." In *Cartooning in Latin America*, edited by John A. Lent. Cresskill, New Jersey: Hampton Press, 2003.

10088. Istituto Italo – Latino Americano Ambasciata dell'Uruguay in Italia. "Desde Uruguay con Humor." Exhibition catalogue. Rome: 1997. 16 pp.

10089. "Mafalda se Estrena en Uruguay." *Quevedos*. July 2001, p. 21.

10090. "Premio Internacional de Humor Gráfico 'Pelodouro.'" *Quevedos*. January 2003, p. 26.

10091. Puch, Daniel. "Cartooning in Uruguay: Not Yet the White Flag." *International Journal of Comic Art*. Fall 2001, pp. 116-126.

10092. Puch, Daniel. "Cartooning in Uruguay, a Short History." In *Cartooning in Latin America*, edited by John A. Lent. Cresskill, New Jersey: Hampton Press, 2003.

10093. Puch, Daniel. "Land in Zicht: Uruguay." *Stripschrift*. June 2002, p. 21.

Venezuela
Cartoonist

10094. Gil-Egui, Gisela. "Venezuela's Alonso and the Art of Leaving It All to Art." In *Cartooning in Latin America*, edited by John A. Lent. Cresskill, New Jersey: Hampton Press, 2003.

10095. Gil-Egui, Gisela. "Venezuela's Alonso and the Art of Leaving It All to Art." *International Journal of Comic Art*. Fall 2001, pp. 127-137.

CARIBBEAN

Cuba
General Sources

10096. Boadle, Anthony. "Cuban Painting Gathers Dust." Reuters dispatch, July 12, 2002.

10097. Centro Informazione e Educazione allo Sviluppo. *Un Sorriso Cubano*. Rome: l'Associazone Culturale "Lo Scigno dell'Arte," 2001 (?). 32 pp.

10098. Columba, Ramón. *Qué Es la Caricatura*. Buenos Aires: Editorial Columba, 1959.

10099. *Cuarenta Caricaturas y Algunas Intromisiones*. Catalogue, Exposition, Galería de la Habana, May 1978.

10100. de Juan, Adelaida. *Caricatura de la República*. Havana: Ediciones UNIÓN, 1999. 260 pp.

10101. de Juan, Adelaida *Pintura y Grabado Coloniales Cubanos*. Contribución a su Estudio. Havana: Editorial Pueblo y Educación, 1974.

10102. de la Nuez, René. "Al Son del Pincel Mordido." *Quevedos*. June 2002, p. 7.

10103. Dimitrieva, N. "El Papel Heuristico del Humor." *Unión* (Havana). February 1980, pp. 14-116.

10104. "Futbol, Iuego Existo." *Kayhan Caricature*. November 2001, 2 pp.

10105. Gómez Sicre, José. "Caricaturas para la Guerra." *El Mundo* (Havana). April 21, 1943.

10106. Martí, Agenor. "Marinello, Un Obre Vital." *Cuba Internacional*. January 1976, p. 38.

10107. Mogno, Dario. "Parallel Lives: A History of Comics and Animated Cartoons in Cuba." In *Cartooning in Latin America*, edited by John A. Lent. Cresskill, New Jersey: Hampton Press, 2003.

10108. "Muestra Antológica y Solidaria de Humor Gráfico Cubano." *Quevedos*. February 2002, p. 25.

10109. "Postales con Caricaturas Conmemoran el Centenario de la Biblioteca Nacional de Cuba." *Quevedos*. February 2002, p. 24.

10110. Ramos, José A. *Manual del Perfecto Fulanista*. Havana: 1916.

10111. Regalado, Yamile. "*Revolución* and *Notícias de Hoy*: Cuban Visual Propaganda in 1959." Master of Arts thesis, Florida State University, 1999. 201 pp. (Political cartoons).

10112. Tabatabai, Massoud Shojai. "Cartoon in Cuba." *Iran Cartoon*. September 2001, pp. 30-33.

10113. Venereo, Ricardo A. "Humor y Poesía, Homenajeados en Cuba." *Quevedos*. January 2003, p. 26.

Dedeté

10114. El Zorro. "Machón de Junio." *Dedeté*. No. 11, 2001, p. 1.

10115. R.A.V. "32 Años de DDT." *Quevedos*. July 2001, p. 21.

Palante

10116. Betán. "Concurso 40mo. Aniversario de Palante." *Palante*. December 2001, pp. 8-9.

10117. "40 Aniversario Palante. Una Etapa de Yuca y Ñame." *Palante*. August 2001, p. 10.

10118. "Museo del Humor Felicita a Palante." *Palante*. November 2001, p. 5.

10119. R.A.V. "La Revista *Palante* Cumple Años." *Quevedos*. July 2001, p. 23.

10120. "Seguimos Palante y Parriba." *Palante*. September 2001, p. 10.

10121. "Un Lustro de 4 Años y Una Siesta de 3 Meses." *Palante*. July 2001, p. 10.

Cartoonists

10122. Apeldoorn, Ger. "Prohias." *Stripschrift*. July 2002, pp. 13-14.

10123. Carmona, Darío. "Un Caricaturista con Historia la Caricatura." *Cuba Internacional*. March 1964, pp. 44-51.

10124. David, Juan. "Los Artistas Escriben." *El País* (Havana). April 24, 1941.

10125. Elena, M. [Horacio Rodríguez]. *Palante*. August 2001, p. 16.

10126. Elene, M. "Bromeando en Serio Con Enrique." *Palante*. July 2001, pp. 8-9. (Enrique Nuñez Rodríguez).

10127. Marsal, L. Frau. "Nuestras Entrevistas. Hablando con Ricardo Torriente." *La Ilustración* (Havana). February 26, 1916.

10128. Mogno, Dario. "Casi Cincuenta Años con el Pincel en Mano. Charla con Eduardo Muñoz Bachs." *Revista Latinoamericana de Estudios sobre la Historieta*. September 2001, pp. 193-200.

10129. Nale Roxlo, Conrado. *Antología Apócrifa*. Buenos Aires: 19(?). (Toño Salazar).

10130. "Nueva Entrega de los Premios 'Curuxas' de Humor." *Quevedos*. July 2001, p. 22. (Tomy).

10131. Ono, Kosei. "Cartoonists I Met in Cuba." *Eye Mask: The Art and Humour Magazine*. December 1993, pp. 16-31.

10132. R.A.V. "Nuevo Premio para el Cubano Jerez." *Quevedos*. July 2001, p. 26. (Alberto Jerez).

10133. Ronda, Felix. *Estres, Escuatro, Escinco...*. Havana: Caixa Catalunya, n.d. 12 pp.

10134. Ross. "Palante." *Palante*. July 2001, p. 16. (H. Nordelo).

10135. "Tomy, Premiado en Turquía." *Quevedos*. January 2003, p. 22.

10136. Venereo, Ricardo A. "Éxito del Humorista Cubano." *Quevedos*. July 2001, p. 21. (Manuel).

Ares

10137. "The Ares Book." *Iran Cartoon*. September 2001, p. 58.

10138. "Ares, Humor en Serio." *Chocarreros*. August 2002, pp. 16-20.

10139. Blanco de la Cruz, Caridad. "Ares: An Undomesticated Humorist." *International Journal of Comic Art*. Fall 2001, pp. 106-115.

10140. Piñera, Toni. "Ares. ¿Colirio Contra el Estrés?" *La Jicotea*. No. 16, 1998, p. 9.

10141. Venereo, Ricardo A. "Ares se Expone." *Quevedos*. June 2002, p. 22.

Chago

10142. Blanco de la Cruz, Caridad. "Always the Other One: Salomón." In *Cartooning in Latin America*, edited by John A. Lent. Cresskill, New Jersey: Hampton Press, 2003.

10143. Feijóo, Samuel. "Chago el Gráfico." *Signos* (Villa Clara). 21, 1978, pp. 528-601.

10144. Fernández, Antonio E. "Brillo de Chago: Salomón Compartido." *Arte Cubano*. No. 1, 1998, pp. 13-19.

10145. R.A.V. "El Cubano Armada, Inaugura en Nueva York." *Quevedos*. July 2001, p. 23.

David, Juan

10146. Bianchi Ross, Ciro. "David, Más Allá de lo Aparente." *Unión* (Havana). March 1981, pp. 8-22.

10147. de la Nuez, René. "Juan David, Maestro de la Caricatura Personal." *Granma*. August 10, 1981, p. 4.

10148. Evora, José Antonio. *David*. Havana: Editorial Letras Cubanas, 1986. 193 pp.

10149. Guillén, Nicolás. "A Juan David." *Bohemia* (Havana). May 8, 1981, p. 21.

10150. Guirao, Ramón. "David." *Grafos*. May 1941.

10151. Labrador Ruiz, Enrique. "David, Beauty Parlor." *Gaceta del Caribe* (Havana). April 1944, p. 29.

10152. Lázaro, Ángel. "Apuntes: de la Exposición de David." *Carteles* (Havana). November 16, 1941, p. 16.

10153. López Nussa, Leonel. "David y el Bobo." *Bohemia*. May 16, 1975, p. 26.

10154. "Maestrazos: David." *Dedeté*. No. 12, 2001, p. 4.

10155. Marquina, Rafael. "El Gran Arte Humorista del Gran Caricaturista Cubano Juan David." *Información* (Sunday supplement, Havana). August 10, 1952, p. 28.

10156. Martí, Agenor. "David y sus Indagaciones." In *Con Tres Humoristas*. Havana: 1980.

10157. Pérez de Cisneros, Guy. "David Caricaturista." *Verbum* (Havana). June 1937, p. 68.

10158. Roa García, Raúl. "La Honda Onda de David." *Bohemia*. May 8, 1981, p. 21.

10159. Rodríguez, Carlos R. "La Exposición de David." *Mediodía* (Havana). May 15, 1937, p. 4.

10160. Rodríguez, Carlos R. "Mención y Muestra de Juan David." *Resumen* (Havana). August 12, 1935.

10161. Rodríguez, Rolando. "Una Imagen al Dorso de la Caricatura de Juan David." *Granma*. August 18, 1981, p. 4.

10162. Santana, Joaquin G. "Juan David, un Modo Cubano de Reír." *Bohemia*. March 6, 1970, pp. 40-42.

10163. Sarusky, Jaime. "Juan David." *Bohemia*. September 1, 1978, pp. 8-9.

10164. Siquitrilla y Korda. "David, Caricatura Periodista." *Revolución*. January 12, 1962, p. 6.

10165. Tamayo, Évora. "David." *Palante*. August 14, 1981, p. 2.

10166. Tatler, "Jean E. David, Artista del Trazo." *El Comercio* (Cienfuegos). July 3, 1931.

10167. Velázquez, José Sergio. "La Exposición de David." *El Mundo*. May 4, 1937.

Garrincha

10168. Lent, John A. "Uphill All the Way: The Career of Cuba's Garrincha." *FECO News*. No. 34, 2001, pp. 4-5.

10169. Lent, John A. "Uphill All the Way: The Career of Cuba's Garrincha." *Kayhan Caricature*. May 2002, pp. 2-3.

Massaguer, Conrado W.

10170. Massaguer, Conrado W. *Grignol: Colleción de Caricaturas*. Havana: 1922.

10171. Massaguer, Conrado W. *Massaguer, su Vida y Obra, Autobiografía, Historia Gráfica, Anecdotario*. Havana: 1957.

Padrón, Juan

10172. Lent, John A. "Cuban Animation and Juan Padrón." Paper presented at Society for Animation Studies, Glendale, California, September 28, 2002.

10173. Lent, John A. "Vampires, Lice and a Dose of History: Juan Padrón and Cuban Animation." *Animation World*. February 2002, pp. 22-28.

10174. "Maestrazos: Juan Padrón." *Dedeté*. No. 14, 2001, p. 4.

10175. Pérez Alfaro, Manuel. "La Historieta y el Cine de Animación. Charla con Juan Padrón." *Revista Latinoamericana de Estudios sobre la Historieta*. June 2001, pp. 131-136.

Characters and Titles

10176. Blanco de la Cruz, Caridad. "Salomón, Un Mutante Perturbador." *Revista Latinoamericana de Estudios sobre la Historieta*. June 2001, pp. 109-118.

10177. de Juan, Adelaida. *Hacerse el Bobo de Abela*. Havana: Editorial de Ciencias Sociales, 1978. 177 pp.

"Spy vs. Spy"

10178. Prohias, Antonio. *Spy vs. Spy: The Complete Casebook*. New York: Watson-Guptill, 2001. 304 pp.

10179. "Terugkeer van Spy vs. Spy." *Stripschrift*. September 2002, p. 32.

Exhibitions, Festivals

10180. "Convocateria XIII Bienal Internacional de Humorismo Gráfico Cuba 2003." *Chocarreros*. September 2002, pp. 26-27.

10181. "Exposición de Caricaturistas Cubanos." *Quevedos*. February 2002, p. 23.

10182. "Naš Čovek na Kubi." *Kart*. October 2001, p. 15.

10183. Piñero, Jorge A. "'Los 20 del Siglo XX' en Cuba." *Quevedos*. June 2002, p. 26.

10184. "7° Encuentro Internacional de Historietistas La Habana, 11-15 de Febrero de 2002." *Revista Latinoamericana de Estudios sobre la Historieta*. March 2002, pp. 1-8.

10185. Tabatabai, Massoud Shojai. "Flight to Minus 28." *Kayhan Caricature*. June 2001, pp. 2-5.

10186. "XII Salón Nacional de Caricatura." *Quevedos*. February 2002, p. 23.

10187. Venéreo, Ricardo A. "Bienal de Humor de San Antonio de los Baños." *Quevedos*. July 2001, pp. 12-13.

10188. Venereo, Ricardo A. "Premios del Salón Nacional de Humor de la Unión de Periodistas de Cuba." *Quevedos*. February 2002, p. 22.

Comics

10189. Blanco de la Cruz, Caridad. "Cuadros." *Revista Latinoamericana de Estudios sobre la Historieta*. April 2001, pp. 31-45.

10190. Hernández, Roberto. "Dispositivo Didáctico para la Formación de Una Cultura Integral en la Historieta Cubana." *Revista Latinoamericana de Estudios sobre la Historieta*. March 2002, pp. 13-22.

10191. Lent, John A. "Strips uit Cuba." *Stripschrift*. July 2002, pp. 12-15.

10192. Mogno, Dario. "Parallel Lives: Comics and Animated Cartoons in Cuba from Beginning to Present." *International Journal of Comic Art*. Fall 2001, pp. 83-105.

Political Cartoons

10193. Lent, John A. "Cuban Political, Social Commentary Cartoons." In *Cartooning in Latin America*, edited by John A. Lent. Cresskill, New Jersey: Hampton Press, 2003.

Puerto Rico
Comics

10194. Fernández L'Hoeste, Héctor. "Resurrecting the Nation Through the Eyes of a Native: The Case of Turey el Taíno." *International Journal of Comic Art*. Fall 2002, pp. 70-83.

10195. Fernández L'Hoeste, Héctor D. "Resurrecting the Nation Through the Eyes of a Native: The Case of Turey el Taíno." Paper presented at Popular Culture Association, Toronto, Canada, March 16, 2001.

10196. Hitchcock, Eric. "Comics Shops Keep Puerto Rico Awash in Four Colors." *Diamond Dialogue*. June 2002, p. 54.

INDEX

Numbers in this index refer to entry numbers in the Bibliography.

ABOUT THE AUTHOR

JOHN A. LENT has taught at various universities in the United States and was a visiting lecturer at Shanghai University. He is the founder and editor of *The International Journal of Comic Art*.